Mastering the Olympus OM-D E-M1

CW00796454

Darrell Young (DigitalDarrell) is a professional nature and event photographer and an active member of Professional Photographers of America, North American Nature Photography Association, and Nikon Professional Services. He's been an avid photographer since 1968 when his mother gave him a Brownie Hawkeye camera.

Darrell is a full-time professional photographer with 35 years of experience in event shooting. He also produces commercial and editorial images for two major stock agencies. When Darrell writes a book on a particular camera, it is based on real-life experience with the camera in a production environment.

Living in the foothills of Great Smoky Mountains National Park has given Darrell a real concern for environmental issues and a deep interest in nature photography. You will often find him on the trails and byways of the Appalachian Mountains, standing behind a tripod with a beautiful landscape in view.

Darrell Young

Mastering the
Olympus OM-D E-M1

rockynook

Darrell Young (www.PictureAndPen.com)

Editor: Jocelyn Howell
Copyeditor: Jeanne Hansen
Layout: Petra Strauch
Cover Design: Helmut Kraus, www.exclam.de
Printer: Versa Press, Inc.
Printed in USA

ISBN 978-1-937538-54-5

1st Edition
© 2015 Darrell Young

Rocky Nook, Inc.
802 E. Cota Street, 3rd Floor
Santa Barbara, CA 93103

www.rockynook.com

Library of Congress Control Number: 2014959164

All rights reserved. No part of the material protected by this copyright notice may be reproduced or utilized in any form, electronic or mechanical, including photocopying, recording, or by any information storage and retrieval system, without written permission of the publisher.

Many of the designations in this book used by manufacturers and sellers to distinguish their products are claimed as trademarks of their respective companies. Where those designations appear in this book, and Rocky Nook was aware of a trademark claim, the designations have been printed in caps or initial caps. All product names and services identified throughout this book are used in editorial fashion only and for the benefit of such companies with no intention of infringement of the trademark. They are not intended to convey endorsement or other affiliation with this book. Adobe Photoshop™ and Adobe Lightroom™ are registered trademarks of Adobe Systems, Inc. in the United States and other countries.

While reasonable care has been exercised in the preparation of this book, the publisher and author(s) assume no responsibility for errors or omissions, or for damages resulting from the use of the information contained herein or from the use of the discs or programs that may accompany it.

This book is printed on acid-free paper.

This book is dedicated to:

My wife of many years, Brenda; the love of my life and best friend…

*My children, Autumn, David, Emily, Hannah, and Ethan,
five priceless gifts …*

*My mother and father, Barbara and Vaughn, who brought me into this world and
guided my early life, teaching me sound principles to live by …*

*The wonderful staff of Rocky Nook, including:
Gerhard Rossbach, Scott Cowlin, Ted Waitt, Joan Dixon, Jocelyn Howell,
and Matthias Rossmanith …*

My favorite copy editor, Jeanne Hansen …

And, finally, to Olympus, who makes the world's best mirrorless cameras and lenses.

Special Thanks to:

Brad Berger of **www.Berger-Bros.com** (800-542-8811) for helping me obtain an Olympus OM-D E-M1 early in its production cycle so that I could write this book. I personally buy from and recommend Berger-Bros.com for Olympus cameras, lenses, and accessories. They offer old-time service and classes for your photographic educational needs!

Table of Contents

Foreword

Dear E-M1 Owner,

The year 2008 saw the birth of the Micro Four Thirds format, pioneered by Olympus. At that time, only a handful of forward-thinking manufacturers embraced the new format and joined the consortium. Fast forward to 2015, and there are now 17 different manufacturers of cameras and lenses who have joined the consortium and are bringing high-value products to consumers! Our first OM-D model, the E-M5, was introduced in the first half of 2012. The OM-D E-M5 was our first mirrorless camera to incorporate a high-resolution and high-speed electronic viewfinder. It was an immediate hit with both photographers and editors and put the world on notice that mirrorless products were the future of imaging.

Of course, we continued to listen to our customers' demands, and in the fall of 2013 we introduced the OM-D E-M1—the flagship of the OM-D family. The E-M1 embodies all of the key attributes of the successful E-M5 and more. A newly developed sensor that supports phase detection autofocus allows photographers to utilize their highly acclaimed Four-Thirds lenses on a modern mirrorless body. Olympus continued to take advantage of the creative freedom that the interactive EVF allowed and expanded on creative features such as the "color creator" feature first seen in the E-M1.

Our philosophy at Olympus is "we don't stand still." We continually look to the future and continue to innovate. We were the first to bring technologies such as effective sensor dust-removal systems, live view electronic viewfinders, and articulating LCD monitors to digital cameras—technologies that are now commonplace in the market. Our ZUIKO lens manufacturing know-how is second to none and is an integral part of the OM-D system.

The OM-D E-M1 is packed with many advanced features that will be appreciated by serious photographers. I know this because I own and photograph with an E-M1. Not being a professional photographer, I am so grateful for Mr. Darrell Young and Rocky Nook for having produced this fine book! It is not only teaching me all of the deep and amazing features of this camera, it has shown me how to use this great photographic tool to realize some of the creative things I try to do with my photography.

Olympus deeply appreciates that you have chosen to make the OM-D E-M1 the photographic tool that you will use to "Capture Your Own Stories." Please enjoy this fine and informative book.

Thank you,

Hirohide "Harry" Matsushita
President, Olympus America Inc.
Consumer Products Group

Control Location Reference

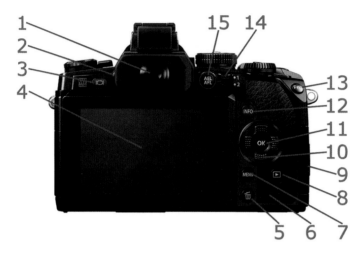

Figure 1: Back of camera body

1. Viewfinder (EVF)
2. Diopter adjustment dial
3. LV button
4. Monitor (Live view touch screen)
5. Erase button (Delete)
6. Speaker
7. MENU button
8. Playback button
9. Card slot cover (memory card)
10. Arrow Pad buttons
11. OK button
12. INFO button
13. Fn1 button
14. Lever
15. AEL/AFL button

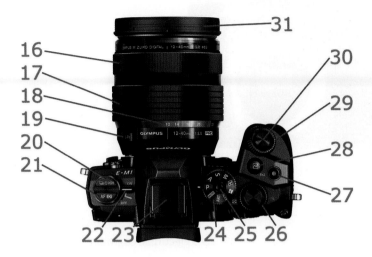

Figure 2: Top of camera body

16. Lens focus ring
17. Lens zoom ring
18. Lens zoom numbers (current focal length)
19. L-Fn button (only on certain lenses)
20. Sequential shooting/Self-timer/HDR button
21. AF/Metering mode button
22. On/Off lever
23. Hot shoe
24. Mode dial
25. Mode dial lock button
26. Rear dial
27. Movie button
28. Fn2 button
29. Front dial
30. Shutter button
31. Lens shade mount

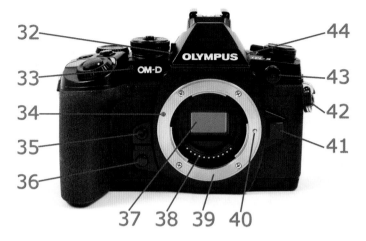

Figure 3: Front of camera body

32. Stereo microphone (right channel)
33. Self-timer lamp/AF illuminator
34. Lens attachment mark
35. One-touch white balance button
36. Preview button
37. Micro Four Thirds (4:3) Imaging Sensor (16 MP)
38. Lens electronic communication connectors
39. Lens bayonet mount
40. Lens lock pin
41. Lens release button
42. Strap eyelet
43. External flash connector (wired)
44. Stereo microphone (left channel)

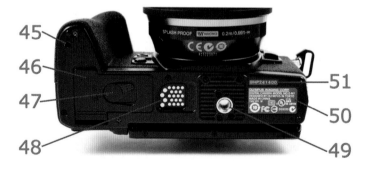

Figure 4: Bottom of camera body

45. Power battery holder (PBH) pin hole
46. Battery compartment cover
47. Battery compartment lock lever
48. Power battery holder electronic connectors (rubber cover removed)
49. Tripod socket
50. Camera ID plate
51. Serial number

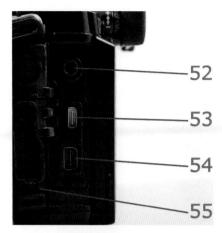

52
53
54
55

Figure 5: Camera external connector ports

52. Microphone connector
53. HDMI connector (Type C)
54. Multi connector (USB)
55. Rubber covers (held open)

Colors and Wording Legend

Throughout this book, you'll notice in the step-by-step instructions that there are colored terms as well as terms that are displayed in italic or bold font.

1. Blue is used to refer to the camera's physical features.
2. Green is for functions and settings displayed on the camera's screens.
3. *Italic* is for textual prompts seen on the camera's LCD screens.
4. *Italic* or **bold** type is also used on select occasions for special emphasis.

Here is a sample paragraph with the colors and italic font in use:

Press the MENU button to open Shooting Menu 1, and then scroll to the Card Setup option by pressing the right Arrow pad button. Select Format and choose Yes from the menu. *All images on Memory card will be deleted.* Press the OK button to format the memory card. See page 131 in the **Shooting Menu 1** chapter, under the **Card Setup** heading for deeper information.

With Card Setup highlighted, you can press the Info button to use the camera's menu help system. The help system will inform you of the purpose of the Card Setup function, with the following explanation: *Delete all pictures in the memory card or format the memory card.*

1 Camera Setup and Control Reference

Image © Darrell Young

Congratulations! You've purchased, or are about to purchase, Olympus's professional-level, mirrorless, interchangeable lens, Micro Four Thirds format camera: the OM-D E-M1.

While no professional digital camera is inexpensive, the E-M1 provides passionate photographers with a camera that has excellent resolution, an interactive electronic view-finder, easy-to-use physical controls, and deep custom menu configurability, all at an attractive price. The E-M1's strong, magnesium-alloy body is also weather sealed, dust sealed, and freeze proof. It should remain a reliable camera for years of faithful service.

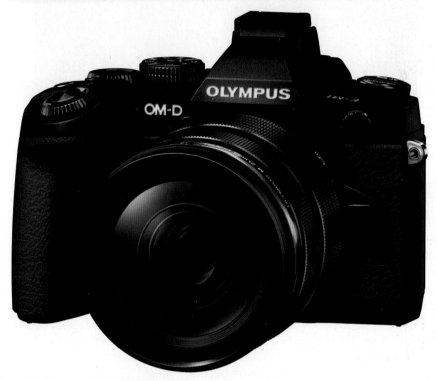

Figure 1.1: Olympus OM-D E-M1 front view

The small size of the camera allows great portability for a full photography system. The entire system—including lenses, a battery pack, a flash unit, and accessories—can be contained in a small camera bag, allowing you to carry a full range of equipment without wearing yourself out.

The 16.3-megapixel imaging sensor, interactive electronic viewfinder, tilting and touch live view display screen, 10 frames-per-second shooting rate, 5-axis image stabilization, contrast and phase detection autofocus, and Digital ESP metering system allow you to take complete creative control of the scene in front of your lens.

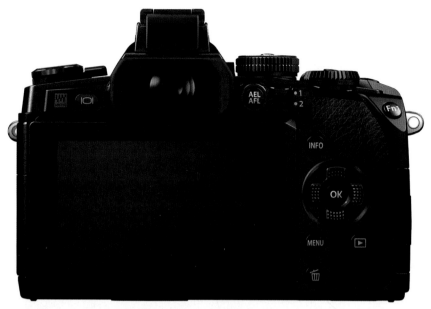

Figure 1.2: Olympus OM-D E-M1 back view

The E-M1 is one of the most configurable cameras ever created. The deep menu system allows for custom configuration, making the E-M1 an ideal camera for photographers who want absolute control over every aspect of their photography. On the other hand, the camera offers fully automatic modes that allow a new photographer to create outstanding images without excessive camera setup. You can start with the E-M1 as a new photographer and grow into the camera, gradually learning about custom features and relying less on automatic features over time. Or as an experienced photographer, you can take immediate control of every aspect of digital photography with full camera cooperation and assistance.

This book will explore your incredibly feature-rich camera in great detail, using everyday language. We will cover virtually every button, dial, switch, and menu setting, giving you how, when, and why information so that you can become a master of your new, powerful imaging instrument. Your passion for excellent photography can be fully expressed with your E-M1. Let's take control of it!

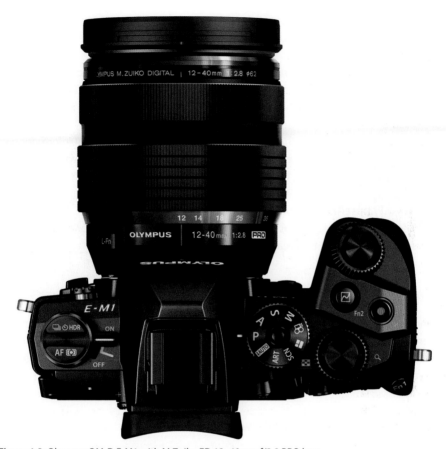

Figure 1.3: Olympus OM-D E-M1 with M.Zuiko ED 12–40mm f/2.8 PRO lens

How to Use This Book

The upcoming sections and chapters are best read with your camera in hand, ready for configuration. There are literally hundreds of things to configure on this advanced, mirrorless interchangeable-lens compact (MILC) camera.

This chapter will give new E-M1 users a place to start. Later, as you progress through the book, we'll look at all the buttons, switches, dials, and menu settings in detail. You will be able to fully master the operation of your Olympus OM-D E-M1.

This book is a super user's manual that goes way beyond the small manual that comes with the camera. It covers not only how a certain function works (like the basic manual), but also when it is best to use certain features and why the features are best configured in particular ways. You will find a Settings Recommendation feature at the end of most sections, in which I offer suggestions for the best use of the various setting choices for different styles of photography.

There is an individual chapter for all the visual display touch screens and for each menu system in the camera, giving you a detailed examination of virtually every aspect of the camera's control systems.

Because the E-M1 is a camera made primarily for advanced and professional users, this book assumes you have knowledge of basic things like depth of field; lens focal length and angle of view; and how the aperture, shutter speed, and ISO sensitivity control exposure.

If you need to brush up on these subjects, you can find a lot of helpful information in my book *Beyond Point-and-Shoot*. It assumes absolutely no previous knowledge of photography and covers the basics for new users of MILC and DSLR cameras. You can find out more about *Beyond Point-and-Shoot* at my website:
http://www.PictureAndPen.com/BeyondPS

I sincerely hope this book is useful to you and greatly expands your understanding of your new Olympus OM-D E-M1 camera.

Charge the Battery

When you first open the box that contains your new E-M1, you should charge the camera's battery. The battery may have enough life in it for an hour or two of use, so it may not be critical to charge it immediately. However, for extended configuration and use, it is best to have a fully charged battery in the camera.

Super Control Panel or Live View Screen?

When you turn your new camera on, the first screen that appears on the rear monitor is the Super Control Panel (figure 1.4, image 1). This panel allows you to control things like the shutter speed, aperture, ISO, autofocus, and several other key camera functions. It is a very convenient screen, and we will consider it in detail in the chapter **Screen Displays for Camera Control**.

When the Super Control Panel is displayed on the monitor, you will need to use the electronic viewfinder (EVF) to compose your pictures. If you want to use the Live View screen (figure 1.4, image 3) to compose your pictures instead of the EVF, you will need to press the LV button (figure 1.4, image 2). My camera's Live View screen is displaying my current subject, a battery and some Lego blocks in my light tent. The LV button toggles between the Super Control Panel and the Live View screen, as shown in figure 1.4.

While the Super Control Panel is active you can use the EVF to compose and take pictures. While the Live View screen is active you can use either the Live View screen or the EVF to compose and take pictures.

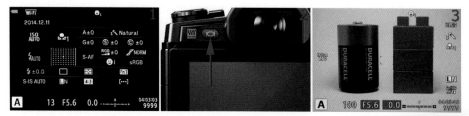

Figure 1.4: Switching between the Super Control Panel and Live View screen with the LV button

If the Live View screen is active and you place your eye near the viewfinder, the E-M1 will instantly switch the subject display to the EVF and turn off the Live View screen. When you remove your eye from the EVF, the camera will immediately turn off the EVF and turn on the Live View screen.

Settings Recommendation: If you prefer to compose your images with the viewfinder and not hold the camera out at arm's length to compose with the Live View screen, you may want to leave the Super Control Panel active to have quick access to its settings. To use the Super Control Panel, press the OK button. However, if you like to compose with the rear monitor (Live View), then you may want to leave the Live View screen active.

Firmware 2.0 and 3.0 Updates

In October 2014, Olympus released a major firmware update for the Olympus OM-D E-M1. This update added a considerable number of new features and refined a number of older features. We delayed the publication of this book for several weeks so that we could include the features found in firmware update 2.0.

Additionally, in February 2015, firmware update 3.0 was released. This update increased the camera's Sequential L (Low) burst shooting rate from 6.5 fps to 9 fps, with autofocus (AF) and potentially more efficient subject tracking. Sequential H (High) fires the shutter at 10 fps with *no AF* (use S-AF mode), and with firmware update 3.0, Sequential L shoots at 9 fps *with AF* (use C-AF mode). See page 194 for more information on Sequential H and L burst shooting modes, and page 274 for information on S-AF and C-AF modes.

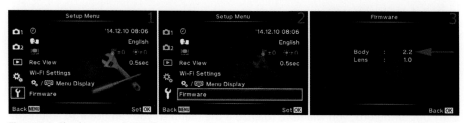

Figure 1.5: Checking your E-M1's firmware version

Please use the following steps to check your camera's firmware version:

1. Press the Menu button and scroll down to the Setup Menu (figure 1.5, image 1; the icon that looks like a wrench on the left side of the screen). You will see the menu name at the top of the screen. Now scroll to the right with the Arrow pad (the buttons surrounding the OK button on the back of the camera).
2. Select Firmware from the Setup Menu and scroll to the right (figure 1.5, image 2).
3. Notice the firmware version listed next to Body. Figure 1.5, image 3, shows firmware 2.2 (red arrow). This book is not concerned with the Lens firmware version, just the Body version.

If your camera does not have Body firmware 2.0 or greater installed, it is important that you update your camera's firmware before proceeding. This book is based on firmware 3.0. If your camera is running an earlier version of the firmware, some of the screens, menu choices, and functions discussed in this book will not be available.

Because earlier versions of Body firmware are a subset of firmware 2.0, this book will cover all the features found in your camera for earlier firmware versions. However, you will see features mentioned in this book that your camera does not currently offer.

Upgrading the firmware is an automated process and requires little knowledge on your part. You can download the free Olympus Digital Camera Update software at this website: **http://www.olympusamerica.com/cpg_section/cpg_downloads_updater.asp**

To load the firmware update software provided by Olympus onto your camera, plug the camera into your computer with the included USB cable, select Storage from the camera menu, and follow the instructions found on your computer screen.

Please make sure that the battery in your camera is fully charged before starting the firmware update, and do not disconnect the USB cable or turn off your camera during the firmware update or it may become inoperable.

Since the October 2014 firmware 2.0 update release, there have been three more updates. At the time of this book going to press the camera has had two "bug fix" updates and the Sequential L update (9 fps vs. 6.5 fps, with active AF). My E-M1 is currently running firmware version 3.0 for the camera body.

Enable the Custom Menu System

The camera includes a Custom Menu that initially is not displayed on many E-M1 cameras. The Custom Menu is composed of over 100 items that you can use to customize how your camera works.

If the Custom Menu does not show up in the list of menus when you take your new E-M1 out of the box, you will have to enable the menu so you can use it to adjust the camera's Custom functions.

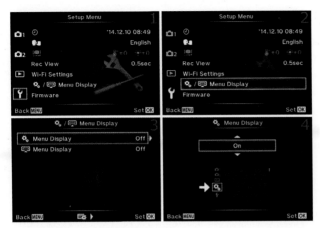

Figure 1.6A: Enabling the Custom Menu

If you press the Menu button and can count five menu icons on the left side of the screen, including one icon that looks like a couple of small gears, your camera's Custom Menu is already enabled. If you see only four menus on the left, use the following steps to enable the very important Custom Menu system:

1. Scroll down to the Setup Menu, the fourth menu on the left (figure 1.6A, image 1). The Setup Menu has a wrench icon. Highlight it and scroll to the right.
2. Scroll down with the down Arrow pad and highlight Menu Display on the Setup Menu, then scroll to the right (figure 1.6A, image 2).
3. Choose the first Menu Display selection, the one with the small gears icon on the left, and then scroll to the right with the Arrow pad (figure 1.6A, image 3).
4. Press up or down until On appears in the up/down menu (figure 1.6A, image 4).
5. Press the OK button to Set the Custom Menu to active so that it will be displayed on the menu system.

Note: The second menu selection shown in figure 1.6, image 3, will not be enabled by the majority of E-M1 owners. It is for a mostly obsolete Peanut image storage and transfer device that was in use some years ago for Olympus cameras. Unless you own the Peanut device, please ignore the second Menu Display setting.

When the Custom Menu is fully enabled it will become the fourth selection down on the left side of the menu system screen (figure 1.6B, red arrow). The Setup Menu (wrench icon) will become the fifth selection.

Figure 1.6B: The Custom Menu gears icon

Initial Camera Configuration

When you first acquire a new or used E-M1 camera, you will want to configure or at least check the camera's date, time, and location, along with several other functions that all new camera users should set up according to their needs. This section lists the most important camera settings for immediate configuration.

This section is not comprehensive because there are literally hundreds of settings you can customize and configure on the E-M1 camera. However, let me suggest some of the more important settings you may want to consider configuring before shooting for the first time.

Instead of repeating material found elsewhere in the book, I've listed the menu setting and the page number where you can find deeper information about that function. Place a bookmark here until you have examined and configured these basic functions. Afterward, you can use the camera for active picture-taking while you are studying its many features in this book.

Here are the most critical functions for immediate configuration:

- *Date and Time:* Page 454
- *Language:* Page 456
- *ISO:* Page 366–370
- *Metering mode:* Page 45
- *White balance mode:* Page 396
- *Color Space:* Page 407
- *Picture Mode:* Page 136
- *Super Fine (SF) JPEG mode:* Page 393
- *Still Picture image format:* Page 175
- *Autofocus mode:* Page 274
- *Manual focus assist modes:* Page 285
- *Image Stabilizer:* Page 198
- *Face Priority for autofocus:* Page 291
- *Autofocus illuminator light:* Page 290
- *Frames per second speed:* Page 194
- *High ISO Noise Filtration:* Page 365
- *Long Exposure Noise Reduction:* Page 363
- *Beep sound:* Page 359
- *Image review timeout:* Page 458
- *Image display rotation:* Page 238
- *Grid display:* Page 431
- *Low battery warning level:* Page 445
- *Touch Screen activation/deactivation:* Page 447
- *Playback screen types (image review)*: Page 334
- *Live View screen types:* Page 338

- *Copyright and Artist Name for image metadata:* Page 419
- *Image file naming system:* Page 414
- *Eye detection sensor:* Page 432
- *Button function configuration (takes some time)*: Page 296
- *Connection to your smart phone or tablet:* Page 459

Now that you have configured your camera's initial functions, let's examine the various buttons, dials, and switches on the camera and briefly discuss the functionality of each one.

Camera Control Reference

This camera control reference is designed to help you locate and understand the purpose of each of the buttons, dials, and levers on the camera.

Many (if not most) of the buttons on the camera can be configured to offer alternate functionality. In fact, the E-M1 is *the* most configurable camera I have used in over 40 years of photography. You can truly customize this camera to work the way you prefer, for both external controls and internal functions.

If you have a problem locating one of these buttons, please refer to the **External Control Location** section in the beginning of this book.

Let's examine each of the external camera controls in alphabetical order. We will examine each of the internal functions in later chapters.

Buttons

 AEL/AFL button: The AEL/AFL button is fully programmable and can accept tasks listed in the Appendix. You can find instructions for how to assign a task to the AEL/AFL button on page 299. Its factory default task is AEL/AFL, which locks autoexposure (AEL) and autofocus (AFL) when you press the button, and unlocks it when you press it again.

 AF/Metering mode button: This button allows you to control the type of light meter and autofocus the camera will use. Press the button and turn the Front Dial to control the metering type. Press the button and turn the Rear Dial to control the autofocus modes. There is a limited amount of programmability for these two buttons, tied in with the Lever functions in the Custom Menu, as described on page 319.

 Arrow pad buttons: The Arrow pad buttons are normally used to scroll through camera menus, pictures, and various screens. The Arrow pad has four buttons, including one each for up, down, left, and right. As you read through the instructions for configuring many of the camera functions in this book, you will often read "scroll to the right," or some other direction. This is a reference to using the Arrow pad

buttons. The Arrow pad buttons have some programmability through Custom Menu functions, as described on page 304. You can select from as many as eight tasks for the right and down Arrow pad buttons. These tasks are listed in the Appendix.

Erase button: When you want to rid your camera's memory card of an un-needed picture or video, you can display it on the rear monitor, press the Erase button, answer Yes to the query, and press the OK button to delete the picture. This is not a programmable button.

Fn1 button: The Fn1 button is fully programmable and can accept tasks listed in the Appendix. You can find instructions for how to assign a task to the Fn1 button on page 297. Its factory default task is [•••] AF Area Select, which lets you choose an autofocus (AF) point to use during autofocus from among the camera's 81 AF points with a Micro Four Thirds lens, or 37 AF points with a Four Thirds lens.

Fn2 button: The Fn2 button is fully programmable and can accept tasks listed in the Appendix. You can find instructions for how to assign a task to the Fn2 button on page 298. Its factory default task is Multi Function, which lets you choose from one of four specialized functions—Highlight&Shadow Control, Color Creator, Magnify, and Image Aspect—by holding the button and rotating the Rear Dial.

Info button: The Info button is used to enable or disable the menu help system. It is also used to scroll through and select various screen overlays for Live View or EVF shooting (e.g., Live Histogram, Level). Throughout this book, you will find that the Info button is used to choose various individual items within groups of items. This is not a programmable button.

Lens release button: This non-programmable button has one function: releasing the lens lock so that you can change lenses. To remove a lens, press and hold the Lens release button while turning the lens in a counter-clockwise direction until it stops. Then pull the lens straight out of the body. To mount a different lens, do not press the Lens release button. Insert the new lens by matching the orange dot on the top of the lens with the orange dot on the left side of the camera's lens mount. Turn the lens in a clockwise direction, without forcing it, until it clicks. It should turn very easily. The camera and lens is then ready to use.

LV button: The LV button was discussed in a previous section of this chapter titled **Super Control Panel or Live View Screen**, on page 6. The button is used to toggle between the Super Control Panel and the Live View screen on the rear monitor. It is also used to access the Flash Remote Control panel for wirelessly controlling multiple external flash units when *Shooting Menu 2 > [Flash] RC Mode* is set to On, as described on page 222. This is not a programmable button.

 Menu button: The Menu button is primarily used to access the menu systems (e.g., Shooting Menu 1, Setup Menu, Custom Menu). Press the Menu button when the rear monitor is active and the Menu system will open. Scroll up or down with the Arrow pad buttons to select one of the camera's menus, and then scroll to the right to access that menu. The Menu button is often used to cancel actions, and to return to the main menu from within a function. This is not a programmable button.

 Mode dial lock button: This button is used for one thing only: to lock the Mode dial so that it cannot accidentally be moved from the current Mode dial setting (e.g., P, S, A, M). It works like the button on a retractable ball-point pen. Press it once to lock the Mode dial and press it again to unlock the Mode dial. This is not a programmable button.

 Movie button: The Movie button is fully programmable and can accept tasks listed in the Appendix. You can find instructions for how to assign a task to the Movie button on page 299. Its factory default task is REC, which is used to start and stop the camera's video recording functions.

 OK button: The OK button is used extensively to confirm configurations of camera functions. It can also be used to choose items. When you are done configuring a camera setting you will usually need to press the OK button to lock in your changes. You can also press the OK button to open the Live Control when the Live View screen is showing your subject. The Live Control allows you to select many of the camera's most important settings along the right side of the screen. You can use the Arrow pad or camera dials to configure the selected Live Control item. Additionally, you can edit images by pressing OK when a picture is on the screen. This is not a programmable button.

 One-Touch White Balance button: This button is fully programmable and can accept tasks listed in the Appendix. You can find instructions for how to assign a task to the One-touch WB button on page 300. Its factory default task is One-touch WB, which lets you immediately take a white balance reading from a white or gray card and store it in one of the four Capture WB custom white balance storage areas, as described on page 497.

 Playback button: This non-programmable button is for reviewing images and movies. You will press this button to examine images and videos saved on the camera's memory card. When you take an image, the camera defaults to a half-second display of an image after taking it. Therefore, unless you increase the image display time, which could interfere with using the EVF for follow-up shots (the just-taken image will display in the EVF), you will use the Playback button often to examine your images and videos.

 Preview button: The Preview button is fully programmable and can accept tasks listed in the Appendix. You can find instructions for how to assign a task to the Preview button on page 301. Its factory default task is Preview, which lets you see the depth of field for the current aperture setting as you look at the EVF or Live View screen.

 Shutter button: The Shutter button is primarily used to release the camera's shutter to take a picture (full press). It is also used to initiate autofocus (half press). The autofocus function can be relegated to the AEL/AFL button instead of the Shutter button for back-button focusing, as described on page 282.

 Sequential shooting/Self-timer/HDR button: This button allows you to control the camera's high dynamic range (HDR) system, along with the Sequential shooting frames-per-second rate (fps) and self-timer. Press the button and turn the Front Dial to control the HDR system. Press the button and turn the Rear Dial to control the Sequential shooting fps rate or to select the self-timer. There is a limited amount of programmability for these two buttons, tied in with the Lever functions in the Custom Menu, as described on page 319.

Next let's consider each of the cameras four dials and what they do.

Dials

 Diopter adjustment dial: The Diopter adjustment dial changes the optical power of a lens that's located in front of the camera's EVF so that you do not strain your eye when you are looking into the viewfinder. It works sort of like a pair of glasses to bring the image you see on the EVF into sharper focus for your eye; however, it does not correct for astigmatism. If you look into the EVF and feel eyestrain or get a headache after using it, you should adjust the Diopter adjustment dial until the view is comfortable for you. You may have to use a different diopter setting for each eye.

 Front Dial: The Front Dial changes the aperture setting when the camera is set to Manual (M) mode on the Mode Dial. In other modes it is usually used to set +/- Exposure compensation. You can also use the Front Dial to zoom in and out of images displayed on the rear monitor. The Front Dial is sometimes used to select a single item from a list of items, such as subfunctions in the camera's menus. The Front Dial has a measure of programmability, as described on page 309 under the Custom Menu's Dial Function. You can change which dial (Front or Rear) does what, and which direction you turn it to accomplish its task.

 Mode Dial: The E-M1 is a multimode camera. It has a Mode Dial on top that allows you to change how the camera works. You can select from modes that turn your camera into a fully automatic (iAUTO), point-and-shoot camera, or a fully manual (M), user-controlled camera, or various modes in between. In addition to

the normal P, S, A, and M exposure modes, the Mode Dial offers various specialty modes including: ART mode (exotic filters), SCN mode (scene modes for inexperienced photographers), Photo Story mode (multi-image assembly), and Movie mode (video recording). Some of the modes on the Mode Dial can be programmed to a degree with the Dial Function of the Custom Menu, as described on page 301. However, the Mode Dial itself is not programmable.

 Rear Dial: The Rear Dial changes the shutter speed setting when the camera is set to Manual (M) mode on the Mode Dial. In other modes it is used to set the current controllable setting. For instance, when you use Aperture-priority (A) mode on the Mode Dial, you will use the Rear Dial to set the aperture. When you use Shutter-priority (S) mode on the Mode Dial, you will use the Rear Dial to set the shutter speed. When you are examining an image on the monitor, you can use the Rear Dial to advance to the next image or go back to the previous image. The Rear Dial can also be used as a substitute for the Arrow pad buttons when moving in and out of functions in the camera's menus. The Rear Dial has a measure of programmability, as described on page 310 under the Custom Menu's Dial Function. You can change which dial (Front or Rear) does what, and which direction you turn it to accomplish its task.

Finally, let's consider each of the camera's two levers and what they do.

Levers

 Lever: This Lever is designed to give the camera more than one basic way of doing things. You can configure some of the camera's functions to work one way when the Lever is set to position 1 and another way when the Lever is set to position 2. This is a programmable lever, with specific functionality, as described on page 318.

 On/Off lever: This non-programmable lever has only one purpose: turning the camera on and off. If left in the On position, the camera will turn itself off after a specific period of time, which you can set with the *Custom Menu > D. Disp/[Sound]PC > Auto Power Off* function, as described on page 358. If the camera has shut down while the lever in in the On position, you will have to move the lever to the Off position and then back to On to bring the camera back to life.

Unusual Icons in Menu Names

Olympus uses unusual icons in some of its camera menus, in some cases making it hard to understand exactly what a menu selection means. For instance, in figure 1.8 you can see an icon that represents image quality at the point of both arrows in images 1 and 2.

Figure 1.8: Unusual icons in menu names

You will see several icons of this type spread throughout the camera's menu system. Some will be intuitive and others not. Because I do not have access to the Olympus icons, I have substituted words where an icon is used.

For example, the icon that represents the camera's image quality (figure 1.8) is called Record Mode by the Olympus user's manual. Therefore, when I refer to the image quality menu in this book I will use the words Record Mode in brackets, like this: [Record Mode].

In figure 1.8, image 2, you can see the same odd graphic used in a menu item that contains several more names. When I refer to the menu shown at the point of the red arrow in image 2, I will use: G. [Record Mode]/Color/WB.

Throughout the book, when you see a word in brackets as part of a menu name or function name, please remember that the word is used in place of the icon and represents the specific functionality that the icon is supposed to impart.

Contacting the Author

If you would like to contact me directly to comment on the book, ask questions, or report errata, please use the contact link at my website:
http://www.PictureAndPen.com
You can also join my non-public Facebook group, **Master Your Olympus** (MYO), at the following web address:
https://www.facebook.com/groups/MasterYourOlympus/
Additionally, I have created a public Facebook site that allows members to freely associate with general Olympus camera users. It is called **Olympus Digital Camera & Photo Enthusiasts** (ODCPE), and is found here:
https://www.facebook.com/groups/ODCPE/
These two Facebook groups, one private and one public, will allow us to stay in touch, display photographs created with our Olympus cameras, and learn from each other.

You will find a series of downloadable resources for this book, along with a list of any errata corrections, at the following website:
http://www.rockynook.com/OlympusEM1

Author's Conclusion

Now that we have completed some basic camera configuration and discussed the external controls on the E-M1, let's proceed into a detailed examination of the camera's various control screens. Many of these screens have selections that are touch sensitive, allowing you to choose that setting either with a touch of your finger or by using the Arrow pad keys and scrolling around.

2 Screen Displays for Camera Control

Image © Darrell Young

The Olympus OM-D E-M1 has very deep text menus to configure hundreds of camera settings, which we will consider in other chapters. The camera also has quite a few visual and touch screen displays for people who want to make basic camera adjustments with the built-in Live View monitor and touch screen.

The E-M1 is unusual in that it presents you with multiple ways to configure your favorite settings. Many settings can be adjusted visually, with the screens discussed in this chapter, or by using the text-based menu system. In some cases the menus let you configure things more deeply and offer more settings than the visual screens. Therefore, as we discuss the individual settings on the visual touch screens in this chapter, there will often be references to later chapters with even deeper configuration settings in the menus.

We will also explore various controls that allow the camera to use the visual side of the user interface, such as the Exposure (P, S, A, M), Scene (SCN), iAUTO, and Art modes; Photo Story; the video recording system; high dynamic range (HDR) imaging; and the Metering system.

To start our exploration of the camera's visual touch interface, let's first examine the important touch screens you may use nearly every time you take pictures, depending on your style of photography.

> **Note:** In the other chapters of this book, I use numbered, step-by-step instructions to describe how to use the menu screens and subfunctions. In this chapter, I use paragraphs instead of numbered steps because describing how to use a visual screen requires a lot of words. Using the step-by-step method would not have allowed me to break some of the long, descriptive paragraphs into sections, and would have made the text difficult to read.

Super Control Panel

The Super Control Panel (figure 2.1A) is one of the first screens the camera will display when a new E-M1 is turned on for the first time.

As described in chapter 1, **Camera Setup and Control Reference,** you will need to set the camera's date as one of the first steps. The red arrow in figure 2.1A points to the date. When you first turn

Figure 2.1A: The Super Control Panel

on the camera it will list the month, day, and year in this location (abbreviated and in the form most used in your geographic area).

The Super Control Panel is a visual form of a few of the camera's text menus, exposing some important settings for easy access. It contains 21 settings or functions that you can adjust, and each of them has a secondary screen. To access the Super Control Panel if it is not displayed on the rear monitor, simply press the LV button at the left of the viewfinder.

The Super Control Panel defaults to AF Area mode, which allows you to select one of the 81 AF points for targeted autofocus when you use a Micro Four Thirds lens (37 AF points with an older Four Thirds lens). Therefore, if you simply press the left or right keys on the Arrow pad when the Super Control Panel is active, you may find that the camera has changed to AF Area mode and displays a grid of 81 AF points on the screen. If that happens, select the middle AF point and press the OK button, which will return you to the Super Control Panel. We will discuss AF Area mode later in this section.

Using camera controls

When the Super Control Panel is active, press the OK button, and one of the settings, usually ISO, will be highlighted. When any function is highlighted, you can scroll around the Super Control Panel with the Arrow pad keys until the function you want to adjust is highlighted.

When a function is highlighted you can either turn the Front Dial to see the choices scroll by in the highlighted area, or you can press the OK button to enter the secondary screens for that Super Control Panel function.

Using the touch screen

If you prefer, you can use the touch screen to access the features on the Super Control Panel. If nothing is highlighted on the Super Control Panel, you must double-tap the screen to wake it up. When it is awake, simply touch one of the settings to highlight it. Double-tapping a setting will open a secondary screen in which you can make adjustments. Secondary Super Control Panel screens are not touch sensitive, so you must use normal camera controls (e.g., Arrow pad, Front Dial, and OK button) to change the settings. We will discuss this in more detail under the **Touch Screen** subheading, on page 76, later in this chapter.

Let's examine each of the functions in the Super Control Panel.

ISO Sensitivity

The ISO function changes the camera's sensitivity to light. The higher the ISO, the greater the sensitivity, and vice versa. Higher ISO sensitivities can add grainy digital noise to the darker areas of your image; therefore, keep the ISO as low as possible for the current lighting conditions.

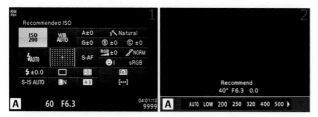

Figure 2.1B: Choosing an ISO sensitivity value or AUTO

The camera recommends ISO 200 as a base—you will see Recommended ISO displayed on the Super Control Panel and Recommend displayed on the secondary screen when you have ISO 200 selected (figure 2.1B). Of course, the ISO is variable, and you can change it to meet your needs.

To access the ISO sensitivity function, use the Arrow pad keys to highlight the ISO position, as shown in figure 2.1B, image 1. You can turn the Front Dial to select a new ISO sensitivity value, or you can press the OK button to enter the secondary ISO screen (figure 2.1B, image 2).

When the secondary ISO screen is active you will see a range of ISO sensitivity values at the bottom of the screen (figure 2.1B, image 2). Use the Arrow pad keys to scroll left or right and select an ISO sensitivity value, which will be highlighted. In figure 2.1B, image 2, you can see that 200 is selected. The range of ISO values runs from LOW (ISO 100) to ISO 25600. You can also select AUTO, which allows the camera to select an ISO value depending on the ambient light conditions. AUTO is a great choice when you do not have time to adjust the ISO yourself. However, be aware that the camera will use high ISO values to get the picture in dark conditions, regardless of whether ISO noise is introduced. For the best quality, control the ISO sensitivity yourself.

When you have selected the ISO sensitivity value you want to use, press the OK button and the camera will return to the Super Control Panel with nothing selected.

Note: Olympus considers ISO 100 (LOW) to be an extended ISO value in the E-M1. The recommended base ISO is 200. When LOW is selected you will see ISO Extension displayed on the main Super Control Panel and Extension displayed on the secondary ISO screen. This simply means that LOW approximates ISO 100, which is outside the normal ISO range for the camera. Do not worry, ISO LOW works great, and I use it much of the time to capture low-noise images when the ambient light allows it.

Settings Recommendation: I usually leave my camera set to ISO 200, and I find that it has low noise for everyday photography. When I shoot landscapes on a tripod, I often set it to LOW (ISO 100). The camera does well up to about ISO 1600, even though the Micro Four Thirds sensor is small. I would use ISO values above 1600 only in emergencies because the noise levels may become objectionable. You should test this for yourself to see where your noise tolerance lies.

White Balance

The E-M1 offers a wide range of preset white balance (WB) values, plus several custom WB settings, for a total of 13 WB settings.

As you may know, WB affects how the image records color in the ambient light. White should record as white; it should not have a tint. Other colors should be recorded as they appear in real life.

This is a very important setting for people who shoot JPEG files. It is difficult to change the hue of a JPEG image after the fact, and the change lowers the quality of the image due to compression losses when the file is modified and saved more than once.

A photographer who shoots in RAW does not have to worry as much about WB because it can be changed after the fact in computer software, with no damage to the image. However, it is still good for RAW shooters to use the best WB because it saves time in the post-processing workflow (the digital darkroom).

Let's see how to select a WB value from the Super Control Panel.

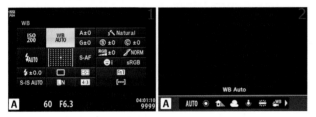

Figure 2.1C: Choosing a WB type

First let's examine where the WB function is located on the Super Control Panel. It is highlighted in figure 2.1C, image 1. Use the Arrow pad keys to select that setting, and press the OK button to enter the secondary WB screen. Alternatively, you can turn the Front Dial to scroll through the 13 WB values shown at the bottom of the secondary screen without entering the secondary screen.

On the secondary screen you can select a WB value by scrolling left or right with the Arrow pad keys to highlight the WB value you want to use then pressing the OK button to lock in a value. I chose AUTO (figure 2.1C, image 2).

There are several preset WB values, as follows (in order of appearance on the screen): AUTO WB; five named WB values for specific light types (Sunny, Shadow, Cloudy, Incandescent, Fluorescent); an Underwater WB; a Flash WB; four custom Capture WB values that you can use for ambient light readings from a gray or white card; and CWB (custom white balance), which allows you to directly set a Kelvin (K) WB value from 2000 (cool blue) to 14000 (warm red). For a detailed study of each of these WB types, see the **Custom Menu** chapter under the *Custom Menu > G. [Record Mode]/Color/WB > WB* function on page 396. The Super Control Panel WB screen is a lite version of the function settings provided in the WB Custom Menu, as discussed on page 396. In this chapter we will discuss how to select settings. In the **Custom Menu** chapter we will discuss how, why, and when.

Fine-Tuning the WB

Notice the A±0 and G±0 selections to the right of the WB function in figure 2.1D, image 1. These selections allow you to fine-tune the currently selected WB value if you want to change the hue. A stands for amber, and G stands for green.

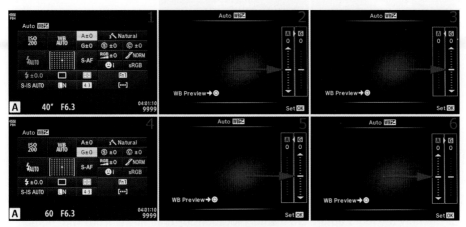

Figure 2.1D: Fine-tuning the amber and green white balance settings

Referring to figure 2.1D, select either the A±0 setting (image 1) or the G±0 setting (image 4) and press the OK button to enter the secondary screen. To adjust the A±0 or G±0 setting, use the screens shown in images 2 and 3, or 5 and 6 (respectively).

In image 2 the red arrow is pointing to the adjustment indicator for the A setting. The A±0 amber setting can be fine-tuned over a range of 14 increments (A+7 to A-7). Move the yellow bar shown at the point of the red arrow up (+) or down (-) with the Arrow pad keys. Press the Movie button to take a temporary picture with the new setting and display it on the screen. If you like the adjusted hue, press the OK button to Set the new value for the A (amber) fine-tuning value. In a similar manner, adjust the G (green) setting (image 3). You can reset the fine-tuning by returning the yellow indicator bar back to 0 for both A and G.

Repeat the previous instructions for the G±0 setting (figure 2.1D, images 4–6).

Capture WB Ambient Light Reading

Let's examine how to do an ambient light reading from a white or gray card under the current light source and assign it to one of the four Capture WB memory locations for taking pictures later under the same light source.

In figure 2.1E, image 1, the first of four Capture WB values has been selected by turning the Front Dial. Use this setting to select a previously created Capture WB ambient light reading or to create a new one and save it in a Capture WB memory location. If you have not yet created any Capture WB readings, read the following paragraphs.

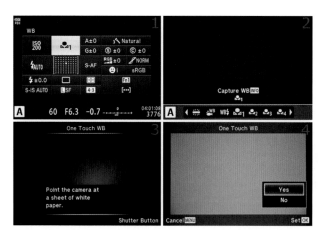

Figure 2.1E: Capturing an ambient WB reading from a gray or white card

To create and store a new Capture WB value, press the OK button when WB is selected on the Super Control Panel. Now scroll to one of the four Capture WB memory locations. You can identify the four Capture WB memory locations by their flower icons with numbers 1–4 (figure 2.1E, image 2). Notice also in image 2 that INFO is displayed after the Capture WB label. If you press the Info button while one of the Capture WB memory locations is selected, the camera will prepare for a Capture WB reading from a white or gray card.

Figure 2.1E, image 3, shows the screen that appears next. It tells you to *Point the camera at a sheet of white paper.* You can also use a standard gray card. After you have positioned the white or gray card in front of the lens, press the Shutter button to take a picture. The camera does not store the picture on the memory card. Instead, it makes an accurate WB reading from the white or gray card. The camera will not attempt to focus on the card; it will simply fire the shutter.

Note: If the camera cannot successfully make a Capture WB reading, it will display the following message to let you know the reading was unsuccessful: *X [Flower icon] WB NG Retry.*

Figure 2.1E, image 4, shows the screen after a successful Capture WB reading has been made. You can now decide whether you want to store the WB reading in the currently se-lected Capture WB location. To store the WB reading select Yes and press the OK button. If you do not want to save it, select No and press the OK button, or press the Menu button to cancel.

Your new Capture WB reading is now stored in the memory location you selected and has been applied to the camera for immediate or later use.

CWB Custom WB Kelvin Value

If you know how to use direct Kelvin (K) WB values and want to input your own custom white balance (CWB), you can input a range from 2000 K (cool) to 14000 K (warm), which is a significantly broader range than many other camera brands. Let's see how it works.

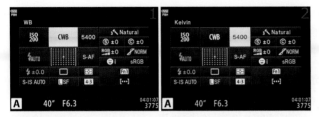

Figure 2.1F: Creating a custom white balance (CWB) reading

Select CWB by highlighting the WB function and turning the Front Dial until CWB appears (figure 2.1F, image 1).

Scroll to the right to select the K value (figure 2.1F, image 2), and rotate the Front Dial to select a K value between 2000 K (cool blue) and 14000 K (warm red). I chose 5400 K.

Press the OK button to lock in the CWB setting.

An alternate way to set a CWB value is to use the WB secondary screen, as follows.

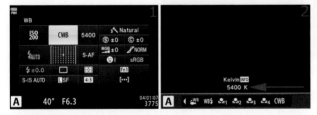

Figure 2.1G: Creating a custom white balance (CWB) reading with secondary screen

Highlight the WB function, as seen in figure 2.1G, image 1, and press the OK button to open the secondary WB screen (figure 2.1G, image 2).

Scroll until you find the CWB setting, which is located all the way to the right (the 13th setting). Press the Info button to highlight the value (figure 2.1G, image 2, red arrow), and rotate the Front Dial to select a K value between 2000 K (cool blue) and 14000 K (warm red). I chose 5400 K.

Press the OK button to lock in the CWB setting.

Settings Recommendation: The WB system in the E-M1 is pretty flexible. I use AUTO WB most of the time. However, when I shoot without flash indoors, I have found that the camera makes fairly warm images—sometimes a bit too warm under incandescent light. Therefore, I often find a white subject and do a One Touch WB reading so the color temperature more closely matches the light. (One Touch WB is not available from the Super Control Panel. See page 399 for instructions.) You could also do a Capture WB ambient light reading, as previously described, or set the WB manually to something like

Incandescent or Fluorescent when you are shooting under those light sources. For the best solution, shoot in a JPEG+RAW mode, which allows you to change the WB of the RAW file after the fact (*Shooting Menu 1 > [Record Mode]*).

Picture Mode

Individual Picture Modes impart a specific look to images. There are 23 modes available under the Super Control Panel main and secondary screens.

In this chapter we will discuss how to select individual Picture Modes. In the **Shooting Menu 1** chapter, under the **Picture Mode** heading on page 136, we will discuss the how, when, and why of each Picture Mode in much greater detail.

Picture Modes permanently add stylish looks to JPEG images. RAW shooters can use the current Picture Mode setting or change Picture Modes after an image is taken and then save the file as a JPEG with a new look.

Let's see how to select a Picture Mode, which also includes 14 of the camera's ART modes.

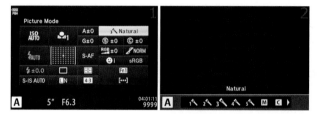

Figure 2.1H: Selecting a Picture Mode

In figure 2.1H, image 1, the Picture Mode function is highlighted. When you rotate the Front Dial a series of 23 Picture Modes will scroll by. When the Picture Mode you want to use is in the highlighted area, it is selected.

Another way to select a Picture Mode is to highlight Picture Mode (figure 2.1H, image 1) and press the OK button, which will open the secondary screen (figure 2.1H, image 2). Highlight the mode you want to use then press the OK button to select it. I chose 3, which is Natural Picture Mode.

Partial Color Picture Mode

The Picture Mode called ART 14 Partial Color allows you to choose a narrow range of color to appear in your image; all other hues become shades of gray. Let's see how to use it.

Choose the Picture Mode position on the Super Control Panel (figure 2.1I, image 1) and press the OK button to enter the secondary screen.

Scroll to the right until you reach the last Picture Mode selection, ART 14 (figure 2.1I, image 2). Press the Info button to open the Partial Color screen.

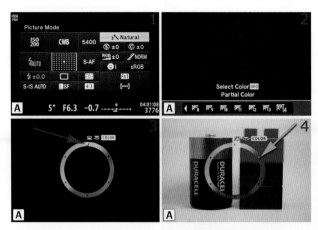

Figure 2.1I: Using the ART 14 Partial Color Picture Mode

The Partial Color screen (figure 2.1I, image 3) allows you to select a narrow range of color to include in your image, with all other colors rendered in grayscale. I left the cap on my lens in image 3 so you can see the Partial Color screen with a black background. Notice the small indicator at the top of the color circle (red arrow). You can move this indicator into the color range areas with either the Front Dial or Rear Dial. The colors of the rainbow are available to you as you move the indicator.

In figure 2.1I, image 4, you can see that I moved the indicator into the red zone of the color wheel (blue arrow). Notice that this zone allows the red block in the image to display in red, and the lower two blocks, which are actually green and blue, display in shades of gray. Also notice that the copper color of the battery top is displayed. As you move the indicator around the color wheel, you will see changes in the colors of your image. The colors fade to gray as you move the indicator into and out of the color ranges. When you have selected the color range that gives you the Partial Color look you desire, press the OK button and take the picture.

When you are done, be sure to cancel Partial Color mode by selecting a Picture Mode other than ART 14.

Note: We will discuss the Partial Color system again, in greater detail, in the **Shooting Menu 1** chapter under the **Partial Color (Art 14)** subheading on page 172.

Picture Mode: Sharpness, Contrast, Saturation, and Gradation

Most of the Picture Modes allow you to fine-tune several variables. Non-ART color Picture Modes provide four specific fine-tuning adjustments: Contrast, Sharpness, Saturation, and Gradation.

Let's see how to adjust these values for Picture Modes that allow it.

Sharpness

In figure 2.1J, image 1, you can see that 3 Natural Picture Mode is selected. In the high-lighted area just below Natural, an S in a circle and a ±0 symbol is displayed. This is the Sharpness setting. Sharpness affects how well you can see fine details in an image.

When you adjust the Sharpness it applies only to the Picture Mode shown in the Super Control Panel; it does not affect any other Picture Modes. With S±0 highlighted, press the OK button to open the secondary screen.

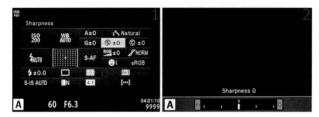

Figure 2.1J: Fine-tuning Sharpness

On the secondary screen (figure 2.1J, image 2) you can adjust the Picture Mode Sharpness over a range of four increments (+2 to −2). Move the yellow indicator bar under the 0 to the left or right with the Arrow pad keys (toward the − or + signs) to add or subtract Sharpness for that Picture Mode. Press the OK button to lock in your choice.

Contrast

In figure 2.1K, image 1, you can see that the 3 Natural Picture Mode is selected. The high-lighted area just below Natural shows a C in a circle and a ±0 symbol. This is the Contrast setting.

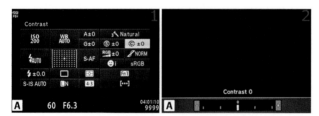

Figure 2.1K: Fine-tuning Contrast

Contrast affects the relationship between light and dark in the image. High-contrast images have very dark blacks, very bright whites, and strong colors. Low-contrast images often have weak light and dark areas and muted colors.

When you adjust the Contrast setting it applies only to the Picture Mode shown in the Super Control Panel; it does not affect any other Picture Modes. With C±0 highlighted, press the OK button to open the secondary screen.

On the secondary screen (figure 2.1K, image 2) you can adjust the Picture Mode Contrast over a range of four increments (+2 to −2). Move the yellow indicator bar under the 0 to the left or right with the Arrow pad keys (toward the − or + signs) to add or subtract Contrast for that Picture Mode. Press the OK button to lock in your choice.

Saturation

In figure 2.1L, image 1, you can see that the 3 Natural Picture Mode is selected. RGB and a ±0 symbol is displayed in the highlighted area below Natural. This is the Saturation setting.

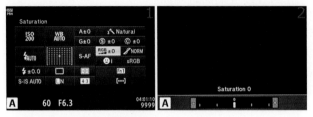

Figure 2.1L: Fine-tuning Saturation

Saturation affects how strong the colors in an image appear. A high-saturation image will have strong, bold colors; a low-saturation image will have weaker, muted colors.

When you adjust the Saturation setting it applies only to the Picture Mode shown in the Super Control Panel; it does not affect any other Picture Modes. With RGB±0 highlighted, press the OK button to open the secondary screen.

On the secondary screen (figure 2.1L, image 2) you can adjust the Picture Mode Saturation over a range of four increments (+2 to −2). Move the yellow indicator under the 0 to the left or right with the Arrow pad keys (toward the − or + signs) to add or subtract color Saturation for that Picture Mode. Press the OK button to lock in your choice.

Gradation

In figure 2.1M, image 1, you can see that the 3 Natural Picture Mode is selected. On a new E-M1, NORM is displayed in the highlighted area below Natural; however, on a preowned camera it might show AUTO, HIGH, or LOW. This is the Gradation setting.

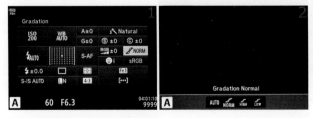

Figure 2.1M: Fine-tuning Gradation

Gradation affects the smoothness with which colors change into other shades. Here are the four Gradation settings and a brief description of each:

- **AUTO:** The camera divides the image into detailed regions and adjusts the brightness for each region on an individual basis. The camera decides how to handle gradation, with special attention on resolving the smoothness between areas of very high contrast.
- **NORM:** This is the default. It provides a smooth look between contrast and color changes for everyday photography.
- **HIGH:** This mode is best used for high-key subjects that tend to have very bright highlights and little darkness in the image.
- **LOW:** This mode is best used for low-key subjects that tend to be dark and have few bright areas in the image.

When you adjust the Gradation it applies only to the Picture Mode displayed in the Super Control Panel; it does not affect any other Picture Modes. With NONE (or another mode) highlighted, press the OK button to open the secondary screen.

On the secondary screen (figure 2.1M, image 2) you can adjust the Picture Mode Gradation by using the Arrow pad keys to select one of the four available modes: AUTO, NORM, HIGH, and LOW. Your Gradation choice affects only the current Picture Mode. Press the OK button to lock in your choice.

Monotone Picture Mode

The Monotone Picture Mode is a little different than the color Picture Modes. It has the normal Sharpness and Contrast adjustments as discussed in the previous subsections. However, Monotone does not have Saturation or Gradation settings. Instead, it substitutes a B&W Filter and Pict. Tone setting in place of Saturation and Gradation.

B&W Filter

In figure 2.1N, image 1, you can see that the M Monotone Picture Mode is selected. Below that is an F in a circle, followed by N. The F stands for B&W Filter, and N is one of the settings (Neutral).

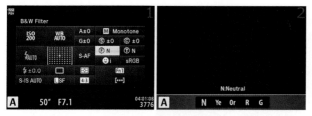

Figure 2.1N: Using the B&W Filter mode

The B&W Filter setting gives you four filter effects that allow you to change how the camera records various colors. Like glass lens filters that can be used to darken the sky or lighten the clouds, you can achieve similar effects with the four filters in the E-M1. Here are the four B&W Filter settings, with a brief description of each:

- **N (Neutral):** Makes a normal black-and-white image.
- **Ye (Yellow):** Makes clearly defined white clouds and a sky with normal brightness.
- **Or (Orange):** Moderately emphasizes blue skies and sunset colors.
- **R (Red):** Strongly emphasizes red and crimson colors. Makes blue skies with clouds that are dark and contrasty.
- **G (Green):** Strongly emphasizes green and red.

On the secondary screen (figure 2.1N, image 2) you can choose one of the Monotone Picture Mode B&W Filters by scrolling to it and highlighting it with the Arrow pad keys. Your choice affects the Monotone Picture Mode only. Press the OK button to lock in your choice.

Pict. Tone

In figure 2.1O, image 1, you can see that the M Monotone Picture Mode is selected. A circled T followed by N is highlighted below Monotone. The T stands for Pict. Tone, and N is one of the settings (Neutral).

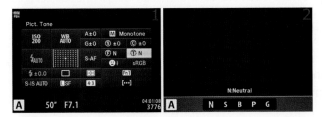

Figure 2.1O: Using the Pict. Tone setting

The Pict. Tone setting gives you four special effects that allow you to change how the camera records various colors. Here are the four Pict. Tone settings, with a brief description of each:

- **N (Neutral):** Makes a normal black-and-white image.
- **S (Sepia):** Makes a monotone image with a sepia (brownish) color.
- **B (Blue):** Makes a monotone image with a light blue tint.
- **P (Purple):** Makes a monotone image with a light purple tint.
- **G (Green):** Makes a monotone image with a light green tint.

On the secondary screen (figure 2.1O, image 2) you can choose a Pict. Tone setting by scrolling to it and highlighting it with the Arrow pad keys. Your choice affects the Monotone Picture Mode only. Press the OK button to lock in your choice.

Note: ART Picture Modes provide fine-tuning controls in a different way. The adjustments to the ART Modes are not available from the Super Control Panel. Instead, you must use the *Shooting Menu 1 > Picture Mode* settings to adjust the Filter Types and Add Effects. See the **Shooting Menu 1** chapter under the subheading **Using Art Picture Modes** on page 152.

Settings Recommendation: For everyday shooting I usually choose Natural Picture Mode. However, for some types of nature shooting I may use Vivid Picture Mode to pop the colors. When I need the widest dynamic range for nature shooting, I may use the Muted Picture Mode then later increase the saturation and contrast manually for the best look. For portraits I often use Portrait Picture Mode to preserve natural-looking skin tones. When I am feeling adventurous, I even use some of the Art Modes. They can be quite fun! It's good that we have so many choices.

☺ Face Priority AF Mode

The ☺ Face Priority AF mode is designed to make your camera extra sensitive to human faces. When this mode is enabled, the E-M1 will detect human faces, adjust the focus to capture them sharply, and tweak the camera's metering system to expose more accurately for human skin tones.

Additionally, you can select Eye Priority and even choose which eye to focus on. When any type of ☺ Face Priority is active, the camera looks for human faces in the subject area and gives them priority for exposure. It then uses the selected type of ☺ Face Priority to decide how to autofocus. Let's examine the five available modes:

- **Off:** ☺ Face Priority is off.
- ☺: The camera uses ☺ Face Priority for autofocus and exposure.
- ☺i: The camera uses the pupil of the nearest eye for the best autofocus.
- ☺iR: The camera uses the pupil of the right eye for the best autofocus.
- ☺iL: The camera uses the pupil of the left eye for the best autofocus.

In figure 2.1P, image 1, you can see that ☺i (Face and nearest Eye Priority) is turned on. Highlight the ☺ Face Priority position on the Super Control Panel. You can now use the Front Dial of the camera to scroll through the various modes and stop scrolling when your favorite mode appears. Alternately, you can use the secondary screen to select a mode, as described next.

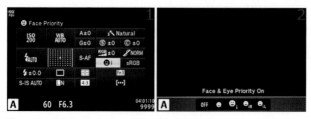

Figure 2.1P: Selecting a Face & Eye Priority mode

Figure 2.1P, image 2, shows the ☺ Face Priority modes along the bottom of the screen. Use the Arrow pad keys to scroll back and forth until the mode you want to use is highlighted. Press the OK button to lock in your choice.

 Settings Recommendation: I have found that the camera works well with some form of ☺ Face Priority mode always active. It focuses normally on nonhuman subjects when no face is present, and it uses face detection only when it can detect human faces. I normally leave ☺i (Face & Eye Priority) set to On.

Color Space

The Color Space setting allows you to change the color gamut that your camera uses. That means the camera can capture colors over a narrower or wider range. Adobe RGB can capture color over a wider range than sRGB. Adobe RGB can capture about 50 percent of the color range that an average human eye can see, whereas sRGB can capture about 35 percent.

 However, there are other factors to consider before you select a Color Space setting. For instance, websites, basic home inkjet printing, and retail color printing labs normally use sRGB because most amateur shooters use that camera setting. Commercial printers (books and magazines) and stock photo agencies prefer Adobe RGB.

 This subject in considered in greater detail in the **Custom Menu** chapter under the subheading **Color Space** on page 407. Please read that section to more fully understand the consequences of selecting one Color Space setting over the other.

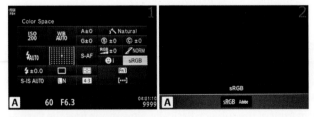

Figure 2.1Q: Choosing a Color Space

In figure 2.1Q, image 1, you can see that sRGB is selected. This is the Color Space position on the Super Control Panel. When it is highlighted, use the Front Dial to toggle between the two Color Spaces, and stop turning the dial when your favorite appears. Alternately, you can use the secondary screen to select a Color Space, as described next.

 Figure 2.1Q, image 2, shows the Color Space selections along the bottom of the screen. Use the Arrow pad keys to scroll back and forth until the mode you want to use is highlighted. Press the OK button to lock in your choice.

 Settings Recommendation: As a stock photographer who licenses images online, I generally use the Adobe RGB Color Space because it maps well to CMYK offset printing that is used by commercial printers. Most stock sites expect you to submit images with the Adobe RGB Color Space. However, when I am shooting snapshots for online use, I

use sRGB because it better matches the requirements of websites and home color inkjet printers.

Flash Mode

The E-M1 offers you a choice of eight flash modes. Let's examine each mode and see what it does:

- **Flash Auto:** The camera controls the flash. It will fire when the camera senses that the light is too low for a good picture. It will not fire when the camera meter says the ambient light is sufficient.
- **Redeye:** This mode tries to cause the subject's pupils to contract by firing a preflash and blinking the red AF illuminator light on the camera body twice before the main flash fires. This may reduce the eerie red-eye look that can be seen in so many pictures.
- **Fill in:** This mode puts the flash entirely in your control. The flash will fire each time you take a picture, and it will attempt to balance the flash with ambient light (it fills in).
- **Flash Off:** The flash is off and will not fire.
- **Red-Eye Slow:** This mode executes the same actions as the Redeye mode mentioned previously; however, it also uses Slow flash, as described next. Basically, the camera fires a preflash to reduce red eye and also uses shutter speeds that can get very slow in dim ambient light. Therefore, this mode helps you use mostly ambient light to illuminate the subject, adds some fill light from the flash, and does red-eye reduction for good measure.
- **Slow:** This mode fires the flash as soon as the first curtain of the shutter is fully open. Then, if the ambient light is dim, it allows the shutter to remain open to pull in background light. If you are shooting in low light it is best to use a tripod for this mode (and other modes that use Slow), or at least brace yourself against a solid object when you take the picture. Otherwise, you may have a well-exposed subject with ghosting from camera movement after the flash fires. If a subject is moving when you use this mode, a ghosted trail may appear in *front* of the subject. Basically, Slow mode fires the flash at the beginning of the shutter speed time and allows the camera to continue gathering light for the rest of the time the shutter is open.
- **Slow2:** This mode operates like Slow mode, except it fires the flash at the end of the shutter speed time, just before the second shutter curtain closes. In effect, the camera has already made an ambient light exposure before it fires the flash. For that reason, this mode is often called rear-curtain or second-curtain flash. If the subject is moving, a ghosted trail may appear *behind* the subject. Many people use this mode to imply motion in photographs.
- **Manual Value:** You can manually choose a flash power, as described in the paragraphs accompanying figure 2.1S. You can choose from the range of full power (Full) to 1/64 of full power.

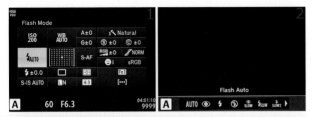

Figure 2.1R: Choosing a Flash Mode

In figure 2.1R, image 1, you can see that the Flash Mode position is highlighted. You can turn the Front Dial to scroll through the eight available modes and stop when the symbol of the mode you want to use is highlighted. If you don't know what the symbols mean, it may be best to use the secondary screen because it displays both the symbol and the name of the mode above the symbol area. Press the OK button to enter the secondary screen.

In figure 2.1R, image 2, the secondary screen is open. Along the bottom of the screen you can scroll left or right with the Arrow pad keys and select the mode you prefer. The name of the mode will appear where you can see Flash Auto in image 2. I chose AUTO; the word AUTO is highlighted, and the words Flash Auto are displayed above the symbol area. Press the OK button to lock in your chosen Flash Mode.

Manual Value Flash Mode

For studio shooters or individuals who prefer to very carefully control the flash output, Manual Value Flash Mode is available. This mode, as described in the previous list, allows you to manually choose a flash output power from a range of 1/64 power to Full power. Let's see how to use the Manual Value mode.

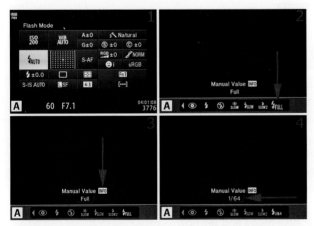

Figure 2.1S: Choosing a Manual Value for manual flash output control

In figure 2.1S, image 1, the Flash Mode position is highlighted. Press the OK button to open the secondary screen.

Choose the Manual Value flash symbol at the far right end of the Flash Mode choices by highlighting it (figure 2.1S, image 2). If this mode has not been moved from maximum power, it will display a small lightning bolt symbol and the word Full.

Press the Info button to enable the adjustment system (figure 2.1S, image 3). Notice that the word Full just below Manual Value Info becomes a field that accepts input when you press the Info button.

Rotate the Front Dial to change the values in the input field. I chose 1/64 power, which is the lowest output setting (figure 2.1S, image 4). Again, the range of flash output is from 1/64 to Full.

After you have chosen the value you want to use, press the OK button to lock it in.

Settings Recommendation: I use the Fill in flash mode most of the time. It seems to balance the flash well with ambient light, and the mode lets me, not the camera, decide when to use flash. When I first got my E-M1, I was shooting a graduation ceremony and could not get the flash to fire when I photographed the graduation cake with white icing. After much frustration, I realized that the E-M1 defaults to AUTO flash. The camera thought there was sufficient light without flash, so it would not fire the flash. I no longer use AUTO mode! However, if you are shooting for fun or don't have much experience with flash, AUTO is good for helping you decide when to use flash. The other modes (e.g., Slow, Slow2) are available for when you want special effects. Redeye seems to help somewhat for reducing the red-eye effect in portraits, but you should warn the subjects to stand still until after the second flash—first there is the preflash to reduce pupil size, then the main flash fires.

AF Area Mode and ☺ Face Priority

The AF Area mode affects which AF point, or points, are used when you initiate autofocus. You can select a single point anywhere in the grid of 81 AF points (37 AF points with an older Four Thirds lens), or you can use a group of AF points. You can move the individual AF point or the group of AF points around the grid by pressing the Arrow pad keys. This allows you to move one or more points to a particular area of the subject—such as an eye—as you view it on the Live View screen or through the electronic viewfinder (EVF) to ensure the best autofocus.

The ☺ Face Priority mode allows you to choose different ways to detect human faces. We discussed ☺ Face Priority in a previous section of this chapter, ☺ **Face Priority AF Mode**. The interface we will discuss here is another way to access the ☺ Face Priority system.

Let's discuss how to use AF Area mode and see how ☺ Face Priority mode can be accessed from this screen.

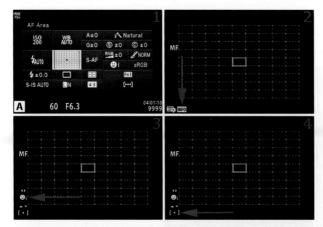

Figure 2.1T: Choosing a ☺ Face Priority mode, AF point location, AF point size, and AF point pattern

In figure 2.1T, image 1, you can see that the AF Area mode position is highlighted. Press the OK button keys to see a larger version of the grid. You can use the Arrow pad buttons to move the AF point to any of the locations in the grid and press the OK button to select it for autofocus.

In figure 2.1T, image 2, the center AF point is selected. You can move the AF point with the Arrow pad buttons, or you can change it to a group of points (figure 2.1U) that can also be moved around the screen. In figure 2.1T, image 2 (red arrow) you can see that INFO is displayed. Press the Info button to open two more adjustments. Once you have pressed the INFO button, scrolling left or right with the Arrow pad buttons changes ☺ Face Priority modes and scrolling up or down changes AF Area modes.

In figure 2.1T, image 3 (red arrow), you can see the ☺ Face Priority adjustment, and below that is the AF Area mode adjustment. Let's first consider the ☺ Face Priority mode adjustment. Select a ☺ Face Priority setting by pressing the left or right Arrow pad keys, which will scroll though the five ☺ Face Priority settings. Here is a list of the five settings and what they do:

- **Off:** ☺ Face Priority is off.
- **☺:** The camera uses ☺ Face Priority for autofocus and exposure.
- **☺i:** The camera uses the pupil of the nearest eye for the best autofocus.
- **☺iR:** The camera uses the pupil of the right eye for the best autofocus.
- **☺iL:** The camera uses the pupil of the left eye for the best autofocus.

The ☺ Face Priority setting causes the camera to use the human faces it detects to calculate the best exposure, and it varies the autofocus method depending on which you select. In figure 2.1T, image 3, ☺ Face Priority is set to ☺i (nearest eye autofocus). Scroll left or right until the ☺ Face Priority mode you want to use is displayed.

Now let's consider the AF Area mode adjustment. In figure 2.1T, image 4 (red arrow), you can see the AF Area mode adjustment. Scroll up or down with the Arrow pad keys to see a series of AF Area modes (figure 2.1U).

Figure 2.1U: Four AF point arrangements

Figure 2.1U, image 1 (red arrow), shows the normal grid of 81 AF points that is available when you use a Micro Four Thirds lens. (Figure 2.1V, image 2, shows the 37-point grid that is available for older Four Thirds lenses.)

In figure 2.1U, image 2 (red arrow), the small mode has been selected, which reduces the size of the AF points for very precise focusing on a specific area of the subject.

Figure 2.1U, image 3 (red arrow), shows a group of nine AF points that you can move around the grid. This works great for tracking.

Figure 2.1U, image 4 (red arrow), shows that AUTO AF Area mode is selected, which allows the camera to select the AF point.

Note: All these screens display the type of focus you are using. I chose manual focus (MF) in figure 2.1U. You can see MF in the top left area of the images. In figure 2.1V, image 2, you can see that I chose Single-frame autofocus (S-AF). You can also use Continuous autofocus (C-AF); however, in C-AF the camera cannot detect pupils in ☺ Face Priority mode. Select an autofocus mode (e.g., S-AF, C-AF) by using the instructions in the **AF Mode** subsection later in this chapter.

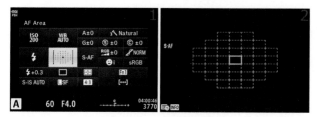

Figure 2.1V: The 37 AF points for Four Thirds lenses

If you are using an older Four Thirds lens, the available AF point grid will contain 37 points instead of 81 points. Notice that figure 2.1V shows the smaller grid in both images.

[•••] AF Area Select Button Task

If you prefer not to use the Super Control Panel to select an AF point type and size, there is a Button task called [•••] AF Area Select that can be assigned to one of the programmable buttons (Button Functions) mentioned in the **Camera Setup and Control Reference** chapter.

In fact, the [•••] AF Area Select button task is already assigned to the Fn1 button by default. Therefore, if you have a brand new E-M1, pressing the Fn1 button should open the AF Area mode screen, allowing you to choose both AF points and ☺ Face Priority settings, as previously described. Assigning Button tasks is discussed on page 297.

Settings Recommendation: Most of the time my style of photography is well served with the normal single AF point in figure 2.1U, image 1. I rarely use the other modes. The nine-point group mode does come in handy for actions shots, and I may use the full 81-point AUTO AF mode when I am shooting at a party and don't want to bother with moving the AF point. AUTO mode with ☺ Face Priority set to ☺i seems to work great at parties. Experiment with these modes to see which you like best in different styles of photography.

AF Mode

The AF Mode function provides several focus methods. Four of them are for autofocus, and one is for manual focus. One of the autofocus methods will allow focus tracking.

This subject is considered in more depth in the **Custom Menu** chapter under the **AF Mode** subheading on page 274 (see *Custom Menu > A. AF/MF > AF Mode*). Let's examine each of the modes and see how to select one:

- **Single AF (S-AF):** When you hold the Shutter button halfway down, the camera autofocuses on the subject, beeps once, and locks focus. In the top-right corner of the EVF (or Live View screen) you will see a small green dot. This indicates that the focus is good. If the subject moves, the focus may no longer be accurate; therefore, you must release the Shutter button and press it halfway again to update the focus. S-AF is best for static subjects or subjects that move very slowly. The AF point target indicator is a small green rectangle.
- **Continuous AF (C-AF):** Similar to S-AF, the camera will focus when you hold the Shutter button down, and it beeps when it has acquired good focus, up to two times. It also displays the round green good focus indicator at the top right of the camera screens. However, if the subject moves, the camera continues autofocusing on the subject. Unlike S-AF, the camera never really locks the focus permanently; it continues to seek the best autofocus at all times. If you change to a different subject, or if the subject moves, the camera will do its best to automatically update the focus. The AF point target indicator is a small green rectangle.

- **Manual focus (MF):** When you use MF mode you are entirely responsible for focusing the camera. The AF point target indicator is not used. Since the E-M1 does not have a split-prism screen to assist with focus, you may want to enable focus Peaking and/or Magnify under the *Custom Menu > A. AF/MF > MF Assist > Peaking* [or *Magnify*] setting. Peaking makes it easy to see when the subject is in focus because it outlines the edges of the subject in white (or black) to indicate where the best focus is currently located. Peaking is discussed and samples are provided in the **Custom Menu** chapter under the **MF Assist** heading and the **Peaking** subheading on page 286. In the **MF Assist** section of that chapter I also discuss the **Magnify** function, which automatically zooms in to pixel-peeping levels when you turn the lens focus ring, and it results in extremely accurate manual focus. Combining Peaking and Magnify makes manual focus easy.
- **Single AF + MF (S-AF+MF):** This mode is almost exactly like the S-AF mode, with its focus lock, beep, and round green good focus indicator. However, it offers one powerful extra feature: manual focus fine-tuning. After you press the Shutter button halfway and the camera has autofocused and locked focus on the subject (S-AF), you can fine-tune the focus with the lens focus ring (MF). If you have focus Peaking and Magnify enabled, as discussed in the previous paragraph, the camera will use those features during fine-tuning. The AF point target indicator is a small green rectangle.
- **AF Tracking (C-AF+TR):** This mode is for autofocus with subject tracking. For general use this mode works like C-AF mode, with continuous autofocus updating. However, if the subject moves, the camera will carefully track it and lock on to its location with the bigger focus point target indicator while continuously updating the focus as the subject moves. To help you understand how to use this feature, select C-AF+TR, then focus on a small subject. Move the camera around and you will see the AF point target indicator stay locked on the subject. It is effective at staying with a subject as long as the light is reasonably good and the subject is not moving too quickly. The AF point target indicator is a larger green square with bars sticking out of each side.

Now let's examine how to select one of the focus modes.

Figure 2.1W: Choosing an Autofocus (AF) mode

In figure 2.1W, image 1, you can see that the AF Mode position is highlighted (S-AF). Turn the Front Dial, and the five AF Modes will scroll by. Stop scrolling on the mode you want to use. If you prefer to use the secondary screen to select a mode, press the OK button to open it.

Figure 2.1W, image 2, shows the secondary AF Mode screen with Single AF selected. Use the Arrow pad keys to scroll left or right until the mode you want to use is highlighted. Press the OK button to lock in the AF Mode.

Settings Recommendation: I like to use S-AF+MF mode so I can use autofocus most of the time, but I can still turn the focus ring to enable manual focus, along with Peaking and Magnify. The S-AF mode is fine for slow shooting with well-defined, static subjects. C-AF works quite well when I am shooting something like a wedding and the bride and groom are walking toward me. I use MF mode most often when I am taking macro shots and need to carefully control where the focus falls, due to the shallow depth of field in that type of photography. The tracking mode (C-AF+TR) works well for moving subjects, especially larger wildlife, cars, and airplanes. Small birds are harder to track because they move so quickly and tax the AF tracking system. However, with careful use, even small bird photography is possible with the E-M1.

Flash Intensity Control (Compensation)

Flash Intensity Control is similar to a flash compensation system. If you are taking pictures and the background of the subject is exposed well but the subject is overexposed, you may want to dial back the power or intensity of the flash unit. If the subject is underexposed and the background is well exposed, you may want to increase the flash output to light the subject a little better. Flash Intensity Control gives you the power to do either. In effect, you are dialing in flash exposure compensation. Let's see how to adjust it.

Figure 2.1X: Choosing a Flash Intensity Control exposure compensation value

Select the Flash Intensity Control symbol, a small lightning bolt followed by ±0.0, as shown in figure 2.1X, image 1. The 0.0 represents the EV value that can be dialed in, over a range of six EV steps (+3.0 to −3.0). Turn the Front Dial to change the flash intensity. You will see the EV value change to plus or minus, depending on which direction you turn the dial. As expected, turning the dial toward + makes the flash put out more power, and turning it toward − makes it put out less power. Stop turning the dial when you see the EV compensation value you want to use. You can also use the secondary screen if you want a more visual representation of the flash intensity change. Press the OK button to open the secondary screen.

Figure 2.1X, image 2, shows the secondary screen with a 6-stop (EV step) scale (+3.0 to −3.0). Use the Arrow pad keys to move the indicator bar left or right on the scale, toward

the + or − signs. The positive or negative EV value will display where 0.0 is located in image 2. Press the OK button to lock in your flash intensity choice.

Settings Recommendation: I tend to shoot a little brighter than many photographers because I use RAW mode for the best image quality most of the time. When you use RAW (ORF) image quality mode, the picture files have more overexposure headroom than you might think. Therefore, I generally leave the Flash Intensity Control set to +0.3, for a one-third stop overexposure. When you shoot JPEG files it is important to watch the histogram closely to prevent unrecoverable overexposure (highlight data loss), especially when shooting up close.

Sequential Shooting/Self-Timer

The camera's Sequential shooting/Self-timer system is designed to let you control the frame rate of the camera when you are shooting in bursts. It also lets you control remote shooting with three Self-timer controls. These six modes are called Release modes. Let's examine each of the modes and see how they work:

- **Single-Frame shooting:** This mode causes the camera to take one picture each time you fully press the Shutter button.
- **Sequential High (H):** The camera will take a continuous series of pictures at about 10 frames per second (fps). Autofocus, exposure, and white balance are frozen at the values determined by the camera for the first picture and are not updated during the series.
- **Sequential Low (L):** The camera will take a continuous series of pictures at about 6.5 fps with firmware 2.0 or 9 fps with firmware 3.0. Autofocus, exposure, and white balance are updated for each picture in the series, based on which autofocus mode you selected (e.g., S-AF, C-AF, MF) and whether you are using autoexposure lock (AEL) or autofocus lock (AFL).
- **Self-timer 12 sec (12s):** The camera will take a single photograph 12 seconds after you press the Shutter button all the way down. The orange focus assist light on the front of the camera will shine solid for 10 seconds, then it will blink for 2 seconds before the shutter fires and the picture is taken.
- **Self-timer 2 sec (2s):** The camera will take a single photograph two seconds after you press the Shutter button all the way down. The orange focus assist light on the front of the camera will blink for two seconds before the shutter fires and the picture is taken.
- **Self-timer Custom (C):** This variable self-timer function allows you to select the number of images the camera will take when the self-timer expires (Frame), the time in seconds the camera will wait before firing (Timer), and the period of time between each picture (Interval Time) if you have selected more than one picture with the Frame setting. You can also choose whether or not to have the camera autofocus between each picture.

Now let's examine how to select one of the modes.

Figure 2.1Y: Choosing a Sequential shooting or Self-timer Release mode

In figure 2.1Y, image 1, the Sequential shooting/Self-timer position is highlighted. Turn the Front Dial, and the six modes will scroll by. Refer to the previous list to determine which of the modes works best for your current needs. Stop scrolling on the mode you want to use. If you prefer to use the secondary screen to select a mode, press the OK button to open it.

Figure 2.1Y, image 2, shows the secondary Sequential shooting/Self-timer screen with Single (Single-frame shooting) mode selected. Use the Arrow pad keys to scroll left or right until you see the mode you want to use. Press the OK button to lock in your selection.

If you choose the Self-timer Custom mode, which is on the far right end of the mode selections, you can make several custom adjustments to how the Self-timer works. Let's consider the Self-timer Custom mode more closely.

Self-Timer Custom Mode

The Self-timer Custom mode allows the camera to automatically take one or a series of pictures with one press of the Shutter button. This allows you to take consecutive pictures without touching the camera and introducing new vibrations, which results in sharper pictures.

You can adjust the number of frames, the self-timer wait time, the interval between frames, and whether the camera autofocuses between each frame. Let's see how.

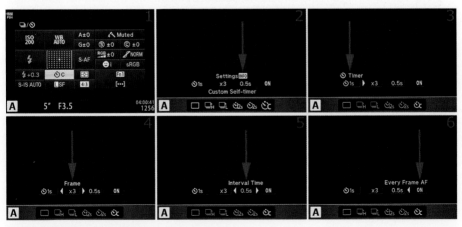

Figure 2.1Z: Adjusting the Self-timer Custom mode

In figure 2.1Z, image 1, the Sequential shooting/Self-timer position is highlighted. Rotate the Front Dial, and the six modes will scroll by. Stop scrolling on the Self-timer Custom (C) mode, as pictured in image 1. You cannot adjust the settings of the Custom mode unless you use the secondary screen. It will simply use the last settings you configured or the default settings. Press the OK button to open the secondary screen.

Figure 2.1Z, image 2, shows the secondary Sequential shooting/Self-timer screen with Custom Self-timer (C) mode selected. Press the Info button to open the custom setting fields. Descriptions of the four custom settings are as follows:

- **Timer:** Choose the timeout period (Timer) before the *first* Frame is taken during the self-timer cycle (figure 2.1Z, image 3). You can choose from as short as 1 second (1s) to as long as 30 seconds (30s). The camera will fire the first Frame only after the Timer delay you selected has expired. This gives you time to get in position, even if you must run a distance from the camera to be in the frame or need the delay for some other reason. Scroll up or down with the Arrow pad keys to choose a value. When you have chosen a value, scroll to the right.
- **Frame:** This setting allows you to choose the total number of pictures (Frames) the camera will take during the self-timer cycle (figure 2.1Z, image 4). I chose three Frames (x3). You have a choice of from 1 (x1) to 10 (x10) Frames. Scroll up or down with the Arrow pad keys to choose a value. When you have chosen a value, scroll to the right.
- **Interval Time:** This setting controls the time between Frames *after* the first Frame is taken (figure 2.1Z, image 5). The camera will delay for the amount of time specified in the Timer setting, then it will use the Interval Time to pause between the rest of the Frames. Scroll up or down with the Arrow pad keys to choose a value. When you have chosen a value, scroll to the right.
- **Every Frame AF:** Select either On or Off from the Every Frame AF field (figure 2.1Z, image 6). On tells the camera to autofocus for every shot in the Self-timer series of pictures, and Off means the camera will autofocus on the first frame of the series only. After you have selected the value, press the OK button to save your settings. Prepare the camera for shooting and press the Shutter button to start the initial Self-timer (Timer) countdown.

Note: The camera will remember your Self-timer Custom settings and will use them over and over until you change them. If these settings are useful for most of your Self-timer photography, simply select Self-timer Custom to use the settings in the future.

These Release modes are considered in more detail under the **Shooting Menu 2** chapter in the **Sequential/Self-timer Shooting** subsection on page 194.

Settings Recommendation: As a nature photographer and a portrait photographer, I normally use Single-frame shooting. However, if I'm at an event such as a car race or airplane show, I often switch to Sequential Low (L), which gives me a shooting speed of about 6.5 fps with firmware 2.0 or 9 fps with firmware 3.0, with autofocus between each frame. I rarely use the Sequential High (H) setting because I normally do not need a speed

of 10 frames per second, and I want autofocus between frames, which H mode does not provide.

When it is time to use the Self-timer, I normally choose the 12s setting and take a single picture. However, if I want to be creative and use the Self-timer for multiple frames, I often use the Self-timer Custom setting.

Metering Mode

The E-M1 has five light meter types that give you great flexibility in how you expose your images. Using the different meter styles built in to the camera will help you make some of the most well exposed images you've ever created.

We will consider more detail about the Metering mode types in the **Custom Menu** chapter under the **Metering** subheading on page 370. In the meantime, let's look more closely at the five types of light meters built in to the camera and discuss their differences:

- **ESP:** The camera meters the image with a grid of 324 metered areas that cover the frame. It uses complex mathematical computations to arrive at an excellent exposure. This metering mode works best for portraits when ☺ Face Priority is enabled.
- **Ctr-Weighted:** The camera averages the light between the subject and the background. It places more emphasis on exposure for the center area of the EVF or Live View screen, with less emphasis on parts of the scene that are farther away from the center.
- **Spot:** The camera uses a small circle in the center of the EVF or Live View screen for metering. This circle is equivalent to 2 percent of the frame, and all metering takes place in this 2 percent area. Therefore, you must place this stationary spot on the area of the subject that you want to correctly meter by moving the camera then using autoexposure lock (AEL/AFL button) to lock the exposure while you recompose the image. Or you can take multiple readings of different areas of the scene, determine the total light range, and set the exposure manually.
- **Spot Hilight (HI):** This type of metering is similar to standard Spot metering in that the camera uses a small circle in the center of the frame to meter. The metering circle is equivalent to 2 percent of the frame. This metering mode is different from standard Spot metering because the camera tries to make white areas (highlights) stay white by increasing the exposure beyond a normal Spot reading to give a bright, high-key look to the image.
- **Spot Shadow (SH):** This type of metering is also similar to normal Spot metering in that the camera uses a small circle in the center of the frame to meter. The metering circle is equivalent to 2 percent of the frame. This metering mode is different from normal Spot metering because the camera tries to make dark areas (shadows) stay dark by decreasing the exposure below a normal Spot reading to give a low-key look to the image.

Now let's examine how to select one of the metering modes.

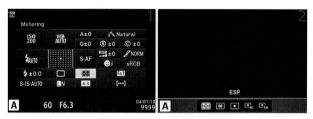

Figure 2.1AA: Choosing a Metering mode

In figure 2.1AA, image 1, the Metering position is highlighted. Turn the Front Dial, and the five modes will scroll by. Refer to the previous list to determine which of the modes works best for your needs. Stop scrolling on the mode you want to use. If you prefer to use the secondary screen to select a mode, press the OK button to open it.

Figure 2.1AA, image 2, shows the secondary Metering screen with ESP metering mode selected. Use the Arrow pad keys to scroll left or right until you see the mode you want to use. Press the OK button to lock in the mode.

Settings Recommendation: Digital ESP metering (ESP) is a very effective form of metering. I rarely have to use the other metering modes. Sometimes I might use the Spot meter to meter a bright subject against a darker background, but otherwise I am quite happy with ESP. Be sure to use a form of ☺ Face Priority when you are taking portraits with ESP. That seems to make the camera extra sensitive to exposing faces accurately, even if the background is dark and could cause some facial overexposure.

Button Function Task Assignment

In the **Camera Setup and Control Reference** chapter we examined each of the external controls on the camera body. Recall that a number of the buttons are programmable; that is, you can assign a task to the button and change it to another task later. The 28 Button tasks are listed in the Appendix.

The Button Function Task Assignment position on the Super Control Panel is a shortcut to the *Custom Menu > B. Button/Dial/Lever > Button Function* settings. These Button Function settings allow you to assign Button tasks directly to the programmable buttons. We will cover the Button function task assignments in great detail in the **Custom Menu** chapter, under the **Button Function (Programmable Buttons)** subheading on page 297.

Since the full description of how to use this function is lengthy, there is no need to repeat it here. This section will give a brief explanation of how to do a single button assignment, with the understanding that you will refer to the later material for a complete description.

Note: Olympus uses the term *Button function* to describe the physical button control to which a task can be assigned. The functionality that can be assigned to the button (what it does) is called a *Button task* (my words, to make it easier to understand). Therefore, in

this book you will read that a particular Button task has been assigned to a certain Button function, which simply means the button (Button function) has been given a task (Button task) to do when you press the button. As previously mentioned, there is a list of 28 Button tasks in the Appendix.

Let's see how to assign a Button task to the Fn1 Function.

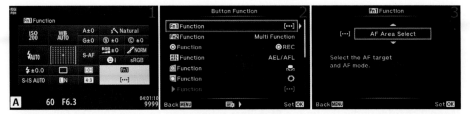

Figure 2.1AB: Assigning a task to a Button function (such as Fn1)

In figure 2.1AB, image 1, you can see that the Fn1 Button Function position is highlighted. You can scroll through the various Button Functions (e.g., Fn1, Fn2) by turning the Front Dial. Stop turning the dial when the setting you want to use is highlighted. Select a Button Function to which you want assign a Button task. Press the OK button, and a secondary screen will open.

Figure 2.1AB, image 2, shows the Button Function selection menu. On this screen you will find a list of 12 Button Functions. Highlight the one to which you want to assign a Button task, and scroll to the right. In this example we are working with the Fn1 Function.

Figure 2.1AB, image 3, displays an up/down menu that you can scroll through by pressing up or down on the Arrow pad keys. There are many Button tasks listed in this up/down menu. Refer to the Appendix at the back of the book for a list of 28 Button tasks that you can assign to the Fn1 Function. Not all tasks are available for all buttons. After you have assigned a Button task, the task will execute when you press the Fn1 button on the upper-right corner on the back of the E-M1. You can see in figure 2.1AB, image 3, that I selected the factory default Button task called [•••] AF Area Select. Choose a Button task from the menu.

Press the OK button to lock in the task for the Fn1 Function.

Settings Recommendation: This camera is very flexible and powerful due to the large number of tasks you can assign to the individual buttons, dials, and levers. You will spend a lot of time examining and making decisions about which Button task to assign to which Button Function. Please get used to calling the camera buttons *Button Functions,* not just buttons, at least when you are making task assignments. That's what Olympus does, and if you do not understand this, it will be difficult to configure your camera later. The same goes for the dials and levers. They are called Dial Functions and Lever Functions instead of just dials and levers. The entire B. Button/Dial/Lever section of the Custom Menu is devoted to assigning various tasks to Button, Dial, and Lever *Functions.*

Image Stabilizer

The 5-axis image stabilization (IS) system in the E-M1 is world class and renowned as one of the best IS systems in any camera today. It will cut down on camera shake when you handhold the E-M1, allowing you to use slower shutter speeds, smaller apertures, and lower ISOs while still getting sharp images.

Since the IS system is built in to the camera, it will work with any lens you use, including brands that require a nonintelligent adapter with no electronic connection to the camera. If you have Nikon or Canon (or other brand) lenses from one of your DSLRs, you can buy an inexpensive adapter to use them on the E-M1.

Basically, the IS system will stabilize the image with virtually any lens that can be mounted on the camera. This subject will be examined in greater detail in the **Shooting Menu 2** chapter under the **Image Stabilizer** subheading on page 198. The following is a list of the various modes available in the Image Stabilizer menu:

- **Off:** No image stabilization is provided.
- **S-IS 1:** This is a general automatic mode that allows the Image Stabilizer to compensate in five directions (roll, pitch, yaw, vertical, and horizontal). It automatically corrects for movement in any or all of the directions (axes) at any time. It is not as sensitive to panning as S-IS AUTO.
- **S-IS 2:** The image stabilization system corrects only for the vertical axis (Vertical IS). Use this mode when you are moving the camera vertically and are not concerned about horizontal correction. If you are panning horizontally, such as at a car race, and are holding the camera in a horizontal (landscape) orientation, this mode may perform well for you.
- **S-IS 3:** The image stabilization system corrects only for horizontal camera shake (Horizontal IS). If you are panning horizontally, such as at a car race, and are holding the camera in a vertical (portrait) orientation, this mode may perform well for you.
- **S-IS AUTO:** Olympus suggests this mode when you are unsure what you will be shooting and want to be prepared for any kind of movement. The camera automatically chooses the best type of image stabilization for the subject it detects. This is the factory default mode.

Let's see how to configure the IS system.

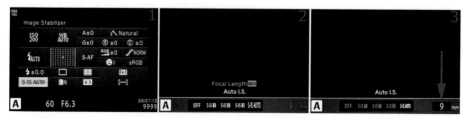

Figure 2.1AC: Choosing an image stabilization method

Figure 2.1AC, image 1, shows the Image Stabilizer setting highlighted with S-IS AUTO se-
lected. You can scroll through the five IS settings by turning the Front Dial. Stop turning
the dial when the setting you want to use is highlighted. If you prefer to use the second-
ary screens, or if you are using a lens that is not a Micro Four Thirds or Four Thirds type
that is attached to the camera with an adapter that does not have electronic connections
for communication with the camera (a dumb adapter), press the OK button to open the
secondary screen.

Figure 2.1AC, image 2, shows the Image Stabilizer settings in a row at the bottom of
the screen. Refer to the previous IS settings list and use the left or right Arrow pad keys to
move along the row until you highlight the setting you want to use. Press the OK button
to lock in the setting. I selected Auto I.S. (S-IS AUTO). If you are using a Micro Four Thirds
or Four Thirds lens, press the OK button and the IS system is ready to use. Skip the rest of
this step and the next step. However, if you are using a dumb lens adapter with any type
of lens, you will need to input the focal length of the mounted lens. Press the Info button
to move to the Focal Length screen.

Figure 2.1AC, image 3 (red arrow), allows you to register a focal length for a lens that is
mounted on the camera with a dumb adapter. Press up or down on the Arrow pad keys to
select a focal length. The range of focal length choices are from 8mm to 1000mm. I chose
9mm in figure 2.1AC, image 3 (red arrow), which is the default. This focal length value
is *not used* when you have a Micro Four Thirds lens mounted directly on the camera or
when you mount a Four Thirds lens on a communicating (smart) adapter (e.g., an Olympus
MMF-3). In those situations, the lens electronically communicates the focal length to the
E-M1 body. After you have selected a value, press the OK button to lock it in.

Note: If you are using a zoom lens (not a prime lens) on a dumb adaptor you will have
to estimate the focal length you will most often use and set that value in the screen shown
in figure 2.1AC, image 3. If you use a different focal length than the one you entered, the IS
system may not be quite as effective. However, since the 5-axis IS system is one of the best
in the world, I am sure it will work quite well at any focal length you may use on a dumb
adapter. You may want to experiment for the best results, especially at extreme angles of
view, such as long telephoto or superwide.

Additionally, if you are using a tripod Olympus recommends that you set IS to off. If you
are using a lens with built-in image stabilization, the lens stabilization settings (switch)
have priority over the camera body stabilization settings. If you are using S-IS AUTO along
with a lens that has built-in stabilization, the camera body stabilization will back up the
lens stabilization by automatically using S-IS 1, instead of S-IS AUTO.

Settings Recommendation: I have found that S-IS AUTO works beautifully for still im-
ages of any type. If you do a lot of panning, the S-IS AUTO mode is particularly effective.
The camera allows you to disable certain types of IS directional correction (e.g., horizon-
tal or vertical). Refer to the list of IS modes and select the mode that works best for your
circumstances.

Record Mode (Image Quality)

The Record Mode function allows you to choose the image quality for your pictures. You can shoot in RAW (ORF) mode or in various JPEG sizes and pixel counts, including Large (L), Middle (M), and Small (S). You can also choose from several JPEG compression levels, including Super Fine (SF), Fine (F), Normal (N), and Basic (B).

This chapter will discuss how to choose an image quality for taking still pictures. However, there is a lot to discuss in making these choices. There is deeper information on this subject available in the **Shooting Menu 1** chapter under the **Record Mode** subheading on page 175. Be sure to read that information before you shoot too many important images so you can make the best image quality choices.

On the Super Control Panel menus, you will see JPEG size and compression rate names combined. For instance, a Large-size, Fine-compression rate JPEG will be listed as LF, and a Medium-size, Normal-compression rate JPEG will be shown as MN.

The size for RAW mode, or the RAW file in a combination mode (e.g., LF+RAW), is always Large (L) with a 4608 × 3456 pixel ratio. RAW files always contain all available image data and cannot be resized in-camera. JPEG images have adjustable sizes, pixel counts, and compression rates.

Let's see how to select an image quality Record Mode.

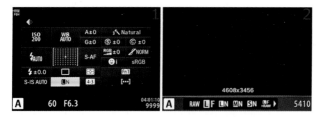

Figure 2.1AD: Choosing an image quality (Record Mode) setting

Figure 2.1AD, image 1, shows the [Record Mode] position highlighted with Large Normal (LN) JPEG image quality selected. You may select one of the nine image quality settings by turning the Front Dial until the mode you want is displayed in the highlighted position. If you want to use the secondary screen to select a new image quality, press the OK button to open the secondary screen.

Figure 2.1AD, image 2, shows the image quality secondary screen. You will find nine image quality choices along the bottom of the screen. Use the Arrow pad keys to scroll left or right until you highlight the mode you want to use, and press the OK button to lock in the mode. The approximate number of images that can be held on the current memory card is displayed on the bottom-right side of the secondary screen. The 64 GB memory card in my camera can currently hold 5410 more images. This number will vary depending on which image quality setting you have chosen.

Note: When it is enabled in the Custom Menu, there is also a JPEG Large Super Fine (LSF) image quality Record Mode. It will not appear in any of the image quality menus

unless you enable it with the *Custom Menu > G. [Record Mode]/Color/WB > [Record Mode] Set* function. Enabling this option is discussed in the **Custom Menu** chapter under the **[Record Mode] Set** subheading on page 392.

Settings Recommendation: Because of its smaller sensor, I want my E-M1 to capture the best possible quality, so I most often use the RAW setting. However, shooting in RAW requires that I post-process the files and later convert them to JPEGs. If I need to give images to someone quickly, I may use the LSF+RAW setting and shoot both file types at the same time. This gives me the best of both worlds: a RAW file for when I have time to make a masterpiece, and a JPEG file for immediate use.

Even if you do not know how to post-process RAW files, I suggest that you capture both RAW and JPEG files so you will have an uncompressed original (RAW) file for especially good images later, when you have learned the needed post-processing skills. Shooting a Large Super Fine JPEG (LSF) and a RAW file at the same time is as easy as selecting it from the Super Control Panel menu. Just look for LF+RAW or LSF+RAW. The camera will write both file formats to the memory card at the same time. The Large Super Fine (LSF) JPEG setting will be available *only* after you enable it, as previously described.

Aspect

The E-M1 is a Micro Four Thirds camera, which describes the aspect ratio of the sensor (4:3). Other camera brands have sensors with different aspect ratios. The Aspect function on the E-M1 allows you to change the normal 4:3 image aspect ratio to a different ratio that more closely matches the aspect ratios of other camera brands. In other words, the length and width of the image is cropped into a new relationship. The five available ratios are 4:3, 16:9, 3:2, 1:1, and 3:4.

The new Aspect ratio changes the final shape of the image, which means the camera has to crop the picture. Therefore, use a different ratio only when you must to prevent quality losses when an image is enlarged.

Image Aspect ratio is discussed in more detail in the **Shooting Menu 1** chapter under the **Image Aspect** subheading on page 186, including samples of the different ratios.

Let's examine how to select one of the five image Aspect ratios.

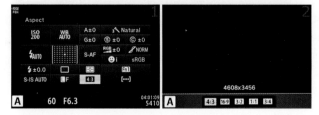

Figure 2.1AE: Choosing an image Aspect ratio

Figure 2.1AE, image 1, shows the Aspect position highlighted on the Super Control Panel with the 4:3 Aspect ratio selected. To select a different Aspect ratio, turn the Front Dial

and the Aspect ratios will scroll by. Stop scrolling when the ratio you want to use is high-lighted. You can also use the Aspect secondary screen to select an Aspect ratio. Press the OK button to open the secondary screen.

Figure 2.1AE, image 2, shows a list of five Aspect ratios across the bottom of the screen. There is also a handy guide above the line of ratios that shows the pixel dimensions of the corresponding Aspect ratio. I chose the default 4:3 Aspect, which displays pixel dimensions of 4608×3456. You can determine the megapixel (MP) rating of each Aspect ratio by multiplying the pixel dimensions. For instance, 4,608 × 3,456 = 15,925,248, or approximately 16 MP. If you scroll through the rest of the settings and multiply the rest of the pixel dimensions, you will see that all but the 4:3 ratio results in images of less than 16 MP. That is, Aspects other than 4:3 create smaller images due to cropping. Choose the Aspect you want to use by scrolling left or right with the Arrow pad keys, highlighting the ratio you want to use, then pressing the OK button to lock in the Aspect.

Note: As you change Aspect ratios, the electronic viewfinder (EVF) will adjust to the new shape so you can accurately shoot with the new Aspect. As a test, change the Aspect ratio, then hold your camera up to your eye to see the difference in the black EVF borders.

Settings Recommendation: I rarely change the Aspect ratio of the image with this function. I prefer to simply crop the image after the fact in my computer. However, if you need a specific Aspect ratio but don't have time to crop your images, the camera is ready to provide the ratio you need with no hassle and only minor image quality loss.

We will now consider another set of screens called Live Control, which many people prefer over the Super Control Panel.

Live Control

Live Control is another convenient way to access the most-often used camera configuration items. We have already considered the Super Control Panel in detail; now we will consider Live Control, which accesses basically the same settings as the Super Control Panel. In the next several chapters we will cover the same functions again, along

Figure 2.2A: Live Control functions (right side)

with a *large* number of other functions that are not available from the Super Control Panel or Live Control.

As you proceed through the 14 Live Control settings, keep in mind that Live Control is just another front end to the same settings as in the Super Control Panel. To avoid

repeating material, this section about Live Control will show you how to do basic setting configurations and provide page number cross-references to the Super Control Panel section in this chapter, and to other chapters, for more details.

Live Control is a very convenient type of camera control system. In some ways it is more convenient than the Super Control Panel. While the Super Control Panel will be used mostly by photographers who dislike using Live View and would rather use the electronic viewfinder (EVF) to take pictures, Live Control is for those who don't mind having both Live View and the EVF available at all times. Live Control and the Super Control Panel are mutually exclusive. When you enable one of them, it disables the other.

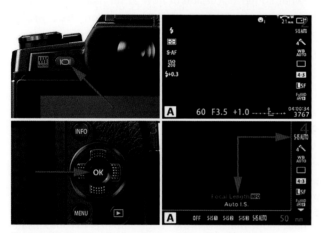

Figure 2.2B: Enabling the Live View and Live Control screens

To toggle between the Super Control Panel and Live View, simply press the LV button (figure 2.2B, image 1).

The Live View screen will open, as shown in figure 2.2B, image 2, which has the lens cap on for maximum contrast. Normally both the Live View screen (image 2) and the Live Control screen (image 4) will display the subject.

When you see the Live View screen on the back of your camera (figure 2.2B, image 2), press the OK button (figure 2.2B, image 3) to open Live Control (image 4).

The Live Control screen is shown in figure 2.2B, image 4. This screen has a menu of 14 items on the right side; seven of them are shown at one time. In figure 2.2B, image 4, the Image Stabilizer (IS) mode is selected, which is currently set to S-IS AUTO (Auto I.S.). Each of the 14 items on the right side of the screen can be selected by scrolling up or down with the Arrow pad keys. When a menu item is highlighted on the right side of the screen, its settings are available along the bottom of the screen (figure 2.2B, image 4, red arrows). Notice at the bottom of image 4 that you can see the settings for the IS system. Scroll left or right with the Arrow pad keys to highlight the setting you want to use.

After you have selected a setting, press the OK button to lock it in.

Necessary Repetition of Setting Information

Now let's consider each of the 14 items on the Live Control screen. Much of the material in this section is also provided in the previous Super Control Panel section because the 14 Live Control functions access many of the same settings as the Super Control Panel in a slightly different way.

Because this is a reference manual for the E-M1, it is best to allow some repetition to prevent you from having to flip around in the book so much. There are differences in how you set most of the features, and Live Control is often simpler to use.

Since this section is a somewhat lighter discussion of how to set many of the same functions we have already discussed in the Super Control Panel section, there will be less detail. You should be able to determine how to use a certain function immediately; however, if you want greater detail, refer to the page number cross-references to help you find it.

Image Stabilizer

The E-M1's 5-axis Image Stabilizer compensates for camera shake in five axes: roll, pitch, yaw, vertical, and horizontal. With this feature enabled you can handhold your camera at much lower shutter speeds.

The following is a list of modes that are available in the Image Stabilizer menu:

- **Off:** No image stabilization is provided.
- **S-IS1:** This is a general automatic mode that allows the Image Stabilizer to compensate in five directions. It automatically corrects for movement in any or all of the directions (axes) at any time. It is not as sensitive to panning as S-IS AUTO.
- **S-IS2:** The image stabilization system corrects only for the vertical axis (Vertical IS). Use this mode when you are moving the camera vertically and are not concerned about horizontal correction. If you are panning horizontally, such as at a car race, and are holding the camera in a horizontal (landscape) orientation, this mode may perform well for you.
- **S-IS3:** The image stabilization system corrects only for horizontal camera shake (Horizontal IS). If you are panning horizontally, such as at a car race, and are holding the camera in a vertical (portrait) orientation, this mode may perform well for you.
- **S-IS AUTO:** Olympus suggests this mode when you are unsure what you will be shooting and want to be prepared for any kind of movement. The camera automatically chooses the best type of image stabilization for the subject it detects. This is the factory default mode.

Let's see how to configure the IS system.

Figure 2.2C: Image Stabilizer function on the Live Control screen

Figure 2.2C, image 1, shows that the Image Stabilizer (IS) system has been selected. On the right side of the screen you will see that the Image Stabilizer (S-IS AUTO) is the first menu item. At the bottom of the screen you can see all five of the IS settings. Use the Arrow pad keys to scroll left or right until the setting you want to use is highlighted. If you are using a Micro Four Thirds or Four Thirds lens, press the OK button and the IS system is ready to use. Skip the rest of this step and the next two steps. If you are using a lens mounted on an adapter that does not communicate with the camera body (a dumb adapter), you will need to complete the following two steps to get the best performance from the IS system.

Figure 2.2C, image 2 (red arrow), shows how to start the process of letting the camera know the focal length of the lens that is mounted on a dumb adapter. With any of the IS settings highlighted, press the Info button to open the Focal Length registration screen.

Figure 2.2C, image 3 (red arrow), allows you to register a focal length for a lens that is mounted on a dumb adapter. Press up or down on the Arrow pad keys to select a focal length. The range of focal length choices are from 8mm to 1000mm. I chose 50mm (red arrow).

Note: The focal length shown in figure 2.2C, image 3 (red arrow), is *not used* when you have a Micro Four Thirds lens mounted directly on the camera or when you mount a Four Thirds lens on a communicating (smart) adapter (e.g., an Olympus MMF-3). In those situations, the lens electronically communicates the focal length to the E-M1 body.

Deeper Information: This subject will be examined in greater detail in the **Shooting Menu 2** chapter under the **Image Stabilizer** subheading on page 198.

Settings Recommendation: I have found that S-IS AUTO works well for still images of any type. If you do a lot of panning, the S-IS AUTO mode is particularly effective. The camera allows you to disable certain types of IS directional correction (e.g., horizontal or vertical). Refer to the list of IS modes and select the mode that works best for your circumstances.

Picture Mode

Individual Picture Modes impart a specific look to JPEG images. RAW shooters can use the current Picture Mode setting or change Picture Modes after the image has been taken and then save the file as a JPEG with a new look. There are 23 modes available at the bottom

of the Live Control screen, including several Art Modes. Let's discuss how to select individual Picture Modes.

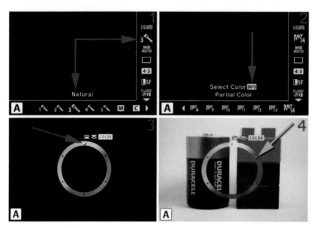

Figure 2.2D: Selecting a Picture Mode and using the Partial Color system

In figure 2.2D, image 1, the Picture Mode function is highlighted on the right. At the bottom of the screen you can see several of the 23 Picture Modes. Use the left or right Arrow pad keys to scroll through the settings at the bottom of the screen until you have located the mode you want to use. I chose 3, the Natural Picture Mode. Press the OK button to lock in the mode, and skip the rest of these steps. The Art 14 or Partial Color mode requires additional input. If you would like to use this mode, follow the upcoming steps.

The ART 14 Partial Color Picture Mode allows you to choose a narrow range of color to appear in your image, and all other hues become shades of gray. Scroll to the right until you reach the last Picture Mode selection, which is ART 14 (figure 2.2D, image 2). Press the Info button to open the Partial Color screen.

The Partial Color screen (figure 2.2D, image 3) allows you to select a narrow color range to include in your image, and all other colors will be rendered in grayscale. I left the cap on my lens in image 3 so you can see the Partial Color screen with a black background. Notice the small indicator at the top of the color circle (red arrow). You can move this indicator into the color range areas with either the Front Dial or Rear Dial. The colors of the rainbow are available to you as you move the indicator.

In figure 2.2D, image 4, you can see that I have moved the indicator into the red zone of the color wheel (blue arrow). Notice that this zone allows the red block in the image to display in red, and the lower two blocks, which are actually green and blue, display in shades of gray. Also notice that the copper color of the battery top is displayed. As you move the indicator around the color wheel, you will see changes in the colors of your image. The colors fade to gray as you move the indicator into and out of the color ranges. When you have selected the color range that gives you the Partial Color look you desire, press the OK button and take the picture.

When you are done, be sure to cancel Partial Color mode by selecting a Picture Mode other than ART 14.

Deeper Information: In the chapter named **Shooting Menu 1,** under the **Picture Mode** heading on page 136, we will discuss the how, when, and why of each Picture Mode in much greater detail. We will have a deeper discussion of the Partial Color system in the **Shooting Menu 1** chapter under the **Partial Color (Art 14)** subheading on page 172.

Additionally, you can fine-tune the Sharpness, Contrast, Saturation, and Gradation of several Picture Controls. Refer to the **Super Control Panel** section earlier in this chapter under the **Picture Mode: Sharpness, Contrast, Saturation, and Gradation** subheading on page 19.

Settings Recommendation: For everyday shooting I usually choose Natural Picture Mode. However, for some types of nature shooting I may use Vivid Picture Mode to pop the colors. When I need the widest dynamic range for nature shooting, I may use the Muted Picture Mode then later increase the saturation and contrast manually for the best look. For portraits I often use Portrait Picture Mode to preserve natural-looking skin tones. When I am feeling adventurous, I even use some of the Art Modes. They can be quite fun! It's good that we have so many choices.

White Balance

The E-M1 offers several preset White Balance (WB) values (e.g., Sunny, Cloudy, Incandescent). In addition, you can take an ambient light reading (Capture WB) and directly input a Kelvin (K) color temperature (custom white balance, CWB), for a total of 13 WB settings. Let's see how to select a WB value from the Live Control screen.

Figure 2.2E: Selecting a WB mode

In figure 2.2E you can see the WB position highlighted on the right and the available WB settings in the bottom row. I chose WB AUTO. To change the WB value, scroll left or right with the Arrow pad keys and highlight the WB value you want to use, then press the OK button.

Capture WB Ambient Light Reading

Next let's examine how to do an ambient light reading from a white or gray card under the current light source and assign it to one of the four Capture WB memory locations for taking pictures later under the same light source.

In figure 2.2F, image 1, you can see that I chose WB AUTO. Now we will read the ambient light source, set the WB to that source, and save the reading into a memory location for immediate and future use.

Figure 2.2F: Capturing an ambient WB reading from a gray or white card

In figure 2.2F, image 2, I have scrolled to the right and highlighted the first of four Capture WB settings. You can see that the first one is highlighted, and three more follow it. Notice on the right side that the highlighted symbol has changed to match the selected WB setting. You can use the Capture WB settings to select a previously created Capture WB ambient light reading or to create a new one and save it in one of the four Capture WB memory locations.

To create a Capture WB reading, locate one of the four Capture WB memory locations; they are indicated by a flower icon followed by a number from 1–4 (figure 2.2F, image 2). Capture WB 1 is currently selected. Notice that INFO is displayed after the Capture WB label. If you press the Info button while one of the Capture WB memory locations is selected, the camera will prepare for a Capture WB reading from a white or gray card.

Figure 2.2F, image 3, shows the next screen, which tells you to *Point the camera at a sheet of white paper.* You can also use a standard gray card. After you have positioned the white or gray card in front of the lens, press the Shutter button to take a picture. The camera does not store the picture on the memory card. Instead, it makes an accurate WB reading from the white or gray card. The camera will not attempt to focus on the card; it will simply fire the shutter.

Note: If the camera cannot successfully make a Capture WB reading, the camera will display the following message to let you know the reading was unsuccessful: *X [Flower icon] WB NG Retry.*

Figure 2.2F, image 4, shows the screen after a successful Capture WB reading has been made. You can now decide whether you want to store the WB reading in the currently selected Capture WB location. To store the WB reading, select Yes and press the OK button. If you do not want to save it, select No and press the OK button, or press the Menu button to cancel.

CWB Custom WB Kelvin Value

If you know how to use direct Kelvin (K) WB values and want to input your own custom white balance (CWB), you can input a range from 2000 K (cool) to 14000 K (warm). Let's see how it works.

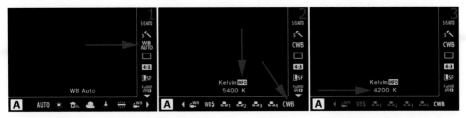

Figure 2.2G: Selecting a Kelvin (K) WB value

In figure 2.2G, image 1, you can see that we are starting from the WB AUTO setting again. At the bottom of the screen, use the Arrow pad keys to scroll all the way to the right of the 13 WB settings to find the CWB setting.

In figure 2.2G, image 2 (right red arrow), you can see that I selected CWB (the 13th setting). The current Kelvin (K) reading is 5400 K (left red arrow), but we will change it. Press the Info button to open the next screen, which will allow you to change the K value.

Figure 2.2G, image 3, shows that the K value has been changed to 4200 K (a cooler value). To change the value, press the up or down Arrow pad keys to select a K value between 2000 K (cool) and 14000 K (warm). Press the OK button to lock in the CWB setting.

Deeper Information: For a detailed study of each of these WB types see the **Custom Menu** chapter under the *Custom Menu > G. [Record Mode]/Color/WB > WB* function on page 396. The Live Control WB screen is a lite version of the function settings provided in the WB Custom Menu. In this chapter we've discussed how to select settings. In the **Custom Menu** chapter we will discuss how, why, and when.

If you want to fine-tune the hue of the WB for a particular Picture Mode, you can do so with the extra control screens discussed in the **Super Control Panel** section earlier in this chapter. Look under the subheading **Fine-Tuning the WB** on page 23.

Settings Recommendation: The WB system in the E-M1 is pretty flexible. I use AUTO WB most of the time. The range of choices at your fingertips guarantees that you can use an accurate WB and capture true colors. Why not take time to shoot some pictures with the various WB values to see how the camera changes the color balance? Also experiment with taking an ambient Capture WB reading from a white or gray card. That experience is vital if you find yourself in a situation where you must carefully control the color.

Sequential Shooting/Self-Timer

The camera's Sequential shooting/Self-timer system is designed to let you control the frame rate of the camera when you are shooting in bursts. It also lets you control remote shooting with three Self-timer controls. Let's examine each of the modes and see how they work:

- **Single:** This mode causes the camera to take one picture each time you fully press the Shutter button.
- **Sequential H:** The camera will take a continuous series of pictures at about 10 frames per second (fps). Autofocus, exposure, and white balance are frozen at the values determined by the camera for the first picture and are not updated during the series.
- **Sequential L:** The camera will take a continuous series of pictures at about 6.5 fps with firmware 2.0 or 9 fps with firmware 3.0. Autofocus, exposure, and white balance are updated for each picture in the series.
- **[Self-timer] 12 sec:** The camera will take a single photograph 12 seconds after you press the Shutter button all the way down. The orange focus assist light on the front of the camera will shine solid for 10 seconds, then it will blink for 2 seconds before the shutter fires and the picture is taken.
- **[Self-timer] 2 sec:** The camera will take a single photograph two seconds after you press the Shutter button all the way down. The orange focus assist light on the front of the camera will blink for two seconds before the shutter fires and the picture is taken.
- **[Self-timer] C (Custom Self-timer):** This variable self-timer function allows you to select the number of images the camera will take when the self-timer expires (Frame), the time in seconds the camera will wait before firing (Timer), and the period of time between each picture (Interval Time) if you have selected more than one picture with the Frame setting. You can also choose whether or not to have the camera autofocus between each picture (Every Frame AF).

Now let's examine how to select one of the modes.

In figure 2.2H, image 1, the Sequential shooting/Self-timer position is highlighted. You can see all six modes at the bottom of the screen. Single (Single-frame shooting) is currently selected. The first three modes are Sequential shooting modes (Single, Sequential H, and Sequential L), and the last three are Self-timer modes (12 sec, 2 sec, and Custom Self-timer). Refer to the previous list to determine which of the modes works best for your current needs. To select a mode, use the Arrow pad keys to scroll left or right and highlight the mode you want to use. Press the OK button to select it. Figure 2.2H, images 2–6, show the Custom Self-timer screens. The Custom Self-timer (C) gives you fine control over how the camera's self-timer system works. The next few paragraphs describe how to use it.

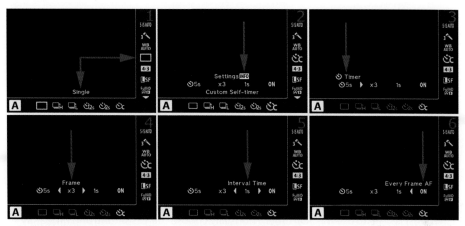

Figure 2.2H: Selecting a Sequential shooting or Self-timer mode

Figure 2.2H, image 2, shows the Sequential shooting/Self-timer screen with Custom Self-timer (C) mode selected. Press the Info button to open the custom setting fields. The four custom settings are as follows:

- **Timer:** Choose the timeout period (Timer) before the *first* Frame is taken during the self-timer cycle (figure 2.2H, image 3). You can choose from as short as 1 second (1s) to as long as 30 seconds (30s). The camera will fire the first Frame only after the Timer delay you selected has expired. This gives you time to get in position, even if you must run a distance from the camera to be in the frame or need the delay for some other reason. Scroll up or down with the Arrow pad keys to choose a value. When you have chosen a value, scroll to the right.
- **Frame:** This setting allows you to choose the total number of pictures (Frames) the camera will take during the self-timer cycle (figure 2.2H, image 4). I chose three Frames (x3). You have a choice of from 1 (x1) to 10 (x10) Frames. Scroll up or down with the Arrow pad keys to choose a value. When you have chosen a value, scroll to the right.
- **Interval Time:** This setting controls the time between Frames *after* the first Frame is taken (figure 2.2H, image 5). The camera will delay for the amount of time specified in the Timer setting, then will use the Interval Time to pause between the rest of the Frames. I chose 1 second (1s). Scroll up or down with the Arrow pad keys to choose a value. When you have chosen a value, scroll to the right.
- **Every Frame AF:** Select either On or Off from the Every Frame AF field (figure 2.2H, image 6). On tells the camera to autofocus for every shot in the Self-timer series of pictures, and Off means the camera will autofocus on the first frame of the series only. After you have selected the value, press the OK button to save your settings. Prepare the camera for shooting and press the Shutter button to start the initial Self-timer (Timer) countdown.

Note: The camera will remember your Self-timer Custom settings and will use them over and over until you change them. If these settings are useful for most of your Self-timer photography, simply select Self-timer Custom to use the settings in the future.

Deeper Information: These Release modes are considered in more detail under the **Shooting Menu 2** chapter in the **Sequential/Self-timer Shooting** subsection on page 194.

Settings Recommendation: As a nature and portrait photographer, I normally use Single-frame shooting. However, if I'm at an event such as an auto race, I will often switch to Sequential Low (L), which gives me a shooting speed of about 6.5 fps with firmware 2.0 or 9 fps with firmware 3.0, with autofocus between each frame. I rarely use the Sequential High (H) setting because I normally do not need a speed of 10 frames per second, and I want autofocus between frames, which H mode does not provide.

When it is time to use the Self-timer, I normally choose the 12s setting and take a single picture. However, if I want to be creative and use the Self-timer for multiple frames, I often use the Self-timer Custom setting.

Aspect

The E-M1 is a Micro Four Thirds camera, which describes the aspect ratio of the sensor (4:3). Other camera brands have sensors with different aspect ratios. The Aspect function on the E-M1 allows you to change the Micro Four Thirds (4:3) standard image aspect ratio to various different Aspect ratios that more closely match the ratios of other brands. In other words, the length and width of the image is cropped into a new relationship. The five available ratios are 4:3, 16:9, 3:2, 1:1, and 3:4.

The new Aspect ratio changes the final shape of the image, which means the camera has to crop the picture. Therefore, use a different ratio only when you must to prevent quality losses when an image is enlarged.

Let's examine how to select one of the five image Aspect ratios.

Figure 2.2I shows the Aspect position highlighted on the Live Control screen with the 4:3 Aspect ratio selected. There are five Aspect ratios displayed across the bottom of the screen. There is also a handy guide above the line of ratios that shows the pixel dimensions of the corresponding Aspect ratio. I chose the default 4:3 Aspect ratio, which displays pixel dimensions of 4608×3456. Choose the Aspect ratio you want to use by scrolling left or right with the Arrow pad keys. When the ratio you want to use is displayed, stop scrolling and press the OK button to lock in the setting.

Figure 2.2I: Selecting an image Aspect ratio (pixel ratio)

Note: As you change to a different Aspect ratio, the electronic viewfinder (EVF) and Live View screen will adjust to the new shape so you can accurately shoot with the new Aspect ratio.

Deeper Information: Image Aspect ratio is discussed in more detail in the **Shooting Menu 1** chapter under the **Image Aspect** subheading on page 186, including picture samples of the different ratios.

Settings Recommendation: I rarely change the Aspect ratio of the image with this function. I prefer to simply crop the image after the fact in my computer. However, if you need a specific Aspect ratio but don't have time to crop your images, the camera is ready to provide the ratio you need with no hassle and only minor image quality loss.

Record Mode (Image Quality)

The Record Mode function allows you to choose the image quality for your pictures. You can shoot in RAW (ORF) mode or in various JPEG sizes and pixel counts, including Large (L), Middle (M), and Small (S). You can also choose from several JPEG compression levels, including Super Fine (SF), Fine (F), Normal (N), and Basic (B).

On the Live Control image quality settings, you will see JPEG size and compression rate names combined. For instance, a Large-size, Super Fine compression rate JPEG will be listed as LSF, and a Large-size, Fine compression rate JPEG will be listed as LF.

The size for RAW mode, or the RAW file in a combination mode (e.g., LF+RAW), is always Large (L) with a 4608 × 3456 pixel ratio. Let's examine how to select an image quality Record Mode.

Figure 2.2J shows the image quality position high-lighted with Large Super Fine (LSF) selected. You can select one of the nine image quality settings by scrolling left or right with the Arrow pad keys until the mode you want to use is highlighted. The approximate number of images that can be held on the current memory card is displayed on the bottom-right side of the screen. The 64 GB memory card in my camera can currently hold 3767 more images. This number will vary depending on which image quality setting you have chosen. Press the OK button to lock in the image quality.

Figure 2.2J: Choosing a JPEG, RAW, or JPEG+RAW image quality Record Mode

Deeper Information: There is deeper information on this subject in the **Shooting Menu 1** chapter under the **[Record Mode]** subheading on page 175. Be sure to read that information before you shoot too many important images so you can make the best image quality choices.

Additionally, you may have noticed in figure 2.2I that I used the *Custom Menu > G. [Record Mode]/Color/WB > [Record Mode] Set* function to change all my image quality choices to Super Fine (LSF, MSF, SSF). The JPEG Super Fine (SF) Record Mode is available only when it is enabled in the Custom Menu. It will not show up in any of the image quality menus unless you enable it. Instructions are provided in the **Custom Menu** chapter under the **[Record Mode] Set** subheading on page 392.

Settings Recommendation: Because of its smaller sensor, I want my E-M1 to capture the best possible quality, so I most often use the RAW setting. However, shooting in RAW requires that I post-process the files and later convert them to JPEGs. If I need to give images to someone quickly, I may use the LSF+RAW setting and shoot both file types at the same time. This gives me the best of both worlds: a RAW file for when I have time to make a masterpiece, and a JPEG file for immediate use. For fun shooting, you may set your camera to one of the JPEG modes so you won't have to store the extra RAW file, yet you will still have great images to e-mail, print, or use on Instagram, Facebook, or Google+.

Video Frame Size, Rate, and Format

This function allows you to choose the frame size (e.g., 1080p, 720p) and bit rate (e.g., Fine, Normal) for your video recordings. It also lets you to choose the video format (container) for your videos (e.g., MOV or AVI Motion JPEG). The following is a description of the six video types:

Full HD Video (MOV format)

- **FullHD-F:** This is the best-quality video setting. It offers Full HD (1920 × 1080) or 1080p at 30 fps (actually, 29.97 Mbps), with a Fine (F) bit rate of 24 Mbps. A one-minute video is approximately 177 MB in size. A FullHD-F video uses the MOV file format (container) for ease of viewing with an Apple QuickTime compatible video player. The video has a 16:9 aspect ratio with H.264 MPEG-4 AVC compression.
- **FullHD-N:** This setting is the second best video quality mode. It offers Full HD (1920 × 1080) or 1080p at 30 fps (actually, 29.97 Mbps), with a Normal (N) bit rate of 16 Mbps. A one-minute video is approximately 130 MB in size and uses the MOV file format (container) for viewing with an Apple QuickTime compatible video player. The video has a 16:9 aspect ratio with H.264 MPEG-4 AVC compression.
- **HD-F:** This setting provides an HD (1280 × 720) or 720p video at 30 fps (actually, 29.97 Mbps), with a Fine (F) bit rate of 12 Mbps and a MOV file format (container). A one-minute video is approximately 81 MB in size and plays on an Apple QuickTime compatible video player. The video has a 16:9 aspect ratio with H.264 MPEG-4 AVC compression.
- **HD-N:** This setting offers an HD (1280 × 720) or 720p video at 30 fps (actually, 29.97 Mbps), with a Normal (N) bit rate of 8 Mbps and a MOV file format (container). A one-minute video is approximately 67 MB in size and plays on an Apple QuickTime compatible video player. The video has a 16:9 aspect ratio with H.264 MPEG-4 AVC compression.

Motion JPEG Video (AVI format)

- **HD:** This setting gives you an HD (1280 × 720) or 720p video that uses an AVI file format (container). It has a 30 fps video recording speed. A one-minute video is approximately 243 MB in size. The AVI file format will play on a Windows Media Player compatible video player. The video has a 16:9 aspect ratio and Motion JPEG compression.
- **SD:** This setting gives you an SD (640 × 480) or 480p video that uses an AVI file format (container). It has a 30 fps video recording speed. A one-minute video is approximately 122 MB in size. The AVI file format will play on a Windows Media Player compatible video player. The video has a 4:3 aspect ratio and Motion JPEG compression.

Note: The HD and SD formats have extra-large file sizes, compared to the four previous MOV formats, because they use Motion JPEG compression in an AVI container. Each individual frame of the video is a small compressed JPEG file. This type of video is easy to post-process, but it's much larger to store.

The FullHD-F, FullHD-N, HD-F, and HD-N formats are created with H.264 MPEG-4 AVC compression in a MOV container. Although they are not as easy to post-process, they provide efficient, high-quality videos that take up much less space.

If you use certain ART filters that have a heavy processing overhead while recording Motion JPEG HD or SD video, you may not be able to shoot at a full 30 fps.

Now let's examine how to choose a video type.

Figure 2.2K shows the video type position highlighted (right arrow), with FullHD-F selected (MOV 1920×1090 Fine). Along the bottom of the screen are six video type settings (you can see only four of them without scrolling). Referring to the previous lists of video types, use the Arrow pad keys to scroll left or right and highlight the video format you want to use. Press the OK button to lock in the setting.

Figure 2.2K: Choosing a video recording type

Notice at the bottom-right corner of figure 2.2K that you can see the approximate maximum video recording time for the memory card that is currently in the camera. My 64 GB card can record a little more than four hours (04:00:34) of video in the currently selected FullHD-F format (the card contains other images). When I format the 64 GB card, this screen says I can record the following to the blank card:

- **FullHD-F:** 05:23:54
- **FullHD-N:** 07:52:04
- **HD-F:** 10:12:02
- **HD-N:** 14:30:00
- **HD:** 03:40:46
- **SD:** 07:03:14

Settings Recommendation: I normally shoot video in the FullHD-F format because I want great quality and a reduced file size (compared to Motion JPEG video). If you want to learn how to post-process video, you may want to shoot some short videos with a Motion JPEG AVI type selected (HD or SD). It is much easier to work with these videos in basic video editing software because every frame contains a small compressed JPEG picture.

Editing videos that use H.264 MPEG-4 AVC compression is more difficult because of the way the video is stored in each frame. The individual frames store only things that have changed (the motion), and the entire scene is recorded as key frame every few frames. To work with this type of video in editing software, you must have experience working with H.264 MPEG-4 AVC compressed videos.

If all you want to do is shoot great video, I suggest that you experiment with the first four modes using the MOV format to get the smallest file sizes.

Flash Mode

The E-M1 offers you a choice of eight flash modes. Let's examine each mode and see what it does:

- **Flash Auto:** The camera controls the flash. It will fire when the camera senses that the light is too low for a good picture. It will not fire when the camera meter says the ambient light is sufficient.
- **Redeye:** This mode tries to cause the subject's pupils to contract by firing a preflash and blinking the red AF illuminator light on the camera body twice before the main flash fires. This may reduce the eerie red-eye look that can be seen in so many pictures.
- **Fill In:** This mode puts the flash entirely in your control. The flash will fire each time you take a picture, and it will attempt to balance with ambient light (it fills in).
- **Flash Off:** The flash is off and will not fire.
- **Red-Eye Slow:** This mode executes the same actions as the Redeye mode mentioned previously; however, it also uses Slow flash, as described next. Basically, the camera fires a preflash to reduce red eye and also uses shutter speeds that can get very slow in dim ambient light. Therefore, this mode helps you use mostly ambient light to illuminate the subject, adds some fill light from the flash, and does red-eye reduction for good measure.
- **Slow:** This mode fires the flash as soon as the first curtain of the shutter is fully open. Then, if the ambient light is dim, it allows the shutter to remain open to pull in background light. If you are shooting in low light it is best to use a tripod for this mode (and other modes that use Slow), or at least brace yourself against a solid object when you take the picture. Otherwise, you may have a well-exposed subject with ghosting from camera movement after the flash fires. If a subject is moving when you use this mode, a ghosted trail may appear in *front* of the subject. Basically, Slow mode fires the flash at the beginning of the shutter speed time and allows the camera to continue gathering light for the rest of the time the shutter is open.

- **Slow2:** This mode operates like the Slow mode, except it fires the flash at the end of the shutter speed time, just before the second shutter curtain closes. In effect, the camera has already made an ambient light exposure before it fires the flash. For that reason, this mode is often called rear-curtain or second-curtain flash. If the subject is moving, a ghosted trail may appear *behind* the subject. Many people use this mode to imply motion in photographs.
- **Manual Value:** You can manually choose a flash power, as described in the paragraphs accompanying figure 2.2L. You can choose from the range of full power (Full) to 1/64 of full power.

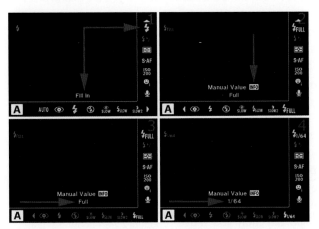

Figure 2.2L: Choosing a Flash Mode and using Manual flash

In figure 2.2L, image 1, you can see that the flash mode position is highlighted, with Fill In mode selected on the bottom of the screen. If you don't know what a symbol means, look at the text above the symbol (image 1, red arrow). To choose one of the eight available flash modes, refer to the previous flash mode list, then use the left or right Arrow pad keys to scroll through the modes. Stop when the symbol of the mode you want to use is highlighted. Press the OK button to lock in the flash mode.

If you are shooting in a studio and need to carefully control the flash manually, you can use the Manual Value mode. In figure 2.2L, image 2, the Manual Value flash symbol at the far right end of the eight modes is selected. If this mode has not been moved from maximum power, it will display a small lightning bolt symbol and the word FULL. After you select Manual Value, press the Info button to enable the adjustment system.

In figure 2.2L, image 3, notice that the word Full, just below Manual Value Info, becomes a field that accepts input when you press the Info button. Scroll up or down with the Arrow pad keys, and you will see the values change in the field that previously reported Full. In figure 2.2L, image 4, you can see that I chose 1/64 power, which is the lowest output setting. Again, the range of flash output is from 1/64 to Full. After you have selected the value you want to use, press the OK button to lock it in.

Settings Recommendation: I use the Fill In flash mode most of the time. It seems to balance the flash well with ambient light, and the mode lets me, not the camera, decide when to use flash. However, if you are shooting for fun or don't have much experience with flash, Flash Auto mode is good for helping you know when to use flash. The other modes (e.g., Slow, Slow2) are available for when you want special effects. Redeye seems to help somewhat for reducing the red-eye effect in portraits.

Flash Intensity Control (Compensation)

Flash Intensity Control is similar to a flash compensation system. If you are taking pictures and the background of the subject is exposed well but the subject is overexposed, you may want to dial back the power or intensity of the flash unit. If the subject is underexposed and the background is well exposed, you may want to increase the flash output to light the subject a little better. Flash Intensity Control gives you the power to do either. In effect, you are dialing in flash exposure compensation. Let's see how to adjust it.

Select the Flash Intensity Control symbol, a small lightning bolt followed by +/− (figure 2.2M, right arrow). The +/−0.0 symbol at the bottom of the screen represents the EV compensation value that you can choose, which ranges over six EV steps (+3.0 to −3.0 EV).

Press the left or right Arrow pad keys to change the flash intensity. You will see the EV value change to plus or minus, depending on which direction you move the indicator. As expected, moving it toward + makes the flash put out more power, and moving it toward −

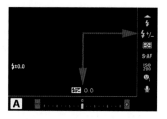

Figure 2.2M: Choosing a Flash Intensity Control exposure compensation value

makes it put out less power. Set the indicator at the EV compensation value you want to use. The positive or negative EV value will display where 0.0 is located. For instance, to add 1 stop (1 EV step) of flash power, move the indicator to the right until +1.0 appears above the indicator scale. Press the OK button to lock in your flash intensity choice.

Settings Recommendation: I tend to shoot a little brighter than many photographers because I use RAW mode for the best image quality most of the time. When you use RAW (ORF) image quality mode, the picture files have more overexposure headroom than you might think. Therefore, I generally leave the Flash Intensity Control set to +0.3, for a one-third stop overexposure. When you shoot JPEG files it is important to watch the histogram closely to prevent unrecoverable overexposure (highlight data loss), especially when shooting up close.

Metering Mode

The E-M1 has five light meter types that give you great flexibility in how you expose your images. Let's look more closely at the five types of light meters built in to the camera and discuss their differences:

- **ESP:** The camera meters the image with a grid of 324 metered areas that cover the frame. It uses complex mathematical computations to arrive at an excellent exposure. This metering mode works best for portraits when ☺ Face Priority is enabled.
- **Ctr-Weighted:** The camera averages the light between the subject and the background. It places more emphasis on exposure for the center area of the EVF or Live View screen, with less emphasis on parts of the scene that are farther away from the center.
- **Spot:** The camera uses a small circle in the center of the EVF or Live View screen for metering. This circle is equivalent to 2 percent of the frame, and all metering takes place in this 2 percent area. Therefore, you must place this stationary spot on the area of the subject that you want to correctly meter by moving the camera then using autoexposure lock (AEL/AFL button) to lock the exposure while you recompose the image. Or you can take multiple readings of different areas of the scene, determine the total light range, and set the exposure manually.
- **Spot Hilight (HI):** This type of metering is similar to standard Spot metering in that the camera uses a small circle in the center of the frame to meter. The metering circle is equivalent to 2 percent of the frame. This metering mode is different from standard Spot metering because the camera tries to make white areas (highlights) stay white by increasing the exposure beyond a normal Spot reading to give a bright, high-key look to the image.
- **Spot Shadow (SH):** This type of metering is also similar to normal Spot Metering in that the camera uses a small circle in the center of the frame to meter. The metering circle is equivalent to 2 percent of the frame. This metering mode is different from normal Spot metering because the camera tries to make dark areas (shadows) stay dark by decreasing the exposure below a normal Spot reading to give a low-key look to the image.

Let's examine how to select one of the metering modes.

In figure 2.2N, the Metering position is highlighted on the right, with ESP Metering mode selected at the bottom of the screen. Refer to the previous list of Metering modes, then use the Arrow pad keys to scroll left or right until the mode you want to use is highlighted. Press the OK button to lock in the mode.

Figure 2.2N: Choosing a Metering mode

Deeper Information: We will consider more detail about the Metering mode types in the **Custom Menu** chapter under the **Metering** subheading on page 370.

Settings Recommendation: Digital ESP metering (ESP) is a very effective form of metering. I rarely have to use the other metering modes. Sometimes I might use the Spot meter to meter a bright subject against a darker background, but otherwise I am quite happy with ESP. Be sure to use a form of ☺ Face Priority when you are taking portraits with ESP. That seems to make the camera extra sensitive to exposing faces accurately, even if the background is dark and could cause some facial overexposure.

AF Mode

The AF Mode function provides several focus methods. Four of them are for autofocus and one is for manual focus. Also, one of the autofocus methods will allow focus tracking. Let's examine each of the modes and see how to select one:

- **Single AF (S-AF):** When you hold the Shutter button halfway down, the camera auto-focuses on the subject, beeps once, and locks focus. In the top-right corner of the EVF (or Live View screen) you will see a small green dot. This indicates that the focus is good. If the subject moves, the focus may no longer be accurate; therefore, you must release the Shutter button and press it halfway again to update the focus. S-AF is best for static subjects or subjects that move very slowly. The AF point target indicator is a small green rectangle.

- **Continuous AF (C-AF):** Similar to S-AF, the camera will focus when you hold the Shutter button down, and it beeps when it has acquired good focus, up to two times. It also displays the round green good focus indicator at the top right of the camera screens. However, if the subject moves, the camera continues autofocusing on the subject. Unlike S-AF, the camera never really locks the focus permanently; it continues to seek the best autofocus at all times. If you change to a different subject, or if the subject moves, the camera will do its best to automatically update the focus. The AF point target indicator is a small green rectangle.

- **Manual focus (MF):** When you use MF mode you are entirely responsible for focusing the camera. The AF point target indicator is not used. You may want to enable focus Peaking and/or Magnify under the *Custom Menu > A. AF/MF > MF Assist > Peaking* [or *Magnify*] setting to make manual focusing easy and accurate. See the following **Deeper Information** subheading for more information on those two modes.

- **Single AF + MF (S-AF+MF):** This mode is almost exactly like the S-AF mode, with its focus lock, beep, and round green good focus indicator. However, it offers one powerful extra feature: manual focus fine-tuning. After you press the Shutter button halfway and the camera has autofocused and locked focus on the subject (S-AF), you can fine-tune the focus with the lens focus ring (MF). If you have focus Peaking and Magnify enabled, as discussed in the previous paragraph, the camera will use those features during fine-tuning. The AF point target indicator is a small green rectangle.

- **AF Tracking (C-AF+TR):** This mode is for autofocus with subject tracking. For general use this mode works like C-AF mode, with continuous autofocus updating. However, if the subject moves, the camera will carefully track it and lock on to its location with the bigger focus point target indicator while continuously updating the focus as the subject moves. To help you understand how to use this feature, select C-AF+TR, then focus on a small subject. Move the camera around and you will see the AF point target indicator stay locked on the subject. It is effective at staying with a subject as long as the light is reasonably good and the subject is not moving too quickly. The AF point target indicator is a larger green square with bars sticking out of each side.

Now let's examine how to select one of the focus modes.

In figure 2.20 you can see that the AF Mode position is highlighted, with S-AF mode selected. Refer to the previous list of focus modes, then use the Arrow pad keys to scroll left or right until the mode you want to use is highlighted. Press the OK button to lock in the AF Mode.

Figure 2.20: Choosing a focus mode

Deeper Information: This subject is considered more thoroughly in the **Custom Menu** chapter under the **AF Mode** subheading on page 274 (see *Custom Menu > A. AF/MF > AF Mode*).

Since the E-M1 does not have a split-prism screen to assist with Manual focus (MF), you may want to enable focus Peaking and/or Magnify. Peaking makes it easy to see when the subject is in focus because it outlines the edges of the subject in white (or black) to indicate where the best focus is currently located. Peaking is discussed and samples are provided in the **Custom Menu** chapter under the **MF Assist** heading and the **Peaking** subheading on page 286. In the **MF Assist** section of that chapter I also discuss the **Magnify** function, which automatically zooms in to pixel-peeping levels when you turn the lens focus ring, and it results in extremely accurate manual focus. Combining Peaking and Magnify makes manual focus easy.

Settings Recommendation: I like to use S-AF+MF mode so I can use autofocus most of the time, but I can still turn the focus ring to enable manual focus, along with Peaking and Magnify. The S-AF mode is fine for slow shooting with well-defined, static subjects. C-AF works quite well when I am shooting something like a wedding and the bride and groom are walking toward me. I use MF mode most often when I am taking macro shots and need to carefully control where the focus falls, due to the shallow depth of field in that type of photography. The tracking mode (C-AF+TR) works well for moving subjects, especially larger wildlife, cars, and airplanes.

ISO Sensitivity

The ISO function changes the camera's sensitivity to light. The higher the ISO, the greater the sensitivity, and vice versa. Higher ISO sensitivities can add grainy digital noise to the darker areas of your image; therefore, keep the ISO as low as possible for the current lighting conditions.

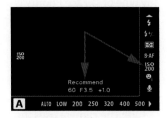

Figure 2.2P: Choosing an ISO sensitivity

In figure 2.2P, the ISO sensitivity position is highlighted on the right. You will see a range of ISO sensitivity values at the bottom of the screen. Use the Arrow pad keys to scroll left or right and select an ISO sensitivity value.

In figure 2.2P I chose ISO 200. The camera recommends ISO 200 as a base—you will see Recommend at the bottom of the screen when you select ISO 200. Of course, the ISO is variable, and you can change it to meet your needs. The range of ISO values runs from LOW (ISO 100) to ISO 25600.

You can also select AUTO, which allows the camera to select an ISO depending on the ambient light conditions. AUTO is a great choice when you do not have time to adjust the ISO yourself, and it also shows on the bottom of the screen as Recommend. However, be aware that the camera will use high ISO values to get the picture in dark conditions, regardless of whether ISO noise is introduced. For the best quality, control the ISO sensitivity yourself.

When you have selected the ISO sensitivity value you want to use, press the OK button to lock it in.

Note: Olympus considers ISO 100 (LOW) to be an extended ISO value in the E-M1. The recommended base ISO is 200. When LOW is selected you will see ISO Extension displayed at the bottom of the screen. This simply means that LOW approximates ISO 100, which is outside the normal ISO range for the camera. Do not worry, ISO LOW works great, and I use it much of the time to capture low-noise landscape and portrait images when the ambient light allows it.

Settings Recommendation: I usually leave my camera set to ISO 200 because it has low noise for everyday photography. When I shoot landscapes on a tripod, I often set it to LOW (ISO 100). The camera does well up to about ISO 1600, even though the Micro Four Thirds sensor is small. I would use ISO values above 1600 only in emergencies because the noise levels may become objectionable. You should test this for yourself to see where your noise tolerance lies.

☺ Face Priority AF Mode

The ☺ Face Priority AF mode is designed to make your camera extra sensitive to human faces. When this mode is enabled, the E-M1 will detect human faces, adjust the focus to capture them sharply, and tweak the ESP metering to expose more accurately for human skin tones.

Additionally, you can select Eye Priority and even choose which eye to focus on. When any type of ☺ Face Priority is active, the camera looks for human faces in the subject area and gives them priority for exposure. It then uses the selected type of ☺ Face Priority to decide how to autofocus. Let's examine the five available modes:

- **Off:** ☺ Face Priority is off.
- ☺**:** The camera uses ☺ Face Priority for autofocus and exposure.
- ☺**i:** The camera uses the pupil of the nearest eye for the best autofocus.
- ☺**iR:** The camera uses the pupil of the right eye for the best autofocus.
- ☺**iL:** The camera uses the pupil of the left eye for the best autofocus.

In figure 2.2Q, on the right, you can see that I chose ☺ Face Priority, and ☺i or Face & Eye Priority is displayed on the bottom of the screen. Refer to the previous list of ☺ Face Priority settings, then use the Arrow pad keys to scroll left or right until the mode you want to use is highlighted. Press the OK button to lock in your choice.

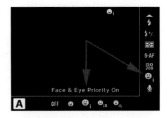

Figure 2.2Q: Selecting a Face & Eye Priority mode

 Deeper Information: This subject is also considered, with more detail, in the **Custom Menu** chapter, under the ☺ Face Priority subheading on page 291.

 Settings Recommendation: I have found that the camera works well with some form of ☺ Face Priority mode always active. It focuses normally on nonhuman subjects when no face is present, and it uses face detection only when it can detect human faces. I normally leave ☺i (Face & Eye Priority) set to On.

Movie Sound

This simple function turns the camera's built-in stereo sound recorder on or off when you are recording videos. If you are recording sound with an external digital audio recorder, you may not want the camera to record sound at all. Or you may be shooting a family video and do want to record stereo sound.

 Let's see how to enable or disable video sound recording.

 Figure 2.2R shows the movie sound recorder position highlighted on the right with Movie [Sound] On selected at the bottom of the screen. Use the left or right Arrow pad keys to select On or Off, then press the OK button to lock in your choice.

Figure 2.2R: Enabling or disabling video sound recording

 Settings Recommendation: I leave the Movie sound recorder turned on all the time. I do not use an external audio recorder; therefore, I want my camera to use the built-in stereo mic system (found on either side of the EVF on top of the camera). If you shoot professional video, you may need to disable the sound recorder feature, and this function makes it easy to do so.

 Now let's examine the various icons you will find on the Live View screen and in the electronic viewfinder (EVF), which is usually a duplicate of the Live View screen.

Live View and Electronic Viewfinder Screens

Screen Icons

The 1,037k dot resolution, 3.0 inch (7.6 cm) Live View screen on the back of the camera and the 2.36 M dot resolution electronic viewfinder (EVF) usually have the same appearance. You can select from three EVF styles, as shown in figure 2.3A.

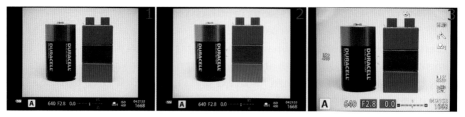

Figure 2.3A: EVF screen styles 1, 2, and 3

Two of the three EVF styles are very similar (figure 2.3A, images 1 and 2). They have sparse screens that display only information that is absolutely necessary. Because they are similar to displays from the old film days, they are considered retro styles.

Style 1 has a blue band at the bottom of the screen with white and yellow text (image 1), and style 2 has a black bar with white and yellow text (image 2). Both of these styles limit information mostly to the bottom bar, although they display some of the symbols shown in figure 2.3B in upper areas of the screen.

Style 3 (figure 2.3A, image 3) is the default EVF style. It is modern and magnifies the subject more for ease of viewing, plus it displays more symbols and text while you shoot. Style 3 matches the Live View monitor virtually all the time, so when you switch from the EVF to the Live View monitor, there will be no change in the appearance of the screen. This cuts down on confusion when you are shooting quickly.

To change to a different EVF style, use the *Custom Menu > J. Built-In EVF > Built-In EVF style* function, as discussed in the **Custom Menu** chapter under the **Built-In EVF Style** subheading on page 428.

Figure 2.3B is a screen that reflects EVF style 3 and the normal Live View screen. EVF styles 1 and 2 have similar symbols. Most photographers leave the camera set to style 3 so the EVF and Live View screen will match.

Let's discuss the symbols you will see on the EVF and Live View screens. Each of the numbered items are identified in the following list.

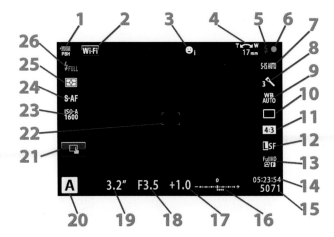

Figure 2.3B: Live View and EVF screen symbols

1. **Battery level:** When an HLD-7 battery pack is mounted, PBH stands for power battery holder.
2. **Wi-Fi:** Enables the Wi-Fi system upon your touch.
3. ☺ **Face Priority:** Displays the current Face Priority mode setting.
4. **Lens focal length:** Displays the focal length of the lens as you turn the zoom ring. Also shows the direction to turn the lens for telephoto (T) and wide angle (W).
5. **Flash:** Shows the status of the flash unit that is mounted on the Hot shoe. It blinks while the flash unit is recharging and shines solid when the flash unit is ready.
6. **AF confirmation mark:** Lets you know when the autofocus system has acquired good focus.
7. **Image Stabilizer:** Confirms the Image Stabilizer (IS) mode.
8. **Picture Mode:** Confirms which Picture Mode the camera is using.
9. **White Balance (WB):** Confirms the WB mode.
10. **Sequential shooting/Self-timer:** Confirms the Sequential shooting mode or the Self-timer mode.
11. **Aspect ratio:** Confirms the image Aspect ratio.
12. **Record Mode:** Confirms the image quality mode (JPEG and RAW modes).
13. **Video Mode:** Confirms the video frame size, bit rate, and format.
14. **Video recording time:** Reports the hours, minutes, and seconds of available video recording time for the current memory card.
15. **Image capacity:** Reports the available image capacity for the current memory card.
16. **Exposure Compensation and Flash Intensity indicator scale:** If a yellow line of dots appears below the scale, it indicates the amount of the current Exposure Compensation. If a line appears above the scale, it shows the amount of the Flash Intensity setting.

17. **Numerical Exposure Compensation value:** Shows the current Exposure Compensation value (−2.0 to +3.0).
18. **Aperture:** Confirms the current aperture.
19. **Shutter speed:** Confirms the current shutter speed.
20. **Shooting mode:** Shows the current shooting mode on the Mode Dial.
21. **Touch screen operations control:** Confirms the current touch screen mode. Use it to select other touch screen modes.
22. **AF point indicator:** Shows the currently active moveable AF point.
23. **ISO sensitivity:** Confirms the current ISO sensitivity level and ISO mode.
24. **AF mode:** Confirms the current autofocus (AF) mode.
25. **Metering mode:** Confirms the current Metering mode.
26. **Flash Mode:** Confirms the current Flash Mode.

Note: When the Live View screen or EVF is active, pressing one of the Arrow pad keys opens the AF Area Select screen, with its grid of 81 AF points, which allows you to move the AF point indicator (number 22) to a location on the subject, such as an eye. Try it!

Touch Screen

The 3-inch touch screen on the back of your E-M1 can be quite useful. You can use the touch screen to execute various camera functions, including the following:

- Set certain camera settings through the Super Control Panel
- Initiate autofocus only or initiate autofocus and also take a picture
- Zoom in up to 14x to see extreme detail for focusing before taking a picture
- Swipe to view pictures on the monitor
- Zoom in and out on pictures you are viewing on the monitor
- Enable or disable the wireless LAN (Wi-Fi) function
- Use the Live Guide system when iAUTO is selected on the Mode Dial

Let's examine the main functions the touch screen offers and see how they work.

Enabling or Disabling the Touch Screen

Some photographers may not want to use the touch screen. You can disable it by setting the *Custom Menu K. Utility > Touch Screen Settings* function to Off (figure 2.3C).

Most E-M1 users enjoy using the touch screen. Most of us have become used to smartphones and tablets, and the practice of touching a screen to execute an app or function is becoming second nature. However, keep this function in mind if you want to enable or disable the touch screen in the future. The default setting is On.

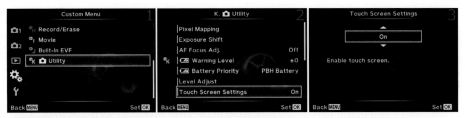

Figure 2.3C: Enabling or disabling the touch screen (default is On)

Use these steps to enable or disable the touch screen:

1. Select K. Utility from the Custom Menu and scroll to the right (figure 2.3C, image 1).
2. Select Touch Screen Settings from the K. Utility menu and scroll to the right (figure 2.3C, image 2).
3. Press up or down on the Arrow pad keys to use the up/down menu. Select On to enable the touch screen and Off to disable it (figure 2.3C, image 3).
4. Press the OK button to Set your choice.

Settings Recommendation: There are certain times when accidentally touching the screen could cause you to take a picture. For instance, let's say you are a photojournalist and are using the tiltable screen while you hold the camera over your head to see above a crowd. You have the touch screen enabled, and while you adjust the angle of the screen you accidentally touch it, causing the camera to take a picture or focus on something other than the subject. In that kind of situation, disabling the touch screen makes sense.

However, for most of us, the touch screen offers excellent features and is enjoyable to use. After all, we are using one of the most high-tech cameras ever invented. Why not use it to the fullest? Other photographers are jealous that their cameras don't have a touch screen. Your E-M1 does!

Now let's consider how to use the touch screen.

Touching the Super Control Panel

In this chapter we have already considered how to use the Super Control Panel, but we examined it mostly from the perspective of using external controls. Let's briefly examine how to use the Super Control Panel from the touch screen.

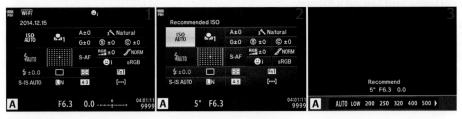

Figure 2.3D: Using the touch screen with the Super Control Panel

Figure 2.3D, image 1, shows the Super Control Panel when the camera is first turned on. The screen has nothing highlighted and awaits your OK button press to select one of the settings. However, you are not limited to just pressing the OK button; you can also use the touch screen to select a setting on the Super Control Panel. While the Super Control Panel is in the state seen in image 1—with no setting highlighted—touching the screen does nothing. However, if you first double-tap the screen on the setting you want to use, it will unlock and that function will be highlighted. After that you can touch other functions and they will be immediately highlighted.

Figure 2.3D, image 2, shows that I have double-tapped the ISO function and it has become highlighted. I could simply touch a different function and it would become highlighted. While a function is highlighted you can turn the Front Dial to scroll the settings for that function and stop when the one you want to use is highlighted. Or when a function is highlighted, you can double-tap it to open the secondary screen for that function (figure 2.3D, image 3). You must then use physical camera controls to select settings from the secondary screen. Unfortunately, the secondary screens are not touch sensitive.

Settings Recommendation: Double-tapping the Super Control Panel is easy and fast. It prevents me from accidentally using the Arrow pad keys and opening the Super Control Panel's default [•••] AF Area Select setting instead of scrolling around on the Super Control Panel as I expected. Remember that any time you use the Arrow pad keys on the Super Control Panel with no function highlighted, the camera defaults to showing you the 81-point AF grid so you can select an AF point for autofocus. I keep forgetting this and find myself grinding my teeth when I discover I have, yet again, opened the [•••] AF Area Select screen when I didn't mean to.

To save myself some aggravation, I simply double-tap the Super Control Panel to select the function I want to adjust, then I use the physical camera controls to make adjustments.

Touch Focusing with Drag and Zoom In

The camera touch screen has two modes for autofocus. The first one allows you to touch any area of the screen to focus on a certain area of the subject, drag the focus to somewhere else on the screen, or zoom in over an adjustable range (3x to 14x) to see extreme subject detail for very accurate focus. The second one lets you take a picture by touch (instead of with the Shutter button), which I will discuss in the upcoming subsection **Touch Focusing and Taking a Picture**.

Let's see how to use the touch screen for high-detail autofocus or manual focus.

Figure 2.3E is the Live View screen with the cap on the lens to show maximum contrast. Normally you will see your subject on this screen behind an overlay of the symbols. Have your camera in hand while you walk through these steps to make sure you understand how to use the touch features correctly.

Figure 2.3E: Using Autofocus with the zoom-in touch screen method

In figure 2.3E, image 1, repeatedly tap the symbol shown at the red arrow until you see the hand and finger touching a green rectangle. This represents the touch focus only mode. After the symbol is selected, touch the portion of the subject that you want to have in sharpest focus. The camera will autofocus at that location and display a green AF target rectangle that shows where you touched.

You can now do one of several things: press the Shutter button and take a picture, change the size of the AF target rectangle and drag it to any point on the screen with your finger, or make the camera zoom in for extreme detail focusing.

With figure 2.3E as a guide, let's consider each of these actions:

- **Take a picture:** In figure 2.3E, image 2, touch the screen to focus on a particular area of the subject, then press the Shutter button all the way down to take a picture.
- **Drag the AF target rectangle:** With your finger touching the screen over the green AF target rectangle in the middle of figure 2.3E, image 2, drag the AF target to any point on the Live View screen, then lift your finger and reapply it to activate autofocus and take a picture.
- **Zoom in for extreme focus detail:** The top red arrow in figure 2.3E, image 2, points to the zoom scale on the Live View screen. This scale appears for only a few seconds and then disappears. You can touch the screen again to make it reappear. With your finger, you can slide the indicator from 3x to 14x, and you will see the AF target change size to match. This changes the area inside the AF target rectangle and makes it more or less sensitive to the exact area it is focusing on. The 14x position is extremely sensitive to detail and uses a very small AF target rectangle that covers a very small area of the subject. The 3x position uses a much larger AF target area and makes the AF target rectangle less sensitive to specific details in the subject because autofocus is based on a larger area. You can drag the resized AF target rectangle with your finger to a differ-ent area of the subject. Then you can refocus by lifting your finger and touching the

screen again, or you can simply take a picture with the Shutter button. You can also move the AF target area on the Live View screen with the Arrow pad keys. If you want to confirm the area that the camera is using for autofocus, you can touch the magnifying glass symbol at the bottom-right corner of the screen (figure 2.3E, image 2, bottom red arrow). If the symbol has disappeared, touch the screen again to make it reappear. The magnifying glass symbol will make the camera zoom in and display the subject at whatever magnification you previously selected.

When you touch the magnifying glass symbol at the bottom-right of figure 2.3E, image 2, the zoomed-in view will be displayed on the screen (figure 2.3E, image 3), and the zoom level you selected will be indicated in green at the bottom-left of the screen (I chose 7x). You can move the zoomed view around by sliding your finger on the screen. A small white rectangle will appear in a larger gray rectangle; this shows you where in the image your AF target is located (figure 2.3E, image 3, top red arrow). The small white rectangle represents the AF target area within the screen, and the gray rectangle represents a full-size view of the subject on the Live View screen. Touch focus does not work when the lens is zoomed in; you must press the Shutter button halfway down to autofocus, then press it the rest of the way down to take a picture. Or you can touch the 1x symbol at the bottom right of the screen (figure 2.3E, image 3, bottom red arrow) to return to the normal 1:1 view before you take the picture. Be sure not to move the camera, or the autofocus may be out of date when you zoom back out. If the 1x button is not displayed, touch the screen again to make it appear.

Now that you have touch focused, zoomed in and out, and taken a picture, it is time to leave the special mode that allows you to zoom in. If you don't, the AF target rectangle will stay on the screen in whatever size you previously chose. To exit touch focus mode, touch the symbol shown in figure 2.3E, image 4 (red arrow). The symbol is a green rectangle followed by the word Off. The camera will now return to normal nontouch operation.

Settings Recommendation: The touch focus, drag, and zoom method is a fast way to get a zoomed-in view of a subject that requires high-detail focusing. It works for both autofocus and when you are manually focusing. Touch focus does not work when you focus manually, but the zooming feature does. When you use Manual focus the camera does not show focus Peaking, even if it is enabled for normal manual focus. Learn to use this method for when you really need it, such as during macro shooting.

Touch Focusing and Taking a Picture

We discussed how to use touch focus in the previous subsection. Now we will look at the second mode for the touch screen. It works like the camera on a smartphone or tablet. You can focus on a particular area of the subject by touching that area, and then you take the picture. However, the E-M1 does it in a slightly different way. Instead of separating the focus and picture-taking actions, it combines the two. When you touch an area of the

subject on the Live View screen, the camera will immediately autofocus and take a picture. Let's examine how it works.

Figure 2.3F shows a Live View screen with the lens cap on for maximum contrast. The red arrow points to the symbol that indicates you can touch the screen to focus and take a picture. It looks like a hand with a finger touching the side of a button. If a different symbol is displayed, tap it repeatedly until the correct symbol appears.

Figure 2.3F: Enabling the touch function

To focus and take a picture with the Live View screen, compose the picture and touch the area of the subject that you want to focus on. The camera will autofocus on that area then take a picture.

Settings Recommendation: Taking a picture with the touch method is simpler than using a smartphone camera app. All you have to do is lightly touch the screen, and the camera will autofocus and snap the picture. This is convenient for some types of shooting, such as when you use the tilted screen over the top of a crowd or low to the ground for macro shooting. Give it a try!

Touch Screen Image Viewing

The touch screen system makes it easy for you to do full-frame, indexed, or calendar playback of images on your memory card. It works like a smartphone or tablet for full-frame image viewing, where you swipe left or right to view pictures. You cannot pinch or spread two fingers to zoom in and out, but the E-M1 has an easy-to-use zoom slider.

You can also select one or more images for protection to prevent the *Shooting Menu 1 > Card Setup > All Erase* function and the Delete (red trash can) button from removing the images (formatting the memory card will still remove them, though).

Additionally, you can create a Share Order to mark images for sharing with your tablet or smartphone after you install the Olympus Image Share (OI.Share) app.

Let's see how to use the touch screen image viewing system.

Full-Frame Image Viewing

Using the touch system to view your images is the ultimate in simplicity. You simply pull up an image and swipe left or right to view other pictures.

In figure 2.3G, image 1, you can see the Playback button. Press it to open the full-frame image viewing system. Figure 2.3G, image 2, shows a picture of a sleeping baby on the monitor. To change to a different picture, just swipe left or right. Give it a try!

Figure 2.3G: Full-frame image viewing with the swipe method

Note: When a picture is displayed on the monitor in full-frame Playback mode, you can turn the Front Dial, or press the left or right Arrow pad keys, to scroll through your pictures.

Zooming In on a Full-Frame Image

You can zoom in and out on the image displayed on the monitor with magnifications from 1x (full frame) to 14x. Let's see how.

Figure 2.3H: Zooming in on an image

Figure 2.3H, image 1, is a picture of a maple leaf on a log in direct sunshine. To zoom in, touch the screen. A control bar on the bottom of the screen will open, along with a sliding zoom control (figure 2.3H, images 2 and 3, red arrows). Use your finger to slide the zoom control up or down.

In figure 2.3H, image 2, the zoom indicator is at the bottom of the scale, which is the 1x full-frame position. In image 3 the zoom indicator is at the middle of the scale at the 6x zoom position. The zoom magnification of 6x is displayed in green at the bottom left of the monitor (figure 2.3H, image 3). At 6x, the leaf is much larger and you can see more detail. Zooming in to 14x brings in very fine detail so you can see if the image is sharp.

Note: When you view a full-frame picture on the monitor, you can turn the Rear Dial counterclockwise to zoom in. This can be a faster way to zoom in. After you zoom in on a picture, you can scroll around the frame with the Arrow pad keys, as indicated by green arrow tips on each edge of the frame.

Index and Calendar Image Viewing

If you want to scroll through 25 image thumbnails instead of a single image in full-frame mode, you can use Index viewing. When the Index is displayed, you can scroll around within the thumbnails to find an image you want to view in full-frame mode.

Additionally, you can view a monthly Calendar that shows one thumbnail for each day you took pictures. Days with no pictures do not have a thumbnail. Let's see how to use these features.

Figure 2.3I: Using the Index and Calendar

Figure 2.3I, image 1, shows a full-frame picture. To use the Index and Calendar system, touch the monitor to open the control bar on the bottom of the screen (figure 2.3I, image 2). The Index symbol is on the right end of the control bar. Touch it to open the Index of 25 thumbnails (figure 2.3I, image 3).

In figure 2.3I, image 3, notice that the current image of the leaf is at the top red arrow. When the Index is open you can tap any thumbnail to open the corresponding image to a full-frame size. To scroll through additional thumbnails, slide your finger up or down on the screen. Or you can use the Arrow pad keys to scroll around within the thumbnails, then press the OK button to open an image to full size. In figure 2.3I, image 3, the bottom red arrow is pointing to the symbol that returns the display back to full-frame mode with the control bar at the bottom of the monitor.

Note: Touching an image in Index view will open it to full-frame size only if the symbol at the left end of the control bar says Off with a check mark (figure 2.3I, image 3). If the symbol says On with a check mark, touching a thumbnail will mark the corresponding image for other functions, such as deletion protection (Protect), sharing with a smart device (Share Order), or targeted multi-image deletion (Erase selected). We will discuss each of these functions in upcoming subsections.

The Calendar symbol is shown in figure 2.3I, image 4 (red arrow). Touch this symbol to open Calendar mode.

Figure 2.3I, image 5, shows the Calendar mode. October 2014 is displayed (2014.10), and you can see that I took pictures only on October 26 because that is the only date that has a thumbnail. If you touch the thumbnail for a certain day, the Calendar will open to

full-frame mode, and the first image you took on that day will be displayed. You can swipe up or down on the Calendar to see other months.

In figure 2.3I, image 6, you can see that I swiped down to December 2014 (2014.12) and that I took pictures on December 5, 29, and 30. I could touch any of those days to see a full-frame image of the first picture I took. In the bottom-right corner of image 6, you can see the symbol that returns the camera to full-frame mode. If the symbol is not displayed, touch the screen anywhere, except on a thumbnail, and it will reappear for a few seconds.

Note: When you view a full-frame picture on the monitor, turning the Rear Dial clockwise opens the Index and Calendar modes, which can be faster. If you use the Rear Dial to enter the Index or Calendar mode, the control bar will be condensed into a tab at the bottom center of the screen. Touch the tab to open the control bar.

Protecting an Image from Accidental Deletion

When you are taking pictures, some will be excellent and others will not be as good. While you are deleting some of the less desirable images, you may accidentally delete an image you want to keep, then you have to stop using that card until you run an image recovery program on it. To avoid this scenario, you can protect your excellent images against deletion immediately after you take them.

The protection function of the E-M1 allows you to select one or many images and mark them against deletion. The camera will not delete the image, even if asked to, unless you format the card. Let's see how it works.

Figure 2.3J: Setting deletion protection on an individual image

Press the Playback button to display an image from the memory card (figure 2.3J, image 1), then touch the monitor to open the control bar at the bottom of the screen.

Figure 2.3J, image 2 (red arrow), shows the control bar. The arrow points to a key symbol that you can touch to add protection to the currently displayed image.

Figure 2.3J, image 3 (red arrow), shows the Protect (key) symbol that appears when you touch the symbol on the control bar. You can toggle protection on and off by repeatedly touching the key symbol on the control bar. When the key symbol is displayed at the top-right corner of the image, the image is protected from deletion (except during card formatting).

Now let's examine how to protect multiple images while using the Index format for viewing thumbnails on the monitor.

Protecting Multiple Images from Accidental Deletion

If you would like to set deletion protection on a group of images, the camera gives you an interface that makes it relatively easy to do so. You will use the 25-image Index display to select images by touching their thumbnails then setting protection. Let's see how.

Figure 2.3K: Setting deletion protection on multiple images

Press the Playback button to display a picture from the memory card (figure 2.3K, image 1), then touch the monitor to open the control bar at the bottom of the screen.

Figure 2.3K, image 2, shows the open control bar, and the red arrow points to the Index symbol. Touch the symbol to open the 25-image thumbnail Index.

Figure 2.3K, image 3, shows the open Index. The left red arrow points to a symbol with a check mark and the word On. Notice in figure 2.3K, image 2, that the same symbol is a check mark with the word Off. By touching this symbol repeatedly you can toggle it from On to Off. When On is selected you can touch multiple images, and a red check mark will appear in the upper-right corner of each thumbnail. If you touch a thumbnail with Off displayed, the camera will open the thumbnail to a full-frame display. Therefore, to select multiple images for protection (add red check marks), be sure that On with a check mark is displayed on the control bar. In figure 2.3K, image 3, the three red arrows on the right are pointing to three consecutive images that I want to protect from deletion. These three images are ready for the next step.

After you have selected the images you want to protect, touch the Protect key symbol (figure 2.3K, image 4, left red arrow). The key symbol will appear on all images with red check marks (figure 2.3K, image 4, three red arrows on right). Now lightly touch the Shutter button, and the camera will switch back to the Live View screen. Your selected images are protected.

Note: To unprotect a group of protected images, you can use an item on the Playback Menu to reset all protected images at once: *Playback Menu > Reset Protect* (select Yes under Reset Protect, then press the OK button). This is faster than unprotecting individual images.

There is another way to apply protection, which we will discuss in a later section of this chapter on page 93. It involves using the menu that pops up when you press the OK button while a single image is displayed on the monitor.

Creating a Share Order

The E-M1 allows you to import images into an app called Olympus Image Share (OI.Share). You can use the camera's Wi-Fi system to send images to your smartphone or tablet. When you use the Share Order function to create a Share Order, OI.Share will ask if you want to import marked images when you connect the camera to a smart device.

Let's examine how to create a Share Order and how to use it to import pictures.

Figure 2.3L: Creating a Share Order for a single image

Press the Playback button to display an image (figure 2.3L, image 1), then touch the monitor to open the control bar at the bottom of the screen.

In figure 2.3L, image 2 (red arrow), the control bar is open. The arrow points to the share symbol that adds the image to the current Share Order or automatically creates a new one. Touch the share symbol.

The share symbol appears on the image when you touch it on the control bar (figure 2.3L, image 3, red arrow). You can toggle the Share Order for that image by repeatedly touching the share symbol on the control bar. When the share symbol is displayed on the image, it is in the current Share Order, and it will automatically be shared with a smart device through the OI.Share app.

Now let's examine how to add multiple images to a Share Order while using the Index format for viewing thumbnails on the monitor.

Press the Playback button to display a picture from the memory card (figure 2.3M, image 1), then touch the monitor to open the control bar at the bottom of the screen.

Figure 2.3M, image 2, shows the control bar open, and the red arrow points to the Index symbol. Touch the symbol to open the 25-image thumbnail Index.

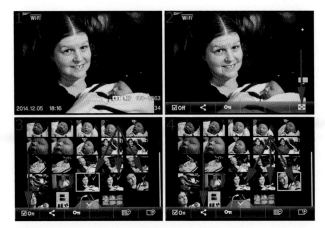

Figure 2.3M: Creating a Share Order for multiple images

Figure 2.3M, image 3, shows the open Index. The left red arrow points to a symbol with a check mark and the word On. Notice in figure 2.3M, image 2, that the same symbol is a check mark with the word Off. By touching this symbol repeatedly you can toggle it from On to Off. When On is selected you can touch multiple images, and a red check mark will appear in the upper-right corner of each thumbnail. If you touch a thumbnail with Off displayed, the camera will open the thumbnail to a full-frame display. In figure 2.3M, image 3, the three red arrows on the right are pointing to three consecutive images that will be added to a Share Order for transmission through OI.Share. These three images are ready for the next step.

After you have selected the images you want to add to the Share Order, touch the share symbol (figure 2.3M, image 4, left red arrow). The share symbol will appear on images that have red check marks (figure 2.3M, image 4, three red arrows on the right). Now lightly touch the Shutter button, and the camera will switch back to the Live View screen. Your selected images are in a Share Order and are ready to share as soon as you connect OI.Share to your camera's Wi-Fi system.

Note: To remove all images from the existing Share Order, you can use an item on the Setup Menu to reset all shared images at once: *Setup Menu > Wi-Fi Settings > Reset share Order* (select Yes under Reset share Order and press the OK button). This is faster than removing individual images from the Share Order.

Importing Images from a Share Order

An upcoming subsection, **Wireless LAN (Wi-Fi) System,** will discuss how to use the Wi-Fi system to connect the E-M1 with a tablet (page 90). Figure 2.3N is a screenshot of OI.Share after it has been connected to my E-M1.

Figure 2.3N shows OI.Share as it responds to a Share Order. The app finds the Share Order on the memory card and automatically offers to import marked files when you choose Save (red arrow).

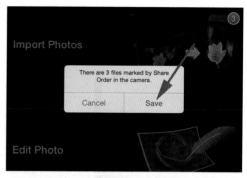

Figure 2.3N: Importing images from a Share Order to OI.Share

As mentioned previously, we will discuss how to connect the camera and OI.Share in an upcoming subsection, but here is a preview of the process.

Erasing a Single Image

The camera allows you to delete a single image very quickly. Any image that is displayed on the screen and is not marked with the image protection key symbol can be deleted by using the following steps.

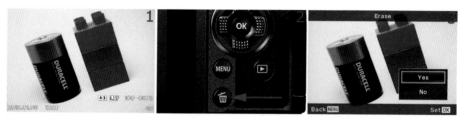

Figure 2.3O: Erasing a single image that is displayed on the monitor

Figure 2.3O, image 1, is a badly composed image. The first step to delete an unwanted image is to display it on the monitor.

Figure 2.3O, image 2, shows the Erase button, which has a red trash can symbol. Press the Delete button once.

Figure 2.3O, image 3, shows the menu that opens after you have pressed the Erase button. You have the choice of Yes or No. Select Yes and press the OK button to delete the current image, or press No to cancel.

Next let's see how to delete a few selected images by using the Index thumbnail system.

Erasing a Few Selected Images

If you need to delete a few images to save space, you can use the camera's multi-image deletion method. It allows you to use the Index thumbnail system to examine 25 images at a time and choose several for deletion. Let's examine how it works.

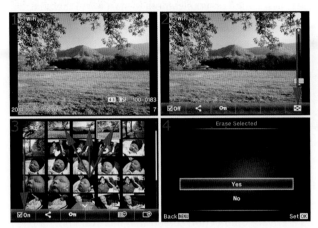

Figure 2.3P: Erasing a few selected images

Press the Playback button to display a picture on the monitor (figure 2.3P, image 1), then touch the monitor to open the control bar at the bottom of the screen.

Figure 2.3P, image 2, shows the open control bar, and the red arrow points to the Index symbol. Touch the symbol to open the 25-image thumbnail Index.

Figure 2.3P, image 3, shows the open Index. The left red arrow points to a symbol with a check mark and the word On. When On is selected you can touch multiple images, and a red check mark will appear in the upper-right corner of each thumbnail. Be sure that On is selected for this function because if you touch a thumbnail with Off displayed, the camera will open the thumbnail to a full-frame display. In figure 2.3P, image 3, the three red arrows at the top are pointing to three consecutive images that we will delete. I touched these thumbnails to make the red check marks appear. After you select the images you want to delete, press the Delete button (with the trash can icon) (figure 2.3O, image 2).

Figure 2.3P, image 4, shows the confirmation screen that appears after you press the Delete button. To delete the images, select Yes and press the OK button, or select No to cancel.

Note: There are two other, more radical, ways to erase all images on the memory card: All Erase and Format. All Erase deletes all images that are not marked with a Protect key symbol, and Format erases all images on the memory card regardless of protection. All Erase is discussed on page 130, and Format is discussed on page 131.

Wireless LAN (Wi-Fi) System

One of the powerful features of the E-M1 is its ability to communicate with a smartphone or tablet (smart device). You can use a smart device to control the camera, change settings, and take pictures. You can also transfer pictures to your smart device.

Let's examine how to use the touch screen on your camera to start a Wi-Fi session.

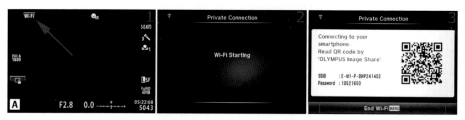

Figure 2.3Q: Initiating a Wi-Fi session

In figure 2.3Q, image 1, you can see the Wi-Fi symbol on the Live View screen. Touch the symbol to start a Wi-Fi session.

Figure 2.3Q, image 2, shows the screen that appears while the Wi-Fi system is activating.

Figure 2.3Q, image 3, shows a Private Connection screen that lets you know a Wi-Fi session is active.

Now activate the Olympus Image Share (OI.Share) app on your smart device. Use OI.Share to scan the QR code on the right side of the Private Connection screen (figure 2.3Q, image 3). The rest of the operation is fairly automated within OI.Share. See the following **Deeper Information** paragraph for information about making a good connection.

Deeper Information: Using the Wi-Fi system is a rather detailed subject. The previous discussion explained only how to start the process of making an initial Wi-Fi connection by using the touch screen. However, the camera and smart device interface process and the use of OI.Share requires a lengthy description. Please refer to the **Playback Menu** chapter, under the **Connection to Smartphone (or Tablet)** subheading on page 269, for complete information. We will consider how to make a wireless connection between your smart device and camera, along with configuration information for OI.Share.

Working with Images In-Camera

Some people do not enjoy working with computers, yet they want to shoot in RAW format and convert their images to JPEGs, or even edit JPEGs, in-camera. The E-M1 gives you a fully featured post-processing system that you can use without a computer. You can shoot RAW images, or JPEG+RAW images, and later post-process the RAW image in the camera and save the processed image to the memory card.

Additionally, the camera has several other functions that allow you to do various things with the pictures on the memory card. You can edit, share, protect, voice annotate, rotate,

overlay, print, erase, or create a slideshow with images you have already taken—all without using a computer.

The functions described in this section are available in two places: first, by pressing the OK button when an image is displayed on the monitor; and second, by using the function selections that are available when you press the Menu button. Several of these settings, such as the image editing functions, are rather comprehensive and require lengthy explanations. This section will give you an overview of these functions and will direct you to deeper information that is provided elsewhere in this book.

RAW Data Edit

RAW Data Edit allows you to convert a file from RAW to JPEG in-camera. If you prefer to shoot RAW files for maximum image quality and you quickly need a JPEG for some reason, you can create one without using a computer. This item will not appear on the RAW/JPEG menu when a JPEG-only image is displayed on the monitor.

Let's look at an overview of how to access the RAW file editing system from the visual screens, then refer to the deeper information that is provided later in this book.

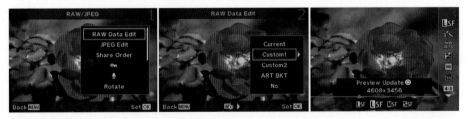

Figure 2.4A: Using the RAW Data Edit in-camera post-processing functions

Figure 2.4A, image 1, shows the RAW Data Edit menu, which will appear when a RAW file is viewed on the monitor and the OK button is pressed once. Display a RAW file on the camera monitor, highlight RAW Data Edit, and press the OK button.

Figure 2.4A, image 2, shows the RAW Data Edit menu with its five choices. Several of the choices have secondary screens, such as the one seen in figure 2.4A, image 3. These screens allow you to manipulate all aspects of the image and resave the RAW file as a new JPEG image without making any changes to the original RAW file.

Deeper Information: This is a rather deep menu system with many individual subfunctions. These same functions are also accessible from the Playback Menu under the Edit selection. To learn more about the deep capabilities of the RAW Data Edit functions, please see the **Playback Menu** chapter, under the **Edit** subheading, on page 239.

JPEG Edit

The JPEG Edit function lets you make in-camera changes to your JPEG image files then save them as new files. It works only with JPEG files. This item will not appear on the RAW/JPEG menu when a RAW-only image is displayed on the monitor.

Let's examine how to access the JPEG file editing system from the visual screens, then refer to the deeper information that is provided later in this book.

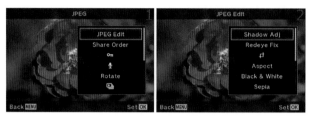

Figure 2.4B: Editing JPEG images

Figure 2.4B, image 1, shows the JPEG Edit menu, which appears when a JPEG file is displayed on the monitor and the OK button is pressed once. Display a JPEG file on your camera monitor, highlight JPEG Edit, and press the OK button.

Figure 2.4B, image 2, shows the JPEG Edit menu with its nine choices. These choices allow you to manipulate, resize, and resave the JPEG image as a new JPEG file, without making any changes to the original JPEG image.

Deeper Information: This is a deep menu system with nine individual subfunctions. These same functions are also accessible from the Playback Menu, under the Edit selection. To learn about the deep capability found in the JPEG Edit functions, please see the **Playback Menu** chapter, under the **Edit** subheading, on page 239.

Share Order

This chapter previously considered how to create a Share Order for individual images and groups of images (page 86). This function is another way the camera allows you to add individual images to an existing Share Order or to create a new one. When new images are added to a Share Order, the OI.Share app will automatically import them to your smartphone or tablet when you open the app and connect it to your camera with the Wi-Fi system. Let's examine how it works.

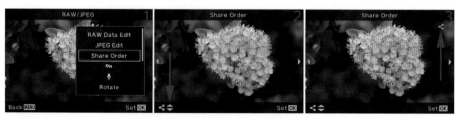

Figure 2.4C: Adding an image to a Share Order for sharing with a smart device

In figure 2.4C, image 1, I displayed an image on the monitor then pressed the OK button to open the RAW/JPEG menu. I can now select Share Order from the menu and press the OK button.

Figure 2.4C, image 2, shows the Share Order screen that allows you to add or remove the image from a Share Order. Press up or down with the Arrow pad keys to add the image to a Share Order (red arrow). A share symbol will appear in the upper-right corner of the image when it is shared (figure 2.4C, image 3, red arrow). You can toggle this symbol on or off to add or subtract the image from a Share Order.

Scroll to the right or left with the Arrow pad keys to select other images to add or remove from a Share Order.

Protecting Images

Previously in this chapter we discussed how to protect an individual image or a group of images from deletion (page 84). This function is an additional way to protect or unprotect individual images. When you add protection to an image, the camera will refuse to delete it except when you format the memory card. Let's see how it works.

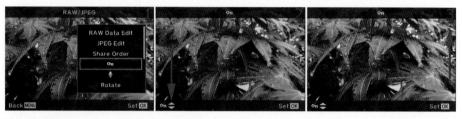

Figure 2.4D: Protecting an image from deletion

In figure 2.4D, image 1, I displayed an image on the monitor then pressed the OK button to open the RAW/JPEG menu. I can now select the Protect key symbol from the menu and press the OK button.

Figure 2.4D, image 2, shows the Protect screen that allows you to protect or unprotect the image. Press up or down with the Arrow pad keys to toggle protection (red arrow). A small key symbol will appear in the upper-right corner of the image when it is protected (figure 2.4D, image 3, red arrow).

Scroll to the right or left with the Arrow pad keys to select other images to which you want to add or remove deletion protection.

Voice Annotation

Voice Annotation lets you add a voice message up to 30 seconds long to an image file while you view it on the camera monitor. This will allow you to add some fairly detailed information about the image for later reference.

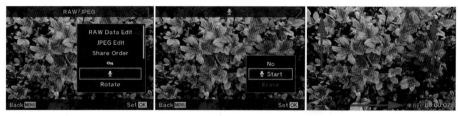

Figure 2.4E: Adding a voice message to an image file

Choose the image you want to add the voice message to and press the OK button to open the RAW/JPEG menu (figure 2.4E, image 1). Highlight the microphone symbol and press the OK button again.

Figure 2.4E, image 2, shows the screen that allows you to cancel (No), record (Start), or Erase a voice annotation for the displayed image. Highlight Start and press the OK button to begin recording your voice annotation.

Figure 2.4E, image 3, shows two symbols and a timer. The symbol at the top-left arrow is the card access symbol, which will blink during the recording process. The symbol at the top-right arrow is a small music note symbol. The note symbol informs you that a voice message is attached to the image. It will stay with the image when you view it on the camera unless you Erase the Voice Annotation. The bottom-right arrow points to a red REC symbol, which indicates that a message is being recorded. To the right of the REC symbol is a counter (00:00:07), which seems to imply that you can record a long message, but the camera will stop recording at exactly 30 seconds.

Deeper Information: The Voice Annotation functions are also accessible from the camera's Playback Menu. You can read deeper information about the functions in the **Playback Menu** chapter, under the **[Voice Annotation]** subheading, on page 257.

Rotate Image

The Rotate Image function allows you to change how an image is displayed on the camera monitor. This function does not appear to affect images after you export them to an external device; on such a device, images are displayed as they were taken.

If a picture has a vertical orientation and you would rather display it horizontally on the camera monitor, use the following steps.

Figure 2.4F, image 1, shows a vertical image that would also look good as a horizontal image. With the image displayed on the monitor, press the OK button to open the RAW/JPEG menu.

Figure 2.4F, image 2, shows the menu with the Rotate selection highlighted. Choose Rotate and press the OK button.

Figure 2.4F, image 3 (red arrow), shows that pressing the up or down keys on the Arrow pad will rotate the image. The image is rotated to an upside-down direction. Images 4 and 5 show the image being rotated to two horizontal positions. I like the image rotated as shown in image 5.

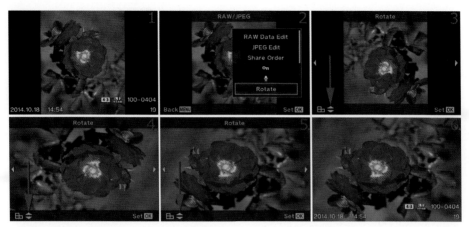

Figure 2.4F: Rotating images for in-camera display

When you are happy with how the image is rotated, press the OK button to lock the direction (figure 2.4F, image 6). The image will now be displayed in that direction when you view it on the camera monitor (compare images 1 and 6 for before and after).

Slideshow

When you have a card full of great pictures, you may want to share a slideshow with friends and family. The camera makes it easy and allows you to display timed still images or movies with background music, if you choose.

You have full control over which images are displayed, as well as the time intervals between JPEG images (a slideshow does not work with RAW files) and videos. You can also download several songs from Olympus to use as background music (BGM).

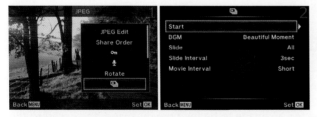

Figure 2.4G: Starting a Slideshow with default settings

It is extremely easy to start a slideshow with default values. Display any image on the monitor, and it will be the first one in the slideshow. Press the OK button to open the menu. Figure 2.4G, image 1, shows the JPEG menu with the Slideshow symbol highlighted. Press the OK button again to open the secondary menu, which is a duplicate of the screen found under the Playback Menu.

In figure 2.4G, image 2, I selected Start. Scroll to the right, or press the OK button with Start highlighted, and the camera will start a slideshow of JPEG images and videos with a three-second (3sec) delay between each image and video. The default is to play only a few seconds of videos then move on to the next item.

You can modify the settings in figure 2.4G, image 2, including the following: background music (BGM); whether the slideshow should include images only, videos only, or both images and videos (Slide); Slide Interval time; and Movie Interval (partial or full video play).

To stop a slideshow, press the Menu button or Playback button, or lightly press the Shutter button.

Deeper Information: Each of the items in figure 2.4G, image 2, are further explained in the **Playback Menu** chapter, under the **[Slideshow]** subheading, on page 232.

Image Overlay

Image Overlay allows you to take two or three images, vary their transparency, overlay them into one image, then save the image as a new JPEG file. Let's see an overview of how it works.

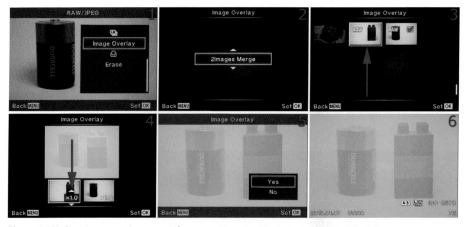

Figure 2.4H: Creating a two-image overlay

In figure 2.4H, image 1, I selected an image to be the primary image, and I pressed the OK button to open the RAW/JPEG menu. Now I can select Image Overlay and press the OK button again to start the overlay process.

Figure 2.4H, image 2, offers an up/down menu with the choices of 2Images Merge or 3Images Merge. I chose 2Images Merge. Make your choice and press the OK button to move to the next screen.

In figure 2.4H, image 3, you can see that the right thumbnail is the primary image because it has a red check mark. It is also displayed in image 1. The red arrow in image 3

shows that another image is selected as the secondary image. It will be overlaid with the primary image. After you have selected the secondary image, press the OK button to use it.

Figure 2.4H, image 4, shows two overlay density controls in separate thumbnails, just under a preview of the overlaid image (blue box). You can use the density controls to visually set the density of each layer, with an adjustment range of x0.1 to x2.0. After you have modified the density to your liking (I left mine at the default), press the OK button.

Figure 2.4H, image 5, provides a larger preview of the overlaid image. You can select Yes to save the new overlaid image, or select No to return to the previous screen (density controls).

Select Yes and press the OK button to finalize the overlay process, and the new combined image will be saved and displayed on the monitor (figure 2.4H, image 6).

Deeper Information: The overlay process is covered in greater detail later in the book; see the **Playback Menu** chapter, under the **Image Overlay** subheading, on page 260.

Print Order

You can use Print Order to print JPEG images without doing much more than taking pictures then inserting a memory card into a Digital Print Order Format (DPOF) compatible printing device. The printing device will read the Print Order and output the number of prints you specify.

The Print Order function will not allow you to select RAW images, only JPEGs. We will now examine an overview of setting up a basic Print Order for a single image.

Figure 2.4I: Creating a DPOF Print Order for an individual image

On the camera monitor, display an image you want to print, then press the OK button to open the JPEG menu and select the Print Order symbol (figure 2.4I, image 1). Press the OK button again to open the next screen.

Figure 2.4I, image 2, shows the Print Order menu. You can choose a single image or All images. This overview will examine the single-image method. Refer to the upcoming **Deeper Information** paragraph for multiple-image Print Orders. Choose the top Print Order symbol from the menu and press the OK button to move to the next screen.

In figure 2.4I, image 3, you can see a small control in the top-right area of the screen. This control allows you to choose the number of prints you want for this image; the available range is 1 print (x1) to 10 prints (x10). Select the number of prints by pressing up or down on the Arrow pad keys. Press the OK button to set the number and move to the next screen.

In figure 2.4I, image 4, you can select No, Date, or Time. Select No if you do not want to use a Date or Time stamp. Select one or both of the other options to add a Date and Time stamp to your printed image. (Date and Time stamps will be covered in greater detail in a later chapter. See the upcoming **Deeper Information** subheading.) With your choice highlighted, press the OK button to move to the next screen.

Figure 2.4I, image 5, allows you to select Set to confirm your choices, which means this image will be added to the Print Order on the memory card, or you can select Cancel to stop the process.

When you remove the memory card from the camera and insert it into a DPOF-compatible printing device, the device's software will offer you various choices based on what it finds in the Print Order.

Figure 2.4I, image 6, shows what a thumbnail of an image in a Print Order looks like. The red arrow points to a red symbol that is identical to the Print Order symbol in figure 2.4I, image 1.

Deeper Information: The Print Order processes for both single- and multiple-image Print Orders are covered in much greater detail in the **Playback Menu** chapter, under the **Print Order** subheading, on page 262.

Erase

The Erase function allows you to delete a single image (RAW or JPEG) or video that is displayed on the camera monitor. This is similar to erasing a single image by displaying it on the monitor and pressing the Delete button. However, it offers a different and more complex approach to deleting an image. Let's see how it works.

Figure 2.4J: Deleting a single image (RAW or JPEG) or a video

On the camera monitor, display an image or video that you no longer want, then press the OK button to open the RAW/JPEG menu (figure 2.4J, image 1). At the bottom of the menu you can see the Erase function. Choose Erase, then press the OK button again to start the deletion process, which will be finalized on the next screen.

In figure 2.4J, image 2, you can see a small menu with the choices of Yes or No. Choose Yes and press the OK button to immediately delete the displayed image or video. Press No to cancel.

Mode Dial Setting Control Screens

The Mode Dial on top of the E-M1 has nine settings. Each setting has a control screen that lets you use the camera in specific ways.

Let's examine each mode briefly. They will be used throughout the rest of this book as we discuss how they relate to photography with the E-M1 and individual camera settings.

Manual (M) Mode

Manual (M) is the ultimate mode for taking your time and getting it right. For photographers who want complete control of their cameras, M mode is best. The camera makes no decisions about the exposure triangle (shutter speed, aperture, and ISO sensitivity) for still pictures, leaving it up to the photographer to take full creative control of the exposure. You control the shutter speed with the Rear Dial and the aperture with the Front Dial.

Let's examine the control screens you use in M mode.

Figure 2.5A: Using Manual (M) mode on the Mode Dial

Figure 2.5A, image 1, shows the Mode Dial set to Manual (M) mode. With this mode you have full control of the shutter speed, aperture, and ISO, as well as exposure compensation. Notice in images 2–4 that an M appears in the lower-left corner of the Live View screen.

Figure 2.5A, image 2, shows a good exposure of my battery and blocks. The exposure control settings are displayed at the bottom of the screen (30 F11 0.0). Notice that both the shutter speed (30) and aperture (F11) settings are in dark rectangles, which means you have manual control of the settings. The current shutter speed is 1/30 sec (30) and is *controlled with the Rear Dial*. The current aperture is f/11 (F11) and is *controlled with the Front Dial*. Notice that to the right of 0.0, at the bottom of image 2, there is a –/+ exposure indicator that is currently zeroed out. There is a tiny square under the 0 point of the scale, and there are no other tiny squares along the bottom of the scale. This indicates that the exposure is good, and the camera is ready for you to press the Shutter button and take a picture. If you press the Info button, a small Live histogram (not shown) will appear on the screen. You can use the histogram to help gauge the exposure.

Figure 2.5A, image 3, shows that I have adjusted the shutter speed by 1 EV step (1 stop). It was set to 1/30 sec (30) in image 2, and now it is set to 1/15 sec (15). Turn the Rear Dial to change the shutter speed. Also, notice that since I added an extra stop (+1.0) of exposure, the –/+ exposure indicator now displays +1.0, and there are several tiny squares under the –/+ exposure scale (image 3). The squares are extending toward the first major division on the + side of the scale, which represents 1 stop overexposure. The camera gives you both a numerical (e.g., 0.0, +1.0) value and a –/+ scale value. The numerical value can register a maximum of 3 stops (+3.0) overexposure and 3 stops underexposure (–0.3). The –/+ scale registers the same 3 stops. If you exceed 3 stops (3 EV steps) of over- or underexposure, the numerical exposure value and the squares under the –/+ scale blink rapidly.

Figure 2.5A, image 4, shows that I have restored the shutter speed to 1/30 sec (30) and adjusted the aperture from f/11 (F11) to f/8 (F8.0). You adjust the aperture with the Front Dial. Notice also that since 1/30 sec at f/11 is the correct exposure for this subject (image 2), and my camera is set to 1/30 sec at f/8 in image 4, the numeric exposure value and –/+ scale are both again registering 1 stop of overexposure (+1.0 EV).

Basically, you can use either the aperture or shutter speed to dial in the best exposure. This allows you to use the aperture to control depth of field and the shutter speed to control motion.

After you have the exposure set the way you want it, take your pictures.

Adjusting the ISO Sensitivity
If needed, you can make the camera more or less sensitive to light by raising or lowering the ISO sensitivity.

The ISO sensitivity, shown on the left side of figure 2.5B (ISO 400), can be accessed by pressing the OK button to open the Live Control. Look for the ISO setting, which is the third from the bottom setting on the right side of the Live Control (figure 2.5B, image 1).

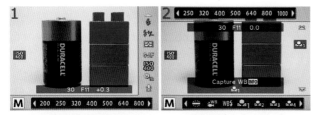

Figure 2.5B: Adjusting the ISO value in M mode

Or you can flip the Lever on the back of the camera (surrounding the AEL/AFL button) to the second position (2) and turn the Front Dial to adjust the ISO sensitivity (figure 2.5B, image 2) and White Balance. Flip the Lever back to its first (1) position to resume using the dials as exposure controls (shutter speed and aperture). You can also adjust the White Balance at the same time as the ISO sensitivity, if there is a need to do so.

Using the Live Histogram

Another excellent control screen to help with manual exposure is the Live histogram overlay, which will be discussed in detail later in the book. Many photographers use the histogram extensively. The availability of a Live histogram is one of the better features of a mirrorless camera. Cameras with mirrors can give you an after-the-fact histogram when you use the optical viewfinder, but the E-M1 mirrorless camera has a Live histogram available for the electronic viewfinder. It's a powerful feature!

While using the Live View screen, press the Info button repeatedly until you see the Live histogram scale appear (figure 2.5C). It can help you judge exposure with great accuracy. If the histogram is cut off on the left side of the graph window, the image may be too dark. If it is cut off on the right, the image may be too light. Using the exposure meter and Live histogram together makes for some very accurate exposures.

Figure 2.5C: Opening the Live histogram (red arrow) in M mode

Note: When you turn the Front and Rear Dials to change the shutter speed and aperture, each click of the dial changes the exposure by an amount equal to the value in the EV Step function at *Custom Menu > E. Exp/[Meter]/ISO > EV Step*. The factory default is 1/3 EV (1/3 stop) for each click. However, you can set the value to 1/2 EV or 1 EV per click in the EV Step function.

Next let's consider Shutter priority (S) mode for photographers who need to control motion.

Shutter Priority (S) Mode

Shutter priority (S) mode is for photographers who shoot moving subjects and need to stop action, such as for sports photography. It is also used by photographers who need to blur motion, such as when shooting a waterfall.

S mode is a semiautomatic mode; the photographer takes manual control of the shutter speed, and the camera provides automated aperture control.

The ISO sensitivity can be set to either manual or automatic in S mode. Basically, a good exposure will be maintained when the camera and photographer work together.

Let's see how to adjust the camera in S mode.

Figure 2.5D: Using Shutter priority (S) mode

Figure 2.5D, image 1, shows the Mode Dial set to Shutter priority (S) mode. When you use this mode you have full control of the shutter speed, and the camera automatically adjusts the aperture when you change the shutter speed so the exposure is always accurate. Notice in images 2 and 3 that an S appears in the lower-left corner of the Live View screen.

Figure 2.5D, image 2, shows a good exposure of my battery and blocks. You can see the exposure control settings at the bottom of the screen (30 F11 0.0). The current shutter speed is set to 1/30 sec (30) and is *controlled with the Rear Dial*. Notice that the shutter speed (30) is in a dark rectangle and the aperture (F11) is not. This indicates that you have manual control of the shutter speed, and the camera automatically controls the aperture. Also, notice that the 0.0 setting (exposure compensation) is in a dark rectangle, which means you can control it and override the camera's automatic exposure value by adding or subtracting light. You control –/+ exposure compensation with the Front Dial. You can dial in exposure compensation over a range of 10 EV steps (–5.0 to +5.0). The –/+ scale shows the current compensation value in either a negative or positive direction.

Note: Be careful when you use exposure compensation because Live View can fool you. If the aperture number starts to blink on the monitor, the camera cannot provide additional compensation. The Live View monitor may continue to brighten or darken, but no light is being added or subtracted to the image (also see the next **Note**).

In figure 2.5D, image 3, I dialed in +1.0 EV of exposure compensation. The camera adjusted the aperture from F11 (image 2) to F8.0 (image 3) to provide one additional EV step of exposure. After you have the exposure set the way you want it, take your pictures.

While you use S mode, you can set the ISO sensitivity to AUTO and let the camera adjust it, or you can leave it set to a certain number (e.g., ISO 200, 400, 800) depending on the

ambient light conditions. You can also select the Live histogram control overlay by pressing the Info button until the Live histogram appears on the screen.

Note: While you are making shutter speed adjustments with the Rear Dial, you may see the aperture number start to blink. This means the camera has reached its maximum or minimum aperture and cannot open or close the aperture any further, even though the monitor may brighten or darken. If this happens, you may want to consider using ISO AUTO so the camera can increase or decrease the ISO sensitivity to maintain a good exposure. Do not let the image you see on the Live View screen fool you when the aperture number is blinking.

Aperture Priority (A) Mode

Aperture priority (A) mode is for photographers who need to control the depth of field (zone of sharp focus), such as in portrait or landscape photography.

The A mode is a semiautomatic mode; the photographer manually controls the aperture, and the camera automatically controls the shutter speed.

The ISO sensitivity can be set to either manual or automatic in A mode. Basically, a good exposure will be maintained when the camera and photographer work together.

Let's see how to adjust the camera in A mode.

Figure 2.5E: Using Aperture priority (A) mode

Figure 2.5E, image 1, shows the Mode Dial set to Aperture priority (A) mode. When you use this mode you have full control of the aperture, and the camera automatically adjusts the shutter speed so the exposure is always accurate. When you use A mode at small apertures be sure the shutter speed does not get too slow to handhold. With the 5-axis Image Stabilizer (IS) built in to the E-M1, you may be able to get sharp pictures down to 1/15 sec (15) unless you are a shaky person. When you shoot at slow shutter speeds, use a monopod or tripod for the best results. Notice in images 2 and 3 that an A appears in the lower-left corner of the Live View screen when you use A mode.

Figure 2.5E, image 2, shows a good exposure of my battery and blocks. You can see the exposure control settings at the bottom of the screen (30 F11 0.0). The aperture is set to f/11 (F11) and is *controlled with the Rear Dial*. Notice that the aperture setting (F11) is in a dark rectangle and the shutter speed setting (30) is not. This indicates that you have manual control of the aperture, and the camera automatically controls the shutter speed. Also, notice that the 0.0 setting (exposure compensation) is in a dark rectangle, which

means you can control it and override the camera's automatic exposure value by adding or subtracting light. You control −/+ exposure compensation with the Front Dial. You can dial in exposure compensation over a range of 10 EV steps (−5.0 to +5.0). The −/+ scale shows the current compensation value in either a negative or positive direction.

Note: Be careful when you use exposure compensation because Live View can fool you. If the shutter speed number starts to blink on the monitor, the camera cannot provide additional compensation. The Live View monitor may continue to brighten or darken, but no light is being added or subtracted to the image (also see the next **Note**).

In figure 2.5E, image 3, I dialed in +1.0 EV of exposure compensation. The camera adjusted the shutter speed from 30 (image 2) to 15 (image 3) to provide one additional EV step of exposure. After you have the exposure set the way you want it, take your pictures.

While you use A mode, you can set the ISO sensitivity to AUTO and let the camera adjust it, or you can leave it set to a certain number (e.g., ISO 200, 400, 800) depending on the ambient light conditions. You can also select the Live histogram control overlay by pressing the Info button until the Live histogram appears on the screen.

Note: While you are making aperture adjustments with the Rear Dial, you may see the shutter speed number start blinking. This means the camera has reached its maximum 1/8000 second (8000) or minimum 60 second (60″) shutter speed and cannot adjust the shutter speed any further, even though the monitor may brighten or darken. If this happens, you may want to consider using ISO AUTO so the camera can increase or decrease the ISO sensitivity to maintain a good exposure. Do not let the image you see on the Live View screen fool you when the shutter speed number is blinking.

Program (P) Mode

Program (P) mode is a throwback to when full automation first arrived on cameras. In the olden days, P mode was the equivalent to today's iAUTO mode. P mode provides fully automatic control of the shutter speed and aperture and lets the photographer concentrate on taking pictures. In a sense, the camera becomes a point-and-shoot camera when you use P mode.

However, unlike iAUTO mode, where the camera takes complete control of all aspects of getting the picture, P mode allows you to have some control for special circumstances. You can take control of the aperture by turning the Rear Dial and overriding the camera's aperture choice. This allows you to shoot without thinking about camera settings, but when you need to, you can override the camera's aperture setting with one of your own; the camera still controls the shutter speed.

When you override the aperture setting with the Rear Dial, you place the camera into a special version of the Program mode, called Program shift (Ps) mode. Ps mode is very similar to A mode, which we considered in the previous chapter subsection.

Let's see how to use P mode and Ps mode.

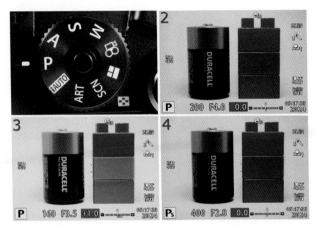

Figure 2.5F: Using Program (P) and Program shift (Ps) modes

Figure 2.5F, image 1, shows the Mode Dial set to Program (P) mode. Notice in images 2 and 3 that a P appears in the lower-left corner of the Live View screen when you use Program mode, and Ps appears when you use Program shift mode (image 4). Also notice that in images 2–4 the shutter speed and aperture numbers are not in dark rectangles (unlike M, A, and S modes). This indicates that the camera automatically controls the shutter speed and aperture in P mode, even though you can override the aperture setting in Ps mode.

In figure 2.5F, image 2, the shutter speed of 1/200 sec (200) and aperture of f/4.0 (F4.0) are just right for a good exposure. At this point I could take the picture and not worry about any of the settings. The camera is in control.

In figure 2.5F, image 3, I used the Front Dial to add +1.0 EV exposure compensation. The camera changed the shutter speed from 1/200 sec (200) to 1/160 sec (160) and the aperture from f/4.0 (F4.0) to f/3.5 (F3.5). This maintains a balanced exposure with +1.0 EV of compensation.

In figure 2.5F, image 4, I removed the exposure compensation value and overrode the aperture setting by turning the Rear Dial. The camera changed the P in the bottom-left corner to Ps. It is now using Program shift mode. I chose an aperture of f/2.8 (F2.8), which is 1 EV step more exposure than f/4.0 (image 2), or double the light. The camera changed the shutter speed from 1/200 sec (image 2) to 1/400 sec (image 4), or half the time, to compensate for the extra stop of light I added by opening the aperture. Double the light for half the time is an equivalent exposure, except the new settings will result in a shallower depth of field (larger aperture) and faster shutter speed. To exit Ps mode, turn the Rear Dial until the camera displays the original shutter speed. When you are ready, take your pictures.

iAUTO and the Live Guide System

When you place your E-M1 in iAUTO mode on the Mode Dial (figure 2.5G), it becomes a point-and-shoot camera. You press the Shutter button, and the camera does the rest. You can relax and take pictures without worrying about camera settings. Even for a professional photographer, a fully automatic mode is welcome at certain times.

Figure 2.5G: Selecting iAUTO mode on the Mode Dial

Not every picture you take is destined to be a masterpiece, some are just for fun. When you're at a party taking snapshots, as long as the image looks nice, who cares how it got that way? Using a fully automatic mode is good for fun photography, but it is not available on many professional cameras.

Try iAUTO mode when you are taking snapshots and see if you enjoy using it. The camera software is capable of making nice images for sharing on social media sites, and the built-in Wi-Fi makes it easy to transfer the pictures.

Live Guide System

In addition to offering complete camera automation in iAUTO mode, the E-M1—continuing with the idea that everything should be configurable—also provides a way to fine-tune the images that are taken with fully automatic settings. It is called the Live Guide system.

This section is an overview of the Live Guides. There is more information on the Live Guide system later in the book. See the upcoming **Deeper Information** paragraph for more information.

Now let's examine the Live Guides.

Figure 2.5H: Using the Live Guide system

Set the Mode Dial to iAUTO. You will see a small tab at the right side of the Live View screen (figure 2.5H, image 1). When you touch the tab, the Live Guide system will open. You can use Live Guides to change the appearance of the subject in various ways before you take a picture, or you can see Shooting Tips for various types of picture taking. Touch the Live Guides tab to open the Live Guide menu.

Figure 2.5H, image 2, displays the six Live Guide selections. Here are brief descriptions of what each guide does (top to bottom):

- **Change Color Saturation:** Visually change the color saturation of a subject just before you make the picture.
- **Change Color Image:** Visually change the color temperature of a subject just before you make the picture. You can make the color warmer (more red) or cooler (more blue).
- **Change Brightness:** Visually change the brightness of a subject in real time just before you make the picture.
- **Blur Background:** Change the lens aperture by moving the adjustment slider while visually previewing the depth of field (zone of sharp focus) just before you make the picture.
- **Express Motions:** Visually control the shutter speed by moving the adjustment slider.
- **Shooting Tips:** Get tips on various photographic subjects, including Child, Pet, Flower, and Cuisine photography. You will also find screens for suggestions on framing an image and using camera accessories.

If you slide your finger up and down the screen over the Live Guides, the highlighted area will follow your finger and stop when you lift it. Or you can simply touch one of the six Live Guide icons to open that guide's secondary screen.

Figure 2.5H, image 3, shows the secondary screen for the Change Color Saturation Live Guide. Notice the slider on the right of the screen, which is currently at the zero (0) position. Slide the indicator toward the top to increase saturation or toward the bottom to reduce saturation. You will see the saturation change on the Live View screen as you move the indicator. When the saturation looks good, remove your finger and press the OK button to lock in the setting.

The rest of the Live Guides work in a similar manner. If your camera is using firmware update 2.0 or later, you can visually combine the effects of several Live Guides, and they will remain in effect for the current shooting session until you press the Menu button to cancel them (or turn the camera off). Before firmware version 2.0 you could use only one Live Guide at a time.

When you use a secondary screen for one of the Live Guides, you can touch the Menu icon in the lower-left corner of the screen (figure 2.5H, image 3) to return to the Live View screen, with a tab showing on the right, for later Live Guide usage (image 1).

Deeper Information: You can assign the Live Guide system to a camera button (as a Button task) for immediate access. There is a much deeper discussion of the Live Guide system in the **Appendix** under the **Live Guide** heading on page 482. The discussion is approached as a Button task instead of a subfunction of the iAUTO Mode dial setting; however, they both work the same.

ART Modes

The ART modes setting on the Mode Dial allows you to choose from 14 individual ART modes to take highly stylized images with specialized contrast, framing, and tinting (figure 2.5I). There are 15 Art modes on the menu; however, only 14 are designed to modify an image.

Figure 2.5I: ART Modes

The 15th mode, ART BKT, allows you to take one picture and automatically bracket all 14 of the ART filters.

In other words, when ART BKT is selected and you take a picture, you can watch the monitor as the camera creates 14 copies of the image, each with a different ART filter applied. As a new copy is created, it will briefly appear on the monitor. When the process is done, the memory card will contain the original image with no ART filter applied, as well as 14 copies of the original image with a different ART filter applied to each image.

ART modes are really a type of Picture Mode, which are in Shooting Menu 1. In addition to the 15 ART modes, there are also nine Picture Modes, which are discussed in greater detail in the **Shooting Menu 1** chapter under the **Picture Mode** subheading (see page 136).

The following list examines each of the 15 Art Picture Modes:

- **Pop Art (Art 1):** This mode is like the Vivid Picture Mode on steroids. All colors are saturated to the max, and contrast is raised to an even higher level than in Vivid Mode. This mode is best when you are in a playful mood and want to create an exciting image. The intense colors will not be close to reality, but who needs reality when you are having fun?
- **Soft Focus (Art 2):** This mode provides a high-key and blurred effect. The contrast is very low, and there is an overall softness like fine gauze. The subject appears sharp, but it is covered with blur. The effect looks a bit like when you see yourself in a foggy mirror. It has a bright glowing effect that is sharp and blurry at the same time.
- **Pale&Light Color (Art 3):** This mode washes out all the colors and lowers the contrast so blacks become grays. You might think of this as being opposite of Pop Art or Vivid Modes. It gives an image a high-key, cooler, and pastel look.
- **Light Tone (Art 4):** This mode is similar to the Pale&Light Color Mode in that it lowers contrast and desaturates colors. However, instead of having a somewhat cool (bluish), high-key look, the colors look like they are overlaid with gray film and have a darker, low-key look. Light Tone makes the image look like the effect you see when an overdone high dynamic range (HDR) image has too few shadows.
- **Grainy Film (Art 5):** This mode provides an extremely high-contrast black-and-white effect. All colors become extra-dark shades of gray, and most highlight details become pure white. This mode would be great for shooting a bare tree in a snow-covered field on a misty, overcast day. This mode creates stark images and is best for low-contrast scenes because it will obliterate any detail in strongly colored or bright scenes by adding extreme contrast to the picture.

- **Pin Hole (Art 6):** This mode has a relatively saturated look like Vivid Mode, but it adds a heavy vignette effect to the corners of the image, as if the light rapidly diminishes. It's as though you were using a pinhole camera to make the image, except the picture is nice and sharp. Primarily, Pin Hole provides a vignette effect.
- **Diorama (Art 7):** A diorama is a three-dimensional miniature in which small artificial objects are arranged and photographed to resemble real life. You can use Diorama Mode to create a reverse diorama, where real-life places like city scenes can be made to look artificial. This mode creates a band of sharpness either in a horizontal or vertical direction (it's adjustable), and everything outside of the band is blurred, making the picture seem like it has a very limited depth of field.
- **Cross Process (Art 8):** This mode imitates an old method of developing film in chemicals that were designed for different types of film. Often there are odd colors and higher than normal contrast. Images shot with Cross Process have a green cast and high contrast.
- **Gentle Sepia (Art 9):** This mode converts all colors to monochrome and adds a warm, brownish effect that resembles less-saturated sepia toning. It could be used with old-fashioned clothing to imitate antique portrait pictures, or you could shoot a nature scene with this mode and make it look like a bygone era.
- **Dramatic Tone (Art 10):** This mode is unusual. It creates a low-key tone where normal highlights are darkened and dark tones are lightened. Bright colors are somewhat muted, and detail is maintained, even in dark areas. There is strong contrast without being overly bright. The look is dramatic and unlike anything I have seen from other camera brands.
- **Key Line (Art 11):** This mode converts the edges of the subject and the borders of contrast changes (color gradations) into line drawings. It maintains a lot of detail, unlike the cartoonish look from some other cameras. The color is mostly maintained, although it is more pastel and muted, and blacks become quite gray.
- **Watercolor (Art 12):** This mode gives colors and edges a watercolor effect that tends to blow out highlights and dark areas. Most detail is lost in a normal exposure, so experiment with underexposure when you use this mode. Dark tones and extreme highlights seem to turn stark white and disappear completely from the image, and other colors become pale and washed out.
- **Vintage (Art 13):** The Vintage Art Filter allows you to tint the image in such a way that it appears to be a faded, color-shifted image you would expect to see after a print has been hanging on a wall for many years.
- **Partial Color (Art 14):** The Partial Color Picture Mode is designed to let you use a previously configured Partial color setup. To choose a partial color, see the **Shooting Menu 1** chapter under the **Partial Color (Art 14)** subheading on page 172. After you have configured a Partial Color, only that color will display, and other colors will appear as monotone shades.

• **ART BKT (Art 15):** This mode takes a single picture with no special effects, then it creates 14 copies of the picture and applies each of the ART filters. Taking one picture will result in 15 pictures being created. You can also have the camera apply the normal Picture Modes (e.g., Vivid, Natural) to the picture for up to seven additional copies. If you apply all ART filters and Picture Modes, one picture will result in 21 pictures being created. Please see the chapter **Shooting Menu 2,** under the subheading **ART BKT (Art Mode Bracketing)** on page 209, for information about ART bracketing.

As an example, let's examine how to select the Grainy Film ART mode (refer to the upcoming **Deeper Information** paragraph for references to additional information later in the book).

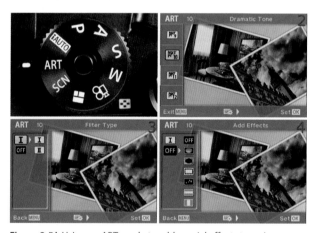

Figure 2.5J: Using an ART mode to add special effects to an image

Figure 2.5J, image 1, shows the Mode Dial set to ART. When you first choose ART mode on the dial, the camera will display a screen similar to the one seen in figure 2.5J, image 2. Usually it will display ART 1 Pop Art; however, if you have previously used ART modes, it will display the previous ART mode that was selected.

Figure 2.5J, image 2, shows that the ART 10 Dramatic Tone mode is selected. I chose this mode as an example because it offers both Filter Types and Add Effects. Other modes may offer only one or the other. Filter Types usually change something within the contrast or color balance of the image, and Add Effects does things like selective blurring, edge effects, and special framing. When you see the initial screen for an ART mode (such as image 2), scroll up or down with the Arrow pad keys to select an ART mode (ART 1–ART 15). Press the OK button to apply that mode and its default settings, skip the following two paragraphs, and take your pictures. To fine-tune the effects of the ART mode before you use it, scroll to the right to open the secondary screens.

Figure 2.5J, image 3, displays the Filter Type secondary screen, where you can select a Filter Type. Our example mode has Filter Type I and Filter Type II. Type I makes a color

picture with dramatic tones. Type II makes a black-and-white image with dramatic tones. Scroll to the right to select either I or II. Most ART modes have at least Filter Types I and II, a few have a third filter (III), and a few have no filters. After you have highlighted the Filter Type you want to use, press the OK button to choose the filter. The highlight will pop back to the left so you can scroll down and select an Add Effects Type.

Figure 2.5J, image 4, shows the Add Effects secondary screen. This screen offers all sorts of special effects, including shaped frames, starbursts, soft focus, edge effects, pinhole effect, and blurring. Not all ART modes offer all Add Effects. It varies from ART mode to ART mode. Choose an Add Effect and press the OK button to use that effect. (To change ART modes, press the OK button while still on the Live View screen, and the ART mode selection screen will reopen). Take your pictures.

Deeper Information: These Art modes each have different internal settings. The settings allow you to change things like filter types and to add special effects. To fully understand how the Art mode system works, see the **Shooting Menu 1** chapter under the subheading **Art Picture Modes** on page 141. For the ART BKT mode, see the chapter **Shooting Menu 2** under the subheading **ART BKT (Art Mode Bracketing)** on page 209.

Note: To reopen the ART mode screen and select a different ART mode than the one you originally used, make sure the camera is still set to ART mode on the Mode Dial, then press the OK button. Also, the ART mode screen is touch sensitive. You can touch the small arrows at the top and bottom of the list of ART modes to scroll up and down. To select a mode, touch that mode's main icon on the left. The camera will activate the mode and switch back to the Live View screen. I have not found a way to use the touch screen to open an ART mode's secondary screens. Scroll with the right Arrow pad key to open the secondary screen.

SCN Modes

SCN (Scene) modes are special camera configurations that match a specific type of photography. The individual SCN modes are designed for inexperienced photographers who still want to get great images in difficult situations.

There are 25 SCN modes that are named for the type of photography they are used for. Each mode optimizes camera settings for a specific type of photography. They are simple to use because you only have to select the SCN mode that closely matches your current photography needs then shoot your pictures.

The SCN mode screen is touch sensitive. Simply touch an icon on the list that appears on the left side of the screen, and the camera will configure itself for that style of shooting.

Let's examine the 25 SCN modes then look at an example:

- **Portrait:** Use this mode to take portraits of people.
- **e-Portrait:** This mode smooths skin tones so your portraits look good on an HDTV.
- **Landscape:** This mode adds saturation to blues and greens for excellent landscape pictures.

- **Landscape + Portrait:** This mode adds saturation to blues and greens for excellent landscape pictures while protecting skin tones for nature portrait sessions.
- **Sport:** This mode helps you capture fast action without excessive blur. It tends to use faster shutter speeds.
- **Hand-held Starlight:** This modes reduces blur when you are handholding your camera and shooting pictures of low-light scenes, such as a city view at night.
- **Night Scene:** Use this mode on a tripod. It is for shooting scenes in low light in the evening or at night. It may use very slow shutter speeds. This mode is not designed for handheld photography.
- **Night + Portrait:** Use the FL-LM2 flash attachment on your camera and ask portrait subjects to be still when you take night portraits with this mode. It uses slow shutter speeds to capture background lights and fill flash to light the subject.
- **Children:** Use this mode for taking pictures of active children playing.
- **High Key:** This mode emphasizes bright areas and highlights to make an image have a very bright look.
- **Low Key:** This mode emphasizes dark areas and enhances contrast to create a dark effect.
- **DIS Mode:** This mode attempts to reduce blur in a moving subject or, if the camera is moving, when you take action pictures. It uses Digital Image Stabilization techniques to stabilize the picture when movement is present.
- **Macro:** Use this mode to enhance the appearance of closeup (macro) pictures.
- **Nature Macro:** When you are taking closeup pictures of small objects in nature, such as a butterfly, use this mode to enhance the subject's appearance.
- **Candle:** This mode enhances images taken in low ambient light conditions, such as by candlelight. It tends to impart a warm white balance to make inviting pictures.
- **Sunset:** This mode reproduces reds and yellows with extra saturation to make a beautiful sunset have even more saturated colors. Use it when you shoot the setting or rising sun.
- **Documents:** This high-contrast mode emphasizes the contrast between dark letters and white paper. Use it to make easy-to-read copies of text documents.
- **Panorama:** This mode uses special frames that let you overlap panorama images so you can later combine them in your computer. It works for horizontal and vertical panoramas.
- **Fireworks:** This mode uses very slow shutter speeds and small apertures to allow you to capture fireworks images. You will need to use at least a monopod, if not a tripod, with this mode. It is not designed for handholding your camera. My camera seems to consistently select a 4 second shutter speed at f/11, with −1.0 EV compensation.
- **Beach & Snow:** When you want to shoot a picture with lots of white, such as on a snowy day or at a white-sand beach, this mode will enhance the image for the prevalence of white.

- **Fisheye Effect:** This mode allows you to shoot semifisheye pictures when you use an M.Zuiko Digital 14–42mm f/3.5–5.6 II lens with an Olympus Fisheye Converter FCON-P01 mounted on it (figure 2.5K, image 1).
- **Wide-Angle:** This mode allows you to shoot super-wide-angle pictures when you use an M.Zuiko Digital 14–42mm f/3.5–5.6 II lens with an Olympus Fisheye Converter FCON-P01 mounted on it (figure 2.5K, image 1).
- **Macro:** This mode allows you to shoot macro (closeup) pictures when you use one of three M.Zuiko lenses (see the upcoming lens list) with an Olympus Macro Converter MCON-P01 mounted on it (figure 2.5K, image 2).
- **3D Photo:** This mode takes pictures for display on a 3-D TV or monitor with a 3-D lens mounted on the camera. The camera monitor cannot display 3-D images. If you try to use a normal lens with this mode, the camera will inform you: *This lens is not supported*.
- **Panning:** This mode causes the camera to notice when you are panning with the subject, such as when you take a picture of a person riding by on a bicycle, and it will try to use the best shutter speed for the subject and provide a blurred background to imply motion.

Two of the 25 SCN modes require the use of a special fisheye adapter that fits the low-cost M.Zuiko Digital 14–42mm f/3.5–5.6 II lens only. The adapter is called the Fisheye Converter FCON-P01 (Figure 2.5K, image 1). If you have the 14–42mm lens and want to use the three SCN modes that require the adapter, you will need to purchase the adapter from a camera dealer.

Figure 2.5K: Fisheye Converter FCON-P01 (left) and Macro Converter MCON-P01 (right)

The Macro SCN mode requires the Macro Converter MCON-P01 (figure 2.5K, image 2) to be mounted on one of the following three lenses:

- M.Zuiko Digital 14–42mm f/3.5–5.6 II
- M.Zuiko Digital ED 14–150mm f/4.0–5.6
- M.Zuiko Digital ED 40–150mm f/4.0–5.6

Now let's examine how to choose a SCN mode and see what it does.

Figure 2.5L: Selecting a SCN mode

Figure 2.5L, image 1, shows the Mode Dial set to SCN mode. After you set the Mode Dial to SCN, the screen shown in image 2 will appear. If you select a SCN mode and decide to use another SCN mode later, you can get back to the SCN mode selection screen by pressing the OK button while the Live View screen is active.

Figure 2.5L, image 2, shows the main SCN mode screen and a list of 25 SCN modes on the left side of the screen. A picture and title will appear in the middle of the screen to let you know what a particular mode does. You can scroll up or down with the Arrow pad keys to select one of the 25 modes. You can also touch the arrow tips that appear above and below the modes to scroll, then touch a SCN mode icon to select it. Refer to the previous list to see which mode will work best for you. After you have highlighted a mode, you can scroll to the right to see a help screen that reminds you what it does (figure 2.5L, image 3). Now you can scroll left to select another mode, or press the OK button to lock in the SCN mode.

Settings Recommendation: If you are not sure how to set your camera for a certain type of photography, you can use the SCN modes. Try them and see how they work for you. You can use your camera for advanced photography without needing experience. Nothing replaces experience, but this advanced technology helps you enjoy your photography while you learn.

Photo Story

The Photo Story function allows you to combine multiple images into one individual picture—a photomontage. When you take a series of images, they are saved as part of an incomplete photomontage on the memory card until you finish shooting the Photo Story. When the Photo Story is completed, the E-M1 assembles the images into a montage, saves the montage, and saves each image in the montage as separate images.

The camera offers six Photo Story types with various filters, effects, and aspect ratios. Let's examine them.

Figure 2.5M: Six Photo Story types

Figure 2.5M, images 1–6, show the Photo Story types you can use to create your own multi-image montages. The Photo Story types and brief descriptions are as follows:

- **Standard:** This Photo Story offers four frame edge types, four special effects, and four photo arrangements with various aspect ratios. It can be considered a general purpose Photo Story type.
- **Speed:** This Photo Story offers three photo arrangements with equal aspect ratios. Use this Photo Story type to capture sequential motion.
- **Zoom In/Out:** This Photo Story offers two frame edge types, two special effects, and two aspect ratios. One of the images is normal, and one is automatically zoomed in digitally for a closeup of the subject.
- **Layout:** This Photo Story offers four aspect ratios, all with wide white borders.
- **Fun Frames:** This Photo Story offers three photo arrangements: one with a small Polaroid-looking film image overlaying a larger image, one with sprocket holes along the edges, and one with five narrow stripes.
- **Works in Progress:** This is not exactly a Photo Story. It lets you continue with any Photo Story you started but didn't finish. This function allows you to shoot a picture in one place, go to another place to shoot another picture, and so on, until you have filled all the frames. You don't have to complete a Photo Story immediately. Instead, you can do part of it and continue adding images later. We will discuss this in more detail shortly.

Configuring a Photo Story Shooting Session

Now let's examine how the Photo Story system works by choosing one of the Photo Story types and putting it through its paces. We will use the Standard Photo Story, which combines three images into one photomontage. Each type of Photo Story works basically the same way, so the following steps apply to all Photo Stories.

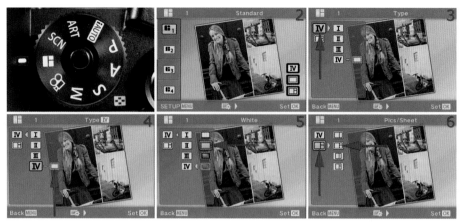

Figure 2.5N: Configuring a Photo Story

Figure 2.5N, image 1, shows that my camera is set to the Photo Story symbol on the Mode Dial. Use this Mode Dial position to begin your Photo Story. If you are about to take the first picture in your current Photo Story and decide you would rather use a different Photo Story type, simply press the Menu button and the camera will return to the main Photo Story screen. You can touch the screen to select a Photo Story, or you can use the Arrow pad keys to scroll up and down until you find the Photo Story you want to use.

In figure 2.5N, image 2, I selected the Standard Photo Story. To access the Photo Story's secondary screen and make some adjustments, scroll to the right.

Figure 2.5N, image 3, shows the Photo Story's Type selections. I selected Type IV. As you scroll up and down in Types I–IV, you will see different color balances, frame widths, and frame colors. When you see a Type that you want to use, press the OK button to lock it in.

In figure 2.5N, image 4, you can see that certain special effects are available. To the right of Type IV you can see a symbol (red arrow) that means special effects are available. Scroll to the right to access these special effects.

Figure 2.5N, image 5, displays the four special effects that you can use for this particular Type. I chose the White frame effect, which means the frames around the edges of the picture will be white. The four effects are as follows:

- **Black:** The frame lines will be black.
- **White:** The frame lines will be white.
- **Black/Pin-Hole:** The frame lines will be black, and the montage will have a dark vignette in the corners (the entire montage, not the individual pictures), as if it were taken with a pinhole camera.
- **White/White Edge:** The frame lines will be white, and the montage will have a white vignette in the corners (the entire montage, not the individual pictures).

These effects are somewhat similar to the Add Effects settings we discussed in the previous **ART Modes** section. Choose one of the four effects and press the OK button to lock it in.

Figure 2.5N, image 6, shows the Pics/Sheet selection, which allows you to select various aspect ratios for your montage. Basically, you can vary the number of pictures and the shape of each picture. Choose the Pics/Sheet setting you most enjoy and press the OK button to Set it.

Note: Not all Photo Story types offer all the settings. Some of them offer only the Type setting, and others offer only the Pics/Sheet setting. You should experiment with each Photo Story type until you learn how they work so you can quickly choose your favorite in the future.

Now let's create a Photo Story montage (figure 2.5O).

Creating a New Photo Story

After we configure a Photo Story, we can create and combine images into a montage. Let's see how it is done.

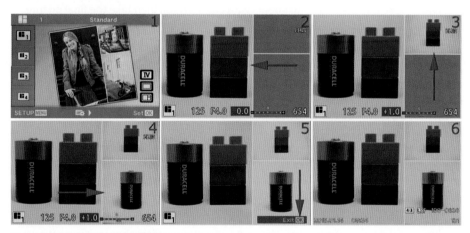

Figure 2.5O: Creating a Photo Story

Figure 2.5O, image 1, shows that I selected the Standard Photo Story. We configured it in the previous subsection. After you configure the Photo Story according to your needs, press the OK button to begin (or lightly press the Shutter button).

Figure 2.5O, image 2, shows the first frame of the Photo Story. The subject is in the frame on the left. There are several things to consider before you take the first picture. Before you capture an image, you can touch one of the frames on the monitor. The camera will highlight the frame and place the next picture in that frame. If you don't touch a frame first, the camera will fill the frames in order. The Photo Story system uses AUTO White Balance, but you can change it for each picture in the montage. You can see in the figure that the colors of my images are off. I shot them on a white background under a

basic fluorescent light. The bulb caused the background to be a very warm color. Before you shoot an image, you can control the White Balance by pressing the OK button, opening the Live Control, and setting an appropriate White Balance for the subject. The camera also allows you to set exposure compensation. I took my first image with no compensation; that is, with 0.0 at the numerical exposure compensation position (figure 2.5O, image 2, at the bottom center of the image).

Figure 2.5O, image 3, shows that I have already taken the first image (left frame) and that I am about to take the second image (top-right frame). Notice that I have dialed in +1.0 EV Exposure compensation for the second image to more closely match the brightness of the first image. Each image allows you to use a different Exposure compensation, White balance, Flash type, Flash compensation, AF mode, ISO sensitivity, Image stabilization, and RAW/JPEG format. All those settings are available just before you take a picture when you press the OK button and open the Live Control screen. Many other menu items are not available during a Photo Story session, so they are grayed out. After you select your settings, take the second picture.

Figure 2.5O, image 4, shows that I am ready to take the final picture for my Photo Story montage. Make any needed adjustments with Live Control, then take the final picture.

Figure 2.5O, image 5, shows a preliminary version of a Photo Story montage. To save the Photo Story (Exit), press the OK button.

A Busy screen will appear with a progress indicator while the Photo Story is being saved (not shown, between images 5 and 6). When the progress indicator is complete, the finished Photo Story will be displayed (figure 2.5O, image 6). You can scroll through Photo Story montages on the monitor just like normal images.

Note: At any time during the initial shooting of a Photo Story, if you decide you do not want the Photo Story, you can press the OK button with the incomplete Photo Story on the screen, and a menu will open with a Discard selection. Choose Discard and press the OK button to delete the entire Photo Story. Also, if you turn the Mode Dial to another setting or turn the camera off during an active Photo Story, the camera deletes the images in the shoot. If you want to save an incomplete Photo Story, save it before you exit the session to avoid losing the images. The next subsection explains how to save a Works in progress (incomplete) Photo Story.

Saving and Resuming a Works in Progress Photo Story

You do not have to finish a Photo Story in one shooting session. You can shoot a picture or two today, save the Works in progress, and return later to finish the montage. Let's see how to save an incomplete Photo Story and reopen it to shoot the final images.

Figure 2.5P, image 1, shows a Photo Story shoot in progress. The first image (left frame) has been taken, and the second frame is ready for input. Instead of taking the second image, press the Menu button.

Figure 2.5P: Stopping and resuming a Photo Story

Figure 2.5P, image 2, shows the menu that opens when you press the Menu button during a Photo Story shoot. This menu offers three choices:

- Save cancels the rest of the Photo Story shoot. It saves individual copies of any images you have already taken and an incomplete copy of the Photo Story montage.
- Finish later saves the current status of the Photo Story, with all images bundled inside the shoot, but it does not save individual images yet. You can continue the shoot later.
- When you select Discard before you have saved an incomplete Photo Story (Works in progress), the camera deletes all images in the Photo Story. Be careful with Discard!

If you select Discard for a previously saved but incomplete Photo Story, the camera cancels the operation and does not delete the Photo Story. For now, select Finish later, and the camera will save the current status of the Photo Story as a Works in progress. The incomplete Photo Story is now waiting for future picture additions.

Suppose that between images 2 and 3 in figure 2.5P, some time has passed. You have traveled to a different location for the next picture in your Photo Story, or it could even be a different day. Now you want to continue the Photo Story shooting session. Set the Mode dial to the Photo Story symbol and turn the camera on. If you have been using the Photo Story system recently and have an incomplete Photo Story saved, the Works in progress screen will appear. If the screen does not appear, simply select the Works in progress icon on the Photo Story screen (the sixth choice, which is highlighted in figure 2.5P, image 3). Press the OK button or scroll to the right to open the secondary screen.

Figure 2.5P, image 4, shows current Photo Stories. The Works in progress Photo Stories are highlighted (red arrow). You can see that the highlighted Photo Story is missing some of its images because there is a white space on the right side of the thumbnail. Only Works in progress Photo Stories can be selected in this menu. Choose a Work in progress and press the OK button to open it. A Busy screen and progress indicator will appear

(figure 2.5P, image 5), then the Works in progress Photo Story will open and is ready for new images to be added. I can now take more pictures and finish the Photo Story (figure 2.5P, image 6), using the steps provided in the previous subsection called **Creating a New Photo Story**.

Note: Being the curious type, I tested to see what the camera was doing with each image in the Photo Story before it was written to the memory card as a montage and individual images. I planned to shoot a couple of images in the Photo Story then, before I finished the session, delete one of the individual images. I wanted to see how the camera would handle losing one of the images before the shooting session was done. I discovered that the clever E-M1 does not save the individual images in the Photo Story until *after* the Photo Story is complete. That prevents accidental deletion of individual images in the Photo Story.

You can choose to save a Photo Story before you complete a shoot, and the E-M1 will keep all the images. You can also reopen and save a Work in progress Photo Story, without completing it, and the camera will keep all the individual images and the partially complete montage.

Movie Mode

The E-M1 has a full-featured video recording system that lets you create Full HD (1080p), HD (720p), or SD (480p) videos. It's easy to use the Movie mode. Let's see how.

Figure 2.5Q: Starting a video recording

Figure 2.5Q, image 1, shows my camera set to iAUTO mode. This lets the camera act like a standard video recorder for everyday family events.

Figure 2.5Q, image 2, shows the Movie button, which has a red dot. When you are ready to record a video, press the Movie button.

Figure 2.5Q, image 3, shows a video being recorded with the lens cap on. Notice in the lower-right corner that there is a red dot followed by a REC symbol. It appears any time you are recording a video. Just below the REC symbol is a timer that counts the recording time, which can be as long as 29 minutes per video recording. I have recorded a video that is 01 minute, 20 seconds long (00:01:20). At the top-left corner of the screen, the card access symbol will blink as video is written to the memory card.

After you are finished recording a video, press the Movie button again to stop recording. This is a very basic way to record video. You can gain greater control over video

recording by configuring the camera for more advanced operations (refer to the following **Deeper Information** paragraph).

Geek Facts: Full HD (1080p) or standard HD (720p) video is recorded with the following maximum specifications, which vary depending on the settings at *Shooting Menu 1 > Record Mode > Movie:*

- Up to 1920×1080 (1080p) at 30 frames per second (fps)
- Bit rate of up to 24 Mbps
- H.264 MPEG-4 AVC compression or Motion JPEG compression
- Up to 29 minutes of recording time per video clip
- Up to 4 GB per video clip
- MOV container format for Full HD and standard HD (H.264)
- AVI container format for standard HD and SD (Motion JPEG)

Deeper Information: See the **Shooting Menu 1** chapter, under the subheading **Video Formats** on page 183, for deeper information on video format specifications. Also, see the **Custom Menu** chapter, under the **Custom Menu I. Movie** heading (contains five subsections) on page 421, for deeper information on configuring the camera for advanced video recording.

Using Video Special Effects

A somewhat more advanced way to enjoy recording videos is to use the Movie mode setting on the Mode Dial. This allows you to record videos in a similar approach as previously described, but it adds five special effects for video recording that you activate with the touch screen. Let's discuss each of the special effects.

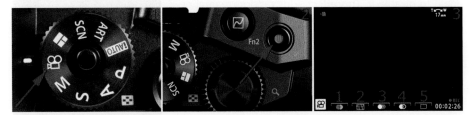

Figure 2.5R: Using the Movie mode and five video special effect modes

Figure 2.5R, image 1, shows that Movie mode is set on the Mode Dial.

Press the Movie button (figure 2.5R, image 2) to start the video recording.

Figure 2.5R, image 3, shows the video screen with an active recording. At the bottom of the screen there are five touch-activated special effects. Touch an effect icon to enable it, and touch it again to disable it. Let's examine each of the five effects modes and see how to use them.

Art Fade

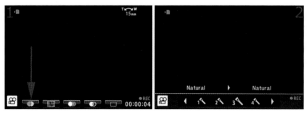

Figure 2.5S: Using the Art Fade effects mode

Figure 2.5S, image 1 (red arrow), shows the Art Fade effects icon. Touch the icon to open the secondary screen.

Figure 2.5S, image 2, shows the Art Fade screen. There are arrow tips to the left and right of the Picture Modes row along the bottom of the screen. The Natural Picture mode is currently selected. Touch one of the arrow tips to scroll through the Picture Modes until you see the mode you want to use. Touch the icon; when you remove your finger the new Picture Mode will be applied to the video recording. The effect will transition in gradually so the change will not be abrupt. The regular Picture Modes do not have strong effects, and they are hard to see on the Live View screen. However, you will see a pronounced effect when you use one of the ART modes. Before you use effects in a video recording, experiment with this mode to learn how it works.

Old Film

Figure 2.5T (red arrow) shows the Old Film effects icon. Touch the icon to enable Old Film effects, and touch it again to disable it. This effect adds random scratches and dust to the video, and it varies the brightness. It makes a video look like an old 1930s film. Be sure to try this in black-and-white!

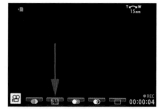

Figure 2.5T: Using the Old Film effects mode

Multi Echo

Figure 2.5U (red arrow) shows the Multi Echo effects icon. Touch the icon to enable the effect, and touch it again to disable the effect. This effect causes an echo to follow the main subject. It looks like the subject is repeated dozens of times in a continuous stream as it moves. Any movement in the frame is smeared in a strange, flowing way that is quite appealing.

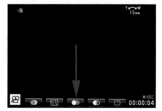

Figure 2.5U: Using the Multi Echo effects mode

One Shot Echo

Figure 2.5V (red arrow) shows the One Shot Echo effects icon. Touch the icon to instantly echo any movement in the frame. This is similar to the Multi Echo effect, except there is only one repetition that lasts about one second with smearing, instead of dozens of repetitions.

Movie Tele-Converter

Figure 2.5W, image 1 (red arrow), shows the Movie Tele-converter icon. Touch the icon to open the secondary screen.

Figure 2.5V: Using the One Shot Echo effects mode

Figure 2.5W: Using the Movie Tele-converter effects mode

Figure 2.5W, image 2, shows the Movie Tele-converter secondary screen. You can see two button symbols on the bottom-right of the screen. The symbol at the red arrow in image 2 is the zoom symbol. The symbol at the red arrow in image 3 is the Off symbol that exits the mode. If you touch the zoom icon (image 2), the camera will instantly jump to a zoomed-in view of the subject. The zoom motion is sudden, not gradual. That adds instant drama to the video, but it can become aggravating if it is overused.

Since this digital zoom does not involve turning the lens or moving the camera, it is, in effect, a crop of the video frames. You would normally expect that to result in seriously reduced image quality, but it looks like the camera subsamples a small area of the image sensor and does not actually digitally zoom in or crop the video. The image quality remains good, without aliasing (stair steps) or losing sharpness. Press the Off symbol to close the function.

Note: These five effects modes are mutually exclusive, which means only one effect can be active at a time. If you touch a different icon than the one that is currently active, the camera ignores you. You have to close one and open another!

Snapping a Picture during a Video Recording

You can press the Shutter button all the way down during a video recording to take a picture. As soon as you snap the picture, the camera stops recording the video, takes the picture, and immediately resumes recording. Three files will be written to the memory

card: the original video up to the point of the snapshot, the still picture, and the video recording that resumes after the still image is taken.

To finish this chapter we will examine three multifunction screens that are not touch sensitive. However, they need to be explained because they are activated by primary controls on the camera.

[Sequential Shooting]/[Self-Timer]/HDR Button Control Screen

The Sequential shooting/Self-timer/HDR button allows you to access three systems at any moment: Sequential shooting mode, Self-timer mode, and high dynamic range (HDR) mode. Let's see how it works.

Figure 2.6: Accessing Sequential shooting, Self-timer, and HDR modes

Figure 2.6, image 1, shows the [Sequential shooting]/[Self-timer]/HDR button on the top left of the camera. Press this button to open a secondary adjustment screen.

Figure 2.6, image 2, shows the multipurpose screen with settings at the top and bottom. Turn the Front Dial to control the HDR system. Turn the Rear Dial to control the [Sequential shooting] and [Self-timer] modes.

After you have selected the settings you want to use, press the OK button.

Deeper Information: The Sequential shooting and Self-timer modes were discussed earlier in this chapter under both the **Super Control Panel** (page 19) and **Live Control** (page 52) main sections. Refer to those sections to review how to use the Sequential shooting and Self-timer modes.

The HDR system is covered extensively in the **Shooting Menu 2** chapter, under the **HDR** subheading, on page 211.

AF/[Metering] Mode Button Control Screen

The AF/[Metering] mode button allows you to quickly access the autofocus (AF) and Metering modes. Let's examine how to access them.

Figure 2.7: Accessing the Metering and AF modes

Figure 2.7, image 1, shows the AF/[Metering] mode button. Press this button to open the secondary screen.

Figure 2.7, image 2, shows the secondary screen with the Metering modes along the top and the AF modes along the bottom. Turn the Front Dial to select the Metering modes. Turn the Rear Dial to select the AF modes.

After you have made your selections, press the OK button.

Deeper Information: The Metering modes are covered in detail under the **Super Control Panel** section (page 46) and **Live Control** section (page 68) of this chapter. They are also covered in the **Custom Menu** chapter, under the **Metering** subheading, on page 370.

The AF modes are covered in detail under the **Super Control Panel** section (page 39) and **Live Control** section (page 70) of this chapter. They are also covered in the **Custom Menu** chapter, under the **AF Mode** subheading, on page 274.

Lever Control Screen

The Lever on the back of the camera allows you to quickly access the ISO sensitivity and White Balance (WB) systems. Let's examine how to access them.

Figure 2.8: Accessing the ISO sensitivity and WB systems

You will normally leave the Lever on the camera set to the first (1) position. However, while you are taking pictures, you can quickly access the ISO sensitivity and WB systems. Flip the

Lever to the second (2) position (figure 2.8, image 1) and turn the Front Dial or Rear Dial to open the secondary screen (figure 2.8, image 2).

When the secondary screen is open, turn the Front Dial to scroll through the ISO sensitivity values, and stop on the ISO value you want to use. Turn the Rear Dial to scroll through the WB selections, and stop on the one you want to use.

After you have made your selections, press the OK button.

Deeper Information: The ISO sensitivity modes are covered in detail under the **Super Control Panel** section (page 20) and **Live Control** section (page 71) of this chapter.

The WB modes are covered in detail under the **Super Control Panel** section (page 22) and **Live Control** section (page 57) of this chapter. They are also covered in the **Custom Menu** chapter, under the **WB** subheading, on page 396.

Author's Conclusions

This chapter has introduced the many control screens you will see while you are using the Super Control Panel and the Live Control, Live Guides, Live View, and EVF screens. Many of these screens are discussed in greater detail throughout this book as they are applied to the hundreds of choices in the camera menus.

The next several chapters will be devoted to a deep examination of the E-M1 menu system, including Shooting Menu 1 and 2, the Playback Menu, Custom Menu, and Setup Menu.

The number of settings in the E-M1 makes it one of the most configurable, and complex, cameras available today. That complexity is manageable when you have a good guide, such as this book. Keep your camera in-hand as you work through this book and continue your journey to mastery of the Olympus OM-D E-M1 professional, mirrorless, interchangeable-lens camera. Now, let's look at those deep menus!

Settings Recommendation: The camera has a help system that is active when you use the camera's text-based menus. Although the help system is useful, it can sometimes get in the way of the menu selections. You can toggle the help system off and on by pressing the Info button when a menu is active. I use the help system when I have forgotten what a symbol means. When I am finished, I turn the help system off again.

3 Shooting Menu 1:
Preliminary and Basic Shooting Options

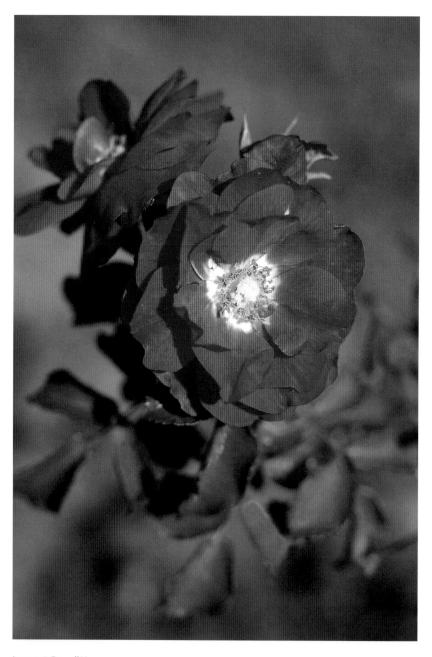

Image © Darrell Young

Shooting Menu 1 is the first in a series of camera configuration menus that we will consider in great detail. The E-M1 is one of the most configurable cameras I've ever owned. With that powerful flexibility comes a great deal of complexity. Unfortunately, the user's manual provided with the camera is woefully inadequate at helping you understand how to work with all these menus and their functions. Only through much experimentation and discussion with Olympus's upper-level technical support have I been able to ferret out how all these functions work.

Therefore, this book is filled with hands-on knowledge derived from hundreds of hours of experimentation. You could probably do the same as me and struggle through the process of figuring it all out, but now you don't have to. I've done it for you. At the very least, I hope that *Mastering the Olympus OM-D E-M1* helps you better understand and enjoy your new camera.

Now, let's get started on all these functions. It is best if you have your camera in hand and work through the functions one by one. Even if you don't think you need a certain function right now, why not take time to at least examine each menu item? Then, if your needs change, you will remember that your camera can do a certain thing and you can research how to configure it for that need.

The following is a look at the menu we will consider in this chapter (figure 3.1). Let's jump right in and start examining this camera's deepest parts.

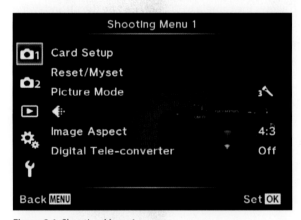

Figure 3.1: Shooting Menu 1

On Shooting Menu 1 you will find the following functions:

- **Card Setup:** This function allows you to delete all images or only nonprotected images, or you can format the memory card and delete everything.
- **Reset/Myset:** This function lets you save up to four camera configurations. In other words, you can set the many functions of the camera to work a certain way and then save those settings. Then you can configure the camera to work in a completely different way and save that configuration too. You can do this up to four times, with each

configuration being a completely separate setup. Then you can choose one of the four configurations from the Myset menu. You can reset a configuration any time.

- **Picture Mode:** The camera has 23 Basic, Creative, and Art Picture Modes that you can use to change how your images look. Just as with different film types, you can create pictures to reflect your mood or suit your clients' needs. From a standard look to a wildly outrageous one, you can create images that few other cameras can. In fact, you would normally have to use an expensive computer program like Adobe Photoshop to create some of the special effects that are built in to your camera.
- **[Record Mode]:** This function allows you to choose an image format for still photography, such as JPEG or RAW (ORF). For video, you can choose Full HD (1080), HD (720), or SD (480).
- **Image Aspect:** This function allows you to choose from various horizontal-to-vertical ratios. You can make pictures that vary in width and height, or they can be square.
- **Digital Tele-converter:** This simple function allows you to exceed the focal length of your lens by two times (2x), with a resulting loss in image quality. This is not a true zoom function. The camera merely enlarges the image in-camera and then crops a new image from the middle of the enlargement. Even though the subject appears to be closer when you see it on the camera monitor, it is an artificial enlargement that significantly reduces image quality.
- **Keystone Comp.:** This function allows the camera to digitally imitate the tilt and swing functions of a view camera or a tilt-shift lens. You can pull the edges of the image toward or away from you to correct distortion, such as the leaning-backwards effect you see when you use a wide-angle lens and point it up to photograph a tall building.

Let's examine each of these menu items in detail and determine how you may best use them. We will start at the top of Shooting Menu 1 and work our way down the menu.

Card Setup

Card Setup allows you to prepare a memory card for use in your camera. There are two parts to Card Setup: All Erase and Format. What is the difference?

All Erase

All Erase allows you to remove all images that have not been previously lock protected on the memory card. In other words, a protected image is one that you mark so the All Erase function will not remove it.

When an image is protected, the camera will ignore it when you execute the All Erase function, even though it deletes all the other images on the memory card. This is an easy way to get rid of images you do not want to keep. (See page 93 for more information about protecting an image.)

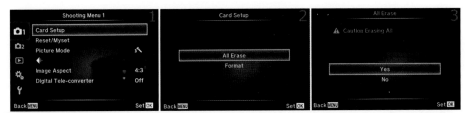

Figure 3.2A: Executing the All Erase function

Here are the steps to execute the All Erase function:

1. Select Card Setup from Shooting Menu 1 and scroll to the right (figure 3.2A, image 1).
2. Choose All Erase from the Card Setup menu and scroll to the right (figure 3.2A, image 2).
3. Select Yes from the All Erase menu. The camera will warn you, *Caution Erasing All* (figure 3.2A, image 3).
4. Press the OK button to erase all nonprotected images. Protected images will not be removed.

Format

The Format function deletes all images from the memory card, including protected images. Use this function when you get a new memory card or when you use a memory card that has been formatted in a different camera or in a computer. Formatting a card in the camera tends to cut down on long-term memory card problems.

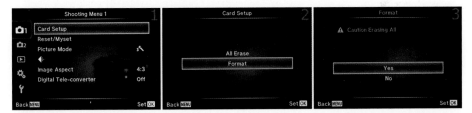

Figure 3.2B: Executing the Format function

Here are the steps to execute the Format function:

1. Select Card Setup from Shooting Menu 1 and scroll to the right (figure 3.2B, image 1).
2. Choose Format from the Card Setup menu and scroll to the right (figure 3.2B, image 2).
3. Select Yes from the Format menu. The camera will warn you, *Caution Erasing All* (figure 3.2B, image 3).
4. Press the OK button to erase all nonprotected images. Protected images will not be removed.

Note: Formatting a memory card doesn't actually remove images from the card. Instead, it removes their entries from the memory card's file allocation table (FAT) so the images can no longer be seen or found by the camera. However, you can use card recovery software to rescue the images if you do not write any new pictures to the card after you format it. That is a good thing to remember in case you accidentally format a card that contains images you wanted to keep.

Settings Recommendation: I always format a new memory card with the E-M1's Format function before I use it. There is no way to know if the current format on the card is in good shape. Also, many other camera brands create their own folder structure when a card is formatted. It is wise to remove all traces of any other brand's folder structure by formatting a used card in your E-M1. Why take any chances with your valuable images?

I don't use the image protect system much, so the All Erase function is not that useful to me. However, you may want to protect your best images as you make them, and at the end of the day you can use All Erase to remove nonprotected images. Just be sure you haven't missed any images you wanted to keep. This approach seems a bit dangerous to me!

Reset/Myset

If you want to use your camera for different styles of shooting, you can completely change how the camera functions for each style by saving a different camera configuration in each of the Myset storage locations. Then you can recall the configuration by selecting the corresponding location. The Myset storage locations are numbered from Myset1 through Myset4.

In effect, you have five memory locations for camera settings, the one currently in use (camera's active memory) and the four saved Myset locations. When you recall one of the Myset locations, it replaces the settings configuration currently in use in the camera's active memory, without changing the four Myset locations in any way. When you save a camera configuration to one of the four Myset locations, you are writing a copy of the settings in use by the camera's active memory into one of the Myset locations. This allows you to recall favorite configurations at any time.

You can also reset the Shooting Menu (1 and 2) functions, or nearly all the camera's settings, back to the factory defaults. First, let's consider how to save camera configurations, then we will examine how to reset them.

Saving or Overwriting a Camera Configuration

Configure the camera so it meets your needs for a certain shooting style. Since you have four storage locations, you can repeat the following steps to save separate configurations.

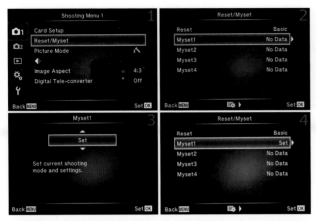

Figure 3.2C: Saving the current camera configuration to one of the Myset locations (Myset1 through Myset4)

Use these steps to save the current camera configuration to one of the Myset storage locations (Myset1 through Myset4):

1. Choose Reset/Myset from Shooting Menu 1 and scroll to the right (figure 3.2C, image 1).
2. You can choose one of four storage locations to save a configuration (Myset1 through Myset4). Select one of the Myset locations in which to save the current configuration. Choose one with NoData displayed if you want to save a new configuration, or choose one with Set displayed if you want to overwrite an existing configuration (figure 3.2C, image 2). If Set is not displayed after any of the Myset locations, there are no previously saved camera configurations. Once you have chosen the Myset location you want to use, scroll to the right.
3. Choose Set from the up/down menu to prepare for saving the configuration to that Myset location (figure 3.2C, image 3).
4. Press the OK button to save the current camera configuration. After the settings are saved, the camera will switch back to the Reset/Myset menu with your chosen Myset location highlighted, and Set will be displayed instead of NoData (figure 3.2C, image 4). You have now saved your camera settings, and you can recall this configuration any time by following the steps in the next section.

Recalling a Saved Camera Configuration

This function allows you to recall one of the camera configurations stored in Myset 1 through Myset 4. This action replaces the setting configuration you are currently using in the camera's active memory with the setting configuration from the Myset storage location you choose to recall. Use the following steps to load a previously saved configuration:

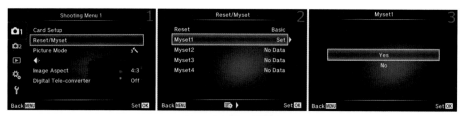

Figure 3.2D: Recalling a previously saved camera configuration

1. Choose Reset/Myset from Shooting Menu 1 and scroll to the right (figure 3.2D, image 1).
2. Highlight one of the previously saved Myset locations, indicated by Set instead of NoData, and press the OK button—do not scroll to the right (figure 3.2D, image 2). The Yes/No Myset menu will appear when you press the OK button.
3. Select Yes from the Myset menu (figure 3.2D, image 3), then press the OK button to switch the current configuration to the one saved in the Myset location you chose. Select No to cancel the operation.

Resetting One of the Myset Locations

If you want to erase a Myset location that has a camera configuration stored in it (displays Set) and return it to an empty state (displays NoData), use the following steps:

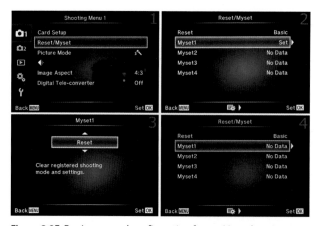

Figure 3.2E: Erasing a saved configuration from a Myset location

1. Select Reset/Myset from Shooting Menu 1 and scroll to the right (figure 3.2E, image 1).
2. Highlight the Myset location that you want to erase (figure 3.2E, image 2)—this will change the Set indicator back to NoData—and scroll to the right. If you reset a Myset location that is displaying NoData instead of Set, nothing will happen.
3. Choose Reset from the up/down menu to prepare for deleting the saved configuration from the Myset location you chose (figure 3.2E, image 3).

4. Press the OK button to delete the camera configuration. Afterward, the camera will switch back to the Reset/Myset menu with your chosen Myset location highlighted and with NoData displayed instead of Set (figure 3.2E, image 4). This Myset location is now empty and ready for a new configuration.

Resetting the Camera to Factory Default

There are two ways to return the camera to the default state when it left the factory. One approach resets only what Olympus considers to be basic items (Reset/Myset: Basic), and the other approach (Reset/Myset: Full) returns almost all settings back to the factory defaults. Basic resets general camera functions that are not controlled from the exterior (e.g., ISO, Metering, Picture Mode, Image Aspect), and Full resets even your carefully configured buttons, dials, and switches. See the note at the end of this section to see which functions are affected by these two reset methods.

If you want to start fresh, these two functions will be valuable to you. First, you must select either Basic or Full, then you can reset the functions.

Let's examine how to reset the camera settings.

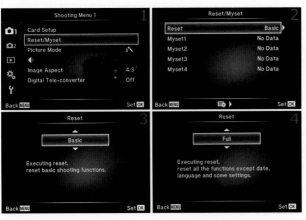

Figure 3.2F: Resetting the camera to factory default, step 1

In step 1 you will choose either a Basic reset or a Full reset. Choosing one of them does *not* execute a reset. You will need to use the steps accompanying figure 3.2G to do the actual reset. As previously mentioned, Basic resets only certain general functions, and Full resets virtually all camera functions (except for things like Date, Time, and Language), so choose carefully. Use the following steps to select which reset method you will use:

1. Select Reset/Myset from Shooting Menu 1 and scroll to the right (figure 3.2F, image 1).
2. Choose Reset from the Reset/Myset menu and scroll to the right (figure 3.2F, image 2).
3. Figure 3.2F, images 3 and 4, show both menu items from the same menu. Choose Basic or Full and press the OK button.

The camera will switch back to the Reset/Myset menu with your selection highlighted. Figure 3.2G shows the steps to execute the reset command. In this example, I chose Basic.

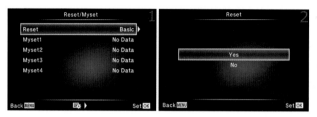

Figure 3.2G: Resetting the camera to the factory defaults, step 2

4. With Reset and your chosen reset method highlighted (Basic or Full), press the OK button (figure 3.2G, image 1).
5. The Reset menu will appear with Yes or No available (figure 3.2G, image 2).
6. Choose Yes if you want to execute the reset, and choose No if you want to cancel the operation. Press the OK button and the camera will immediately reset the functions to the factory defaults.

Note: There is an extensive Menu Directory list in the camera user's manual on pages 142–147. This list shows which camera settings can be saved or reset with the *Reset/Myset > Myset1* [through Myset4] > *Set* [or Reset] function. It also shows which settings can be reset to the factory defaults when you use the *Reset/Myset > Reset > Basic* [or Full] function. The Menu Directory is several pages long and quite dense because it lists virtually every function in the camera. When you look a function up in the list, notice if there is a check mark under the column labeled *1. If there is a check mark, that function can be saved in a Myset location; no check mark means it cannot be saved.

Picture Mode

Picture Mode allows you to choose one of 23 adjustable image effects for each shooting session. If you have ever used film, you know that there are distinct looks to each film type. No two films produce color that looks the same.

Picture Mode gives you the ability to impart a specific look to your images as if you were using different types of film or simply wanted to create special effects. You can use the Picture Modes as they are provided from the factory, or you can fine-tune Contrast, Sharpness, Saturation, and Gradation.

The Picture Mode settings you choose are applied permanently to JPEG images as soon as you press the Shutter button. Modifying and resaving a JPEG image causes gradual damage because of data losses that occur during compression, so be sure to select the best Picture Mode setting when you shoot.

When you shoot in RAW (ORF) mode, Picture Mode settings are *not* permanently applied to the image. Instead, the Picture Mode information is saved in the metadata of the image. The camera and your computer will display each RAW image with the Picture Mode settings temporarily applied; however, unlike with JPEG images, settings can be changed after the fact with RAW images with no damage. See the **[Record Mode]** section later in this chapter to find out how to choose an image quality mode.

There are five basic Picture Modes that you will use frequently, and there are 18 additional Creative and Art Picture Modes. This abundance of special effect modes gives you freedom to express yourself creatively with your pictures, from stoic to wildly overblown.

Figures 3.3A-1 through 3.3A-4 show the 23 Picture Modes. They are broken down into four groups to make them easier to see in this book. Each mode is set to the default level in the figure, which you can adjust. We will consider how to adjust the modes after we examine them.

Note: This section is a superset of the Art selection on the camera's Mode dial. We discussed the Mode Dial Art settings in the chapter titled **Screen Displays for Camera Control** on page 108. The Mode Dial Art selection offers only 14 of the 23 Basic, Creative, and Art Picture Modes discussed in this section, so this is the master reference for both. When you adjust the Art Picture Modes, some of the settings in the Picture Mode menus affect how the Art Picture Modes work when you select them from the Mode Dial, and vice versa. Therefore, you will need to familiarize yourself with using Art Picture Modes from both the Art selection on the Mode Dial and the Art Picture Modes that are available in the Picture Mode menu screens.

Now, let's discuss each of the available modes and how they affect your images.

In a printed book it is hard to reproduce the sometimes subtle shade variations in the various Picture Modes; therefore, you should take a picture in each mode and examine how each one looks on your computer or tablet. As we consider each of the Picture Modes, you will learn a lot more about them if you can see a sample on your tablet or monitor.

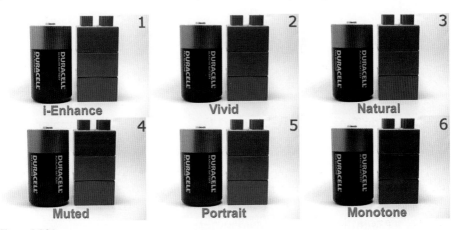

Figure 3.3A1

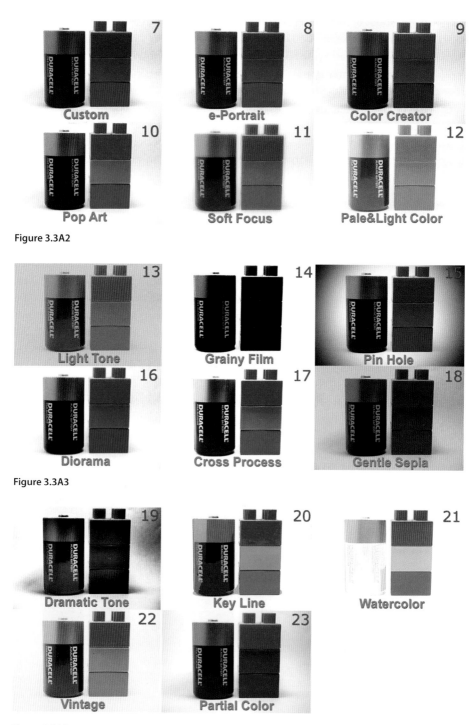

Figure 3.3A2

Figure 3.3A3

Figure 3.3A4

Basic Picture Modes

The five basic Picture Modes will be used most often by experienced photographers:

- **i-Enhance:** This mode gives your images "more impressive-looking results suited to the scene," according to Olympus. The effect looks very similar to the Vivid Picture Mode, with a little less contrast. It will provide the snap of the saturated colors that Vivid Mode provides, but it will have a little more dynamic range due to slightly lighter blacks. From the description provided by Olympus, it seems the camera software may provide a little extra smarts so it can adjust to the scene in front of your lens.

- **Vivid:** This mode adds saturation and contrast to your images and creates pictures with deep color, dark blacks, and white whites. Vivid Mode produces images similar to Velvia transparency film by Fuji, which is a favorite of many landscape photographers. For images with a lot of color, Vivid Mode will make your pictures pop.

- **Natural:** This mode gives a more balanced look to your images, with color and contrast that is not too intense or muted. This is an excellent mode for general photography, and many photographers will use it much of the time. It is comparable to Provia transparency film from Fuji. It has enough saturation and contrast to create a beautiful image without going overboard.

- **Muted:** This Picture Mode is best for an image that will be post-processed later in a computer. It is a balanced setting that applies minimal camera processing so you can do more with the image during post-processing. The Muted Picture Mode has less saturation and weaker shadows, so the image will be less contrasty—that is, there will be more shadow and highlight detail. The look is comparable to color negative film, such as Fuji Superia or Kodak Gold.
- **Portrait:** This mode gives a more natural texture and coloration to skin. It is similar to the Muted Picture Mode, with emphasis on making sure that skin tones are rendered in a pleasing way. Skin tones get the most emphasis with Portrait Picture Mode, so it may be best for individuals and groups of people. It is similar to Fuji NPS or Kodak Portra color negative films.

The next 16 modes may be used by people who want to add special effects inside the camera, without using a computer. They are variations on the five basic Picture Modes, with strong changes in the Contrast, Sharpness, Saturation, and Gradation adjustments. These 16 special effect modes can save time and help you have fun with your camera.

Settings Recommendation: For JPEG shooting I normally use one of the basic Picture Modes. I usually use the Natural setting. Remember that a Picture Mode is applied to a JPEG image immediately and irreversibly, but you can change the Picture Mode of a RAW image after you shoot it, so it doesn't really matter which mode you select. Your RAW conversion software will try to display the image the way you took it, but you can change it without much trouble.

We will look at the 4 Creative Modes and the 14 Art Picture Modes next. Many advanced photographers do not use Art Picture Modes because they would rather create their own art in Photoshop, Lightroom, or other imaging software. However, some of the Art Picture Modes included with the E-M1 are great fun, even for jaded professionals. If you would normally not consider using scene or effects modes with other camera brands, take a few minutes to play around with the E-M1's Art Picture Modes. You might find something that you will use often, like I did!

Creative Modes

The Creative Modes allow you to do specialized things with your images, such as black-and-white shooting, skin tone smoothing, specialized color manipulation, and even the creation of your own Custom Picture Mode. Here are the four Creative Modes:

- **Monotone:** This mode allows black-and-white lovers to shoot in that style. Monotone Mode provides images with dark shadows and pleasing whites and grays. In fact, the monochrome images straight from the camera are perfectly usable and require little adjustment, unlike black-and-white images from some other cameras. You can use the image as a base for contrast and brightness adjustments, and few other post-processing adjustments are needed. The film that is closest to Monotone Mode may be Kodak Plus-X, without all the grain.

- **Custom:** This mode allows you to choose one of the five basic Picture Modes as a base, then you can adjust the mode's Contrast, Sharpness, Saturation, and Gradation until it is just right for your needs. The camera will remember your adjustments and use them when you select this mode. We will examine how to adjust and save a Custom Mode in an upcoming subsection.

- **e-Portrait:** This mode is designed for when you are shooting a portrait session. According to Olympus, the e-Portrait Mode produces "smooth skin textures," whereas the basic Portrait Mode "produces beautiful skin tones." The camera does special in-camera post-processing (skin smoothing) on portraits made with e-Portrait Mode, as described in the upcoming subsection called **Using e-Portrait Picture Mode**. Comparing regular Portrait Mode pictures with e-Portrait Mode pictures does reveal a difference. The e-Portrait Mode gives a distinctly smoother appearance to the skin, which may be a blessing for older portrait subjects. Which do you like best: "beautiful skin tones" or "smooth skin textures"? Try both Portrait and e-Portrait Modes and see which you prefer.

- **Color Creator:** This mode lets you make on-the-fly adjustments to hue and saturation. If the image in your viewfinder or in the monitor live view does not show the hue or saturation you would like to see, you can make adjustments by using a color wheel. If the image seems a little cool, you can simply dial in some red to warm it up (either a little or a lot); if the color seems too muted, you can change the saturation from almost nothing to extremely saturated. We'll discuss how to do this in an upcoming subsection.

Art Picture Modes

The Art Picture Modes give you great freedom in creating nonstandard photography. You can create special effects, such as pastel or wildly saturated colors, extreme grain, high- and low-key images, and specialized blurring.

Don't completely discount these Art Picture Modes if you make a living with photography. There are some interesting effects that may be useful even for imaging professionals. For enthusiast photographers, the Art Picture Modes can provide a refreshing break from reality.

Here's a list of the 14 Art Picture Modes:

- **Pop Art:** This mode is like the Vivid Mode on steroids. All colors are saturated to the max, and contrast is raised to an even higher level than in Vivid Mode. This mode is best when you are in a playful mood and want to create an exciting image. The intense colors will not be close to reality, but who needs reality when you are having fun?
- **Soft Focus:** This mode provides a high-key and blurred effect. The contrast is very low, and there is an overall softness like fine gauze. The subject appears sharp, but it is covered with blur. The effect looks a bit like when you see yourself in a foggy mirror. It has a bright glowing effect that is sharp and blurry at the same time.
- **Pale&Light Color:** This mode washes out all the colors and lowers the contrast so blacks become grays. You might think of this as being opposite of Pop Art or Vivid Modes. It gives an image a high-key, cooler, and pastel look.
- **Light Tone:** This mode is similar to the Pale&Light Color Mode in that it lowers contrast and desaturates colors. However, instead of having a somewhat cool (bluish), high-key look, the colors look like they are overlaid with gray film and have a darker, low-key look. Light Tone makes the image look like the effect you see when an overdone high dynamic range (HDR) image has too few shadows.
- **Grainy Film:** This mode provides an extremely high-contrast black-and-white effect. All colors become extra-dark shades of gray, and most highlight details become pure white. This mode would be great for shooting a bare tree in a snow-covered field on a misty, overcast day. This mode creates stark images and is best for low-contrast scenes because it will obliterate any detail in strongly colored or bright scenes by adding extreme contrast to the picture.
- **Pin Hole:** This mode has a relatively saturated look like Vivid Mode, but it adds a heavy vignette effect to the corners of the image, as if the light rapidly diminishes. It's as though you were using a pinhole camera to make the image, except the picture is nice and sharp. Primarily, Pin Hole provides a vignette effect.
- **Diorama:** A diorama is a three-dimensional miniature in which small artificial objects are arranged and photographed to resemble real life. You can use Diorama Mode to create a reverse diorama, where real-life places like city scenes can be made to look artificial. This mode creates a band of sharpness either in a horizontal or vertical direction (it's adjustable), and everything outside of the band is blurred, making the picture

seem like it has a very limited depth of field. We will examine how to adjust this effect in a later subsection.

- **Cross Process:** This mode imitates an old method of developing film in chemicals that were designed for a different type of film. Often there are odd colors and higher than normal contrast. Images shot with Cross Process have a green cast and high contrast.

- **Gentle Sepia:** This mode converts all colors to monochrome and adds a warm, brownish effect that resembles less-saturated sepia toning. It could be used with old-fashioned clothing to imitate antique portrait pictures, or you could shoot a nature scene with this mode and make it look like a bygone era.

- **Dramatic Tone:** This mode is unusual. It creates a low-key tone where normal highlights are darkened and dark tones are lightened. Bright colors are somewhat muted, and detail is maintained, even in dark areas. There is strong contrast without being overly bright. The look is dramatic and unlike anything I have seen from other camera brands.

- **Key Line:** This mode converts the edges of the subject and the borders of contrast changes (color gradations) into line drawings. It maintains a lot of detail, unlike the cartoonish look from some other cameras. The color is mostly maintained, although it is more pastel and muted, and blacks become quite gray.

- **Watercolor:** This mode gives colors and edges a watercolor effect that tends to blow out highlights and dark areas. Most detail is lost in a normal exposure, so experiment with underexposure when you use this mode. Dark tones and extreme highlights seem to turn stark white and disappear completely from the image, and other colors become pale and washed out.

- **Vintage:** This mode provides three filter types that create a vintage look with varying levels of contrast and tinting. The colors are what you would expect to see from an old print that's been hanging on a wall or in an album for a long time. The various filters allow for creativity within the range of vintage looks.

- **Partial Color:** This mode gives you a color wheel from which you can choose a particular color or range. Once you've chosen a color, all other colors are rendered in monochrome shades. In addition to the color wheel, you can choose from three filter effects within the partial color scheme. These affect the contrast of the image and mild tinting of the monochrome shades.

Choosing, Fine-Tuning, and Using Picture Modes

Now that we have examined each of the Picture Modes, let's see how to select one and fine-tune it. Plus we'll see how to use the modes that allow special configuration choices, such as Monotone, Custom, and Color Creator.

Selecting a Picture Mode

Selecting a Picture Mode is simple; you use two screens to select one. Let's see how.

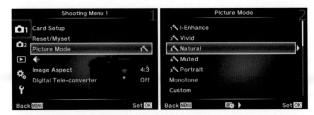

Figure 3.3B: Selecting a Picture Mode

Use these steps to select a Picture Mode:

1. Choose Picture Mode from Shooting Menu 1 and scroll to the right (figure 3.3B, image 1).
2. Select the Picture Mode you want to use and press the OK button. Natural is selected in figure 3.3B, image 2. The camera will switch back to the main Shooting Menu 1 screen, and you can take your pictures. As described in the next subsection, you can fine-tune the control if you want to change one of its parameters.

Fine-Tuning a Basic Picture Mode

Fine-tuning allows you to change the internal values of a Picture Mode. You can adjust Contrast, Sharpness, Saturation, and Gradation.

Contrast controls the ratio between dark and light in the image and extends or reduces the amount of detail. Sharpness lets the camera add or take away sharpness in the image. Saturation controls how vivid the colors look. Gradation modifies how the camera handles light and dark tones, such as a normal, bright (high-key), or dark (low-key) look.

Let's fine-tune a basic Picture Mode, using Natural as an example.

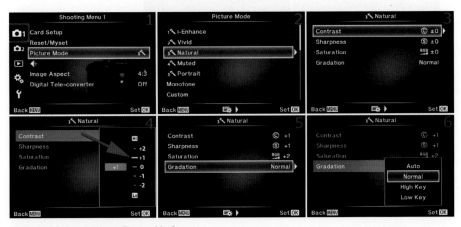

Figure 3.3C: Fine-tuning a Picture Mode

Use the following steps to fine-tune a basic Picture Mode (i-Enhance, Vivid, Natural, Muted, and Portrait):

1. Choose Picture Mode from Shooting Menu 1 and scroll to the right (figure 3.3C, image 1).
2. Select the Picture Mode you want to fine-tune then scroll to the right (figure 3.3C, image 2). I decided to work with Natural.
3. Contrast, Sharpness, and Saturation are adjusted the same way, so only the screens for Contrast are shown. Gradation is different, and we will consider it in steps 5 and 6. Highlight Contrast, Sharpness, or Saturation and scroll to the right (figure 3.3C, image 3).
4. Set the value on the scale from Hi (+2) to Lo (−2), or leave it at 0 for no change. In figure 3.3C, image 4, Contrast +1 is selected (red arrow). If you want to modify Sharpness or Saturation, repeat steps 3 and 4. In figure 3.3C, image 5, I set Contrast to +1, Sharpness to +1, and Saturation to +2. Experiment with the values to see how they affect your images. Press the OK button any time to save the setting. To change Gradation, move on to steps 5 and 6.
5. Choose Gradation from the menu and scroll to the right (figure 3.3C, image 5).
6. Choose one of the four values—Auto, Normal, High Key, or Low Key—and press the OK button (figure 3.3C, image 6). The four values have the following effects:
 - **Auto:** Lets the camera choose the Gradation
 - **Normal:** Makes a regular picture with no unusual Gradation changes
 - **High Key:** Shifts the picture toward bright values
 - **Low Key:** Shifts the picture toward dark values

The i-Enhance Picture Mode adds another setting called Effect (figure 3.3D, image 1). It controls the amount of enhancement (High, Standard, Low) the camera makes to the image. There are two additional screens for i-Enhance.

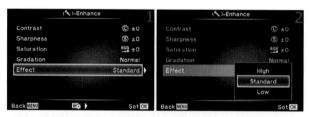

Figure 3.3D: The Effect setting for i-Enhance Mode

7. Select Effect from the menu and scroll to the right (figure 3.3D, image 1).
8. Highlight one of the three enhancement levels—High, Standard, or Low—and press the OK button to choose it (figure 3.3D, image 2). Experiment with this setting by taking pictures with all three enhancement levels.
9. When you have i-Enhance configured, scroll to the left until you return to the Picture Mode screen, then press the OK button to select the current Picture Mode. The camera will return to the Shooting Menu 1 screen with the symbol of the current mode displayed. Take your pictures.

Using Monotone Picture Mode

Monotone Picture Mode allows you to get creative with black-and-white images. You can use built-in color filters for changing the contrast, and you can even add toning, such as sepia, blue (cyanotype), and several others. Let's examine how to use Monotone Mode.

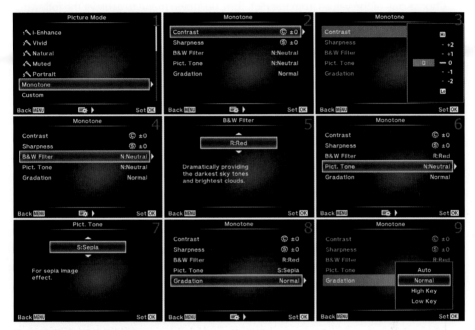

Figure 3.3E: Monotone Mode

Use these steps to control Monotone Mode:

1. Select Monotone from the Picture Mode menu and scroll to the right (figure 3.3E, image 1).
2. Choose Contrast or Sharpness and scroll to the right (figure 3.3E, image 2).
3. Contrast and Sharpness are adjusted using the same method. I'll use Contrast as an example. The menu that opens for Contrast or Sharpness allows you to increase or decrease the setting, up to two levels in either direction. Set the value on the scale from Hi (+2) to Lo (−2), or leave it at 0 for no change. Press the OK button to choose a value (figure 3.3E, image 3).
4. Select B&W Filter from the menu and scroll to the right (figure 3.3E, image 4).
5. You can now choose one of the following B&W Filter values from the up/down menu (figure 3.3E, image 5):
 - **N:Neutral:** Provides a standard monochrome image
 - **G:Green:** Improves skin tones for portraits
 - **R:Red:** Creates dark skies and bright clouds for maximum sky contrast
 - **Or:Orange:** Removes some of the foggy bluish haze when you use a telephoto lens for a distant subject

- **Ye:Yellow:** Increases the contrast between the sky and clouds, but not as much as the R:Red filter

6. Next, if you want to add a colored tone to your image, select Pict. Tone and scroll to the right (figure 3.3E, image 6).

7. Choose one of the values from the Pict. Tone up/down menu to achieve the following results (figure 3.3E, image 7):
 - **N:Neutral:** Provides a standard monochrome image
 - **G:Green:** Adds a green tone to a monochrome image
 - **P:Purple:** Adds a purple tone to a monochrome image
 - **B:Blue:** Adds a blue tone to a monochrome image, similar to the old-fashioned cyanotype look
 - **S:Sepia:** Adds a warm brown tone to a monochrome image, which resembles an antique sepia look

8. To set the Gradation level, choose Gradation from the menu and scroll to the right (figure 3.3E, image 8).

9. Choose one of the four values—Auto, Normal, High Key, or Low Key—and press the OK button (figure 3.3E, image 9):
 - **Auto:** Lets the camera choose the Gradation
 - **Normal:** Makes a regular monochrome picture with no unusual Gradation changes
 - **High Key:** Shifts a monochrome picture toward bright values
 - **Low Key:** Shifts a monochrome picture toward dark values

10. When you have Monotone fully configured, scroll to the left until you return to the Picture Mode screen, then press the OK button to select the current Picture Mode. The camera will return to the Shooting Menu 1 screen with the symbol of the current mode displayed. Take your pictures.

Using Custom Picture Mode

Custom Picture Mode allows you to create your own Picture Mode and tweak it for your style of photography. Since Custom Mode lets you control the appearance of an image in exquisite detail, let's carefully examine each step.

1. Choose Picture Mode from Shooting Menu 1 menu and scroll to the right (figure 3.3F, image 1).

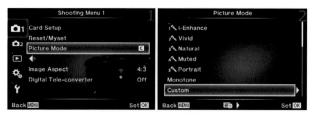

Figure 3.3F: Creating a Custom Picture Mode

2. Select Custom from the Picture Mode menu and scroll to the right (figure 3.3F, image 2).

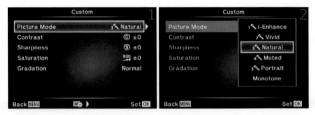

Figure 3.3G: Creating a Custom Picture Mode

3. Choose Picture Mode from the Custom Menu and scroll to the right (figure 3.3G, image 1).

4. Highlight one of the five basic Picture Modes or the Monotone Art Picture Mode as the base for your Custom Picture Mode. I highlighted Natural. Press the OK button to select the mode (figure 3.3G, image 2).

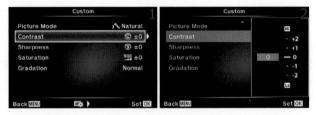

Figure 3.3H: Creating a Custom Picture Mode

5. Contrast, Sharpness, and Saturation are adjusted the same way, so I'll use Contrast as an example. Highlight Contrast, Sharpness, or Saturation and scroll to the right (figure 3.3H, image 1).

6. Set the value on the scale from Hi (+2) to Lo (−2), or leave it at 0 for no change. In figure 3.3H, image 2, I selected Contrast 0. If you want to modify Sharpness or Saturation, repeat steps 5 and 6. Press the OK button to save the setting.

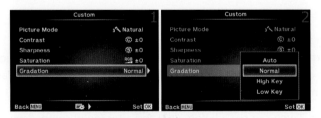

Figure 3.3I: Creating a Custom Picture Mode

7. To set the Gradation, choose Gradation from the menu and scroll to the right (figure 3.3I, image 1).

8. Choose Auto, Normal, High Key, or Low Key and press the OK button (figure 3.3I, image 2):
 - **Auto:** Lets the camera choose the Gradation
 - **Normal:** Makes a regular picture with no unusual Gradation changes
 - **High Key:** Shifts the picture toward bright values
 - **Low Key:** Shifts the picture toward dark values

9. When you have the Custom Picture Mode fully configured, scroll to the left until you return to the Picture Mode screen, then press the OK button to select the current Picture Mode. The camera will return to the Shooting Menu 1 screen with the symbol of the current mode displayed. Take your pictures.

Using e-Portrait Picture Mode

The e-Portrait Picture Mode is designed to make skin look smooth and translucent. It imitates the look of skin-smoothing plug-ins for Photoshop and is designed for taking pictures of faces. When you take a picture in e-Portrait Mode, the camera takes longer to write the image to the memory card, so the card access symbol will flash a little longer than usual.

Because the camera does internal image post-processing on skin tones, e-Portrait Mode cannot be used when you shoot video or if you bracket your images, whereas Portrait Picture Mode can be used in both of these situations because it does perform post-processing to smooth the skin. You cannot adjust e-Portrait Mode.

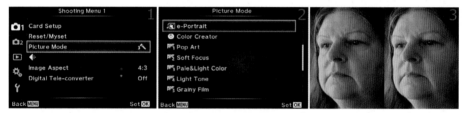

Figure 3.3J: e-Portrait Mode

Use these steps to select e-Portrait Mode:

1. Choose Picture Mode from Shooting Menu 1 and scroll to the right (figure 3.3J, image 1).
2. Highlight e-Portrait on the Picture Mode menu and press the OK button to select it (figure 3.3J, image 2). The camera will return to the Shooting Menu 1 screen and display the e-Portrait Mode symbol. Take your pictures.

Note: In figure 3.3J, image 3, you can see a before *(left)* and after *(right)* comparison of e-Portrait Mode. The image on the right has smoother skin tones.

Using Color Creator Picture Mode

Color Creator allows you to adjust the color of the subject by using a color wheel that controls hue and saturation while you look at the subject through the viewfinder or on the monitor.

Note: The Color Creator assignment wheel is available from within a group of functions called the Multi Function group. The factory default for the Multi Function group is assigned to the Fn2 button. We will consider how to access and use the Color Creator in the following steps. Keep in mind that you can change the button assignments on your E-M1, so you can assign the Multi Function group to some other button. If the Multi Function group containing the Color Creator wheel does not show up under the Fn2 button—because someone has reassigned Fn2—check the *Custom Menu > Button/Dial/Lever > Button Function* to see which button is assigned to Multi Function. Then you can use that button, or reassign the Fn2 button, to open the Multi Function group and see the Color Creator. This will become more obvious as we consider how to select the Color Creator.

First, let's examine how to choose Color Creator from the Picture Mode menu. There are 11 steps to make on-the-fly color adjustments:

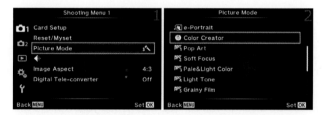

Figure 3.3K: Selecting Color Creator from the Picture Mode menu

1. Choose Picture Mode from Shooting Menu 1 and scroll to the right (figure 3.3K, image 1).
2. Highlight Color Creator and press the OK button to choose it (figure 3.3K, image 2). The camera will return to the Shooting Menu 1 screen and display a small round Color Creator icon to the right of Picture Mode. Take your pictures.

Now we will use external camera controls to bring up the Color Creator wheel on the viewfinder or monitor. Starting with step 3 it is important that you have your camera in your hand and operate it along with the instructions, otherwise they will make little sense. It is harder to describe what happens than to watch it unfold on your camera monitor or in the viewfinder.

Figure 3.3L: Selecting Color Creator from the Multi Function group

Here are the steps to select Color Creator from the Multi Function group:

3. The Front Dial surrounds the Shutter button and is located above the Fn2 button (figure 3.3L, image 1, red arrow). The Rear Dial (figure 3.3L, image 2, red arrow) is below the Fn2 button. Remember the location of these two dials because we will use them to adjust the color, hue, and saturation starting in step 8.
4. Press and hold the Fn2 button (figure 3.3L, image 1, red arrow).
5. Rotate the Rear Dial one click (figure 3.3L, image 2, red arrow), and the Multi Function group will appear in the viewfinder or on the monitor.
6. Select the second item, Color Creator, from the horizontal menu at the bottom of the screen (figure 3.3L, image 3) by turning the Rear Dial.
7. Release the Fn2 button, and the camera will display the subject in the viewfinder or on the monitor. Take your pictures.

Now we will adjust the hue and saturation of the colors in the image by using the Color Creator wheel. The sample images are black so you can see the menus. Your camera will display the scene in front of the lens, and you will see the effect of the color change when you move the dials. Let's see how.

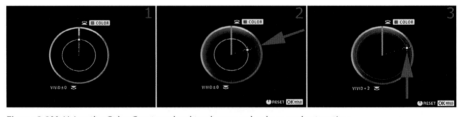

Figure 3.3M: Using the Color Creator wheel to change color, hue, and saturation

8. If you have followed steps 4–7 correctly, you can press the Fn2 button once (do not hold it) and the Color Creator adjustment wheel will appear in the viewfinder or on the monitor. If the Color Creator has not been adjusted in the past, you will see the wheel's default appearance (figure 3.3M, image 1).
9. Turn the Front Dial and you will see a dotted line, which represents the hue, move in the direction you turned the dial (figure 3.3M, image 2, red arrow). As you rotate the dial, watch the subject carefully in the viewfinder or on the monitor. Its hue will change

as you rotate through the red, green, blue, and yellow portions of the wheel. The dotted line will travel 360 degrees around the wheel until it is back at the 12 o'clock position, which represents neutral. You can see a small white box with the word Color at the top right of the Color Creator. To the left of that you will see a tiny square. As you rotate the Front Dial and as the dotted line travels around the wheel, you will see that square change color to indicate the hue that will be added to your image when you take a picture.

10. After you have chosen the hue you want, you can control the saturation. To do so, turn the Rear Dial and you will see a slightly larger dot with two horizontal lines and two vertical lines extending outward (figure 3.3M, image 3, red arrow). This dot will move away from or toward the middle of the circle as you turn the Rear Dial. You will see a smaller ring inside the Color Creator wheel that follows the dot as you move it. When the dot is closer to the middle of the Color Creator wheel, the saturation decreases; when the dot is closer to the outside of the Color Creator wheel, the saturation increases. You will see the word Vivid with a number at the bottom left of the Color Creator wheel. The vividness, or saturation, will vary from −4 to +3, as indicated by the small number after the word Vivid.

11. Press the OK button to accept the color scheme. It will be applied to all the pictures you take until you reset the Color Creator to neutral. Take your pictures.

Note: To reset the Color Creator to neutral, bring it up in the viewfinder or on the monitor by pressing the Fn2 button (or whatever button is assigned to the Multi Function group). Then press and hold the OK button for about two seconds until the Color Creator resets to neutral hue and saturation, as shown in figure 3.3M, image 1.

Settings Recommendation: Because we accessed the Color Creator from Shooting Menu 1, we included the preliminary step of selecting Color Creator from the Picture Mode menu (figure 3.3K and steps 1 and 2). However, steps 1 and 2 are not absolutely necessary. Let's say you have Natural Picture Mode selected and you suddenly want to add some oversaturated red to your image. If you had previously selected Color Creator from the Multi Function group, all you have to do is follow steps 3–11, using figures 3.3L and 3.3M.

Color Creator is available any time you open it with the Fn2 button. There is one small issue, though. If you select Color Creator with the Fn2 button, the camera will automatically select the Color Creator Picture Mode and leave it there until you change it to something else, such as Natural or Vivid. That's not a problem unless you were previously shooting in Vivid Mode or with one of the Art Picture Modes. The camera does not revert to the previously selected Picture Mode after you take a picture. It stays in the Color Creator Mode you selected until you change it to another Picture Mode or reset the Color Creator to neutral.

Even if you reset the Color Creator to neutral and shoot in that Picture Mode, you will find that the colors in your image are less saturated and contrasty. If you compare the

Picture Modes in figures 3.3A-1 through 3.3A-4, you will see that the neutral setting for Color Creator Picture Mode seems fairly close, and perhaps less contrasty, than the Muted Picture Mode.

If you want to regularly change the hue and saturation in your images, experiment with the Color Creator. If you leave it at neutral, your images will be less saturated and have lower contrast, and they will be easier to work with in post-processing on your computer. If you modify the hue and saturation in Color Creator, remember to change the camera to a different Picture Mode when you are done.

And remember, if you shoot RAW (ORF) images, it's easy to change the color and contrast afterwards, so it doesn't matter which Picture Mode you choose. We'll discuss this a little more in the **[Record Mode]** section later in this chapter.

Using Art Picture Modes

There are 14 Art Picture Modes available in the E-M1. Each Art Picture Mode imparts a specific look to your images. If you like to convey different moods in your pictures and do not like post-processing RAW files on a computer, you might enjoy these Art Picture Modes (and maybe even the SCN or Scene Modes).

Each Art Picture Mode was briefly examined in the **Screen Displays for Camera Control** chapter on page 108. We used the shortcut of setting the Mode Dial to Art, pressing the OK button, and selecting one of the Art Picture Modes. This section provides more detail on how the modes work.

Pop Art (Art 1)

The Pop Art Picture Mode allows you to create very colorful and exciting images with various filters and effects. The filter is applied first, then the effect is added.

The available filters and effects include the following:

Filter types
- **Filter Type I:** A bright, exciting, oversaturated look is imparted to your images when you select this filter. If you are feeling wild, young, and free, this is the filter for you.
- **Filter Type II:** This filter is similar to Type I, but a low-key look is imparted. The colors are quite saturated, but the highlights are significantly toned down.

Add effects
- **Off:** No extra effects are added to the image. Only the filter is added.
- **Soft Focus:** A dreamy blur effect is added to the image.
- **Pin Hole:** The corners of the image are darkened to pure black.
- **White Edge:** The corners of the image are brightened to pure white.
- **Frame:** A white frame is added to the image, and a processed film look is added to the edges of the picture inside the frame.
- **Star Light:** A four-point star effect is added to points of light in the image.

- **Blur Effect: Top and Bottom:** A band of sharpness extends horizontally through the middle of the image, and the top and bottom of the image are blurred.
- **Blur Effect: Left and Right:** A band of sharpness extends vertically through the middle of the image, and the left and right sides of the image are blurred.

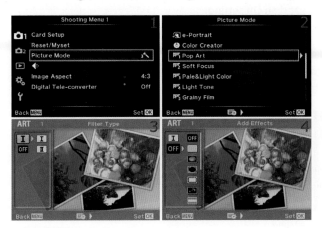

Figure 3.3N: Pop Art (Art 1) Picture Mode

Use these steps to select and use the Pop Art Picture Mode:

1. Choose Picture Mode from Shooting Menu 1 and scroll to the right (figure 3.3N, image 1).
2. Highlight Pop Art on the Picture Mode menu and press the OK button to select it for immediate use in default mode, which applies Filter Type I and no Add Effects. If you want to change the Filter Type and Add Effects settings before you take pictures, scroll to the right and proceed to step 3 (figure 3.3N, image 2).
3. Select a Filter Type (figure 3.3N, image 3). Your choices are I or II, as described in the previous list. Scroll to the right, then scroll up or down to highlight I or II, then press the OK button.
4. Select an Add Effects type (figure 3.3N, image 4). Scroll to the right, then scroll up or down to highlight one of the seven Add Effects types, or Off, as described in the previous list. Set the Add Effects type by pressing the OK button.
5. When you are done, scroll to the left until you return to the Picture Mode screen, then press the OK button to select the current Art Picture Mode. The camera will return to the Shooting Menu 1 screen with the symbol of the current mode displayed. Take your pictures.

Settings Recommendation: Pop Art Picture Mode applies strong colors and gives images an exciting, contrasty appearance. You will need to experiment to find your favorite look. I usually use Filter Type I because I like the bright look. I also like the Pop Art Soft Focus effect for some of my subjects.

Soft Focus (Art 2)

The Soft Focus Art Picture Mode makes images that have a dreamy blur. The image is still sharp, but a milky whiteness covers it. The higher contrast and slight blur makes the subject seem to glow. It is a very interesting effect, similar to old movies.

There are two special effects and an Off setting:

Add effects

- **Off:** No extra effects are added to the image.
- **White Edge:** The corners of the image are brightened to pure white.
- **Star Light:** A four-point star effect is added to points of light in the image.

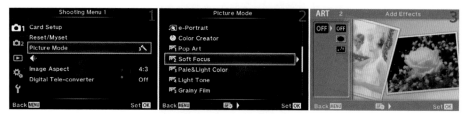

Figure 3.30: Soft Focus (Art 2) Picture Mode

Use these steps to create Soft Focus images of your subject:

1. Choose Picture Mode from Shooting Menu 1 and scroll to the right (figure 3.30, image 1).
2. Highlight Soft Focus on the Picture Mode menu and press the OK button to select it for immediate use in default mode, which uses no extra Add Effects. If you want to add one of the Add Effects settings before you take pictures, scroll to the right and proceed to step 3 (figure 3.30, image 2).
3. Off will be highlighted on the Add Effects screen (figure 3.30, image 3). Scroll to the right, then scroll down or up to highlight the Add Effect you want to use. Press the OK button to lock in the effect.
4. When you are done, scroll to the left until you return to the Picture Mode screen. Press the OK button to select the current Art Picture Mode. The camera will return to the Shooting Menu 1 screen with the symbol of the current mode displayed. Take your pictures.

Settings Recommendation: Soft Focus Mode is great in certain circumstances. I like to use it for some portraits, and I have seen some interesting wildlife shots made with this mode. The mild glowing fog is intriguing because the image remains sharp under the glow. Try this mode in some of your pictures, and it might become one of your favorites.

Pale&Light Color (Art 3)

The Pale&Light Color Art Picture Mode mildly desaturates the colors in your image and makes colors look pastel, and a low-contrast overlay is added to the image. The highlights

become brighter—almost high key—and more shadow detail is apparent due to the lower contrast.

Pale&Light Color includes the following filters and effects:

Filter types
- **Filter Type I:** A pastel, high-key look is imparted to your images and gives them a cool whitish-blue appearance.
- **Filter Type II:** This filter is similar to Type I, but images look a little warmer and have a more reddish-yellow appearance.

Add effects
- **Off:** No extra effects are added to the image. Only the filter is added.
- **Soft Focus:** A dreamy blur effect is added to the image.
- **Pin Hole:** The corners of the image are darkened to pure black.
- **White Edge:** The corners of the image are brightened to pure white.
- **Frame:** A white frame is added to the image, and a processed film look is added to the edges of the picture inside the frame.
- **Star Light:** A four-point star effect is added to points of light in the image.
- **Blur Effect: Top and Bottom:** A band of sharpness extends horizontally through the middle of the image, and the top and bottom of the image are blurred.
- **Blur Effect: Left and Right:** A band of sharpness extends vertically through the middle of the image, and the left and right sides of the image are blurred.

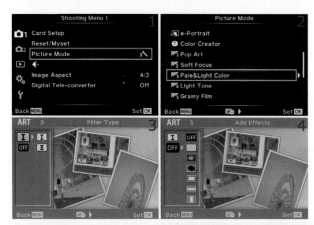

Figure 3.3P: Pale&Light Color (Art 3) Picture Mode

Use these steps to select and use the Pale&Light Color Picture Mode:

1. Choose Picture Mode from Shooting Menu 1 and scroll to the right (figure 3.3P, image 1).
2. Highlight Pale&Light Color on the Picture Mode menu and press the OK button to select it for immediate use in default mode, which applies Filter Type I and no Add Effects.

If you want to change the Filter Type and Add Effects settings before you take pictures, scroll to the right and proceed to step 3 (figure 3.3P, image 2).

3. Select a Filter Type (figure 3.3P, image 3). Your choices are I or II, as described in the previous list. Scroll to the right, then scroll up or down to highlight Filter Type I or II. Set the Filter Type by pressing the OK button.

4. Select an Add Effects type (figure 3.3P, image 4). Scroll to the right, then scroll up or down to highlight one of the seven Add Effects types, or Off, as described in the previous list. Set the Add Effects type by pressing the OK button.

5. When you are done, scroll to the left until you return to the Picture Mode screen. Press the OK button to select the current Art Picture Mode. The camera will return to the Shooting Menu 1 screen with the symbol of the current mode displayed. Take your pictures.

Settings Recommendation: If you want to take pale, pastel images, this is the perfect Art Picture Mode. It creates a look that most cameras cannot duplicate. Try this on some shots of a friend reading a book on a park bench or with some other outdoor portrait. The effect is unique, so experiment with it to discover how you would like to use it.

Light Tone (Art 4)

The Light Tone Art Picture Mode increases the dynamic range of an image by dramatically lowering the contrast. Colors become muted, and dark tones become mostly gray with much more detail. This mode creates images that resemble the shadowless, overcooked HDR look that is popular these days. The highlights seem a little brighter, and the blacks turn into grays.

The effects available in Light Tone Art Picture Mode are as follows:

Add effects

- **Off:** No extra effects are added to the image.
- **Frame:** A white frame is added to the image, and a processed film look is added to the edges of the picture inside the frame.
- **Blur Effect: Top and Bottom:** A band of sharpness extends horizontally through the middle of the image, and the top and bottom of the image are blurred.
- **Blur Effect: Left and Right:** A band of sharpness extends vertically through the middle of the image, and the left and right sides of the image are blurred.

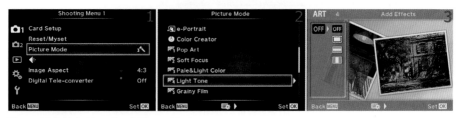

Figure 3.3Q: Light Tone (Art 4) Picture Mode

Use these steps to create Light Tone images:

1. Choose Picture Mode from Shooting Menu 1 and scroll to the right (figure 3.3Q, image 1).
2. Highlight Light Tone on the Picture Mode menu and press the OK button to select it for immediate use in default mode, which uses no extra Add Effects. If you want to add one of the three Add Effects settings before you take pictures, scroll to the right and proceed to step 3 (figure 3.3Q, image 2).
3. Off will be highlighted on the Add Effects screen (figure 3.3Q, image 3). Scroll to the right, then scroll down or up to highlight the Add Effect you want to use, as described in the previous list. Press the OK button to lock in the effect.
4. When you are done, scroll to the left until you return to the Picture Mode screen. Press the OK button to select the current Art Picture Mode. The camera will return to the Shooting Menu 1 screen with the symbol of the current mode displayed. Take your pictures.

Settings Recommendation: This mode will create images similar to the shadowless HDR look that is prevalent on many social media sites. It has a wider dynamic range and less shadow than normal. Any time you want to create an extremely low-contrast image, you may want to give Light Tone Mode a try.

Grainy Film (Art 5)

The Grainy Film Art Picture Mode was created for people who love extremely high-contrast, grainy black-and-white photography. It imitates photography from the days of yore when the Graflex Speed Graphic camera was the camera of choice for photojournalists and chemical darkrooms were in full swing. You can produce the bygone look of black-and-white film classics, similar to Kodak high-contrast panchromatic films, without all the chemicals.

Grainy Film Art Picture Mode includes two Filter Types, three Add Effects, five B&W Filter effects, and five Pict. Tone effects that modify the base black-and-white image:

Filter types
- **Filter Type I:** An extreme contrast is imparted to images that are created with this filter. The blacks are deep black, and the whites have little detail for maximum contrast.
- **Filter Type II:** This filter is similar to Type I. Although images still have high contrast, it is toned down a little.

Add effects
- **Off:** No extra effects are added to the image.
- **Pin Hole:** The corners of the image are darkened to pure black.
- **White Edge:** The corners of the image are brightened to pure white.
- **Frame:** A white frame is added to the image, and a processed film look is added to the edges of the picture inside the frame.

B&W Filter

B&W Filter lightens similar colors and darkens complimentary colors:

- **N:** The Neutral filter creates a normal black-and-white image, with colors rendered as shades of gray, but the image will have a much higher contrast and be far grainier than an image shot in Monotone Picture Mode.
- **Ye:** The Yellow filter creates a black-and-white image that lightens reds, darkens blues, and has little effect on greens.
- **Or:** The Orange filter creates a black-and-white image that somewhat darkens reds and greens; it more heavily darkens blues.
- **R:** The Red filter creates a black-and-white image that lightens reds, somewhat darkens greens, and more heavily darkens blues.
- **G:** The Green filter creates a black-and-white image that darkens reds, lightens greens, and darkens blues.

Pict. Tone

- **N:** The Neutral tone creates a grainy, high-contrast black-and-white image with no special toning.
- **S:** The Sepia tone gives an image a light brown tone that resembles the sepia images introduced in the 1880s.
- **B:** The Blue tone creates an image with a bluish color, similar to cyanotype images that were introduced in the 1840s.
- **P:** The Purple tone adds a light purple color to an image.
- **G:** The Green tone adds a light green color to an image.

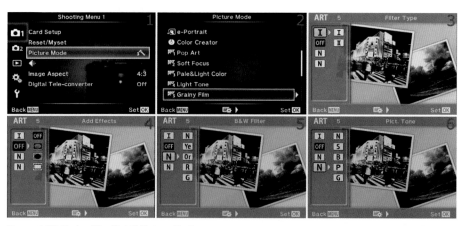

Figure 3.3R: Grainy Film (Art 5) Picture Mode

Use these steps to select and use the Grainy Film Picture Mode:

1. Choose Picture Mode from Shooting Menu 1 and scroll to the right (figure 3.3R, image 1).

2. Highlight Grainy Film on the Picture Mode menu and press the OK button to select it for immediate use in default mode, which applies Filter Type I and no Add Effects, B&W Filters, or Pict. Tones. If you want to change the filter, effect, and tone settings before you take pictures, scroll to the right and proceed to step 3 (figure 3.3R, image 2).

3. Select a Filter Type (figure 3.3R, image 3). Your choices are I or II, as described in the previous list. Scroll to the right, then scroll up or down to highlight Filter Type I or II. Set the Filter Type by pressing the OK button.

4. Select an Add Effects type (figure 3.3R, image 4). Scroll to the right, then scroll up or down to highlight one of the three Add Effects types, or Off, as described in the previous list. Set the Add Effects type by pressing the OK button.

5. Choose a B&W Filter effect by scrolling down to the first N (Neutral) and then scrolling to the right (figure 3.3R, image 5). Highlight one of the B&W Filter effects, as described in the previous list. Set the B&W Filter effect by pressing the OK button.

6. Select a Pict. Tone by scrolling down to the second N (Neutral) and then scrolling to the right (figure 3.3R, image 6). Highlight one of the Pict. Tone effects, as described in the previous list. Set the Pict. Tone by pressing the OK button.

7. When you are done, scroll to the left until you return to the Picture Mode screen. Press the OK button to select the current Art Picture Mode. The camera will return to the Shooting Menu 1 screen with the symbol of the current mode displayed. Take your pictures.

Settings Recommendation: If you are shooting outside on an overcast, gloomy winter day and want some dramatic contrast, the Grainy Film Mode will definitely do the job. This mode produces deep, dark blacks and burned-out whites with a heavy dose of grain thrown in. Try it out to create images that will get people talking.

Pin Hole (Art 6)

The Pin Hole Art Picture Mode is designed to imitate a pinhole camera, which is a simple box with a small hole in the side. The pinhole is covered, a piece of film is placed at the back of the box, and the box is put in position to take a picture. Then you uncover the hole to expose the film. After the film is processed, you have a pinhole picture.

Pinhole camera pictures are usually not sharp and have a lot of light falloff on the edges, but images from an E-M1 are sharp. Aren't you glad you can make imitation pinhole pictures without going through all those steps?

The filters and effects in Pin Hole Art Picture Mode include the following:

Filter types
- **Filter Type I:** A slight greenish tint is added to the image.
- **Filter Type II:** A slight bluish tint is added to the image for a cooler look.
- **Filter Type III:** A slight reddish tint is added to the image for a warmer look.

Add effects

• **Off:** No extra effects are added to the image. Only the filter is added.
• **Frame:** A white frame is added to the image, and a processed film look is added to the edges of the picture inside the frame.

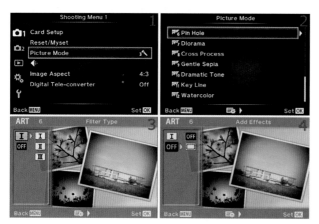

Figure 3.3S: Pin Hole (Art 6) Picture Mode

Use these steps to select and use Pin Hole Art Picture Mode:

1. Choose Picture Mode from Shooting Menu 1 and scroll to the right (figure 3.3S, image 1).
2. Highlight Pin Hole on the Picture Mode menu and press the OK button to select it for immediate use in default mode, which applies Filter Type I with no Add Effects. If you want to change the Filter Type and Add Effects settings before you take pictures, scroll to the right and proceed to step 3 (figure 3.3S, image 2).
3. Select a Filter Type (figure 3.3S, image 3). Your choices are I, II, or III as described in the previous list. Scroll to the right, then scroll up or down to highlight Filter Type I, II, or III. Set the Filter Type by pressing the OK button.
4. Select an Add Effects type (figure 3.3S, image 4). Scroll to the right, then scroll up or down to highlight an effect that is described in the previous list. Set the Add Effects type by pressing the OK button.
5. When you are done, scroll to the left until you return to the Picture Mode screen. Press the OK button to select the current Art Picture Mode. The camera will return to the Shooting Menu 1 screen with the symbol of the current mode displayed. Take your pictures.

Settings Recommendation: This mode is fun if you want to imitate a pinhole camera. However, I do not like the tones that are produced by any of the Filter Types. To me it would be better to offer normal picture colors, along with the green, blue, and red filter types. Then you could use this mode any time you want a picture with dark corners, which

can be quite nice for emphasizing a subject. With the toning you are limited to special effects pictures. Try this mode and see if you like one or more of the tones.

Diorama (Art 7)

The Diorama Art Picture Mode allows you to shoot city scenes or any type of image in which you want normal-sized subjects to look like tiny artificial subjects. This effect is created through the use of a shallow depth of field (area of sharp focus) that can be produced when you take closeup pictures of small subjects. The camera emulates a shallow depth of field by artificially blurring either the top and bottom of the image, or the left and right sides, with a band of sharpness across the middle of the picture.

This Diorama Art Picture Mode includes the following filters and effects:

Filter types
- **Filter Type I:** A horizontal band of sharpness appears across the picture, with both the top and bottom of the image blurred.
- **Filter Type II:** A vertical band of sharpness appears along the picture, with both the left and right sides of the image blurred.

Add effects
- **Off:** No extra effects are added to image. Only the filter is added.
- **Frame:** A white frame is added to the image, and a processed film look is added to the edges of the picture inside the frame.

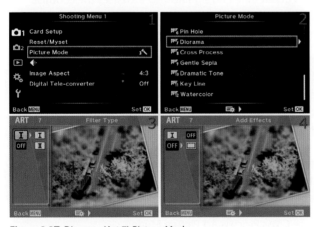

Figure 3.3T: Diorama (Art 7) Picture Mode

Use these steps to select and use the Diorama Art Picture Mode:

1. Choose Picture Mode from Shooting Menu 1 and scroll to the right (figure 3.3T, image 1).
2. Highlight Diorama on the Picture Mode menu and press the OK button to select it for immediate use in default mode, which applies Filter Type I and no Add Effects. If you

want to change the Filter Type and Add Effects settings before you take pictures, scroll to the right and proceed to step 3 (figure 3.3T, image 2).

3. Select a Filter Type (figure 3.3T, image 3). Your choices are I or II as described in the previous list. Scroll to the right, then scroll up or down to highlight Filter Type I or II. Set the Filter Type by pressing the OK button.

4. Select an Add Effects type (figure 3.3T, image 4). Scroll to the right, then scroll up or down to highlight one of the effects as described in the previous list. Set the Add Effects type by pressing the OK button.

5. When you are done, scroll to the left until you return to the Picture Mode screen. Press the OK button to select the current Art Picture Mode. The camera will return to the Shooting Menu 1 screen with the symbol of the current mode displayed. Take your pictures.

Cross Process (Art 8)

The Cross Process Art Picture Mode applies an old-fashioned look that results when film is processed in chemicals that are intended for a different type of film. The results are usually odd colors and abnormal contrast. The Cross Process Mode therefore makes oddly colored (green or red toned) pictures with high contrast.

The filters and effects for Cross Process Art Picture Mode include the following:

Filter types
- **Filter Type I:** This filter adds a green tone and significantly increases the contrast.
- **Filter Type II:** This filter adds a red tone and significantly increases the contrast.

Add effects
- **Off:** No extra effects are added to the image. Only the filter is added.
- **Pin Hole:** The corners of the image are darkened to pure black.
- **White Edge:** The corners of the image are brightened to pure white.
- **Frame:** A white frame is added to the image, and a processed film look is added to the edges of the picture inside the frame.
- **Blur Effect: Top and Bottom:** A band of sharpness extends horizontally through the middle of the image, and the top and bottom of the image are blurred.
- **Blur Effect: Left and Right:** A band of sharpness extends vertically through the middle of the image, and the left and right sides of the image are blurred.

Use these steps to select and use Cross Process Art Picture Mode:

1. Choose Picture Mode from Shooting Menu 1 and scroll to the right (figure 3.3U, image 1).
2. Highlight Cross Process on the Picture Mode menu and press the OK button to select it for immediate use in default mode, which applies Filter Type I and no Add Effects. If you want to change the Filter Type and Add Effects settings before you take pictures, scroll to the right and proceed to step 3 (figure 3.3U, image 2).

3. Select a Filter Type (figure 3.3U, image 3). Your choices are I or II, as described in the previous list. Scroll to the right, then scroll up or down to highlight Filter Type I or II. Set the Filter Type by pressing the OK button.
4. Select an Add Effects type (figure 3.3U, image 4). Scroll to the right, then scroll up or down to highlight one of the five Add Effects types, or Off, as described in the previous list. Set the Add Effects type by pressing the OK button.
5. When you are done, scroll to the left until you return to the Picture Mode screen. Press the OK button to select the current Art Picture Mode. The camera will return to the Shooting Menu 1 screen with the symbol for the current mode displayed. Take your pictures.

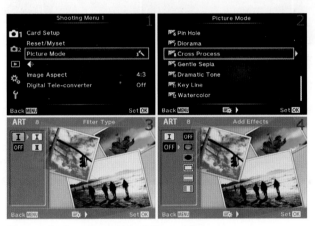

Figure 3.3U: Cross Process (Art 8) Picture Mode

Settings Recommendation: I guess the team that created the E-M1 remembers the good old film days. Some of these effects will mean little to a digital photographer who has not shot film or used a wet chemical darkroom. If you suddenly want a green or red toned, overexposed image, the camera stands ready to deliver.

Gentle Sepia (Art 9)

The Gentle Sepia Art Picture Mode allows you to take your images back to the 1880s by toning them with the sepia look that was common in those days. Sepia is a light brown tone that looks very old fashioned to our color-conditioned eyes. The result looks like a regular black-and-white image, with brown tones instead of gray ones.

No filters are available, but several Add Effects are available:

Add effects
- **Off:** No extra effects are added to the image.
- **Soft Focus:** A dreamy blur effect is added to the image.
- **Pin Hole:** The corners of the image are darkened to pure black.
- **White Edge:** The corners of the image are brightened to pure white.

- **Frame:** A white frame is added to the image, and a processed film look is added to the edges of the picture inside the frame.
- **Blur Effect: Top and Bottom:** A band of sharpness extends horizontally through the middle of the image, and the top and bottom of the image are blurred.
- **Blur Effect: Left and Right:** A band of sharpness extends vertically through the middle of the image, and the left and right sides of the image are blurred.

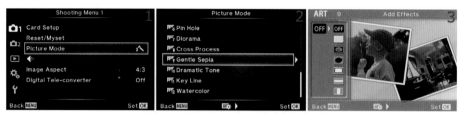

Figure 3.3V: Gentle Sepia (Art 9) Picture Mode

Use these steps to create Gentle Sepia images:

1. Choose Picture Mode from Shooting Menu 1 and scroll to the right (figure 3.3V, image 1).
2. Highlight Gentle Sepia on the Picture Mode menu and press the OK button to select it for immediate use in default mode, which does not use Add Effects. If you want to add one of the six Add Effects, scroll to the right and proceed to step 3 (figure 3.3V, image 2).
3. Off will be highlighted on the Add Effects screen (figure 3.3V, image 3). Scroll to the right, then scroll down or up to highlight the Add Effect you want to use, as described in the previous list. Press the OK button to lock in the effect.
4. When you are done, scroll to the left until you return to the Picture Mode screen. Press the OK button to select the current Art Picture Mode. The camera will return to the Shooting Menu 1 screen with the symbol for the current mode displayed. Take your pictures.

Settings Recommendation: If you enjoy old-fashioned things, why not dress up a few of your friends in vested suits and long dresses and have a Gentle Sepia portrait session? You could also try Gentle Sepia when you take Monotone shots. Instead of shooting only standard black-and-white images, you can add some sepia shots for variety.

Dramatic Tone (Art 10)

The Dramatic Tone Art Picture Mode adds a bit of drama to an image. All of the tones become edgy, with higher contrast and a mild low-key highlight effect. The filters allow you to switch between color and black-and-white images.

Colors are extra saturated in the color images, and dark tones have extra blackness in black-and-white images. They don't have the grain or extreme contrast of Grainy Film

Mode. The Dramatic Tone Art Picture Mode seems like a combination of the Monotone and Grainy Film Modes that uses the best features of each one.

The available filters and effects include the following:

Filter types
- **Filter Type I:** Dramatic color images, with higher contrast and more saturated colors, are produced.
- **Filter Type II:** Dramatic black-and-white images with higher contrast are produced. You can also add B&W Filter and Pict. Tone effects.

Add effects
- **Off:** No extra effects are added to the image. Only the filter is added.
- **Pin Hole:** The corners of the image are darkened to pure black.
- **White Edge:** The corners of the image are brightened to pure white.
- **Frame:** A white frame is added to the image, and a processed film look is added to the edges of the picture inside the frame.
- **Star Light:** A four-point star effect is added to points of light in the image.
- **Blur Effect: Top and Bottom:** A band of sharpness extends horizontally through the middle of the image, and the top and bottom of the image are blurred.
- **Blur Effect: Left and Right:** A band of sharpness extends vertically through the middle of the image, and the left and right sides of the image are blurred.

The following selections are available only when Filter Type II (black-and-white) is selected:

B&W Filter
B&W Filter lightens similar colors and darkens complimentary colors:
- **N:** The Neutral filter creates a normal black-and-white image, with colors rendered as shades of gray, but the image will have a much higher contrast and be far grainier than an image shot in Monotone Picture Mode.
- **Ye:** The Yellow filter creates a black-and-white image that lightens reds, darkens blues, and has little affect on greens.
- **Or:** The Orange filter creates a black-and-white image that somewhat darkens reds and greens; it more heavily darkens blues.
- **R:** The Red filter creates a black-and-white image that lightens reds, somewhat darkens greens, and more heavily darkens blues.
- **G:** The Green filter creates a black-and-white image that darkens reds, lightens greens, and darkens blues.

Pict. Tone
- **N:** The Neutral tone creates a grainy, high-contrast black-and-white image with no special toning.
- **S:** The Sepia tone gives an image a light brown tone that resembles the sepia images introduced in the 1880s.

- **B:** The Blue tone creates an image with a bluish color, similar to the cyanotype images that were introduced in the 1840s.
- **P:** The Purple tone adds a light purple color to an image.
- **G:** The Green tone adds a light green color to an image.

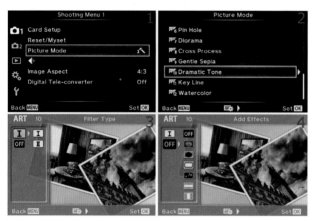

Figure 3.3W: Dramatic Tone (Art 10) Picture Mode

Use these steps to select and use the Dramatic Tone Picture Mode:

1. Choose Picture Mode from Shooting Menu 1 and scroll to the right (figure 3.3W, image 1).
2. Highlight Dramatic Tone on the Picture Mode menu and press the OK button to select it for immediate use in default mode, which applies Filter Type I (color) and no Add Effects, B&W Filters, or Pict. Tones. If you want to change the filter, effects, and tone settings before you take pictures, scroll to the right and proceed to step 3 (figure 3.3W, image 2).
3. Select a Filter Type (figure 3.3W, image 3). Your choices are I or II, as described in the previous list. Scroll to the right, then scroll up or down to highlight Filter Type I or II. Set the Filter Type by pressing the OK button.
4. Select an Add Effects type (figure 3.3W, image 4). Scroll to the right, then scroll up or down to highlight one of the six Add Effects types, or Off, as described in the previous list. Set the Add Effects type by pressing the OK button.
5. Steps 5 and 6 apply only if you selected Filter Type II (black-and-white). If you chose Filter Type I (color), skip steps 5 and 6 and go directly to step 7.
6. When you select Filter Type II (black-and-white) (figure 3.3X, image 1), you can choose a B&W Filter by scrolling down to the first N (figure 3.3X, image 2) then scrolling to the right. Highlight one of the B&W Filter effects, as described in the previous list. Set the B&W Filter effect by pressing the OK Button.

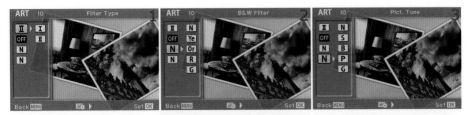

Figure 3.3X: Additional selections when Filter Type II is enabled

7. Select a Pict. Tone by scrolling down to the second N (figure 3.3X, image 3) and then scrolling to the right. Highlight one of the Pict. Tone effects, as described in the previous list. Set the Pict. Tone effect by pressing the OK button.

8. When you are done, scroll to the left until you return to the Picture Mode screen. Press the OK button to select the current Art Picture Mode. The camera will return to the Shooting Menu 1 screen with symbol for the current mode displayed. Take your pictures.

Settings Recommendation: This is a useful function if you like to shoot unique images. You can add drama to color images or extend the Monotone Picture Mode's functionality with dramatic black-and-white images.

Why not experiment with Monotone, Grainy Film, and Dramatic Tone (using the B&W Filter) Picture Modes to see which black-and-white mode you might use at various times. The E-M1 gives you an amazing number of choices!

Key Line (Art 11)

The Key Line Art Picture Mode looks for contrast and color changes and uses them to modify an image into a line drawing with glowing pastel colors and indistinct puddles of color in areas where there is little depth of field (blur). The image takes on a somewhat painterly look while maintaining a degree of sharpness.

This mode's available filters and effects include the following:

Filter types
- **Filter Type I:** Color line art images with medium contrast and pastel colors are created.
- **Filter Type II:** Color line art images with high contrast and pastel colors are created.

Add effects
- **Off:** No extra effects are added to the image. Only the filter is added.
- **Soft Focus:** A dreamy blur effect is added to the image.
- **Pin Hole:** The corners of the image are darkened to pure black.
- **White Edge:** The corners of the image are brightened to pure white.
- **Frame:** A white frame is added to the image, and a processed film look is added to the edges of the picture inside the frame.
- **Star Light:** A four-point star effect is added to points of light in the image.

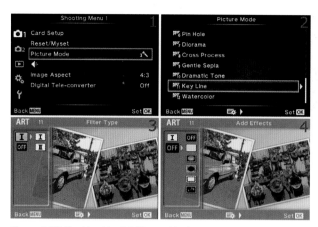

Figure 3.3Y: Key Line (Art 11) Picture Mode

Use these steps to select and use the Key Line Art Picture Mode:

1. Choose Picture Mode from Shooting Menu 1 and scroll to the right (figure 3.3Y, image 1).

2. Highlight Key Line on the Picture Mode menu and press the OK button to select it for immediate use in default mode, which applies Filter Type I and no Add Effects. If you want to change the Filter Type and Add Effects settings before you take pictures, scroll to the right and proceed to step 3 (figure 3.3Y, image 2).

3. Select a Filter Type (figure 3.3Y, image 3). Your choices are I or II, as described in the previous list. Scroll to the right, then scroll up or down to highlight Filter Type I or II. Set the Filter Type by pressing the OK button.

4. Select an Add Effects type (figure 3.3Y, image 4). Scroll to the right, then scroll up or down to highlight one of the five Add Effects types, or Off, as described in the previous list. Set the Add Effects type by pressing the OK button.

5. When you are done, scroll to the left until you return to the Picture Mode screen. Press the OK button to select the current Art Picture Mode. The camera will return to the Shooting Menu 1 screen with the symbol for the current mode displayed. Take your pictures.

Settings Recommendation: You may enjoy experimenting with this mode if you have an image that has lots of color. You can feel like a painter, or even use your image as the base for an actual painting. Use it with some of Photoshop's plug-ins or special tools to make it even more painterly. Have some fun with this one!

Watercolor (Art 12)

The Watercolor Art Picture Mode takes the Key Line Mode a step further. It keeps some detail and changes everything into a watery, pastel art form that some will like and others will avoid. Colors tend to change into other colors; for instance, most whites seem to look

yellowish, although stronger colors seem to remain intact. Most highlight detail washes out to pure white, and dark colors turn light gray. This mode makes images into colorful, high-key puddles with some detail.

The available filters and effects include the following:

Filter types

- **Filter Type I:** This filter creates pastel colors and lines with medium contrast. There is little highlight detail.
- **Filter Type II:** This filter creates pastel colors and lines with low contrast. There is almost no highlight detail.

Add effects

- **Off:** No extra effects are added to the image. Only the filter is added.
- **Soft Focus:** A dreamy blur effect is added to the image.
- **Pin Hole:** The corners of the image are darkened to pure black.
- **White Edge:** The corners of the image are brightened to pure white.
- **Frame:** A white frame is added to the image, and a processed film look is added to the edges of the picture inside the frame.

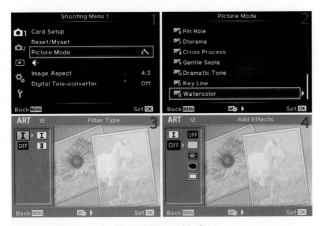

Figure 3.3Z: Watercolor (Art 12) Picture Mode

Use these steps to select and use the Watercolor Picture Mode:

1. Choose Picture Mode from Shooting Menu 1 and scroll to the right (figure 3.3Z, image 1).
2. Highlight Watercolor on the Picture Mode menu and press the OK button to select it for immediate use in default mode, which applies Filter Type I and no Add Effects. If you want to change the Filter Type and Add Effects settings before you take pictures, scroll to the right and proceed to step 3 (figure 3.3Z, image 2).

3. Select a Filter Type (figure 3.3Z, image 3). Your choices are I or II, as described in the previous list. Scroll to the right, then scroll up or down to highlight Filter Type I or II. Set the Filter Type by pressing the OK button.

4. Select an Add Effects type (figure 3.3Z, image 4). Scroll to the right, then scroll up or down to highlight one of the four Add Effects types, or Off, as described in the previous list. Set the Add Effects type by pressing the OK button.

5. When you are done, scroll to the left until you return to the Picture Mode screen. Press the OK button to select the current Art Picture Mode. The camera will return to the Shooting Menu 1 screen with the symbol for the current mode displayed. Take your pictures.

Settings Recommendation: This mode is almost too far out for me. There is so little highlight detail left that you would need to shoot in a darker area, or take a picture of a subject with very strong lines, to maintain any detail. Images taken in bright areas, or with low-texture subjects, can become featureless. If you use this mode, experiment in different light levels and in areas with different amounts of color and texture. Who knows, you may like it.

Vintage (Art 13)

The Vintage Picture Mode's Filter Types allow you to tint an image so it looks like a faded, color-shifted image you would expect to see after a print has been hanging on a wall for many years. Vintage Picture Mode lets you choose from three Filter Types and nine Add Effects settings. The Add Effects settings offer virtually every special effect the camera can create, including two that are not available with any other Art Filter (i.e., the Shade Effect).

The available filters and effects are as follows:

Filter types
- **Filter Type I:** This filter creates a yellow-green pastel tint and lines with high contrast. There is little highlight detail.
- **Filter Type II:** This filter creates even lighter pastel colors with a more whitish, faded look, yet it retains high contrast. There is almost no highlight detail.
- **Filter Type III:** This filter creates more neutral and darker colors with a bit more highlight detail, yet it retains high contrast.

Add effects
- **Off:** No extra effects are added to the image. Only the filter is added.
- **Soft Focus:** A dreamy blur effect is added to the image.
- **Pin Hole:** The corners of the image are darkened to pure black.
- **White Edge:** The corners of the image are brightened to pure white.
- **Frame:** A white frame is added to the image, and a processed film look is added to the edges of the picture inside the frame.
- **Star Light:** A four-point star effect is added to points of light in the image.

- **Blur Effect: Top and Bottom:** A band of sharpness extends horizontally through the middle of the image, and the top and bottom of the image are blurred.
- **Blur Effect: Left and Right:** A band of sharpness extends vertically through the middle of the image, and the left and right sides of the image are blurred.
- **Shade Effect: Top and Bottom:** This effect provides a graduated darkening, similar to the Pin Hole effect. It is applied only to the top and bottom of the image.
- **Shade Effect: Left and Right:** This effect provides a graduated darkening, similar to the Pin Hole effect. It is applied only to the left and right sides of the image.

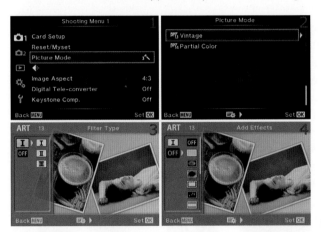

Figure 3.3ZA: Vintage (Art 13) Picture Mode

Use these steps to select and use the Vintage Picture Mode:

1. Choose Picture Mode from Shooting Menu 1 and scroll to the right (figure 3.3ZA, image 1).
2. Highlight Vintage on the Picture Mode menu and press the OK button to select it for immediate use in default mode, which applies Filter Type I and no Add Effects. If you want to change the Filter Type and Add Effects settings before you take pictures, scroll to the right and proceed to step 3 (figure 3.3ZA, image 2).
3. Select a Filter Type (figure 3.3ZA, image 3). Your choices are I, II, or III, as described in the previous list. Scroll to the right, then scroll up or down to highlight Filter Type I, II, or III. Set the Filter Type by pressing the OK button.
4. Select an Add Effects type (figure 3.3ZA, image 4). Scroll to the right, then scroll up or down to highlight one of the nine Add Effects types, or Off, as described in the previous list. Set the Add Effects type by pressing the OK button.
5. When you are done, scroll to the left until you return to the Picture Mode screen. Press the OK button to select the current Art Picture Mode. The camera will return to the Shooting Menu 1 screen with the symbol for the current mode displayed. Take your pictures.

Settings Recommendation: This mode provides an interesting way to tint your images. The three Filter Types provide colors that many people will like. I see this sort of thing a lot on Instagram and Facebook. Maybe the camera is imitating all the old filter effects you see from iPhone posts.

The Add Effects settings allow you to do all sorts of unusual things with the picture. This mode has more Add Effects types than any other Art Picture Mode. Therefore, you can experiment and enjoy your camera even more.

Partial Color (Art 14)

The Partial Color Picture Mode lets you use a previously configured Partial Color setup. After you have configured a Partial Color, all other colors will appear as monotone shades. You must use the ART Mode on the Mode Dial to choose a particular color. After you choose a color, it will appear as your Partial Color in any pictures you take while the Partial Color Picture Mode is selected.

Unfortunately, you cannot use the Shooting Menu 1 Partial Color selection to choose the Partial Color. You must configure the ART Mode on the Mode Dial before you use this Picture Mode. After you configure the Partial Color, the camera will use it to record pictures until you deselect Partial Color Picture Mode.

Let's see how to choose a Partial Color.

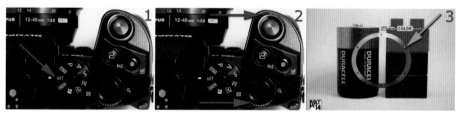

Figure 3.3ZB: Choosing a Partial Color in ART Mode on the Mode Dial

Use these steps to choose a Partial Color:

1. Set the Mode Dial to ART (figure 3.3ZB, image 1).
2. Turn either the Front Dial or the Rear Dial (figure 3.3ZB, image 2).
3. Move the indicator dot around the color circle until the color you want to use is shown as the Partial Color in the Live View display. As you can see from the blue arrow in figure 3.3ZB, image 3, I chose red. All red and reddish shades, such as the copper orange on the top of the battery, will be in color and the rest of the colors will be monotone shades of gray.
4. Take your pictures.

Note: If you select a Picture Mode other than Partial Color and use the ART Mode on the Mode Dial to take some Partial Color Pictures, the camera will use whatever Picture Mode you previously selected. When you leave the ART Mode set on the Mode Dial, it will not stay in Partial Color mode.

If you decide to take more pictures with the Partial Color you previously chose, simply select Partial Color Picture Mode. The camera will immediately use the Partial Color you selected while you were using the ART Mode until you change the Partial Color Picture Mode to another mode, such as Natural. (How to use Partial Color is described in more detail in the chapter titled **Screen Displays for Camera Control** on page 26.)

After you have selected Partial Color Picture Mode, you can modify how the chosen color and the other monotone shades are recorded by using a different Filter Type. You can also select one of the Add Effects types to change the picture borders and add other special effects.

The available filters and effects are as follows:

Filter types
- **Filter Type I:** This filter obeys the Partial Color you previously selected with the ART selection, camera dials, and color wheel. Filter Type I is a neutral filter. It renders all shades in the image in a neutral way.
- **Filter Type II:** This filter also obeys the Partial Color you previously selected with the ART selection, camera dials, and color wheel. Filter Type II gives the image a somewhat cooler look.
- **Filter Type III:** This filter also obeys the Partial Color you previously selected with the ART selection, camera dials, and color wheel. Filter Type III gives the image a somewhat warmer look.

Add effects
- **Off:** No extra effects are added to the image. Only the filter is added.
- **Soft Focus:** A dreamy blur effect is added to the image.
- **Pin Hole:** The corners of the image are darkened to pure black.
- **White Edge:** The corners of the image are brightened to pure white.
- **Frame:** A white frame is added to the image, and a processed film look is added to the edges of the picture inside the frame.
- **Star Light:** A four-point star effect is added to points of light in the image.
- **Blur Effect: Top and Bottom:** A band of sharpness extends horizontally through the middle of the image, and the top and bottom of the image are blurred.
- **Blur Effect: Left and Right:** A band of sharpness extends vertically through the middle of the image, and the left and right sides of the image are blurred.

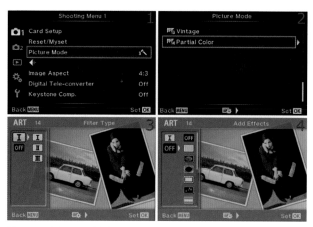

Figure 3.3ZC: Partial Color (Art 14) Picture Mode

Use these steps to select and use the Partial Color Picture Mode:

1. Choose Picture Mode from Shooting Menu 1 and scroll to the right (figure 3.3ZC, image 1).

2. Highlight Partial Color on the Picture Mode menu and press the OK button to select it for immediate use in default mode, which applies whatever Partial Color, Filter Type, and Add Effects settings you selected before entering the Partial Color Picture Mode (figure 3.3ZC, image 2). If you want to change the Filter Type and Add Effects settings before you take pictures, scroll to the right and proceed to step 3.

3. Select a Filter Type (figure 3.3ZC, image 3). Your choices are I, II, or III, as described in the previous list. Scroll to the right, then scroll up or down to highlight Filter Type I, II, or III. Set the Filter Type by pressing the OK button.

4. Select an Add Effects type (figure 3.3ZC, image 4). Scroll to the right, then scroll up or down to highlight one of the seven Add Effects types, or Off, as described in the previous list. Set the Add Effects type by pressing the OK button.

5. When you are done, scroll to the left until you return to the Picture Mode screen. Press the OK button to select the current Art Picture Mode. The camera will return to the Shooting Menu 1 screen with the symbol for the current mode displayed. Take your pictures.

Settings Recommendation: Shooting with only one or two colors in the image has become quite popular these days. Who hasn't seen a lovely rose with the red showing and everything else in black-and-white? The firmware 2.0 update for the E-M1 allows you to easily shoot those interesting Partial Color pictures and videos.

 Note: Don't discount all these filter types and effects. You would have to work hard in a program such as Photoshop or Lightroom to obtain similar results. I suggest that you experiment with these modes and see what you can come up with!

Art Picture Mode Bracketing

As if the E-M1 is not amazing enough, it has one of the most unusual functions I have ever seen in a camera. You can take a single picture and the camera will make 14 duplicates while you watch. It applies each of the 14 Art Picture Modes to the new images. You end up with the original image plus 14 pictures that display each Art Mode. It takes only a few seconds and gives you a wide variety of images to choose from.

This function is not part of the menu-based Picture Mode system. It is available only when you select the Art Picture Modes from the Mode Dial on top of the camera. See the chapter called **Screen Displays for Camera Control** under Art Picture Mode selection number 15 (**ART BKT**) for information about how to use the Art Picture Mode bracketing function.

[Record Mode]

[Record Mode], also known as image quality or movie quality mode, provides the basic file formats your camera uses for taking still pictures and shooting video. Basically, the camera can capture still images in several varieties of JPEG, or in ORF files, which is the Olympus RAW image format. Additionally, the E-M1 has several high definition (HD) video modes and one standard definition (SD) mode. Let's examine the still and video formats.

Still Image Formats

There are two still image formats available in the E-M1: JPEG and RAW (ORF). We will examine both of these formats and discuss their pros and cons, but first let's see how to select a format.

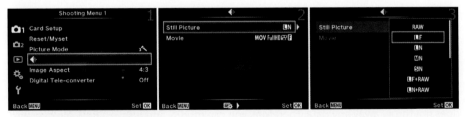

Figure 3.4A: Selecting a JPEG format

1. Select [Record Mode] (it looks like a diamond) from Shooting Menu 1 and scroll to the right (figure 3.4A, image 1).
2. Choose Still Picture from the [Record Mode] menu and scroll to the right (figure 3.4A, image 2).
3. You will see five basic modes and four combination modes (figure 3.4A, image 3). If the camera is set to the defaults, the basic modes are RAW, LF, LN, MN, and SN. (The menu shown in figure 3.4A, image 3, can be configured to reflect the modes you use

most frequently. We will discuss how to change it in the note after these steps.) The JPEG+RAW combination modes create both a RAW file and a JPEG file each time you take a picture. The default selections for the combination modes are LF+RAW, LN+RAW, MN+RAW, and SN+RAW. You can't see the last two combination modes in figure 3.4A, image 3, because you have to scroll down. We will talk more about RAW images in the next subsection. Highlight one of the basic or combination formats and press the OK button to select it. I chose Large Fine or (LF).

Note: There is another setting called Super Fine (SF). It is not enabled when your camera is new. Large Super Fine (LSF) creates even better images than Large Fine (LF). To make LSF available, you must adjust a setting under the Custom Menu, then LSF will appear instead of LF on the menu in figure 3.4A, image 3. In the Custom Menu, adjust the (G) [Record Mode] Set function to SF, as shown in figure 3.4B (see the next subsection).

Image Size, Pixel Count, and JPEG Compression Ratios

The E-M1 gives you a choice of several RAW or JPEG image sizes and pixel counts, including Large (L), Middle (M), and Small (S). You can also choose from several JPEG compression levels, including Super Fine (SF), Fine (F), Normal (N), and Basic (B). JPEG files have a certain compression ratio, depending on the compression rate (SF, F, N, and B). Table 3.1 lists the compression rate names and the compression ratio for that type of JPEG.

For instance, the Fine (F) compression ratio is 1:4, which means the file size will be 25 percent of the original file size ($1 \div 4 = 0.25$). The Normal (N) compression ratio is 1:8, which means the compressed JPEG is 12.5 percent of the original file size ($1 \div 8 = 0.125$). JPEG files are compressed with *lossy* compression, which means a large portion of the image data is thrown away. A 1:4 compression ratio, with a file size that is only 25 percent of the original file size, results in a permanent loss of 75 percent of the image data. That's why you must take accurate JPEG pictures so you don't have to post-process them later. When you change and resave a JPEG image, more compression is applied to an already compressed image and even more data is thrown away.

On the other hand, RAW files are compressed with automatic (you can't change it) *lossless* compression that keeps all data and still compresses the image by 20 to 40 percent, depending on the complexity of the subject. The lossless compression of a RAW file does not throw away any data. Therefore, you can modify and resave a RAW file over and over with no data loss. You cannot disable the lossless compression on RAW files. Don't worry, though, because the lossless compression of a RAW file is like the familiar ZIP format on your computer. All the original data returns when the file is uncompressed. Your RAW conversion software will decompress the RAW file without your intervention.

On your camera menus, you will see the size and compression rate names combined for JPEG settings. For instance, a Large-size, Fine-compression rate JPEG will be listed as LF, and a Medium-size, Normal-compression rate JPEG will be shown as MN.

Size	Pixel Count	Compression Rate for JPEG			
Large (L)	4608 × 3456	Large Super Fine (LSF)	Large Fine (LF)	Large Normal (LN)	Large Basic (LB)
		Ratio = 1:2.7	Ratio = 1:4	Ratio = 1:8	Ratio = 1:12
Middle (M)	3200 × 2400	Middle Super Fine (MSF)	Middle Fine (MF)	Middle Normal (MN)	Middle Basic (MB)
	2560 × 1920				
	1920 × 1440	Ratio = 1:2.7	Ratio = 1:4	Ratio = 1:8	Ratio = 1:12
	1600 × 1200				
Small (S)	1280 × 960	Small Super Fine (SSF)	Small Fine (SF)	Small Normal (SN)	Small Basic (SB)
	1024 × 768				
	640 × 480	Ratio = 1:2.7	Ratio = 1:4	Ratio = 1:8	Ratio = 1:12

Table 3.1: JPEG format size, pixel count, and compression

Table 3.1 lists the available image sizes, pixel counts, and compression ratios in the E-M1. The size for RAW mode is always Large (L) 4608 × 3456. RAW files always contain all available image data and cannot be resized in-camera. JPEG images have adjustable sizes, pixel counts, and compression rates.

Figure 3.4B shows how to use the *Custom Menu > G. [Record Mode]/Color/WB > [Record Mode] Set* function to change the default choices for the compression rate (SF, F, N, and B). After you make a change on the Custom Menu screen shown in figure 3.4B, image 3, the Shooting Menu 1's [Record Mode] (image quality) will offer you the compression choices you chose in the Custom Menu, instead of the factory default settings. Before making the change in the Custom Menu, your camera most likely offers you the following compression rates: LF, LN, MN, and SN.

Why settle for a Large Fine (LF) JPEG when a Large Super Fine (LSF) JPEG is available? I set my camera to use LSF, LF, MF, and SF. However, you may have a need for a normal (N) or basic (B) JPEG. The camera gives you the ability to make any of those settings available to the *Shooting Menu > [Record Mode] > Still Picture* function by changing the settings in the *Custom Menu > G. [Record Mode]/Color/WB > [Record Mode] Set* function.

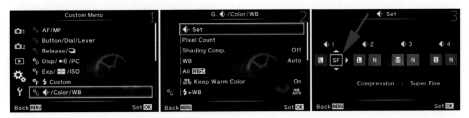

Figure 3.4B: Changing the default compression rate

The compression rate for JPEGs shown in table 3.1 is controlled through the Custom Menu, as shown in figure 3.4B. You can modify any of the four JPEG settings shown in figure 3.4B, image 3, and the new settings will replace the old ones. Large Super Fine (LSF)

is selected in figure 3.4B, image 3. Your selections will also appear in other camera menus that offer JPEG size and compression settings (such as the menu shown in figure 3.4A, image 3). This is discussed in more detail in the **Custom Menu** chapter under the **[Record Mode] Set** subheading on page 392.

You can also choose a different pixel count if you need to shoot a smaller megapixel (MP) size than the camera's native 4608×3456 pixel count (16 MP). Only JPEG images are affected by changing the pixel count. Figure 3.4C shows the screens used to choose a different MP size for your JPEG pictures.

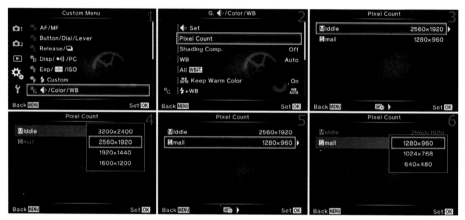

Figure 3.4C: Choosing a smaller MP size for your images

You can control the pixel count, as shown in table 3.1, with the Custom Menu (figure 3.4C). This is discussed in more detail in the **Custom Menu** chapter under the **Pixel Count** subheading on page 394.

Now, let's examine the two available formats and see how they work.

JPEG Format

JPEG format is used by people who want excellent image quality but have little time for, or interest in, post-processing or converting images to another format. They want to use images immediately with no major adjustments.

The JPEG format applies your chosen camera settings to the image when it is taken. The image comes out of the camera ready to use, as long as you have exposed it properly and have configured all the other settings appropriately.

Since JPEG is a lossy format—because image compression permanently throws data away—you cannot modify and save a JPEG file more than a time or two before compression losses begin to degrade the image. Therefore, make sure to shoot JPEG images correctly in the first place.

The compression rate of a JPEG image affects the overall image quality. Super Fine mode will give you the best looking picture since the compression ratio is rather low. Each higher compression rate, Fine through Basic, throws away more color information, but the

smaller file takes up less room on your computer. You will need to balance your desire for image quality with your available storage space.

Photographers who shoot a lot of images or don't have time to post-process RAW often shoot JPEGs. That encompasses a lot of photographers.

Nature photographers might want to use RAW (ORF) format since they often have more time for processing images and wringing the last drop of quality out of them, but event or journalist photographers on deadlines may not have the time for, or interest in, processing images, so they often use the JPEG format.

Here are the pros and cons of capturing JPEG images:

JPEG positives
- Allows for the maximum number of images on a memory card and computer hard drive.
- Allows for the fastest transfer from the camera memory buffer to a memory card.
- Compatible with everything and everybody in imaging.
- Uses the printing industry standard of 8 bits.
- Produces high-quality, first-use images.
- No special software is needed to use the image right out of the camera (no post-processing).
- Immediate use on websites with minimal processing.
- Easy transfer across the Internet and as e-mail attachments.

JPEG negatives
- JPEG is a lossy format.
- You cannot manipulate a JPEG image more than once or twice before it degrades to an unusable state. Every time you modify and save a JPEG image, it loses more data and quality because of data compression losses.

Settings Recommendation: Because JPEG images are compressed, even the largest files do not take up that much space. Therefore, when I shoot JPEGs, I use Large Super Fine (LSF) most of the time. The only time I would use a higher compression rate is if I were running out of card space on an important shoot. Computer hard drives are cheap these days. Why limit the quality of your images just to save some storage space?

RAW (ORF) Format
RAW [Record Mode] is the image purist's mode of choice. It's important that you under-stand that RAW (ORF) file s are not really images—yet. The RAW format is merely a con-tainer that stores a small sample JPEG file, black-and-white image data, color information markers, and camera setting markers. The RAW file must be converted to another file type before you can use it.

When you take a picture in RAW format, the camera records the raw image data from the sensor and stores markers for how the camera's color, sharpening, contrast, saturation,

and so forth are set, but it does not apply the camera setting information to the image. In your post-processing software, the image will appear on-screen with the settings you initially configured in your E-M1 (or a best estimate). However, these settings are applied temporarily so you can see them.

If you don't like the white balance you selected when you took the picture, simply apply a new white balance and the image will appear as if you had used that setting when you captured the image. If you used Natural Picture Mode and now want to use Vivid Picture Mode, you can apply it before the final conversion, and it will be as if you used it when you shot the picture. You can even apply an Art Picture Mode after the fact if you want to.

This is quite powerful! Virtually no camera settings are applied to a RAW file permanently. During post-processing you can apply completely different settings to the image and it will look like you used those settings when you took the picture. This allows a lot of flexibility later. You simply cannot do that with a JPEG file without causing compression damage.

RAW (ORF) is generally used by photographers who are concerned with maximum image quality and who have time to convert the images. When you shoot a RAW image, it is saved on the memory card in your camera, and later in your computer, as a file ending in ORF.

Here are the pros and cons of RAW (ORF) format:

RAW (ORF) positives
- Allows the manipulation of image data to achieve the highest-quality image available from the camera.
- All original details stay with the image for future processing needs.
- No conversions, sharpening, sizing, or color rebalancing will be performed by the camera. Your image data is untouched and pure!
- You can convert ORF files to any other image format by using your computer's much more powerful processor instead of your camera's processor.
- You have much more control over the final look of the image since you, not the camera, make the final decisions about the appearance of the image.
- The ORF file's 14-bit format stores maximum color information for later use.

RAW (ORF) negatives
- Not often compatible with the publishing industry, except after conversion to another format.
- Requires post-processing with proprietary Olympus software or third-party software.
- Larger file sizes are created, so you must have more storage media.
- There is no industry-standard RAW format. Each camera manufacturer has its own proprietary format. Adobe has developed a generic RAW format called digital negative

(DNG) that is becoming an industry standard. You can use various types of software, such as Adobe Lightroom, to convert your RAW images to DNG if you desire.

• The industry standard for home and commercial printing is currently 8 bits, not 14 bits.

Steps for RAW Conversion in Olympus Viewer 3 Software

Here are the basic steps to convert a RAW (ORF) file into JPEG or TIFF format by using the free Olympus Viewer 3 software:

1. Transfer the images from your camera to your computer.
2. When you see images on the computer screen in Viewer 3, you will see the word RAW in the upper-right corner of the RAW (ORF) images (or R+J when there is both a RAW and a JPEG image).
3. Right click the RAW image and select Open Edit Window.
4. On the right side of the screen under the Histogram display, you will see two tabs: Edit and Raw. Both of these screens allow you to change all sorts of things in the RAW image before you save it as a JPEG (or other format). The Raw tab even lets you change things like Picture Mode and White balance.
5. Make your changes, and the computer will update the image immediately after each change. The changes won't be permanently saved until you save the file as another format.
6. When you are done adjusting the image, open the File menu and select Export. The Export Image window will open.
7. Select a file name, format (JPEG, TIFF), JPEG compression, and Resize for converting the image. Use Exif-JPEG or Exif-TIFF if you want to preserve the EXIF data in the image metadata (e.g., lens, focal length, shutter speed, aperture, ISO setting).
8. Press the Export by Batch Processing button. In the right-lower corner the software will show a progress bar that says Processing... and the number of images being converted in parenthesis (you can convert a large number of images in one batch).
9. Finish will appear where Processing... was previously, with a solid orange progress bar, after your images have been converted.

Settings Recommendation: I use the RAW (ORF) format most of the time. I think of a RAW file like I thought of my slides and negatives a few years ago. It's my original image that must be saved and protected. I am primarily a nature photographer, so I make time to post-process each important image. You may not have time for that, or maybe you're not interested in post-processing. In that case JPEG images may be more reasonable for your shooting style. The format you use most often will be dictated by your time constraints and digital workflow.

If you normally shoot JPEGs, experiment with the free Olympus Viewer 3 software by converting a few RAW images as previously described.

Combined JPEG+RAW Shooting (Two Images at Once)

Some photographers use one of the four [Record Mode] settings (partially shown in figure 3.4A, image 3). These JPEG+RAW modes save two images at the same time: one JPEG and one RAW. Here are the factory default settings for the combined format shooting:

- LF+RAW
- LN+RAW
- MN+RAW
- SN+RAW

These settings give you the best of both worlds because the camera saves an ORF file and a JPEG file each time you press the Shutter button.

You can use the RAW (ORF) file to store all the image data and later process it into a masterpiece, and you can use the JPEG file immediately with no adjustment.

The JPEG+RAW modes have the same features as their stand-alone modes. In other words, a RAW file in a JPEG+RAW mode works like a RAW file in RAW (ORF) mode, and a JPEG file in a JPEG+RAW mode works like a JPEG SF, F, N, or B file on its own.

Keep in mind that you can change the default settings for the combined modes by changing the Custom Menu (G) [Record Mode] Set values for JPEG compression (figure 3.4B). The JPEG compression modes you choose appear both in the camera menus for standard JPEG files and for the combined shooting modes.

Image Format Recommendation

Which format do I prefer? Why, RAW, of course! But it does require a bit of commitment to shoot in this format. RAW (ORF) files are not yet images and must be converted to another format for use. After they are converted, they can provide the highest-quality images your camera can possibly create.

When you shoot in RAW, the camera is simply an image-capturing device and you are the image manipulator. You decide the final format, compression ratio, size, color balance, and so forth. In RAW (ORF) mode, you get the best image your camera can produce. It is not modified by the camera software and is ready for your personal touch. No camera processing allowed!

If you get nothing else from this section, remember this: by letting your camera process images in *any* way, it modifies or throws away data. There is a finite amount of data for each image that can be stored in your camera, and later in your computer. With JPEG, your camera optimizes the image according to the assumptions recorded in its memory. Data is thrown away permanently, in varying amounts.

If you want to keep *all* the image data that was recorded with your images, you must store your originals in RAW format. Otherwise you'll never be able to access the original data to change how it looks. A RAW file is the closest thing to a film negative or transparency that your digital camera can make. That's important if you would like to modify the image later. If you are concerned with maximum quality, you should probably shoot and

store your images in RAW format. Later, when you have the urge to make another masterpiece out of the original RAW image file, you'll have *all* your original data intact for the highest-quality image.

Video Formats

The E-M1 not only lets you take excellent still images, but it also offers a series of excellent video modes that allow you to make movies up to 29 minutes long.

The camera has three video capture modes: 1080/30p, 720/30p, and 480/30p. They use two common compressed-video formats: H.264 MPEG-4 AVC and Motion JPEG. Table 3.2 lists the available video recording formats.

Record mode	Pixel Count/ Frame Rate*	Bit Rate in Megabits Per Second	File Format (Container)	Video Length/ Size
Full HD Fine	1920 × 1080/30p	24 Mbps	H.264 MPEG-4 AVC	22 min/4 GB
Full HD Normal	1920 × 1080/30p	16 Mbps	H.264 MPEG-4 AVC	29 min/4 GB
HD Fine	1280 × 720/30p	12 Mbps	H.264 MPEG-4 AVC	29 min/4 GB
HD Normal	1280 × 720/30p	8 Mbps	H.264 MPEG-4 AVC	29 min/4 GB
HD	1280 × 720/30p	n/a	Motion JPEG	7 min/2 GB
SD	640 × 480/30p	n/a	Motion JPEG	14 min/2 GB

Table 3.2: Video [Record Mode] formats, pixel counts, frame and bit rates, video lengths, and file sizes

* Even though 30p is the listed video frame rate, the frame rate is actually 29.97 frames per second (fps) in the H.264 MPEG-4 AVC format. This may be important when you try to interface your camera with other devices. The Motion JPEG format also lists 30p as the frame rate, but that frame rate can vary when you use Art Picture Modes while shooting video. Some Art Picture Modes require more processing time and will slow the frame rate by various amounts, depending on the filter. Therefore, 30p is the best Motion JPEG frame rate you can expect, but it will often be less.

External Video Output

The E-M1 can send video out of its HDMI port for capture by an external recorder, such as the Atomos Blade **(www.Atomos.com)**. However, the camera does *not* provide clean, uncompressed video when it uses the HDMI port, so the viewfinder and monitor screen overlays will appear in the video when you use an external video recorder.

You may want to play with capturing video from the camera's USB A/V port. You'll need an Olympus CB-AVC4 USB A/V cable. Similar to the output from the HDMI port, the viewfinder and monitor screen overlays will appear in output from the A/V port, too.

To get video free of the viewfinder and monitor screen overlays, you must use the standard video [Record Modes] listed in table 3.2 and as shown in figure 3.4D.

Note: When you use the HDMI port to send video to an external HDTV, monitor, or recorder, you can select the following output formats: 1080i, 720p, or 480p NTSC (576p PAL) by using the *Custom Menu > Disp/[Sound]/PC > HDMI Out* setting.

Video Container Formats

The H.264 MPEG-4 AVC and Motion JPEG file formats use MOV and AVI containers that hold the video, audio, and supporting data inside one file. When you are doing research on the Internet about these formats, add the words MOV or AVI *containers* to your search.

The H.264 MPEG-4 AVC format has an unusual way of compressing data. Instead of storing a series of discrete picture frames, it stores only areas of the frame with motion changes between key frames; the key frames store full pictures. This results in very compressed video with relatively high quality, but it is more difficult to edit the video because the editing software has to reconstruct individual frames.

The Motion JPEG format provides a series of small, very compressed JPEG images. Each image is an integral picture that you can easily edit. For people who like to do extensive editing, Motion JPEG may be the best option. However, this format makes much larger files than the H.264 format, so the video length and file size are seriously limited when you shoot in this format.

Selecting a Video Format

It's easy to select a Movie (video) format, but you should carefully consider the previous information before you shoot.

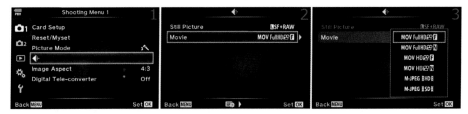

Figure 3.4D: Selecting a Movie mode for recording videos

Use the following steps to choose a [Record Mode]:

1. Select the [Record Mode] symbol (looks like a diamond shape) from Shooting Menu 1 and scroll to the right (figure 3.4D, image 1).
2. Choose Movie from the [Record Mode] menu and scroll to the right (figure 3.4D, image 2).
3. The Movie Record selection menu will display the six modes that are listed in table 3.2 (figure 3.4D, image 3). Highlight one of the modes. I chose MOV Full HD Fine. Press the OK button to lock it in, then shoot your movie!

Note: All modes that start with *MOV* use H.264 MPEG-4 AVC format and use a MOV container. The modes that start with *M-JPEG* use Motion JPEG format and use an AVI container. Refer to table 3.2 to review the limitations of each mode.

Making a Video Recording

After you have configured your camera for video capture, you are ready to record a video.

Figure 3.4E: Use the Movie button to start and stop a video recording

Use these steps to start, record, and stop a video capture session:

1. Start the video recording by pressing the Movie button (figure 3.4E, image 1).
2. A REC symbol will blink to indicate that video is being captured. The time counter just below the REC symbol will display the recording time. My video has been recording for 1 minute and 15 seconds, which is represented by 00:01:15 (figure 3.4E, image 2).
3. Press the Movie button again to stop the video. You've made a movie!

Settings Recommendation: I want my videos to have the greatest possible quality, so I normally shoot in MOV Full HD Fine (1080/30p at 24 Mbps) for up to 22 minutes of video. I record multiple segments and use Adobe Premier Pro to assemble the segments into a movie.

If I wanted to record for a longer time period (up to 29 minutes) and were willing to accept a little lower video quality, I might use the MOV Full HD Normal mode (1080/30p at 16 Mbps). That's about as low I will allow my video quality to go. However, it might be fun to shoot some SD 480/30p videos just for fun and to post on social media sites.

One thing you need to carefully experiment with when you shoot video is the Image Stabilizer. This function is configured at *Shooting Menu 2 > Image Stabilizer > Movie*. You can select On or Off. If you are shooting video while you are walking straight forward or are not moving the camera from side to side, stabilization works amazingly well to keep the image stable. But if your video requires panning from side to side, you may not want to use image stabilization. The camera will attempt to correct the panning motion until it runs out of room to adjust, then it will make a little jump in your video. This looks strange and might even ruin the video. You will have to try it and see if the panning motion jumps are acceptable to you.

Image Aspect

The Image Aspect ratio of a picture is the ratio of the sides to each other. When the length of the sides change, the horizontal to vertical ratio changes.

The easiest way to understand Image Aspect is to see a group of images that were taken with the five available Image Aspect ratios, which are 4:3, 3:4, 1:1, 3:2, and 16:9.

I tried to maintain the size of the birdhouse in the images shown in figure 3.5A so you can see how the ratio affects the image frame. The E-M1 camera uses 4:3 as the default ratio. Many other camera brands use 3:2 as the default, which results in longer and more narrow images.

You can choose from five Image Aspect ratios. Be aware that changing the Image Aspect ratio also changes the megapixel rating of the image.

Figure 3.5A: Comparison of Image Aspect ratios

Image Aspect ratios apply only to JPEG images. When you shoot RAW images the camera will store a reference to the ratio in the metadata, and it will display the aspect ratio as a smaller frame inside the normal 4:3 image border.

Figure 3.5B: RAW image displaying a 1:1 Image Aspect ratio frame

Figure 3.5B shows a RAW image taken with the 1:1 Image Aspect ratio. The normal 4:3 image is displayed on the camera screens and in the Olympus Viewer 3 software. When you view the image it has a temporary frame that outlines the chosen aspect ratio, which, in this case, is 1:1.

If you later decide you do not want to use the ratio you chose, you can change it later without affecting the image size, but only if you shot the image in RAW format. With a JPEG you would have to crop the image, which discards part of the image, to change the aspect ratio.

Now, let's examine how to choose an Image Aspect ratio.

Figure 3.5C: Choosing an Image Aspect ratio

Use the following steps to choose an Image Aspect ratio:

1. Select Image Aspect from Shooting Menu 1 and scroll to the right (figure 3.5C, image 1).
2. Using the up/down menu, select one of the five Image Aspect ratios: 4:3, 3:4, 1:1, 3:2, or 16:9. I chose 1:1 (figure 3.5C, image 2).
3. Press the OK button, and the camera will display the Shooting Menu 1 screen with the selected Image Aspect showing.

Determining the Megapixel Size for a New Image Aspect Ratio

In figure 3.5C, image 2, you can see that pixel dimensions are displayed for each Image Aspect ratio you choose (below the up/down menu). The pixel dimensions of a RAW image will not change because the camera saves all the image data when you shoot in RAW (ORF).

However, you will see the Large, Middle, and Small JPEG pixel dimensions change with each Image Aspect ratio change. You can compare the new dimensions with the dimensions of the normal 4:3 Image Aspect ratio because they are displayed on the right side of the screen.

You can determine the megapixel size of the new image by multiplying the numbers in the pixel dimensions. For instance, in figure 3.5C, image 2, a Large JPEG is 3456×3456 when you use the 1:1 Image Aspect ratio. Multiply the numbers to find the megapixel size of the image:

$$3456 \times 3456 = 11,943,936$$

The image will have a size of almost 12 MP (11.94 MP). This number will vary with each Image Aspect ratio.

Settings Recommendation: Image Aspect ratios are useful primarily for people who shoot a lot of JPEG images and don't want to crop the image later. Basically the camera crops the image for you, in-camera, when you select an Image Aspect ratio other than the default of 4:3. If you shoot in RAW most of the time, you can safely ignore this function. RAW shooters are accustomed to post-processing their images, and adjusting the aspect ratio (cropping) is a common post-processing step.

Digital Tele-converter

Digital Tele-converter makes the camera function as if the mounted lens has a longer focal length than it really does.

Let's say you have a 12–40mm lens on the camera. Normally the maximum zoom would be 40mm. However, when you enable the Digital Tele-converter you can zoom to 80mm instead of 40mm. Although this may seem appealing, the 2x zoom factor is *not an optical zoom*. Instead, the camera crops the image so it looks like the scene is twice as close. It then saves the image at the normal size with a loss of image quality. You could do the same thing by enlarging the image in your computer then cropping it.

Let's see how to use this function in case you want to experiment with it.

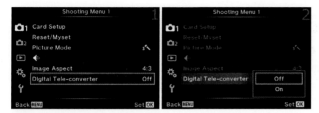

Figure 3.6: Enabling or disabling Digital Tele-converter

Use the following steps to use the Digital Tele-converter:

1. Select Digital Tele-converter from Shooting Menu 1 and scroll to the right (figure 3.6, image 1).
2. Highlight Digital Tele-converter and scroll to the right. A menu will open (figure 3.6, image 2). Scroll to choose Off or On.
3. Press the OK button to lock in your selection.

If you are shooting JPEG files, the camera will artificially double the focal length of your lens by cropping the image in-camera. Your 12–40mm lens becomes a 24–80mm lens, and the images will have much lower quality when they are enlarged.

If you are shooting in RAW mode, the camera captures all the image data and puts a frame around the area the Digital Tele-converter would have captured. The frame is displayed on the camera screens and in the Olympus Viewer 3 software. However, a RAW image is still a RAW image, and all the data is available.

Settings Recommendation: Unless you are in the woods without a long telephoto lens and you see Bigfoot or a yeti that you must capture, I would leave this function alone. Just shoot the image normally and crop it later. This type of function is offered on the cheapest point-and-shoot cameras, but cropping an image from the center of a picture and then enlarging it destroys the image quality.

Keystone Comp.

Keystone Comp. makes your E-M1 act like one of those big view cameras, with its tilts, swings, and excellent distortion correction. You use the function while you view the subject on the monitor, not later in post-processing. Keystone Comp. allows you to correct the odd leaning-backwards perspective distortion you see when you point a wide-angle lens upward to capture a tall subject (vertical plane tilt). Additionally, you can use this function to correct perspective distortion on a horizontal plane (swing). The results of this powerful function are easier to see than describe, so let's examine how it works.

In figure 3.7A you can see a battery and building blocks in a normal, straight-on configuration. Notice that there are two adjustable indicators on the screen (red arrows). The top red arrow points to the tilt control, which allows you to tilt the top or bottom of the image toward or away from you. Tilt correction is applied with the Rear Dial. The bottom red arrow points to the swing control, which allows you to swing the left or right side of the image toward or away from you. Swing correction is applied with the Front Dial.

Figure 3.7A: Normal subject view with Keystone Comp. function set to on

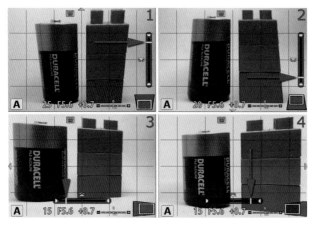

Figure 3.7B: Making adjustments to the subject with the Keystone Comp. function

In figure 3.7B I used the tilt-swing features of the Keystone Comp. function to make the subject swing left and right or tilt front to back—without moving the camera.

In image 1 the tilt indicator is at the top of the scale, and the camera is tilting the top edge of the image toward you. The bottom of the image stays the same.

In image 2 the tilt indicator is at the bottom of the scale, and the camera is tilting the bottom edge of the image toward you. The top of the image stays the same.

In image 3 the swing indicator is at the left side of the scale, and the camera is swinging the left side of the image toward you. The right side of the image stays the same.

In image 4 the swing indicator is at the right side of the scale, and the camera is swinging the right side of the image toward you. The left side of the image stays the same.

Now let's examine how to enable and disable Keystone Comp.

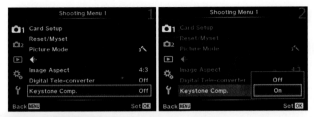

Figure 3.7C: Enabling or disabling Keystone Comp.

Use the following steps to use the Keystone Comp. function:

1. Select Keystone Comp. from Shooting Menu 1 and scroll to the right (figure 3.7C, image 1).
2. Highlight Keystone Comp. and scroll to the right. A menu will open (figure 3.7C, image 2). Scroll to choose Off or On. If you choose On, the camera will switch the Live View screen to Keystone Comp. mode, with the tilt-swing indicators (figure 3.7B). When the camera is in this mode you can't easily change the exposure because the Front Dial and Rear Dial are tied up with Keystone Comp. adjustments. Therefore, it's important to set the exposure correctly before you enter Keystone Comp. mode to take a picture.
3. Press the OK button to lock in your selection.

Settings Recommendation: Although this tilt and swing method is not quite up to the standards of a view camera's tilt and swing system or an optical tilt-shift lens, it is a quick way to add some distortion correction on the fly. It tends to stretch the edges of images, so I don't use this function for large adjustments. However, for a little tweaking it's fun to use.

Author's Conclusions

This is one complex little camera! However, with complexity comes great configurability and power. The next chapter will consider the more advanced options of Shooting Menu 2, which lets you control things like Frame Speed, Bracketing, HDR, Multiple Exposures, and Time Lapse.

4 Shooting Menu 2:
Advanced Shooting Options

Image © Darrell Young

Shooting Menu 2 contains advanced shooting options for the E-M1. In this chapter we will discuss how to use functions that are used less often than the functions in Shooting Menu 1. The advanced options are important for expert use of this professional camera.

Here is a basic look at Shooting Menu 2 and its seven selections. We will take a closer look later in this chapter. Be sure to have your camera in hand and make adjustments as you work through the sections.

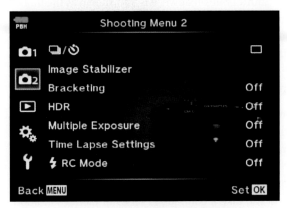

Figure 4.1: The seven functions in Shooting Menu 2

On Shooting Menu 2 you will find the following functions:

- **[Sequential]/[Self-timer] shooting:** You can choose single-frame shooting, [Sequential] H (high), or [Sequential] L (low) for taking either one picture at a time or continuous images up to 10 frames per second. Also, the camera has a Self-timer that offers various time lengths, intervals, and frame counts.
- **Image Stabilizer:** This option uses the camera's 5-axis image stabilization capability. You can choose from several image stabilization modes when you shoot still pictures, or you can choose on or off for Movie mode.
- **Bracketing:** You can choose from a series of Bracketing types, including exposure, white balance, flash, ISO sensitivity, and Art Mode.
- **HDR:** You can chose a high dynamic range (HDR) mode, including several frame counts for the bracket, along with two special high-contrast modes.
- **Multiple Exposure:** You can shoot multiple frames and combine or overlay them in various ways to create one picture.
- **Time Lapse Settings:** You can shoot up to 999 frames with a specific time interval between the individual images. You can automatically combine pictures into a Time Lapse Movie.
- **[Flash] RC Mode:** The included FL-LM2 accessory flash unit can be used as a remote control (RC) wireless flash controller so you can use more powerful off-camera Olympus flash units.

Now, let's consider each of these functions in detail.

[Sequential]/[Self-Timer] Shooting

The Sequential and Self-timer shooting modes use the same menu. They are known as release modes because they control when and how fast the camera releases the shutter and takes pictures.

The Sequential shooting modes control how many pictures your camera can take each second, in bursts, when you hold the Shutter button down. It is also known as the frames per second (fps) or frame rate setting.

The Self-timer modes allow you to select a specific time delay for taking hands-off pictures. You press the Shutter button and the camera will automatically take pictures a few seconds later.

Let's look at the details of each mode:

- **[Single-Frame] shooting:** This mode causes the camera to take one picture each time you fully press the Shutter button.
- **[Sequential] High (H):** The camera will take a continuous series of pictures at about 10 fps. Autofocus, exposure, and white balance are frozen at the values determined by the camera for the first picture and are not updated during the series.
- **[Sequential] Low (L):** The camera will take a continuous series of pictures at about 6.5 fps with firmware 2.0 or 9 fps with firmware 3.0. Autofocus, exposure, and white balance are updated for each picture in the series, based on which autofocus mode you selected (e.g., S-AF, C-AF, MF) and whether you are using autoexposure lock (AEL) or autofocus lock (AFL).
- **[Self-timer] 12 sec (12s):** The camera will take a single photograph 12 seconds after you press the Shutter button all the way down. The orange focus assist light on the front of the camera will shine solid for 10 seconds, then it will blink for 2 seconds before the shutter fires and the picture is taken.
- **[Self-timer] 2 sec (2s):** The camera will take a single photograph 2 seconds after you press the Shutter button all the way down. The orange focus assist light on the front of the camera will blink for two seconds before the shutter fires and the picture is taken.
- **[Self-timer] Custom (C):** This variable self-timer function allows you to select the number of images the camera will take when the self-timer expires (Frame), the time in seconds the camera will wait before firing (Timer), and the period of time between each picture (Interval Time) if you have selected more than one picture with the Frame setting.

Note: The camera's large internal memory buffer can hold a burst series of about 41 RAW (ORF) images, 79 Large Super Fine (LSF) JPEG images, or 114 Large Fine (LF) JPEG images while it writes them sequentially to the SD card. This is an impressive number of images, especially for RAW, and it proves this camera was designed for professional image making.

If you exceed the number of images that can be held in the internal memory buffer, the camera's frame rate will slow down considerably as it writes images to the memory card.

Geek Facts: There is a chart on page 124 of the E-M1 user's manual that shows the record modes, compression rates, and pixel ratios and how many images the camera can hold in its internal memory buffer during bursts, per selected mode. For instance, if you shoot Small Basic (SB) JPEGs, the camera can hold 10,170 images in its internal memory buffer as it writes them to the card.

Some of these numbers are merely projections because even at 10 fps (600 frames per minute) it would take almost 17 minutes to shoot 10,170 frames. Who is going to hold the Shutter button down for 17 minutes? It's nice to know you could if you really wanted to!

Interestingly, if you multiply some of these numbers (file size x number of frames), it appears that the E-M1 has an internal memory buffer size of about 1.5 GB (e.g., Small Normal (SN) JPEGs at 0.2 MB each x 7,627 maximum images in the buffer = 1,525.4 MB or 1.5 GB).

Now, let's look at how to select the individual modes and then examine how to configure the Self-timer Custom mode.

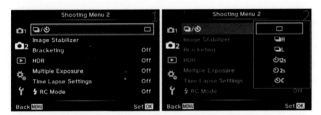

Figure 4.2A: Selecting a frame rate or self-timer mode

Use these steps to select one of the [Sequential]/[Self-timer] shooting modes:

1. Select the symbols for the [Sequential]/[Self-timer] shooting modes from Shooting Menu 2 and scroll to the right (figure 4.2A, image 1).
2. A small window will open with all the choices for the two modes. Scroll up or down and select the mode you want to use, then press the OK button to lock in your setting (figure 4.2A, image 2). I chose [Single-Frame] shooting mode.

If you use the [Self-timer] Custom (C) mode, you will have a series of additional menu screens to use, as described next.

[Self-timer] Custom (C) Mode

The [Self-timer] Custom mode allows the camera to automatically take one or a series of pictures with one press of the Shutter button. This allows you to take consecutive pictures without touching the camera and introducing new vibrations, which results in sharper pictures.

You can adjust the number of frames, the self-timer wait time, and the interval between frames. Let's see how.

Figure 4.2B: Using Self-timer Custom mode and setting the number of frames

The following steps show you how to use the [Self-timer] Custom mode. First we'll set the number of frames:

1. Select the symbols for the [Sequential]/[Self-timer] shooting mode from Shooting Menu 2 and scroll to the right (figure 4.2B, image 1).
2. A small window will open with all the choices for the two modes. Scroll down to the last item and highlight the [Self-timer] Custom (C) mode, then scroll to the right (figure 4.2B, image 2).
3. Highlight Frame and scroll to the right (figure 4.2B, image 3). In the next step we will choose the number of frames we want the camera to shoot after the Self-timer delay.
4. Use the up/down menu to choose from 1 to 10 frames (1f to 10f). The camera will take that number of pictures after it counts down the Self-timer delay you will choose for the Timer setting (coming up next). I chose 2f (two frames) (figure 4.2B, image 4).
5. Press the OK button to lock in your choice.

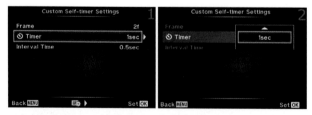

Figure 4.2C: Choose a Self-timer delay (Timer)

6. Now you can choose a Timer setting—the Self-timer delay. Highlight Timer on the menu and scroll to the right (figure 4.2C, image 1).
7. Use the up/down menu to select 1 to 30 seconds (1sec to 30sec), which the camera will use for counting down the Self-timer delay (figure 4.2C, image 2). The orange AF illuminator lamp will shine steadily until the last two seconds before the camera fires the

shutter. The orange light will blink for the last two seconds and then take the picture or pictures, depending on the Frame setting you chose in steps 3 and 4 (figure 4.2B, images 3 and 4). I chose 1sec from the menu.

8. Press the OK button to set the Timer selection.

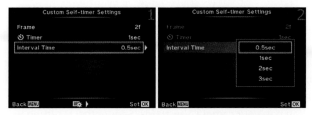

Figure 4.2D: Choose a delay between pictures (Interval Time)

9. Now you can choose a time delay or interval between the number of frames you se-lected. If you chose a Frame setting of at least 2f, the camera will pause for the amount of time you specify between pictures. Highlight Interval Time and scroll to the right (figure 4.2D, image 1).

10. A small window will open where you can choose an Interval Time of 0.5 second to 3 seconds (0.5sec to 3sec) between pictures. Highlight your choice and press the OK button to select it. I chose 0.5sec (figure 4.2D, image 2).

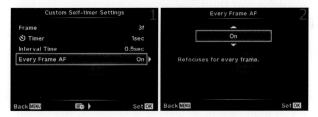

Figure 4.2E: Using autofocus during the self-timer operation

11. Next you must choose whether you want the camera to autofocus for each frame taken during the self-timer operation, or to autofocus on the first frame only. Choose Every Frame AF and scroll to the right (figure 4.2E, image 1). Scroll up or down to select On or Off from the Every Frame AF menu (figure 4.2E, image 2). If you select On, the camera will auto-focus for every shot in the self-timer series. If you select Off, the camera will autofocus on the first frame of the series only.

12. You are almost done, but you must make a final choice from the menu. When you pressed the OK button to choose the Interval Time in step 10, the camera switched back to the menu you started with when you began to configure the [Self-timer]

Figure 4.2F: Locking in the Self-timer Custom mode for immediate use

Custom setting. Simply press the OK button again, with C highlighted, and the camera will stay in [Self-timer] Custom mode until you change it (figure 4.2F). Take your pictures.

Settings Recommendation: When you are taking your time and shooting something like beautiful landscapes one frame a time, the [Single-Frame] shooting mode is perfect. It takes one picture for each press of the Shutter button, which is what most of us need much of the time.

However, if you are a sports or action shooter, you will need to use the fast, continuous frame rate and large buffer size of the E-M1. Your primary choices are [Sequential] H and [Sequential] L. If the subject is moving from side to side in front of you in consistent lighting conditions so you can pan your camera, the 10 fps [Sequential] H setting will be quite useful. The autofocus, exposure, and white balance will be locked, so make sure the subject is not moving toward or away from you or moving through areas with different light levels or color temperatures. If the subject strays from a singular path or if the light changes, it may be better to use the [Sequential] L setting, which fires at 6.5 fps with firmware 2.0 or 9 fps with firmware 3.0. Although it is not quite as fast, the camera updates the focus, exposure, and white balance so you can track and shoot subjects that move toward or away from you and still capture sharp, well-exposed, and balanced pictures.

When you use the [Self-timer] shooting mode, you have two preset choices (12s and 2s), along with a completely customizable custom function. Why not experiment with the [Self-timer] Custom mode so you will know how to use it later?

Image Stabilizer

Image stabilization is critical for people who shoot a lot of handheld images and videos. Instead of getting blurry images from camera movement at slower shutter speeds, the amazing Image Stabilizer built into the E-M1 makes it one of the best cameras in the world for shooting handheld.

The vibration reduction in the camera's 5-axis, sensor-shifting stabilizer system is one of the best—or perhaps *the* best—available today. It is built into the camera body, so any lens you mount on the camera has automatic stabilization and vibration reduction. While most other cameras and lens manufacturers offer only 2- or 3-axis image stabilization, the E-M1 takes it all the way to 5-axis. This is indeed a pro camera!

As shown in figure 4.3A, the camera compensates for moderate movement by shifting the sensor in several directions: roll, pitch, yaw, vertical, and horizontal. The following list describes each of the corrections:

- **Axis 1, Roll:** Imagine turning your camera like you would the steering wheel of a car, and you will understand roll. You rotate the camera clockwise or counterclockwise in a semicircle while keeping the lens level and pointing directly forward.

- **Axis 2, Pitch:** Imagine moving the front of the lens up or down, the way you look up to the sky or down to the ground. The end of the lens moves up or down like the tip of your nose.
- **Axis 3, Yaw:** Imagine turning the front of the lens left and right while you keep the end of the lens level. This is similar to how you turn your head to the left and right to see the area around you. Your nose stays level and your head turns.
- **Axis 4, Vertical:** Imagine picking up a box and setting it back down. That is a vertical up-and-down movement, with no rotation. Similarly, raising or lowering the camera body without tilting the lens or the camera body in any direction is vertical movement.
- **Axis 5, Horizontal:** When you clean a window and move your hand back and forth from left to right, that is horizontal motion. In a similar way, if you move the camera left and right without raising, lowering, or tilting it, that is horizontal motion.

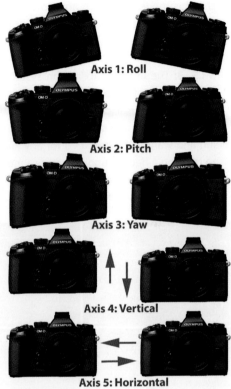

Figure 4.3A: The 5-axis, sensor-shifting Image Stabilizer system in the E-M1

The camera can compensate for all these motions. In fact, it compensates much more than you might expect, if you have used any other brands of image-stabilization or vibration-reduction systems. I've never used a better system!

Let's discuss each type of Image Stabilizer mode and how to select them.

Still Image Stabilization

First let's examine the image stabilization system for still images (not video). There are four Image Stabilizer modes, and Off:

- **Off:** No image stabilization is provided.
- **S-I.S. 1:** This is a general automatic mode that allows the Image Stabilizer to compensate in all five directions, as previously described. It automatically uses any or all of the axes at any time. It is not as sensitive to panning as S-I.S. AUTO.

- **S-I.S. 2:** The image stabilization system corrects only for the vertical axis (Vertical IS). Use this mode when you are moving the camera vertically and are not concerned about horizontal correction. If you are panning horizontally, such as at a car race, and are holding the camera in a horizontal (landscape) orientation, this mode may perform well for you.
- **S-I.S. 3:** The image stabilization system corrects only for horizontal camera shake (Horizontal IS). If you are panning horizontally, such as at a car race, and are holding the camera in a vertical (portrait) orientation, this mode may perform well for you.
- **S-I.S. Auto:** Olympus suggests this mode when you are unsure what you will be shooting and want to be prepared for any kind of movement. From shooting landscapes to tracking a deer bounding across a meadow and jumping over a fence, the camera automatically chooses the best type of image stabilization for the subject it detects. This is the factory default mode.

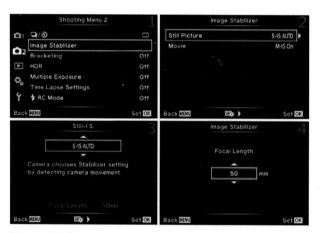

Figure 4.3B: Choosing an Image Stabilizer mode for still images

Use these steps to choose one of the Image Stabilizer modes for still images:

1. Select Image Stabilizer from Shooting Menu 2 and scroll to the right (figure 4.3B, image 1).
2. Highlight Still Picture on the Image Stabilizer menu and scroll to the right (figure 4.3B, image 2).
3. Use the up/down menu to choose one of the Image Stabilizer modes, or Off (figure 4.3B, image 3). I left the camera to the factory default of S-I.S. Auto. Press the OK button to lock in your choice. (If you are *not* using a Micro Four Thirds or Four Thirds lens on an intelligent adapter [e.g., an Olympus MMF-3], proceed to step 4. Why? When you are using a lens with no electronic connection to the camera [dumb adapter] that lens cannot transmit the focal length electronically to the E-M1 body.)
4. Choose a value from the up/down menu to register a Focal Length for a lens mounted on a lens adapter that does not have communication with the camera body

(figure 4.3B, image 4). Press up or down on the Arrow Pad buttons to select a Focal Length. The range of Focal Length choices are from 8 mm to 1000 mm. My camera has 50 mm selected. The camera will not know what focal length is mounted on a dumb adapter unless you tell it with this screen (image 4). Once you have selected a value, press the OK button to lock it in.

Settings Recommendation: Most people leave the Image Stabilizer set to S-I.S. Auto. The camera seems to handle all sorts of angles and movement. If you pan your camera in specialized situations, such as at air shows or car races, and you could use stabilization for a certain type of movement, be sure to experiment with S-I.S. 2 and 3.

I don't see any good reason to use S-I.S. 1 because it seems so similar to S-I.S Auto, without panning smarts. After shooting hundreds of images, I have come to trust the Image Stabilizer in my E-M1. I use S-I.S. Auto virtually all the time.

Movie Mode Stabilization

Next let's consider how to use the image stabilization system for shooting videos. I have heard the S-I.S. system for video described as one of the best ever for shooting video. Although the Image Stabilizer does have some gotchas, the camera can definitely be held more steadily than most other cameras you've used to shoot video. It is almost as good as having a video frame with a stabilizer that you bolt the camera into. If you are standing fairly still or walking slowly, the camera will amaze you with how steady the video looks.

Here is a description of the two modes available for video stabilization:

- **M-I.S. On:** The camera uses 5-axis video correction at all times.
- **M-I.S. Off:** The camera provides no video stabilization.

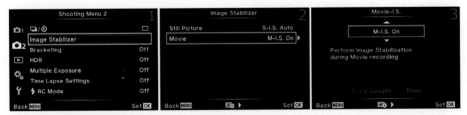

Figure 4.3C: Choosing an Image Stabilizer for Movie mode

Use these steps to choose one of the Image Stabilizer modes for video:

1. Select Image Stabilizer from Shooting Menu 2 and scroll to the right (figure 4.3C, image 1).
2. Highlight Movie on the Image Stabilizer menu and scroll to the right (figure 4.3C, image 2).
3. Choose either M-I.S. On or M-I.S. Off (figure 4.3C, image 3).
4. Press the OK button to lock in the setting.

Settings Recommendation: The one gotcha you will need to experiment with is the tendency for a jump to occur in the video when you are quickly panning from left to right. It seems that the camera tries to keep up with the panning, gives up, then does a major correction. This causes a jump in the video that can be distracting.

If you are walking along and shooting video ahead of you, without a lot of side-to-side movement, or if you are holding the camera still while you shoot video, the image stabilization system works well. The jumpiness occurs only with panning. Test it for yourself and see if it bothers you. It bothers me, so I leave M-I.S. Off for video.

Unfortunately, Olympus does not provide a way to turn off one direction of image stabilization for video, as with still images. If they did, I would turn off horizontal correction to stop the jumpiness.

Bracketing

Bracketing is when you take multiple images of the same subject using different settings, either to guarantee at least one balanced picture or to combine multiple pictures for various effects.

The E-M1 provides five bracketing methods that cover virtually all types of image bracketing: Auto Exposure (AE BKT), White Balance (WB BKT), Flash (FL BKT), ISO sensitivity (ISO BKT), and Art Bracketing (ART BKT).

This section describes how to configure bracketing. You will often have to return to this menu to configure how bracketing works, even though you can select it with external controls. First let's consider how the camera shoots individual frames in a bracketed series.

Shooting a Bracketed Series of Images

You need to be aware of the options you have to shoot the bracketed series of frames. There are several choices:

- **[Single-Frame] shooting:** If you are using [Single-Frame] shooting, one picture in the bracket series will be taken with each full press of the Shutter button.
- **[Sequential] H or L:** If you switch to [Sequential] H or [Sequential] L mode, you can hold down the Shutter button and the camera will shoot only the number of images in the bracket, then it will stop.
- **[Self-timer] Custom:** For hands-off bracketing while the camera is on a tripod, you may use the [Self-timer] Custom mode while AE BKT is enabled. You simply set the Timer (e.g., 5sec delay) and the Interval Time (e.g., 0.5sec between frames) to whatever you want, and you set the Frame (e.g., 7f) to match the number of frames in the bracket. The camera will wait for the Timer delay to expire, shoot one of the bracketed frames, wait for the Interval Time to shoot the next frame, and continue this sequence until the series is completed. (See the previous subsection in this chapter, **[Self-timer] Custom (C) Mode,** to see how to use the self-timer.)

The shooting methods for bracketing in the previous list apply only to AE BKT, FL BKT, and ISO BKT. For WB BKT and ART BKT, you take only one picture and the camera creates multiple copies of that picture and applies effects.

When you take pictures in brackets that allow you to control individual frames, the camera always shoots frames with exposure variations in this order: *normal exposure > underexposure > overexposure*. For example, if you choose to shoot a seven-frame bracket (7f) in AE BKT, the camera will shoot the bracket in this sequence: *normal exposure > underexposure 1 > underexposure 2 > underexposure 3 > overexposure 1 > overexposure 2 > overexposure 3*.

Now, let's consider the five bracketing types and see what each does.

AE BKT (Auto Exposure Bracketing)

Auto Exposure bracketing allows you to shoot from two to seven images in a bracket. The exposure of each shot varies by 0.3, 0.7, or 1.0 EV steps. Later you can select the best image from the series or combine the images into one high dynamic range (HDR) image.

Let's examine how to select and use AE BKT.

Use these steps to configure AE BKT:

1. Choose Bracketing from Shooting Menu 2 and scroll to the right (figure 4.4A, image 1).
2. A small menu will open and allow you to select Off or On. Highlight On and scroll to the right (figure 4.4A, image 2). Or you can disable AE BKT by selecting Off and pressing the OK button (then skip the rest of these steps).
3. Highlight AE BKT and scroll to the right (figure 4.4A, image 3).

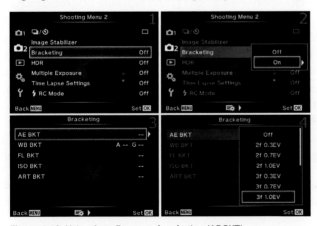

Figure 4.4A: Using Auto Exposure bracketing (AE BKT)

4. A menu will open with many bracketing choices that look like this: 3f 1.0EV (figure 4.4A, image 4). The first two characters represent the number of frames in the bracket, from two to seven frames (2f to 7f). The second group of characters represent the EV variation between images in the bracket. Your choices are 1/3 EV step (0.3EV), 2/3 EV step

(0.7EV), and 1 EV step (1.0EV). If you choose 3f, 5f, or 7f, skip step 5 and go directly to step 6. If you choose 2f, move on to step 5 because the three 2f choices bring up an extra screen.

5. If you choose any of the three 2f choices, you will need to decide if the second image in the bracket will be overexposed (Over Exp. Pic.) or underexposed (Under Exp. Pic.). Figure 4.4B shows the screens you use to make your selection. Image 1 is the same as figure 4.4A, image 4, except 2f has been selected. Use the up/down menu shown in figure 4.4B, image 2, to choose either an overexposed image (Over Exp. Pic.) or an underexposed image (Under Exp. Pic.) for the second picture in the 2f bracket series. Press the OK button to lock in your choice, and take your pictures. Skip step 6.

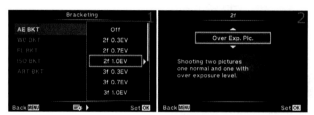

Figure 4.4B: A 2f exposure variance is selected

6. Highlight 3f, 5f, or 7f and press the OK button. The screen in figure 4.4A, image 2, will reappear. Select On and press the OK button to lock in your choice, then take your pictures.

Note: Be sure to disable AE BKT when you are done taking exposure-bracketed pictures.

Settings Recommendation: If you are shooting a two- or three-frame bracket it may be best to choose a 1.0EV. That will result in enough difference among the exposures to combine them or choose the best one. When you shoot a five- or seven-frame bracket, so much extra light is captured that you may get by with smaller variations between the images (e.g., 0.3EV or 0.7EV). Experiment with this to see what works for you. Auto Exposure bracketing is a useful tool for HDR shooters and people who want to have the best exposure and don't mind the extra shots.

WB BKT (White Balance Bracketing)

White Balance (WB) bracketing lets you shoot one image and have the camera bracket the WB on the Amber–Blue (A–B) axis, the Green–Magenta (G–M) axis, or a combination of both axes (A–B + G–M).

You can select two, four, or six steps of color change for the A–B or G–M axis, or you can apply two, four, or six steps of color change to the combined A–B + G–M axes. The camera will create two WB-modified copies of the original image for each single-axis bracket (three images per axis), or eight copies plus the original image for the combined-axes bracket (nine images total). Tables 4.1–4.3 demonstrate this in an easy-to-understand pattern.

This function may seem complex, but you don't have to fully understand it to success-fully bracket the white balance of your image. You can simply fire off a bracket and look at the resulting images to choose the one you like. However, it's more efficient to understand what happens when you use WB bracketing.

First let's discuss how to configure WB BKT, then we will look at the WB bracket system in more detail.

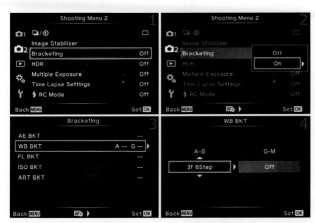

Figure 4.4C: Using White Balance bracketing (WB BKT)

Use these steps to configure WB BKT:

1. Choose Bracketing from Shooting Menu 2 and scroll to the right (figure 4.4C, image 1).
2. A small window will open where you can choose Off or On. Highlight On and scroll to the right (figure 4.4C, image 2). Or you can disable WB BKT by selecting Off and press-ing the OK button (and skipping the rest of these steps).
3. Highlight WB BKT and scroll to the right (figure 4.4C, image 3).
4. You will see two up/down menus (figure 4.4C, image 4). One is for the A–B axis and the other is for the G–M axis. You can choose two steps (3f 2Step), four steps (3f 4Step), or six steps (3f 6Step) of color change. The 3f simply means the camera will create three images per axis. Select a value for one or both of the axes and press the OK button. The screen shown in figure 4.4C, image 2, will reappear. Highlight On and press the OK button again to lock in your WB BKT configuration. I chose to bracket the A–B axis only, and I used six steps (6Step) of color changes for maximum color shift in the bracket.
5. Take a single picture and the camera will create color-shifted copies to complete the bracketed series (refer to tables 4.1–4.3).

Note: Be sure to turn WB BKT off when you are done bracketing.

Tables 4.1–4.3 show the pattern the camera uses for White Balance bracketing. The tables demonstrate only the two-step version (3f 2Step) of WB BKT. All three bracketing variations use the same pattern with wider color steps or more intense color changes. As you increase the bracket from two steps (2Step) to four steps (4Step) to six steps (6Step),

the color changes become more saturated. Therefore, you can substitute 4 or 6 for 2 in the tables and see that the 2Step, 4Step, and 6Step patterns work the same.

A–B axis bracket (3f 2Step)		
Image number	A–B	G–M
1	A +0	G +0
2	A −2	G +0
3	A +2	G +0

Table 4.1: The WB BKT A–B pattern (notice that G–M stays at 0)

G–M axis bracket (3f 2Step)		
Image number	A–B	G–M
1	A +0	G +0
2	A +0	G −2
3	A +0	G +2

Table 4.2: The WB BKT G–M pattern (notice that A–B stays at 0)

A–B + G–M axes bracket (3f 2Step)		
Image number	A–B	G–M
1	A +0	G +0
2	A +0	G −2
3	A +0	G +2
4	A −2	G +0
5	A −2	G −2
6	A −2	G +2
7	A +2	G +0
8	A +2	G −2
9	A +2	G +2

Table 4.3: The WB BKT combined A–B + G–M pattern

Settings Recommendation: This complex-sounding WB bracketing system is not as hard as it looks. Just remember that you can simply create the bracket and then select the image you like best. If none of them are color shifted enough for your liking, use more steps in the bracket—that is, switch from 3f 2Step to 3f 4Step, or even 3f 6Step.

FL BKT (Flash Bracketing)

Flash bracketing varies the light output of the flash over three frames (3f) so you can get the best exposure. You can select bracket levels of 0.3EV, 0.7EV, or 1.0EV, which gives you a difference of as little as 1/3 stop, and as much as 1 stop, between the images in the bracket.

The bracketing order for the three frames is *normal > underexposed > overexposed*. The camera will take a normal exposure with the flash and then two more exposures with under- and overexposure; the amount depends on the bracket levels you selected.

Let's examine how this works.

Use these steps to configure FL BKT:

1. Choose Bracketing from Shooting Menu 2 and scroll to the right (figure 4.4D, image 1).
2. A small window will open and allow you to select Off or On. Highlight On from the menu and scroll to the right (figure 4.4D, image 2). Or you can disable FL BKT by selecting Off and pressing the OK button (and skipping the rest of these steps).
3. Highlight FL BKT on the Bracketing menu and scroll to the right (figure 4.4D, image 3).
4. You will now see a small popup menu with four choices (figure 4.4D, image 4). The available selections are three frames with a variance of 1/3 EV (3f 0.3EV), three frames with a variance of 2/3 EV (3f 0.7EV), and three frames with a variance of 1 EV (3f 1.0EV). Highlight your selection and press the OK button. The camera will switch back to the menu in figure 4.4D, image 2. Select On and press the OK button again to lock in your selection. Take your pictures.

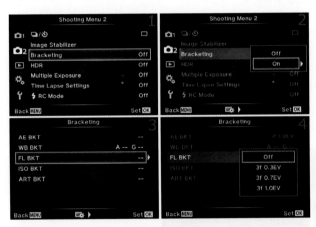

Figure 4.4D: Using Flash bracketing (FL BKT)

Note: Be sure to disable FL BKT when you are done taking flash bracketed pictures.

Settings Recommendation: The recharge cycle time of your flash unit will determine how quickly you can fire the three bracketed images in the series. When I used the FL-LM2 flash included with the camera, it took at least one second before I could fire the second and third images in the bracket. Evidently, the small flash unit takes a little longer to recharge itself for the next shot. However, when I used my Olympus FL-600R flash unit, I was able to fire the flash bracket series with no delay between the images.

A larger flash unit will perform better when you need rapid flash bracketing. If you can wait a moment between shots, the small included flash will suffice for closer subjects.

ISO BKT (ISO Bracketing)

ISO bracketing allows you to bracket three frames with bracket levels of 0.3EV, 0.7EV, or 1.0EV for two of the pictures. The bracket order for the three frames is *normal > underexposed > overexposed*.

The camera will take a picture at the ISO sensitivity you selected. You can then take two more pictures with different ISO settings: one underexposed and another overexposed. The amount of under- and overexposure depends on the EV you select.

There are two things you need to be aware of when you use ISO bracketing:

- **Continuous bracketing:** With other types of bracketing, when you use Sequential H or Sequential L modes and hold down the Shutter button, the E-M1 will take only the number of frames in the bracket and then stop taking pictures. However, with ISO BKT the camera will *not* stop taking pictures when it reaches the end of the bracket. If you hold down the Shutter button in Sequential H or Sequential L modes, the camera will continue firing at full speed until the image buffer is full, and the three-frame bracketing sequence will repeat. This feature allows you to bracket rapidly moving subjects while you track them with your camera.
- **Nothing lower than Low ISO:** If you have your camera set to Low ISO, which is below ISO 200 and is equivalent to ISO 100, it will not be able to shoot the underexposed frame of the bracket. Instead you will have two normal (Low or ISO 100) exposures and one overexposed image in the three-frame bracket (*normal > normal > overexposed*). Obviously, the camera cannot go below its lowest ISO value to capture an underexposed image.

Now, let's see how to configure ISO bracketing.

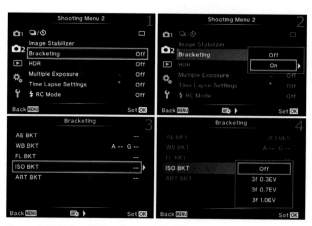

Figure 4.4E: Using ISO Bracketing (ISO BKT)

Use these steps to configure ISO BKT:

1. Choose Bracketing from Shooting Menu 2 and scroll to the right (figure 4.4E, image 1).
2. A small window will open where you can select Off or On. Highlight On and scroll to the right (figure 4.4E, image 2). Or you can disable ISO BKT by selecting Off and pressing the OK button (and skipping the rest of these steps).
3. Highlight ISO BKT on the Bracketing menu and scroll to the right (figure 4.4E, image 3).
4. You will see a small popup menu with four choices (figure 4.4E, image 4). The available selections are three frames with a variance of 1/3 EV (3f 0.3EV), three frames with a variance of 2/3 EV (3f 0.7EV), and three frames with a variance of 1 EV (3f 1.0EV). Highlight your selection and press the OK button. The camera will switch back to the menu in figure 4.4E, image 2. Select On and press the OK button again to lock in your selection. Take your pictures.

Note: Be sure to disable ISO BKT when you are finished.

Settings Recommendation: For subjects that have a lot of contrast, you will want to use a wider range of EV in the ISO BKT, such as 3f 1.0EV. For lower-contrast subjects you may be able to fine-tune the exposure by using 3f 0.3EV. Experiment with this setting so you'll know how to use it when you need to make sure you get a good exposure.

ART BKT (Art Mode Bracketing)

When you use Art bracketing from the Art selection on the camera's Mode dial, the camera will make copies of a picture and apply each of the Art Modes you select (shown in figure 4.4G). You can take just one picture and the camera will bracket, or copy, it and apply each of the selected Art Modes to the copies. This results in numerous copies of the original image with a different filter applied to each one.

You can choose from 14 Art Modes for ART BKT, and you can even add the normal basic filters to the bracket. This will create an additional 7 images. That's up to 21 copies of a single image with all sorts of Art and Basic filters applied. Imagine that many pictures from a single shot—perhaps too many!

Let's see how to select the filters you would like to use in the ART bracket.

Use these steps to configure ART BKT:

1. Choose Bracketing from Shooting Menu 2 and scroll to the right (figure 4.4F, image 1).
2. A small window will open where you can select Off or On. Highlight On and scroll to the right (figure 4.4F, image 2). Or you can disable ART BKT by selecting Off and pressing the OK button (and skipping the rest of these steps).
3. Highlight ART BKT on the Bracketing menu and scroll to the right (figure 4.4F, image 3).
4. You will see a small popup menu with two choices: On and Off (figure 4.4F, image 4). Highlight On and scroll to the right.

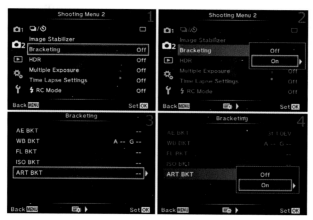

Figure 4.4F: Using Art Mode Bracketing (ART BKT)

5. The camera will display a list of 14 Art Modes that have already been checked and 7 unchecked Basic filters, as partially seen in figure 4.4G, images 1 and 2. Scroll up or down and check or uncheck any number of filters by highlighting a filter type and pressing the OK button. When you are done checking and unchecking filters, press the Menu button to return to the screen in figure 4.4F, image 4. Be sure On is highlighted and press the OK button again. The camera will return to the menu shown in figure 4.4F, image 3, except On will be displayed after ART BKT. Press the OK button once more and the camera will return to the screen in figure 4.4F, image 2. Select On and press the OK button a final time to enable Bracketing, and the camera is ready to use.

Figure 4.4G: Choosing an ART or Basic Filter

6. Take a *single* picture. The red card write symbol will flash in the upper-left corner of the viewfinder or monitor until all the copies (up to 21) are created. You will see each image displayed briefly—with a different filter applied—as it is created.

Note: Be sure to turn off ART BKT or you will create multiple pictures each time you press the Shutter button.

Settings Recommendation: This bracketing method is fun a time or two, but then you might wonder why you're using it. About the only time I use ART BKT is when I want to show off the prowess of this camera. I usually say something like, "I bet your camera won't do this!"

Unless you like a buffet of arty pictures to choose from, I don't see the point of this function. Try it a time or two and see what you think. And remember, if you shoot in RAW mode, any of these filters can be applied after the fact in the Olympus Viewer 3 software.

Bracketing Chaos

Be sure to disable *all* forms of bracketing within their respective configuration screens when you are done with that bracketing type. If you don't, *the camera will stack the bracketing methods* and use them at the same time.

Suppose you have AE BKT and ART BKT enabled simultaneously. The camera will create three AE BKT pictures with the *normal > underexposure > overexposure* AE bracketing, and it will also create up to 21 ART BKT images for each of the three AE BKT images. The camera will apply each AE BKT to every ART BKT image, and you could end up with dozens of images. Imagine what would happen if you have several bracketing methods turned on at the same time and take pictures—bracketing chaos!

Some forms of bracketing are mutually exclusive to other forms of bracketing. If you have a certain bracketing type enabled, another bracketing type will disable the previously selected type. Experiment by trying to enable multiple bracketing types and you will see what I mean.

Be careful with these bracketing methods. I have not seen any warnings when multiple bracketing types are enabled at the same time. This could be useful if that is your intention, but I am afraid that many people will forget to turn them off and will get results they never expected. Be aware that bracketing chaos is entirely possible!

HDR

High dynamic range (HDR) imaging allows you to shoot several images of the same scene, with different exposures, and combine them into one image either immediately in-camera or later during post-processing. The result is an image with a massive dynamic range that is more like what the human eye can see than what a camera can normally capture in just one image.

The camera offers two modes that automatically combine the images in-camera (HDR1 and HDR2). Five other modes shoot three, five, or seven images with different exposure values. You can combine them into a single HDR image during post-processing on your computer (figure 4.5A).

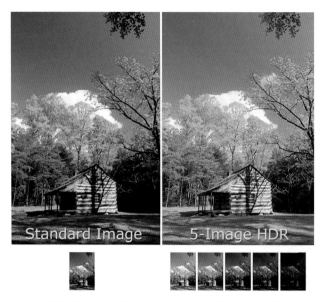

Figure 4.5A: A Standard picture compared to a five-image HDR picture

HDR1 and HDR2

If you have the camera set to RAW and enable the HDR1 or HDR2 setting, the camera will switch to a JPEG+RAW mode (if it is not already set to such a mode) and capture a normal RAW image; it will also combine the separate JPEG images into one HDR image. The result is two images: one RAW and one combined HDR JPEG.

If the camera is set to a JPEG mode, it will take three to seven pictures as JPEGs only and combine them into a single HDR JPEG.

The following are descriptions of each in-camera, automatic HDR mode:

- **HDR1:** The camera takes four images in rapid succession and combines them, in-camera, to create an HDR image that does not overdo the HDR look. It keeps some shadow contrast so the image does not look overprocessed. It looks more like a well-exposed image with a wider dynamic range than normal.
- **HDR2:** The camera takes four images in rapid succession and combines them, in-camera, to create a painterly, overprocessed HDR image with very light shadows that contain much more detail than normal.

Note: The HDR1 and HDR2 modes use ISO 200, the Picture Mode is set to Natural, and the Color Space is set to sRGB. The slowest available shutter speed you can choose as a base is 1 second. The camera will automatically make a maximum exposure of up to 4 seconds, as the longest exposure during the bracketed image series. Continuous autofocus (C-AF) will not function, so the camera automatically switches to Single autofocus (S-AF).

The Other Five HDR Modes

If you want to combine your own HDR images in your computer, the camera is ready to provide what you need.

In addition to the two automatic HDR modes, five other HDR modes create individual images with various exposure levels so you can combine them yourself in software like Photomatix Pro or Photoshop:

- **3f 2.0EV:** Creates three frames (3f) with 2 EV steps between each frame (2.0EV). It uses the *normal > underexposure > overexposure* method of exposing the images.
- **5f 2.0EV:** Creates five frames (5f) with 2 EV steps between each frame (2.0EV). It uses the *normal > underexposure > underexposure > overexposure > overexposure* method of exposing the images.
- **7f 2.0EV:** Creates seven frames (7f) with 2 EV steps between each frame (2.0EV). It uses the *normal > underexposure > underexposure > underexposure > overexposure > overexposure > overexposure* method of exposing the images.
- **3f 3.0EV:** Creates three frames (3f) with 3 EV steps between each frame (3.0EV). It uses the *normal > underexposure > overexposure* method of exposing the images.
- **5f 3.0EV:** Creates five frames (5f) with 3 EV steps between each frame (3.0EV). It uses the *normal > underexposure > underexposure > overexposure > overexposure* method of exposing the images.

The camera will use whichever image quality mode you select—RAW or JPEG—to create the individual files.

If you are shooting in a JPEG+RAW mode, the camera will create all the HDR images for each mode. If you select 3f 2.0EV and shoot in JPEG+RAW mode, the camera will create two normally exposed images (one JPEG and one RAW), two underexposed images (one JPEG and one RAW), and two overexposed images (one JPEG and one RAW).

Let's examine how to configure the HDR system.

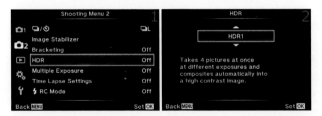

Figure 4.5B: Selecting and using an HDR mode

1. Choose HDR from Shooting Menu 2 and scroll to the right (figure 4.5B, image 1).
2. Use the up/down menu to select one of the HDR types (figure 4.5B, image 2). Your choices include HDR1 and HDR2, the five other HDR modes discussed in the previous list, and Off.

3. Press the OK button to lock in the HDR mode of your choice. If you select HDR1 or HDR2, the camera will automatically take four pictures with one press of the Shutter button, and then combine them into a single HDR image. In any of the other five HDR modes (e.g., 3F 2.0EV, 5F 2.0EV), you can use Sequential H or Sequential L release mode to shoot the frames in the HDR series. You can press and hold down the Shutter button until the camera stops taking pictures; the camera is smart enough to take only the selected number of pictures in the bracketed series. Or you can use Single-Frame shooting release mode to take one picture in the series at a time and allow the camera vibrations to die down between images (it's good to use a tripod). Unfortunately, you cannot use the Self-timer to take the HDR image series.

Note: The HDR mode will remain enabled until you select Off from the up/down menu and press the OK button. Be sure to turn off HDR mode when you are done.

Settings Recommendation: You can let the camera combine the images for you, or you can combine them yourself in your computer. I find myself using the HDR1 or HDR2 automatic modes when I am just enjoying photography and want extra range in a certain image. It is very convenient to have the camera do it for you. However, when I am shooting landscapes and am concerned about maximum image quality, I prefer to do my own image combining and tone mapping with Photomatix Pro or Photoshop.

Fortunately, the camera lets us choose how we use HDR—for fun or for professional results.

Multiple Exposure

Multiple Exposure in the E-M1 lets you shoot two separate images and combine them into one image. This process differs from HDR because the exposures of the two images are the same.

There are three ways to use Multiple Exposure:

- **Multiple Exposure without Auto Gain:** Two images are taken with a standard exposure for each, then they are combined in-camera.
- **Multiple Exposure with Auto Gain:** Two images are taken at one-half exposure for each, then they are combined in-camera.
- **Multiple Exposure with Overlay:** You choose a RAW image from the memory card and then take another picture. The camera combines the image from the memory card with the new picture. You can repeat this action to add new exposures to the combined image. Just choose the combined image from the memory card again and shoot another new picture.

Standard Multiple Exposure with and without Auto Gain

The process is harder to describe than to perform. The camera displays the two images on the monitor or in the viewfinder, then you visually line up the two images you want to combine. After you learn about the Multiple Exposure options, the process is easy.

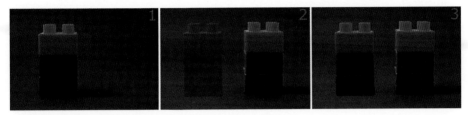

Figure 4.6A: A simulation of combining two images in-camera

Figure 4.6A is a simulation of how to combine two images. Image 1 is the first exposure, and image 2 is the second exposure—image 1 still shows up as a shadowy figure that overlays the live image. Image 3 is the combined image after you press the Shutter button. While you are shooting image 2, you can still see image 1 in your viewfinder or on the camera monitor, so it is easy to align the elements before you press the Shutter button. Use the following steps to try it.

Figure 4.6B: Combining two images in-camera

Use these steps to create a Multiple Exposure:

1. Choose Multiple Exposure from Shooting Menu 2 and scroll to the right (figure 4.6B, image 1).
2. Select Frame from the Multiple Exposure menu and scroll to the right (figure 4.6B, image 2).
3. A small window will open where you can choose Off or 2f (figure 4.6B, image 3). Activate the Multiple Exposure system by highlighting 2f and pressing the OK button. The camera is now ready to take two frames (2f) that will be combined.
4. Select Auto Gain from the Multiple Exposure menu and scroll to the right (figure 4.6B, image 4).
5. A small window will open with two choices: Off and On (figure 4.6B, image 5). Auto Gain affects how the exposure for the two images is made. If you enable Auto Gain (On), the camera will take the two images at half their normal exposure, which will make the background look normal after the two images are combined (because each image has half the needed exposure), and the subjects may be a little transparent. If you do not enable Auto Gain (Off), the camera exposes the two images normally, which will create a much brighter background in the final combined image. Choose On or Off and press the OK button. I chose On in figure 4.6B, image 6.
6. Now you can take the two pictures that the camera will combine. Figure 4.6B, image 7, shows what was displayed in my viewfinder and on my camera or monitor for the first picture. I snapped the picture.
7. Figure 4.6B, image 8, shows what was displayed in my viewfinder and on my camera monitor, including the shadowy figure of the first picture. I moved my camera around until the two images were lined up the way I wanted them, then I pressed the Shutter button.
8. The camera then overlaid the two images and combined them (figure 4.6B, image 9). In a printed book it is difficult to accurately simulate the steps because you cannot see the images being created. However, figure 4.6C shows the results of a Multiple Exposure operation without Auto Gain (image 1) and with Auto Gain (image 2).

Figure 4.6C: Multiple Exposures without Auto Gain (*image 1*) and with Auto Gain (*image 2*)

Next, let's consider how to use the Multiple Exposure Overlay system.

Multiple Exposure with Overlay

The Multiple Exposure Overlay function allows you to choose a RAW image from the memory card and take a new picture that overlays it. The two exposures are then combined (figure 4.6D).

Figure 4.6D: Choosing a RAW image and then overlaying a new picture

This is similar to a normal Multiple Exposure, except the first image already resides in RAW format on the memory card. You chose it from a list of images on the camera monitor and then take the second image for the Multiple Exposure.

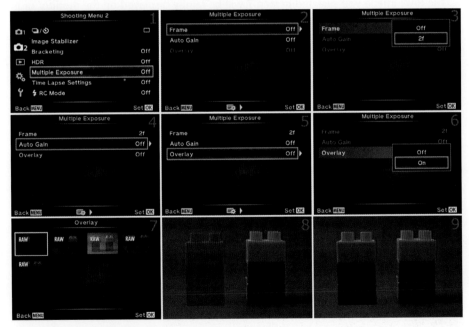

Figure 4.6E: Using the Multiple Exposure Overlay system

Use the following steps to overlay an existing RAW image with a new exposure. Make sure you shoot in RAW mode!:

1. Choose Multiple Exposure from Shooting Menu 2 and scroll to the right (figure 4.6E, image 1).

2. Select Frame from the Multiple Exposure menu and scroll to the right (figure 4.6E, image 2).

3. A small window will open and allow you to choose Off or 2f (figure 4.6E, image 3). Activate the Multiple Exposure system by highlighting 2f and pressing the OK button. The camera is now ready to combine two frames (2f).

4. Select Auto Gain from the Multiple Exposure menu and scroll to the right (figure 4.6E, image 4). I left out the next two screens to keep the figure to a manageable size, but choose On or Off, depending on whether you want to use Auto Gain.

5. Scroll down and select Overlay from the Multiple Exposure menu then scroll to the right (figure 4.6E, image 5).

6. Enable Overlay by selecting On from the small window, then press the OK button (figure 4.6E, image 6).

7. Now you will see a list of all the RAW images on your memory card (figure 4.6E, image 7). A yellow rectangle will surround one of the RAW images. Move the rectangle to the image you want to use as the base for the overlay to select it. I chose a stack of blocks positioned on the left side of the frame.

8. The RAW image you selected in step 7 will be faintly displayed on the monitor or in the viewfinder (figure 4.6E, image 8). You will also see the current scene in front of your lens. Compose the current subject in relation to the RAW image and press the Shutter button.

9. The camera will combine the current subject with the RAW image (figure 4.6E, image 9). You can keep taking pictures and the camera will continue to combine them. You can see the combined image on the monitor or in the viewfinder before you press the Shutter button, so you can make some creative compositions.

Note: Remember that you can combine many exposures into one image. Start at step 7 (figure 4.6E, image 7) and choose a previously combined RAW image to be the base for the Multiple Exposure Overlay, then take a new picture to add to the Multiple Exposure.

Settings Recommendation: Multiple Exposures and Overlays are a lot of fun. You could take a picture of one person and create a twin using Multiple Exposure. Or you could take a RAW picture and later overlay a different subject (or two).

Time Lapse Settings

The Time Lapse function allows you to automatically take a series of images—from 1 to 999—over a period of time and later use the images individually or combine them into a Time Lapse Movie. Maybe you would like to shoot a series of images during an event or shoot star trails overnight with a sunrise at the end. There are many creative ways you can use Time Lapse.

The Time Lapse system has four internal settings:

- **Frame:** This setting allows you to choose from 1 to 999 still images during the automatic shooting interval. They can be used individually or combined into a Time Lapse Movie.
- **Start Waiting Time:** This setting allows you to choose a time delay before the first Time Lapse picture is taken, from 1 second to 99 hours, 99 minutes, and 99 seconds after you press the Shutter button.
- **Interval Time:** This setting configures how much delay occurs between pictures after the Start Waiting Time expires.
- **Time Lapse Movie:** If this setting is Off, the camera records each frame as an individual picture and does nothing else. If it is On, the camera will take each picture, and at the end of the Time Lapse series it will combine all the pictures into a 720p Motion JPEG HD Time Lapse Movie at 10 frames per second (fps) in AVI format. With either setting, you will have all the still pictures at the end. If Time Lapse Movie is On, you have the added benefit of a movie along with the still images. **Note:** Be sure to turn this On if you want a movie, otherwise you will have to combine the frames into a movie in post-processing software, such as Olympus Viewer 3. You can't make a movie in-camera from existing images, except at the end of the Time Lapse series.

Now, let's examine how to configure these settings so you can make some Time Lapse Movies!

Figure 4.7A: Starting the Time Lapse sequence

1. Choose Time Lapse Settings from Shooting Menu 2 and scroll to the right (figure 4.7A, image 1).

2. A small window will open and allow you to choose Off or On (figure 4.7A, image 2). To configure the Time Lapse system, highlight On and scroll to the right.

Figure 4.7B: Choosing the number of images in the Time Lapse series (1–999)

3. Choose Frame from the Time Lapse Settings menu and scroll to the right (figure 4.7B, image 1).
4. Use the three up/down menus to select the number of Frames (pictures) for the Time Lapse series, from 001 to 999 (figure 4.7B, image 2). The factory default is 099 images.

Figure 4.7C: Choosing when the Time Lapse series will start

5. Choose Start Waiting Time from the Time Lapse Settings menu and scroll to the right (figure 4.7C, image 1).
6. Use the three up/down menus to set an hour (hour), minute (min), and second (sec) delay, from 00:00:00 to 99:99:99, before the first Time Lapse frame is taken (figure 4.7C, image 2). The factory default is 00:00:01.

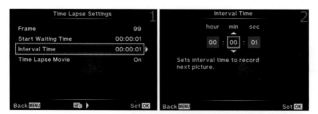

Figure 4.7D: Choosing the delay between frames of the Time Lapse series

7. Choose Interval Time from the Time Lapse Settings menu and scroll to the right (figure 4.7D, image 1).
8. Use the three up/down menus to set an hour (hour), minute (min), and second (sec) delay, from 00:00:00 to 99:99:99, between each frame of the Time Lapse sequence (figure 4.7D, image 2). The factory default is 00:00:01. Remember that you set the number of frames in the Time Lapse sequence in steps 3 and 4 (figure 4.7B). The Interval Time is the delay between each frame. It begins as soon as the first frame at the end of the Start Waiting Time has been taken.

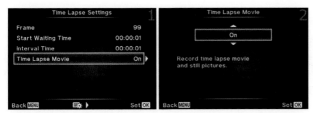

Figure 4.7E: Choosing whether to combine images into a Time Lapse Movie

9. Choose Time Lapse Movie from the Time Lapse Settings menu and scroll to the right (figure 4.7E, image 1).
10. Use the up/down menu to select On or Off (figure 4.7E, image 2). On means the camera will take still Time Lapse images plus make a Time Lapse Movie, and Off means it will take still images and *not* make a movie.

Power Sources for Long Time Lapse Sequences

Be sure you have a fully charged battery before you start a time lapse sequence. A single battery may not last through a longer series of images. Serious time lapse shooters have both a battery pack and an AC adapter for long-term time lapse sequences (figure 4.7F).

Many people use the Olympus HLD-7 battery pack so they can use two internal BLN-1 lithium ion (li-ion) batteries. They use an Olympus AC-3(U) AC adapter for an even longer time lapse series and more frames. The AC-3(U) adapter plugs in to the HLD-7 battery pack, not the camera itself. You therefore need to purchase both items shown in figure 4.7F, which costs around $300.

Figure 4.7F: Olympus HLD-7 battery pack (*left*) and Olympus AC-3(U) AC adapter (*right*)

Settings Recommendation: This camera makes it very easy to create short or long time lapse still-image sequences and movies. If you want to assemble your own time lapse movie outside the camera, you can use the provided Olympus Viewer 3 (or later) software. Or you can let the camera do it all for you. If you have always wanted to make some cool time lapse movies, you now have an easy way to do it. Why not try it tonight?

[Flash] RC Mode

[Flash] RC Mode allows you to use the separate FL-LM2 flash unit that is included in the box with the camera as a controller for an external, off-camera flash unit, such as the Olympus FL-600R or FL-300R. Those two Olympus flash units are recommended in the user's manual, on page 131, as the best flash units for wireless remote control.

You can control up to three banks of multiple flash units, or just one or two external flashes, for much nicer flash light than direct on-camera flash.

We will examine how to make the E-M1 interface with an Olympus FL-600R flash unit and set it up to fire wirelessly as a slave, while using the small, hotshoe-mounted FL-LM2 flash unit as a master. First, let's set up the camera, then we'll configure the external flash unit(s).

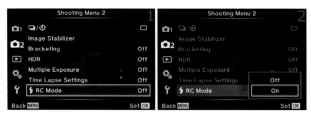

Figure 4.8A: Enabling RC Mode

1. Mount the FL-LM2 flash unit on the camera hot shoe and raise it up into firing position.
2. Press the Menu button, choose [Flash] RC Mode from Shooting Menu 2, and scroll to the right (figure 4.8A, image 1).
3. A small window will open and allow you to choose Off or On (figure 4.8A, image 2). To configure and use [Flash] RC Mode, select On and press the OK button. The live view screen will appear on the camera monitor, but we are not ready to shoot. We need to configure the Super Control Panel for remote-controlled flash.

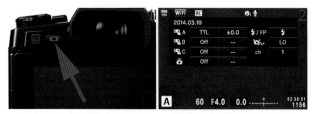

Figure 4.8B: Opening the Super Control Panel with the LV button

4. Press the LV button (figure 4.8B, image 1) to switch out of Live View and open the Super Control Panel (figure 4.8B, image 2). This version of the Super Control Panel is devoted to RC flash control and differs from the normal Super Control Panel. You will see this panel only when [Flash] RC Mode is On. We will use this panel to set up our camera to interface with and control an Olympus FL-600R flash unit. **Note:** If you do not see the

Super Control Panel shown in figure 4.8B, image 2, after you press the LV button, you may need to press the Info button repeatedly to bring it up.

Figure 4.8C: Configuring flash bank A

5. Figure 4.8C, image 1, shows three flash control bank settings (A, B, and C) and a fourth setting (camera symbol) on the left. Each of the A, B, and C banks may control one or many flash units; you can set up complex lighting arrangements and control them wirelessly. Each bank can be configured separately for different lighting effects in various areas of your scene. We will configure only bank A in this example. Highlight TTL (figure 4.8C, image 1, yellow box) and press the OK button. This opens the TTL Auto window, which has four choices: TTL, Auto, M, and Off (figure 4.8C, image 2). You can change the flash mode for the remote slave flash by selecting a mode:

- **TTL mode:** The TTL mode, which is also known as TTL Auto, uses through-the-lens (TTL) technology to automatically create excellent exposures from any combination of flash units on that bank. The flash units send out a nearly imperceptible preflash immediately before the main flash fires. This lets the camera and flash combination balance the light so you don't have to calculate lighting ratios; you just set it to TTL and take pictures.

- **Auto mode:** The Auto mode is an older non-TTL technology that is included for people who are accustomed to using an older type of flash unit. It works pretty much the same as TTL mode, without the preflash that helps the camera and flash unit more accurately balance the light. You can safely ignore Auto mode unless you want to experiment with it. The flash exposures may not be as accurate as those in TTL mode.

- **M mode:** M or manual mode is designed for photographers who are accustomed to using flash units in studios. You can control the power settings for each bank individually, from 1/1, or full power, to as low as 1/128 power. Many people are used to working with flash units this way, so this mode is familiar to them. It is often necessary to calculate flash ratios when you use this mode because there is no automation.

- **Off:** When you choose Off, a flash bank is disabled and does nothing. If you have a group of flash units set up to use this bank, you can temporarily disable the bank—for light testing purposes—by setting it to Off.

Figure 4.8D: Preparing bank A for using TTL mode

6. Now, let's examine how to choose and prepare each of the three active settings in the previous list (TTL, Auto, and M). Remember, you set each flash bank (A, B, or C) individually so you can organize them separately. First we will look at TTL mode and make an exposure compensation for bank A. Choose TTL from the panel (figure 4.8D, image 1) and scroll to the right until ±0.0 is highlighted (figure 4.8D, image 2). Now press the OK button and the screen shown in figure 4.8D, image 3, will appear. You can enter a + or − exposure compensation value, and any flash unit on this bank will use that compensation. Scroll to the left or right to move the yellow-green indicator (in image 3 it is directly below the tiny 0 on the −/+ scale). Scroll left for underexposure (down to −5.0 EV TTL Value) and right for overexposure (up to +5.0 EV TTL Value). Press the OK button and that EV will be used by all flash units on that bank (in this case, bank A). If you want no exposure compensation, leave the TTL Value set to 0.0.

Figure 4.8E: Preparing bank A for AUTO mode

7. Choose Auto from the panel (figure 4.8E, image 1) and scroll to the right until ±0.0 is highlighted (figure 4.8E, image 2). Press the OK button and the screen shown in figure 4.8E, image 3, will appear. You can enter a + or − exposure compensation value, and any flash unit on this bank will use that compensation. Scroll to the left or right to move the yellow-green indicator (in image 3 it is directly below the tiny 0 on the −/+ scale). Scroll left for underexposure (down to −5.0 EV Auto Value) and right for overexposure (up to +5.0 EV Auto Value). Press the OK button and that EV will be used by all flash units on that bank (in this case, bank A). If you want no exposure compensation, leave the Auto Value set to 0.0.

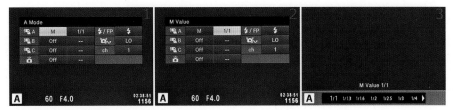

Figure 4.8F: Preparing bank A for M mode

8. Choose M from the panel (figure 4.8F, image 1) and scroll to the right until 1/1 is high-lighted (figure 4.8F, image 2). Press the OK button and the screen shown in figure 4.8F, image 3, will appear. You can enter an M Value from 1/1 to 1/128, which corresponds to the power output of every flash unit on the bank (in this case, bank A). Scroll left for more flash power (up to 1/1, or full power) or right for less flash power (down to 1/128). Press the OK button and that power level will be used by all flash units on that bank.

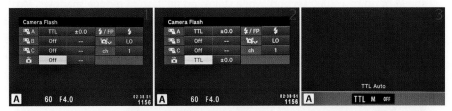

Figure 4.8G: Adding fill light with the FL-LM2 flash unit

9. Now you must decide if you want the FL-LM2 flash unit to add light to the image. The default is Off, as shown in figure 4.8G, image 1. That means the small FL-FM2 master flash will not provide a main flash burst like the slave units do. If it did, it would pro-vide direct flash, which may not be what you want. Even with the FL-FM2 flash Off (figure 4.8G, image 1), you still must raise the flash unit to firing position and prepare it for use so it can fire a preflash to communicate with the slave units. Be careful that it does not add unwanted light to your image (e.g., eyeglass reflections). If it does, use a smaller aperture or move the camera farther away from your subject. If you do want the FL-FM2 flash to provide extra fill light, you can set it to TTL or M mode (figure 4.8G, images 2 and 3) and it will behave like the bigger slave units. When the FL-FM2 flash unit provides light to the scene, it has its own bank without an A, B, or C label.

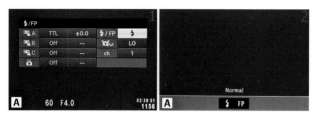

Figure 4.8H: Using normal x-sync or Super FP sync mode

10. Your camera will typically use a Normal maximum x-sync shutter speed of 1/250 second. However, that may not work if you are shooting outside and want to use a wider aperture and faster shutter speed. The camera can use a faster sync speed called Super FP (focal plane) high-speed sync mode (figure 4.8H, image 1) or FP mode. The upcoming sidebar titled **Super FP Sync Mode** describes how that mode works. You might want to shoot at f/2.8 in direct sunlight for a shallow depth of field, and use a shutter speed of up to 1/8000 second, while still using fill flash to reduce shadows. Most of the time this setting can stay at the Normal x-sync setting (maximum 1/250 second shutter speed), which is indicated by the lightning bolt symbol in figure 4.8H, image 2. You can select FP if you want to experiment with Super FP high-speed sync mode (up to 1/8000 second shutter speed).

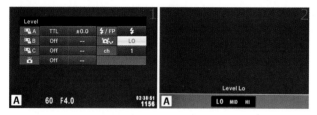

Figure 4.8I: Changing the power level of the master flash communication light output

11. When ambient light conditions are very bright or the slave flash units are farther away from the camera, you may need to increase the light output from the preflash of the master flash, which is how it communicates with the slave units (figure 4.8I). You can't leave it set to Hi all the time because the Hi setting may cause the preflash to produce enough light to interfere with your lighting arrangement. You will need to experiment with this setting, especially if some or all of the slave flash units are not responding to the master flash. You many need to increase the power from Level Lo to Level Mid or even to Level Hi.

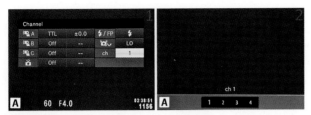

Figure 4.8J: Choosing a communication channel for the master and slaves

12. The master flash unit communicates with the slave units on a channel, so the master unit and each slave unit must be set to the same channel. You can choose from four channels (ch 1–4). The factory default is ch 1, so if you do not modify the channel setting, the flash system is ready to go (figure 4.8J, image 1). But if you buy a flash unit that has been changed, or if another photographer is working nearby, you may need to change the channel. You can choose from ch 1 to ch 4 and then press the OK button (figure 4.8J, image 2). I left the camera (master flash) set to ch 1 and I'll need to set the slave unit to the same channel for each bank, which we will do in the next few steps.

13. In this step we will prepare an Olympus FL-600R flash unit to use the correct bank and channel so it can receive communications from the preflash of the FL-LM2 flash unit.

First we must set the flash unit to RC mode (figure 4.8K, top arrow). Turn the flash unit on and press the silver ring above MODE (figure 4.8K, bottom arrow) until you see A flashing under the MODE label on the flash unit's LCD display. Turn the silver ring two clicks clockwise until RC appears under MODE (figure 4.8K, top arrow). Press the OK button on the flash unit to set RC mode. The accessory light on the front of the FL-600R unit will flash every few seconds to let you know it is in remote control (RC) mode and is ready to be used as a slave.

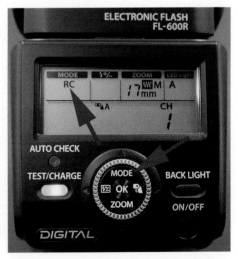

Figure 4.8K: Preparing an Olympus FL-600R flash unit for slave control

14. Now we must match the communication channel of the slave to the channel of the master. Press the OK button on the FL-600R flash (figure 4.8L, bottom arrow) and you will see RC start flashing under the MODE label of the flash unit's LCD. Press the bottom of the silver ring below the OK button and the number under CH will start flashing on the LCD (figure 4.8L, top arrow). Turn the silver ring until the slave flash unit's channel (CH) number matches the channel you chose for the master flash unit in step 12. I left the FL-600R flash set to CH 1, which matches the master flash unit's ch 1. When you are done, press the OK button on the flash unit to set the channel.

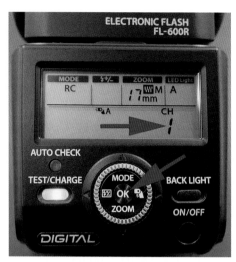

Figure 4.8L: Matching the slave unit channel to the master flash unit channel

15. The final step is to decide which bank (A, B, or C) to put the slave flash unit on. In our example, we prepared only bank A, and we left banks B and C set to Off. Therefore, we must set this FL-600R slave unit to bank A. It happens to be on bank A already (figure 4.8M, top arrow) because that is the factory default. However, let's discuss how to change it. Press the OK button on the flash unit (figure 4.8M, bottom arrow) and RC will start flashing under the MODE label on the flash unit's LCD. Press the bottom of the silver ring to move down, then press left on the silver ring to move to the bank

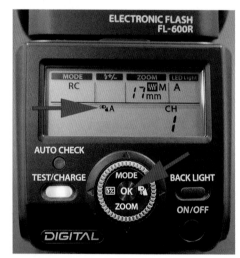

Figure 4.8M: Choosing a bank (A, B, or C) for your slave flash unit

label. (**Note:** If something else besides RC is flashing on the LCD, simply press down, up, left, or right on the silver ring to move to the bank location shown in figure 4.8M, top arrow). When the bank letter is flashing, rotate the silver ring to select a different bank (A, B, or C). When you are done, press the OK button on the flash unit. Raise the small master flash, position the slave flash, and start taking pictures.

Settings Recommendation: Keep in mind that we have configured only bank A, and the camera has three banks. You could have a large number of flash units configured in different lighting positions and with different power levels, all controlled by your FL-LM2 master flash unit. That tiny flash has a lot of power. It can control a virtually unlimited number of external flash units that are placed at a reasonable distance from the camera. It is quite a creative lighting system, isn't it?

Super FP Sync Mode

The E-M1 has an additional mode that lets it exceed the normal flash sync speed of 1/250 second. It is called Super FP (focal plane) sync mode. Normally, both the front and rear shutter curtains must be out of the way before the flash fires. Super FP sync mode lets you use shutter speeds all the way up to 1/8000 second. At these speeds, the rear shutter curtain follows the front shutter curtain so closely that only a traveling narrow, horizontal slit exposes the sensor at any given time.

When you select a sync speed faster than 1/250 second, the camera fires the flash in a series of short pulses instead of one big flash. The pulses fire as the narrow shutter curtain slit moves across the face of the sensor. The faster the shutter speed, the less power the flash can manage. You must be able to depend on ambient light in addition to flash when you use Super FP sync mode, especially at higher shutter speeds. However, this lets you use faster lenses (e.g., f/1.4, f/2.8) wide open in bright light, due to the very fast shutter speed. You can expose properly with a very shallow depth of field, even though the light is very bright.

Author's Conclusions

We've reached the end of another chapter full of configuration details. This camera is amazingly, if not overwhelmingly, configurable.

As we move into the next chapter, we will discuss the Playback Menu in detail. It lets you control things like displaying images on the monitor and in print (printing an image is a form of playback, when you think about it).

When we study the Playback menu, we will learn to display, edit, print, and protect our images. We will also learn how to use the camera's built-in Wi-Fi to send pictures to a smartphone or tablet for immediate posting on social media and other websites.

Grab your phone, tablet, and camera, and have all of them available as we work through the next chapter.

5 Playback Menu

Image © Darrell Young

The Playback Menu is the third system menu in this camera, and it is primarily used for working with images you've already taken. We will discuss viewing and printing images and transferring them to devices via Wi-Fi.

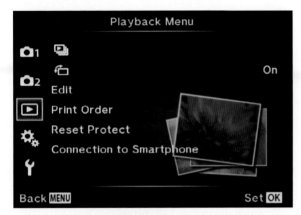

Figure 5.1: The Playback Menu

In this chapter we will discuss the options in the Playback Menu (figure 5.1):

- **[Slideshow]:** This function lets you present slideshows on the camera monitor. You can also connect your camera to an HDTV and display a slideshow on it—you can even play background music.
- **[Image Rotation]:** This setting lets you choose whether to display a vertical image in a vertical or horizontal orientation. If it is displayed vertically (as shot), it will look smaller on the camera monitor. If it is displayed horizontally, it will fit on the screen.
- **Edit:** This complex function allows you to do some in-camera image processing on photos you have already taken. If you don't like to use computers, you can do basic image post-processing with this built-in system.
- **Print Order:** Allows you to create a digital print order format (DPOF) for individual images or all images on the memory card. After you create a Print Order you can insert the memory card into a kiosk (e.g., Kodak) at a superstore, or into your own DPOF-compatible printer, to get prints.
- **Reset Protect:** When an image is displayed on the camera monitor, you can press the OK button and select the key icon to lock the image, or protect it from deletion, during an All Erase memory card operation (but not a full card Format). The Reset Protect function allows you to remove the protection lock from all images on the memory card.
- **Connection to Smartphone:** This function lets your camera become a Wi-Fi access point so you can connect to it through an Android or iOS app on your smartphone or tablet and retrieve images from your camera. You can also control the camera with the smartphone or tablet and view through the lens remotely, change the settings, and take pictures.

Let's consider each of these functions in much more detail.

[Slideshow]

When you have a card full of great pictures, you may want to share a slideshow with friends and family. The camera makes it easy and allows you to display timed still images or movies with background music, if you choose.

There are basically three ways to view a slideshow: on the camera monitor (but not in the viewfinder), on an HDTV or other HDMI-compatible device, or on an older TV or other device that uses RCA jacks.

Viewing a slideshow on the camera monitor is very easy, and we will discuss the steps in the upcoming subsection called **Configuring and Displaying a Slideshow**. But first let's briefly consider how you might use the camera to display your slideshow on a TV (HDTV or SDTV).

Output to HDTV via HDMI Port

The E-M1 has a micro HDMI port on its left side, which you can use to display your images and movies on a large HDTV screen for much greater viewing pleasure.

You can adjust the camera for 1080i or 720p video output with the *Custom Menu > Disp/[Sound]/PC > HDMI > HDMI Out* setting. You can even use a compatible HDTV remote to control the camera directly if you set the *Custom Menu > Disp/[Sound]/PC > HDMI > HDMI Control* to On.

To connect to an HDTV that has a standard HDMI port, you will need a cable with an HDMI type A connector for the HDTV and a micro-HDMI type D connector for the camera's HDMI port. This cable is readily available online and at stores. Use the steps in the upcoming subsection called **Configuring and Displaying a Slideshow** to send video to the HDTV.

We will discuss connecting the camera to an HDTV in more detail in the chapter titled **Custom Menu** and the subsection called **HDMI** on page 329.

Output to SDTV via USB Port

The camera can send a slideshow to an older SDTV, VCR, or other device that has RCA jacks. You will need a proprietary USB A/V out cable, called Audio/Video Cable Replacement (CB-AVC4), from Olympus (**http://www.getolympus.com**).

Configuring and Displaying a Slideshow

There are five selections within the [Slideshow] menu, four of which are configurable. Most of the time you will not need to change the configurable settings, but you can if you want to. Here are descriptions of each setting:

- **Start:** Start begins the slideshow immediately, using the values found in the next four configurable settings.

- **BGM:** This acronym stands for background music. The camera comes with one song called "Joy." You can download several other songs from the Olympus website to replace "Joy."
- **Slide:** This setting controls the type of slideshow the camera will display. You can display only still pictures, only movies, or both within one slideshow.
- **Slide Interval:** This setting controls the interval of time between each image or movie in the slideshow. You can choose from 2 to 10 seconds.
- **Movie Interval:** This setting controls what happens when the slideshow displays a movie. You can show each movie in its entirety or only a few seconds at the beginning of each movie before you continue to the next movie.

First we'll examine how to start a slideshow with the default settings. Then we'll see how to configure a slideshow and take advantage of all the options.

Starting a Slideshow with Default Settings
If you want to display a slideshow right away, with no fuss or configuration, you can simply start it. The slideshow will use whatever settings are already configured, which will be either the factory default settings or settings you used for the previous slideshow.

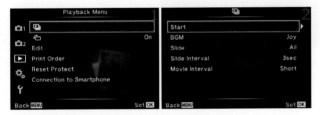

Figure 5.2A: Starting a slideshow with default options

Use the following steps to start a slideshow:

1. On the camera monitor, view the image or movie that you want to use as the first item in the slideshow.
2. Select the [Slideshow] symbol from the Playback Menu and scroll to the right (figure 5.2A, image 1).
3. Choose Start from the menu then scroll to the right. The slideshow will begin immediately with the default settings (figure 5.2A, image 2).
4. Press the OK button or Menu button to stop the slideshow. It will repeat until you stop it. If you want to restart the slideshow where it left off, repeat steps 1 and 2.

Note: The camera starts the slideshow on the most recently displayed image. If you want the slideshow to start with the first image on the memory card, you must view that image immediately before you start the slideshow. If you take a new picture just before you start a new slideshow, the camera will start the slideshow on that picture because it was

the last picture displayed. Even removing the card and reinserting it does not cause the camera to start at the beginning of the memory card.

Modifying the Default Settings for Slideshows

You may want your slideshow to include only still images or only videos. You might not want to have the camera play background music during the show, or you might want to look at each image in the show for longer than the default time of 3 seconds.

You can configure these settings before you start a new slideshow. Let's see how.

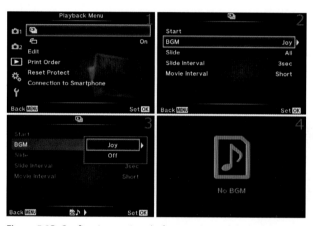

Figure 5.2B: Configuring settings before starting a slideshow

Use the following steps to configure then start a slideshow:

1. Select the [Slideshow] symbol from the Playback Menu and scroll to the right (figure 5.2B, image 1).
2. Select BGM (background music) then scroll to the right (figure 5.2B, image 2).
3. In figure 5.2B, image 3, you can see that the song Joy is available as the factory default. The song will play as soon as this screen appears so you can decide if you want to use it as background music.
4. An arrow appears beside the song name, so it looks like you can scroll to the right and select another song. If you do, you will see a big red musical note and *No BGM* (figure 5.2B, image 4). Joy is the only song included with the camera. If you want to use it, press the OK button with Joy highlighted and playing, then move to the next step.
5. You can adjust the volume of the background music during the slideshow by pressing up or down on the Arrow pad keys. You can also adjust the balance of the background music for sound in a video by pressing left or right on the Arrow pad.

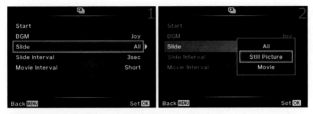

Figure 5.2C: Choosing what displays in a slideshow

6. Next you must decide whether you want to display only images (Still Picture), only videos (Movie), or both (All). First choose Slide and scroll to the right (figure 5.2C, image 1), then choose the type of slideshow you want to display from the menu that opens (figure 5.2C, image 2). After you have highlighted your selection, press the OK button to lock it in.

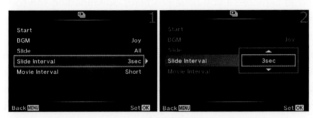

Figure 5.2D: Choosing a delay between items in a slideshow

7. Now you can choose a delay between each image or video. The default is 3 seconds (3sec), but you can choose an interval from 2 seconds to 10 seconds (2sec to 10sec). Select Slide Interval from the menu and scroll to the right (figure 5.2D, image 1). A small up/down menu will appear. Scroll up or down and choose from 2sec to 10sec (figure 5.2D, image 2). Press the OK button to lock in your time delay.

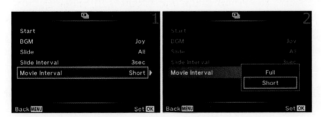

Figure 5.2E: Choosing entire (Full) or partial (Short) videos

8. You can choose whether your movies play all the way through or partially before the slideshow moves to the next movie or image. If you chose Still Picture in step 6, ignore this step. But if you chose Movie or All in step 6, you can decide how much of each movie will play. Select Movie Interval from the menu and scroll to the right (figure 5.2E, image 1). Choose Full or Short from the menu (figure 5.2E, image 2).

9. Now that you have configured all the settings for a slideshow, you select Start from the menu and scroll to the right to start it (figure 5.2A, image 2).

Downloading Alternate Slideshow Songs from Olympus

If you want to play a different song than "Joy" with your slideshow, you can download 10 other songs from Olympus at this website:

http://support.olympus-imaging.com/bgmdownload/

As of early 2015, the song choices are:

- "Beat"
- "Beautiful"
- "Cool"
- "Landscape"
- "Love"

- "Melancholy"
- "My Life"
- "Nostalgic"
- "Precious Memory"
- "The Drums"

Note: The download instructions on the Olympus website (*right click > Save Target As*) seem to be written for Internet Explorer. If you have problems downloading the songs, try pressing Alt+Click on the download graphic. That worked for me in Chrome, but not in Firefox. You may have to use Internet Explorer to download the songs.

If you download these songs, you cannot simply install them and select one from a list, as you might expect. When you install a new song, it replaces "Joy." You can install only one song at a time, and it overwrites the current song. Unless you don't want to ever use "Joy," be sure to download it from the Olympus website because it will be overwritten when you replace it, and you will have to reinstall it if you want to use it later. That will give you 11 songs you can install in your camera.

You can listen to the songs on the Olympus website to see if you like them, then you can download one song or all of them. Each song is 6 MB and is in a nonstandard WAV format. I tried to play them on my computer but they would not play in iTunes, and I could not use a WAV file I created.

To use the songs, create a folder on your memory card named BGM. Copy all the songs into the BGM folder. When you reinsert the memory card into the camera and select a song, a list of songs will replace the *No BGM* error (figure 5.2F, image 4).

Use these steps to install a song other than "Joy" from the BGM folder on your memory card:

1. Select the [Slideshow] symbol from the Playback Menu and scroll to the right (figure 5.2F, image 1).
2. Select BGM then scroll to the right (figure 5.2F, image 2). You can see that Joy is currently selected (figure 5.2F, image 3). It will start to play as soon as this screen appears. Scroll to the right, and you can see the list of songs in the BGM folder on your memory card (figure 5.2F, image 4).

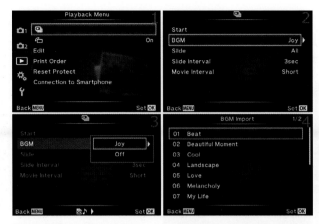

Figure 5.2F: Installing a song

3. Figure 5.2G takes over where figure 5.2F leaves off. Select a song from the BGM Import menu (figure 5.2G, image 1). I selected Beautiful Moment, which started playing immediately. Press the OK button to choose the song, and the screen in figure 5.2G, image 2, will appear. The words *BGM is overwritten* will appear. Select Yes from the menu and press the OK button. Your new song will be playing and its name will appear on the camera monitor (figure 5.2G, image 3).

4. When you start the next slideshow, your new song will play instead of Joy.

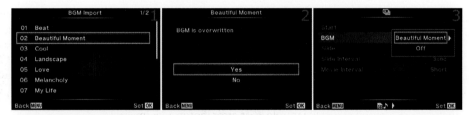

Figure 5.2G: Choosing a song from the BGM Import menu

Settings Recommendation: I configured my slideshow settings before I displayed my first slideshow, and I rarely change things. I might want to change the background music from time to time, but that's about all. I normally turn off movie replay during a slideshow because I want to see just still images. If I want to watch a movie, or a series of movies, I find it more convenient to simply choose one from the monitor when I am ready to view it.

When you choose to display movies in a slideshow, they cleverly blend with still images. However, the music keeps playing through the movie, which I find distracting most of the time. Unless your movies are lovely nature videos, it may be better to leave music turned off in a slideshow that includes both movies and still images. You can adjust the balance of the recorded sound and the background music by pressing left and right on the Arrow pad while the movie is playing.

[Image Rotation]

[Image Rotation] allows you to choose if an image taken in portrait (vertical) orientation is displayed upright or rotated onto its side on the camera monitor.

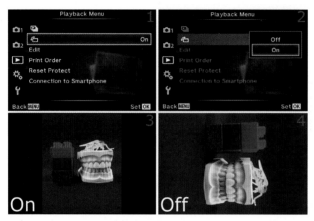

Figure 5.3: Choose how a vertical image will display on the camera monitor

Use these steps to choose how a vertical image will display:

1. Select the [Image Rotation] symbol from the Playback Menu and scroll to the right (figure 5.3, image 1).
2. A small menu with On and Off choices will open (figure 5.3, image 2). If you want a vertical image to display as shown in figure 5.3, image 3, choose On. If you want it to be rotated onto its side, as shown in figure 5.3, image 4, choose Off.
3. Press the OK button to lock in your choice.

Settings Recommendation: I leave this function set to On so the image on the monitor will be easier to review as I scroll through all my images. The E-M1 displays an image on the monitor for only about one-half second, which is not enough time to see it unless you change the default image review timeout setting in *Setup Menu > Rec View*. I leave Rec View set to one-half second so it won't delay my ability to take the next picture.

If you change the Rec View default to a longer time, you may want to leave [Image Rotation] Off so you can review your image on the monitor in the same direction you were holding the camera when you took the picture.

Edit

If you don't like working with images on the computer, or if you are on a tour in the wilds and don't have a computer available, you can still do basic in-camera image processing. You can take an original RAW or JPEG image, modify it in various ways, then save it as a new JPEG image.

Sel. Image

Sel. Image (Select Image) is the first of the image editing tools, which also includes Image Overlay.

There are three basic ways to modify images with the Sel. Image tool: RAW Data Edit, JPEG Edit, and [Voice Annotation]. Let's examine them.

RAW Data Edit

RAW Data Edit allows you to convert a file from RAW to JPEG in-camera. If you prefer to shoot in RAW for maximum image quality and quickly need a JPEG for some reason, you can create one without using a computer. Here are the conversion types:

- **Current:** You will choose a RAW image on the monitor and the camera will create a JPEG image using whatever camera settings are currently set on the camera.
- **Custom1 and Custom2:** These two functions allow you to select individual changes to image exposure settings. The camera will then convert a RAW image into a JPEG image with the settings you choose. You can save the Custom1 or Custom2 settings and use them later.
- **ART BKT:** You can choose a RAW file, apply one of the 12 Art Modes to it, then save it as a JPEG. This is a good way to apply an Art Mode to an image after the fact.

The RAW Data Edit function works only with RAW files. There is a separate JPEG Edit function for JPEG files, which we will discuss in the upcoming **JPEG Edit** subsection. If there are only JPEG images on the memory card, the RAW Data Edit choice will be grayed out and unavailable.

There are nine conversion factors to consider when you convert a file from RAW to JPEG. When you use the Current and Custom RAW Data Edit functions, you will notice that each has a different way to configure the nine settings.

RAW to JPEG conversion factors
- JPEG quality setting (e.g., LSF, LF, MN)
- Picture Mode (e.g., Vivid, Natural, Muted)
- White Balance (e.g., Sunny, Cloudy, Incandescent)
- Exposure Compensation (±3.0 EV)
- Brighten Area Adjust (Hi light using Highlight&Shadow Control, ±7 steps)
- Shadow Area Adjust (Shadow using Highlight&Shadow Control, ±7 steps)

- Image Aspect Ratio (e.g., 4:3, 16:9, 3:2)
- Noise Filter (i.e., Low, Std, High)
- Color Space (i.e., sRGB, Adobe RGB)

Let's examine each of the three RAW to JPEG conversion types: Current; Custom1 and Custom2; and ART BKT.

Current

This form of RAW (ORF) to JPEG conversion uses the camera's current settings as a guide to conversion. These nine settings are listed in the previous ***RAW to JPEG conversion factors*** list. Before you start the RAW Data Edit in Current mode, you must configure your camera settings for converting a file to JPEG.

After you have adjusted each of these items, you will execute the following steps to convert the image from RAW to JPEG.

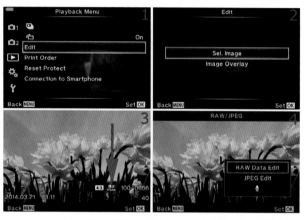

Figure 5.4A: Converting RAW to JPEG with Current camera settings (first four steps)

Use these steps to convert a RAW file on the memory card into a new JPEG file, which will have a new file number and show up as the last image on the memory card:

1. Choose Edit from the Playback Menu and scroll to the right (figure 5.4A, image 1).
2. Choose Sel. Image from the Edit Menu and press the OK button (figure 5.4A, image 2).
3. The camera will display the images on the memory card. Scroll through the images with the Arrow pad until you find the RAW file you want to convert. The format of the image will be displayed (figure 5.4A, image 3, red arrow). The picture in our example is stored in both RAW and JPEG formats on the memory card. Press the OK button.
4. The camera will display a menu with two choices: RAW Data Edit and JPEG Edit (figure 5.4A, image 4). Since the picture in image 4 has both RAW and JPEG versions available (JPEG+RAW), both choices are available on the menu. Choose RAW Data Edit and press the OK button.

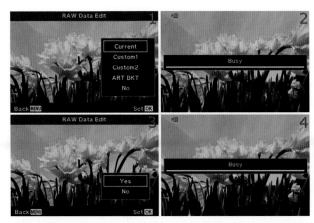

Figure 5.4B: Converting RAW to JPEG with Current camera settings (next two steps)

5. Figure 5.4B takes up where figure 5.4A leaves off. Select Current from the menu (figure 5.4B, image 1). This tells the camera to use its current settings (see the **RAW to JPEG conversion factors** list) to convert the file from RAW to JPEG. Press the OK button to continue, and you will briefly see a Busy screen (figure 5.4B, image 2).

6. Next you decide how the image will look on the camera monitor with the current settings applied (figure 5.4B, image 3). If you think it looks fine, select Yes and press the OK button, which will make a new JPEG file while a Busy screen is displayed (figure 5.4B, image 4). If you want to adjust the image further, select No and start over with new camera settings.

Figure 5.4C: Converting RAW to JPEG with Current camera settings (final step)

7. Figure 5.4C takes up where figure 5.4B leaves off. The camera gives you a preview of the conversion, which hasn't yet been saved to the memory card. A menu with Reset and No choices will appear (figure 5,4C, image 1). If you select Reset, the camera will abandon the current conversion and jump back to the screen shown in figure 5.4B, image 1, so you can start over at step 5. If you select No—which, ironically, means you do want to save the newly converted JPEG image—the camera will save the JPEG to a new file name as the last image on the memory card. The image will appear on the monitor with the new file name displayed (figure 5.4C, image 2, red arrow).

Custom1 and Custom2

The two Custom RAW Data Edit modes let you choose nine factors for conversion. Unlike the Current RAW Data Edit mode discussed in the previous subsection, which used current camera settings for the conversion, the Custom functions allow you to adjust individual settings before you convert your image from RAW to JPEG.

The nine settings you can adjust are shown in the ***RAW to JPEG conversion factors*** list. These are the same nine functions used by the Current method. The difference between the Current and Custom RAW Data Edit settings is that the camera automatically saves the Custom settings so you can use them later. If you use the Custom function again without changing the settings, the camera will use your previous settings.

There are two Custom settings: Custom1 and Custom2. Configuring them works exactly the same way, so we will use Custom1 as an example. Remember that Custom1 and Custom2 can be configured with different settings and you can reuse them later. Maybe you will use one Custom setting to convert RAW images to high-quality JPEGs and the other to convert RAW images to smaller JPEGs for online use.

Note: Pressing the Movie button at any time while you configure any of the nine conversion factor settings will give you a Preview Update of what the image will look like after conversion. The Movie button is on top of the camera—just behind the Shutter button, next to the Fn2 button—and has a red dot. Preview Update will apply the current conversion settings, without saving the file, so you can see what the conversion looks like up to that point. You can test the conversion with each change if you want to. Each screen has a reminder that you can see a Preview Update (figure 5.4E, image 2, bottom red arrow).

Now, let's see how to use the Custom RAW Data Edit function.

Figure 5.4D: Converting RAW to JPEG with Custom camera settings

1. Choose Edit from the Playback Menu and scroll to the right (figure 5.4D, image 1).
2. Choose Sel. Image from the Edit Menu and press the OK button (figure 5.4D, image 2).
3. The camera will now display the images on the memory card. Scroll through the images with the Arrow pad until you find the RAW file you want to convert. The format of the image will be displayed (figure 5.4D, image 3, red arrow). The picture in our example is stored in both RAW and JPEG formats on the memory card. Press the OK button.
4. The camera will display a menu with two choices: RAW Data Edit and JPEG Edit (figure 5.4D, image 4). Since the picture in image 4 has both RAW and JPEG versions available (JPEG+RAW), both choices are available on the menu. Choose RAW Data Edit and press the OK button.

Figure 5.4E: Choosing a Record Mode (image size and quality) for the converted JPEG

5. Figure 5.4E takes up where figure 5.4D leaves off. You will see a menu with the two Custom settings. Select Custom1 or Custom2 and scroll to the right (figure 5.4E, image 1).
6. Figure 5.4E, image 2, shows the first of nine screens we will use to configure the RAW to JPEG conversion settings, shown in the ***RAW to JPEG conversion factors*** list. The first setting is Image size and quality (Record Mode). The items along the right side of the screen are headings, and their adjustments are shown at the bottom of the screen. Scroll up or down on the right side of the screen with the Arrow pad to select a conversion setting, and scroll left or right on the bottom of the screen to make adjustments to that conversion setting. The Record Mode heading on the right (LF) has the following choices at the bottom of the screen: LSF, LF, MF, and SF (figure 5.4E, image 2). Your camera may display LF, LN, MN, and SN instead. (You can adjust the display by changing *Custom Menu > G. [Record Mode]/Color/WB > Set*. I use LSF, LF, MF, and SF so I can always shoot JPEG Fine images instead of JPEG Normal. See page 175, under the heading **[Record Mode]**, for more information about image size and quality settings.) Choose one of the Record Modes, such as LF (Large Fine JPEG), by scrolling left or right. Press the Movie button for a Preview Update to see how the conversion will look so far. Do not press the OK button unless you have completed all the changes you want to make. After you have chosen the Record Mode you want, scroll down one space on the right side of the screen to select a Picture Mode.
7. You can choose a Picture Mode to give a certain look to your new JPEG image (figure 5.4F). There are 21 modes available, including 12 Art Modes, so you can do all sorts of in-camera image processing. There are also six basic modes—including

i-Enhance, Vivid, Natural, Muted, and Portrait—that are commonly used and do not have heavy effects. The Muted Picture Mode is selected in figure 5.4F. (See page 136, under the heading **Picture Mode,** for more information about Picture Modes.) Choose the Picture Mode you want to use for this conversion by scrolling left or right with the Arrow pad. Press the Movie button for a Preview Update to see how the image conversion will look so far. Do not press the OK button unless you have completed all the changes you want to make. Scroll down to the next setting, White Balance (WB).

Figure 5.4F: Choosing a Picture Mode for the converted JPEG

8. The White Balance (WB) setting (figure 5.4G) lets you choose from 13 WB types, including eight standard settings (e.g., Auto, Sunny, Cloudy), four custom WB settings captured previously with a gray card, and a kelvin setting (2000K to 14000K). (See the chapter titled **Custom Menu** on page 396, under the **White Balance (WB)** heading, for more information about WB settings.) Choose the WB you want to use for this conversion by scrolling left or right with the Arrow pad. I chose

Figure 5.4G: Choosing a White Balance (WB) for the converted JPEG

the WB Auto setting in figure 5.4G. Press the Movie button for a Preview Update to see how the image conversion will look so far. Do not press the OK button unless you have completed all the changes you want to make. Scroll down to the next setting, Exposure compensation (+/−).

The Exposure compensation setting (+/−) lets you add or subtract light from the converted image in 1/3 EV steps, with maximum increments from −3.0 to +3.0 EV steps (figure 5.4H). Choose an Exposure compensation value for this conversion by scrolling left or right with the Arrow pad. You will see the number next to the +/− symbol change in 1/3 EV step increments. Press the Movie button for a Preview Update to see how the image conversion will look so far. Do not press the OK button unless you have completed all the changes you want to make. Scroll down to the next setting, Brighten Area Adjust (Hi).

Figure 5.4H: Choosing an Exposure compensation value for the converted JPEG

9. The Brighten Area Adjust setting lets you add or subtract light from the highlights (Hi) of the image in +/−7 steps (e.g., +1, +2, −1, −2) (figure 5.4I). Choose a Brighten Area Adjust (Hi) value for this conversion by scrolling left or right with the Arrow pad. This adjustment will brighten or darken the bright areas of the image. You will see the number next to Brighten Area Adjust (Hi) change one step at a time. Press the Movie button for a Preview Update to see how the image conversion will look so far. Do not press the OK button unless you have completed all the changes you want to make. Scroll down to the next setting, Shadow Area Adjust (Sh).

Figure 5.4I: Choosing a Brighten Area Adjust value for the converted JPEG

10. The Shadow Area Adjust setting lets you add or subtract light from the shadows (Sh) of the image, in +/−7 steps (e.g., +1, +7, −1, −7) (figure 5.4J). Choose a Shadow Area Adjust (Sh) value for this conversion by scrolling left or right with the Arrow pad. This adjustment will brighten or darken the dark areas of the image. You will see the number next to Shadow Area Adjust (Sh) change one step at a time. Press the Movie button for a Preview Update to see how the image conversion will look so far. Do not press the OK button unless you have completed all the changes you want to make. Now scroll down to the next setting, image Aspect Ratio (4:3).

Figure 5.4J: Choosing a Shadow Area Adjust value for the converted JPEG

11. The image Aspect Ratio setting (4:3) lets you change the shape of the image (figure 5.4K). You can change it from the normal Micro Four Thirds setting (4:3) to a different Aspect Ratio, such as a long and narrow HD view (16:9); the shape of most non-Micro Four Thirds digital images (3:2); square (1:1); or vertical Micro Four Thirds portrait mode (3:4). Choose one of the Aspect Ratio values for the conversion by scrolling left or right with the Arrow pad. You will notice that the camera displays the pixel ratio for each Aspect Ratio (e.g., 4608×3456). To see how the change affects the image, press the Movie button for a Preview Update. Do not press the OK button unless you have completed all the changes you want to make. After you have selected the Aspect Ratio you want to use for the conversion, scroll down to the next setting, Noise Filter (NF).

Figure 5.4K: Choosing an image Aspect Ratio value for the converted JPEG

12. The Noise Filter (NF) setting lets you select the strength of noise reduction (figure 5.4L). You can select from Off, Low, Std, and High. It will be hard to see how the noise reduction system affects the image on the small camera monitor. You may want to experiment with noise reduction in advance so you can make a better choice during the conversion process. (See the chapter titled **Custom Menu,** on page 363, under the heading **Noise Reduct.,** for more information.) Most people leave Noise Filter (NF) set to Standard (Std). Press the Movie button for a Preview Update to see how the image conversion will look so far. Do not press the OK button unless you have completed all the changes you want to make. Scroll down to the next setting, Color Space (sRGB).

Figure 5.4L: Choosing a Noise Filter for the converted JPEG

13. The Color Space setting lets you choose whether to use the generally noncommercial sRGB color space or the commercial Adobe RGB color space (figure 5.4M). Most noncommercial photographers will leave Color Space set to sRGB because that works best for home, online, and superstore printing, and for display on social media sites and websites. If you are a stock photographer who submits images to a stock agency or are involved in other purely commercial photography endeavors where the images will be printed on an offset press, you will usually need to shoot with the Adobe RGB color space because it matches commercial CMYK color printing more closely. (See page 407 under the heading **Color Space** for more information.) Now it's time to finish the RAW to JPEG conversion with all our settings.

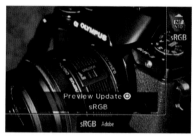

Figure 5.4M: Choosing a Color Space for the converted JPEG

The camera saves your settings so you can make many more conversions using the settings you just prepared. Press the OK button to start the final conversion process.

14. The camera will display a final Preview Update of the image, with all your carefully crafted settings in place. You will also see a small menu with Yes and No choices (figure 5.4N, image 1). If you choose No the camera will revert to the image selection screen and you will have to start over. If you choose Yes the camera will execute the final conversion from RAW to JPEG, a Busy screen with a progress bar will display while the conversion is taking place (figure 5.4N, image 2), and finally you will see the converted JPEG image.

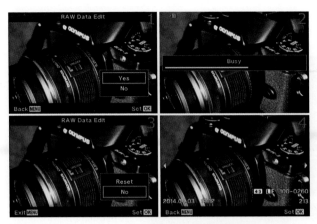

Figure 5.4N: Converting a RAW file to a new JPEG file

15. Before you save the new JPEG image to the memory card, the camera opens a menu with Reset and No options (figure 5.4N, image 3). If you select Reset the camera will not save the new image. Instead, it will jump back to the beginning of the conversion process and display the screen shown in figure 5.4E, image 1 (step 5), where you select the type of conversion you want to do. If you select No the camera will save the new JPEG image under a new file name as the last JPEG image on the memory card. The final converted image will be displayed on the camera monitor (figure 5.4N, image 4).

Now, let's consider how to use the third type of RAW to JPEG conversion: converting to JPEG with an Art Mode.

ART BKT

The ART BKT function allows you to choose a single RAW image and create up to 21 JPEG images from it. Each image can have a different Basic, Creative, or Art Mode applied to it, which is why the function has the letters BKT (bracket) in its name. In effect, when you create more than one JPEG image from a single RAW file, you are creating an Art Mode Bracketing series.

 Note: The camera allows you to select all 21 Picture Modes in the ART BKT function, not just the Art Modes, as the function name implies. We discussed each Basic, Creative, and Art Mode in the chapter titled **Shooting Menu 1: Preliminary and Basic Shooting Options,** on page 136, under the subheading **Picture Mode**. For more information on each mode, see the corresponding subsection.

 If you are unsure which of the Picture Modes—Basic, Creative, or Art—you want to use, and if you would like to make a test image with each one, you can do it with ART BKT. Or if you want to make a single JPEG image with only one of the special looks in Art Mode (e.g., Pop Art, Grainy Film, Soft Focus), you can do that too.

Now, let's examine how to create a RAW to JPEG conversion with one or multiple JPEG files, each with a specific Picture Mode effect.

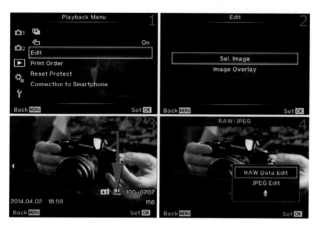

Figure 5.4O: Creating a RAW to JPEG ART BKT conversion (first four steps)

Use the following steps to make a RAW to JPEG conversion using one or more of the camera's available Picture Modes:

1. Select Edit from the Playback Menu and scroll to the right (figure 5.4O, image 1).
2. Choose Sel. Image from the Edit Menu and press the OK button (figure 5.4O, image 2).
3. The camera will display the images on the memory card. Scroll through the images with the Arrow pad until you find the RAW file you want to convert. The format of the image will be displayed (figure 5.4O, image 3, red arrow). The picture in our example is stored in both RAW and JPEG formats on the memory card. Press the OK button.
4. The camera will display a menu with two choices: RAW Data Edit and JPEG Edit (figure 5.4O, image 4). Since the picture in image 4 has both RAW and JPEG versions available (JPEG+RAW), both choices are available on the menu. Choose RAW Data Edit and press the OK button.

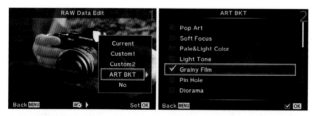

Figure 5.4P: Creating a RAW to JPEG ART BKT conversion (next two steps)

5. Figure 5.4P takes up where figure 5.4O leaves off. You will now see the RAW Data Edit Menu and a choice of conversion types (figure 5.4P, image 1). Highlight ART BKT and scroll to the right.

6. The ART BKT list of Picture Modes will now appear, with the Art Modes (e.g., Pop Art, Soft Focus) at the top (figure 5.4P, image 2). When this screen first appears it will have quite a few Picture Modes checked. Only 7 of the 21 available modes are visible on the screen in image 2; you must scroll down to see the rest. If you do the conversion with more than one Picture Mode checked, the camera will create a JPEG image for each of the checked Picture Modes. To check or uncheck a Picture Mode simply highlight it and press the OK button, and you will see the check mark appear or disappear. In image 2, all Picture Modes except Grainy Film are unchecked, which means only one JPEG file will be created with that Art Mode applied. Check however many of the modes you want to use and you will get one new JPEG, created from the original RAW file, for each of the modes you checked. After you check the modes you want to use, scroll to the left with the Arrow pad or press the Menu button once to get back to the previous screen (figure 5.4P, image 1) and execute the ART BKT conversion.

Figure 5.4Q: Creating a RAW to JPEG ART BKT conversion (final steps)

7. Figure 5.4Q takes up where figure 5.4P leaves off. The screen in figure 5.4Q, image 1, lets you select Picture Modes from the ART BKT list. Now you will execute the conversions and create a new JPEG file for each Picture Mode you selected in step 6. Make sure ART BKT is still highlighted, and press the OK button to start the conversions.
8. You will see a Busy screen with a progress indicator while the camera creates the new JPEG images (figure 5.4Q, image 2). The more images you are converting, the longer the Busy screen will be displayed. Allow some time if you checked a lot of Picture Modes in step 6.
9. When the conversion is complete, the camera will display one of the images from the conversion, along with a menu that has two choices: Reset and No (figure 5.4Q, image 3). If you select Reset at this point, the camera will return to the screen shown in figure 5.4Q, image 1, which stops the conversion and lets you select a different Picture Mode from the ART BKT list. If you choose No, the camera will save the new JPEG

images to the memory card and display the last image in the series—or a single image if you chose only one Picture Mode—on the monitor (figure 5.4Q, image 4). If there are multiple JPEGs in the conversion, you can scroll to the left with the Arrow pad to see each of the images with the Picture Mode applied.

Now, let's examine the next type of image editing, JPEG edit.

JPEG Edit

The JPEG Edit function lets you make in-camera changes to your existing JPEG image files and then save them as new files. It works only with JPEG files. There is a separate RAW Data Edit function for RAW files, which we discussed in the previous **RAW Data Edit** subsection.

When you select and modify a JPEG file, the original file is not changed. A new modified JPEG file is created and stored with a new file name as the last image on the memory card. If you don't like using computers to modify files, or if you immediately need a modified JPEG, the JPEG Edit function is easy and quick to use.

There are nine adjustments for JPEG images:

- **Shadow Adj:** This setting automatically adjusts the shadows of an image to reveal more image data. Use it to brighten mildly underexposed images or to open the shadows on well-exposed images.
- **Redeye Fix:** The camera attempts to remove red eye when the subject has that strange-looking, red-eye reflection caused by flash.
- **[Crop]:** You can crop the image up to four ways: both horizontal and both vertical sides.
- **Aspect:** This setting changes the aspect ratio from the standard Micro Four Thirds 4:3 ratio to 3:2, 16:9, 1:1, or 3:4.
- **Black & White:** You can convert an image to a retro-looking, grayscale, black-and-white image.
- **Sepia:** The camera will give your image an old-fashioned sepia, brown-toned look.
- **Saturation:** This setting allows you to increase or decrease the color saturation by using a sliding +/- indicator.
- **[File Size]:** You can choose from three smaller file sizes: 1280×960 (1.2 MP), 640×480 (0.3 MP), and 320×240 (0.075 MP).
- **e-Portrait:** This setting makes skin tones smoother and adds translucense for an antiaging effect.

Adjusting a JPEG image is different from cumulatively setting the conversion factors on a RAW file, as we did in the previous subsection. You can apply a new adjustment to a previously adjusted image, but be careful because making repeated changes to one JPEG file results in data losses due to recompression of the image. To maintain maximum quality, think of these adjustments as effects that you can apply to different images, not as cumulative steps that you'll apply to one JPEG image.

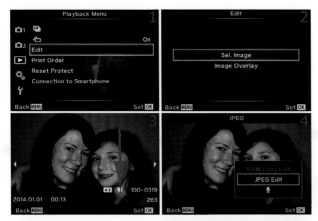

Figure 5.5A: Choosing a JPEG image and starting the JPEG Edit steps

Use the following steps to choose an image for modification and to make some or all of the available changes:

1. Select Edit from the Playback Menu and scroll to the right (figure 5.5A, image 1).
2. Choose Sel. Image from the Edit Menu and press the OK button (figure 5.5A, image 2).
3. The camera will display the images on the memory card. Scroll through the images with the Arrow pad until you find the JPEG file you want to convert. The format of the image will be displayed (figure 5.5A, image 3, red arrow). Press the OK button.
4. You will see a menu with three choices: RAW Data Edit, JPEG Edit, and the [Voice Annotation] microphone symbol (figure 5.5A, image 4). You can tell that this image is not a RAW file because it is labeled LF in image 3; also, in image 4 the RAW Data Edit choice is grayed out and unavailable. If this image had been shot in a JPEG+RAW format, the memory card would have both files and you could edit either the RAW file or the JPEG file. Choose JPEG Edit and press the OK button.

The images in figure 5.5A are the first four screens for the next nine subsections (figures 5.5B to 5.5J). Each of the upcoming adjustments will begin where figure 5.5A leaves off.

Shadow Adj (Opening the Shadows)

Figure 5.5B: Opening the shadows

1. Choose Shadow Adj from the JPEG Edit Menu and press the OK button (figure 5.5B, image 1).
2. You will briefly see a Busy screen with a progress bar as the camera adjusts the shadows. When it is done, you will see the adjusted image with a menu that has Yes and No choices (figure 5.5B, image 2). To make the Shadow Adj modification permanent, select Yes. The camera will apply the adjustment and save the new JPEG image with a new file name. To cancel and start over, select No.

Redeye Fix (Removing Red Eye)

Figure 5.5C: Removing red eye

1. The Redeye Fix adjustment removes glowing red eyes that occur when the subject's retinas reflect flash light back into the lens. Choose Redeye Fix from the menu and scroll to the right (figure 5.5C, image 1).
2. The camera will now find and remove red eye from the image. A Busy screen and progress bar will stay on the monitor for a few moments while face detection and red eye removal takes place (figure 5.5C, image 2). The camera will attempt to remove red eye even from images in which there is no red eye.
3. If the camera does not detect a human face, it will display an error message (figure 5.5C, image 3). Either the picture has no people in it, their faces are too small, or their faces are at a bad angle. If you see this screen, the camera cannot work with the image. If the camera does detect a human face, you will see the screen shown in image 4.
4. Since the camera can detect a human face in the example picture, you will see a menu with Yes and No choices (figure 5.5C, image 4). Choose Yes to save the new JPEG image with red eye removed, and No to cancel and start over.

[Crop] (In-Camera Image Cropping)

Figure 5.5D: Cropping the image

1. You can crop an image to remove unwanted surroundings and show only the most important part of the picture. Select [Crop] from the menu and press the OK button (figure 5.5D, image 1).
2. Rotate the Rear Dial to see a series of preset image crop sizes. Figure 5.5D, image 2, shows the largest horizontal crop, and image 3 shows the largest vertical crop. There are also two smaller crop sizes that you can see when you rotate the Rear Dial. Select one of the crop sizes, use the Arrow pad to move the green crop rectangle to the desired location, and press the OK button to execute the crop. I have not found a way to resize these crops.
3. You will see an unsaved preview of the cropped image on the monitor (figure 5.5D, image 4). The screen will have a menu with Yes and No choices. Select Yes to save the new image and No to cancel and start over.

Aspect (Changing Image Proportions)

Figure 5.5E: Adjusting the Aspect ratio

1. The aspect ratio is the relationship of the picture's horizontal sides to its vertical sides. The Aspect ratio setting allows you to choose from several preset image sizes. The basic Micro Four Thirds (4:3) ratio can be cropped to one of four additional ratios. Choose Aspect from the JPEG Edit Menu and press the OK button (figure 5.5E, image 1).
2. A menu will open with several aspect ratio choices: 3:2, 16:9, 1:1, and 3:4 (figure 5.5E, image 2). Choose the aspect ratio that best fits the subject matter and press the OK button.
3. A green aspect ratio frame will surround the subject (figure 5.5E, image 3). Use the Arrow pad buttons to move the green aspect ratio frame to the desired position, then press the OK button to execute the aspect ratio change. I selected a square (1:1) aspect ratio (figure 5.5E, image 3). All four sides are of equal length; that is, 1:1. If you do not like the aspect ratio you chose, simply press the Menu button and the camera will return to the screen shown in figure 5.5E, image 2, and you can choose a different one. After you have chosen a ratio, positioned the frame, and are ready to execute the change, press the OK button.
4. You will see an unsaved preview of the new image on the monitor (figure 5.5E, image 4). The screen will have a menu with Yes and No choices. Select Yes to save the new image and No to cancel and start over.

Black & White (Converting to Grayscale)

Figure 5.5F: Converting an image to Black & White

1. Black & White conversion lets you change a color image into a grayscale or monochrome picture. Choose Black & White from the JPEG Edit Menu and press the OK button (figure 5.5F, image 1).
2. You will see an unsaved preview of the new image on the monitor (figure 5.5F, image 2). The screen will have a menu with Yes and No choices. Select Yes to save the new image and No to cancel and start over.

Sepia (Converting to Antique Brown Tones)

Figure 5.5G: Converting an image to Sepia

1. Sepia conversion lets you change a color image to a monochrome image with brown tones instead of gray tones. Choose Sepia from the JPEG Edit Menu and press the OK button (figure 5.5G, image 1).
2. You will see an unsaved preview of the new image on the monitor (figure 5.5G, image 2). The screen will have a menu with Yes and No choices. Select Yes to save the new image and No to cancel and start over.

Saturation (Changing Image Color Strength)

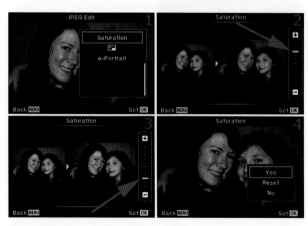

Figure 5.5H: Changing the color saturation

1. The Saturation setting lets you change the strength of the colors in the image. Choose Saturation from the JPEG Edit Menu and press the OK button (figure 5.5H, image 1).
2. You will see small before (left) and after (right) versions of the selected image (figure 5.5H, image 2). There will be a sliding scale with a green dash that indicates the current Saturation position. You can make the colors stronger (more saturated) by moving the slider up, or weaker (less saturated) by moving the slider down, on a scale of 10 steps. I moved the slider three steps toward increased Saturation (figure 5.5H, image 2, red arrow). Use the up and down buttons on the Arrow pad to change the Saturation level. I then reduced the Saturation level (figure 5.5H, image 3, red arrow).

You can see the differences in Saturation on the left sides of images 2 and 3. When you are happy with the Saturation level, press the OK button.

3. You will see an unsaved preview of the new image on the monitor (figure 5.5H, image 4). The screen will have a menu with Yes and No choices. Select Yes to save the new image. Select Reset to move the slider back to the middle of the scale so you can make new adjustments. Select No to cancel and start over. When you are done, press the OK button to create and save the new JPEG image.

[File Size] (Downsizing an Image)

Figure 5.5I: Downsizing an image

1. Normal 4:3 images from your E-M1 have 4608×3456 megapixels. That is equivalent to a 16 MP image, which is much too big to display on social media sites and usually too large to e-mail. You can quickly make a smaller JPEG by using the [File Size] function. Select the [File Size] symbol from the JPEG Edit Menu and press the OK button (figure 5.5I, image 1).

2. You will see a menu of file sizes: 1280×960 or 1.2 MP, 640×480 or 0.3 MP, and 320×240 or 0.075 MP. There is also a No option, which cancels the operation. Any of these smaller file sizes can be e-mailed or used on social media sites. Select the file size you want to use and press the OK button, or select No to cancel (figure 5.5I, image 2).

3. A Busy screen with a progress indicator will display on the camera monitor while the image is converted to the smaller size (figure 5.5I, image 3). Then the camera will display the new, smaller JPEG image (figure 5.5I, image 4), which is saved as the last image on the memory card.

e-Portrait (Smoothing Skin Tones)

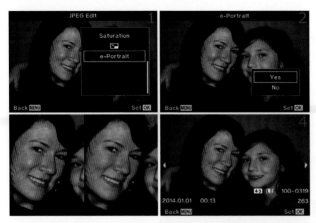

Figure 5.5J: Smoothing skin tones

1. The e-Portrait function converts a normal JPEG portrait into a new portrait with smoother skin tones. Choose e-Portrait from the JPEG Edit Menu and press the OK button (figure 5.5J, image 1).
2. You will see a small menu with Yes and No selections. Choose Yes to start the conversion process or No to cancel and start over (figure 5.5J, image 2).
3. A Busy screen with a progress indicator will display during the conversion process. When the conversion is done, a before-and-after screen will appear (figure 5.5J, image 3). This screen stays on the monitor for a few seconds, then the camera displays the final image that has been saved to the memory card (figure 5.5J, image 4).

Now let's examine the final form of image editing, [Voice Annotation].

[Voice Annotation]

The [Voice Annotation] setting lets you add a voice message to an image file while you view it on the camera monitor. This is a powerful tool found only in professional-level cameras such as the E-M1.

How can voice annotation be useful for a professional, or an enthusiast, for that matter? Let's say you are shooting a beautiful landscape on the Blue Ridge Parkway and you add a voice annotation to the first image in the series with important information from a sign so you can later create an accurate caption. Or maybe you are photographing the bride's grandmother, Myrtle May, at a wedding and you want to remember her name later when you are preparing the wedding album. Voice annotation is an easy way to take notes about an image, without carrying anything extra.

The voice file is a standard WAV format that can be played by your computer, tablet, smartphone, or camera. That makes sense because you want to store the sound file with

the image file so you can reference it years later, long after your camera is obsolete and we are using holographic imaging like on *Star Trek*.

If you use Olympus Viewer 3 software to transfer your images from your camera to your computer, you can listen to the voice sound files from within the software. Open the image in Viewer 3 and use the following menu selections to play the sound file: *File Menu > Linked Sound > Play*.

If you transfer images to your computer another way, do not overlook copying your sound files along with the image files. The sound files will have the same names as the image files, except the three-character extension is different. For instance, if you record a sound file for an image with a filename of P4000250.JPG, the linked sound file will have the filename of P4000250.WAV.

Let's see how to make a voice recording for any image on the memory card.

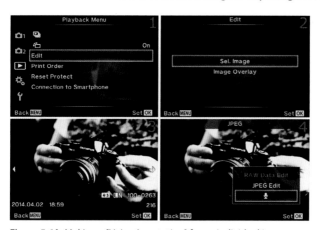

Figure 5.6A: Making a [Voice Annotation] for an individual image

Use these steps to make a [Voice Annotation] for any image you can view on your camera monitor:

1. Select Edit from the Playback Menu and scroll to the right (figure 5.6A, image 1).
2. Choose Sel. Image from the Edit Menu and press the OK button (figure 5.6A, image 2).
3. Images will be displayed on the camera monitor. Use the Arrow pad buttons to scroll back and forth until you find an image to which you want to add a voice annotation (figure 5.6A, image 3). After you have found the image, press the OK button.
4. I chose a JPEG image, and the camera displayed a menu with a speaker symbol, the [Voice Annotation] setting (figure 5.6A, image 4). Highlight it and press the OK button.

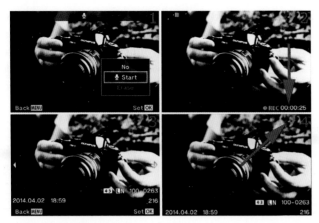

Figure 5.6B: Making the voice recording

5. Figure 5.6B picks up where figure 5.6A leaves off. Now you will record the actual voice annotation. Before you record your voice, you need to know where the Stereo microphone pickups are on your camera so you can talk directly at them for the best reception. Look at the *front* of your camera, at the Olympus logo on the viewfinder bump. On either side of the bump you will see a small hole. One of them is located just above the E-M1 logo. Each of the holes is a Stereo microphone pickup (left channel and right channel). The best recording will be made if you talk with your mouth near the top of the camera. Just act as if the Hot shoe is a microphone, and your voice will be picked up. In figure 5.6B, image 1, you can see the recording menu that appeared when you completed step 4. Select Start from the menu, and when you are ready to talk press the OK button to start recording.

6. Figure 5.6B, image 2, shows the screen that will be visible while you are recording a voice annotation. A red REC symbol will appear at the bottom of the screen (figure 5.6B, image 2, red arrow) along with a timer. The red card access symbol will blink in the top-left corner of the screen while you make the recording. Even though the timer seems to indicate that you could record for a long time, you are limited to 30 seconds. When you are done recording, press the OK button to stop. If you keep talking longer than 30 seconds, the camera will cut you off.

7. Nothing obvious appears on the screen when you are done making a voice recording. The camera continues to display the image for which you were making the voice annotation (figure 5.6B, image 3). If you want to hear the recording, press the Playback button to the right of the Menu button and the annotation will play back though the Speaker on the back of the camera, just to the right of the Erase button (red garbage can). **Note:** You can record new voice annotations for different images by pressing the OK button on a new image, selecting the microphone symbol (similar to figure 5.6A, image 4), then starting again at step 5.

8. A green musical note symbol will appear on the camera monitor for any image that has a voice annotation (figure 5.6B, image 4, red arrow). As soon as the camera displays an image with a music note symbol on the monitor, the recording will play. You can adjust the volume by using the Arrow pad buttons; up increases the volume, and down decreases it. A volume indicator scale will appear on the right side of the monitor when you adjust the volume.

Settings Recommendation: Recording a voice annotation through the Edit Menu is really the long way around. You can record a voice recording any time you see an image on the camera monitor by pressing the OK button and selecting the [Voice Annotation] microphone symbol (review steps 5–8).

Image Overlay

Image Overlay allows you to take two or three images, vary their transparency, and overlay them into one image. This is an easy way to do something like add a picture of the moon to a nighttime landscape image.

This works differently than Multiple Exposures because there is no Auto Gain function to keep the backgrounds from overwhelming multiple subjects in different parts of the image. Instead you use a transparency adjustment to vary the transparency of each image in the overlay.

The effectiveness of this method will vary greatly depending on how complex the images are. Let's examine how it works and see how you might use it to combine two or three images.

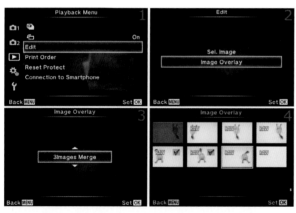

Figure 5.7A: Creating a three-image overlay (first four steps)

Use the following steps to start combining images:

1. Choose Edit from the Playback Menu and scroll to the right (figure 5.7A, image 1).
2. Select Image Overlay from the Edit Menu and press the OK button (figure 5.7A, image 2).

3. Choose 2Images Merge or 3Images Merge from the Image Overlay up/down menu, depending on whether you want to combine two or three images (figure 5.7A, image 3). I chose 3Images Merge.
4. The screen will display images from the memory card. Although it shows both JPEG and RAW images, only RAW images can be selected for overlaying. The word RAW will appear in the top-left corner of each available image. JPEG images are slightly grayed out and cannot be selected (figure 5.7A, image 4). Choose each image you want to use with the green selection frame and press the OK button, which will place a red check mark in the top-right corner of the image. On the bottom row of the rubber chicken images you can see that I have selected two images because they have red check marks. The third image I want to use in the overlay is surrounded by the green selection frame. As soon as you select the final image, the camera will start creating the overlay. You won't see the check mark for the final image. When the overlay process begins, a Busy screen appears with a progress bar. When the overlay is done, figure 5.7B, image 1, appears.

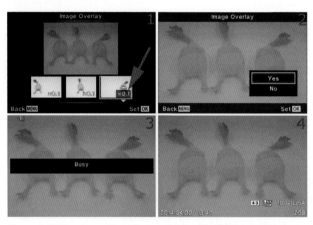

Figure 5.7B: Creating a three-image overlay (final three steps)

5. You will see before and after images on the screen. The after image is the larger one on top, and the before images are on the bottom (figure 5.7B, image 1). The red arrow points to an up/down menu with a range from x0.1 to x2.0. You adjust the transparency of each image with the up and down buttons of the Arrow pad. Each before image has this up/down menu. The range from x0.1 to x2.0 controls the transparency of the corresponding image. You can see that I set each image to the lowest setting of x0.1 so the combined backgrounds do not obscure the chicken. At first I was confused because my after image was pure white, and I couldn't see any rubber chickens. That's because each image contains both a chicken and a white background. Each chicken is positioned differently, but in the overlay the backgrounds of the other two images completely hide them. After I lowered the transparency of all the images, the three chickens appeared.

Although you see three chickens in the after image, you also see the backgrounds of each one, with the transparency lowered to let the other pictures show through. **Note:** When you change the transparency level, allow a little time after each change for the camera to respond. It will seem to be locked up and nonresponsive, but the overlay takes a lot of processing power. After you have the transparency adjusted the way you want it on each picture, press the OK button.

6. The camera will display the overlaid image and a menu with Yes and No choices (figure 5.7B, image 2). Choose Yes to finish creating the new JPEG image or No to cancel and start over. Press the OK button.

7. A Busy screen will appear with a progress bar (figure 5.7B, image 3). When it is done, the finished JPEG image will appear, which is saved with a new file name as the last image on the memory card (figure 5.7B, image 4).

Settings Recommendation: The final picture in figure 5.7B, image 4, is not very colorful or useful. You may be able to come up with a better example of how to overlay two or three images than my rubber chicken and white background; however, if you are really into overlaying images, you might want to consider Multiple Exposure for better-looking images. You will need to experiment with Image Overlay and show off some of your creations on this book's Facebook site:

https://www.facebook.com/groups/ODCPE/

Print Order

When you create a Print Order on your memory card, you can insert the card into a Digital Print Order Format (DPOF) printing device, such as a photo kiosk at a superstore or a DPOF-compatible inkjet printer. The kiosk or printer will then print the order without your camera. If you don't like to post-process images or work with computers, you can print images without doing much more than inserting a memory card into a compatible printing device. It's convenient even if you do like computers.

There are three things you need to know about the Print Order function:

- How to print one or several copies of a few selected images on the memory card
- How to print one copy of each image on the memory card
- How to clear a Print Order from the memory card

There can be only one Print Order at a time on a memory card. If you are the curious sort, you will find the Print Order in a folder named MISC on the memory card. The camera creates that folder and saves the Print Order inside it. The Print Order is held in a small file named AUTPRINT.MRK, which can be read by all DPOF-compatible printing devices.

Now, let's examine each of the Print Order methods.

Selected Image(s) Print Order

This Print Order method lets you scroll through the images on your memory card. As each image is displayed on the camera monitor, you can select the number of prints (up to 10) you want to make for that image. Let's see how it works.

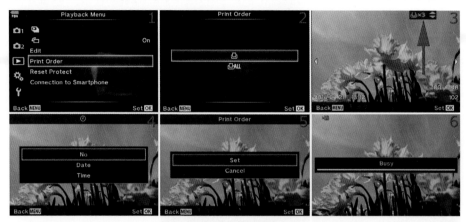

Figure 5.8A: Creating a Print Order for individual images

Use these steps to create a new Print Order for individual images. The upcoming steps assume there is no current Print Order on the memory card. If there is an existing Print Order, you will see an extra screen between images 2 and 3 in figure 5.8A, as we will discuss:

1. Choose Print Order from the Playback Menu and scroll to the right (figure 5.8A, image 1).
2. Select the printer symbol from the Print Order menu to choose how many prints you want for individual images. Press the OK button (figure 5.8A, image 2).
3. If there is an existing Print Order on the memory card, an additional screen will appear. Instead of figure 5.8A, image 3, you will see the screen shown in figure 5.8B, image 3, which allows you to Reset or Keep the current Print Order. If you Reset it, the camera will remove the current Print Order. If you Keep it, the camera will start displaying pictures, as seen in figure 5.8A, image 3, and it will leave any current Print Orders intact. In effect, you will update an existing Print Order.
4. Use the adjustable counter to select the number of copies you want of the current picture (figure 5.8A, image 3, red arrow). Scroll up and down with the Arrow pad to select a number from 0 to 10. I selected 3 copies. Scroll left or right to choose other images and select the number of copies you want. Leave any images you do not want printed set to 0. When you have selected the number of copies for each of the images you want to print, press the OK button to lock in the numbers.
5. The camera will now display the Date and Time screen (figure 5.8A, image 4). This allows you to have either the shooting Date or Time written on the print. Select Date for the shooting date, Time for the shooting time, or No for neither. Press the OK button to lock in your choice.

6. The camera will switch to the final Print Order menu where you can Set the order or Cancel it (figure 5.8A, image 5). If you select Set, the camera will display the Busy screen (figure 5.8A, image 6). The progress indicator will advance, and the red card symbol will blink in the top-left corner of the monitor as the camera writes the Print Order to the memory card. If you select Cancel the selections you made will be ignored and the camera will return to the Playback Menu.

If you simply want to clear the Print Order from your memory card, it is a straightforward process, as we will see in the next subsection.

Clearing a Print Order

You may want to remove an old Print Order after you print your images. To do so, use the Print Order Reset function.

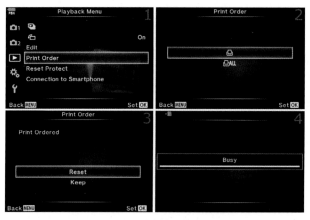

Figure 5.8B: Resetting a Print Order for individual images

Use these steps to clear an old Print Order from a memory card:

1. Choose Print Order from the Playback Menu and scroll to the right (figure 5.8B, image 1).
2. Select either of the two symbols from the Print Order menu. I chose the top symbol for individual images (figure 5.8B, image 2). The following instructions work the same way for the All selection, which we will discuss in the next subsection (**All Print Order**). Press the OK button with one of the Print Order items selected.
3. You will now have two choices: Reset and Keep (figure 5.8B, image 3). If you select Reset, the camera will immediately reset, or delete, the current Print Order. The Busy progress indicator will show the progress, and the red card activity symbol will flash in the top-left corner of the camera monitor (figure 5.8B, image 4). If you choose Keep, the camera will leave the existing Print Order on the memory card and return to the images in the existing Print Order, with the number of copies you selected, so you can make modifications.

Now, let's see how to select a Print Order in which every image on the card is set to print one copy.

All Print Order

All Print Order allows you to create a Print Order that will cause a DPOF printing device to make one copy of each image. After we explore how this works, we'll take a look at how you can have the camera print more than one copy of selected pictures and one copy of the rest of the pictures.

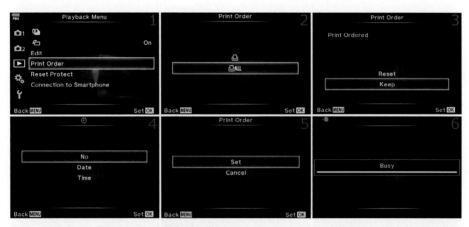

Figure 5.8C: Create or Reset a Print Order for all images

1. Choose Print Order from the Playback Menu and scroll to the right (figure 5.8C, image 1).
2. Select the bottom symbol from the Print Order menu. It looks like a printer with the word All after it. This will cause one copy of each image on the memory card to be printed. Press the OK button (figure 5.8C, image 2).
3. The screen shown in figure 5.8C, image 3, *will not appear* if there are no existing Print Orders on the memory card. If you are like me, you will forget to remove the last Print Order you created. Carefully read and understand this step through step 5 if you want to Keep an existing Print Order. If there is an old Print Order on the memory card, the screen shown in image 3 will appear and you will need to choose either Reset or Keep. Choosing Reset will immediately delete the old Print Order. Choosing Keep will leave the old Print Order in place *only if you select* Cancel *in step 5* (figure 5.8C, image 5). Otherwise, it makes absolutely no difference whether you choose Reset or Keep, the old Print Order will be deleted anyway.
4. If you are creating a new Print Order you can choose whether a Date or Time stamp is applied to the printed image (figure 5.8C, image 4). If you selected Keep in the previous screen to prevent the deletion of the old Print Order, just select No and press the OK button to move forward—there is no point in selecting a Date or Time stamp because you must press Cancel in the next step to Keep an existing Print Order.

5. Pay careful attention here so you don't lose the old Print Order you want to Keep. If you select Set the camera will merrily overwrite the Print Order you told it to Keep in step 3. Selecting Set always recreates the Print Order with one copy selected for each image. Select Cancel if you are working with an *existing* Print Order that you want to Keep, or select Set if you want to create a *new* one. You will see a Busy screen and a progress bar if you create a new Print Order (figure 5.8C, image 6). The Busy screen will show the progress of the images being marked for printing. When the Print Order has been created the camera will return to the Playback Menu.

The circular logic of these last few steps is quite confusing. It is a rather weak screen-flow design, in my opinion. Instead of continuing when you selected Keep in figure 5.8C, image 3, the camera should simply exit the screens and go back to the images on the monitor, with the number of copies still in place, so you can make direct modifications to the Print Order you decided to Keep. That is the way it works for individual images as described in the **Selected Image(s) Print Order** subsection.

Increasing the Number of Copies on a Few Images in an All Print Order

As you know, an All Print Order sets the number of printed copies to 1 for each image on the memory card. But what if you want more than 1 printed copy of a few images and 1 printed copy of the rest? I found a way to increase the number of copies to more than 1 for selected images within the All Print Order. Here's how.

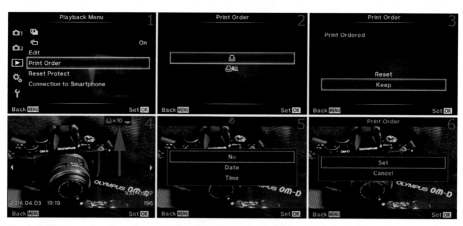

Figure 5.8D: Increasing the print count for a few images in an All Print Order

1. First you must create a new All Print Order by using the steps accompanying figure 5.8C. The next few steps assume that a new All Print Order is on the card with 1 selected as the print count for each image on the memory card.
2. Choose Print Order from the Playback Menu and scroll to the right (figure 5.8D, image 1).

3. Select the top symbol from the Print Order menu, which allows you to select the number of copies for individual images. Press the OK button (figure 5.8D, image 2).
4. Select Keep from the Print Order menu (figure 5.8D, image 3). Press the OK button to continue. You have just told the camera that you want to keep the All Print Order you created in step 1. Now, we will modify it!
5. The camera will display the images that are currently on the memory card, and each of them will have the number of printed copies set to 1 because we are looking at the results of an All Print Order. Scroll back and forth with the Arrow pad keys until you find an image for which you want to increase the number of printed copies. I chose a picture I took of my new Olympus E-M10. I want 10 copies of this image, so I increased the print count to 10 by scrolling up on the Arrow pad (figure 5.8D, image 4). You can keep scrolling back and forth to find other images you want more prints of and increase the numbers. When you are done increasing the numbers, press the OK button to modify the All Print Order. Now you will get one copy of most of the images, and you'll get the number of copies you chose for the rest of the images.
6. On the Date and Time stamp screen, choose Date, Time, or No (neither) and press the OK button (figure 5.8D, image 5).
7. The final screen allows you to modify the existing All Print Order and make extra copies of a few images. Select Set and press the OK button (figure 5.8D, image 6). The camera will show the Busy screen progress indicator with a flashing red card icon in the top-left corner. When it's done, the card is ready to insert into a DPOF-compatible device to print your custom All Print Order. Press Cancel and the OK button to cancel the process.

Settings Recommendation: Print Orders can be quite useful in some circumstances. You may want to print a few images, so you create a Selected Image(s) Print Order and make your prints. Or you may have shot an event and would like to deliver the images to your client so they can have them printed right away. You could create an All Print Order (and modify it if necessary) and then give the memory card to your client. They can go straight to a DPOF printing device and plug in the memory card. The DPOF device will do the rest.

Reset Protect

You can set an image protection lock on any of the images on a memory card, and Reset Protect cancels the protection lock.

Adding Image Protection

When you press the OK button while you view an image on the camera monitor, you will see a menu for editing that image. The menu has a key symbol, which means you can add protection to an image.

After you apply protection, the image will be displayed with a green key (lock) symbol, then it won't be deleted during an All Erase operation (*Shooting Menu 1 > Card Setup > All Erase*). We discussed image protection in the chapter titled **Screen Displays for Camera Control,** on page 84, under the subheading **Protecting Images**. For more information on adding protection, please review that subheading.

It's easy to remove image protection, as we'll see in the next subsection.

Removing Image Protection

To remove image protection, you simply choose Reset Protect from the Playback Menu and answer Yes to the query.

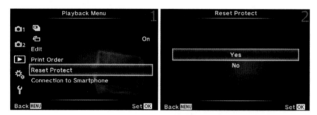

Figure 5.9: Removing image protection with Reset Protect

Use the following steps to remove image protection from all protected images on the memory card:

1. Select Reset Protect from the Playback Menu and scroll to the right (figure 5.9, image 1).
2. A menu with Yes and No choices will appear (figure 5.9, image 2). Choose Yes to reset the image protection or No to cancel.
3. Press the OK button to remove protection. A Busy screen with a progress bar will appear briefly, then the camera will return to the main screen of the Playback menu.

Settings Recommendation: This function resets all protected images at the same time. If that is too drastic, you can remove protection from individual images by following these steps:

1. Display an image with the green key protection symbol on the monitor.
2. Press the OK button and select the key symbol from the menu.
3. Scroll up or down with the Arrow pad until the green key symbol disappears.
4. Press the OK button to remove the protection.

This process is the opposite of adding protection. Adding protection is discussed in the chapter titled **Screen Displays for Camera Control**, on page 84.

Connection to Smartphone (or Tablet)

The E-M1 has a powerful feature that relatively few cameras have—the ability to become a Wi-Fi wireless access point. That means the camera can wirelessly communicate with your smartphone or tablet, which I'll refer to collectively as a smart device.

You can use the screen of your smart device as a remote monitor and control the camera directly from the device. You can also transfer images wirelessly to your smart device for immediate use on social media sites, blogs, and websites.

There is a free Olympus app for both iOS (iPhone and iPad) and Android devices. Do a search for "Olympus Image Share" in your app store and download it to your smart device before you proceed with this section.

There are two parts to communicating with a smart device. First you must enable Wi-Fi on the camera, then you must create a relationship between the camera and the device. Let's examine the process.

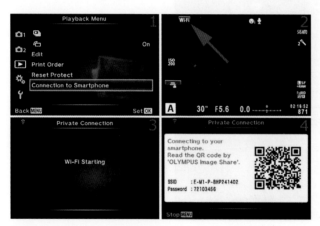

Figure 5.10A: Making a Wi-Fi connection to your smart device

Use the following steps to connect your camera to the Olympus Image Share (OI.Share) app:

1. Figure 5.10A, images 1 and 2, show two entry points to the Wi-Fi system. You will not see image 2 unless you are accessing the Wi-Fi system from the Live View screen instead of the Playback Menu. However, I wanted to show the alternate entry point (image 2, red arrow) so you can access it if you want to. You can touch the Wi-Fi icon on the touch screen, or you can select Connection to Smartphone on the Playback Menu and scroll to the right. Either one of these screens will take you to the screen in image 3.
2. Figure 5.10A, image 3, shows that Wi-Fi is in the process of activating. The green Wi-Fi broadcast symbol in the upper-left corner of image 3 will blink while Wi-Fi is starting up.

3. When Wi-Fi is active, you will see the screen shown in figure 5.10A, image 4. This screen contains all the information you need to connect your camera and your smart device. It even includes a QR code that the Olympus Image Share app can scan and use to connect with your camera.

Figure 5.10B: Olympus Image Share setup

4. Figure 5.10B shows the main screen of the Olympus Image Share app on an iPad. Touch the bottom tab that has a camera symbol and Off, then touch the Easy Setup button (red arrow). The app will walk you through the process of scanning the QR code on the camera monitor, creating a profile on your smart device, and using the app.

Note: Within the camera's Setup Menu is another menu called Wi-Fi Settings (see the chapter **Setup Menu,** on page 459, under the heading **Wi-Fi Settings**). Within the Wi-Fi Settings menu you can change the connection type and password, reset the share order, and completely reset the camera's Wi-Fi settings.

Settings Recommendation: The Olympus Image Share app is great for controlling your camera. However, it is beyond the scope of this book to describe its many functions. That would take an extra chapter!

You can control many camera settings from within the app, including the shutter speed, aperture, exposure compensation, ISO, white balance, and shutter-release mode. Plus you can import your photos, edit them on your smart device, and even add a geotag (GPS information) to the pictures. You can also take pictures remotely by using the larger screen on your smart device.

There are many YouTube videos that demonstrate how to make a connection between the camera and a smart device. Do a YouTube search on the words "Olympus Image Share" to find literally thousands of how-to videos. Most people don't have trouble making the connection because it is a fairly automated process. But if you do have problems, there are easily accessible resources.

Also, you can stop by the Facebook page for this book and discuss any problems you have in creating a connection between the camera and app:

https://www.facebook.com/groups/ODCPE/

Author's Conclusions

This chapter covered different ways you can view and use images from your Olympus E-M1.

Our next chapter, **Custom Menu,** covers the dozens of functions you can customize on this camera. It is a primary reference chapter for many of the settings you will use when you configure buttons and dials on the camera. Although there are a lot of functions, you will be a master of your camera if you take time to carefully study the chapter.

Now, let's customize our cameras!

6 Custom Menu

Image © Darrell Young

The Custom Menu is the heart of camera configuration for enthusiast and professional users. It allows you to make extensive customizations to the camera functions. There are 101 functions in the Custom Menu (in firmware version 2.0), and each one affects an aspect of camera performance. The sheer number of functions may seem overwhelming, but just take your time and configure each setting the way you want it to work.

Enabling the Custom Menu

The Custom Menu may not show up in the list of menus when you take a new E-M1 out of the box. You may have to enable the menu so you can see it and adjust the functions. The following steps tell you how.

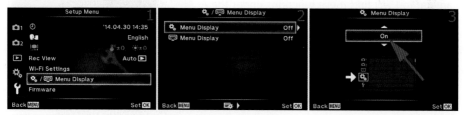

Figure 6.1A: Enabling the Custom Menu

Use these steps to make the Custom Menu visible:

1. Select Menu Display from the Setup Menu and scroll to the right (figure 6.1A, image 1).
2. Choose the top menu selection, which is the gear symbol followed by Menu Display, then scroll to the right (figure 6.1A, image 2).
3. Press up or down on the Arrow pad until On appears in the up/down menu (figure 6.1A, image 3, red arrow).
4. Press the OK button to Set the Custom Menu so it will display on the menu system.

Figure 6.1B: The Custom Menu

When the Custom Menu is enabled, it is the fourth menu down on the left side of the menu system screen (figure 6.1B).

The Custom Menu is composed of 11 major sections (A–K), with many individual functions under each section. We will consider each of the functions in detail. Here is a look at the Custom Menu after it has been enabled.

Now, let's see how each of the functions in the Custom Menu work.

Custom Menu A. AF/MF

The AF/MF function gives you complete control over the autofocus and manual focus capabilities of your camera. You will find these functions under the A. AF/MF heading, as shown in figure 6.2.

Figure 6.2: The opening menu selection for the A. AF/MF functions

AF Mode

AF Mode allows you to choose the type of focus when you take still pictures and shoot videos. Each of the two modes—still pictures and video—can have its own focus settings that are independent of the other. There are five focus settings available for either mode:

AF Mode focus settings
- **S-AF:** When you press the Shutter button halfway down, the camera focuses on the subject, locks the focus, and sounds a beep. The green AF Area Pointer will be displayed, and a small green dot (AF confirmation mark) will appear in the top-right corner of the monitor when focus is confirmed. This type of focus is best for subjects that are not moving or are moving very slowly. The camera *does not update the focus* unless you release the Shutter button and reapply pressure. When you shoot video, no beep or focus indicators will sound or display on the monitor.
- **C-AF:** As long as you continuously hold the Shutter button halfway down, the camera will continuously update the focus as long as you or the subject are moving. When it can acquire focus, the camera will beep and the green AF confirmation mark (dot) will display without blinking. If you or the subject start moving, the camera will notice the movement and attempt to update the focus. It will beep each time it locks focus on the subject, up to twice, then it stops the beep so it doesn't become a nuisance in a quiet environment. The difference between S-AF and C-AF is that S-AF does not update focus, while C-AF causes the focus to continuously update. When you are shooting a video, no beep or focus indicators will sound or display on the monitor.
- **MF:** You must use the focus ring on the lens to focus manually when this mode is enabled. Autofocus is disabled and you are responsible for focusing. This mode is often

used by people who shoot macro (closeup) still images and videos to increase the reliability of focusing.

- **S-AF+MF:** This mode works exactly the same as the S-AF mode. The only difference is that S-AF does not let you fine-tune autofocus with the manual focus ring, while S-AF+MF does. You can let the camera autofocus and then manually adjust the focus yourself, with the focus ring on the lens. If you have focus Peaking enabled *(A. AF/MF > MF Assist > Peaking),* a white outline will be displayed on the edges of your image, to help you fine-tune the focus.

- **C-AF+TR:** This mode makes the camera sensitive to moving subjects. Select the subject by pressing the Shutter button halfway until focus locks on the subject. The AF Area Pointer will change from its normal small green rectangle to a much larger square with a line sticking out of each side (figure 6.3C, image 2). As the subject moves, the camera will maintain focus and track it across the viewfinder or monitor. As long as the AF Area Pointer remains green, the camera is tracking; if it turns red, the camera has lost the subject and you should reacquire it by refocusing until the focus locks and tracks again. How well the camera can track a moving subject when other objects intervene is controlled by the C-AF Lock function that is considered later in this chapter section. When you shoot a video, the camera will not beep, but it will display the tracking AF Area Pointer so you will know that it is tracking successfully.

Now, let's see how to select your favorite focus mode for both still pictures and videos.

Still Pictures

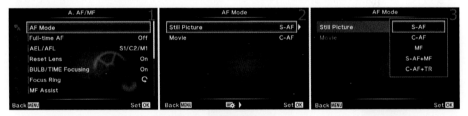

Figure 6.3A: Selecting a focus mode for still pictures

Use these steps to select a focus mode for still pictures:

1. Select AF Mode from the A. AF/MF menu and scroll to the right (figure 6.3A, image 1).
2. Choose Still Picture from the AF Mode menu and scroll to the right (figure 6.3A, image 2).
3. A menu will appear with five focus mode choices. Refer to the *AF Mode focus settings* list and select the mode you want to use (figure 6.3A, image 3).
4. Press the OK button to Set the mode. Now, take your pictures.

Movie

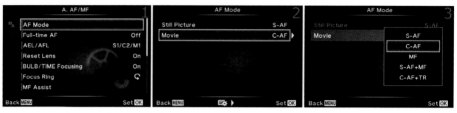

Figure 6.3B: Selecting a focus mode for movies

Use these steps to select a focus mode for movies:

1. Select AF Mode from the A. AF/MF menu and scroll to the right (figure 6.3B, image 1).
2. Choose Movie from the AF Mode menu and scroll to the right (figure 6.3B, image 2).
3. A menu will appear with five focus mode choices. Refer to the **AF Mode focus settings** list and select the mode you want to use (figure 6.3B, image 3).
4. Press the OK button to Set the mode. Now, make your movie.

AF Area Pointers

When you use the modes in the autofocus system, you will see a focus point indicator in the viewfinder or on the monitor. This indicator tells you what the camera is focused on. It is called the AF Area Pointer.

The AF Area Pointer is a small green rectangle (Single Target) or a small square (Small Target) for normal focus, a green square with lines for focus tracking, or a large or small green square for face and eye recognition modes.

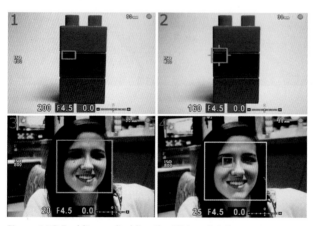

Figure 6.3C: Enabling or disabling the AF Area Pointer

Here are the types of AF Area Pointers that are shown in figure 6.3:

- The Single Target AF Area Pointer is a small green rectangle that you will see in various AF modes, such as S-AF and C-AF (figure 6.3C, image 1). This AF Area Pointer is also available in a smaller version (Small Target), which allows finer AF points for more detailed autofocus.
- The AF tracking symbol will appear when you use your camera to track a subject C-AF+TR mode (figure 6.3C, image 2).
- In Face Priority (see Note), a large white square is overlaid with a green focus-confirmation square of the same size. Sometimes the white face-tracking square and the green focus-confirmation square are slightly offset (figure 6.3C, image 3).
- In Face Priority (see Note), a larger face-tracking white square and a smaller green eye-detection AF confirmation square appear over the subject's eye on the left side of the frame (figure 6.3C, image 4).

Note: The larger squares shown in figure 6.3C, images 3 and 4, will appear instead of the Single Target or Small Target AF Area Pointers when you have one of the Face Priority modes enabled *and* a detectable human face is in the subject area. We will consider the Face Priority modes in an upcoming section.

With Face Priority enabled and when no people are in the subject area, the camera will use its normal AF Area Pointers and switch to the larger Face Priority squares only if a human face is detected.

If you want the camera to ignore human faces so you can use the normal AF Area Pointers all the time, you can disable Face Priority. We will consider how to use Face Priority in the upcoming subsection titled **Face Priority** on page 291.

Settings Recommendation: For everyday shooting of still pictures, the S-AF mode works well. If the subject is moving erratically, it may be a good idea to use C-AF. I leave my camera set to S-AF+MF most of the time because, as a nature photographer, I find that it allows me the most flexibility. I can use autofocus and then fine-tune it for things like macro shots or portraits in nature.

When I am shooting video I often use C-AF, but I find myself helping a little from time to time by pressing the Shutter button halfway down to force an AF operation. Many serious videographers like to use MF so they can have full control of what is in focus.

When I shoot sports or action, I often use C-AF and Sequential L mode so I can get good focus updating on my subjects. When I shoot wildlife, I often use C-AF+TR and Sequential L mode to track an animal as it moves around, especially for creatures like flying birds. Sequential L mode fires at 6.5 fps with firmware 2.0 or 9 fps with firmware 3.0.

Using the 10 fps Sequential H mode is not a great idea for many moving subjects because the camera cannot update the autofocus at that speed. However, if the subject is moving parallel to you, such as a race car, you may be able to use the 10 fps mode since the focus locks on the first frame and the distance to the subject does not vary greatly. If the aperture is small enough, the depth of field may cover most focus errors.

Full-Time AF

Full-Time AF is similar to C-AF, except the camera does not require you to press the Shutter button to initiate autofocus. Instead, the camera decides what the subject is and does its best to maintain focus on it without your assistance.

Figure 6.4: Enabling Full-Time AF

Use these steps to enable or disable Full-Time AF:

1. Choose Full-Time AF from the A. AF/MF menu and scroll to the right (figure 6.4, image 1).
2. A menu will open that has two choices: Off and On. Choose On to enable Full-Time AF, and choose Off to keep it disabled (figure 6.4, image 2).
3. Press the OK button to Set your choice.

Note: Full-Time AF does not work with Four Thirds lenses and an MMF adapter (Olympus-brand adapter for converting a Four Thirds lens for use on a Micro Four Thirds body). The camera will use Micro Four Thirds lenses only for this mode.

Settings Recommendation: This mode will work best when the subject is large in the frame and has plenty of contrast between itself and the background. If your subject is in an area with lots of bright, high-contrast items, the camera may have a hard time keeping the subject in focus because it gets distracted by other objects.

I rarely use this mode because I simply don't trust any camera to decide what I want to have in focus. Instead, I use one of the A. AF/MF modes considered in the previous subsection.

This mode may be useful if you hand your camera to your grandmother to take pictures and she has never used a mirrorless interchangeable-lens camera before.

AEL/AFL

The AEL/AFL button allows you to control AEL (autoexposure lock) and AFL (autofocus lock). The AEL/AFL button has a strong relationship with the Shutter button. The camera allows you to configure various combinations of the two buttons to accomplish different methods of locking exposure, autofocus, and taking a picture.

There are three focus modes that we must consider: single AF (S-AF), continuous AF (C-AF), and manual focus (MF). We will configure the AEL/AFL button and Shutter button for each focus mode.

First, select a focus mode (S-AF, C-AF, or MF) from the AF Mode function. Second, configure the AEL/AFL button and Shutter button relationship for the focus mode you just chose. (See the previous **AF Mode** subheading for AF Mode selection.)

There are three combination modes available for the AEL/AFL button and Shutter button when you use S-AF and MF: mode1, mode2, and mode3. When you use C-AF mode, a fourth mode, mode4, is also available.

Let's consider these button combination modes for each focus mode.

S-AF Mode

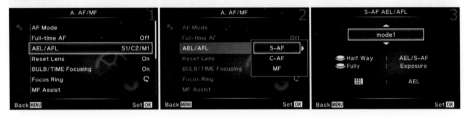

Figure 6.5A: AEL/AFL button and Shutter button relationship in S-AF focus mode

Use the following steps to configure the relationship of the AEL/AFL and Shutter buttons when you select S-AF focus mode:

1. Select AEL/AFL from the A. AF/MF menu and scroll to the right (figure 6.5A, image 1).
2. A menu with three choices will appear: S-AF, C-AF, or MF. Choose S-AF and scroll to the right (figure 6.5A, image 2).
3. An up/down menu will appear with the choices of mode1, mode2, or mode3 (figure 6.5A, image 3). Below the up/down menu is a short description of what each mode does. Here are better descriptions of what the AEL/AFL and Shutter buttons do in each mode:
 a. *mode1*
 - **Shutter button:** Pressing the Shutter button Half Way provides autoexposure lock (AEL) and single AF (S-AF) autofocus. Pressing the Shutter button Fully takes the picture (Exposure).
 - **AEL/AFL button:** Pressing the AEL/AFL button toggles autoexposure lock (AEL).
 b. *mode2*
 - **Shutter button:** Pressing the Shutter button Half Way provides single AF (S-AF) autofocus. Pressing the Shutter button Fully provides autoexposure lock (AEL) and takes the picture (Exp).
 - **AEL/AFL button:** Pressing the AEL/AFL button toggles autoexposure lock (AEL).
 c. *mode3*
 - **Shutter button:** Pressing the Shutter button Half Way provides autoexposure lock (AEL). Pressing the Shutter button Fully takes the picture (Exposure).
 - **AEL/AFL button:** Pressing the AEL/AFL button provides single AF (S-AF) autofocus.

4. Scroll up or down with the Arrow pad and select one of the modes. Press the OK button to Set it. Now, whenever you choose S-AF or S-AF+MF from the AF Mode menu, your camera will use the relationship mode you chose.

C-AF Mode

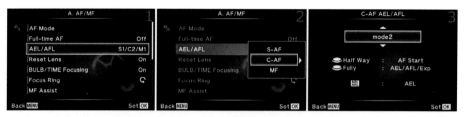

Figure 6.5B: AEL/AFL button and Shutter button relationship in C-AF focus mode

Use the following steps to configure the relationship of the AEL/AFL and Shutter buttons when you select C-AF focus mode:

1. Select AEL/AFL from the A. AF/MF menu and scroll to the right (figure 6.5B, image 1).
2. A menu with three choices will appear: S-AF, C-AF, or MF. Choose C-AF and scroll to the right (figure 6.5B, image 2).
3. An up/down menu will appear with the choices of mode1, mode2, mode3, or mode4 (figure 6.5B, image 3). Below the up/down menu is a short description of what each mode does. Here are better descriptions of what the AEL/AFL and Shutter buttons do in each mode:
 a. *mode1*
 - **Shutter button:** Pressing the Shutter button Half Way provides autoexposure lock (AEL) and starts continuous AF (C-AF) autofocus. Pressing the Shutter button Fully locks autofocus (AFL) and takes the picture (Exp).
 - **AEL/AFL button:** Pressing the AEL/AFL button toggles autoexposure lock (AEL).
 b. *mode2*
 - **Shutter button:** Pressing the Shutter button Half Way starts continuous AF (C-AF) autofocus. Pressing the Shutter button Fully provides autoexposure lock (AEL), autofocus lock (AFL), and takes the picture (Exp).
 - **AEL/AFL button:** Pressing the AEL/AFL button toggles autoexposure lock (AEL).
 c. *mode3*
 - **Shutter button:** Pressing the Shutter button Half Way provides autoexposure lock (AEL). Pressing the Shutter button Fully provides autofocus lock (AFL) and takes the picture (Exp).
 - **AEL/AFL button:** Pressing the AEL/AFL button starts continuous AF (C-AF) autofocus.

d. *mode4*
- **Shutter button:** Pressing the Shutter button Half Way does nothing. Pressing the Shutter button Fully provides autoexposure lock (AEL), autofocus lock (AFL), and takes the picture (Exp).
- **AEL/AFL button:** Pressing the AEL/AFL button starts continuous AF (C-AF) autofocus.

4. Scroll up or down with the Arrow pad and select one of the modes. Press the OK button to Set it. Now, whenever you choose C-AF or C-AF+TR from the AF Mode menu, your camera will use the relationship you chose.

MF Mode

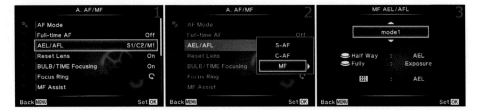

Figure 6.5C: AEL/AFL button and Shutter button relationship in MF focus mode

Use the following steps to configure the relationship of the AEL/AFL and Shutter buttons when you select MF focus mode:

1. Select AEL/AFL from the A. AF/MF menu and scroll to the right (figure 6.5C, image 1).
2. A menu with three choices will appear: S-AF, C-AF, or MF. Choose MF and scroll to the right (figure 6.5C, image 2).
3. An up/down menu will appear with the choices of mode1, mode2, or mode3 (figure 6.5C, image 3). Below the up/down menu is a short description of what each mode does. Here are better descriptions of what the AEL/AFL and Shutter buttons do in each mode:
 a. *mode1*
 - **Shutter button:** Pressing the Shutter button Half Way provides autoexposure lock (AEL). You must manually focus the lens. Pressing the Shutter button Fully takes the picture (Exposure).
 - **AEL/AFL button:** Pressing the AEL/AFL button toggles autoexposure lock (AEL).
 b. *mode2*
 - **Shutter button:** Pressing the Shutter button Half Way does nothing, and you must manually focus the lens. Pressing the Shutter button Fully provides autoexposure lock (AEL) and takes the picture (Exp).
 - **AEL/AFL button:** Pressing the AEL/AFL button toggles autoexposure lock (AEL).

c. *mode3*

- **Shutter button:** Pressing the Shutter button Half Way provides autoexposure lock (AEL), and you must manually focus the lens. Pressing the Shutter button Fully takes the picture (Exposure).
- **AEL/AFL button:** Pressing the AEL/AFL button provides single AF (S-AF) autofocus.

4. Scroll up or down with the Arrow pad and select one of the modes. Press the OK button to Set it. Now, whenever you choose MF or S-AF+MF from the AF Mode menu, your camera will use the relationship mode you chose.

Back-Button Focus Using the AEL/AFL Button

The E-M1 can provide back-button focus for people who want to separate the autofocus and shutter-release actions that are normally assigned to the Shutter button. The configuration steps for S-AF, C-AF, and MF modes are as follows:

Single AF (S-AF) mode

1. Set *Custom Menu > A. AF/MF > AF Mode > Still Picture* to S-AF.
2. Set *Custom Menu > A. AF/MF > AEL/AFL > S-AF* to mode3.

Continuous AF (C-AF) mode

1. Set *Custom Menu > A. AF/MF > AF Mode > Still Picture* to C-AF.
2. Set *Custom Menu > A. AF/MF > AEL/AFL > C-AF* to mode4.

Manual focus (MF) mode

1. Set *Custom Menu > A. AF/MF > AF Mode > Still Picture* to MF.
2. Set *Custom Menu > A. AF/MF > AEL/AFL > C-AF* to mode3.

Note: The Shutter button will not initiate autofocus when you set the camera to manual focus (MF) mode; this allows you to use the manual focus ring on your lens for precise focusing. To enable back-button focus in manual focus (MF) mode, you can use single AF (S-AF) by pressing the AEL/AFL button. This gives you the best of both worlds: full manual focus and autofocus on demand.

For all three focus modes, the Shutter button will not start autofocus; instead, it will initiate AEL, AFL (or both), and/or shutter release only. The AEL/AFL button will provide autofocus in this manner: single AF for S-AF and MF focus modes, and continuous AF for C-AF focus mode.

Settings Recommendation: Because I am a nature photographer, I do not use back-button focus very often. When I am shooting nature, events, or portraits and use the Shutter button for focus, I configure my AEL/AFL settings this way: S-AF mode: mode1; C-AF mode: mode2; and MF mode: mode3.

If you want to use back-button focus instead of Shutter button focus, use these settings: S-AF mode: mode3; C-AF mode: mode3 or mode4; and MF mode: mode3.

Reset Lens

Reset Lens is a simple function that resets the focus of your lens to infinity each time you turn the camera off. It works for both standard zoom and power zoom lenses.

Figure 6.6: Set the lens to infinity when the camera powers off

Use the following steps to enable or disable Reset Lens:

1. Choose Reset Lens from the A. AF/MF menu and scroll to the right (figure 6.6, image 1).
2. A menu will appear with two choices: On and Off (figure 6.6, image 2). Choose On to reset the lens to infinity when the camera powers off, or select Off to retain the focus position of the lens when the camera powers off. This function will have no effect on manual focus lenses.
3. Press the OK button to Set the choice.

Settings Recommendation: I leave this feature On. Why not focus the lens to infinity when the camera is turned off? This setting will not affect the zoom setting of the lens, just its focus position. Manual lenses are not controlled by the camera, so they will not be reset to infinity. If you don't want your lens to be set to infinity when the camera powers off, leave this setting Off.

BULB/TIME Focusing

When you use Live Time or Live Bulb modes to see a short time-exposure image come up gradually on the monitor, or when you do light writing in an image, the camera normally locks focus during the long exposure when you use manual focus (MF) mode.

If you want to use the focus ring on your lens to update focus during the long exposure, you must set this function to On.

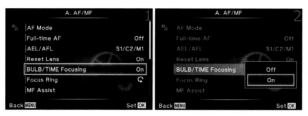

Figure 6.7: Enabling manual focus during Live Time and Live Bulb modes

Use the following steps to enable or disable manual focus during Live Time and Live Bulb operations:

1. Choose BULB/TIME Focusing from the A. AF/MF menu and scroll to the right (figure 6.7, image 1).
2. A menu will appear with two choices: On and Off (figure 6.7, image 2). Choose On to enable manual focus with the lens focus ring, or select Off to disable manual focus during a long exposure.
3. Press the OK button to Set the choice.

Settings Recommendation: I leave BULB/TIME Focusing set to On. When I take a Live Bulb shot, I may want to change the focus slightly to focus on multiple people who are light writing. Why disable something you may need to use, even if only occasionally?

Focus Ring

When you turn the focus ring toward infinity, you normally rotate it counterclockwise (from behind the camera). For a closeup picture (macro), you rotate the focus ring clockwise. If you want to reverse the direction, you can change it with this setting.

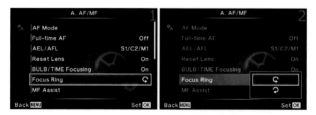

Figure 6.8: Reversing the directional effect of rotating the lens focus ring

Use the following steps to change the directional effect of rotating the lens focus ring:

1. Choose Focus Ring from the A. AF/MF menu and scroll to the right (figure 6.8, image 1).
2. A small menu will appear with two circular arrows that represent rotation directions (figure 6.8, image 2). Choose clockwise or counterclockwise rotation to select the direction you want to turn the lens when you move from infinity to closeup.
3. Press the OK button to Set the choice.

Settings Recommendation: I changed the direction to the opposite of the factory default—clockwise for infinity—so the rotation direction matches my AF-S Nikkor 24–70mm f/2.8G ED lens, which I use on my Nikon D800 (and sometimes, with an adapter, on my E-M1). Why confuse myself by having things work backwards when I switch cameras?

If you do not use lenses from other camera brands that focus in the opposite direction, this function may have little interest to you. However, remember it is there in case you ever want to change it.

MF Assist

MF Assist helps you accurately focus on a subject when you shoot in manual focus (MF) mode. There are two types of MF Assist: Magnify and Peaking.

Figure 6.9A: Using Magnify and Peaking to assist with manual focusing

In figure 6.9A, image 1, the subject is red, green, and blue blocks. When the focus ring is turned with both Magnify and Peaking enabled, the camera displays what you see in figure 6.9A, image 2. The camera zooms in by 10x so you can see fine detail and manually focus more easily.

Notice that Peaking is active, as shown by the white outline on the green and red block borders and white dust specks. Peaking emphasizes the in-focus edges of the subject with a white or black tone (depending on the setting at *Custom Menu > D. Disp/[Sound]/PC > Peaking Settings*) to help you see the exact point of focus. Peaking appears only briefly, while you turn the focus ring, as does the magnification. If you stop focusing for about a half second, both Magnify and Peaking turn off. As soon as you turn the focus ring again, they reappear.

The combination of these methods gives you very fine control over manual focus. Let's see how to enable and disable the two focus assistance aids.

Magnify

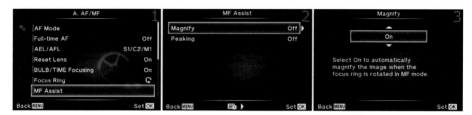

Figure 6.9B: Enabling Magnify to assist with manual focusing

Use these steps to enable or disable Magnify for manual focus assistance:

1. Select MF Assist from the A. AF/MF menu and scroll to the right (figure 6.9B, image 1).
2. Choose Magnify and scroll to the right (figure 6.9B, image 2).
3. From the up/down menu, choose On or Off (figure 6.9B, image 3). On enables Magnify and Off disables it.
4. Press the OK button to Set your choice.

Peaking

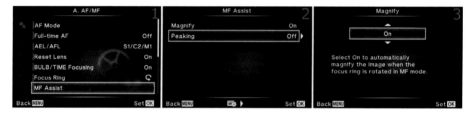

Figure 6.9C: Enabling Peaking to assist with manual focusing

Use these steps to enable or disable Peaking for manual focus assistance:

1. Select MF Assist from the A. AF/MF menu and scroll to the right (figure 6.9C, image 1).
2. Choose Peaking and scroll to the right (figure 6.9C, image 2).
3. From the up/down menu, choose On or Off (figure 6.9C, image 3). On enables Peaking and Off disables it.
4. Press the OK button to Set your choice.

Settings Recommendation: I use both of these functions to assist with manual focus. I leave Peaking On all the time and Magnify On part of the time. Some subjects require both to get accurate focus, others do not. Experiment with both of these focus aids so you will have full control with no other focusing aids.

[•••] Set Home

The [•••] Set Home function works in conjunction with a Button task called [•••] Home. You can store a single autofocus point (AF point) target position from the camera's 81 AF points in [•••] Set Home. Then, when you assign the [•••] Home function to one of the camera's buttons (such as Fn1) and press that button, the camera immediately moves the AF Area Pointer (green focus rectangle) to the AF point position stored in [•••] Set Home.

Note: See the Button task called **[•••] Home** in **Appendix: Button Tasks Reference,** on page 479, to assign [•••] Home to a camera button.

There are four types of AF point arrangements in the camera, which you can select by having one of the camera buttons assigned to AF Area Select. The four AF Target Types are All Targets, Single Target, Small Target, and Group Target. Information about how they work and how to select one is provided on page 470 under **Appendix: Button Tasks Reference** and the subheading **[•••] AF Area Select**.

Additionally, in this chapter subsection, when 81 focus points are mentioned, be aware that this applies only to Micro Four Thirds (m4/3) lenses. If you have an older Four Thirds (4/3) lens mounted with an MMF adapter, the camera will display only 37 focus points.

Let's see how to store an AF point position from each of the four types of AF points in the [•••] Set Home memory location.

All Targets

The All Targets function allows the camera to decide which AF point target to use for the best autofocus. You will see the AF Area Pointer flash and a beep will sound when the camera chooses a focus target—usually the nearest high-contrast object it can detect, unless Face Priority is enabled and a human face is in the frame, in which case it will select the face.

When you choose All Targets for the [•••] Set Home Task, the camera will use all 81 AF points to detect a subject, and when you press the button assigned to the [•••] Home Task, the 81 focus points will display in green.

You will not choose an individual AF point target since all AF points will be used by the camera for automatic focus selection.

Figure 6.10A: Choosing the All Targets focus system

Use the following steps to select the All Targets focus arrangement:

1. Choose [•••] Set Home from the A. AF/MF menu and scroll to the right (figure 6.10A, image 1).
2. A menu will open and allow you to choose All Targets, which is represented by a small grid in brackets at the top of the menu (figure 6.10A, image 2). All AF points will be active for autofocus (81 AF points with m4/3 lenses, or 37 AF points with 4/3 lenses). There is no single home position when you use All Targets. Therefore, the camera will display all AF points in bright green when you press the button assigned to [•••] Home.
3. Press the OK button to Set the camera to All Targets, with all available AF points in the home position, when you press the button assigned to [•••] Home.

Single Target

The Single Target function allows you to choose a single AF point target that you can scroll around the screen. You can position the AF Area Pointer on the subject for the best autofocus on that specific area.

Figure 6.10B: Choosing the [•••] Home position of the Single Target focus system

Use the following steps to select the Single Target focus arrangement and assign a home point (HP) that you can later select by pressing the button assigned to [•••] Home:

1. Choose [•••] Set Home from the A. AF/MF menu and scroll to the right (figure 6.10B, image 1).
2. A menu will open and allow you to choose Single Target, which is represented by single AF point in brackets, second from the top (figure 6.10B, image 2). Scroll to the right.
3. Choose one of the AF point target positions from the grid (81 points with m4/3 lenses and 37 points with 4/3 lenses). I chose the center AF point (figure 6.10B, image 3).
4. Press the OK button to Set the home point for Single Target.

Small Target

Small Target is very similar to Single Target in that you can scroll the AF Area Pointer around within all the focus points on the screen and position it where you want it. The difference is in the size of the AF Area Pointer. It is significantly smaller than the normal green rectangle, which tends to make it more detail sensitive for smaller subjects. If you are doing macro photography and want to focus on a very small area of the subject, this is the best setting.

Figure 6.10C: Choosing the [•••] Home position of the Small Target focus system

Use the following steps to choose the Small Target focus arrangement and assign a home point (HP) that you can later select by pressing the button assigned to [•••] Home:

1. Choose [•••] Set Home from the A. AF/MF menu and scroll to the right (figure 6.10C, image 1).
2. A menu will open and allow you to choose Small Target, which is represented by the single AF point in brackets, followed by a small *s*, third from the top (figure 6.10C, image 2). Scroll to the right.
3. Choose one of the AF point target positions from the grid (81 points with m4/3 lenses and 37 points with 4/3 lenses). I chose the center AF point (figure 6.10C, image 3).
4. Press the OK button to Set the camera's home point for Small Target.

Group Target

The Group Target setting causes the camera to use an array of nine AF points in a small grid. The camera will decide which of the AF point targets from within the nine-point grid to use for the best focus. You can move the entire nine-point group around within all the focus points on the screen, just like with a single AF point target.

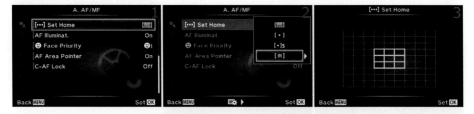

Figure 6.10D: Choosing the [•••] Home position of the Group Target focus system

Use the following steps to choose the Group Target focus arrangement and assign a home point (HP) for the nine-point grid that you can select by pressing the button assigned to [•••] Home:

1. Choose [•••] Set Home from the A. AF/MF menu and scroll to the right (figure 6.10D, image 1).
2. A menu will open and allow you to choose Group Target, which is represented by the small grid in brackets, at the bottom of the menu (figure 6.10C, image 2). Scroll to the right.

3. The Group Target, with nine bright green points, will display on the larger and dimmer grid (81 points with m4/3 lenses and 37 points with 4/3 lenses). I chose the center nine AF points (figure 6.10C, image 3).
4. Press the OK button to Set the camera's home point for Group Target.

Previously Assigned Home Position (HP)

As shown in figure 6.10E, when you are scrolling around in the AF points during the selection process, after you set a home position, you can identify the AF point that was previously assigned to the home position when HP appears above the grid.

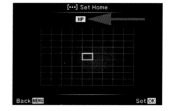

Figure 6.10E: The AF point selection is currently at [•••] HP

Note: The camera automatically changes the AF Target Type to Single Target when you are shooting a video.

Settings Recommendation: I normally leave my camera set to Single Target with the center AF point set to home position so the AF Area Pointer will jump to the center when I press the button assigned to [•••] Home. If you have special needs, such as if you take vertical portraits frequently and would rather have the AF Area Pointer appear at one end of the 81 (or 37) AF points for vertical face selection, you can choose other settings.

Most people leave the center AF point target set at home position, but if you need an off-center AF point to appear when you press the button assigned to [•••] Home, you can configure the camera to make that happen.

AF Illuminat.

The AF Illuminator is the small light next to the OM-D label on the front of the camera (figure 6.11A). It shines red when you start autofocus in a dark area. The light assists the camera by shining on nearby objects.

Figure 6.11A: AF Illuminator light location

The light may be distracting sometimes, so you can turn it Off with the AF Illuminat. function.

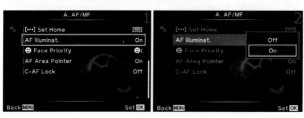

Figure 6.11B: Enabling or disabling the AF Illuminator light

Use these steps to control whether the AF Illuminator light is On or Off:

1. Choose AF Illuminat. from the A. AF/MF menu and scroll to the right (figure 6.11B, image 1).
2. A menu will open with two choices: On and Off (figure 6.11B, image 2). Choose On to allow the light to assist with autofocus, or choose Off to disable the light.
3. Press the OK button to Set your choice.

Settings Recommendation: When I am shooting in an environment where people will not appreciate a shining light, such as at some very traditional weddings, or if I am trying to sneak some pictures and don't want to call attention to myself, I disable the light.

The camera senses when the light is low enough that the AF Illuminator is needed. The light doesn't shine when the ambient light is bright or when you use a flash unit that has a built-in assist light. Therefore, most of the time I leave AF Illuminat. set to On.

☺ Face Priority

Face Priority is a very efficient and accurate human face detection system that is built into the camera. It tells the camera to watch for human faces and, if found, make them the priority for accurate autofocus.

When you are shooting nonhuman subjects the camera works normally and displays a regular green AF Area Pointer as it focuses. However, when the camera detects human faces, it switches all its attention to the faces and uses a much larger white AF square (figure 6.12A).

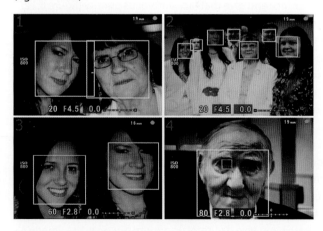

Figure 6.12A: Using Face Priority

Notice how all the faces in figure 6.12A are surrounded by the white face-tracking square. The white squares tend to stay with detected faces as they move, so they'll jump a little as the camera keeps track of detected faces. The white squares are not really in-focus indicators; they merely show the location of a face in the subject area.

When focus initially locks on a face, a separate green focus-confirmation square—the same size as the white square—will appear briefly, along with a beep from the camera. You can see both the white and green AF squares in figure 6.12A, image 2, surrounding the face of the lady on the far right. The green focus-confirmation square is slightly offset from the white face-tracking square.

Figure 6.12A, images 3 and 4, show a tiny green square surrounding an eye. This tiny green eye-focus confirmation square appears briefly when Eye Priority is enabled and focus has locked on an eye. Which eye it locks on is controlled by which Face Priority mode is enabled, as described in the upcoming *Face Priority types* list.

Note that an AF confirmation mark (small green dot) appears in the top-right corner of the viewfinder or monitor when focus has locked on the subject. You can see the green AF confirmation mark (dot) in the top-right corner of all four images in figure 6.12A, showing that the AF system has focused.

Here are the four Face Priority modes (plus Off) and descriptions of how they work:

Face Priority types

- ☺ **(Face Priority On):** This setting causes the camera to seek human faces and give them autofocus priority (figure 6.12A, image 1). Notice how both faces have a white face-tracking square surrounding them. The camera will find and frame each face it detects and try to balance autofocus on the faces depending on which AF mode is selected (e.g., S-AF or C-AF).

- ☺i **(Face Priority and Eye Priority On):** This setting causes the camera to seek a pupil in the eye of the closest human face and give that face autofocus priority (figure 6.12A, image 2). The lady on the right side of the group has the primary point of focus because she is closest to the camera. You can tell that she is the point of focus because the green focus confirmation square is displayed along with the white face-tracking square. The camera has found every face in the seven-person group and has surrounded each one with a white face-tracking square. The camera uses the autofocus mode that is currently selected (e.g., S-AF or C-AF).

- ☺iR **(Face Priority and R. Eye Priority On):** This setting causes the camera to seek the pupil on the right side of the frame and give it autofocus priority (figure 6.12A, image 3). You will see the small green eye-focus confirmation square appear briefly, and the camera will beep when focus has locked on an eye. The camera uses the autofocus mode that is currently selected (e.g., S-AF or C-AF).

- ☺iL **(Face Priority and L. Eye Priority On):** This setting causes the camera to seek the pupil on the left side of the frame and give it autofocus priority (figure 6.12A, image 4). You will see the small green eye-focus confirmation square appear briefly. The camera uses the autofocus mode that is currently selected (e.g., S-AF or C-AF).

- ☺OFF **(Face Priority Off):** This setting disables human face-detection autofocus priority and uses normal autofocus.

Let's see how to enable Face Priority. Most photographers leave it enabled all the time.

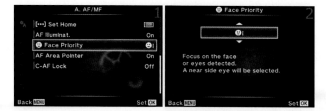

Figure 6.12B: Enabling Face Priority face detection

1. Choose ☺ Face Priority from the A. AF/MF menu and scroll to the right (figure 6.12B, image 1).
2. An up/down menu will open with the five choices shown in the ***Face Priority types*** list (figure 6.12B, image 2). Choose one of the face detection methods or Off. I chose Face Priority and Eye Priority (☺i).
3. Press the OK button to Set the face detection type.

Note: When Face Priority is enabled and when no people are in the subject area, the camera will use its normal AF Area Pointers and switch to the larger Face Priority squares only if a human face is suddenly detected.

If you want your camera to ignore human faces so you can use the normal AF Area Pointers all the time, set Face Priority to Off.

Settings Recommendation: Face detection works very well in this camera. When I am using any form of face detection, autofocus still works just as well for normal autofocus without face detection when no people are present in the image. Therefore, I see no reason to turn it off for the type of photography I do (primarily nature). If a person is in the subject area, I want their face to take autofocus priority—that is, if I am interested in photographing the person.

There may be times when you want the camera to ignore faces, then Face Priority would be an aggravation. If you are trying to photograph a nonhuman subject while humans happen to be in the frame, and if the camera is paying undue attention to the human faces, turn Face Priority Off. When this setting is On, the camera is very persistent about focusing on human faces.

The factory default is for Face Priority to be enabled because so many photographers love people photography.

AF Area Pointer

The AF Area Pointer is green rectangles or squares, of various sizes, that signify when and where the camera has achieved autofocus. You can turn the AF Area Pointer On or Off with this function.

Notice that the current position of the AF Area pointer has very faint black corner brackets where it will display the green AF Area Pointer when focus is locked. The brackets go away when AF Area Pointer is set to Off. However, the green square with lines for focus-tracking mode (C-AF+TR) and the white face-tracking square for face detection (Face Priority) cannot be disabled.

Let's see how to enable or disable the standard green symbol for the AF Area Pointer.

Figure 6.13B: Enabling or disabling the AF Area Pointer

Use these steps to turn the AF Area Pointer On or Off:

1. Choose AF Area Pointer from the A. AF/MF menu and scroll to the right (figure 6.13, image 1).
2. A menu will open with two choices: On and Off (figure 6.13, image 2). Choose On to allow the AF Area Pointer to flash green on the area that is in focus, or choose Off to make it disappear. With no AF Area Pointer enabled, you will have to depend on the round green AF confirmation mark, in the top-right corner of the screen, or the focus beep to tell you when the subject is in focus.
3. Press the OK button to Set your choice.

Settings Recommendation: The AF Area Pointer is not a distraction to me at all. I use it to set the area I want to focus by moving it around within the 81 focus points on my camera screen. When I initiate autofocus, I like that it flashes green when the subject is in focus and that it's backed up by the AF confirmation mark (green dot) and beep.

With the AF Area Pointer, I know which area of the subject the camera is focusing on. I find it extremely useful. However, if you are simply using your camera as an expensive point-and-shoot, or if the AF Area Pointer interferes with viewing the subject in some way, such as in extreme macro shooting, by all means disable it. Most photographers leave it enabled.

C-AF Lock

The C-AF Lock function controls the amount of time the camera waits after it has lost a subject it was tracking before the AF system moves on to another subject.

With C-AF set to Off, the camera will instantly switch to a different subject if it loses the subject it was tracking. With it set to Low, Normal, or High, the camera waits longer periods of time before switching to a new subject.

Having C-AF Lock set to Off is not good for tracking subjects such as flying birds or people playing sports. If the subject is temporarily blocked by an intruding object, the camera will immediately find another subject to focus on and track. For shooting action you will need to experiment with Low, Normal, and High to see which is most useful. Even at High, the camera seems to wait only about two seconds before it switches to a new subject. That short amount of time may allow you to continue tracking a subject that has temporarily become obscured.

Let's see how to select the C-AF Lock modes.

Figure 6.14: Using C-AF Lock

Use these steps to turn the AF Area Pointer On or Off:

1. Choose C-AF Lock from the A. AF/MF menu and scroll to the right (figure 6.14, image 1).
2. A menu will open with four choices: High, Normal, Low, and Off (figure 6.14, image 2). Choose Off to disable the hesitation in continuous subject tracking mode (C-AF+TR). To introduce longer delays before the camera loses tracking on a moving subject when an object gets between you and the subject, use Low, Normal, or High, in that order, to increase the delay time from about 1 second (Low) to 1.5 seconds (Normal) or 2 seconds (High).
3. Press the OK button to Set your choice.

Settings Recommendation: This function is most useful to me when I am using continuous AF subject tracking (C-AF+TR).

Even though the E-M1 user's manual implies that C-AF Lock works when you use C-AF mode alone, it does not seem to me that the camera hesitates before it switches to a different subject. Why would you want it to hesitate? That seems to defeat the purpose of continuous autofocus. Experiment with the setting and see if you find the same thing.

I do see a difference when C-AF+TR is enabled. There is a definite delay before the camera gives up on tracking a subject when C-AF Lock is set to High. When I use this function in C-AF+TR (continuous subject tracking) mode, I want my camera to stay with the subject I am tracking; therefore, I leave my E-M1 set to High C-AF Lock all the time.

If a second or two of delay is too much for a lost subject and you want your camera to switch to a new subject more quickly, try Low or Normal C-AF Lock—or even Off. This function definitely requires experimentation with the type of action photography you do.

Custom Menu B. Button/Dial/Lever

The B. Button/Dial/Lever menu (figure 6.15) has 28 tasks that you can assign to one of the Button functions on the camera and 6 tasks that you can assign to the Lever function on the back of the camera, some of which involve settings that you adjust with the Front and Rear Dials. These dials can be configured to work in various ways. The E-M1 is one of the most configurable cameras I have ever seen, and this section is one of the primary reasons I say that.

Figure 6.15: The opening menu selection for the B. Button/Dial/Lever functions

First let's look at how to open the Button/Dial/Lever functions on the Custom Menu screen, then we will consider how to assign tasks to the Button/Dial/Lever functions. Descriptions of the Button tasks are provided in the appendix, **Button Tasks Reference**.

Important Naming Information

Olympus uses unusual names for the buttons, dials, and levers on the OM-D E-M1. For instance, you can see in the following images that a button is not just called a button, it is called a Button function (e.g., Fn1, Fn2). There are also Dial functions (e.g., P, A, S, M) and Lever functions (e.g., mode1, mode2).

You can assign certain actions to Button, Lever, and Dial functions. To prevent confusion, I will call the assignable action items "tasks." Some examples of Button function tasks are HDR, ISO, BKT, and WB.

For example, the Fn1 function can have the WB task assigned to it. When you press the Fn1 button, the camera will allow you to adjust the White balance (WB). At the same time you could assign the Multi Function task to the Fn2 function.

Figure 6.15 displays the B. Button/Dial/Lever selection on the Custom Menu. All the tasks you can assign to the Button, Dial, and Lever functions are available in this menu (see **Appendix: Button Tasks Reference**). To access them, choose B. Button/Dial/Lever and press the OK button, or scroll to the right with the Arrow pad.

Note: Please make sure your E-M1 is using firmware version 2.0 (or later). Otherwise some of the Button tasks we will discuss in this section and in the Appendix will not appear on your camera's menus.

Button Function (Programmable Buttons)

The Button functions are a group of 11 programmable button functions (e.g., Fn1 Function, Fn2 Function). There are 28 available Button tasks that can be assigned to the 11 Button functions. Not all Button functions can use all 28 Button tasks. You will find information for the 28 assignable Button tasks in the appendix, **Button Tasks Reference**. Let's examine each of the 11 Button functions.

Fn1 Function

The Fn1 button can accept the assignment of most tasks in the **Button Tasks List** in **Appendix: Button Tasks Reference** on page 469. The default factory assignment for the Fn1 Function is [•••] AF Area Select.

First let's find the Fn1 button on the camera body (figure 6.16A).

Next let's consider how to use the menus to assign one of the Button tasks to the Fn1 Button function.

Figure 6.16A: The location of the Fn1 button

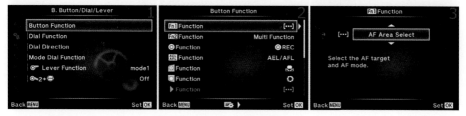

Figure 6.16B: Assigning a Button task to the Fn1 Button function

Use the following steps to assign one of the Button tasks to the Fn1 Button function:

1. Choose Button Function from the B. Button/Dial/Lever menu and scroll to the right (figure 6.16B, image 1).
2. Select Fn1 Function from the Button Function menu and scroll to the right (figure 6.16B, image 2).
3. Choose one of the available Button tasks from the up/down menu (figure 6.16B, image 3). Use the **Button Tasks List** found in **Appendix: Button Tasks Reference** to decide which task you will assign to the Fn1 button.
4. Press the OK button to Set the tasks for the Fn1 button.

Settings Recommendation: As mentioned previously, the default assignment for the Fn1 Button function is the [•••] AF Area Select Button task. That is a useful task, and many people will use the default setting. If you have a PRO lens with an L-Fn button, an alternate choice is to use ISO on Fn1. I have the M.Zuiko PRO 12–40mm f/2.8 ED lens, which has an L-Fn button. I assigned the [•••] AF Area Select task to the L-Fn function on my lens because my hand is on the lens during focusing and zooming, and I can easily select the

AF area I want to use. I constantly adjust the ISO and want to access it easily, so I set my Fn1 button to ISO.

Fn2 Function

The Fn2 button can accept most task assignments shown in the **Button Tasks List** in **Appendix: Button Tasks Reference** on page 469. The default factory assignment for the Fn2 Button function is the Button task named Multi Function.

Figure 6.16C: The location of the Fn2 button

First let's find the Fn2 button on the camera body (figure 6.16C).

Next let's consider how to use the menus to assign one of the Button Tasks to the Fn2 Button function.

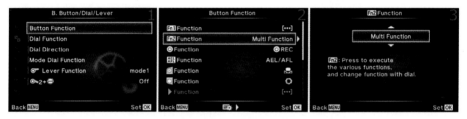

Figure 6.16D: Assigning a Button task to the Fn2 Button function

Use the following steps to assign one of the Button tasks to the Fn2 Button function:

1. Choose Button Function from the B. Button/Dial/Lever menu and scroll to the right (figure 6.16D, image 1).
2. Select Fn2 Function from the Button Function menu and scroll to the right (figure 6.16D, image 2).
3. Choose one of the available Button tasks from the up/down menu (figure 6.16D, image 3). Use the **Button Tasks List** in **Appendix: Button Tasks Reference** to decide which task you will assign to the Fn2 button.
4. Press the OK button to Set the task for the Fn2 button.

Settings Recommendation: As mentioned previously, the default task assignment for the Fn2 Function is Multi Function. I have grown accustomed to using Fn2 for selecting one of the four functions on the Multi Function list. I sometimes use the Highlight&Shadow Control for visually fine-tuning an exposure, so I leave my camera set to the default.

[Movie] Function

The [Movie] button can accept the assignment of most tasks in the **Button Tasks List** in **Appendix: Button Tasks Reference** on page 469. The default factory assignment for the [Movie] Function is REC, which you use to record movies.

Figure 6.16E: The location of the [Movie] button

First let's find the [Movie] button on the camera body (figure 6.16E).

Next let's consider how to use the menus to assign one of the Button tasks to the [Movie] Button function.

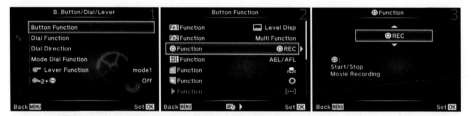

Figure 6.16F: Assigning a Button task to the [Movie] Function

Use the following steps to assign one of the Button tasks to the [Movie] Button function:

1. Choose Button Function from the B. Button/Dial/Lever menu and scroll to the right (figure 6.16F, image 1).
2. Select [Movie] Function from the Button Function menu and scroll to the right (figure 6.16F, image 2).
3. Choose one of the available Button tasks from the up/down menu (figure 6.16F, image 3). Use the **Button Tasks List** in **Appendix: Button Tasks Reference** to decide which task you will assign to the [Movie] button.
4. Press the OK button to Set the task for the [Movie] button.

Settings Recommendation: If you shoot videos with your camera, leave this button set to the factory default of REC. Otherwise you will have no way to start a movie. REC cannot be assigned to any other button. However, if you do not shoot video, you can assign most of the other Button tasks to the [Movie] button. It is conveniently located for quick access.

AEL/AFL Function

The AEL/AFL button can accept the assignment of most tasks in the **Button Tasks List** in **Appendix: Button Tasks Reference** on page 469. The default factory assignment for the AEL/AFL Function is the Button task named AEL/AFL.

Figure 6.16G: The location of the AEL/AFL button

First let's find the AEL/AFL button on the camera body (figure 6.16G).

Next let's consider how to use the menus to assign one of the Button tasks to the AEL/ AFL Button function.

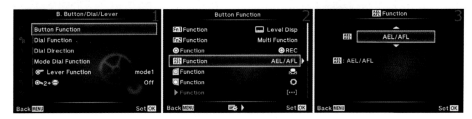

Figure 6.16H: Assigning a Button task to the AEL/AFL Button function

Use the following steps to assign one of the Button tasks to the AEL/AFL Button function:

1. Choose Button Function from the B. Button/Dial/Lever menu and scroll to the right (figure 6.16H, image 1).
2. Select AEL/AFL Function from the Button Function menu and scroll to the right (figure 6.16H, image 2).
3. Choose one of the available Button tasks from the up/down menu (figure 6.16H, image 3). Use the **Button Tasks List** in **Appendix: Button Tasks Reference** to decide which Task you will assign to the AEL/AFL button.
4. Press the OK button to Set the task for the AEL/AFL button.

Settings Recommendation: The factory default for the AEL/AFL button is AEL/AFL (auto-exposure lock and autofocus lock). However, many people enjoy using this button for back-button focus. You can set up back-button focus—where autofocus is initiated by pressing the AEL/AFL button instead of the Shutter button—by using the steps in the **Back-Button Focus Using the AEL/AFL Button** subheading (on page 282) earlier in this chapter.

[One Touch WB] Function

The [One touch WB] button can accept the assignment of most tasks in the **Button Tasks List** in **Appendix: Button Tasks Reference** on page 469. The default factory assignment for the [One touch WB] Function is the Button task with a symbol of a flower (figure 6.16J, image 3), which represents One touch WB.

First let's find the [One touch WB] button on the camera body (figure 6.16I).

Figure 6.16I: The location of the [One touch WB] button

Next let's consider how to use the menus to assign one of the Button tasks to the [One touch WB] Button function.

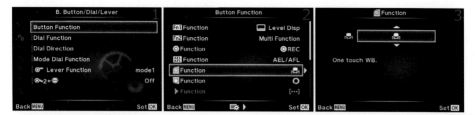

Figure 6.16J: Assigning a Button task to the [One touch WB] Button function

Use the following steps to assign one of the Button tasks to the [One touch WB] Button function:

1. Choose Button Function from the B. Button/Dial/Lever menu and scroll to the right (figure 6.16J, image 1).
2. Select [One touch WB] Function from the Button Function menu and scroll to the right (figure 6.16J, image 2).
3. Choose one of the available Button tasks from the up/down menu (figure 6.16J, image 3). Use the **Button Tasks List** in **Appendix: Button Tasks Reference** to decide which task you will assign to the [One touch WB] button.
4. Press the OK button to Set the task for the [One touch WB] button.

Settings Recommendation: If you do regular white balance readings, the [One touch WB] task makes it very simple to take a new WB reading from a white card and assign it to one of the four Capture WB memory locations on the WB menu.

On the other hand, if you usually use Auto WB and rarely take special WB readings, the [One touch WB] Button function can easily be assigned to another Button task of your choice, such as ISO, BKT (bracketing), Peaking, or Magnify (10x). Since I shoot mostly in RAW mode and seldom do specific WB readings, I often assign Magnify to the [One touch WB] button.

[Preview] Function

The [Preview] button can accept the assignment of most tasks in the **Button Tasks List** in **Appendix: Button Tasks Reference** on page 469. The default factory assignment for the [Preview] Button function is the Button task that has a symbol of the shutter blades of a lens iris (figure 6.16L, image 3), which represents depth of field (DOF) Preview.

First let's find the [Preview] button on the camera body (figure 6.16K).

Next let's consider how to use the menus to assign one of the Button tasks to the [Preview] Button function.

Figure 6.16K: The location of the [Preview] button

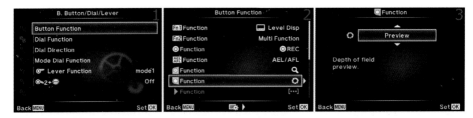

Figure 6.16L: Assigning a Button task to the [Preview] Button function

Use the following steps to assign one of the Button tasks to the [Preview] Button function:

1. Choose Button Function from the B. Button/Dial/Lever menu and scroll to the right (figure 6.16L, image 1).
2. Select [Preview] Function from the Button Function menu and scroll to the right (figure 6.16L, image 2).
3. Choose one of the available Button tasks from the up/down menu (figure 6.16L, image 3). Use the **Button Tasks List** in **Appendix: Button Tasks Reference** to decide which task you will assign to the [Preview] button.
4. Press the OK button to Set the task for the [Preview] button.

Settings Recommendation: Depth of field preview is a very important functionality. The muscle memory of many photographers is tuned to this location for a depth of field preview button because that's where it is on most cameras. I leave my Preview button set to the Preview Task so I can determine how large the zone of sharp focus is for my subject. If you are not using depth of field preview or don't understand depth of field, please take time to learn about it. Depth of field is critical for most types of photography.

My book *Beyond Point-and-Shoot: Learning to Use a Digital SLR or Interchangeable-Lens Camera* covers depth of field quite well. You can review the book here: **http://www.pictureandpen.com/BeyondPS.asp**.

▶ Function

The right button (▶) on the Arrow pad (figure 6.16M) can accept only eight tasks from the **Button Tasks List** in **Appendix: Button Tasks Reference** on page 469.

This Button function will be grayed out and unavailable unless you have the ◀▲▼▶ Function set to the Direct Function task. The ◀▲▼▶ Function is two items below ▶ Function on the Button Function menu.

The default factory assignment for the ▶ Button function is the Button task called Flash Mode (represented by a lightning bolt symbol in figure 6.16N, image 3).

Figure 6.16M: The location of the right Arrow pad button (▶)

First let's find the right Arrow pad button (▶) on the camera body (figure 6.16M).

Next let's consider how to use the menus to assign one of the Button Tasks to the ▶ Button function.

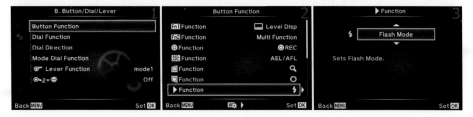

Figure 6.16N: Assigning a Button task to the ▶ Button function

Use the following steps to assign one of the Button tasks to the ▶ Button function:

1. Choose Button Function from the B. Button/Dial/Lever menu and scroll to the right (figure 6.16N, image 1).
2. Select ▶ Function from the Button Function menu and scroll to the right (figure 6.16N, image 2).
3. Choose one of the available Button tasks from the up/down menu (figure 6.16N, image 3). Use the **Button Tasks List** in **Appendix: Button Tasks Reference** to decide which task you will assign to the ▶ button.
4. Press the OK button to Set the Task for the ▶ button.

Settings Recommendation: I use this button to quickly access Flash Mode. This is faster than pressing the OK button when a subject is on the screen and finding the Flash Mode in the list of items. You can safely leave this function set to Flash Mode, or another mode, because it will work only when you are in shooting mode, which will not interfere with the normal use of the Arrow pad buttons, such as scrolling through pictures.

▼ Function

The down Arrow pad button (▼) can accept only eight tasks from the **Button Tasks List** in **Appendix: Button Tasks Reference** on page 469.

Figure 6.16O: The location of the down Arrow pad button (▼)

This Button function will be grayed out and unavailable unless you have the ◀▲▼▶ Function set to the Direct Function task. The ◀▲▼▶ Function is one item below ▼ Function on the Button Function menu.

The default factory assignment for the ▼ Button function is the Sequential Shooting/Self-Timer task, represented by the Sequential Shooting and Self-Timer symbols (figure 6.16P, image 3).

First let's find the down Arrow pad button (▼) on the camera body (figure 6.16O).

Next let's consider how to use the menus to assign one of the Button tasks to the ▼ Button function.

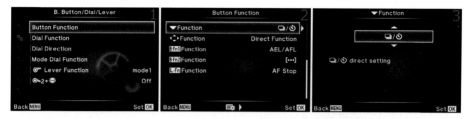

Figure 6.16P: Assigning a Button task to the ▼ Button function

Use the following steps to assign one of the Button tasks to the ▼ Button function:

1. Choose Button Function from the B. Button/Dial/Lever menu and scroll to the right (figure 6.16P, image 1).
2. Select ▼ Function from the Button Function menu and scroll to the right (figure 6.16P, image 2).
3. Choose one of the available Button tasks from the up/down menu (figure 6.16P, image 3). Use the **Button Tasks List** in **Appendix: Button Tasks Reference** to decide which task you will assign to the ▼ button.
4. Press the OK button to Set the Task for the ▼ button.

Settings Recommendation: I use this button to quickly access the WB (white balance) settings. The camera already has a Sequential shooting/Self-timer/HDR button (on the top left of the camera, just above the On/Off button).

You can leave this function set to whatever mode you choose because it will work only when you are in shooting mode, which will not interfere with normal use of the Arrow pad buttons, such as moving the AF Area Pointer around the 81 AF Target positions (or 37 positions if a Four Thirds lens is mounted).

◄▲▼► Function

The Arrow pad's four buttons (◄▼▲►) can accept only one task from the **Button Tasks List** in **Appendix: Button Tasks Reference** on page 469, the [•••] AF Area Select task.

This assignment will cancel the task assignments of the previous two Button functions we discussed: the ► button and the ▼ button. When the normal factory default [•••] AF Area Select is chosen, the ► and ▼ Functions will be grayed out on the Button Function menu. If you want to use the ► and ▼ buttons for one

Figure 6.16Q: The location of the four Arrow pad buttons (◄▼▲►), shown in red

of the eight Button tasks they each support, you must set the ◀▼▲▶ Function to Direct Function.

First let's find the Arrow pad on the camera body (figure 6.16Q).

Next let's consider how to use the menus to configure the ◀▼▲▶ Function.

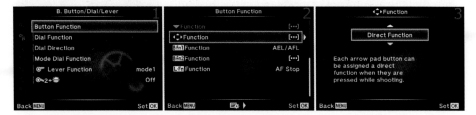

Figure 6.16R: Assigning the [•••] AF Area Select Button task to the ◀▼▲▶ Button function

Use the following steps to configure the ◀▼▲▶ Function:

1. Choose Button Function from the B. Button/Dial/Lever menu and scroll to the right (figure 6.16R, image 1).
2. Select ◀▼▲▶ Function from the Button Function menu and scroll to the right (figure 6.16R, image 2).
3. Choose Off, [•••] AF Area Select, or Direct Function (figure 6.16R, image 3). When it is set to Off the Arrow pad will still do normal things, such as scroll through pictures and move the AF Area Pointer around, but the individual buttons offer no extra functionality. If it is set to [•••] AF Area Select, the Arrow pad displays the 81 point AF Area screen (or 37 points with Four Thirds lenses) when you press any of the four arrow buttons, so you can move the AF Area Pointer to whichever AF point you want to use for autofocus. Either of these two settings (Off or [•••] AF Area Select) disables the ▶ and ▼ Functions, and their menu choices become grayed out. If it is set to Direct Function, you can assign one of eight Button tasks to each of the ▶ and ▼ buttons. Also, when Direct Function is active, the ▲ button opens ± Exposure compensation, and the ◀ button offers the 81 point (or 37 point) AF Target screen.
4. Press the OK button to Set the value for the ◀▼▲▶ buttons.

Settings Recommendation: If you constantly move the AF Area Pointer around the screen and carefully choose which AF point to use for autofocus, you may want to set the ◀▼▲▶ Function to [•••] AF Area Select. This gives you the most direct control over which AF point is in use when you press any of the Arrow pad buttons to open the AF screen with 81 (or 37) points.

If you do not use AF points very often, you may want to set the ◀▼▲▶ Function to Direct Function and then experiment with the seven Tasks you can assign to each of the right and down Arrow pad keys.

B-Fn1 Function

The B-Fn1 button is found on the optional HLD-7 battery holder. You can use this function only if you have an HLD-7 mounted on your camera. The B-Fn1 button can accept the assignment of most tasks in the **Button Tasks List** in **Appendix: Button Tasks Reference** on page 469. The default factory assignment for the B-Fn1 Button function is the Button task named AEL/AFL.

Figure 6.16S: The location of the B-Fn1 button on the HLD-7 battery holder

First let's find the B-Fn1 button on the HLD-7 battery holder (figure 6.16S).

Next let's consider how to use the menus to assign one of the Button tasks to the B-Fn1 Button function.

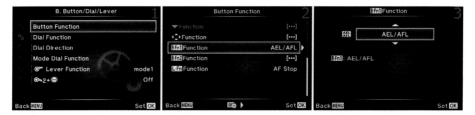

Figure 6.16T: Assigning a Button task to the B-Fn1 Button function

Use the following steps to assign one of the Button tasks to the B-Fn1 Button function:

1. Choose Button Function from the B. Button/Dial/Lever menu and scroll to the right (figure 6.16T, image 1).
2. Select B-Fn1 Function from the Button Function menu and scroll to the right (figure 6.16T, image 2).
3. Choose one of the available Button tasks from the up/down menu (figure 6.16T, image 3). Use the **Button Tasks List** in **Appendix: Button Tasks Reference** to decide which task you will assign to the B-Fn1 button.
4. Press the OK button to Set the task for the B-Fn1 button.

Settings Recommendation: I assigned ISO to the B-Fn1 Button function. I change the ISO quite a lot, and I like it to be both on the camera body's Fn1 button and on the HLD-7's B-Fn1 button. Of course, there are so many Tasks you can assign to the HLD-7 that this extra button adds functionality to the camera. The cost of an HLD-7 is very reasonable, and it adds a bigger grip and more mass for sharper handheld images.

B-Fn2 Function

The B-Fn2 button is found only on the optional HLD-7 battery holder. You can use this function only if you have an HLD-7 mounted on your camera. The B-Fn2 button can accept the assignment of most tasks in the **Button Tasks List** in **Appendix: Button Tasks Reference** on page 469. The default factory assignment for the B-Fn2 Button function is the Button task named [•••] AF Area Select.

First let's find the B-Fn2 button on the HLD-7 power battery holder (figure 6.16U).

Figure 6.16U: The location of the B-Fn2 button on the HLD-7 battery holder

Next let's consider how to use the menus to assign one of the Button tasks to the B-Fn2 Button function.

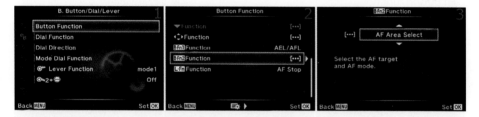

Figure 6.16V: Assigning a Button task to the B-Fn2 Button function

Use the following steps to assign one of the Button tasks to the B-Fn2 Button function:

1. Choose Button Function from the B. Button/Dial/Lever menu and scroll to the right (figure 6.16V, image 1).
2. Select B-Fn2 Function from the Button Function menu and scroll to the right (figure 6.16V, image 2).
3. Choose one of the available Button tasks from the up/down menu (figure 6.16V, image 3). Use the **Button Tasks List** in **Appendix: Button Tasks Reference** to decide which task you will assign to the B-Fn2 button.
4. Press the OK button to Set the Task for the B-Fn2 button.

Settings Recommendation: I assigned the Preview task to the B-Fn2 button. When I rotate the camera for a vertical shot with the HLD-7's Shutter button, I often want to check the depth of field. However, since the camera is rotated my finger will not reach the normal Preview button, so I use the B-Fn2 button instead.

L-Fn Function

The L-Fn button is found only on certain lenses. For instance, the professional M.Zuiko 12–40mm f/2.8 ED lens has one. You can use this Button function only if the lens mounted on your camera has the L-Fn button. The L-Fn button can accept the assignment of most tasks in the **Button Tasks List** in **Appendix: Button Tasks Reference** on page 469. The default factory assignment for the L-Fn Button function is the Button task named AF Stop, which cannot be assigned to any of the buttons on the camera body.

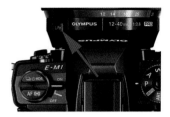

Figure 6.16W: The location of the L-Fn button on an M.Zuiko 12–40mm f/2.8 ED PRO lens

First let's find the L-Fn button on the lens (figure 6.16W).

Next let's consider how to use the menus to assign one of the Button tasks to the L-Fn Button function.

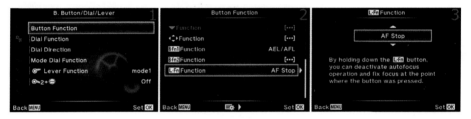

Figure 6.16X: Assigning a Button task to the L-Fn Button function

Use the following steps to assign one of the Button tasks to the L-Fn Button function:

1. Choose Button Function from the B. Button/Dial/Lever menu and scroll to the right (figure 6.16X, image 1).
2. Select L-Fn Function from the Button Function menu and scroll to the right (figure 6.16X, image 2).
3. Choose one of the available Button tasks from the up/down menu (figure 6.16X, image 3). Use the **Button Tasks List** in **Appendix: Button Tasks Reference** to decide which task you will assign to the L-Fn button.
4. Press the OK button to Set the task for the L-Fn button.

Settings Recommendation: I set the L-Fn button on my lens to [•••] AF Area Select because I often have the factory default button for [•••] AF Area Select (Fn1) assigned to ISO instead. It makes a lot of sense to have the [•••] AF Area Select function assigned to a button on the lens since the lens provides focus.

Dial Function

The E-M1 has two dials on top of the camera: Front Dial and Rear Dial (figure 6.17A). These two dials are used to control various camera functions; like the camera buttons, they can be configured to do something different than the factory default settings.

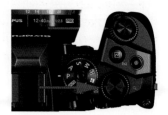

The Front and Rear Dials have a relationship with the Mode Dial, in that you can change what the Front and Rear Dials accomplish when you use the different modes (P, S, A, M) on the Mode Dial.

Figure 6.17A: Front and Rear Dials

Additionally, the two dials have special functionalities when you use the camera menus or look at pictures on the monitor.

Let's examine each of the functions that can be assigned to the Front and Rear Dials.

P Mode Functions

When you set the Mode Dial to P (Program) mode, the Front and Rear Dials offer the eight function combinations shown in table 6.1.

Rear Dial	Front Dial
Ps*	Exposure compensation +/−
Exposure compensation +/−	Exposure compensation +/−
Flash compensation +/−	Exposure compensation +/−
Ps	Flash compensation +/−
Exposure compensation +/−	Flash compensation +/−
Flash compensation +/−	Flash compensation +/−
Ps	Ps
Exposure compensation +/−	Ps

* Ps represents Program shift mode. In P mode the camera controls the shutter speed and aperture so you can simply take pictures. However, Ps allows you to override its choice of aperture for future pictures (until you return to P mode). Ps will be displayed on the camera screens while Program shift mode is active. When you rotate the dial until the camera returns to the original aperture, the camera switches back to P mode.

Table 6.1: P mode Front and Rear Dial function combinations

Now let's examine the screens and steps to choose one of the function combinations shown in table 6.1.

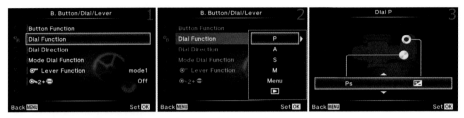

Figure 6.17B: Configuring the Front and Rear Dials for P mode

1. Select Dial Function from the B. Button/Dial/Lever menu and scroll to the right (figure 6.17B, image 1).
2. A small window will open with the following choices: P, A, S, M, Menu, and ▶. Choose P (Program mode) and scroll to the right (figure 6.17B, image 2).
3. You will see a graphical representation of the two dials and their current function assignments (figure 6.17B, image 3). The camera defaults to Ps for the Rear Dial and Exposure compensation (+/−) for the Front Dial. There is a small up/down menu. Press up or down to choose different combinations of functions for the two dials. Table 6.1 lists the sequential combinations for pressing down on the Arrow pad.
4. When you have chosen your favorite dial function combination for P mode, press the OK button to Set the combination.

Settings Recommendation: I leave my camera set to the factory default of Ps/Exposure compensation +/− because I often override the aperture setting when I use P mode.

A Mode Functions

When you set the Mode Dial to A (Aperture-priority) mode, the Front and Rear Dials offer the five function combinations shown in table 6.2.

Rear Dial	Front Dial
FNo.*	Exposure compensation +/−
FNo.	Flash compensation +/−
FNo.	FNo.
Exposure compensation +/−	FNo.
Flash compensation +/−	FNo.

* FNo. stands for f/number or aperture number (e.g., f/2.8, f/5.6, f/8).

Table 6.2: A mode Front and Rear Dial function combinations

Now let's examine the screens and steps to choose one of the function combinations shown in table 6.2.

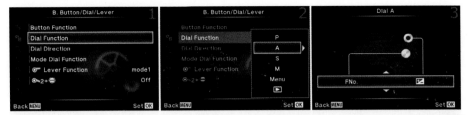

Figure 6.17C: Configuring the Front and Rear Dials for A mode

1. Select Dial Function from the B. Button/Dial/Lever menu and scroll to the right (figure 6.17C, image 1).
2. A small window will open with the following choices: P, A, S, M, Menu, and ▶. Choose A (Aperture-priority) mode and scroll to the right (figure 6.17C, image 2).
3. You will see a graphical representation of the two dials and their current function assignments (figure 6.17C, image 3). The camera defaults to FNo. for the Rear Dial and Exposure compensation (+/−) for the Front Dial. There is a small up/down menu. Press up or down to choose different combinations of functions for the two dials. Table 6.2 lists the sequential combinations for pressing down on the Arrow pad.
4. When you have chosen your favorite dial function combination for A mode, press the OK button to Set the combination.

Settings Recommendation: I leave my camera set to the factory default of FNo./Exposure compensation +/− because it seems reasonable to have the aperture adjusted by the Rear Dial in Aperture-priority mode. However, if you are used to another camera brand, you may be accustomed to having the Front Dial adjust the aperture. Use whichever combination seems most natural to you.

S Mode Functions

When you set the Mode Dial to S (Shutter-priority) mode, the Front and Rear Dials offer the five function combinations shown in table 6.3.

Rear Dial	Front Dial
Shutter*	Exposure compensation +/−
Shutter	Flash compensation +/−
Shutter	Shutter
Exposure compensation +/−	Shutter
Flash compensation +/−	Shutter

* Shutter stands for shutter speed (e.g., 1/60, 1/125, 1/250).

Table 6.3: S mode Front and Rear Dial function combinations

Now let's examine the screens and steps to choose one of the function combinations shown in table 6.3.

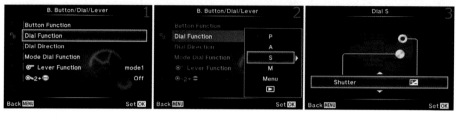

Figure 6.17D: Configuring the Front and Rear Dials for S mode

1. Select Dial Function from the B. Button/Dial/Lever menu and scroll to the right (figure 6.17D, image 1).
2. A small window will open with the following choices: P, A, S, M, Menu, and ▶. Choose S (Shutter-priority) mode and scroll to the right (figure 6.17D, image 2).
3. You will see a graphical representation of the two dials and their current function assignments (figure 6.17D, image 3). The camera defaults to Shutter for the Rear Dial and Exposure compensation (+/−) for the Front Dial. There is a small up/down menu. Press up or down to choose different combinations of functions for the two dials. Table 6.3 lists the sequential combinations for pressing down on the Arrow pad.
4. When you have chosen your favorite dial function combination for S mode, press the OK button to Set the combination.

Settings Recommendation: I leave my camera set to the factory default of Shutter/Exposure compensation +/− because every camera I've used has the rear dial set to adjust the shutter speed in Shutter-priority mode. I don't want to make myself fight muscle memory when I take important pictures!

M Mode Functions

When you set the Mode Dial to M (Manual) mode, the Front and Rear Dials offer the two function combinations shown in table 6.4.

Rear Dial	Front Dial
Shutter*	FNo.*
FNo.	Shutter

* Shutter stands for shutter speed (e.g., 1/60, 1/125, 1/250), and FNo. stands for f/number or aperture number (e.g., f/2.8, f/5.6, f/8).

Table 6.4: M mode Front and Rear Dial function combinations

Now let's examine the screens and steps to choose one of the function combinations shown in table 6.4.

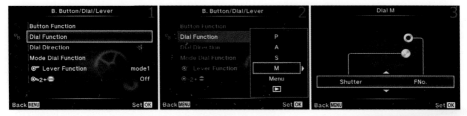

Figure 6.17E: Configuring the Front and Rear Dials for M mode

1. Select Dial Function from the B. Button/Dial/Lever menu and scroll to the right (figure 6.17E, image 1).
2. A small window will open with the following choices: P, A, S, M, Menu, and ▶. Choose M (Manual) mode and scroll to the right (figure 6.17E, image 2).
3. You will see a graphical representation of the two dials and their current function assignments (figure 6.17E, image 3). The camera defaults to Shutter for the Rear Dial and FNo. for the Front Dial. There is a small up/down menu. Press up or down to choose different combinations of functions for the two dials. Table 6.4 lists the sequential combinations for pressing down on the Arrow pad.
4. When you have chosen your favorite dial function combination for M mode, press the OK button to Set the combination.

Settings Recommendation: I leave my camera set to the factory default of Shutter/FNo. because I'm accustomed to that combination. You may prefer a different combination.

Menu Functions

When you use the camera menus to make setting adjustments or when you simply navigate the Menu system, the Front and Rear Dials offer the two combinations shown in table 6.5.

Rear Dial	Front Dial
▲▼/Value	◄►
◄►	▲▼/Value

Table 6.5: Menu system navigation Front and Rear Dial function combinations

The arrows in table 6.5 indicate scrolling directions. The factory default is for the ▲ and ▼ Arrow pad keys to scroll up and down, and the ◄ and ► keys to move left or right within the selected Value.

Now let's examine the screens and steps to choose one of the function combinations shown in table 6.5.

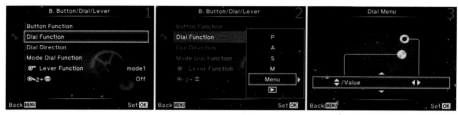

Figure 6.17F: Configuring the Front and Rear Dials for moving around in the Menu system

1. Select Dial Function from the B. Button/Dial/Lever menu and scroll to the right (figure 6.17F, image 1).
2. A small window will open with the following choices: P, A, S, M, Menu, and ▶. Choose Menu and scroll to the right (figure 6.17F, image 2).
3. You will see a graphical representation of the two dials and their current function assignments (figure 6.17F, image 3). The camera defaults to ▲▼/Value for the Rear Dial and ◀▶ for the Front Dial. There is a small up/down menu. Press up or down to choose different combinations of functions for the two dials. Table 6.5 lists the sequential combinations for pressing down on the Arrow pad.
4. When you have chosen your favorite dial function combination for the Menu system, press the OK button to Set the combination.

Settings Recommendation: I leave my camera set to the factory default for using the dials within the Menu system. It seems most natural to me to scroll up and down with the Rear Dial and left and right with the Front Dial. If you prefer the other direction, simply make the change.

Image Viewing Functions

When you review images on the camera monitor, the Front and Rear Dials offer the two function combinations shown in table 6.6.

Rear Dial	Front Dial
[Zoom in/out]*	Prev/Next
Prev/Next	[Zoom in/out]

* The [Zoom in/out] function uses a graphic that resembles a small checkerboard and a magnifying glass (figure 6.17G, image 3). You can zoom in and out on the picture and select the previous or next picture with the dials.

Table 6.6: Image review Front and Rear Dial function combinations

Now let's examine the screens and steps to choose one of the function combinations shown in table 6.6.

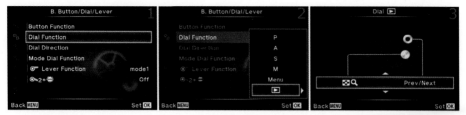

Figure 6.17G: Configuring the Front and Rear Dials for Image review navigation (▶)

1. Select Dial Function from the B. Button/Dial/Lever menu and scroll to the right (figure 6.17G, image 1).
2. A small window will open with the following choices: P, A, S, M, Menu, and ▶. Choose ▶ and scroll to the right (figure 6.17G, image 2).
3. You will see a graphical representation of the two dials and their current function assignments (figure 6.17G, image 3). The camera defaults to [Zoom in/out] for the Rear Dial and Prev/Next for the Front Dial. There is a small up/down menu. Press up or down to choose different combinations of functions for the two dials. Table 6.6 lists the sequential combinations for pressing down on the Arrow pad.
4. When you have chosen your favorite dial function combination for Image review navigation (▶), press the OK button to Set the combination.

Settings Recommendation: I leave my camera set to the factory default of [Zoom in/out] on the Rear Dial and Prev/Next on the Front Dial. If you like the reverse order, you can change it.

Dial Direction

Use Dial Direction to reverse the direction you turn a dial to open and close the aperture (A mode) or raise and lower the shutter speed (S mode). In other words, you can control the direction you turn the dial—clockwise or counterclockwise—to change the aperture or shutter speed.

Dial Direction also allows you to configure Program shift (Ps) mode so the direction you turn the dial either follows or turns in the opposite direction of the current A mode dial direction or S mode dial direction.

Let's examine how the Dial Direction modes are selected.

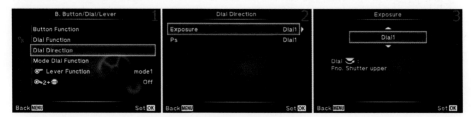

Figure 6.18A: Changing the Dial Direction for the Exposure modes

To change the direction you turn the dial for exposure operations, use the following steps:

1. Select Dial Direction from the B. Button/Dial/Lever menu and scroll to the right (figure 6.18A, image 1).
2. Choose the Exposure setting from the Dial Direction menu and scroll to the right (figure 6.18A, image 2).
3. Select Dial 1 from the Exposure up/down menu to leave the dial rotation direction that raises the f/number or aperture set to the factory default, or select Dial 2 to reverse the normal rotation direction (figure 6.18A, image 3).
4. Press the OK button to Set the dial rotation direction.

Next you should consider if you want the direction you turn the dial in Ps mode to match the direction you turn the dial to change the shutter speed or aperture, or if you want it to turn in the opposite direction. Let's see how.

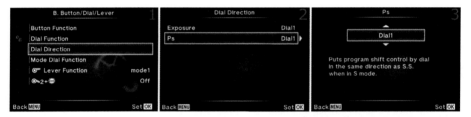

Figure 6.18B: Changing the Dial Direction for Program shift (Ps) mode

To change the direction you turn the dial for Ps mode operations, use the following steps:

1. Select Dial Direction from the B. Button/Dial/Lever menu and scroll to the right (figure 6.18B, image 1).
2. Choose Ps from the Dial Direction menu and scroll to the right (figure 6.18B, image 2).
3. Select Dial 1 from the up/down menu to cause the dial rotation to match the direction used when you have the camera set to Shutter-priority (S) mode (figure 6.18B, image 3). Select Dial 2 to cause the dial rotation to match the direction used when you have the camera set to Aperture-priority (A) mode.
4. Press the OK button to Set the Ps mode's dial rotation direction.

Settings Recommendation: In addition to choosing which dial you use to change the shutter speed and aperture, you can use the Dial Direction setting to change the direction you rotate the dials to make exposure adjustments. This is nice for people who are accustomed to turning different dials or turning dials in a different direction.

Mode Dial Function

If do not regularly use some of the settings on the Mode Dial (e.g., P, A, S, M, ART, SCN), you can reconfigure four of them for different purposes. You can assign up to four Myset locations to one of the Mode Dial choices. If the Mode Dial function is grayed out, it means you have not saved your camera configuration to one of the Myset memory locations in Shooting Menu 1.

Recall that a Myset location allows you to store camera settings. You can configure the camera in different ways and store the settings for later recall. The camera has four Myset locations (Myset1 to Myset4), as discussed in the chapter **Shooting Menu 1** under the subheading **Reset/Myset** on page 132. Refer to that chapter for more information.

Let's examine how to assign a Myset location to the SCN (Scene Modes) position on the Mode Dial. You can assign one of the Myset locations to any position on the dial. We will use the SCN mode position as an example; however, you can assign any of the four Myset memory locations to any of the nine Mode Dial positions. After you make an assignment and select the assigned Mode Dial position, the settings in the Myset location are immediately loaded into the camera's active memory.

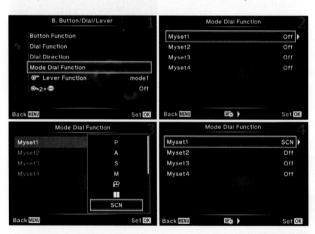

Figure 6.19: Assigning a Myset location to one of the Mode Dial positions

Use the following steps to assign a Myset location to a position on the Mode Dial:

1. Choose Mode Dial Function from the B. Button/Dial/Lever menu and scroll to the right (figure 6.19, image 1).
2. Select the Myset memory location to which you want to assign a Mode Dial position and scroll to the right (figure 6.19, image 2). I selected Myset1.
3. A small window will open and display the nine Mode Dial positions (figure 6.19, image 3). Select the one you want to use. The Myset memory location will be assigned to the selected Mode Dial position and replace the normal functionality of that Mode Dial position. I chose SCN mode.

4. Press the OK button to Set the new function for that Mode Dial position. Repeat steps 2 and 3 for any other Myset locations you want to save to any other Mode Dial positions.
5. The camera will now display SCN (or whichever Mode Dial position you chose to use) next to the Myset number you assigned (figure 6.19, image 4). Whenever I rotate the Mode Dial to SCN, the camera will immediately load the settings stored in the Myset1 memory location.

Note: If you undo this assignment by setting the Myset location in figure 6.19, image 4, to Off, the normal Mode Dial functionality will return.

Settings Recommendation: If you want to customize the Mode Dial, this is a convenient function. Many other camera brands offer similar functions that allow you to load special camera configurations. Not to be outdone, Olympus allows users to assign four Myset camera configurations into four Mode Dial positions.

Lever Function

Use the Lever Function to quickly change how the Dials, Movie button, Fn2 button, and autofocus work according to the current Exposure mode (P, A, S, M). First let's locate the Lever on the camera body and then see how to use it.

In figure 6.20A you can see that the lever has numbered upper (1) and lower (2) positions. Moving the lever between those two positions changes the basic camera functionality for a limited number of controls

Figure 6.20A: The Lever on the back of the E-M1

and settings. To make it simple, let's look at table 6.7, which shows the Lever Function positions and how they affect the Front and Rear Dials, the Movie and Fn2 buttons, and Autofocus.

Lever mode	Position 1 (up)	Position 2 (down)
Off	Lever functions not used	Lever functions not used
mode1	The Front and Rear Dials use their normal assignments	Front Dial: ISO Rear Dial: White balance
mode2	The Front and Rear Dials use their normal assignments	Front Dial: White balance Rear Dial: ISO
mode3	The Movie button and the Fn2 button use their normal assignments	Movie button: ISO Fn2 button: White balance
mode4	The Movie button and the Fn2 button use their normal assignments	Movie button: White balance Fn2 button: ISO
mode5	Autofocus is based on current AF settings	Manual focus (MF) mode

Table 6.7: Lever Function modes

Now let's examine how to choose one of the five modes for the Lever Function.

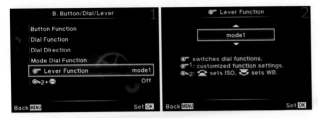

Figure 6.20B: Changing modes for the Lever Function

Use the following steps to assign a mode to the Lever Function:

1. Choose Lever Function from the B. Button/Dial/Lever menu and scroll to the right (figure 6.20B, image 1).
2. From the up/down menu, choose one of the four Lever Function modes (mode1 through mode4) or Off (figure 6.20B, image 2). Refer to table 6.7 for what each mode does.
3. Press the OK button to Set the mode for the Lever Function.

Settings Recommendation: I like to use Lever Function mode1 so I will have a quick way to get to the ISO and White balance settings without tying up any of the camera's assignable buttons. Read table 6.7 carefully and see if you prefer another use for the Lever Function.

Lever Position 2 and the AF/HDR Button

When you press the Sequential shooting/Self-timer/HDR side of the AF/HDR button (figure 6.21A, upper arrow), you will see a screen to adjust the Sequential shooting/Self-timer and HDR settings. When you press the AF/Metering side of the AF/HDR button (figure 6.21A, lower arrow) you will see a screen to adjust Autofocus and Metering.

Figure 6.21A: AF/HDR button

If you set this function to On, the AF/HDR button will change its functionality when you select Lever position 2 (down), and it will use the normal functionality when the Lever is at position 1 (up).

Table 6.8 lists the differences in button functionality when this function is set to On and the Lever is moved between the two positions. If this function is Off, the Lever will not affect the functionality of the AF/HDR button.

Button press	Lever position 1 (up)	Lever position 2 (down)
Sequential shooting/ Self-timer/HDR	HDR mode adjustment Sequential shooting/Self-timer adjustment	Hold button and turn dial: Adjust Bracketing settings
AF/Metering	Metering and Autofocus mode adjustments	Adjust Flash modes and Flash compensation

Table 6.8: AF/HDR buttons and Lever position relationships

Let's see how to enable or disable the Lever Position 2 and AF/HDR button.

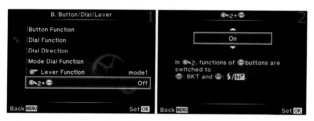

Figure 6.21B: Changing modes for the Lever Function

Use the following steps to change the functionality of the AF/HDR button when the Lever is moved from position 1 to position 2:

1. Choose the symbol that represents the Lever in position 2 and the AF/HDR button from the B. Button/Dial/Lever menu and scroll to the right (figure 6.21B, image 1).
2. From the up/down menu, choose either On or Off (figure 6.20B, image 2). Refer to table 6.8 to see how the AF/HDR and Lever position relationship changes when On is selected.
3. Press the OK button to Set the mode.

Settings Recommendation: I leave this function set to On because it gives me a faster way to enable and use Bracketing and Flash mode adjustments. Having this function set to On does not interfere with the settings of the five Lever modes that we discussed in the previous **Lever Function** subsection.

Custom Menu C. Release/[FPS]

The C. Release/[FPS] (frames per second) menu has an internal selection of eight functions that affect how the camera releases the shutter to take a picture.

First let's examine how to open the Release/[FPS] functions on the Custom Menu screen, then we will consider how the individual Release/[FPS] functions work.

Figure 6.22 displays the C. Release/[FPS] selection on the Custom Menu. All functions listed in this section are under this menu selection. To access them, choose the C. Release/[FPS] menu and press the OK button, or scroll to the right with the Arrow pad.

Figure 6.22: The opening menu selection for the C. Release/[FPS] functions

Let's examine each of the eight C. Release/[FPS] functions.

Rls Priority S

The Rls (release) Priority function tells the camera whether it is more important to release the shutter at all costs or to wait until autofocus has focused on the subject before allowing the shutter to release.

This is a major consideration for most types of photography. Who wants out-of-focus images? Rls Priority S is concerned with how release priority works when the camera is set to AF-S (single AF) release mode.

When you shoot one frame at a time, there is usually sufficient time to make sure the subject is in focus before you release the shutter. Therefore, for most types of single AF shooting (autofocus locks on the subject and does not automatically update) the best choice is to set Rls Priority S to Off (factory default).

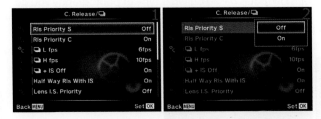

Figure 6.23: Setting release priority for single AF (AF-S) shooting

Use the following steps to enable or disable Rls Priority S:

1. Choose Rls Priority S from the C. Release/[FPS] menu and scroll to the right (figure 6.23, image 1).
2. A small window will open with the choices of Off and On (figure 6.23, image 2). Choose Off if you want the camera to release the shutter only if something is in focus (hopefully

the subject). Set it to On if you want the camera to release the shutter even if nothing is in focus.

3. Press the OK button to Set your choice.

Settings Recommendation: I am a nature shooter and usually have time to make sure the subject is in focus. I don't want the shutter to release unless the subject (or at least something) is in focus. Most photographers do not shoot moving subjects, action, or sports in AF-S release mode. Instead, they use AF-C for continuous AF. Therefore, for most of us, setting this function to On is the best choice.

Rls Priority C

When you are shooting in AF-C (continuous AF) mode, the camera never truly locks focus on the subject. It continually seeks the best focus, and you will notice the lens refocusing as the camera and subject move. Rls Priority C is concerned with how the camera releases the shutter in AF-C mode.

If you are photographing a car race, where the cars are passing parallel directly in front of you, your images are often fine with just an initial autofocus operation because the car, although it is moving very fast, does not change distance from you, which allows the depth of field to cover minor focus variations. The focus does not have to be updated often. You can get many shots of the car as it moves parallel to you. For this type of shooting, the camera could be set to release the shutter without concern about AF (Rls Priority C set to On). Shutter release has priority! There may be a few out-of-focus frames, but the majority of images will be in good focus as the camera tries to maintain AF on the subject.

On the other hand, if you are photographing a marathon and the participants are running toward you, autofocus is critical. In this situation it is probably best to set Rls Priority C to Off so the camera will not release the shutter unless the subject is in focus.

This is a highly subjective decision that is based on what type of photography you do. Simply ask yourself if AF is more important than immediate shutter release for your style of shooting.

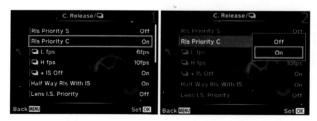

Figure 6.24: Setting release priority for continuous AF (AF-C) shooting

Use the following steps to enable or disable Rls Priority C:

1. Choose Rls Priority C from the C. Release/[FPS] menu and scroll to the right (figure 6.24, image 1).
2. A small window will open with the choices of Off and On (figure 6.24, image 2). Choose Off if you want the camera to release the shutter only if something is in focus (hopefully the subject), or set it to On if you want the camera to release the shutter even if nothing is in focus.
3. Press the OK button to Set your choice.

Settings Recommendation: Being a nature photographer biases me toward making sure the subject is in focus for every shot. I don't often have to suffer the frustration of the subject moving at high rates of speed (other than some wildlife).

Again, whether releasing the shutter or obtaining the best focus has a higher priority is a subjective decision. For most photographers Rls Priority C should be set to Off because who wants a series of out-of-focus images mixed with in-focus images?

On the other hand, if you have a good understanding of depth of field and know how to use it to cover minor focus variations, releasing the shutter and getting the shot may be a bigger priority than how the camera focuses.

Experiment with Rls Priority C when you are using AF-C mode. If the camera performs well enough in AF-C to keep the subject in reasonable focus, you may want the shutter release to have priority over autofocus.

[Sequential] L fps

The E-M1 can shoot in [Sequential] L fps and [Sequential] H fps modes, for low and high frames-per-second rates. These modes set the approximate frames per second (fps) rate that the camera uses to take pictures in fast bursts.

[Sequential] L fps can be set from 1 fps to 6.5 fps with firmware 2.0 or 9 fps with firmware 3.0, and the camera can fully autofocus between each frame. Let's examine how to change the rate.

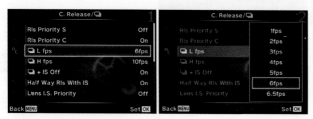

Figure 6.25: Setting a [Sequential] L fps rate

Use these steps to configure the frame rate of [Sequential] L fps:

1. Choose [Sequential] L fps from the C. Release/[FPS] menu and scroll to the right (figure 6.25, image 1).

2. A small window will open and offer you the choice of 1 frame per second (1fps) to 6.5 frames per second (6.5fps). The factory default is 6fps. With firmware 3.0, the maximum was increased to 9 fps (9fps). Choose how many fps you would like your camera to take in [Sequential] L fps mode (figure 6.25, image 2).
3. Press the OK button to Set the frame rate.

Settings Recommendation: I usually leave my camera set to [Sequential] L mode because I want the fastest frame rate I can get that still offers full autofocus. [Sequential L] fps autofocuses on each frame, whereas [Sequential] H fps autofocuses only on the first frame in the series.

For tracking a subject that is moving erratically, [Sequential] L fps is often the best choice. You have to decide how many frames you want to deal with. If you think 6.5 fps (firmware 2.0) or 9 fps (firmware 3.0) will make too many images, you can adjust the frame rate to as low as 1 fps. Most people select the maximum frame rate and never look back!

[Sequential] H fps

[Sequential H] fps makes the camera shoot at its maximum frame rate, 10 fps, unless you decide to throttle it back to between 5 fps and 10 fps.

Unfortunately the camera cannot autofocus between frames when you are using [Sequential] H fps. It autofocuses on the first picture in the series and takes the rest of the pictures without focusing.

If you must have autofocus for each frame in the series of pictures, use [Sequential] L fps instead. That mode was discussed under the previous subheading, **[Sequential] L fps**.

Let's see how to adjust the frame rate for [Sequential] H fps.

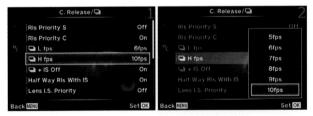

Figure 6.26: Setting a [Sequential] H fps rate

Use these steps to configure the frame rate for [Sequential] H fps:

1. Choose [Sequential] H fps from the C. Release/[FPS] menu and scroll to the right (figure 6.26, image 1).
2. A small window will open and offer you choices from 5 frames per second (5fps) to 10 frames per second (10fps). The factory default is 10fps. Choose how many fps you would like your camera to take in [Sequential] H fps mode (figure 6.26, image 2).
3. Press the OK button to Set the frame rate.

Settings Recommendation: I usually use [Sequential] L fps mode so I can take advantage of the fast frame rate and have autofocus too. When I am trying to impress my friends, though, I switch to [Sequential] H fps and fire off 20 or 30 frames.

On the other hand, if I really need extra speed, I switch to [Sequential] H fps and use the depth of field to cover the focus on subjects that are not moving toward or away from me.

Whether you use [Sequential] L or [Sequential] H fps depends on the type of subject you photograph. If you have a need for speed, 10 fps are at your command.

[Sequential] + IS Off

The 5-axis image stabilizer (IS) of the E-M1 cuts down on camera shake and leads to sharper pictures. But what about when you are shooting in bursts of images with [Sequential] L or [Sequential] H fps mode? Having the stabilization system active during sequential shooting adds a little time to acquiring each image and slows the frame rate because there is slightly more lag time between frames.

Whether to use IS during sequential shooting is a subjective decision based on your style of shooting. You can turn IS on or off during sequential shooting. Let's see how.

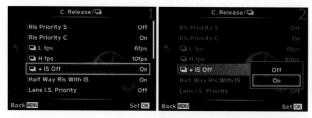

Figure 6.27: Enabling or disabling [Sequential] + IS Off

Use the following steps to enable or disable [Sequential] + IS Off:

1. Choose [Sequential] + IS Off from the C. Release/[FPS] menu and scroll to the right (figure 6.27, image 1).
2. A small window will open with the choices of On or Off (figure 6.27, image 2). If you choose On, the IS system will be disabled. That sounds backwards, but notice that the name of the function is IS Off. You are enabling IS Off, which disables the IS system. If you select Off from the menu, the IS system will work with every frame. The factory default setting is for the IS system to be disabled during sequential shooting.
3. Press the OK button to Set your choice.

Settings Recommendation: I leave this function set to Off because I am not a regular action shooter. If you shoot action frequently, you will have to decide if having stabilized images during sequential shooting is worth the small trade-off in image capture speed. This is a function you will want to test for your style of shooting.

Half Way Rls With IS

When you press the Shutter button halfway down with the Half Way Rls With IS function set to On, the 5-axis image stabilization (IS) system becomes active and stabilizes the image in the viewfinder or on the monitor.

Some people find the sudden cessation of small movements distracting, and others report that it makes them feel queasy. If you are bothered by seeing the IS system in action, you can disable it during subject viewing only. The camera still uses the IS system during the exposure, even if you turn it off for viewing the subject.

I tested this by shooting images with a 1 second shutter speed. When I disabled the IS system during subject viewing by turning off the Half Way Rls With IS function, I was still able to take fairly sharp handheld 1 second exposures. However, when I completely disabled the IS system in *Shooting Menu 2 > Image Stabilizer > Still Picture,* I was not able to make a sharp 1 second exposure. This leads me to believe that the IS system still functions during the actual exposure (i.e., a full press of the Shutter button), even though the user's manual does not confirm this.

Let's examine how to turn IS on and off during subject viewing only (i.e., when you press the Shutter button halfway).

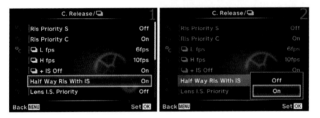

Figure 6.28: Enabling or disabling the IS system during subject viewing only

Use the following steps to enable or disable the IS system during subject viewing in the viewfinder or on the monitor:

1. Choose Half Way Rls With IS from the C. Release/[FPS] menu and scroll to the right (figure 6.28, image 1).
2. A small window will open with the choices of On or Off (figure 6.28, image 2). If you choose On, the camera will use the IS system to stabilize the subject in the viewfinder or on the monitor. If it is set to Off, the camera stabilizes the image only during the actual exposure. The factory default is On.
3. Press the OK button to Set your choice.

Settings Recommendation: I leave this function set to On. I enjoy seeing my subject stabilized in the viewfinder when I hold the Shutter button halfway down. However, you may not like the way it makes you feel, so turn it off. Evidently, the camera will still use the IS system during the exposure. However, I think it is better to have the image stabilized

before the exposure so it doesn't have to be done quickly at the moment of exposure. With fast shutter speeds it may not have time to stabilize. Test this for yourself and form your own opinion.

Lens I.S. Priority

Since the E-M1 is a Micro Four Thirds camera, within a sizable group of other Micro Four Thirds cameras, there are many non-Olympus lens choices. You may own or want to purchase another brand of Micro Four Thirds lens. If the lens has built-in image stabilization, it will work with the in-body stabilization of the E-M1.

Lens I.S. Priority allows you to assign priority to a non-Olympus lens that has stabilization built in. Or you can make the E-M1's IS system take priority. Let's see how it is done.

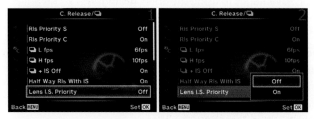

Figure 6.29: Setting the priority for IS to lens or body

Use the following steps to enable Lens I.S. Priority or assign priority to the E-M1's 5-axis in-body sensor stabilization:

1. Choose Lens I.S. Priority from the C. Release/[FPS] menu and scroll to the right (figure 6.29, image 1).
2. A small window will open with the choices of On or Off (figure 6.29, image 2). If you choose On, the camera will use the I.S. system in the lens to stabilize the subject. If you choose Off, the camera's 5-axis IS system stabilizes the image instead. The factory default is Off. If you decide to use the in-camera stabilization with a lens that has built-in stabilization, set this function to Off to disable the stabilization in the lens.
3. Press the OK button to Set your choice.

Settings Recommendation: I enjoy M.Zuiko and Zuiko lenses (with my MMF-3 adapter). Therefore, I don't currently own other brands of Micro Four Thirds lenses, even though there are some mighty appealing lenses out there.

The 5-axis image stabilization in the E-M1 is so amazingly amazing that I am completely amazed! I doubt any other lens stabilization system could match it. Therefore, I prefer to use in-body stabilization.

Release Lag-Time

This function changes the way the camera holds the shutter open. You can use Normal or Short settings. What is the difference? The user's manual does not say.

Evidently, when the Release Lag-Time is set to Normal, the camera uses a mechanical system to hold the shutter open so you can view the subject. When you switch the setting to Short, the camera appears to switch to an electromagnetic shutter hold. When you partially press the Shutter button immediately after switching, you will hear a distinct *click* as the camera switches to the alternate system.

When you turn the camera on with Release Lag-Time set to Short, you will hear a distinct *click* as it switches to the electromagnetic shutter hold system. You cannot hear the *click* when it is set to Normal.

There are advantages and disadvantages to using the Short setting:

Short setting advantages
- The shutter sound is reduced in the Short setting. If you are shooting a wedding, for instance, and need a quieter shutter, the Short setting may help.
- The Short setting has antishock properties because the shutter is released electromagnetically, instead of mechanically. If you are handholding the camera you may get sharper pictures with Release Lag-Time set to Short.
- There is a shorter lag time for firing the shutter. In Short mode with the Image Stabilizer turned off while you press the Shutter button halfway, the camera can release the shutter in 0.044 second. This allows you to shoot moving objects more quickly. If you are an action shooter, you may want to consider using the Short setting since it makes the camera more responsive.

Short setting disadvantages
- The electromagnetic system does not hold the shutter open as strongly as a mechanical system. If the camera is subjected to a strong shock, the shutter may close and disable viewing of the subject. If that happens, you will have to turn the camera off and back on to use the viewfinder or monitor to view the subject.
- The main disadvantage is reduced battery life. The E-M1's battery is already not sufficient to provide a full day's use, in most instances. Reducing the battery life by 20 percent makes that problem even worse. According to Camera & Imaging Products Association (CIPA) standards, Olympus claims the Short setting will reduce the battery life by up to 60 images. If you decide to use the Short setting, you may want to stock up on extra batteries and use an HLD-7 power battery holder, which lets you change the battery that's in the battery holder while the camera is still powered by its internal battery. Having the camera always powered will prevent you from losing shots in a fast-moving environment.

Now let's examine how to choose either Normal or Short Release Lag-Time.

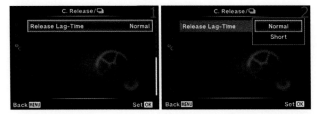

Figure 6.30: Choosing a Release Lag-Time

Use the following steps to choose the Normal or Short Release Lag-Time:

1. Choose Release Lag-Time from the C. Release/[FPS] menu and scroll to the right (figure 6.30, image 1).
2. A small window will open with the choices of Normal or Short (figure 6.30, image 2). If you choose Short, the camera will use an electromagnetic shutter release system. The factory default is Normal.
3. Press the OK button to Set your choice.

Settings Recommendation: As a photographer who does not often take action shots, the reduced battery life of Short mode makes me uninterested in it. However, if I were hired to shoot a car race or airplane show, I would set the Release Lag-Time to Short and take extra batteries. The fact that I use an HLD-7 power battery holder on my E-M1 gives me some flexibility for longer battery life. An action shooter who uses Short mode should seriously consider purchasing the HLD-7.

Custom Menu D. Disp/[Sound]/PC

Custom Menu D. Disp/[Sound]/PC contains 20 functions that pertain to the camera displays, sound system, and connectivity with a personal computer (PC).

Let's look at the location of the settings group on the Custom Menu, then we will consider each of the 20 functions individually.

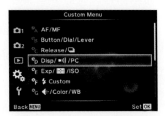

The D. Disp/[Sound]/PC settings group is the fourth item down on the Custom Menu, as seen in figure 6.31. Use this screen as a reference for opening the group to access the 20 internal functions.

Figure 6.31: The opening menu selection for the D. Disp/[Sound]/PC functions

HDMI

High-definition multimedia interface (HDMI) lets your camera communicate with display devices for showing still pictures and videos. Like slideshows of the old film days, HDMI allows you to use a large screen to show off your work for family and friends (or clients).

The E-M1 has an HDMI type D cable connector under the lower rubber flap on the left side, just above the USB A/V Out port. HDMI is engraved in the rubber flap (figure 6.32A). You will need an HDMI type D to type A cable to plug your camera in to a high-definition television (HDTV) or other HDMI device. HDTVs use a type A connector, and the E-M1 uses a type D connector.

Figure 6.32A: HDMI connector

For your camera to interface with an HDTV or other display device, you will have to match the output frequency from your camera to the input frequency of the HDTV. The camera supports standard HDMI output frequencies, including 1080i, 720p, and 480p/576p. There are two ways to figure out which frequency to use when you plug your camera in to an HDTV:

- Look up the required frequency in your HDTV user's manual and set the camera to match.
- Plug the camera in to the HDTV and see if it displays pictures. If not, change the HDMI output frequencies until something shows up on the HDTV screen.

Let's examine how to change the HDMI frequency on the camera.

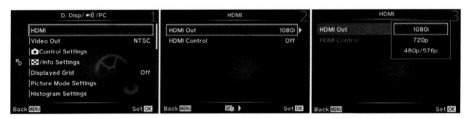

Figure 6.32B: Changing the HDMI output frequency

Use the following steps to change the HDMI output frequency to match an HDMI display:

1. Select HDMI from the D. Disp/[Sound]/PC menu and scroll to the right (figure 6.32B, image 1).
2. Choose HDMI Out from the HDMI menu and scroll to the right (figure 6.32B, image 2).
3. Select one of the listed HDMI output frequencies from the HDMI up/down menu (figure 6.32B, image 3). Most HDTVs support both 1080i and 720p.
4. Press the OK button to Set the output frequency.

The E-M1 supports HDMI-CEC (Consumer Electronics Council) with its HDMI Control function, which allows you to control the camera with the HDTV's remote control. If your HDTV supports CEC, you can enable it in the camera menu and use the HDTV's remote control to direct the camera output. Use the following steps to enable HDMI-CEC.

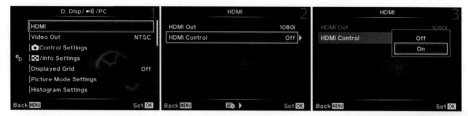

Figure 6.32C: Using HDMI-CEC for camera remote control

1. Select HDMI from the D. Disp/[Sound]/PC menu and scroll to the right (figure 6.32C, image 1).
2. Choose the HDMI Control setting from the HDMI menu and scroll to the right (figure 6.32C, image 2).
3. Select Off or On from the HDMI up/down menu (figure 6.32C, image 3). On enables HDMI-CEC, and Off disables it.
4. Press the OK button to Set your choice.

Settings Recommendation: When I plug my camera into my Vizio flat screen HDTV using the 1080i setting, it works fine. I can even use HDMI-CEC to control the display of images with my HDTV remote control. This is way more fun than the old days of breaking out a slide projector and jumping through hoops to get everything working for a slideshow. I can display videos and still images on my 50 inch (127 cm) HDTV.

Video Out

When you shoot and display video, you should use the standard for your country. There are two primary world standards: National Television System Committee (NTSC) and Phase Alternating Line (PAL). In the United States NTSC is the video standard; in many European countries PAL is the standard.

If you want to make sure which standard to use, download the document called **NTSC versus PAL Countries** from the Rocky Nook downloadable resources website at this URL: **http://www.rockynook.com/OlympusEM1**.

Let's examine how to select one of the video output standards.

Figure 6.33: Selecting a Video Out standard

Use the following steps to select a Video Out standard for your camera:

1. Select Video Out from the D. Disp/[Sound]/PC menu and scroll to the right (figure 6.33, image 1).
2. Select NTSC or PAL from the Video Out up/down menu (figure 6.33, image 2). Refer to the downloadable **NTSC versus PAL Countries** document if you are not sure which to use.
3. Press the OK button to Set your choice.

Settings Recommendation: I live in the United States, so I use NTSC. If you are not in the United States and you are not sure which standard to use, check the **NTSC versus PAL Countries** document. People in the United Kingdom should use PAL.

[Shooting Mode] Control Settings

The E-M1 offers five control panel displays, as discussed further in the chapter **Screen Displays for Camera Control**. You can select which control panel screens are available when you use one of the modes on the Mode Dial (e.g., P, S, A, M, iAUTO, ART, SCN). The control panel displays are as follows (in alphabetical order):

ART menu: Use to select one of 12 ART modes or ART BKT (bracketing)

Live Control: Use to control image stabilization, picture mode, white balance, shutter release mode, image aspect, record mode, movie quality, flash mode, flash compensation, metering mode, autofocus mode, ISO, face & eye priority, and video sound

Live Guide: Use to change color saturation and warmth, brightness, background blur, motion effects, and shooting tips

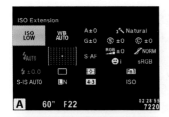

Super Control Panel (SCP): Use to control ISO, white balance, white balance fine-tuning, picture mode, image sharpness, image contrast, flash mode, AF area, AF mode, image saturation, image gradation, face priority, color space, flash intensity, sequential shooting/self-timer, metering mode, Fn1 button assignment, image stabilizer, record mode, and image aspect

Scene menu: Use to select one of 25 scene (SCN) modes

When you have a shooting mode selected on the Mode Dial and have pressed the OK button to open a control panel display, you can press the Info button to move among some of the displays. Table 6.9 shows which control panel displays can be used with which Mode Dial selections when you press the Info button.

	Art menu	Live control	Live guide	Live SCP	Scene menu
iAUTO		✓	✓	✓	
P/A/S/M		✓		✓	
ART	✓	✓		✓	
SCN		✓		✓	✓

Table 6.9: Control panel displays that can be used with Mode Dial selections

Now let's examine how to select which control panel displays cycle through with the Info button when you use each mode on the Mode Dial.

Use the following steps to choose control panel displays for Mode Dial selections:

1. Select [Shooting Mode] Control Settings from the D. Disp/[Sound]/PC menu and scroll to the right (figure 6.34, image 1).
2. Select one of the four shooting mode settings—iAUTO, P/A/S/M, ART, or SCN—from the [Shooting Mode] Control Settings up/down menu (figure 6.34, image 2). Figure 6.34, images 3–6, show the choices under each of the four shooting mode settings. Check each item you want to be available under that shooting mode by highlighting it and pressing the OK button to insert a check mark. Press the Info button to scroll through the selected screens for that shooting mode.
3. Press the OK button on each screen (figure 6.34, images 3–6) to Set your choice for that shooting mode.

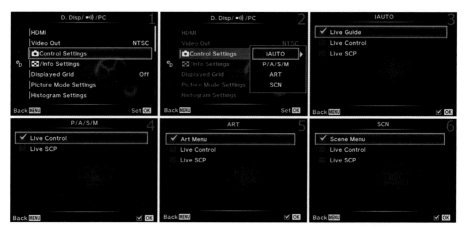

Figure 6.34: Choose control panel displays for Mode Dial selections

Settings Recommendation: I enjoy using Live control. It seems the most intuitive and easy to use, so I like it to be available on any shooting mode I use. Live SCP can also be useful in a similar way, although it is not as intuitive to me. However, I leave it as one of my choices in P/A/S/M and iAUTO modes.

I rarely use the ART or SCN modes. They seem to be useful only when I don't want to worry about camera settings. Therefore, I ignore the Live Control and Live SCP selections under the ART and SCN screens and place checkmarks next to Art Menu and Scene Menu only.

[Image Review]/Info Settings

The E-M1 can display several different picture information screens. Some of them can be disabled, some cannot. The number of information screens varies with each of these camera modes. The camera also provides five different Image Review screen styles.

The first two entries in the following list describe various information (info) screens, and the final entry describes the style of playback screen you will use when reviewing images:

- ► **Info:** The camera enters this mode when you press the image Playback button (►). To change the available information screens, press the Info button.
- **LV-Info:** This mode is available when you are viewing the subject on the monitor or in the viewfinder. To change the available information screens, press the Info button.
- **[Image Review] Settings:** After you press the ► Playback button, you can rotate the Rear Dial to select from the following choices: Single-frame playback; 4, 9, 25, and 100 frame playback; and Calendar display.

Let's take a look at the screens for each of these modes.

▶ Info (Playback)

You can access the five Playback info screens by pressing the ▶ Playback button on the back bottom right of the camera, viewing an image on the screen, then pressing the INFO button repeatedly.

The following list, called the ***Playback info list of screens,*** provides an overview of the six available screens you can use when you view images on the monitor.

Playback info list of screens

Standard Image Review: This basic screen displays the following: Date and time, image number, frame number, image aspect, and record mode. This screen cannot be disabled.

Image Only: This is the most basic screen. It shows only a picture of the subject with no camera or shooting information. This is great for judging the quality of the image with no distractions. This optional screen must be selected (checked) under *Info Settings >* ▶ *Info.*

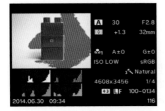

Overall: This more complex screen displays a number of informational items. The following descriptions have values in parenthesis to help you identify the item in the figure:

- Exposure mode (A)
- Shutter speed (30)
- Aperture (f/2.8)
- Metering mode (meter symbol)
- ± compensation (+1.3)
- Lens focal length (32mm)
- White balance mode (Capture WB 1)
- White balance adjustments (A±0, G±0)
- ISO (LOW)
- Color space (sRGB)
- Picture Mode (Natural)
- Image megapixel size (4608×3456)
- JPEG compression ratio (1/4)

- Image aspect (4:3)
- Record mode (LF)
- Image number (100–0134)
- Frame number (116)
- Date (2014.06.30)
- Time (09:34)
- Luminance histogram (white graph)
- RGB channel histograms (red, green, and blue graphs)
- Thumbnail image display with AF point shown

The orange around the subject represents an area that is blown out to pure white; blue represents a totally underexposed area. We will discuss how to use this in the upcoming Highlight&Shadow item. This optional screen must be selected (checked) under *Info Settings > ▶ Info*.

Histogram: The luminance histogram displays a bell curve graph that shows the dynamic range (from light to shadow) in the image. The histogram is very important to understand and use. If the graph is cut off on the left side, some areas are completely black and have no detail. If the graph is cut off on the right side, as seen here, some areas have become pure white with no detail. This optional screen must be selected (checked) under *Info Settings > ▶ Info*.

Highlight&Shadow: This screen is useful when you are shooting in very bright light or when the dynamic range of the scene exceeds the ability of the sensor to capture the full shadow to highlight range. The screen shows any areas where there is no detail in the image by repeatedly blinking from orange to white for overexposed areas, or from blue to white for underexposed areas. Some people call this *blink mode*. A smaller version of this screen is shown as a thumbnail in the Overall screen (discussed previously). This optional screen must be selected (checked) under *Info Settings > ▶ Info*.

1x

Light Box: This screen allows you to view a portion of two images at once for comparison purposes. To use the screen, select it with the INFO button while an image is being displayed. Ignore the image on the left side for now. Use the Arrow pad left and right keys to scroll through your pictures until you find one you want to compare. The frame number of the image will appear on the bottom-right corner of each partial image. Notice as you scroll that the image on the right is the only one that changes. When you find the first image you want to compare, press the OK button, and the selected picture will appear on the left. Again, scroll left or right with the Arrow pad keys until you find the second image you want to compare. After both images are displayed, you can zoom in from 1x to 14x and compare them by turning the Rear Dial. The amount of magnification will be displayed on the bottom left of the dual-image screen. This optional screen must be selected (checked) under *Info Settings > ▶ Info*.

The factory default setting is for Image Only and Overall to be enabled and for Histogram, Highlight&Shadow, and Light Box to be disabled. The Standard Image Review screen is always available and cannot be disabled.

Let's see how to select information screens for ▶ Info.

Figure 6.35G: ▶ Info screen choices

Use the following steps to enable or disable information screens for ▶ Info:

1. Select [Image Review]/Info Settings from the D. Disp/[Sound]/PC menu and scroll to the right (figure 6.35G, image 1).
2. Select the ▶ Info setting from the [Image Review]/Info Settings menu and scroll to the right (figure 6.35G, image 2).
3. You will see five information screen choices (figure 6.35G, image 3). On a new camera, only the first two will be checked. Refer to the ***Playback info list of screens*** and place

a check mark to the left of the screen you want to use. To add or remove a check mark, simply highlight the choice and press the OK button.
4. When you insert a check mark, the camera automatically saves the choice. Press the Menu button to return to the previous screen.

Settings Recommendation: I set my camera to have all the ▶ Info screens available. They are all useful!

Now let's consider the Live View info screens.

Live View (LV) Info

The Live View info screens have similar functionality to the ▶ Info screens, except they are live, based on the subject that is displayed on the monitor instead of an existing picture.

There are five Live View info screens, with four of them available as the factory default. One of the five screens is initially disabled. Here is an examination of the five screens and their functionalities.

Live View info list of screens

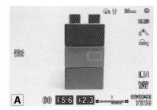

Standard Live View: This screen is always available and cannot be disabled. It provides basic shooting and exposure information, depending on which Mode Dial setting you are using. Some of the settings shown on the screen include the following: Face priority, sound setting, lens focal length, in-focus indicator, image stabilization mode, picture mode, white balance mode, ISO, point of focus (AF point), record mode, video mode, mode dial setting, shutter speed, aperture, ± compensation, exposure indicator scale, time, and frame number.

Histogram: The luminance histogram is a small bell curve graph in the lower part of the screen that shows the dynamic range (from light to shadow) in the image. The screen also contains a subset of the information found on the Standard Live View screen (previously discussed), with a few omissions, and it has a luminance histogram. This optional screen must be selected (checked) under *Info Settings > LV-Info*.

Highlight&Shadow: This screen is useful when you are shooting in very bright light or when the dynamic range of the scene exceeds the ability of the sensor to capture the full shadow to highlight range. The screen shows any blown-out highlight areas—where the image has become pure white with no detail—by continuously displaying orange where the highlight detail has disappeared. If the image is underexposed and some areas of the subject have gone to pure black (no dark detail), those areas will be blue. It does *not* blink as described for the ▶ Info screens. This screen also contains some basic exposure and camera settings. It must be selected (checked) under *Info Settings > LV-Info*.

Image Only: This is the most basic screen. It shows only what the lens currently sees, with no camera or shooting information. This is great for judging the potential quality of the image with no distractions. This optional screen must be selected (checked) under *Info Settings > LV-Info*.

Level Gauge: This screen allows you to level your camera both horizontally and vertically. As you move the camera off level, you will see white squares appear in the two level indicators, showing the degree and direction of level errors. My camera lens is pointed down slightly, and my camera body is rotated counterclockwise. The Level Gauge screen also contains basic exposure and camera settings. This optional screen must be selected (checked) under *Info Settings > LV-Info*.

The factory default setting is for all of the LV-Info screens—except the Highlight&Shadow info screen—to be enabled.

Figure 6.35M: LV-Info screen choices

Use the following steps to enable or disable information screens for LV-info:

1. Select [Image Review]/Info Settings from the D. Disp/[Sound]/PC menu and scroll to the right (figure 6.35M, image 1).
2. Select the LV-Info setting from the [Image Review]/Info Settings menu and scroll to the right (figure 6.35M, image 2).
3. You will see four information screen choices (figure 6.35M, image 3). On a new camera, everything except Highlight&Shadow will be checked. Refer to the **_Live View info list of screens_** and place a check mark to the left of the screen you want to use. To add or remove a check mark, simply highlight the choice and press the OK button.
4. When you insert a check mark, the camera automatically saves the choice. Press the Menu button to return to the previous screen.

Settings Recommendation: I set my camera to have all the LV-Info screens available. As with the ▶ Info screens, they are all quite useful to me. I especially like using the Highlight&Shadow screen when I am shooting in difficult lighting environments.

Now let's consider the [Image Review] Settings screens.

[Image Review] Settings

The Image Review screens provide different ways of viewing images on your memory card. You can view a single image or groups of images in configurations of 4, 9, 25, and 100 images per screen. There is also a Calendar format.

From the factory, only the 25 image and Calendar formats are available, but we will examine how to select the other formats.

Figure 6.35N: [Image Review] Settings

You can rotate the Rear Dial clockwise to see six views of the images on the memory card (turning the Rear Dial counterclockwise zooms in on a single image with magnifications from 1x to 14x).

Figure 6.35N, images 1–5, shows the views for 1, 4, 9, 25, and 100 images. The Calendar view (figure 6.35N, image 6) allows you to scroll to a date and select images that were taken on that day. If there are no thumbnail images on a date, no pictures were taken that day.

Let's examine how to enable and disable the image view screens.

Figure 6.35O: [Image Review] Setting choices

Use the following steps to enable or disable image view screens for [Image Review] Settings:

1. Select [Image Review]/Info Settings from the D. Disp/[Sound]/PC menu and scroll to the right (figure 6.35O, image 1).
2. Select [Image Review] Settings from the [Image Review]/Info Settings menu and scroll to the right (figure 6.35O, image 2).
3. You will be see five information screen choices (figure 6.35O, image 3). On a new camera, 4, 9, and 100 will *not* be checked. Place a check mark to the left of the image review screen type you want to use. To add or remove a check mark, simply highlight the choice and press the OK button.
4. When you insert a check mark, the camera automatically saves the choice. Press the Menu button to return to the previous screen.

Settings Recommendation: I set my camera to use the 4, 9, 25, and Calendar image review screens. The 100 image view is a little small for my eyes, but if you look carefully you can make out enough detail to choose an image. Experiment with these settings and see which are most useful to you.

Displayed Grid

This function allows you to display five types of grids on your camera monitor or in the electronic viewfinder (EVF). Let's examine each one.

Here is a description of the five grid types shown in figure 6.36A:

- Image 1 shows the Live View Image Only screen with no grid lines.
- Image 2 shows a full-screen grid that is useful for many types of camera leveling.
- Image 3 shows a grid that is more centered on the screen. It is almost, but not quite, in the rule of thirds format.

- Image 4 shows a cross-screen grid that is similar to a rifle scope.
- Image 5 shows an X-pattern grid that identifies the center of the screen and uses a receding lines effect.
- Image 6 shows grid lines in the top and bottom areas of the screen. This pattern closely resembles the 16:9 aspect ratio of high-definition movies and some still images.

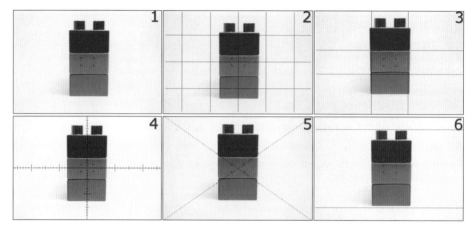

Figure 6.36A: The normal Live View Image Only screen and five types of grids

Now let's see how to select a grid pattern for the monitor and EVF.

Figure 6.36B: Selecting a grid pattern for the monitor or EVF

Use the following steps to choose your favorite grid pattern for the EVF and monitor:

1. Select Displayed Grid from the D. Disp/[Sound]/PC menu and scroll to the right (figure 6.36B, image 1).
2. Select one of the five grid patterns, or Off, from the Displayed Grid menu (figure 6.36B, image 2).
3. Press the OK button to Set the grid pattern.

Settings Recommendation: I like to use the grid pattern shown in figure 6.36A, image 2, which is useful for leveling the horizon, keeping the lens level for architecture, and watching out for perspective distortion. I have never had a camera with so many patterns. Play with each of them and see which ones work best for you.

Picture Mode Settings

The camera has a choice of 20 Picture Modes, as discussed in the **Shooting Menu 1** chapter. If you do not use some of the Picture Modes, you can use this function to hide them from the *Shooting Menu 1 > Picture Mode* menu and any camera screens that allow you to choose a Picture Mode.

Let's say you are not interested in using the Art Picture Modes. You could simply uncheck them from the Picture Mode Settings menu and they will disappear from any menu or screen that normally displays a choice of Picture Modes.

Let's examine how to enable and disable Picture Modes.

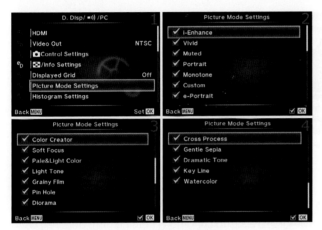

Figure 6.37: Enabling or disabling Picture Modes

Use the following steps to enable or disable Picture Modes from appearing on the camera menus and screens:

1. Select Picture Mode Settings from the D. Disp/[Sound]/PC menu and scroll to the right (figure 6.37, image 1).
2. Scroll up or down with the Arrow pad and highlight any Picture Modes you want to disable or enable. The default is to have all Picture Modes available (figure 6.37, images 2–4). Press the OK button to uncheck any modes that you do not want to use, or to check any modes you want to restore.
3. When you insert a check mark, the camera automatically saves the choice. Press the Menu button to return to the Picture Mode Settings screen.

Settings Recommendation: I leave all the Picture Modes checked and available. Although I don't often use them, I play around with them sometimes. The E-M1 is a fun camera because it has many effects for JPEG pictures. If you are a RAW shooter, Picture Modes are not of much interest because you can apply effects after the fact.

Histogram Settings

The Histogram display on the camera provides a window that shows the cutoff points for losing all detail in an image, which helps you determine how well the image is exposed. The left side of the Histogram window represents shadows, and the right side represents highlights.

The range of light that the camera can capture is symbolized by a Histogram scale that goes from 0 to 255, where 0 represents total black with no detail, and 255 represents pure white with no detail. Figure 6.38A shows a histogram in the shape of a bell curve. You can see the range of 0–255 along the horizontal axis.

Figure 6.38A: The Histogram scale represents total black (0) to pure white (255)

Using the Histogram

You can use the Histogram to protect your images from over- and underexposure. Figure 6.38B shows how the Histogram reacts to conditions ranging from underexposed to well exposed to overexposed.

Figure 6.38B: The Histogram scale can help you expose images properly

Notice how the bell curve graph is crammed to the left (clipped) for the underexposed image. It is cut off midpeak. The clipping indicates that some of the image is pure black (0), with no detail, and the overall image may be too dark.

In the well-exposed image in the middle, you can see that the graph is centered between the left (shadow) and right (highlight) sides.

The graph of the overexposed image is clipped off on the right, at the middle of the peak, and some of the image has become pure white.

Whenever you see the Histogram graph clipped on the left, the image may be too dark; if it is clipped on the right, the image may be too light. If the Histogram is clipped on both the shadow and highlight sides, there is too much light range (contrast) for the camera to capture all detail in the dark and light areas within a single image.

In that case, you must use either high dynamic range (HDR) photography, where multiple images are taken with different exposures then combined, or expose for the highlights to prevent the histogram from clipping on the right side. Notice how the Histogram graph just touches the left and right sides of the Histogram window in the well-exposed image (figure 6.38B). If there is too much contrast in the image, you may have to accept having the Histogram just touch the right side (highlight) only and allow clipping to occur on the left side. That is called exposing for the highlights.

When the Histogram graph just touches the right side without clipping, but it is clipped on the left, there will be dark shadows in the image. That looks normal to our eyes. We expect shadows to be dark, but we do not expect to see a lack of highlight detail.

Use the normal exposure system—shutter speed, aperture, and ISO—to move the histogram to the left or right. You may need to use the ±Exposure Compensation system to fine-tune the position of the Histogram graph for the best exposure. Fortunately, the camera gives you a Live Histogram display, which appears when you repeatedly press the Info button with the subject on the monitor (figure 6.38C) or in the viewfinder.

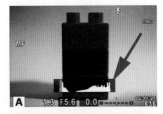

Figure 6.38C: The Live Histogram display for a well-exposed natural light exposure

The E-M1 also gives you control over how conservatively the histogram warns you of over- and underexposure. Normally you will leave the camera set so that pure black equals 0 and pure white equals 255. However, some photographers may want a little padding on either side of the histogram for extra protection. You can adjust the Histogram window size (range) so it no longer ranges from 0 to 255. Instead it can be moved by up to 10 increments on each side (a maximum of 10 to 245).

Let's examine how to change this setting.

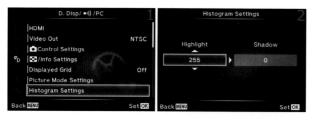

Figure 6.38D: Making the Histogram more or less conservative

Use these steps to change the range the Histogram uses to warn you of exposure problems:

1. Select Histogram Settings from the D. Disp/[Sound]/PC menu and scroll to the right (figure 6.38D, image 1).
2. Select a value for Highlight from 245 to 255 and a value for Shadow from 0 to 10 from the up/down menus (figure 6.38D, image 2).
3. Press the OK button to Set the new Histogram values.

Settings Recommendation: If you are ultraconservative in your exposures, you may want to adjust this setting. Otherwise, leave it at the industry standard of 0–255, which is what I use.

Mode Guide

The Mode Guide reminds you of the purpose of each setting on the Mode Dial on top of the camera. Each of the modes has a help reminder, as follows:

Modes on Mode Dial
- **P:** The camera sets the aperture and shutter speed automatically.
- **A:** You set the aperture manually.
- **S:** You set the shutter speed manually.
- **M:** You set the aperture and shutter speed manually.
- **[Movie]:** Start recording a movie, and take a picture (during the movie).
- **[Image Templates]:** The camera combines two or more template images into one image.
- **SCN:** The camera automatically applies settings to the Scene Mode you select.
- **ART:** Apply creative effects to your images.
- **iAUTO:** The camera selects the ideal mode, and the Live Guide menu is accessible.

Figure 6.39A: Mode Guide reminder for Aperture-priority (A) mode

Figure 6.39A shows the Mode Guide reminder for Aperture-priority (A) mode. Simply selecting a setting by turning the Mode Dial will immediately display the help reminder for that mode on the rear monitor only.

Let's see how to enable or disable the Mode Guide help reminders.

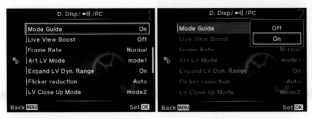

Figure 6.39B: Enabling or disabling the Mode Guide reminder system

Use the following steps to turn the Mode Guide help system on or off:

1. Select Mode Guide from the D. Disp/[Sound]/PC menu and scroll to the right (figure 6.39B, image 1).
2. Select Off or On from the up/down menu (figure 6.39B, image 2). The factory default is On.
3. Press the OK button to Set the Mode Guide value.

Settings Recommendation: I am torn about this setting. I do not need help with understanding what P, S, A, and M modes do. However, the functionality of some other modes, which I rarely use, might slip my mind. For now I have this set to On and tolerate the help screen when I turn the Mode Dial. However, it does aggravate me nearly every time I use the dial. If you are not familiar with what each mode accomplishes, you might want to leave the Mode Guide turned on.

Live View Boost

Live View Boost makes the subject look bright on the monitor, regardless of how little ambient light there may be. It is amazingly capable of artificially opening up the shadows on the monitor and in the viewfinder. If the most important thing is to be able to see the subject in low light, you may want to enable this function. If carefully controlled exposures are more important, do not enable it.

Live View Boost does not affect the exposure of the picture; it affects only how the image appears on the monitor and in the viewfinder. Unfortunately controls such as ± Exposure Compensation, although they still work normally to control exposure, will not display their effects on the screens when Live View Boost is enabled.

Live View Boost even prevents the Live Histogram display from updating correctly for Exposure Compensation changes. With Live View Boost enabled, the Live Histogram is limited to displaying the exposure the camera would provide without compensation. If you turn the dial for Exposure Compensation, the Histogram will not adjust and show the true exposure value, which could easily lead to under- or overexposure.

Let's examine how to turn Live View Boost on and off.

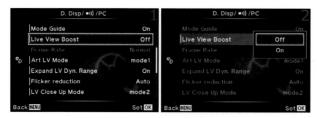

Figure 6.40: Enabling or disabling Live View Boost

Use these steps to turn Live View Boost on or off:

1. Select Live View Boost from the D. Disp/[Sound]/PC menu and scroll to the right (figure 6.40, image 1).
2. Select Off or On from the up/down menu (figure 6.40, image 2). The factory default is Off.
3. Press the OK button to Set the value.

Settings Recommendation: When you turn the dial for Exposure Compensation, you expect to see the image brighten or darken until it looks just right. You will not see the brightening or darkening effect with Exposure Compensation when Live View Boost is enabled because the screen is doing its best to brighten the subject to the max. Also, the Live Histogram will not update correctly for compensation.

If you are in a dark room trying to shoot a subject by candlelight, Live View Boost can help you see the subject. However, I leave Live View Boost set to Off.

Frame Rate

The E-M1 has a frame lag of merely 0.029 second between each frame you shoot. That makes the camera's electronic viewfinders (EVF) one of the fastest on the market today, with much less blackout (flicker) between frames. However, you can speed up the Frame Rate (the lag between frames) even more while shooting, but the display quality on the monitor and in the viewfinder will be reduced. It does *not* affect the quality of the images you take.

Decreasing the frame lag setting to High apparently lowers the camera's processing time to the point that the image display may have marginally less quality. However, for the trade-off in quality of the displayed image, you will experience less frame lag.

Note: The Frame Rate setting will be grayed out and unavailable if focus Peaking is set to On (*Custom Menu > A. AF/MF > MF Assist > Peaking*).

Let's examine how to configure the Frame Rate setting.

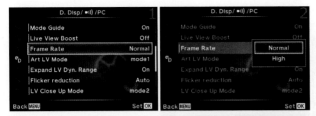

Figure 6.41: Setting the Frame Rate (lag time between frames)

Use the following steps to change the camera's frame lag:

1. Select Frame Rate from the D. Disp/[Sound]/PC menu and scroll to the right (figure 6.41, image 1).
2. Select Normal or High from the up/down menu (figure 6.41, image 2). The factory default is Normal.
3. Press the OK button to Set the value.

Settings Recommendation: As a nature shooter, I find that the camera is plenty fast, and I like to keep the image quality high in the camera displays while I shoot. However, if you are an action shooter and are photographing an event at up to 10 fps, you may want the fastest EVF display possible and will not mind slightly less quality as the images zip by in burst mode.

Art LV Mode

Using an Art filter places high demands on the camera microprocessor. That can lead to jerkiness in the electronic viewfinder (EVF) because it slows down the frame rate when you shoot quickly.

To counteract that demand, you can set the camera so it does not fully display the effect of the Art filter when you have the Shutter button pressed halfway down (mode2). In mode1 the camera displays the full Art filter effect and ignores the reduced EVF frame rate. That doesn't mean you won't see the effect of the Art filter on the monitor and in the viewfinder in mode2—it simply means the effect may not be as pronounced because the camera shoots images so quickly. This function does not affect the look of the pictures you take, just how they are displayed on the camera screens while you shoot.

The point of this function is to allow you to have a faster frame rate, even when you shoot with microprocessor-intensive Art filters.

Note: The camera user's manual has an error, or is out of date, on page 93 where this function is discussed. There it states that this function completely turns off the Art filter when you hold the Shutter button halfway down in mode2. You will still see the effect of the Art filter on the camera display screens, but they may not be quite as deep and the refresh rate will be faster when you are using mode2. The camera's help text for mode2 reports the following in firmware version 1.4: "The Art Filter effect is lightened on the LCD and the viewing frame rate is faster."

Let's examine how to select one of the two modes.

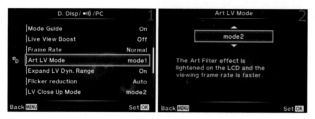

Figure 6.42: Selecting an Art LV Mode for the best frame refresh rate while using Art filters

Use the following steps to modify the Art LV Mode setting:

1. Select Art LV Mode from the D. Disp/[Sound]/PC menu and scroll to the right (figure 6.42, image 1).
2. Select mode1 or mode2 from the up/down menu (figure 6.42, image 2). The factory default is mode1.
3. Press the OK button to Set the value.

Settings Recommendation: Since this function does not affect the pictures you take, only the display screens, you will need to decide if you really need the effect of an Art mode to display with its full effect while you shoot multiple pictures. Most people would rather not have their camera slow down while they shoot quickly, so my recommendation is to use mode2. Of course, if you rarely or never use the Art filters while shooting bursts of images, this function may not be useful to you. I leave mine set to mode2 for the best refresh rate in case I decide to blast off a bunch of Art Grainy Film black-and-white images. If I am shooting with an Art mode at several frames per second, I don't really need to examine each image as it flies by!

Expand LV Dyn. Range

When you set this function to On the camera displays a preview of how the final combined image will look when you use HDR1 or HDR2 mode (firmware version 1.4). It has no effect when you use the other HDR modes (e.g., 3F 2.0EV, 5F 3.0EV).

If you have Expand LV Dyn. Range set to On and switch HDR1 or HDR2 on or off with the Sequential shooting/Self-timer/HDR button, you will see the sample HDR image in the viewfinder or on the monitor.

With this function set to On, the camera expands the dynamic range of the monitor and viewfinder—it tones down the highlights and opens the shadows—so the display image more closely resembles the final combined HDR image. It may not be exactly the same as the final image when there is a wide range of light, but it is much closer than the boosted brightness display you normally see. If this function is set to On and you switch

back and forth between the final combined HDR image and the subject displayed on either of the display screens, you will see that they are fairly close in dynamic range.

When this setting is Off, the camera displays the normal boosted brightness view on the monitor or in the viewfinder when you switch to HDR1 or HDR2.

Both the On and Off settings allow you to view each of the three images while the camera builds the HDR image.

Let's examine how the images are shown on the display screens in both modes.

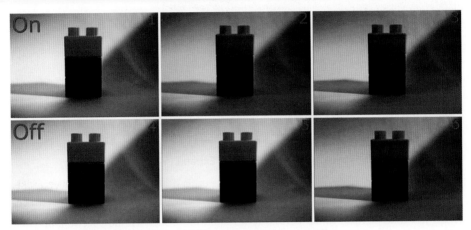

Figure 6.43A: Monitor view with Expand LV Dyn. Range set to On and Off

In figure 6.43A, images 1–3, Expand LV Dyn. Range is set to On, and in images 4–6 it is set to Off. In both rows, the final images (3 and 6) are the actual HDR combinations when I used HDR1 mode. Let's examine both modes more closely:

- **On:** In the top row (figure 6.43A, images 1–3), image 1 is the bright image the monitor normally displays. In image 2, which appears as soon as the camera enters HDR1 or HDR2 mode, you can see that the HDR preview image has toned down the highlights and opened up the shadows—that is, there is a greater dynamic range. Image 3 is the actual HDR combination in HDR1 mode. Notice that images 2 and 3 closely resemble each other. That's because Expand LV Dyn. Range was set to On, and the preview in image 2 closely resembles the final HDR image combination (image 3).
- **Off:** In the bottom row (figure 6.43A, images 4–6), image 4 is the bright image the monitor normally displays. In image 5 you can see that there is no HDR preview image when the camera is set to HDR1 or HDR2 mode. Instead, images 4 and 5 are basically identical. In image 6 the HDR combined image does not resemble image 5. This illustrates that the camera did not expand the dynamic range in image 5. It is not an HDR preview image, whereas image 2 clearly is.

Now let's examine how to choose a setting for Expand LV Dyn. Range.

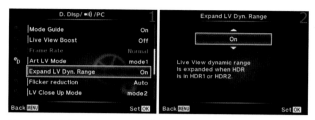

Figure 6.43B: Choosing a setting for Expand LV Dyn. Range

Use the following steps to modify the Expand LV Dyn. Range setting:

1. Select Expand LV Dyn. Range from the D. Disp/[Sound]/PC menu and scroll to the right (figure 6.43B, image 1).
2. Select On or Off from the up/down menu (figure 6.43B, image 2). The factory default is On.
3. Press the OK button to Set the value.

Settings Recommendation: It is a good idea to preview the approximate look of the final HDR image. Therefore, I set my camera to On for Expand LV Dyn. Range.

Flicker Reduction

When you take pictures under certain types of lighting, such as fluorescent lamps, the camera monitor and viewfinder may tend to display dark bands moving through them. This flickering is caused by the normal fluctuations in the electrical flow of alternating current (the frequency of the current is measured in hertz, or Hz) moving through the lamps.

The camera has three modes for reducing flicker: Auto, 50Hz, and 60Hz. It defaults to Auto. Some areas of the world use 50Hz, and others use 60Hz. In Auto the camera will try to determine which frequency is best for flicker reduction, or you can choose 50Hz or 60Hz and see which works best.

Let's examine how to choose one of the Flicker Reduction modes.

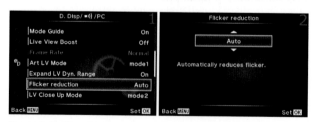

Figure 6.44: Choosing the best way to reduce flicker in the camera display screens

Use the following steps to modify the Flicker Reduction setting:

1. Select Flicker Reduction from the D. Disp/[Sound]/PC menu and scroll to the right (figure 6.44, image 1).

2. Select Auto, 50Hz, or 60Hz from the up/down menu (figure 6.44, image 2). The factory default is On.
3. Press the OK button to Set the value.

Settings Recommendation: A bane of digital photography with an electronic viewfinder or monitor is flickering under fluorescent lights. I have never been able to eliminate the bands that move through the screens, but you can try the three different adjustments and see if they help.

Don't worry, though, because other than being a bit of an aggravation while shooting, the flickering is not captured in the image.

LV Close Up Mode

As discussed in the previous Button Functions section of this chapter and in the appendix (Button Tasks), you can assign the Magnify task to one of the Button functions (e.g., Fn1, Fn2). The Magnify task will let one of the camera buttons zoom in to, or magnify, the subject and show an extreme closeup. This is a great focus aid because you can see a small portion of the subject up close while using autofocus.

The camera defaults to mode2 of the LV Close Up Mode, which allows the autofocus system to work while the subject remains magnified on the enlarged Live View screen.

Mode1 causes the magnification to go away before autofocus will work. The image will zoom back out to normal when you press the Shutter button to initiate autofocus, and it will force you to autofocus with no magnification.

Manual focus can be used with full magnification in either mode1 or mode2. Let's examine how to select one of the two LV Close Up Modes.

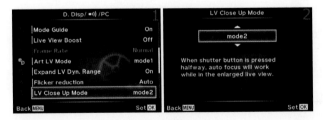

Figure 6.45: Choosing an LV Close Up Mode

Use the following steps to modify the LV Close Up Mode setting:

1. Select LV Close Up Mode from the D. Disp/[Sound]/PC menu and scroll to the right (figure 6.45, image 1).
2. Select mode1 or mode2 from the up/down menu (figure 6.45, image 2). The factory default is mode2, and AF works during magnification.
3. Press the OK button to Set the value.

Settings Recommendation: One of the primary reasons I want to zoom in or magnify the subject is to make sure autofocus is working well, so I leave this function set to mode2. However, if you want to zoom in on the subject for a different reason and would rather have autofocus work only when the camera is zoomed out to normal, use mode2.

[Aperture] Lock

[Aperture] Lock extends the power of the Preview button. Recall that if the Preview button is not assigned to some other task, it will stop down (close) the aperture while it is depressed so you can see the depth of field (zone of sharp focus) in your image. [Aperture] Lock lets you do the same thing, except you don't have to keep the Preview button depressed to preview the stopped-down aperture. Instead, you can press the Preview button once to lock the aperture in its stopped-down position, allowing you to see the depth of field, then press it again to unlock the aperture and open it back up to maximum size for bright subject viewing.

Let's examine how to configure [Aperture] Lock.

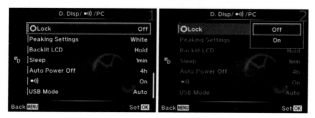

Figure 6.45A: Enabling or disabling the [Aperture] Lock function

Use the following steps to enable or disable the [Aperture] Lock function:

1. Select [Aperture] Lock from the D. Disp/[Sound]/PC menu and scroll to the right (figure 6.45A, image 1).
2. Select On or Off from the up/down menu (figure 6.45A, image 2). The factory default is Off.
3. Press the OK button to Set the value.

Settings Recommendation: Normally, the regular way a Preview button provides depth of field (DOF) preview is fine. Most of the time I leave this function set to Off. However, when I am working with macro shots and want to fine-tune where the depth of field falls within my image, I find it convenient to set this function to On and use [Aperture] Lock to stop down the aperture while I use manual focus to move the depth of field back and forth until it is exactly where I want it. I love the fact that the electronic viewfinder gets rid of most of the darkness that results from a smaller aperture so I can see how to manipulate the DOF until it is exactly where I want it to be. This is a very convenient function for people who like to use hyperfocal focusing and still want to visually confirm the DOF boundaries.

Peaking Settings

Peaking allows you to manually focus the subject by surrounding the in-focus areas in a white or black outline. The default is white, but you can change it to black if you want to.

Figure 6.46A: White (image 1) and Black (image 2) Peaking

White Peaking slightly darkens the entire image and boosts the contrast so you can more easily see the white borders of the in-focus areas (figure 6.46A, image 1). Black Peaking lightens the image and raises the contrast so you can more easily see the black borders of the in-focus areas (figure 6.46A, image 2).

Note: You can enable or disable Peaking with the *Custom Menu > A. AF/MF > MF Assist > Peaking* function.

Let's examine how to select White or Black for when manual-focus Peaking is active.

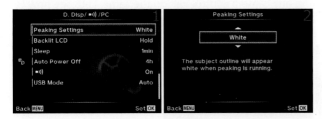

Figure 6.46B: Selecting White or Black Peaking

Use the following steps to modify the Peaking Settings function:

1. Select Peaking Settings from the D. Disp/[Sound]/PC menu and scroll to the right (figure 6.46B, image 1).
2. Select White or Black from the up/down menu (figure 6.46B, image 2). Both colors are useful for enhancing the in-focus edges of your subject. The factory default is White.
3. Press the OK button to Set the value.

Settings Recommendation: I use this function in different ways depending on the subject and background I am photographing. When I shoot a subject in a natural environment, I find that White is easier to see. When I shoot isolated images against a white background in my studio, I find that Black works best. You may want to change this setting if you photograph different types of subjects.

Backlit LCD

The LCD monitor on the rear of the camera uses a lot of battery power. In fact, powering this monitor drains more energy from the battery than any other part of the camera. The Backlit LCD function allows you to set a time limit for the LCD monitor to stay at full brightness. When the time-out expires the monitor will dim significantly and reduce the power drain. It does not go off completely—it just gets very dim. You can choose from 8 seconds (8sec), 30 seconds (30sec), 1 minute (1min), and Hold. The Hold setting effectively cancels the dimming process and retains the brightness all the time.

This function affects only the shooting mode when the subject is displayed on the monitor and the camera is ready to take a picture.

If you venture into the camera menus with the Menu button or start viewing images with the Playback button, the time-out period does not apply. Also, the time-out period does not affect the electronic viewfinder (EVF) display, only the rear LCD monitor.

The camera also has a function called Sleep, which we will consider in the next subsection. The Sleep function completely turns off the camera monitor after one minute. If you have the Backlit LCD time-out set to 1min and Sleep set to 1min, you will not see the backlit display dim. Instead, the Sleep function will override the Backlit LCD function and turn off the monitor.

While the monitor is dimmed, you can return it to full brightness by slightly pressing the Shutter button. In fact, using any camera control will do the same. Let's see how to choose a time-out period for dimming the Backlit LCD monitor.

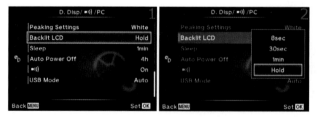

Figure 6.47: Choosing a Backlit LCD time-out period for dimming the monitor

Use the following steps to modify the Backlit LCD function:

1. Select Backlit LCD from the D. Disp/[Sound]/PC menu and scroll to the right (figure 6.47, image 1).
2. Select 8sec, 30sec, 1min, or Hold from the up/down menu (figure 6.47, image 2). The factory default is Hold, which never dims the screen.
3. Press the OK button to Set the value.

Settings Recommendation: I set my camera's Backlit LCD time-out to 8sec so I can save battery life. It is hard to make it through a full day of shooting with the EVF and monitor drawing so much power, so I am glad to have a dim function. I can undim the LCD by merely pressing the Shutter button halfway. If 8 seconds (8sec) is not enough time for you to compose and shoot with the LCD monitor, try 30sec or 1min. If you choose 1min, be aware that the Sleep function (next subsection) will likely prevent the monitor from dimming.

Sleep

The Sleep function could just as easily be called energy-saving mode. It puts the camera to sleep after a time-out period. Backlit LCD, discussed in the previous subsection, causes the monitor to dim significantly after a set period. The Sleep function takes it a step further by turning the monitor and electronic viewfinder (EVF) off until you use a camera control.

You can choose to have the display screens go to sleep after 1, 3, or 5 minutes (1min, 3min, or 5min). After the camera has gone to sleep, it will not wake back up until you press a button or turn a dial. When you do press a button—while the camera is in energy-saving Sleep mode—the camera ignores the normal function of that button and simply wakes up.

If you accidentally forget to turn the camera off and leave it in Sleep mode, it will turn itself off after a set period of time, which you can control with the Auto Power Off function (discussed in the next subsection).

Let's consider how to choose a Sleep mode time-out.

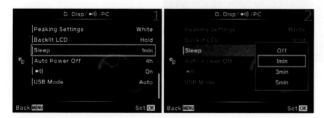

Figure 6.48: Choosing a Sleep time delay

Use the following steps to modify the Sleep function:

1. Select Sleep from the D. Disp/[Sound]/PC menu and scroll to the right (figure 6.48, image 1).
2. Select 1min, 3min, or 5min from the up/down menu (figure 6.48, image 2). You can also choose Off. The factory default is 1min.
3. Press the OK button to Set the value.

Settings Recommendation: I leave my camera set to 1min. The battery draw is so high for the bright screens that I want my camera to go to sleep quickly when I'm not using it.

I have found that the camera will go to sleep even when I am carrying it on a strap around my neck. At first I thought the sensor on the viewfinder eyepiece, which tells the camera to switch to the EVF, might sense my clothing and not let the camera go to sleep, but that's not the case. If you do not use a physical camera control within the time-out period you chose in the Sleep function, the camera will shut down the display screens and go into energy-saving mode.

When the camera is in Sleep mode, it starts the countdown to Auto Power Off, which will shut down the camera completely. We will consider Auto Power Off next.

Auto Power Off

Auto Power Off shuts down your camera if you do not use it for a certain period of time. You can set the camera to automatically shut off after 5 minutes (5min), 30 minutes (30min), 1 hour (1h), or 4 hours (4h).

The camera shuts down after the time-out period you select, even though the On/Off switch is set to On. If the camera has shut down with the On/Off switch set to On, you can to turn the switch Off and back On again to power up the camera. It will not come back on when you use any other camera control, unlike the Backlit LCD and Sleep functions.

Let's examine how to choose an Auto Power Off time-out period.

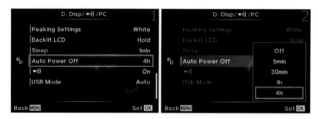

Figure 6.49: Choosing an Auto Power Off time delay

Use the following steps to modify the Auto Power Off function:

1. Select Auto Power Off from the D. Disp/[Sound]/PC menu and scroll to the right (figure 6.49, image 1).
2. Select Off, 5min, 30min, 1h, or 4h from the up/down menu (figure 6.49, image 2). The factory default is 4h.
3. Press the OK button to Set the value.

Settings Recommendation: The 1h setting seems about right to me. If I haven't used my camera in an hour, I probably won't use it for a while, and I can easily switch it off and back on when I need to take more pictures. The 4h setting will work too; however, that seems like a long time to have the camera partially active. Even though the display screens are

asleep while the camera is in energy-saving mode—if the Sleep function is configured correctly—the other parts of the camera are still using more power than when the camera is off.

[Speaker]

The [Speaker] function controls the beep sound you hear when you are taking a picture and the camera successfully autofocuses. The beep can be useful at times—it is a reassurance that AF is working. However, in certain environments the beep simply calls attention to the fact that you are taking pictures.

If you are shooting a wedding, do you really want the camera to beep every time it autofocuses? Or if you are sneaking up on a grizzly bear, shouldn't your camera cooperate by preventing you from becoming dinner?

The beep sound can be turned off (thankfully). Let's see how.

Figure 6.50: Enabling or disabling the beep sound

Use the following steps to modify the [Speaker] (beep sound) function:

1. Select [Speaker] from the D. Disp/[Sound]/PC menu and scroll to the right (figure 6.50, image 1).
2. Select Off or On from the up/down menu (figure 6.50, image 2). The factory default is On.
3. Press the OK button to Set the value.

Settings Recommendation: The first function I modify when I get a new camera is the one that disables beep sounds. I have learned over the years that some subjects don't like the sound. If you are a new photographer you may want to hear the sound for a while as a reassurance that autofocus has completed. Just be careful around large animals!

USB Mode

The E-M1 offers several industry standard modes for connecting the camera to external devices through the factory-supplied USB cable. The camera has a USB connector under the bottom rubber flap to the left of the LCD monitor. You can use the cable to transfer image and video files to your computer and to print pictures on a PictBridge-compatible printer.

Let's consider the three protocols the camera supports for connection to external devices, plus its Auto detect mode:

- **Auto:** This mode lets the camera decide which type of connection to use, depending on the type of device you plug your camera in to. If you get no results with the Auto setting, test the other modes to see what works with the external device.
- **Storage:** This mode refers to the mass storage class (MSC) specification, which is an industry standard for connecting a device containing storage memory to a computer. The MSC protocol is used by your camera, external hard drives, and card readers. You can use the Storage mode to transfer image and video files to your computer through Olympus Viewer software or other software. When you use Storage mode the camera will show up in your computer's file browser as a local hard drive. You can then access the DCIM folder on the memory card directly, then manually copy images and videos to and from the camera. When you plug the camera in to a USB port on your computer using the factory-supplied USB cable, your computer should react by offering to load the Olympus Viewer software if you have installed it. Olympus Viewer (version 3 in late 2014) will help you transfer images to your computer and allow you to enhance them (e.g., convert RAW files to JPEG). This is also the mode you must use when you are updating the firmware on your camera with Olympus Digital Camera Updater software.
- **MTP:** This mode refers to media transfer protocol (MTP), which was created by Microsoft as an extended set of tools for synchronizing pictures, videos, sound files, and songs from devices to a computer with Windows installed. It offers content management tools for creating playlists, autosyncing, and transferring DRM-protected (licensed) media. This mode does not seem to work well with Olympus Viewer 3 software, although it may work with other software. Olympus Digital Camera Updater software (version 1.03) does not recognize the camera when you are using this mode. It generates the following error: *Unable to use this function on this camera.* Therefore, you may want to use Storage mode, instead of MTP mode, when you transfer files. You definitely should use it when you update the camera's firmware. There are probably other types of control/transfer software that will work with MTP mode. It is good to know the camera has it if you need it.
- **Print:** This refers to PictBridge printing mode, which allows you to connect your camera directly to a PictBridge-compatible printer, without a computer, and print some or all of the images on the memory card. When you plug the camera into a PictBridge-compatible printer, you will see a Print Mode Select menu on the camera monitor, which allows you to use the following menu items:

Print Mode Select menu

- **Print:** Print individual images.
- **All Print:** Print all images on the memory card.
- **Multi Print:** Print multiple copies of one image in separate frames on one sheet of paper.
- **All Index:** Print an index of small thumbnails of all the pictures on the card.
- **Print Order:** Print a Print Order that was previously created and stored on the memory card (see page 262 for information about creating Print Orders, which can be used in any printer that will accept an SD card and can read a DPOF Print Order format).

Since this mode requires interfacing directly with various types of PictBridge printers, it is beyond the scope of this book. However, a downloadable document called **PictBridge Printing with Your E-M1** will be available at the downloadable resources website (http://www.rockynook.com/OlympusEM1) in the first quarter of 2015. It fully describes the complex process of PictBridge printing while your camera is connected to an Epson inkjet printer.

In the meantime, there is a brief explanation of PictBridge printing on pages 112–115 of the E-M1 user's manual.

Now let's consider how to select one of the USB modes.

Figure 6.51: Selecting a USB mode for image or video transfer and still image direct printing

Use the following steps to select a USB Mode for image and video transfer and picture printing:

1. Select USB Mode from the D. Disp/[Sound]/PC menu and scroll to the right (figure 6.51, image 1).
2. Select Auto, Storage, MTP, or Print from the up/down menu (figure 6.51, image 2). Refer to the **Print Mode Select menu** list to decide which mode to use.
3. Press the OK button to Set the value.

Settings Recommendation: I leave my camera set to Storage so I can transfer images and videos through my USB cable. I also update my camera's firmware whenever an update is available, which also requires the Storage mode. I rarely do any sort of PictBridge printing because I like to use a professional lab for my commercial work and a local lab for my snapshots.

Custom Menu E. Exp/[Meter]/ISO

The E. Exp/[Meter]/ISO menu is primarily composed of functions that directly affect how the image is exposed. We will start examining the functions by taking a look at the opening menu for the E. Exp/[Meter]/ISO functions in figure 6.52.

To enter the menu, you must select E. Exp/[Meter]/ISO from the Custom Menu and scroll to the right. There are 14 functions inside the E. Exp/[Meter]/ISO menu. Let's consider each of them in detail.

Figure 6.52: The opening menu selection for the E. Exp/[Meter]/ISO functions

EV Step

Use this function to choose an exposure value (EV) increment when you select a shutter speed, aperture, exposure compensation, and bracketing exposure value. As photographers, we think of exposure in stops. A 1-stop increment doubles or halves the amount of light the camera can use for making a picture, depending on whether you are letting in more light (double) or less light (half). A single stop is equivalent to 1 EV step.

The camera allows you to use finer increments than 1 EV step when you make exposure adjustments. You can select from 1/3 EV step, 1/2 EV step, or 1 EV step. The following three EV step lists show a partial breakdown of EV steps that are available as you adjust an exposure:

1/3 EV step
- **Shutter:** 1/100, 1/125, 1/160, 1/200, 1/250, 1/320, etc.
- **Aperture:** f/5.6, f/6.3, f/7.1, f/8.0, f/9.0, f/10, etc.
- **Compensation/bracketing:** 0.0, 0.3, 0.7, 1.0, 1.3, 1.7, 2.0, 2.3, 2.7, 3.0, etc.

1/2 EV step
- **Shutter:** 1/90, 1/125, 1/180, 1/250, 1/350, 1/500, etc.
- **Aperture:** f/5.6, f/6.7, f/8.0, f/9.5, f/11, f/13, etc.
- **Compensation/bracketing:** 0.0, 0.5, 1.0, 1.5, 2.0, 2.5, 3.0, etc.

1 EV step (1 stop)
- **Shutter:** 1/60, 1/125, 1/250, 1/500, 1/1000, 1/2000, etc.
- **Aperture:** f/2.8, f/4.0, f/5.6, f/8.0, f/11, f/16, f/22, etc.
- **Compensation/bracketing:** 0.0, 1.0, 2.0, 3.0, 4.0, 5.0 (note that 5.0 is the maximum)

The fineness of your exposure control will vary depending on how you set this function; that is, which EV step increment you choose (1/3EV, 1/2EV, or 1EV step). Let's examine how to select one of the three EV increment values.

Figure 6.53: Choosing an EV step value for exposure control

Use the following steps to select an EV increment value for camera exposure settings:

1. Select EV Step from the E. Exp/[Meter]/ISO menu and scroll to the right (figure 6.53, image 1).
2. Select 1/3EV, 1/2EV, or 1EV from the menu that appears (figure 6.53, image 2). Refer to the three previous EV step lists to help you decide which EV step is most appropriate for the type of pictures you are creating.
3. Press the OK button to Set the value.

Settings Recommendation: I leave my camera set to 1/3 EV step (1/3EV). Most photographers do the same. While using camera-supplied tools, such as the Live Histogram, it is best to have fine control over the exposure value. With 1/3 EV step you can adjust the exposure in fine increments. If you do not need such fine control, experiment with the other two selections.

Noise Reduct.

During a long exposure the sensor may exhibit more noise than is acceptable. The sensor gets warm after several seconds of use. This warming effect produces amp noise, which causes warmer sections of the sensor to have more noise than cooler sections.

This noise resembles a fog-like brightening around the edges of the frame. Also, there can be bright spots with various colors at numerous places in the image. This special type of long-exposure noise degrades the image in a different way than the noise from high-ISO sensitivity, which presents as grainy ugliness in darker areas of the image.

Using Noise Reduct.

When you enable Noise Reduct. (long-exposure noise reduction) and an exposure is longer than about 2.5 seconds, the camera will take two pictures with approximately the same exposure time. The first picture is normal. The second picture is a black-frame subtraction exposure, which is exposed for about the same duration as the first picture with the shutter closed.

The camera examines the noise in the black-frame subtraction exposure and subtracts it from the first image. Since long-exposure noise (bright spots in random places and fog at the edges) is different from high-ISO noise (grainy degradation in darker areas), the

high-ISO Noise Filter function (next subsection) would not work well with long-exposure noise. Therefore, for those of us who shoot long exposures regularly, the Noise Reduct. function is very important.

The main drawback to long-exposure noise reduction is that the total exposure time can be as much as doubled—a 5-second exposure becomes a 10-second exposure—because two exposures are made. The black-frame subtraction exposure is not written to the memory card; therefore, when the noise reduction process is done you will have only one image with much less noise.

While the black-frame subtraction exposure is being processed, the orange memory card access symbol will blink in the top-left corner of any active displays. While the symbol is flashing, you cannot use the camera. If you turn the camera off during a long-exposure noise reduction session, the image will be lost.

There are three selections available within the Noise Reduct. function:

- **Auto:** The camera chooses whether or not to use long-exposure noise reduction. It will usually kick in at a shutter speed of about 2.5 seconds or with a small aperture that makes the shutter stay open that long.
- **On:** Long-exposure noise reduction is active on all pictures taken at all shutter speeds, not just long exposures.
- **Off:** No long-exposure noise reduction is performed on any image.

Now let's see how to configure your camera to use Noise Reduct.

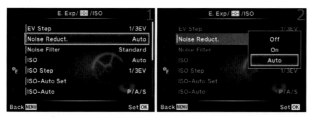

Figure 6.54: Selecting a Noise Reduct. setting for long exposures

Use the following steps to select a long-exposure Noise Reduct. setting:

1. Select Noise Reduct. from the E. Exp/[Meter]/ISO menu and scroll to the right (figure 6.54, image 1).
2. Select Off, On, or Auto from the menu that appears (figure 6.54, image 2).
3. Press the OK button to Set the value.

Note: Noise Reduct. may also kick in when ambient temperatures are high, such as on a hot summer day. The sensor can get quite warm when the camera is in the sun absorbing heat.

If you are shooting in [Sequential] H or [Sequential] L modes, firing off rapid bursts of images, the camera is smart enough to turn off Noise Reduct. for the image bursts. There is no need to slow the bursts down, even on a hot day.

Settings Recommendation: The factory default setting is Auto, and I've found that it works well for me. The camera consistently kicks in long-exposure noise reduction at a shutter speed of about 2.5 seconds and results in nicer-looking long exposures than without the setting enabled. When the picture is taken at a shutter speed faster than 2.5 seconds in Auto, the Noise Reduct. function is not used. Auto may be the best choice for most photographers because many exposures are shorter than 2.5 seconds, and Noise Reduct. will be used only when it is needed.

I don't need Noise Reduct. all the time, so I don't use the On setting, nor do I want to completely shut it Off. Make some long-exposure shots with and without Noise Reduct. enabled and see which works best for you.

Noise Filter

The Noise Filter function is designed to remove high-ISO noise from your images by blurring the image slightly. The blurring action tends to blend the grainy noise detail into the darker background, lessening the degrading effect of noise. The camera then resharpens the image to bring out more edge detail.

There are four settings: Off, Low, Standard, and High. The camera defaults to Standard. Each setting blurs the image more, making noise less apparent (and removing image detail), as you move from Low to High.

In figure 6.55A you can see the progression of the Noise Filter as it is increased in power from Off to High. The pictures were taken at ISO 3200. The four cutouts, as indicated by the red rectangle in the small center picture, are magnified by about 10x. The camera does an excellent job of noise control for its small sensor.

Figure 6.55A: Four settings for the high-ISO Noise Filter

Now let's examine how to choose a Noise Filter setting.

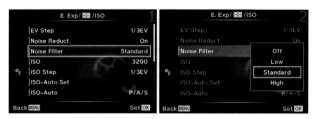

Figure 6.55B: Choosing a high-ISO Noise Filter setting

Use the following steps to select a high-ISO Noise Filter setting:

1. Select Noise Filter from the E. Exp/[Meter]/ISO menu and scroll to the right (figure 6.55B, image 1).
2. Select Off, Low, Standard, or High from the menu that appears (figure 6.55B, image 2). Refer to the four Noise Filter settings in figure 6.55A to help you choose the setting you want to use.
3. Press the OK button to Set the value.

Settings Recommendation: While I was shooting various indoor events (e.g., high school graduations, weddings, baptisms) with my E-M1, I had to shoot in rather low light. I used ISO 1600 and got excellent results as long as I kept my Live Histogram pegged on the bright side (exposed for the highlights). I found that the Standard high-ISO Noise Filter, which is the default, worked well for me. It seems to balance noise removal blurring and resharpening.

With a smaller sensor, such as the E-M1 Micro Four Thirds sensor, it is critical that exposures are correct in low light. Brightening a high-ISO image will often lead to objectionable noise.

Judicious use of the high-ISO Noise Filter will help protect you from excessive noise in images where the light is not ideal.

ISO

The E-M1 has an ISO range from Low (ISO 100) to ISO 25600. ISO 200 is the base ISO and is the factory default. You can choose an ISO sensitivity setting from this Custom Menu, along with several other ISO adjustments, in the next three Custom Menu items (see the upcoming subsections).

The ISO sensitivity choices you will see on the menu, shown in figure 6.56, image 2, are in 1/3 EV steps, but they can be changed to 1 EV steps in the ISO Step value function considered in the next subsection. Let's see how to select an ISO value.

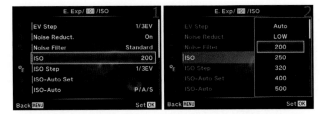

Figure 6.56: Selecting an ISO value from the Custom Menu

Use the following steps to choose an ISO sensitivity setting:

1. Select ISO from the E. Exp/[Meter]/ISO menu and scroll to the right (figure 6.56, image 1).
2. Select an ISO sensitivity value from the menu that appears (figure 6.56, image 2).
3. Press the OK button to Set the value.

Settings Recommendation: I use ISO 200 for standard, noncommercial handheld shooting. When I have my camera on a tripod for maximum sharpness in landscapes, I often use ISO 100. My personal maximum for the highest-quality images is around ISO 1600, and ISO 3200 is the highest ISO I use for standard-quality images.

Experiment with various ISO settings. Make sure the exposure of each image is correct so you won't have to brighten it during post-processing and increase the noise. The smaller sensor in the E-M1 demands a good exposure for the best results. However, your tolerance for noise may be higher than mine.

ISO Step

The previous ISO function presented ISO values in 1/3 EV steps. It and all other camera menus that allow you to change the ISO use the ISO Step function as the basis for the ISO increments on the camera displays. You can choose from either 1/3 EV step or 1 EV step.

Here is a partial list of ISO increments for both ISO Step values:

1/3 EV step: Auto, Low (100), 200, 250, 320, 400, 500, 640, 800, etc.

1 EV step: Auto, Low (100), 200, 400, 800, 1600, 3200, 6400, etc.

If you want to use smaller increments, leave this setting at the factory default of 1/3 EV. If you want to select ISO values in 1 EV step (1 stop) increments, you can change it here. Let's see how.

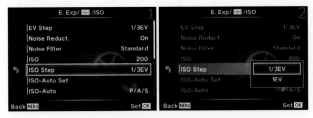

Figure 6.57: Choosing an ISO Step increment

Use the following steps to choose an ISO sensitivity setting:

1. Select ISO Step from the E. Exp/[Meter]/ISO menu and scroll to the right (figure 6.57, image 1).
2. Select 1/3EV or 1EV from the menu that appears (figure 6.57, image 2).
3. Press the OK button to Set the value.

Settings Recommendation: I use the 1/3EV ISO Step value because I want fine increments of ISO values to choose from. If you prefer coarser 1-stop ISO sensitivity increments, choose 1EV instead.

ISO-Auto Set

When you set the ISO sensitivity to Auto, the camera will choose the best ISO to use for the current subject, without concern for image noise from high ISO values.

ISO-Auto Set is used to control the upper and lower range of your camera's ISO sensitivity. In effect, you are telling the camera it can use any ISO value within a certain range, but it cannot exceed that range with higher or lower ISO values. The total available ISO range is from ISO 200 to ISO 25600.

There are two settings in the ISO-Auto Set function:

- **High Limit:** The High Limit setting controls the maximum ISO value that you will allow the camera to use in difficult lighting conditions. The camera is free to use any ISO value up to the High Limit setting. If you choose ISO 1600 as the High Limit, the camera can use any ISO from the lower Default limit (next setting) up to 1600, but it cannot exceed 1600.
- **Default:** The Default setting serves two purposes. First, it is the default ISO value that the camera will use when there is sufficient light to drop the ISO to the lowest setting. Second, it is the lowest ISO value the camera is allowed to use when the light gets brighter. If you select ISO 400 as the Default value, the camera is free to use any ISO from 400 up to the High Limit (previous setting).

Look at the Default and High Limit as a floor and a ceiling. When you use Auto ISO the camera cannot drop the ISO below the Default floor or raise it above the High Limit ceiling. These values give you excellent control of the Auto ISO boundaries.

Let's examine how to choose an ISO value for the two settings.

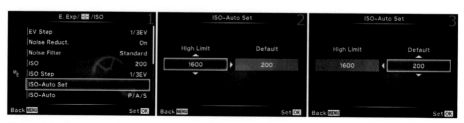

Figure 6.58: Choosing a High Limit and a Default value for Auto ISO

Use the following steps to choose an ISO-Auto Set value for the High Limit and Default settings:

1. Select ISO-Auto Set from the E. Exp/[Meter]/ISO menu and scroll to the right (figure 6.58, image 1).
2. Choose an ISO value from the High Limit up/down menu (figure 6.58, image 2). The available ISO values range from ISO 200 to ISO 25600. I chose a High Limit of ISO 1600.
3. Choose an ISO value from the Default up/down menu (figure 6.58, image 3). The available ISO values range from ISO 200 to ISO 25600. I chose a Default of ISO 200. You cannot select the Low (ISO 100) value.
4. Press the OK button to Set the two values.

Settings Recommendation: I use ISO 1600 as my High Limit. I don't like the noise that results with higher ISO values, especially if I don't nail the exposure. I use ISO 200 to ISO 400 as the lower Default value, depending on the ambient light and whether I am using flash. When I use flash indoors, I often use ISO 400 as Default and ISO 1600 as High Limit.

ISO-Auto

Use the ISO-Auto function to control which modes on the Mode Dial allow the use of automatic ISO (called Auto on the ISO selection menus; I will use Auto ISO in this book.) The factory default is for Auto ISO to be available only in Program (P), Aperture-priority (A), and Shutter-priority (S) modes. Normally Auto ISO is not available when you are using Manual (M) mode, so the selection is grayed out on the menu.

However, the camera allows you to use Auto ISO in Manual (M) mode. There are two settings in the ISO-Auto function:

- **P/A/S:** When this mode is selected the camera allows the Auto ISO function to be accessible on the menus only when you are using Program (P), Aperture-priority (A), and Shutter-priority (S) modes. Auto ISO will be grayed out and unavailable on all ISO selection menus when you are using Manual (M) mode.
- **All:** When you select this mode the camera will offer Auto ISO on all ISO selection menus when you use P, A, S, or M mode on the Mode Dial. Note that Manual (M) mode is included.

Let's see how to select a setting.

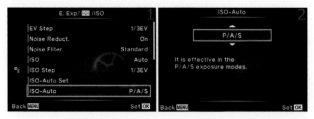

Figure 6.59: Choosing which Mode Dial setting allows Auto ISO

Use the following steps to choose an ISO-Auto setting:

1. Select ISO-Auto from the E. Exp/[Meter]/ISO menu and scroll to the right (figure 6.59, image 1).
2. Select either P/A/S or All from the up/down menu (figure 6.59, image 2).
3. Press the OK button to Set the value.

Settings Recommendation: The All setting makes sense for the types of photography I do (events and nature). I use Auto ISO only when I must get the shot at all costs or when I am shooting just for fun. However, if I wanted to shoot with Auto ISO in Manual (M) mode, I wouldn't want a limitation imposed upon me.

If you do not think you will use Auto ISO in M mode, simply leave this function set to the factory default of P/A/S.

Metering

The E-M1 has five meter types, which gives you great flexibility in how you expose your images. Using the meter styles built in to the camera along with the Live Histogram will allow you to take some of the best-exposed images you've ever created.

Let's look more closely at the five types of light meters built in to the camera and discuss their differences:

[Digital ESP Metering]: ESP stands for electrosensitive pattern. The camera meters the image in a grid of 324 metered areas. It examines each of the 324 areas and uses complex mathematical computations to arrive at an excellent exposure most of the time. This metering mode works best for portraits when Face Priority is enabled.

[Center-Weighted Averaging Metering]: The camera averages the light between the subject and the background. It places more emphasis on the center area of the screen (large fuzzy red circle in the accompanying image) with less emphasis on parts of the scene that are farther away from the center. This mode is provided for those of us who learned to use a center-weighted meter and prefer to use that metering method. You will see a medium-sized circle in the middle of the monitor. The circle does not represent the actual size of the averaging meter's most important metering area; it shows just the center.

[Spot Metering]: The camera uses a small circle in the center of the frame for metering. This circle is equivalent to 2 percent of the frame and is roughly represented by the red dot in the accompanying figure. All metering takes place in this 2 percent area. Therefore, you must place this nonmoveable spot on the area of the subject that you want to correctly meter by moving the camera then using autoexposure lock (AEL/AFL button) to lock the exposure while you recompose the image (see the next subsection, **AEL Metering**). Or you can take multiple readings of different areas of the scene, determine the total light range, and set the exposure manually.

[Spot Metering—Highlight (HI)]: This type of metering is similar to [Spot Metering] in that the camera uses a small circle in the center of the frame to meter. This circle is equivalent to 2 percent of the frame and is roughly represented by the red dot in the accompanying figure. This metering mode is different because the camera tries to make white areas (highlights) stay white by increasing the exposure beyond a [Spot Metering] reading to give a bright, high-key look to the image.

[Spot Metering—Shadow (SH)]: This type of metering is similar to [Spot Metering] in that the camera uses a small circle in the center of the frame to meter. This circle is equivalent to 2 percent of the frame and is roughly represented by the red dot in the accompanying figure. This metering mode is different because the camera tries to make dark areas (shadows) stay dark by decreasing the exposure below a [Spot Metering] reading to give a low-key look to the image.

Now let's examine how to select one of the metering types.

Figure 6.60F: Choosing a light meter type

Use the following steps to choose a Metering type:

1. Select Metering from the E. Exp/[Meter]/ISO menu and scroll to the right (figure 6.60F, image 1).
2. Select one of the five meter types shown in the menu (figure 6.60F, image 2).
3. Press the OK button to Set the value.

Settings Recommendation: I usually use [Digital ESP Metering]. I like the way it evaluates all areas of the screen and arrives at an excellent exposure. However, I have found that it is best to use Face Priority along with this meter type to have the best exposure for portraiture.

There is a meter type for each of us: the [Center-Weighted Averaging Meter] is good for old-timers who like this traditional meter style. The three types of [Spot Metering] allow extremely accurate metering of specific areas of a subject for those who understand how to use a spot meter. The highlight and shadow meters add icing to the cake.

I suggest experimenting with all these meter types until you are familiar with them.

AEL Metering

When you press the AEL/AFL button with the camera configured for autoexposure lock, the camera makes a meter reading then locks the exposure until you release the AEL/AFL button. Olympus has provided a means for you to choose which type of meter your camera will use to make the exposure reading that will be locked.

There are five AEL Metering modes:

- **Auto:** When you press the AEL/AFL button, the camera uses whichever metering mode you selected in the **Metering** subsection. This is the factory default setting, and it is apparently the only way to access [Digital ESP Metering] for autoexposure lock.
- **[Center-Weighted Averaging Metering]:** When you press the AEL/AFL button, the camera switches to [Center-Weighted Averaging Metering], as described in the **Metering** subsection.
- **[Spot Metering]:** When you press the AEL/AFL button, the camera switches to [Spot Metering], as described in the **Metering** subsection.
- **[Spot Metering—Highlight (HI)]:** When you press the AEL/AFL button, the camera switches to [Spot Metering—Highlight (HI)], as described in the **Metering** subsection.
- **[Spot Metering—Shadow (SH)]:** When you press the AEL/AFL button, the camera switches to [Spot Metering—Shadow (SH)], as described in the **Metering** subsection.

Let's see how to select one of the five metering types for autoexposure lock.

Figure 6.61: Choosing a metering mode for autoexposure lock

Use the following steps to choose a Metering type when you press the AEL/AFL button:

1. Select AEL Metering from the E. Exp/[Meter]/ISO menu and scroll to the right (figure 6.61, image 1).
2. Select one of the five meter types shown in the menu (figure 6.61, image 2).
3. Press the OK button to Set the value.

Settings Recommendation: The Auto mode seems to be the most reasonable setting for me. I normally have the best light meter type already selected before I use autoexposure lock.

However, maybe you are metering a beautiful sunset and decide to use autoexposure lock to meter a bright orange cloud. You might want to use [Spot Metering]. If you already had the AEL Metering function set to [Spot Metering], you would be ready to shoot. You could meter the bright cloud, recompose, take the shot, then continue shooting with [Digital ESP Metering] for more images of other subjects. In cases like this it may be wise to separate the Metering types when you use normal metering and after pressing the AEL/AFL button.

BULB/TIME Timer

When you set your camera to Manual (M) mode on the Mode Dial and turn the shutter speed to its lowest setting with the Rear Dial, you will find specific shutter speed settings called BULB (or LIVE BULB) and LIVE TIME. (**Note:** Do not confuse these camera shutter speed settings with the Live BULB and Live TIME function names in upcoming sections of this chapter). The BULB, LIVE BULB, and LIVE TIME shutter speed settings allow you to make long exposures from 1 to 30 minutes in length.

The BULB/TIME Timer function allows you to control the maximum time for the long exposures. You can select from a range of 1min (1 minute) to 30min (30 minutes). When you use the BULB or LIVE BULB shutter speed setting you have to manually hold the shutter open by pressing the Shutter button or using a locking electronic shutter-release cable. We will discuss the BULB and LIVE BULB shutter speeds in more detail in upcoming subsections. When you use the LIVE TIME shutter speed setting, the camera holds the shutter open for you.

Let's examine how to select one of the BULB/TIME Timer settings.

Figure 6.62: Choosing a time-out setting for the BULB/TIME Timer function

Use the following steps to choose a time-out or maximum time to have the shutter open when you use the BULB, LIVE BULB, or LIVE TIME shutter speed settings for long exposures:

1. Select BULB/TIME Timer from the E. Exp/[Meter]/ISO menu and scroll to the right (figure 6.62, image 1).
2. Select one of the eight time-out values from the up/down menu. Your choices range from 1min to 30min (figure 6.62, image 2).
3. Press the OK button to Set the value.

Note: If you are using the Noise Reduct. function (see the **Noise Reduct.** subsection), the camera will use long-exposure noise reduction for each of your BULB, LIVE BULB, or LIVE TIME exposures, effectively doubling the time of the exposure. Therefore, a 1-minute exposure will be doubled to 2 minutes, and an 8-minute exposure will be doubled to 16 minutes. This is due to the black-frame subtraction method the camera uses to reduce noise in long exposures. You can disable Noise Reduct. if you do not want the shutter to be open for double the exposure time, but your images may have fog and bright spots because of amp noise and hot pixels.

Settings Recommendation: You will have to decide how long your exposure needs to be for your purposes. For LIVE BULB and LIVE TIME shutter speed exposures, the camera will show you the light buildup of the actual exposure on the Live view display screen so you can see how the long exposure is progressing over time. The screen can update itself—showing you the progress of the exposure—up to 24 times during each exposure. The number of times the live exposure preview updates is governed by the sensitivity of the ISO setting. The amount of time between each screen update (from 0.5 to 60 seconds) is controlled by the upcoming Live BULB and Live TIME functions. For BULB shutter speed exposures, you will not see the light buildup on the Live view display screen. You will have to wait until you release the shutter and the Noise Reduct. function has finished removing long-exposure noise before the final image will appear on the screen.

BULB/TIME Monitor

You will normally use the BULB, LIVE BULB, and LIVE TIME shutter speeds to take long exposures in the dark. Therefore, you may want the monitor to be very dim to preserve your night vision.

On the other hand, you may be shooting a one- or two-minute daylight exposure with a neutral-density (ND) filter to hold back the brightness of the exposure and allow a long exposure in normal light. In that case you may want a normal or extra-bright monitor.

The camera allows you to change the brightness of the monitor by using the BULB/TIME Monitor function. You can select from –7 to +7, or 14 steps of brightness. The factory default is –7 for a very dim monitor. You will see the monitor dim immediately when you select the BULB, LIVE BULB, or LIVE TIME shutter speeds.

Let's examine how to select the monitor brightness for long exposures.

Figure 6.63: Choosing a monitor brightness level for BULB, LIVE BULB, and LIVE TIME

Use the following steps to choose a monitor brightness level when you use the BULB, LIVE BULB, or LIVE TIME shutter speeds for long exposures:

1. Select BULB/TIME Monitor from the E. Exp/[Meter]/ISO menu and scroll to the right (figure 6.63, image 1).
2. Use the Arrow pad up or down keys to choose one of the 14 brightness levels from –7 to +7 (figure 6.63, image 2). The factory default is –7 (very dim).
3. Press the OK button to Set the value.

Settings Recommendation: I do most of my long exposure shooting at night, so I leave this value set to –7. However, if you like to do daytime long exposures with a neutral-density filter, you will want your monitor to be bright. If you select the BULB, LIVE BULB, or LIVE TIME shutter speeds during the day, with this setting at –7, the monitor will be too dim to see in normal daylight. Therefore, set the value in advance.

Live BULB

When you rotate the Rear Dial while using Manual (M) mode on the Mode Dial, you will find BULB, LIVE BULB, or LIVE TIME *shutter speeds* as the slowest shutter speed settings.

When you set the Live BULB *function* to Off, the camera will use the BULB shutter speed to make exposures. If you select any other setting besides Off for the Live BULB function, the camera will use the LIVE BULB shutter speed instead of the BULB shutter speed.

Note: To avoid confusion, please notice that this function is called Live BULB. It controls a shutter speed setting named LIVE BULB. Notice the differences in uppercase and lowercase notations so you will not get Live BULB (the Custom Menu function) and LIVE BULB (the shutter speed setting) confused as we discuss them. LIVE BULB and BULB work

similarly when starting and ending the image exposure—notice which term is displayed on the camera screens during the exposure so you can tell the difference. Using the Live BULB function with its LIVE BULB shutter speed allows you to see a buildup of the exposure on the camera's Live view monitor. If you use the BULB shutter speed setting, which is available only when the Live BULB function is set to Off, you will not see a buildup of exposure on the monitor. Instead, you will see the results of the exposure when the camera has closed the shutter after the exposure is complete and any long-exposure noise reduction has been completed (see the *Custom Menu > E. Exposure/[Meter]/ISO > Noise Reduct.* function).

When you use the BULB or LIVE BULB shutter speed settings, the camera opens the shutter (starts the exposure) when you press and hold the Shutter button all the way down or when you manually hold the shutter open with a locking electronic cable release. The exposure ends when you release the Shutter button to close the shutter.

When Live BULB (the function discussed in this section) is set to Off and you rotate the Rear Dial to the slowest shutter speed positions, BULB will be displayed instead of LIVE BULB as one of the last few shutter speed choices.

Let's consider each of the BULB-type shutter speed settings.

BULB Shutter Speed

When this setting is selected the word BULB will be displayed in the shutter speed position of the monitor or viewfinder (figure 6.64A, image 1).

Figure 6.64A: Using the BULB shutter speed setting

When you press and hold the Shutter button and start exposing a picture using BULB, the monitor turns black. It displays a countdown timer in the lower-right corner of the screen during the long exposure (figure 6.64A, image 2). The countdown timer shows how long you have held the shutter open when using the BULB shutter speed.

As soon as you release the Shutter button, the exposure ends. If the exposure was longer than about 2.5 seconds and if long-exposure noise reduction is enabled (*Custom Menu > E. Exp/[Meter]/ISO > Noise Reduct.*), the camera will execute a long-exposure noise reduction cycle, doubling the exposure time while removing long-exposure noise. You will see the orange card access symbol flashing in the upper-left corner of the screen during the noise reduction cycle. When it is done, the camera will display the new image on the monitor.

LIVE BULB Shutter Speed

When you use the LIVE BULB shutter speed setting, your camera makes an exposure over time and displays the live results on your camera's current display screen (viewfinder or monitor).

Press and hold the Shutter button to start the exposure, and the camera will start updating the live exposure on the current display screen. You can see the actual image being formed on the monitor during a LIVE BULB exposure in figure 6.64B, images 2–4.

Figure 6.64B: Using the LIVE BULB shutter speed setting

When the Live BULB function is set to any value besides Off, the LIVE BULB shutter speed selection displays on the bottom left of the screen (figure 6.64B, image 1).

Figure 6.64B, image 2, shows the location of the Display Count so you can watch how many times the live exposure update has occurred (up to 24 times maximum). Image 3 shows the Live histogram that you can use to determine when the exposure is correct. If you want a good exposure, release the Shutter button when the histogram graph approaches or touches the right side of the histogram window.

The live exposure display will update in specific increments. You can select from 0.5sec (1/2 second) to 60sec (60 seconds) for the screen update increment. We will discuss how in a moment.

During an exposure using the LIVE BULB shutter speed, the camera will update the screen approximately 9 to 24 times (*how many times* is controlled by the ISO sensitivity). You can use the Live BULB function to choose *how often* the screen updates during the long exposure for each of the 9 to 24 times (Display Count).

In other words, if you select 4sec in Live BULB, the camera will update the live exposure display every four seconds up to 24 times during the actual live exposure process. You will see the image gradually appear on the screen.

The number of times (9 to 24) the live exposure display updates is controlled by the ISO sensitivity, as shown in the following Display Count list (figure 6.64C, image 2):

- **ISO LOW:** Approximately 24 times
- **ISO 400:** Approximately 19 times
- **ISO 800:** Approximately 14 times
- **ISO 1600:** Approximately 9 times

Now let's see how to choose a time increment for the Live BULB function.

Setting a Time Increment for the Live BULB Function

Use the Live BULB function to choose how frequently the monitor displays an updated live exposure view when you use the LIVE BULB shutter speed, or whether the camera shows no live exposure updates when you use BULB (with the Live BULB function set to Off).

Figure 6.64C: Choose how often the live exposure view updates for LIVE BULB time exposures

Use the following steps to choose an update increment for LIVE BULB during long exposures:

1. Select Live BULB from the E. Exp/[Meter]/ISO menu and scroll to the right (figure 6.64C, image 1).
2. Choose one of the values from the up/down menu, ranging from 0.5sec to 60sec (figure 6.64C, image 2). The factory default setting is Off for BULB mode (no live exposure updates). If you want to watch the LIVE BULB mode update the screen with a live exposure, you must select how often you want it to update (e.g., 4sec) from the up/down menu. The approximate Display Count (9 times to 24 times) is shown below the up/down menu in image 2.
3. Press the OK button to Set the value.

Note: During the long exposure, if you have chosen to see the live exposure update—with Live BULB set to anything other than Off—you will see the exposure forming on the screen. If you decide the exposure is correct for your subject, either by viewing it directly or by watching the Live histogram display on the screen, you can release the Shutter button and stop the exposure at that moment.

If you have the Noise Reduct. function enabled, the camera will do a noise reduction cycle equal in time to the original exposure. It will generally double the exposure time while using black-frame subtraction to reduce noise.

Settings Recommendation: I want my camera to show a live exposure update, so I set Live BULB to something like 4sec, or maybe more for a very long exposure. The screen will be updated a maximum of 24 times, so you will need to do some math to calculate an update increment that matches the length of the planned exposure and the number of times the screen is updated.

I try to set the exposure frequency so the screen will update throughout the exposure. For instance, if I am doing a 1min exposure with the LIVE BULB shutter speed setting, at a lower ISO (24 steps) I set the Live BULB function to 2sec so the camera will update each of the 24 steps every 2 seconds. That means I will see updates on my monitor every 2 seconds until the 24 update steps have completed.

There is a nearly identical function called Live TIME (next subsection) that lets you control the updates of the screen when you use the LIVE TIME shutter speed.

Live TIME

When you rotate the Rear Dial while using Manual (M) mode on the Mode Dial, you will find that LIVE TIME is one of the slowest shutter speed settings.

Note: To avoid confusion, please notice that the function we will discuss in this section is called Live TIME. It controls the shutter speed setting named LIVE TIME. Notice the uppercase and lowercase differences so you will not get Live TIME (the Custom Menu function) and LIVE TIME (the shutter speed setting) confused as we discuss them.

When you use the LIVE TIME shutter speed setting, the camera opens the shutter (starts the exposure) when you press the Shutter button all the way down. You do not need to hold the Shutter button down when you use LIVE TIME, as you do when you use LIVE BULB (or BULB), because the camera makes the exposure for you based on the time limit that was set in the previously discussed BULB/TIME Timer function (*Custom Menu > E. Exp/ [Meter]/ISO > BULB/TIME Timer*).

The exposure ends when the BULB/TIME Timer function's exposure time has expired or when you press the Shutter Release button all the way down once more. You may manually stop the exposure when you think it looks right on the monitor (or on the Live histogram display) by pressing the Shutter button.

As the camera makes an exposure over time and displays the live results of that exposure on your camera's current display screen (viewfinder or monitor), you can see the actual image being formed, as shown in figure 6.65A, images 2–4.

Figure 6.65A: Using the LIVE TIME shutter speed setting

The LIVE TIME shutter speed selection is displayed on the bottom left of the screen (figure 6.65A, image 1). Press the Shutter button to start the exposure, and the camera will start updating the live exposure on the current display screen.

Figure 6.65A, image 2, shows the location of the Display Count so you can watch how many times the live exposure update has occurred (up to 24 times). Image 3 shows the Live histogram that you can use to determine when the exposure is correct.

The live exposure display will update in specific increments. You can select from 0.5sec (1/2 second) to 60sec (60 seconds) for the screen update increment. We will discuss how in a moment. Figure 6.55A, image 4, shows the final exposure.

After you have selected a value besides Off for this Live TIME function, the camera will update the screen during a long exposure from approximately 9 to 24 times (*how many times* is controlled by the ISO sensitivity). You can use this Live TIME function to choose *how often* the screen updates during the long exposure for each of the 9 to 24 times.

In other words, if you select 4sec in Live TIME, the camera will update the live exposure display every 4 seconds up to 24 times maximum during the actual live exposure process. You will see the image gradually appear on the screen.

The number of times (9 to 24) the live exposure display updates is controlled by the ISO sensitivity, as shown in the following Display Count list (figure 6.65B, image 2):

- **ISO LOW:** Approximately 24 times
- **ISO 400:** Approximately 19 times
- **ISO 800:** Approximately 14 times
- **ISO 1600:** Approximately 9 times

Use the Live TIME function to choose how frequently the monitor displays an updated live exposure view when you use the LIVE TIME shutter speed setting, or whether the camera shows no live exposure updates when you use LIVE TIME (with the Live TIME function set to Off).

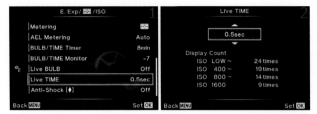

Figure 6.65B: Choose how often the live exposure view updates for LIVE TIME long exposures

Use the following steps to choose an update increment for LIVE TIME during long exposures:

1. Select Live TIME from the E. Exp/[Meter]/ISO menu and scroll to the right (figure 6.65B, image 1).
2. Choose one of the values from the up/down menu, ranging from 0.5sec to 60sec (figure 6.65B, image 2). The factory default setting is 0.5sec (1/2 second live exposure updates). If you want to see up to 24 updates per ISO setting, you must select how often you want an update to display from the up/down menu (not Off). The approximate Display Count (9 times to 24 times) is shown below the up/down menu in figure 6.65B, image 2. During the exposure, you will see the Display Count and a timer on the lower-right side of the screen while a Live histogram appears on the lower-left side of the screen.
3. Press the OK button to Set the value.

Note: During the long exposure, if you have chosen to see the live exposure update—with the Live TIME function set to anything other than Off—you will see the exposure forming on the screen. If you decide the exposure is correct for your subject, either by viewing it directly or by watching the Live histogram display on the screen, you can press the Shutter button again and stop the exposure at that moment.

If you have the Noise Reduct. function enabled, the camera will do a noise reduction cycle equal in time to the original exposure. It will generally double the exposure time while using black-frame subtraction to reduce noise.

Settings Recommendation: I want my camera to show a live exposure update, so I set Live TIME to a value, such as 2sec or 8sec, according to how long of an exposure is set in the BULB/TIME Timer function.

I try to set the exposure frequency so the screen will update all through the exposure. For instance, if I am doing an 8min exposure at a lower ISO (24 steps), I set the Live TIME function to 15sec so the camera will update one of the 24 steps every 15 seconds. That means I will see the updates on my monitor every 15 seconds until the 24 update steps have completed.

Anti-Shock [♦]

The Anti-Shock [♦] function is designed to cut down on sharpness-robbing vibrations that are caused by small camera movements at the time of exposure. The act of pressing the Shutter button causes camera vibrations that can produce image blurring at slow shutter speeds. If you have your camera on a tripod, you can set a delay value before the shutter fires, allowing time for vibrations to die down after you have pressed the Shutter button. You can choose delay values from the Anti-Shock [♦] menu from 1/8 second to 30 seconds.

With firmware version 1.3 (released in March 2014), Olympus added a zero (0) selection ([♦]0sec) to the Anti-Shock [♦] menu, which enables an electronic first-curtain shutter release (instead of a mechanical release). An electronic shutter release may reduce harmonic vibrations that are caused by shutter impact at speeds less than 1/320 second. If you shoot lots of images at slow shutter speeds, the Anti-Shock [♦] setting may produce sharper pictures.

Let's examine how to choose a delay value or the [♦]0sec Anti-Shock [♦] setting.

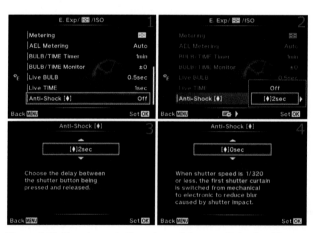

Figure 6.66: Choosing a shutter-release delay or anti-shock setting

Use the following steps to choose an Anti-Shock [♦] setting, which includes time delay and harmonic vibration reduction using an electronic first curtain shutter release, for slow shutter speeds:

1. Select Anti-Shock [♦] from the E. Exp/[Meter]/ISO menu and scroll to the right (figure 6.66, image 1).
2. Choose Off or [♦]2sec (2 seconds) from the small menu that appears (figure 6.66, image 2). At this point you can press the OK button to Set the value and skip the rest of these steps. If you need less or more than a 2 second ([♦]2sec) shutter delay, or if you want to choose the [♦]0sec anti-harmonic vibration value, scroll to the right.

3. An up/down menu will appear with a full range of available settings (figure 6.66, image 3). Use the Arrow pad to scroll up or down, and select the Anti-Shock [♦] value you prefer to use. You can choose delay values ranging from [♦]1/8sec to [♦]30sec, or you can choose the electronic first-curtain shutter release [♦]0sec selection, to reduce harmonic vibrations at certain shutter speeds below 1/320 second (figure 6.66, image 4).
4. Press the OK button to Set your chosen value.

Settings Recommendation: If I am shooting macro shots or handheld shots with slow shutter speeds that are especially prone to being degraded by camera vibrations, I often use the electronic first-curtain shutter release [♦]0sec selection.

When I am shooting on a tripod I use an electronic cable release, such as the Olympus RM-UC1 Remote Cable Release, to prevent camera vibrations from damaging my shot. I also like to use the [♦]2sec setting to allow camera vibrations to die down before I release the shutter. Although a mirrorless camera is not as susceptible to vibrations as a DSLR, it is still wise to use a tripod and hands-off shutter release to make the sharpest possible pictures.

Composite Settings (Live Composite)

The Live Composite function allows you to create composite images of subjects like a fireworks display (figure 6.66A). You can set up many multiple exposures on one frame, with each exposure acting independently.

Figure 6.66A: Sample composite fireworks image

The camera will automatically create a composite image as you watch the exposure timer count down. You can recompose the frame between exposures so you can capture multiple bright subjects with dark backgrounds. Figure 6.66A is 10 separate exposures that I composited.

There are two ways to configure the composite settings. You can use the Custom Menu first to configure the exposure time and then enter the Live Composite system, or you can enter the Live Composite system first then set the exposure time just before you shoot the frames you want to composite. Let's consider both.

Setting the Composite Settings before Entering Live Composite

You can configure the exposure time for each frame before you enter the Live Composite system so your camera will be ready ahead of time. Here is how to preconfigure the composite exposure value (applies to each frame).

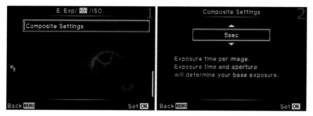

Figure 6.66B: Configuring an exposure value before entering Live Composite mode

Use the following steps to preconfigure an exposure value that will be applied to each frame of the composite image:

1. Select Composite Settings from the E. Exp/[Meter]/ISO menu and scroll to the right (figure 6.66B, image 1).
2. Choose an Exposure time per image from the Composite Settings up/down menu (figure 6.66B, image 2). Your choices in the up/down menu range from 1/2 second (1/2sec) to 60 seconds (60sec). Choose the time you want to use for each exposure in the composite series.
3. Press the OK button to Set your chosen value.

The camera is now ready to enter the Live Composite system and make your composite images.

Next, let's consider how to set the Exposure time per image when you are already in the Live Composite system.

Setting the Composite Settings after Entering Live Composite

Open the Live Composite system by selecting the LIVECOMP shutter speed setting, which is at the slow end of the shutter speed selections, along with BULB and LIVE TIME.

Let's see how to use the Live Composite system to create an image like the one shown in figure 6.66A.

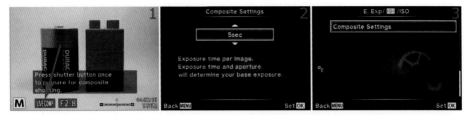

Figure 6.66C: Selecting an exposure time while in Live Composite mode

Use these steps to set the Composite Settings after you activate the Live Composite system:

1. Set the camera to Manual (M) mode on the Mode Dial.
2. Using the Rear Dial, select LIVECOMP from the shutter speed settings. The LIVECOMP choice is the slowest available shutter speed; it is the last setting past BULB and LIVE TIME (figure 6.66C, image 1, red arrow).
3. Press the Menu button to directly enter the Composite Settings screen (figure 6.66C, image 2). Choose an Exposure time per image to be applied equally to each frame in the composite image. Your choices in the up/down menu range from 1/2 second (1/2sec) to 60 seconds (60sec).
4. Press the OK button to select the exposure time, and the camera will switch to the screen in figure 6.66C, image 3. Nothing needs to be done on this screen, so press the Shutter button slightly to return to the first screen in the series (figure 6.66C, image 1). The time value is selected and ready to use. The next few steps will take the pictures to be composited.

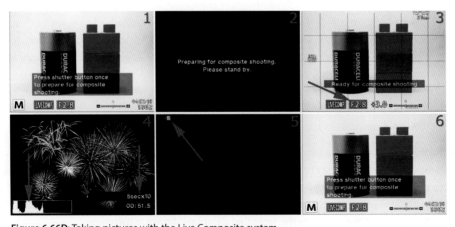

Figure 6.66D: Taking pictures with the Live Composite system

5. The Live Composite screen (figure 6.66D, image 1) will display this message: *Press shutter button once to prepare for composite shooting.*

6. Press the Shutter button all the way down once, and the camera will prepare to take the composite series. A dark screen will open for a few seconds that says, *Preparing for composite shooting. Please stand by* (figure 6.66D, image 2).

7. The next screen says, *Ready for composite shooting*. It will use the settings and exposure value you selected. Before proceeding, use the Front Dial to set the aperture (figure 6.66D, image 3, red arrow). Then focus the camera on the subject or on the area where the subject will appear. It may be a good idea to use manual focus for subjects that will appear later in the series, such as a fireworks show. After you have focused the camera, press the Shutter button completely down one time to start the exposures.

8. The camera will start taking a series of timed pictures until one of the following occurs: you stop Live Composite by pressing the Shutter button fully; three hours have passed; or the battery dies. Three hours is the maximum run time for the Live Composite system before it automatically shuts down. At the left red arrow in figure 6.66D, image 4, you can see that the camera is building a live histogram as it takes the exposures. You can watch this histogram to prevent overexposure as additional images are taken over time. At the right red arrow in image 4, you can see the camera counting down the exposures and time. The image shows 5secx10, which means each exposure is 5 seconds long (5sec), and 10 exposures have been made so far (x10). Just beneath the exposure count is a timer that displays the actual time of the Live Composite session. The time is counted in 1/2 second increments up to three hours. During the series of exposures you can move the camera to position a bright subject somewhere else in the frame, such as in figure 6.66A.

9. Stop the Live Composite session by completely pressing the Shutter button once. The camera monitor will go black except for the orange memory card access symbol in the upper-left corner, which will blink as the camera finishes combining the images (figure 6.66D, image 5). Finally, the camera will display the finished composite picture, according to the value you chose in *Setup Menu > Rec View* (default 1/2 second), then the camera will switch back to the main Live Composite screen so you can prepare for another session (figure 6.66D, image 6).

10. If you would like to shoot another Live Composite series, simply repeat steps 3 through 9. If you are done shooting in Live Composite, select a different shutter speed to exit the Live Composite system.

Note: The camera will automatically adjust the brightness of the monitor during a Live Composite session. It may be best to use an HLD-7 battery pack so you will have two batteries available for long exposures if you shoot in Live Composite for hours at a time. Finally, if you want to see the number of composited shots in the final image, you can find it later in your computer with the included Olympus Viewer 3 software.

Custom Menu F. [Flash] Custom

The F. [Flash] Custom menu is primarily composed of functions that directly affect how the flash system works. First we will take a look at the opening menu screen for the F. [Flash] Custom functions (figure 6.67).

To enter the menu, select F. [Flash] Custom from the Custom Menu and scroll to the right. There are three functions in the F. [Flash] Custom menu. Let's consider each of them in detail.

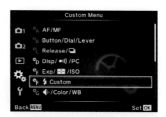

Figure 6.67: The opening menu selection for the F. [Flash] Custom functions

[Flash] X-Sync

The [Flash] X-Sync function (X-Sync) sets a maximum shutter speed for shooting with an electronic flash unit that is mounted in the Hot shoe and turned on.

The X-Sync speed is necessary because the shutter blades in front of the sensor have to be out of the way before the flash can fire. If a shutter blade partially blocks the sensor, a dark shadow or band will appear in the image.

The X-Sync name comes from the old days when lenses had an actual X on them. You had to select the setting with a lever when you used flash. The old mechanical clockwork shutters had an electrical contact that closed the circuit and fired the flash when the shutter blades were completely out of the way. On the EM-1, X-Sync is controlled by an electronic timing circuit instead of a mechanical contact.

The E-M1 allows a faster X-Sync shutter speed than many cameras. You can select an X-Sync speed from 1/60 second to 1/320 second. The 1/320 X-Sync value may be obtained only with the small FL-LM2 flash attachment that came with your E-M1. Other flash units, such as the Olympus FL-600R, cause the camera to drop back to 1/250 second as an X-Sync maximum. The user's manual (page 110) says the X-Sync maximum is "1/320 sec when using the supplied external flash FL-LM2, and 1/125 sec when using a commercially available specialty flash." Depending on which flash unit you are using, the maximum X-Sync value will vary between 1/125 second and 1/320 second.

The [Flash] X-Sync function controls the upper limit or *maximum* shutter speed you can use with flash (without banding). The next subsection will consider the [Flash] Slow Limit, which controls the slowest or *minimum* shutter speed you can use with flash in certain exposure modes. You can use the two functions—[Flash] X-Sync and [Flash] Slow Limit—to control the upper and lower limits of the shutter speed when you use flash to get a mixture of flash light and ambient light. We will discuss how to blend the two types of light in the next subsection, **[Flash] Slow Limit**.

The camera will use the maximum X-Sync value only when you are shooting in a very bright environment in direct flash (Fill In) mode to prevent the ambient light from overly influencing the exposure. Most of the time, in low ambient light, the camera will

automatically select a somewhat slower shutter speed, such as 1/60 second, unless you have [Flash] Slow Limit (next subsection) set so it cannot use a speed that low.

Let's examine how to select an X-Sync value that matches your needs.

Figure 6.68: Selecting an X-Sync value

Use the following steps to choose a maximum shutter speed to use with flash:

1. Select [Flash] X-Sync from the F. [Flash] Custom menu and scroll to the right (figure 6.68, image 1).
2. Use the up or down key of the Arrow pad to choose one of the eight brightness levels, which range from 1/60 to 1/320 (figure 6.68, image 2). The factory default setting is 1/320 second.
3. Press the OK button to Set the value.

Settings Recommendation: I normally use 1/320 second for the X-Sync value when I am depending on the flash unit for lighting a subject. However, when I am trying to synchronize flash with evening light outdoors, I may use a combination of the [Flash] X-Sync speed and [Flash] Slow Limit to allow ambient light to influence the exposure for a more balanced look. The camera has a nice range of shutter speeds for slow flash use.

[Flash] Slow Limit

The [Flash] Slow Limit function allows you to control the lower shutter speed limit when you use flash photography (slow flash). You may need this function when you want ambient light *combined with* light from a flash unit to illuminate the exposure. You may want ambient light to be the primary source of exposure and have the flash provide a little fill light. Or you may want the flash to provide the main illumination, with ambient light opening up the shadows in the background. You may even be using more than one flash in a wireless group of units that work with ambient light.

[Flash] Slow Limit works in partnership with the [Flash] X-Sync function (previous subsection) by allowing you to set the lower limit of the shutter speed when you shoot with flash; the shutter speed can be as slow as 30 seconds. The [Flash] X-Sync function controls the upper shutter speed limit, which cannot exceed 1/320 second and can be set as slow as 1/60 second.

When you have the camera set to Program (P) or Aperture-priority (A) mode on the Mode Dial, the camera controls the shutter speed and you control the aperture. Therefore,

the lower shutter speed limit provided by the [Flash] Slow Limit function is important when you are using flash in P and A modes.

If you are using Shutter-priority (S) or Manual (M) mode on the Mode Dial, the [Flash] Slow Limit function has no effect because you can set the lower shutter speed to be as long (slow) as you would like.

Therefore, if you want to balance the illumination from the flash and the ambient light, you can either do it manually in S or M mode, or you can use P or A mode and depend on the [Flash] Slow Limit function to provide the minimum flash shutter speed.

To effectively balance the ambient light with the flash requires experimentation and experience and is beyond the scope of this book. You know that the camera cannot exceed 1/320 second for a maximum shutter speed ([Flash] X-Sync), and now you also know that the camera will allow you to set a minimum shutter speed ([Flash] Slow Limit). Therefore, you can use mostly ambient light by lengthening the shutter speed with a slower setting under [Flash] Slow Limit to let in more ambient light while the flash provides a burst of light for filling in some shadows.

Or you can use a shutter speed in [Flash] Slow Limit that is somewhat closer to the shutter speed in [Flash] X-Sync so the flash will provide the main light source while ambient light provides some background fill.

You will need to experiment with these two settings to find the appropriate balance for what you are trying to accomplish. Be sure to use a tripod if you use shutter speeds in [Flash] Slow Limit that are slow enough to allow camera shake or subject movement, which will appear in the image. Otherwise ghosting will be apparent in the image where the flash-lit portion of the subject is sharp and the ambient-lit portion of the subject is blurred.

Let's examine how to set the [Flash] Slow Limit function for various shutter speeds.

Figure 6.69: Setting a minimum shutter speed for flash photography

Use the following steps to choose a minimum shutter speed to use with flash:

1. Select [Flash] Slow Limit from the F. [Flash] Custom menu and scroll to the right (figure 6.69, image 1).
2. Use the up or down key of the Arrow pad to choose a minimum flash shutter speed, ranging from 30 seconds to 1/320 second (figure 6.69, image 2). The factory default setting is 1/60 second.
3. Press the OK button to Set the value.

Note: On page 110 of the user's manual, under Flash timing-synchronous, the text seems to say that the camera obeys a photography rule called reciprocal of focal length. This rule states that you should not make an exposure with, let's say, a 200mm lens at a shutter speed of less than 1/200 second because anything slower may cause camera shake. I have tested the EM-1 extensively to see how it obeys this rule when I have [Flash] Slow Limit set to a much slower minimum shutter speed for flash. I found that the camera attempts to obey this rule by trying to keep the shutter speed higher than the reciprocal of the focal length (100mm = 1/100 second shutter speed); however, if there is not enough light to obey this rule, the camera will abandon the rule and drop the shutter speed well below the reciprocal of the focal length. Therefore, be careful when you shoot with the [Flash] Slow Limit function set to a slow shutter speed, regardless of the focal length of the lens. You must use a tripod if the shutter speed is too slow.

Settings Recommendation: I raise the minimum flash shutter speed to 1/100 or 1/125 second when I am shooting with flash indoors. I find that often 1/60 second (the default) is too slow and may allow some ghosting to occur, especially at weddings where I am shooting people walking down the aisle when fairly bright ambient light influences the exposure. If the shutter is open for 1/60 second, the flash will make a nice sharp picture for a short segment of the exposure duration, and ambient light continues to illuminate the subject for the remainder of the exposure duration, resulting in a ghosted blur.

On the other hand, when I am shooting in bright ambient light outside, I may allow the shutter speed to remain slower and take advantage of some ambient light with flash fill. I use a smaller aperture to keep from overexposing the subject.

This type of thing is always an experiment and has to be balanced. You can take advantage of your camera's powerful tools to get the results you want.

[Flash Compensation] + [Exposure Compensation]

This function allows you to combine exposure compensation and flash compensation, and you can control both at the same time with the Front Dial.

Normally, with this function set to Off, when you want to do exposure compensation for your image you simply turn the Front Dial (in P, A, and S modes) and dial in exposure compensation from –5.0 EV to +5.0 EV.

However, when you have a flash unit mounted on your camera, its output is not increased or decreased based on the exposure compensation. Instead, the camera simply opens or closes the aperture, or raises or lowers the shutter speed, to provide more or less exposure. The flash provides a constant output.

Sometimes increasing or decreasing the entire exposure is not sufficient. Maybe you would like to increase or decrease the power of the flash output to perform what Olympus calls "flash intensity control." By setting this function to On, whenever you turn the Front Dial to increase or decrease the camera exposure compensation, the compensation request also affects the flash unit. For example, if you raise the exposure compensation by

1.0 EV, the flash will also raise its power output by 1.0 EV. If you use negative exposure compensation to underexpose the image by 0.3 EV, the flash will also lower its power output by 0.3 EV.

This gives you the ability to control the *intensity* of the flash output very quickly, without having to use the flash unit's compensation controls. It allows you to raise or lower the brightness of the subject visually in case the flash is too strong or too weak.

Basically, Olympus gives you flash intensity control without having to use the camera menus or external flash unit menus. It is a quick way to control the intensity of the flash with the Front Dial when you need more or less light from the flash unit, and you'll still have time to make other adjustments.

Let's examine how to enable or disable [Flash Compensation] + [Exposure Compensation].

Figure 6.70: Combining flash compensation with exposure compensation

Use the following steps to connect or disconnect flash compensation with exposure compensation by using the Front Dial:

1. Select the dual symbols representing [Flash Compensation] + [Exposure Compensation] from the F. [Flash] Custom menu and scroll to the right (figure 6.70, image 1).
2. Choose On to combine flash and exposure compensation, or choose Off to disconnect the two (figure 6.70, image 2). The factory default setting is Off. This function takes effect only when a flash unit is mounted in the Hot shoe.
3. Press the OK button to Set the value.

Settings Recommendation: I leave this function set to On because I love the way it lets me control the intensity of the flash when I turn the Front Dial on my camera in P, A, and S modes on the Mode Dial. Since it has no effect when a flash unit is not mounted, it is safe to leave it on all the time.

If you are an accomplished strobist who wants to completely separate the two forms of compensation to vary the exposures for the background and the subject, you may want to leave flash and exposure compensation separated and use the camera's and flash unit's manual exposure compensation controls.

For most people the power of this function is very useful.

Custom Menu G. [Record Mode]/Color/WB

The G. [Record Mode]/Color/WB menu is primarily composed of functions that control JPEG image quality, image size, and color balance.

These functions do not affect a RAW file, other than providing initial settings when you view them on your computer, because each setting can be changed after the fact.

Think of these options as in-camera RAW to JPEG conversion functions (in-camera post-processing) that you would otherwise have to do on your computer after you shoot a RAW file and convert it to JPEG manually.

We will start examining the functions by taking a look at the opening menu screen for the G. [Record Mode]/Color/WB functions in figure 6.71.

To enter the menu, select G. [Record Mode]/Color/WB from the Custom Menu and scroll to the right. There are eight functions inside the G. [Record Mode]/Color/WB menu. Let's consider each of them in detail.

Figure 6.71: The opening menu selection for the G. [Record Mode]/Color/WB functions

[Record Mode] Set

Your E-M1 can create three JPEG image sizes: Large (L), Middle (M), and Small (S). All three sizes can use four levels of compression (quality) to reduce the file sizes: Super Fine (SF), Fine (F), Normal (N), and Basic (B). Each of these quality types have different lossy compression ratios, with Super Fine having the least amount of compression and Basic having the most (table 6.10).

You can combine JPEG types in the [Record Mode] Set function and they will appear on the [Record Mode] menus of the camera, where you select an image format (i.e., JPEG, RAW, JPEG+RAW).

Table 6.10 shows the available JPEG sizes and qualities, compression ratios, and Pixel Counts. The Pixel Count for the Middle and Fine JPEG sizes is controlled by the Pixel Count function (next subsection):

JPEG Type (size and quality)	Compression ratio	4:3 Pixel Count
Large Super Fine (LSF)	1/2.7	4608×3456
Large Fine (LF)	1/4	4608×3456
Large Normal (LN)	1/8	4608×3456
Large Basic (LB)	1/12	4608×3456
Middle Super Fine (MSF)	1/2.7	2560×1920
Middle Fine (MF)	1/4	2560×1920
Middle Normal (MN)	1/8	2560×1920
Middle Basic (MB)	1/12	2560×1920

JPEG Type (size and quality)	Compression ratio	4:3 Pixel Count
Small Super Fine (SSF)	1/2.7	1280×960
Small Fine (SF)	1/4	1280×960
Small Normal (SN)	1/8	1280×960
Small Basic (SB)	1/12	1280×960

Table 6.10: JPEG size and quality, compression ratio, and 4:3 Pixel Count

The lower the compression ratio, the higher the image quality and the larger its physical storage size on your computer hard drive. You can add any of these JPEG size and quality settings to the 1, 2, 3, and 4 positions of the screen shown in figure 6.72, image 2. Let's see how.

Figure 6.72: Using [Record Mode] Set to choose JPEG type choices for camera menus

Use the following steps to set various JPEG types in four available selection positions:

1. Select [Record Mode] Set from the G. [Record Mode]/Color/WB menu and scroll to the right (figure 6.72, image 1).
2. In figure 6.72, image 2, you will see four available JPEG type selection boxes, numbered 1, 2, 3, and 4. The factory default is LF, LN, MN, and SN. Using table 6.10 as a reference, choose any of the characters from the values in parentheses under the JPEG Type column and set them in these four positions. Whatever you put in the four positions will appear on any camera menus that allow you to select an image format type (JPEG, RAW, and JPEG+RAW).
3. Press the OK button to Set the value.

Settings Recommendation: I have no need for the smaller sizes, so I use LSF, LF, MF, and SF in my [Record Mode] Set function. I prefer to shoot in either RAW or JPEG Large Super Fine (LSF) most of the time.

However, if you need to put a lot of images on a small memory card, or if you are shooting images for use on a website, you could use any of the other size and quality settings. Anything you choose in [Record Mode] Set will appear on the Record Mode menus (image format selection screens).

Pixel Count

The normal Pixel Count for a Micro Four Thirds (4:3) image on the E-M1 is 4608×3456. This is considered the Large Pixel Count size. The Pixel Count directly affects the megapixel size of the image. Simply multiply the Pixel Count to find the total megapixels. For instance, the large 4:3 Pixel Count results in an approximate size of 16 MP (4,608×3,456 = 15,925,248, or 15.9 million pixels).

The image does not use the full Pixel Count of the camera sensor because some pixels around the edges are used for color control. However, camera companies usually advertise the camera's megapixel rating based on the actual size of the sensor. That is the difference between the *actual* and *effective* Pixel Count; the effective count is what you actually get for a usable picture, and the actual count is the full sensor Pixel Count. Usually there is a megapixel or two difference between the actual pixel count (which is usually not provided by camera manufacturers) and the effective pixel count (the 4608×3456 image size).

Note: There are other Image Aspects (aspect ratios) and Large Pixel Counts available, such as 3:2, 1:1, and 16:9. When you select one of the alternate Image Aspect ratios, the Pixel Count for their Middle and Small sizes will vary a bit from those listed under figures 6.73A and 6.73B, which is for the 4:3 Image Aspect. The additional image sizes are controlled by the Image Aspect function in Shooting Menu 1 (*Shooting Menu 1 > Image Aspect*). Selecting one of the other aspect ratios will change the Pixel Count for Large, Middle, and Small JPEG images. None of the Large size Pixel Counts are variable, but the Middle and Small Pixel Counts are. The Medium and Small Pixel Count can change depending on your selections in this function.

Let's examine how to choose a different Pixel Count for when you need to shoot a Middle or Small image, such as for a website. First we will examine how to select one of the four available Middle Pixel Counts.

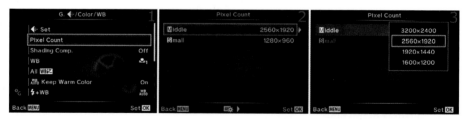

Figure 6.73A: Choosing a Middle Pixel Count size

Use the following steps to choose a Middle Pixel Count size:

1. Select Pixel Count from the G. [Record Mode]/Color/WB menu and scroll to the right (figure 6.73A, image 1).
2. Choose Middle from the Pixel Count menu and scroll to the right (figure 6.73A, image 2).

3. The factory default Middle Pixel Count is 2560×1920 (figure 6.73A, image 3). However, you can choose from three additional Pixel Counts: 3200×2400, 1920×1440, and 1600×1200.
4. Press the OK button to Set the new Middle Pixel Count value.

Next let's examine how to select one of the three available Small Pixel Counts.

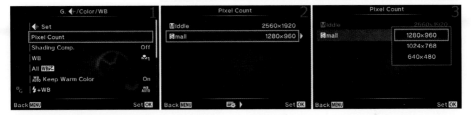

Figure 6.73B: Selecting the Small Pixel Count size

Use the following steps to choose a Small Pixel Count size:

1. Select Pixel Count from the G. [Record Mode]/Color/WB menu and scroll to the right (figure 6.73B, image 1).
2. Choose Small from the Pixel Count menu and scroll to the right (figure 6.73B, image 2).
3. The factory default Small Pixel Count is 1280×960 (figure 6.73B, image 3). However, you can choose from two additional Pixel Counts: 1024×768 and 640×480.
4. Press the OK button to Set the new Small Pixel Count value.

Settings Recommendation: Since I rarely stray from Large Pixel Count because I want to use every available pixel for maximum image size, I don't often select Middle or Small Pixel Count sizes.

However, some sizes exactly fit, or are very close to, HDTV, computer monitor, tablet, and smartphone sizes. If you shoot specifically for these devices, other Pixel Count sizes may come in handy.

Shading Comp.

With many lenses there can be some light falloff at the edges of the frame. Certain wide-angle lenses have this issue. In fact, most lenses have a little light falloff in the peripheral areas—that's just the laws of physics at work. Normally you can correct this problem during post-processing on a computer, especially for RAW files.

However, you may not have the time or inclination to post-process images, so the camera offers a solution. If you have lenses that are especially prone to light falloff, you can enable Shading Comp. and let the camera correct the peripheral dimness for you.

Let's examine how to enable Shading Comp.

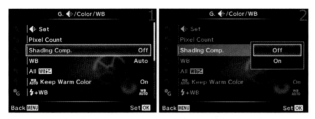

Figure 6.74: Changing the Shading Comp. setting

Use the following steps to enable or disable the Shading Comp. function:

1. Select Shading Comp. from the G. [Record Mode]/Color/WB menu and scroll to the right (figure 6.74, image 1).
2. Choose Off or On from the Shading Comp. menu and scroll to the right (figure 6.74, image 2). If you choose On, the camera will correct for light falloff automatically, according to the type of lens you are using.
3. Press the OK button to Set the value.

Note: Brightening the edges of the image can lead to a little additional noise in those areas. Shading Comp. does not work for teleconverters and extension tubes.

Settings Recommendation: I have found that many Micro Four Thirds lenses are already corrected for light falloff problems, and I usually make any needed corrections when I post-process my RAW images in Photoshop. Therefore, I don't often use this function.

However, this is a useful function, especially for JPEG shooters. Try it for any lenses that may have light falloff issues and see if it helps.

WB

Normally white balance (WB) is used to adjust the camera so that whites are truly white and other colors are accurate under any given light source. You can also use the WB controls to deliberately introduce color casts into your image for interesting special effects.

Camera WB color temperatures are backwards from the Kelvin scale we learned in school for star temperatures. Remember that a red giant star is cool, and a blue-white star is hot. The WB color temperatures are backwards because the WB system adds color to make up for a deficit of color.

For instance, fluorescent light lacks blue, which makes the subject appear greenish yellow. When blue is added, the image is balanced to a more normal appearance.

Another example is when you shoot on a cloudy, overcast day. The cool ambient light could cause the image to look bluish. The Auto WB control in your camera sees the cool color temperature and adds some red to warm up the colors a bit. The normal WB on a cloudy, overcast day might be about 6000K.

Remember that we use the Kelvin temperature range in reverse and that red colors are warm and blue colors are cool. Even though this is backwards from what we were taught

in school, it fits our situation better. To photographers, blue seems cool and red seems warm! Just don't let your astronomer friends convince you otherwise.

> ### White Balance Fundamentals
>
> Understanding WB in a fundamental way is simply realizing that light has a range of colors that go from cool to warm. We can adjust our cameras to use the available light in an accurate and neutral, balanced way that compensates for the actual light source. Or we can allow a color cast to enter the image by unbalancing the settings. In this chapter we will discuss this from the standpoint of the E-M1 controls and how they deal with WB.

Using the WB Function

The E-M1 WB range varies from a very cool 2000K to a very warm 14,000K. What does that mean?

Figure 6.75A shows the same picture adjusted in Photoshop, with the use of photo filters, to three WB Kelvin (K) settings. Notice how the image in the center is about right, the image on the left is cooler (bluish cast), and the image on the right is warmer (reddish cast).

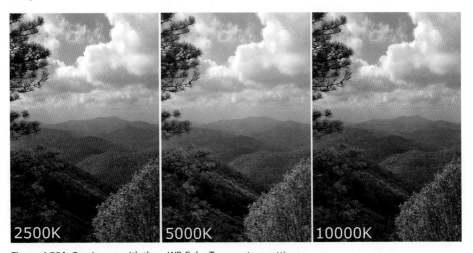

Figure 6.75A: One image with three WB Color Temperature settings

The same adjustments we made in the good old days with film and filters can now be achieved with the WB settings built in to the E-M1. To achieve the same effect as daylight film and a warming filter, simply select the Cloudy WB setting while shooting in normal daylight. This sets the E-M1 to balance at about 6000K, which makes nice warm-looking images. If you want to really warm up the image, choose the WB called Shade, which sets the camera to 7500K.

On the other hand, if you want to make the image appear cool or bluish, try using the Fluorescent (4000K) or Incandescent (3000K) settings in normal daylight.

Remember, the color temperature shifts from cool values to warm values. The E-M1 can record your images with any color temperature from 2000K (very cool or bluish) to 14,000K (very warm or reddish) and any major value in between. There is no need to carry different film emulsions or filters to deal with the range of color in light. The E-M1 has easy-to-use color temperature controls.

Normally you will set the WB from the Live Control screen by pressing the OK button while in Live View. However, you can also use this WB function to set the WB and even fine-tune it (add a color bias).

Here is a list of the 13 WB types you will find on the WB selection screen. Note that six of the WB symbols are followed by a number, such as 5300K. This is the color temperature value for that particular WB setting. We will also discuss how to do an ambient WB reading.

- **Auto:** Camera automatically chooses the best WB setting
- **[Sunlight] 5300K:** Direct sunlight pictures
- **[Shade] 7500K:** Shooting in the shade
- **[Cloudy] 6000K:** Taking pictures on an overcast day
- **[Incandescent] 3000K:** Shooting under an old-fashioned light bulb
- **[Fluorescent] 4000K:** Making pictures under fluorescent light
- **[Underwater]:** Taking pictures with your E-M1 while underwater (in a waterproof underwater housing)
- **[Flash] 5500K:** Making images with an electronic flash unit providing the main light source
- **[One-Touch Capture WB] 1:** Set and store WB with ambient light reading of a white or gray card (must use the Live Control screen to do the reading)
- **[One-Touch Capture WB] 2:** Set and store WB with ambient light reading of a white or gray card (must use the Live Control screen to do the reading)
- **[One-Touch Capture WB] 3:** Set and store WB with ambient light reading of a white or gray card (must use the Live Control screen to do the reading)
- **[One-Touch Capture WB] 4:** Set and store WB with ambient light reading of a white or gray card (must use the Live Control screen to do the reading)
- **CWB (Custom White Balance):** Choose a WB color temperature manually, from a range of 2000K to 14,000K

First, let's consider how to do a One-touch Capture WB reading.

One-Touch Capture WB Reading

For the most accurate WB, it is best to do an ambient light reading from a white or gray card under the same light source as your subject. This will adjust the camera to use the correct WB while you are under that light source. Be sure to set the WB back to Auto or do a new ambient light reading if the light source changes.

In the E-M1 user's manual, Olympus calls an ambient light WB reading both One-touch WB and Capture WB. Therefore, I am combining the two and calling it a One-Touch Capture WB reading or simply a Capture WB reading. Your camera has four memory locations to store WB readings. If you shoot a lot under a certain light source, you can store a Capture WB reading in one location and use it again later.

Let's examine how to do a Capture WB reading. Use a white or gray card if you have one; otherwise you can use a blank sheet of white printer paper.

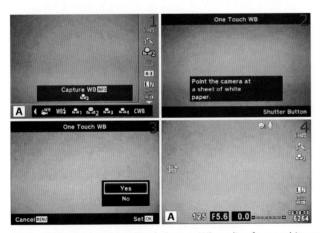

Figure 6.75B: Making a One-Touch Capture WB reading from a white card

Use the following steps to do a One-Touch Capture WB reading from a white or gray card:

1. Press the OK button while in Live View to open the Live Control screen. Find the WB function on the right side by scrolling up or down with the Arrow pad. After you have selected the WB function (figure 6.75B, image 1), scroll to the left or right with the Arrow pad until you highlight one of the Capture WB memory locations. In figure 6.75B, image 1, I selected memory location 2 (looks like a flower with number 2 to the right of it). You have chosen where you are going to store the WB reading and are now ready to take the ambient light reading from the card.

2. Press the Info button to open the One Touch WB screen. You can tell that I am about to take a reading from an incandescent light source because of the warm orange look in figure 6.75B, images 1 and 2. As instructed on the screen in image 2, place the card under the light source you want to measure, then press the Shutter button all the way down as if you are taking a picture of it. The camera will fire the shutter and measure the color temperature of the light source that reflects from the card.

3. A WB reading is ready to be stored in the current Capture WB memory location; however, you must approve it first by scrolling up and selecting Yes from the menu then pressing the OK button (figure 6.75B, image 3). If you do not like the reading, select No to cancel and repeat steps 1 and 2. If you approve of the WB reading it will be stored in the memory location for immediate use and later recall. You can select it on the Live Control screen or within the WB function (this function).

4. After you have approved the WB reading and pressed the OK button, the camera switches to the normal Live Control screen, with the new WB in place. You can tell by looking at the Live View screen in figure 6.75B, image 4, that the camera successfully adjusted the WB under the ambient, incandescent light source so that whites look white and other colors look the same as in real life.

Note: In addition to doing a One-Touch Capture WB reading, you can select any of the 13 available White Balance choices from the Live Control screen (figure 6.75B, image 1). Using the Live Control screen is much faster than scrolling down to the Custom Menu and selecting the WB function to choose a WB setting.

You must use the Live Control screen to do a One-Touch Capture WB reading, but you cannot adjust the amber–blue (A–B) and green–magenta (G–M) color balance of an individual WB setting. You must use the WB function to fine-tune the A–B and G–M color balance for an individual WB setting, but you cannot do a One-Touch Capture WB reading from the WB function.

Even though the 13 Live Control White Balance settings and the 13 Custom Menu White Balance settings are the same WB settings, you must use the Live Control WB to do a One-Touch Capture WB reading and the Custom Menu WB function for WB color adjustment. This is an unusual design, indeed. The only thing they have in common is the ability to select an individual WB setting for camera use and to choose a Custom WB (CWB).

Now let's see how to choose and fine-tune an existing WB setting from the Custom Menu WB function.

Choosing and Fine-Tuning a WB Setting from the Custom Menu

In addition to the Live Control screen we previously considered, you can select any of the 13 White Balance settings from the WB function. You can also adjust the amber–blue (A–B) and green–magenta (G–M) ratios for individual WB settings. Let's see how!

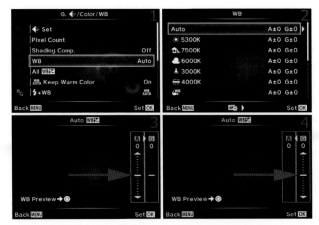

Figure 6.75C: Choose and adjust an individual WB setting

Use the following steps to choose a WB value and modify the color of individual WB settings:

1. Select the WB function from the G. [Record Mode]/Color/WB menu and scroll to the right (figure 6.75C, image 1).

2. Choose one of the individual WB settings, such as Auto, Sunshine (5300K), or Shade (7500K), as seen in figure 6.75C, image 2. I chose the Auto WB setting. Refer to the previous list of 13 WB settings to determine what each WB setting does. If you don't need to adjust the color balance (A–B and G–M) of an individual WB Setting, simply press the OK button to select a WB setting, and skip the next three steps.

3. If you want to fine-tune a certain WB setting you can do so by highlighting it and scrolling to the right. I scrolled to the right on the Auto WB setting, which led me to the screen in figure 6.75C, image 3. I can now fine-tune the color balance of the Auto setting. You can see at the point of the arrow in image 3 that there is an adjustment available. You can slide the yellow bar up toward A (amber) to increase amber for this WB setting, or you can slide it down to reduce amber (add blue). You can see a WB Preview at any time by pressing the Movie button, which causes the camera to take a temporary picture of the subject, with the fine-tuned WB value applied, and display it on the monitor. If you need to fine-tune it some more, simply move the slider again and press the Movie button again to see the results. Do this as many times as you want to fine-tune the WB setting. When you are done, either press the OK button to Set the fine-tuned amber (A–B) ratio and skip the rest of these steps, or scroll to the right to move to the green (G–M) ratio adjustment.

4. After you have fine-tuned the amber (A–B) color balance, you can fine-tune the green (G–M) color balance by scrolling right and selecting the sliding adjustment shown in figure 6.75C, image 4. You can add green to the WB setting by sliding the yellow bar up toward G (green), or you can scroll down to decrease green (add magenta). Press the

Movie button to take a temporary picture (WB Preview), examine the color balance, and make further adjustments if necessary. When you are satisfied with the G adjustment, press the OK button to set the value.

5. Whenever you Set one of the color values in previous steps by pressing the OK button, the camera will return to the WB function on the Custom Menu. You have modified this WB setting for all future pictures until you reset or modify it.

6. Repeat these steps for any other individual WB settings you want to fine-tune.

Choosing a Custom White Balance (CWB)

If you would like to experiment with entering direct Kelvin values into the camera, or if you have specific color temperature needs, you can use the CWB setting under the WB function to choose a custom WB from 2000K to 14,000K. Let's examine how!

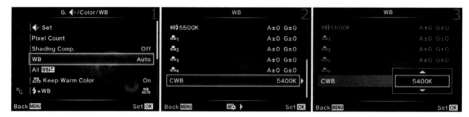

Figure 6.75D: Manually choose a Kelvin WB value from 2000K to 14,000K

Use the following steps to choose a specific custom WB value:

1. Select the WB function from the G. [Record Mode]/Color/WB menu and scroll to the right (figure 6.75D, image 1).

2. Choose the CWB setting (at the end of the list of 13 WB values) and scroll to the right (figure 6.75D, image 2).

3. The CWB setting allows you to experiment with specific values from cool (2000K) to warm (14000K), as shown in figure 6.75D, image 3. If you shoot in a studio and the light does not vary, you can manually find the best WB setting for your product images and portraits. The factory default is 5400K under CWB. Choose the best setting for your style of photography from the up/down menu.

4. Press the OK button to Set the custom WB value. In the future you can choose and use this CWB setting from the WB settings in the Live Control screen or here on the WB function menu.

Settings Recommendation: White balance is an art in itself, especially for JPEG shooters. For RAW shooters this setting does not matter because the WB of a RAW file can be changed after the fact.

You can let the camera choose the best WB by using Auto mode, which is what I often do because I shoot in RAW mode and can change the WB after the fact. As mentioned previously, for a RAW shooter the WB setting is not as critical as it is for a JPEG shooter. RAW

files can be changed to a different WB setting after the picture is taken, but for a JPEG the WB value is a permanent part of the image.

You must use an accurate WB if you shoot JPEGs. Although you can vary the color balance somewhat in a JPEG image, it never is quite right after it has been changed.

You can choose a preset WB value (e.g., Cloudy, Incandescent, Fluorescent), do a One-Touch Capture WB reading from a white or gray card, or enter a custom WB value under CWB. The E-M1 has a full range of WB controls that allow you to use whatever is most convenient.

All WB +/−

In the previous section (**WB**) we discussed fine-tuning the colors of individual White Balance (WB) settings. You could change the amber–blue (A) ratio or the green–magenta (G) ratio for each WB setting individually; CWB cannot be modified.

The All WB +/− function is for people who dislike the color balance of all WB functions. All WB +/− allows you to adjust the amber and green ratios for *all WB settings at the same time* (12 of the 13 WB settings, not including CWB). When you use this function to set the amber–blue (A) ratio, and the green–magenta (G) ratio, it changes the color balance of every WB setting except CWB.

Let's examine how to make a global WB compensation (fine-tuning) adjustment.

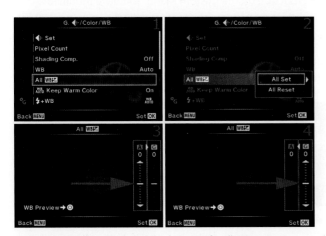

Figure 6.76A: Adjust the A and G color ratios for all WB settings at once (except CWB)

Use the following steps to modify the amber–blue ratio (A), and green–magenta ratio (G), for *all WB settings* at the same time (except CWB):

1. Select the All WB +/− function from the G. [Record Mode]/Color/WB menu and scroll to the right (figure 6.76A, image 1).
2. Choose All Set from the All WB +/− menu and scroll to the right (figure 6.76A, image 2).

3. You can see at the point of the arrow in figure 6.76A, image 3, that there is an adjustment available. You can slide the yellow bar up toward A (amber) to increase the amber color for *all* WB settings, or slide it down to reduce amber (add blue). You can see a WB Preview of the current WB setting that the camera is using by pressing the Movie button, which causes the camera to take a temporary picture of the subject, with the fine-tuned WB value applied, and display it on the monitor. If you need to fine-tune it some more, simply move the slider again and press the Movie button again to see the results. Do this as many times as you want to fine-tune the WB settings. When you are done, you can either press the OK button to Set the fine-tuned (A–B) ratio and skip the rest of these steps, or you can scroll to the right to move into the (G–M) ratio adjustment.

4. After you have fine-tuned the amber (A–B) color balance ratio, you can fine-tune the green (G–M) color balance ratio by scrolling right and selecting the sliding adjustment shown in figure 6.76A, image 4. You can add green to the WB setting by sliding the yellow bar up toward G (green), or you can slide it down to decrease green (add magenta). Press the Movie button to take a temporary picture (WB Preview), examine the color balance, and make further adjustments if necessary. When you are satisfied with the G adjustment, press the OK button to Set the value.

5. When you Set one of the color values in previous steps by pressing the OK button, the camera will return to the WB function on the Custom Menu. You have modified all WB settings, other than CWB, for all future pictures the camera will take using any WB setting, until you reset or modify them with this function.

If you make this comprehensive WB setting modification and later want to change all the WB settings back to their factory default values, you can use the upcoming steps to do so.

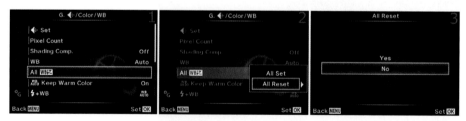

Figure 6.76B: Resetting all modified WB settings

Use the following steps to reset 12 of the 13 WB settings back to factory specs (except CWB):

1. Select the All WB +/− function from the G. [Record Mode]/Color/WB menu and scroll to the right (figure 6.76B, image 1).

2. Choose All Reset from the All WB +/− menu and scroll to the right (figure 6.76B, image 2).

3. Select Yes from the All Reset menu to reset all modified WB settings, or No to cancel (figure 6.76B, image 3).
4. Press the OK button to Set your choice.

Settings Recommendation: I may modify one or two of the WB settings, but never all of them at the same time. However, this function is good for people who modify multiple WB settings and need to return them all to factory specs at the same time. This may also be a good way to reset two or three WB settings you may have modified, instead of going into the menu settings for them one at a time.

WB Auto Keep Warm Color

When you take pictures under incandescent light sources or warm light sources (reddish lighting), the camera will either allow the image to be a little warmer than normal (keep warm color), or it will not.

Many people love the look of warm colors. The human eye seems to be attracted to reddish colors more than bluish colors. Therefore, many people leave this setting On, which keeps the warm colors when the light source is warm. Selecting Off will cause the camera to balance the light toward neutral. The effect is noticeable.

Let's see how to choose one of the WB Auto Keep Warm Color settings.

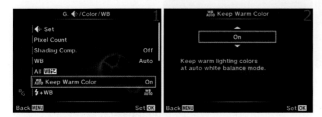

Figure 6.77: Choosing a color warmth setting

Use the following steps to choose color warmth over color neutrality when you shoot under warm light sources, such as incandescent:

- Select the WB Auto Keep Warm Color function from the G. [Record Mode]/Color/WB menu and scroll to the right (figure 6.77, image 1).
- Choose On from the WB Auto Keep Warm Color up/down menu to keep the warm colors, or choose Off to eliminate the warm colors (figure 6.77, image 2).
- Press the OK button to Set your choice.

Settings Recommendation: After testing this function under various light sources, I noticed that warm light sources have a marked effect when this function is set to On. I like warmer colors, but at times the effect seems a little strong to me, especially when I am shooting JPEGs and cannot adjust them later.

I suggest testing this function under various warm light sources to see if the image looks too warm. You may love the warmer images. More neutral images will be best for people who shoot JPEGs, where color accuracy is a must.

If you shoot in RAW mode, it makes no real difference because you can simply change the WB after the fact.

[Flash] + WB

This function allows you to choose various white balance (WB) types when you use electronic flash extensively. There are three settings for [Flash] + WB:

- **Off:** The camera will use the current WB setting (e.g., Sunshine, Cloudy, Incandescent) without regard for the color temperature of the flash unit.
- **WB Auto:** The camera will attempt to balance itself to whatever light source is illuminating the subject.
- **WB [Flash]:** The camera will use the Flash WB setting, which is about 5500K.

Let's examine how to choose a [Flash] + WB value when you use flash to light the subject.

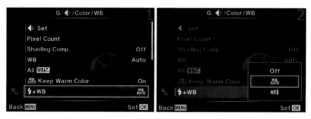

Figure 6.78: White balance choices for flash

Use the following steps to choose an appropriate WB setting for flash:

1. Select the [Flash] + WB function from the G. [Record Mode]/Color/WB menu and scroll to the right (figure 6.78, image 1).
2. Choose one of the settings from the [Flash] + WB menu (refer to the previous list of choices) (figure 6.78, image 2).
3. Press the OK button to Set your choice.

Settings Recommendation: If you are shooting in JPEG mode, the WB needs to be exactly right. Be careful to select the WB Flash setting from the Live Control screen (press OK in Live View) or the WB [Flash] setting on this function's menu.

Alternatively, you can let the camera decide which WB is best by selecting WB Auto. It may not be the best idea to have a WB setting such as Cloudy or Fluorescent selected while shooting with flash because the color may be off.

For RAW shooters, this setting does not matter since the WB of a RAW file can be changed after the fact.

Color Space

Color space is an interesting and important part of digital photography. It helps your camera fit in to a much broader range of imaging devices. Software, printers, monitors, and other devices recognize which color space is attached to your image and use it, along with other color profiles, to help balance the image and produce the correct colors.

The two color spaces available on the E-M1 have different gamuts, or ranges of color. They are called sRGB and Adobe RGB. Let's discuss color space briefly so you can make an educated choice.

Which Color Space Should I Choose?

Adobe RGB uses colors from a broad selection of the total color range that approximates human vision (called CIELAB in the graphics industry), so it has a wider gamut than sRGB (figure 6.79A). If you are taking images that might be printed commercially, Adobe RGB is often the best color space to use (see the sidebar called **Which Color Space Is Best, Technically?**).

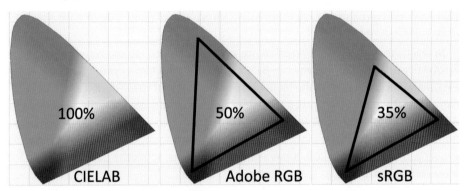

Figure 6.79A: CIELAB, Adobe RGB, and sRGB color spaces

After a JPEG file is created, either in a camera or on a computer, both the Adobe RGB and sRGB color gamuts are compressed into the same number of color levels. A JPEG has only 256 levels for each of its red, green, and blue (RGB) channels. However, since the Adobe RGB color space takes its colors from a wider spectrum, you will have a better representation of reality when there are lots of colors in your image.

If you shoot in RAW format a lot, you may want to consider using Adobe RGB to store the maximum number of colors in your image files for later use, even though, for reasons we'll discuss in a moment, it really doesn't matter in RAW mode. However, it is still a good idea to leave your camera set to Adobe RGB.

An E-M1 lossless compressed 12-bit RAW (ORF) image file can contain 4,096 levels of color per RGB channel, instead of the limited 256 levels in an 8-bit JPEG. Using Adobe RGB makes a lot of sense when you shoot in RAW mode because of its capacity to contain more colors as a base storage medium.

There are some drawbacks to using Adobe RGB, though. The sRGB color space is widely used in printing and display devices. Many local labs print with sRGB because so many point-and-shoot cameras use that format. If you try to print directly to some inkjet printers that are configured for sRGB using the Adobe RGB color space, the colors may not be as brilliant as with sRGB. If you aren't going to modify your images in post-processing and plan to print them directly from your camera, you may want to use sRGB. If you shoot only JPEGs for computer display or Internet usage, it might be better to stay with sRGB for everyday shooting.

If you are a RAW shooter and regularly post-process your images, you should consider using Adobe RGB. You will have a wider gamut of colors to work with and can make your images the best they can be. Later you can convert your images to another color space (e.g., sRGB, CMYK, CIELAB) so you can get great prints from inkjet printers and other printing devices. Here is a rough way to look at it:

- Many people who regularly shoot in JPEG format use sRGB.
- Many people who regularly shoot in RAW format use Adobe RGB.

These are not hard-and-fast rules, but many people follow them. I shoot RAW a lot, so I often use Adobe RGB.

In reality, though, *it makes no difference which color space you choose when you shoot in RAW* because the color space can be changed after the fact in your computer. However, many people are not in the habit of changing the color space during a RAW to JPEG conversion. Therefore, if you need the extra color range, why not leave the camera set to Adobe RGB for later convenience? Why add an extra step to your digital darkroom workflow? If you are shooting for money—such as for stock image agencies—most companies expect you to use Adobe RGB. It has a larger color range, so it's the quality standard for most commercial printing.

Now let's examine how to choose the color space you want to use.

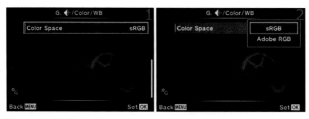

Figure 6.79B: Choosing a Color Space for your images

Use the following steps to choose an appropriate Color Space for your type of photography:

1. Select the Color Space function from the G. [Record Mode]/Color/WB menu and scroll to the right (figure 6.79B, image 1).

2. Choose one of the two Color Space settings (sRGB or Adobe RGB) from the Color Space menu after referring to the previous material in this chapter subsection (figure 6.79B, image 2).
3. Press the OK button to Set your choice.

Settings Recommendation: I use Adobe RGB most of the time because I shoot a lot of nature pictures with a wide range of color. I want the most accurate color my camera can give me. Adobe RGB has a wider range of colors, so it can be more accurate when my subject has a lot of colors.

However, if you are taking JPEG snapshots, there's no need to worry about this. Leave the camera set to sRGB and have fun.

Which Color Space Is Best, Technically?

There is a large color space used by the graphics industry called CIELAB or CIE L*a*b* (figure 6.79A). The CIELAB color space is designed to approximate human vision. Adobe RGB covers about 50 percent of the CIELAB color space, and sRGB covers only about 35 percent. In other words, Adobe RGB has a wider gamut. That means Adobe RGB gives your images access to significantly more colors, especially cyans (bluish tones) and greens. Another important consideration if you'll send your work to companies that use offset printing—such as book and magazine publishers—is that Adobe RGB maps very well to the four-color cyan, magenta, yellow, black (CMYK) printing process. If you are shooting commercial work, you may want to seriously consider Adobe RGB. Stock photo shooters are nearly always required to shoot in Adobe RGB.

Custom Menu H. Record/Erase

The H. Record/Erase menu is primarily composed of functions that work with image file naming, photographer identity, copyright, and image deletion.

We will start examining the functions by taking a look at the opening menu for the H. Record/Erase functions in figure 6.80.

To enter the menu, you must select H. Record/Erase from the Custom Menu and scroll to the right. There are seven functions inside the H. Record/Erase menu. Let's consider each of them in detail.

Figure 6.80: The opening menu for the H. Record/Erase functions

Quick Erase

The Quick Erase function gives you two ways to delete an unwanted image from the memory card: with explicit permission only, and immediately upon request. To erase an image you must display it on the camera monitor and press the Erase button on the back panel of the camera (looks like a red trash can).

At the time of deletion you can have the camera ask your permission first, or you can simply delete the image as soon as you press the Erase button. If you use the latter method (immediate erase), make sure you have selected the correct image to delete because the camera will truly delete it immediately.

Figure 6.81A: Two types of image deletion: with permission (image 1) and immediate (image 2)

Figure 6.81A shows the screens you will see depending on how you configure this function. Image 1 shows the screen that asks permission before erasing the image. Image 2 shows what happens when no permission is required; the image will be immediately deleted when you press the Erase button.

Whichever method you choose affects erasing only one image at a time, and the image to be erased must be displayed on the camera monitor. Let's consider how to choose an erase method for unwanted images.

Figure 6.81B: Choosing erase with permission only, or immediate deletion upon request

Use the following steps to choose the single-image deletion method you prefer:

1. Select the Quick Erase function from the H. Record/Erase menu and scroll to the right (figure 6.81B, image 1).
2. From the Quick Erase menu (figure 6.81B, image 2) choose Off if you want the camera to ask for your explicit permission before it deletes an image when you press the Erase button. Choose On if you want the camera to instantly delete a displayed image as soon as you press the Erase button, without confirmation. The factory default is Off.
3. Press the OK button to Set your choice.

Settings Recommendation: At first I set my camera to erase an image immediately (Quick Erase set to On), then I accidentally deleted a precious image of my pregnant daughter. I had to go through the trouble of using an image recovery program to save the deleted image. This made me rethink immediate deletion. Now I use the permission required method (Quick Erase set to Off) because it displays the image with a Yes/No choice, giving me a moment longer to think before deleting an image.

If you delete a lot of images after you take them, the immediate deletion method (On) will save you considerable time. Just make sure you are deleting the correct image!

RAW+JPEG Erase

When you set the Record Mode for still pictures to JPEG+RAW, the camera creates one identical image in each format for every picture you take (*Shooting Menu 1 > [Record Mode] > Still Picture*).

That means two images are being stored for each picture, which uses up a lot of memory card capacity. Therefore, you will probably delete more images than normal to save space.

The RAW+JPEG Erase function lets you specify how to erase single image pairs. When you press the Erase button, do you want to erase both the RAW and JPEG file, just the RAW file, or just the JPEG file? You can choose. Let's see how!

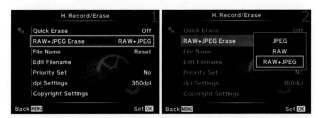

Figure 6.82: Choosing which image formats to erase with the Erase button

Use the following steps to choose how you want to erase RAW+JPEG image pairs:

1. Select RAW+JPEG Erase from the H. Record/Erase menu and scroll to the right (figure 6.82, image 1).
2. From the RAW+JPEG Erase menu, choose RAW+JPEG if you want to delete both images in the set when you press the Erase button (figure 6.82, image 2). Choose RAW to delete only the RAW (ORF) file and leave the JPEG file on the memory card. Or choose JPEG to delete just the JPEG image and keep the RAW file. The factory default for this setting is RAW+JPEG.
3. Press the OK button to Set your choice.

Note: This function is effective only when you are using single-frame playback, where one image at a time is displayed on the monitor or in the viewfinder. Also, if you use All Erase

or Format from the *Shooting Menu 1 > Card Setup* function, *all your images will be erased.* The RAW+JPEG Erase function is for erasing a single image that is displayed on the camera monitor or in the viewfinder.

Settings Recommendation: Generally I leave this function set to the factory default of RAW+JPEG. If I want to delete an image, I normally don't want to keep either of the formats.

However, if you are worried that the image may have some value later, or if you need to free up some memory card space while keeping at least one of the images, you can choose to delete just the RAW file or just the JPEG file when you press the Erase button.

File Name

The camera can create a running sequence of image file numbers so you can maintain a series of image numbers over time, even when a freshly formatted memory card is inserted. Alternatively, the camera can start over with a new sequence of image numbers when you insert a blank, formatted card.

Here are the two available settings and an explanation of how they work:

- **Auto:** The last four digits of the image file name run in a continuous series, even if you insert a blank, formatted memory card. File numbers are remembered from the previous card, and the file number on the next new image will be one higher than the previous number. In other words, if the final image on the memory card you last used had a file name ending in 0135 (e.g., P1010135.JPG), the next image you make will use 0136 (e.g., P1010136.JPG). This numbering sequence will continue until you have taken 9,999 images, then the file number sequence for the last four digits will roll back over to 0001. (See the next subsection, **Edit Filename,** for a clever way to manage images after you have exceeded 10,000 images with the camera.)
- **Reset:** Similar to the Auto mode, the camera will use the next available image number for any series of existing pictures it finds on a memory card. However, if you insert a blank, formatted memory card into the camera, it will forget the previous memory card sequence and start fresh with image numbers beginning at 0001. In other words, when the camera detects a blank memory card, it resets the numbering sequence back to 0001.

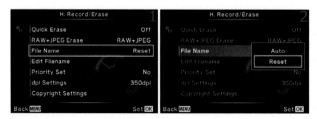

Figure 6.83: Choosing a file naming method (file number sequence)

Use the following steps to choose how you want the camera to handle file number sequences:

1. Select the File Name function from the H. Record/Erase menu and scroll to the right (figure 6.83, image 1).
2. A small up/down menu will appear with two choices: Auto and Reset (figure 6.83, image 2). Make your selection (refer to the previous list for an explanation of how each selection works).
3. Press the OK button to Set your choice.

Special Image Number Sequence Information

If you are interested in maintaining a continuous file number sequence for all future images with the camera using Auto, there are three important facts you should take note of. If you are using Reset instead of Auto, none of the following bulleted items matter because the camera will reset the file number sequence whenever it sees a blank memory card. If you use Auto, read these three bullets carefully:

- **File folder management:** The camera creates a file folder to hold your individual images when you first format or use a blank memory card. The image folder will be in the DCIM folder on the memory card and will have a name like 100OLYMP. If you exceed 9,999 images in the existing 100OLYMP folder, the camera will create a new folder with one higher number (e.g., 101OLYMP). Additionally, if you insert a memory card that has a folder containing an image with a file number ending in 9999, the camera will create a new folder in preparation for the next 9,999 images, even if there aren't actually 9,999 images in the previous folder. Any time the camera sees the number 9999 on the end of an image, it will immediately create the next folder in the series and switch to the new folder.
- **Accidentally disrupting an existing file number sequence:** Since the camera remembers the last file number on the previous memory card that was inserted in the camera, if you insert a memory card with images that have a different sequence of file numbers, the camera will immediately remember the new sequence and disrupt your controlled sequence of file numbers. In other words, if the file number sequence you have been maintaining ends in 8995 and you insert a memory card with existing images that have a different number sequence (e.g., 3456), you will lose your controlled sequence. Therefore, if you want to keep a running sequence, never insert a memory card with foreign images on it. Always use an existing card in the image number series, or start with a blank, formatted card. If you accidentally insert a memory card that has a different sequence, you will need to reinsert a card that contains the old sequence and take a picture. If you cannot reinsert the old card, format a new card in the camera, copy the final image from the old sequence into the DCIM > 100OLYMP folder, then take a picture. That will reestablish the sequence.

- **Using a file number sequence on a new camera:** Be very careful to not insert any memory card with existing images from a different Olympus camera into a brand new E-M1. If you do, the camera will not start your number sequence at 0001 for the new camera. Instead, it may pick up the file number sequence from the other camera's images. Always start your new camera's file number sequence with a blank memory card, then follow the concepts in the previous bulleted item.

Settings Recommendation: I set my camera to Auto because I want to maintain a continuous file number sequence for my images. However, this means I have to be careful about using memory cards with foreign Olympus images on them. If you have no interest in maintaining a file number sequence, just set this File Name function to Reset and forget about it. The next subsection discusses how to start and maintain a file number sequence properly.

Edit Filename

File naming allows you to control the first four characters of the file name for each of your images shot with the sRGB color space, and three characters of the file name for images taken with the Adobe RGB color space. You can change the characters to any alphanumeric characters available on the camera.

The camera defaults to using the following file naming convention for your images:

- **sRGB color space:** P1011234
- **Adobe RGB color space:** _1011234

For the Adobe RGB color space, the camera adds an underscore to the beginning character position, instead of the default P, which allows you to use the next three characters for custom naming. For the sRGB color space, the camera does not add an underscore, so you can use all four character positions for custom naming.

I use this feature on my camera in a special way. Since the camera can count images in a file number sequence (see the previous **File Name** subsection) that continues from 0001 to 9999, I use the Edit Filename function to help me personalize my images. The camera cannot count images higher than 9,999. Instead, it rolls back to 0001 for the 10,000th image.

When I first got my camera, I changed the three default characters from P101 to DRY1 for the sRGB color space and DY1 for the Adobe RGB color space. The 1 tells me how many times my camera has passed 9,999 images, and DRY or DY are my initials, which helps me protect the copyright of my images in case they are ever stolen and misused.

Since the camera's file number sequence counter rolls back to 0001 when you exceed 9,999 images, you need a way to keep from accidentally overwriting images from the first set of 9,999 images. I use the following method:

sRGB color space

- **First 9,999 images:** DRY10001 through DRY19999
- **Second 9,999 images:** DRY20001 through DRY29999
- **Third 9,999 images:** DRY30001 through DRY39999
- **Fourth 9,999 images:** DRY40001 through DRY49999

Adobe RGB color space

- **First 9,999 images:** _DY10001 through _DY19999
- **Second 9,999 images:** _DY20001 through _DY29999
- **Third 9,999 images:** _DY30001 through _DY39999
- **Fourth 9,999 images:** _DY40001 through _DY49999

My system only works up to 89,991 images (9,999×9). If you start your camera at 0 (DRY09999 or _DY09999), you can count up to 99,990 images.

If my method doesn't work for your needs, you can use the three or four custom characters to classify your image names in all sorts of creative ways.

Let's see how to assign custom characters.

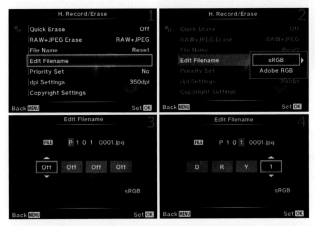

Figure 6.84A: Selecting four beginning file name characters for sRGB image files

Use the following steps to choose four new initial characters for image files created with the sRGB color space:

1. Select the Edit Filename function from the H. Record/Erase menu and scroll to the right (figure 6.84A, image 1).
2. Choose sRGB from the up/down menu and scroll to the right (figure 6.84A, image 2).
3. You will see the current file name for an sRGB file, which is shown as P101 0001.jpg in figure 6.84A, image 3. Choose a number or alphabetical character for each of the up/down menus that have Off displayed. Those four boxes represent the first four characters of the file name, which you can customize. Scroll up or down to select a custom

character for each box. After you have chosen a value for one of the boxes, scroll right or left to select other boxes and change them too. In figure 6.84A, image 4, you can see that I have added my initials (DRY) to the first three custom positions and the number 1 to the fourth custom position. Now all my sRGB images will have a file name that begins with DRY1 (e.g., DRY10123.jpg).

4. Press the OK button to Set your choice.

Next, let's consider how to change the custom characters for Adobe RGB files.

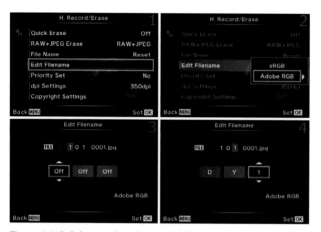

Figure 6.84B: Selecting three beginning file name characters for Adobe RGB image files

Use the following steps to choose three new initial characters for image files created with the Adobe RGB color space:

1. Select the Edit Filename function from the H. Record/Erase menu and scroll to the right (figure 6.84B, image 1).

2. Choose Adobe RGB from the up/down menu and scroll to the right (figure 6.84B, image 2).

3. You will see the current file name for an Adobe RGB file, which is shown as _101 0001. jpg in figure 6.84B, image 3. Choose a number or alphabetical character for each of the small up/down menus that have Off displayed. The first character is not available to customize for Adobe RGB files, unlike sRGB files. The first character will always be an underscore. The three boxes with Off displayed represent the next three characters of the file name, which you can customize. Scroll up or down to select a custom character for each box. After you have chosen a value for one of the boxes, scroll right or left to select other boxes and change them too. In figure 6.84B, image 4, you can see that the default underscore is in the first position, I added my initials (DY) to the second and third character positions, and I added the number 1 to the fourth custom position. Now all my Adobe RGB images will have file names beginning with _DY1 (e.g., _DY10123. jpg). The alignment of the three Off boxes seems to indicate that you can change the

underscore, but you can't. You can change only the second through fourth characters for the Adobe RGB color space.

4. Press the OK button to Set your choice.

Note: To change between the sRGB and Adobe RGB color spaces, see the function at *Custom Menu > G. [JPEG Type]/Color/WB > Color Space.* For detailed information on how to change the color space, see the previous subheading **Color Space,** under main section G, on page 407. Also, to prevent disrupting your carefully created file number sequence, review the subsection called **Special Image Number Sequence Information** at the end of the previous **File Name** function on page 413.

Settings Recommendation: At the beginning of this section we discussed how I use these three or four custom characters. You may want to use your initials or some other numbers or letters. Some people leave these characters at their default values. I recommend at least using your initials so you can easily identify images as yours. With my family of photographers it sure makes it easier for me! If you use my method, be sure to watch for the images to roll over to 9999 so you can rename the numeric custom character for the next sequence of 9,999 images.

Priority Set

When you decide to erase an image, as discussed in the previous Quick Erase function, you press the Erase button and are presented with a choice of Yes or No on a small menu.

The camera has *many* confirmation screens of this type, with Yes or No choices, and you can select which choice the camera defaults to when it asks for confirmation of various actions you want to perform.

Let's see how to select a default value for Yes/No confirmation screens.

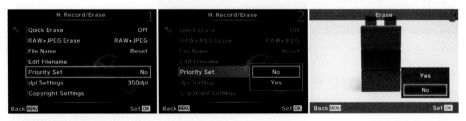

Figure 6.85: Default answer of Yes or No on confirmation screens

Use the following steps to choose a default value for when you request a change or deletion that requires a Yes or No answer:

1. Select the Priority Set function from the H. Record/Erase menu and scroll to the right (figure 6.85, image 1).
2. Choose Yes if you want the camera to always have Yes selected when a Yes/No confirmation screen appears, or choose No if you prefer No to be selected. The camera defaults to No (figure 6.85, image 2).

3. Press the OK button to Set your choice.
4. As an example, figure 6.85, image 3, shows the Erase confirmation screen, which you will see when you press the Erase button. Notice that the default is No when the screen first appears. Change the value to Yes in step 2 if you prefer that to be the default.

Note: The choice of Yes or No in step 2 affects many confirmation screens throughout the camera's entire menu system. All screens with a Yes or No selection will obey the choice you make in step 2.

 Settings Recommendation: I set my camera to Yes because I don't want to make an additional choice when a Yes/No confirmation screen appears. I would rather it just default to Yes, and I can select No if I change my mind.

dpi Settings

With the dpi Settings function, you can select a default dpi (dots per inch) for your images. The dpi information is then embedded in the metadata of your images. This information is primarily for printers to control the dots per inch they use to make a print.

 This value can be changed after the fact in computer software, such as Photoshop. You can therefore ignore this setting unless you want to print your images with a specific dpi setting. This is a useful setting for those who want to print directly from their camera or use DPOF (digital print order format) from a memory card.

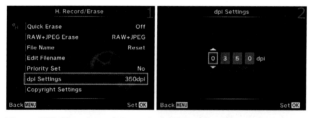

Figure 6.86: Choosing a dots per inch (dpi) setting for printing

Use the following steps to choose a default dpi value for your images:

1. Select the dpi Settings function from the H. Record/Erase menu and scroll to the right (figure 6.86, image 1).
2. Select a dpi value from the up/down menus in figure 6.86, image 2. You can choose from a range of 0001 (1 dpi) to 9999 dpi. The dpi setting will affect the printing resolution of the image on an inkjet printer or other types of printers. Many printing devices have a much more limited range than 0001 to 9999 dpi. The most common dpi for commercial printing in books and magazines is 300 dpi. Since the tiny dots a printer creates to make up an image varies among printer types, you may have to experiment with different dpi settings to see which looks best on your printer.
3. Press the OK button to Set your choice.

Settings Recommendation: I set my camera to 300 dpi because most of my work is printed at that dpi setting. If you rarely print your work, or if you prefer changing the dpi later in the computer, you can ignore this function. The quality (resolution) of the image will not be affected, regardless of how this setting is configured.

In my opinion, it is better to set this value in the computer just before the image is printed; therefore, I look at this function as a convenience setting.

Copyright Settings

The Copyright Settings function allows you to embed Artist Name and Copyright Name into the metadata of each image. With image theft so rampant on the Internet today, it is a good practice to put your personal or business name inside each image so it can be read on a computer. The government has recently been considering legislation for how to handle images that are orphaned. It isn't a good idea to let your images be orphaned!

By adding your initials to the image file name with the Edit Filename function (previous subsection) and adding artist and copyright names with this Copyright Settings function, you are invisibly marking your images internally so that, at the very least, you can prove that you own the copyright to the image. An unscrupulous person could strip out the image EXIF information; however, because your image contains the information in the first place, stripping the image is illegal and can indicate that the image was stolen. This gives you greater ammunition for proving copyright infringement. In addition to using these safeguards, you can register the copyright for your images at http://www.copyright.gov/.

Now let's examine how to add your personal information to your images.

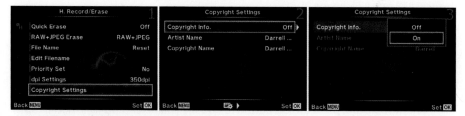

Figure 6.87A: Enabling Copyright Settings

Use the following steps to enable or disable the Copyright Settings function:

1. Select the Copyright Settings function from the H. Record/Erase menu and scroll to the right (figure 6.87A, image 1).
2. Choose Copyright Info and scroll to the right (figure 6.87A, image 2).
3. A small up/down menu will appear and offer you these choices: Off to disable the inclusion of your Artist Name and Copyright Name inside your images, or On to include that very important information (figure 6.87A, image 3).
4. Press the OK button to Set your choice.

Next let's create the Artist Name and Copyright Name so it will be in the image metadata.

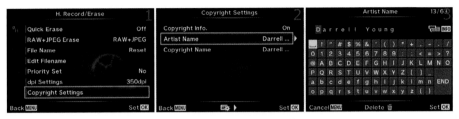

Figure 6.87B: Including your Artist Name in the EXIF information of an image

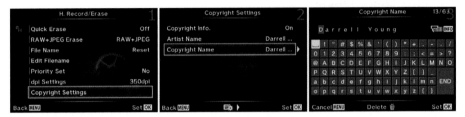

Figure 6.87C: Including your Copyright Name in the EXIF information of an image

Use the following steps to add your Artist Name and Copyright Name to future images. Both names are inserted the same way, so the following steps will work for both:

1. Select the Copyright Settings function from the H. Record/Erase menu and scroll to the right (figure 6.87B or 6.87C, image 1).
2. Choose Artist Name or Copyright Name from the menu and scroll to the right (figure 6.87B or 6.87C, image 2).
3. You will now see a screen with a grid of characters you can use for the Artist Name or Copyright Name (figure 6.87B or 6.87C, image 3). There is a maximum of 63 characters available for each name. Now follow these steps to create the name:
 - **Inserting a character:** Use the Arrow pad to move the yellow highlight square around the gray grid of characters. When the character you want to use is under the yellow highlight, press the OK button to add the character to the line at the top of the screen, where you can see my name, *Darrell Young,* in the figures. Note that there is a space character at the top-left corner of the character grid (yellow highlighted).
 - **Fixing a mistake:** If you make a mistake, simply press the Info button and the cursor will jump to the top where the already inserted characters are. Then you can scroll to the mistake and fix it. Position the cursor over the incorrect character and press the Delete button (red trash can). The incorrect character will disappear. Immediately press the Info button again and the cursor will jump back to the grid of characters so you can insert the correct character. When you select the correct character, the camera will insert it automatically and move the other characters to the right.
 - **Saving the name:** When you are done creating the Artist Name or Copyright Name, move the yellow highlight cursor down to the bottom right of the character grid to the END selection. Highlight END and press the OK button to save the name.

Settings Recommendation: One of the first settings I change on my camera is this one. I want my name and initials all over the internal metadata of my images. This is a form of protection. At the very least, the fact that you own the original image with correct metadata proves that you took the image and own the copyright. Above all else, if you are concerned about your images, especially for commercial reasons, gather up a few hundred of them, put them on a CD, and register them at **www.copyright.gov**.

Custom Menu I. Movie

The I. Movie menu is composed of functions that set the Exposure modes for recording a movie, allow or disallow movie special effects, and determine how the sound recording system works while recording a movie.

We will start examining the functions by taking a look at the opening menu for the I. Movie functions in figure 6.88.

Figure 6.88: The opening menu selection for the I. Movie functions

To enter the menu, select I. Movie from the Custom Menu and scroll to the right. There are six functions inside the I. Movie menu. Let's consider each of them in detail.

[Mode Dial Movie] Mode

The Mode Dial on top of the camera has a Movie setting (figure 6.89A) that allows you to do more with video recording than when you simply press the Movie button.

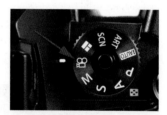

The Record Movie setting allows you to select one of the four primary exposure modes for video recording: Programmed auto (P), Shutter priority (S), Aperture priority (A), and Manual (M). Here is a description of the four modes:

Figure 6.89A: The Movie setting on the Mode Dial

- **P:** Programmed auto (P) mode allows the camera to select the optimal aperture according to how bright the subject is.
- **A:** Aperture priority (A) mode is used to control the depth of field in your video. This value must be set *before* you start the video recording. You cannot adjust the aperture while the camera is making a movie. Use the Rear Dial to adjust the aperture before the recording begins. During a video recording the camera will use the aperture you selected and will automatically select whatever shutter speed and ISO sensitivity are required to get a usable video.

- **S:** Shutter priority (S) mode is used to control motion blur and generally should be set to twice the frame rate of the movie; therefore, if you are using 1080p at 30 fps, the best shutter speed will be 1/60 second. However, you can adjust the shutter speed from as low as 1/30 second to 1/4000 second for special effects. You cannot change the shutter speed during video recording, so be sure to choose the setting you want before you start making your movie. Use the Rear Dial to adjust the shutter speed before the recording begins. During a video recording the camera will use the shutter speed you selected and will automatically select whatever aperture and ISO sensitivity are required to get a usable video.

- **M:** Manual (M) mode allows you to control both the shutter speed and the aperture for motion blur and depth of field control. You cannot adjust the aperture or shutter speed during the creation of a video. You must set the aperture and shutter speed you want to use before starting the recording. You will control the aperture with the Front Dial and the shutter speed with the Rear Dial. During a video recording the camera will use the aperture and shutter speed you selected, and you can also select an ISO range between 200 and 3200 before you start the video. Auto ISO is not used during video recordings in M mode; you have to adjust the camera for the correct lighting conditions before you start the video, and you must be careful not to move into areas where the light varies drastically to prevent over- or underexposure.

Note: Manual exposure compensation is not available in any video recording mode. In P, S, and A modes, the camera will automatically compensate for light variation. In M mode there is no way to compensate for light variance unless you are using a lens with an integrated manual aperture ring, which will allow you to open and close the aperture to allow for light changes.

Now let's examine how to prepare the camera to record a video.

Figure 6.89B: Using various exposure modes when recording video

Use these steps to select an exposure mode before you record a video:

1. Select the [Mode Dial Movie] Mode function from the I. Movie menu and scroll to the right (figure 6.89B, image 1).
2. A small exposure mode menu will appear with four exposure modes: P, S, A, and M (figure 6.89B, image 2). Refer to the previous list, then choose one of the exposure modes and press the OK button to lock it in.

3. Set the Mode Dial to the movie camera icon (figure 6.89B, image 3). When you record the video, the E-M1 will use the exposure mode you selected in step 2. Before you start the video recording, configure the shutter speed, aperture, or ISO, depending on which exposure mode you selected (see list). The camera will record your video when you press the Movie button.

Settings Recommendation: If you are using a lens with an aperture ring, which will allow you to control the depth of field and the amount of light entering the camera, I suggest using the Manual (M) exposure mode. If you don't have such a lens, and therefore no way to control the camera when the light level changes drastically, it may be best to use P, S, or A mode when you record a video. That way the camera can use Auto ISO sensitivity to control the exposure when the light varies greatly.

Movie [Mic]

This simple function allows you to enable or disable the camera's built-in microphone (mic) or an external mic plugged into the mic port under the top rubber flap on the side of the camera.

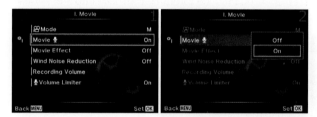

Figure 6.90: Enabling or disabling the camera's mic input for recording movies

Use these steps to enable or disable the camera's microphone for recording sound during video capture:

1. Select the Movie [Mic] function from the I. Movie menu and scroll to the right (figure 6.90, image 1).
2. A small menu will appear with Off and On selections for the mic input (figure 6.90, image 2). If you select Off the camera will not record any sound when you record a video. If it is left On (default), the built-in mic or an external mic plugged in to the mic port will record sound.
3. Press the OK button to Set the microphone to On or Off.

Settings Recommendation: I leave my mic set to On because I often record family videos with the camera's built-in mic. Sometimes I even use an external mic mounted in the Hot shoe and plugged in to the external mic port. If you use the camera for commercial video and use an external digital recorder to capture high-quality sound, you may want to set this function to Off.

Movie Effect

The E-M1 offers five effects during movie recording. These effects are easily accessed with small buttons at the bottom of the Live View touch screen (figure 6.91A).

Figure 6.91A: Five Movie Effect buttons on the Live View touch screen

These five buttons enable the following effects, from left to right: Picture Mode, Old Movie, Multi-ghosting, Single-ghosting, and Digital zoom (figure 6.91A, bottom of screen). You can experiment with the effects before shooting video by placing the camera in Movie mode with the movie camera icon on the Mode Dial. The buttons will appear and you can review their effects before you record the movie. After you start to record a video, the buttons will still be active, and you can lightly touch them to enable or disable the effects.

These Movie Effects are discussed in detail in the chapter **Screen Displays for Camera Control,** on page 121, for movie recording while using touch controls on the Live View screen.

The Movie Effect function allows you to enable or disable the touch buttons for using the Movie Effects. Let's see how.

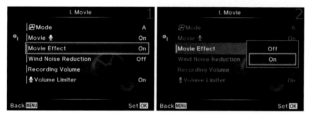

Figure 6.91B: Enabling or disabling the five Movie Effect touch buttons

Use the following steps to enable or disable Movie Effects:

1. Select the Movie Effect function from the I. Movie menu and scroll to the right (figure 6.91B, image 1).
2. A small menu will appear with Off and On options (figure 6.91B, image 2). Select On to enable the Movie Effects buttons or select Off to disable them. The camera defaults to On.
3. Press the OK button to Set your choice.

Settings Recommendation: I leave these Movie Effects enabled all the time. The first one, Picture Mode, allows me to shoot movies using the cool effects found in several of the Picture Modes and all of the Art Filters in the camera. This opens a wide selection of video special effects shooting. We consider each of these modes in the chapter called

Screen Displays for Camera Control. Do not discount these Movie Effects because they are a great deal of fun and will make your videos look unique.

Wind Noise Reduction

When you are recording a video with the built-in mic or an external mic, sometimes the wind blowing on the mic will make a low-frequency rumbling noise that is quite objectionable.

It is usually not possible to completely eliminate strong wind noise, especially with an unprotected mic, but the objectionable sound can be reduced with a low-cut filter. The camera has one built in to the mic circuitry, and it can be set to various levels, including off.

Let's examine how to configure the low-cut Wind Noise Reduction filter in your E-M1.

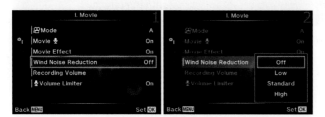

Figure 6.92: Enable or disable the camera's Wind Noise Reduction filter

Use the following steps to set the Wind Noise Reduction level for video recording or turn it off:

1. Select the Wind Noise Reduction function from the I. Movie menu and scroll to the right (figure 6.92, image 1).
2. A small menu will appear with Off, Low, Standard, and High options (figure 6.92, image 2). Select Off to disable the Wind Noise Reduction filter, or choose Low, Standard, or High to select various levels of Wind Noise Reduction. The camera defaults to Off.
3. Press the OK button to Set your choice.

Settings Recommendation: This is an especially useful function if you mostly use the camera's built-in mic. However, most people who are serious about video use a better external mic with special foam shielding around the sensitive mic head to prevent wind noise. I do not generally leave this setting enabled because a low-cut filter of this type tends to reduce some normal low-frequency sounds. However, if you are recording in a windy environment with the built-in mic, or if you are using an unprotected external mic, by all means use this filter. Even a small amount of wind blowing across the face of the camera can make a rumbling noise on the video soundtrack. You will need to experiment with the three levels of Wind Noise Reduction to see which level you prefer.

Recording Volume

With the Recording Volume function you can adjust the microphone sensitivity. There are separate controls for the built-in stereo mic, an external stereo mic plugged in to the mic port, and an external stereo device that produces sound (e.g., music from an iPhone) through the line-in feature of the mic port.

You can record sound to your video from any of these devices (one at a time), and the camera allows you to control the sound input types individually. Let's see how.

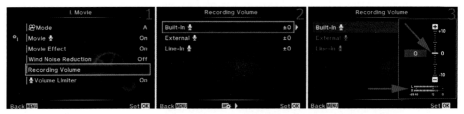

Figure 6.93: Set the Recording Volume level for the sound recording system

Use the following steps to set the Recording Volume or turn it off:

1. Select Recording Volume from the I. Movie menu and scroll to the right (figure 6.93, image 1).
2. Choose Built-in, External, or Line-in and scroll to the right (figure 6.93, image 2). All of these input types work exactly the same way, with the same controls; therefore, I will discuss only the first one, Built-in. Use the following steps for any of the input types to get similar results.
3. Figure 6.93, image 3, shows the control you will use to adjust the sensitivity of the two microphone types (or Line-in). There is a sliding indicator scale with a yellow bar (top red arrow) that you move up or down by rotating the Rear Dial or pressing the up and down keys on the Arrow pad. You can adjust the mic sensitivity over a 20-level range from +10 to –10, and the adjustment value will appear in the gray box that contains a 0 in image 3. The best way to do the adjustment is to watch the sound level on the L (left) and R (right) scale at the lower red arrow, which indicates the stereo sound input. You can see in image 3 that both the left and right channels of my Built-in mic are in the red, which means the sound is overpowering the mic and there is some sound distortion instead of clear sound. As I watch the average sound level, I may decide to dial back the sound input by moving the yellow bar down toward –10 until the L and R sound bars are no longer in the red. If the sound barely registers on the L and R scales, I might increase the mic sensitivity (turn up the gain) by moving the yellow bar up toward the +10 value. Again, this works the same way for all three types of input: Built-in, External, and Line-in.
4. After adjusting the sensitivity for the input type you are using, press the OK button to Set the sensitivity level.

Settings Recommendation: This is a powerful function that allows you to set different sensitivities for the built-in mic, an external mic, or an external sound device, such as an iPhone, iPod, or iPad that is playing music. The camera does a pretty good job of managing the sound level for both mic types, so I rarely use this function. However, when I feed music from my iPhone into the camera, I find that I have to turn the volume down very low on the iPhone and carefully watch the L and R sound level scales to make sure I don't overpower the Line-in port. With a little experimentation and adjustment, you can play your favorite music directly into your camera for videos that need no other type of sound. I bet none of your friends' cameras can do that. Make them jealous!

[Mic] Volume Limiter

When you capture sound of any type while you record a video, the sound may suddenly become overpoweringly loud.

Maybe you are recording a basketball game and the player SCORES! The crowd erupts with fist-shaking screams of delight and generates a sudden explosion of noise that sets off car alarms outside the auditorium. Do you want the energetic yelling and foot stomping to be recorded as distorted crackling in the sound of your video? No? Simply leave the [Mic] Volume Limiter function set to its default of On. The camera will sense the sudden blast of loud sound and limit the input to the camera, and hopefully save your video from requiring extensive sound editing later. Let's see how to enable or disable the [Mic] Volume Limiter.

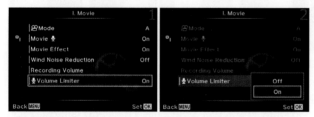

Figure 6.94: Limit the maximum recording volume for loud sounds

Use the following steps to enable or disable the [Mic] Volume Limiter for video recording:

1. Select the [Mic] Volume Limiter function from the I. Movie menu and scroll to the right (figure 6.94, image 1).
2. A small menu will appear with Off and On choices (figure 6.94, image 2). Select Off to disable the [Mic] Volume Limiter or On (default) to enable it.
3. Press the OK button to Set your choice.

Settings Recommendation: It is a good idea to leave this function enabled at all times. Although you can control sound most of the time, sometimes sudden noises can happen too fast to manually compensate for them. To preserve the sound quality in your video, it may be a good idea to let the camera automatically react to overpowering sound.

Custom Menu J. Built-In EVF

The J. Built-In EVF menu is primarily composed of functions that manage the electronic viewfinder (EVF) behind the eyepiece of the camera. It provides settings for things like the style of the EVF, overlays that are displayed on the EVF, how the eye sensor works, and the brightness and color balance of the EVF.

Figure 6.95: The opening menu for the J. Built-In EVF functions

We will start examining the functions by taking a look at the opening menu for the J. Built-In EVF functions in figure 6.95.

To enter the menu, select J. Built-In EVF from the Custom Menu and scroll to the right. There are six functions inside the J. Built-In EVF menu. Let's consider each of them in detail.

Built-in EVF Style

The camera offers three Built-in EVF Styles, as shown in figure 6.96A. Style 1 and Style 2 have a retro film camera look. Style 3 is the factory default, which looks more modern. Style 3 imitates the layout of the rear monitor, so many people prefer this Style.

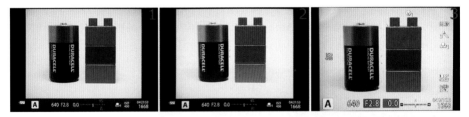

Figure 6.96A: EVF Styles 1, 2, and 3

Styles 1 and 2 provide shooting information in a band at the bottom of the EVF. Style 1 has a blue band with yellow and white characters. Style 2 has a dark gray (almost black) band with yellow and white characters. Style 3 is the default. It has bright white characters with exposure information in yellow. Notice in the figure that Style 3 provides a little more magnification of the subject, making it somewhat easier to see.

Let's examine how to select one of the Styles.

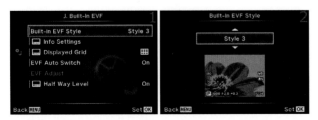

Figure 6.96B: Choosing an EVF Style

Use these steps to select one of the EVF Styles:

1. Select Built-in EVF Style from the J. Built-In EVF menu and scroll to the right (figure 6.96B, image 1).
2. Use the up/down menu to select one of the three Styles. Refer to figure 6.96A to choose your favorite (figure 6.96B, image 2).
3. Press the OK button to Set your choice.

Settings Recommendation: I generally leave my camera set to the factory default of Style 3. I like the larger view of the subject in the viewfinder and having the monitor and viewfinder look the same. However, before you make a final decision about which EVF Style you will use, examine the rest of the functions in the J. Built-In EVF menu. Some of the upcoming functions work differently when you use Styles 1 and 2.

Info Settings

Depending on which Style you chose for the Built-in EVF Style, you can have the EVF display things that are normally seen only on the rear monitor. The EVF can display a Live Histogram, show a Highlight&Shadow screen, present a Level Gauge, or allow a sparse Basic Information screen.

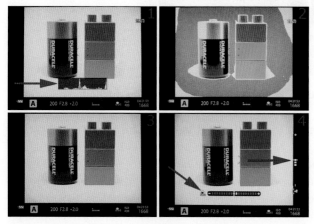

Figure 6.97A: The four Info Settings types: Live Histogram (image 1), Highlight&Shadow (image 2), Basic Information (image 3), and Level Gauge (image 4)

While choosing Info Settings, remember that the Info overlays apply to the EVF, not the Live View monitor. To see all the selected Info Settings, you must look into the viewfinder while pressing the Info button repeatedly.

Let's examine what each of the three EVF Styles display, using the screen overlays in figure 6.97A, images 1–4, as examples:

- **Style 1:** This Style offers a blue band at the bottom with exposure information displayed similarly to a retro film camera. You can select several overlays by pressing the Info button repeatedly. The camera offers Live Histogram (image 1), Highlight&Shadow (overexposed areas turn orange, image 2), Basic Information (image 3), and Level Gauge (image 4).
- **Style 2:** This Style is virtually identical to Style 1, except it uses a black band at the bottom of the EVF instead of a blue band. See Style 1 in the previous bullet for details about the displays.
- **Style 3:** This Style makes the EVF perform like a smaller version of the monitor on the back of the camera. The EVF and monitor will generally look identical. Style 3 offers all the features of Styles 1 and 2 with the exception of the Highlight&Shadow (orange overexposure) mode in figure 6.97A, image 2.

Now let's examine how to select which Info Settings you want to use in the EVF.

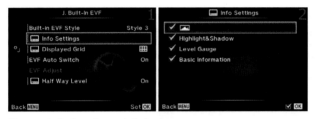

Figure 6.97B: Choosing an Info Settings type

Use these steps to select the Info Settings you want to use on the EVF:

1. Select Info Settings from the J. Built-In EVF menu and scroll to the right (figure 6.97B, image 1).
2. You can make four choices on the Info Settings screen (figure 6.97B, image 2). [Live Histogram], Level Gauge, and Basic Information are checked by default. Highlight& Shadow is not checked and is of no use if you are using Style 3. However, if you are using either Style 1 or 2, you may want to check the Highlight&Shadow setting so it will show blown-out (overexposed) areas in the EVF. To check or uncheck an item, highlight it and press the OK button. When an item is checked, each Info Setting will appear on the EVF when you press the Info button repeatedly.
3. Press the Menu button to return to the main menu when you are done.

Settings Recommendation: I check all the available Info Settings in case I decide to use an EVF Style that works with that setting. I don't see a problem with checking all of them, so why not?

Displayed Grid

The camera can display a series of five grid types as overlays in the EVF, as seen in figure 6.98A. Image 1 is Off, and the other five grid types are shown in images 2–5.

The five grid types will help you align your image correctly for various types of photography. The grid overlays are available only when you use EVF Styles 1 or 2 (not Style 3).

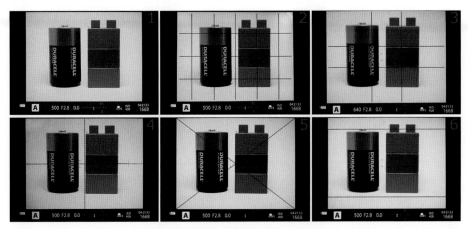

Figure 6.98A: The default EVF screen and five Displayed Grid types

Note: The Displayed Grid function provides no grid displays for EVF Style 3, but all is not lost. You can still use all five grid types with Style 3 by choosing one of the grid types from *Custom Menu > D. Disp/[Sound]/PC > Displayed Grid* instead of using this function.

When you choose a grid type, remember that the grids apply to the EVF, not the Live View monitor. To see the grid, you must be looking into the viewfinder.

Let's examine how to select a Displayed Grid type for EVF Styles 1 and 2.

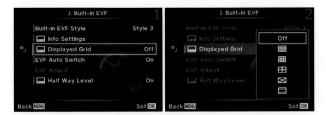

Figure 6.98B: Choosing a Displayed Grid type for EVF Styles 1 and 2 (only)

Use these steps to select a Displayed Grid type when you are using EVF Styles 1 and 2:

1. Select Displayed Grid from the J. Built-In EVF menu and scroll to the right (figure 6.98B, image 1).
2. Use the menu to select one of the five grid types or Off (figure 6.98B, image 2). Refer to figure 6.98A to choose your favorite.
3. Press the OK button to Set your choice.

Settings Recommendation: In figure 6.98A, image 2, you can see that I selected the first Displayed Grid type (directly under Off). I like this grid because it helps me align the horizon when I am shooting landscapes, and it also makes it easier to shoot buildings when I'm walking around town photographing architecture. There is a grid type to suit most photo needs, so experiment with each of them to see which you prefer, if any.

Remember that the grid types from this function apply only to EVF Styles 1 and 2. You can use the same grid types for Style 3 by choosing a grid type from *Custom Menu > D. Disp/[Sound]/PC > Displayed Grid*.

EVF Auto Switch

The camera has a small eye detector built in to the right side of the viewfinder, which is why the rubber viewfinder attachment has such an odd shape. If you look closely you will see two tiny lenses at the bottom right of the viewfinder. These lenses detect when anything gets close to the viewfinder, then it closes the EVF Auto Switch and enables the internal EVF, which turns the rear monitor off.

If you prefer to use the rear monitor for all your pictures, you can disable the EVF Auto Switch. Then the camera will ignore your eye or anything else that gets close to the viewfinder and leave the rear monitor active for shooting pictures.

Let's see how to enable or disable the EVF Auto Switch (eye sensor).

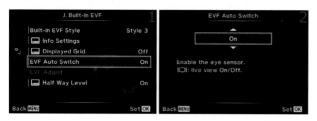

Figure 6.99: Enabling or disabling the EVF eye sensor

Use these steps to enable or disable the viewfinder eye detector:

1. Select *EVF Auto Switch* from the J. Built-In EVF menu and scroll to the right (figure 6.99, image 1).
2. Use the up/down menu to select either On or Off for the eye sensor (figure 6.99, image 2). The On setting enables the Live View Monitor until the camera senses something close to the Viewfinder eyepiece, then it enables the EVF and disables the Monitor. The Off setting uses the Live View Monitor only and turns off the eye sensor. If this function is set to Off, you can manually switch to the EVF by pressing the LV button at the left of the Viewfinder, which will toggle the camera between the EVF and the rear Monitor.
3. Press the OK button to Set your choice.

Note: If you hold down the LV button to the left of the viewfinder eyepiece for about two seconds, the camera will open the EVF Auto Switch menu directly, then you can select On or Off to enable or disable the eye sensor very quickly.

Settings Recommendation: I prefer to use the EVF for most of my photography. However, I do find the Live View monitor to be quite handy for casual photography and for macro shooting. Therefore, I usually leave the EVF Auto Switch set to On so the camera will sense my eye approaching the viewfinder and automatically turn on the EVF and turn off the monitor. However, I shoot macros with the Live View monitor, and I sometimes get my hand too close to the viewfinder and the monitor goes off, causing me to lose sight of my subject. When that happens, I may temporarily disable the EVF Auto Switch (set it to Off) so I can keep the Live View monitor active at all times.

EVF Adjust

The E-M1 automatically controls the brightness and color balance (hue) of the EVF, depending on the ambient light conditions. If you want to control the brightness and color balance of the EVF yourself, you can use this function to do so. Let's see how.

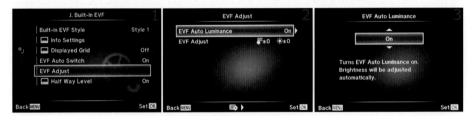

Figure 6.100A: Enabling or disabling EVF Auto Luminance

Use these steps to enable or disable EVF Auto Luminance:

1. Select EVF Adjust from the J. Built-In EVF menu and scroll to the right (figure 6.100A, image 1).
2. Choose EVF Auto Luminance from the EVF Adjust screen and scroll to the right (figure 6.100A, image 2).
3. Use the up/down menu to select either On or Off (figure 6.100A, image 3). If you select On (default), the camera will adjust the EVF brightness and hue automatically. If you choose Off, you can use the EVF Adjust setting (second menu item in image 2) to control the EVF brightness and hue manually. Examine the steps for figure 6.100B to use the EVF Adjust setting for manual EVF brightness and hue control.
4. Press the OK button to Set your choice.

Next let's see how to adjust the EVF brightness and hue manually instead of letting the camera control it automatically.

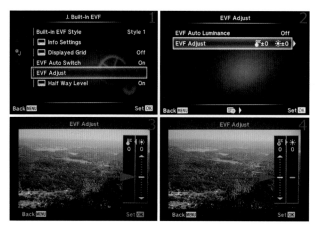

Figure 6.100B: Setting the EVF brightness and color balance

Use these steps to manually control the brightness and hue of the EVF screen. While you make these adjustments, remember that they apply to the EVF, not the Live View monitor. To make the adjustments shown in figure 6.100B, images 3 and 4, you must be looking into the viewfinder to see the screens:

1. Select EVF Adjust from the J. Built-In EVF menu and scroll to the right (figure 6.100B, image 1).
2. Choose EVF Adjust from the EVF Adjust screen and scroll to the right (figure 6.100B, image 2).
3. You will now see a screen in the EVF that displays the last picture you took or the last picture you viewed from the memory card. The picture is overlaid with two adjustment sliders on the right: one for brightness and one for hue or color temperature (figure 6.100B, image 3). The adjustment for brightness is on the far right side of the EVF screen (image 3, red arrow). You can use the keys of the Arrow pad to scroll up or down to adjust the brightness of the EVF over a range of 14 levels. You can move the yellow bar at the point of the red arrow up seven levels (+7) or down seven levels (−7), which brightens or darkens the backlight of the EVF screen.
4. When you are done, scroll to the left with the left key of the Arrow pad to adjust the hue (color temperature) of the EVF (figure 6.100B, image 4). Notice at the point of the arrow that the hue setting is 0. You can adjust the hue up seven levels (+7) or down seven levels (−7). An upward adjustment makes the hue shift toward blue (cooler), and a downward adjustment makes the hue shift toward red (warmer). Adjust the EVF color temperature until it seems right to you.
5. Press the OK button to Set your EVF brightness and hue choices.

Note: The EVF brightness and hue settings are for comfort only and do not affect the brightness or hue of the images you create. The brightness and color temperature of your pictures are controlled by the exposure and white balance settings.

Settings Recommendation: I normally leave my camera set with EVF Auto Luminance set to On. This lets the camera control the brightness and hue of the monitor, similar to how my iPhone adjusts when the ambient light changes. I have found the camera's choices to be satisfactory, and the automatic control is quite convenient.

However, if you are shooting in a controlled studio environment with careful color matching, you may want to adjust the EVF until it looks best for your light source.

Half Way Level

If you are using Built-in EVF Styles 1 and 2, the camera displays a small Half Way Level at the bottom of the EVF. The Half Way Level is not available with Built-in EVF Style 3.

Figure 6.101A: Using the Half Way Level

The level is called a Half Way Level because it activates when you press the Shutter button half-way down. When the level appears, it replaces the –/+ exposure indicator at the bottom of the EVF screen. Figure 6.101A shows the Half Way Level (red arrow) with the camera tilted off axis from the subject.

When the camera is off level horizontally, a series of white bars will extend to the left or right of the center of the scale in the opposite direction of the camera body rotation. If you rotate the camera more than a few degrees horizontally, the scale will run out of white bars, and an orange arrow will appear above the scale to indicate the camera cannot register any more degrees of rotation.

When the camera is exactly level horizontally, the center bar and the two up/down arrows above the center bar will turn green.

Let's examine how to enable or disable the Half Way Level.

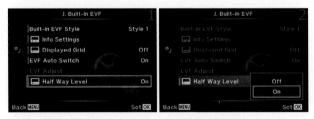

Figure 6.101B: Enabling or disabling the Half Way Level

Use these steps to enable or disable the Half Way Level:

1. Select Half Way Level from the J. Built-In EVF menu and scroll to the right (figure 6.101B, image 1).
2. Use the menu to select On or Off to enable or disable the Half Way Level (figure 6.101B, image 2).
3. Press the OK button to Set your choice.

Settings Recommendation: I leave this level enabled in case I decide to use a different EVF Style than my normal Style 3. However, if I want to use a real level, I simply use the camera's main Virtual level. It is available when you press the Info button until the level appears on the monitor or in the EVF. The Virtual level shows left and right rotation along with forward and backward rotation.

Custom Menu K. Utility

The K. Utility menu is composed of nine functions that don't readily fit into one of the other Custom Menus. We will start examining the functions by taking a look at the opening menu for the K. Utility menu in figure 6.102. This is the last menu system in the group of Custom Menus.

Figure 6.102: The opening menu for the K. Utility functions

To enter the menu, select K. Utility from the Custom Menu and scroll to the right. There are nine functions inside the K. Utility menu. Let's consider each of them in detail.

Pixel Mapping

The E-M1 allows you to run a self-check on the camera sensor and image processing functions. When your camera was first manufactured, one of the final steps before the camera was released was the Pixel Mapping process. Why?

All digital cameras suffer from two maladies, both initially and over time:

- **Dead pixels:** A dead pixel is a photosite on the sensor that has become unresponsive. It will appear as a tiny black spot in the same place on every image unless it is mapped out.
- **Stuck pixels:** A stuck pixel is a photosite that reports full exposure regardless of the actual exposure. This means the pixel will always appear as one color, usually red or white, at the same place in every image. It should be mapped out.

Because the E-M1 is an advanced camera, you can run a similar Pixel Mapping function as the one used by Olympus technicians. You don't want black, white, or colored spots in all your images, so you should run the Pixel Mapping function as needed to remap the dead and stuck pixels on your camera sensor.

Olympus recommends that you run the Pixel Mapping function at least once a year. However, if you detect dead or stuck pixels in your images when they are viewed at 100 percent on your computer monitor, you can run the Pixel Mapping function and map the bad photosites out of future images. The camera will interpolate data from

surrounding pixels to fill in what should be captured at the mapped-out pixel, preventing image degradation that would otherwise be caused by using the Pixel Mapping function.

Mapping the bad pixels takes about 20 seconds, and you will hear the camera make some odd clicking noises as it tests and maps the entire sensor and image processing system.

Let's see how to run the Pixel Mapping function.

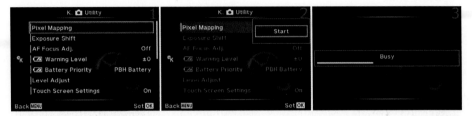

Figure 6.103: Remapping the sensor pixels

Use these steps to run the Pixel Mapping function to tune up your sensor and image processing system:

1. Select Pixel Mapping from the K. Utility menu and scroll to the right (figure 6.103, image 1).
2. Choose Start from the menu and press the OK button to begin mapping the pixels (figure 6.103, image 2).
3. During the Pixel Mapping process, you will hear various clicks from the camera over a period of about 20 seconds. While the camera is working you will see a Busy indicator on the screen (figure 6.103, image 3). When Pixel Mapping is complete, the camera will return to the main menu.

Note: In addition to dead and stuck pixels, you may have heard of hot pixels. A hot pixel is not a dead or stuck pixel, and the Pixel Mapping function is not designed to deal with them specifically. Hot pixels are photosites on the sensor that have become overheated due to long exposures. They will appear in images as various incorrect colors. As the camera cools, the hot pixels will cool off and return to normal. Use the *Custom Menu > E. Exp/[Meter]/ISO > Noise Reduct.* function to deal with hot pixels. The camera should not map out hot pixels because they move around on the sensor.

It is not a good idea to run the Pixel Mapping function after you take a lot of exposures or a long exposure, especially when you are shooting in a warm environment. You don't want the camera to map out pixels that are useful in normal exposures. Therefore, it is best to run Pixel Mapping before you start shooting images for the day. At the very minimum, allow the camera to cool down for at least one minute after you take pictures, and significantly longer if the camera is warm to the touch.

Settings Recommendation: This is a powerful and useful function for photographers who cannot afford to have spots on their pictures. I do not indiscriminately run this

function. I run it at least once per year or more often if I see dead or stuck pixels. All digital cameras will lose a few pixels over time, although not enough to affect the image, even after many years of use. However, aren't you glad that Olympus gave you a Pixel Mapping function so you can take care of the problem yourself instead of having to send your camera in for service?

Exposure Shift

If you think one of your camera light meters (Digital ESP, Center weighted, Spot) needs a little fine-tuning, you can use this function to set up a semipermanent exposure compensation for individual light meter types.

For instance, if you usually shoot with the Digital ESP meter and you want the meter to add a half stop of exposure beyond the default, you can set it up with this function.

The camera allows you to fine-tune each light meter type in 1/6 stop (1/6 EV step) increments, up to one full stop over- or underexposed. In figure 6.104, image 4, you can see that I added 1/2 stop (+3/6). Let's see how to accomplish Exposure Shift fine-tuning.

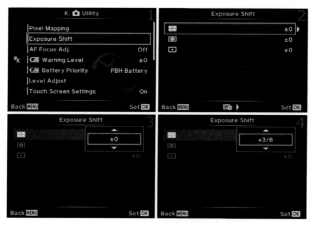

Figure 6.104: Fine-tuning the camera's exposure meters

Use these steps to set up a semipermanent Exposure Shift on any or all of the three light meter types:

1. Select Exposure Shift from the K. Utility menu and scroll to the right (figure 6.104, image 1).
2. The top meter selection is the Digital ESP meter. The second meter type is the Center weighted meter, and the third meter type is the Spot meter (figure 6.104, image 2). Let's use the Digital ESP meter as an example of how to set up an Exposure Shift of 1/2 stop (+3/6). The process is the same for all meter types, so you can use these steps for whichever meter you want to fine-tune. Choose the meter you want to modify and scroll to the right.

3. In figure 6.104, image 3, the Digital ESP meter is selected, the Exposure Shift menu is open, and the camera is currently set to no Exposure Shift (±0). Use the keys of the Arrow pad to select from +1/6 to +1 stop of Exposure Shift in 1/6 stop increments.
4. In figure 6.104, image 4, you can see that +3/6 EV steps (1/2 stop) is selected. The camera will add 1/2 stop of exposure compensation and mildly overexpose the image.
5. After you have selected how much you want to shift the exposure, press the OK button to lock in the Exposure Shift setting. Repeat these steps for any other meter type that you want to adjust.

Note: The Exposure Shift function is a form of exposure compensation. It is applied semi-permanently; that is, it stays in place until you go back to the Exposure Shift function and remove the shift value. When you shift the exposure for any of the light meters, you may find that you do not have the normal range of exposure compensation after you adjust the meter.

Also, you will not see the effects of the Exposure Shift in the EVF or on the rear monitor, although you will be able to detect it in the image histogram.

Settings Recommendation: I have found that the exposure meters in the E-M1 are very accurate, and I am quite satisfied with their performance. However, you may be shooting a style of photography that easily fools your light meter. In that case, experiment with this function to see if it will help overcome the exposure problem. Don't forget that Exposure Shift is in place or you may find that your images are regularly over- or underexposed.

AF Focus Adj.

Some lenses have a tendency to not focus exactly where they should. The lens may focus a little in front of or behind the point where you want the focus to be. A lens may focus well on one camera body and not so well on another. It is almost as if some lenses have a personality.

If you have a lens that acts like that, you may need to have it repaired. However, if the problem is minor, you can use the AF Focus Adj. function to fine-tune the focus of an individual lens, or even all lenses that you mount on your camera.

Let's examine how to work with the focus adjustment system.

Setting an AF Focus Adjustment for All Lenses

If you think your camera has a tendency to focus incorrectly with all lenses you mount on it, you may need to have your camera repaired. In the meantime, though, you may have to shoot some important pictures and want to fine-tune the camera so all lenses focus more accurately.

Experiment first and determine whether you need to push the focus away from the camera or pull it back in to increase sharpness. That is the purpose of the Default Data subfunction. Let's see how to use it.

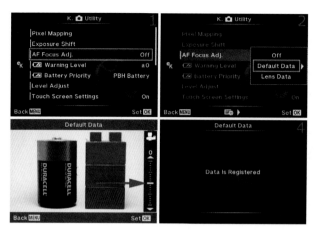

Figure 6.105A: Adjusting the focus for all lenses you mount on your camera

Use these steps to adjust the focus for all lenses you mount on your camera:

1. Select AF Focus Adj. from the K. Utility menu and scroll to the right (figure 6.105A, image 1).
2. Highlight Default Data on the menu and scroll to the right (figure 6.105A, image 2).
3. In figure 6.105A, image 3 (red arrow), you can see the adjustment indicator. You can move this yellow bar up and down with the keys on the Arrow pad over a range of 40 increments (+20 to −20). Moving this bar up moves the focus forward by up to 20 increments; moving it down moves the focus backward by up to 20 increments. The number at the top of the indicator is 0 in the figure, but it will change as you move the yellow bar to a plus or minus value. Choose the amount of focus adjustment you need to use.
4. Press the OK button to Set your choice, then a screen will appear that says *Data Is Registered* (figure 6.105A, image 4). Test the focus and readjust as necessary by repeating steps 1–3.

Now let's examine how to adjust the focus for just one lens. All other lenses will focus normally.

Setting an AF Focus Adjustment for an Individual Lens
If you have a lens that is not focusing correctly and do not want to send it in for repair, you may be able to use the Lens Data subfunction to adjust the focus for only that lens and make it more accurate. You can maintain a custom focus adjustment for up to 20 separate lenses. Let's see how to adjust the focus for a single lens.

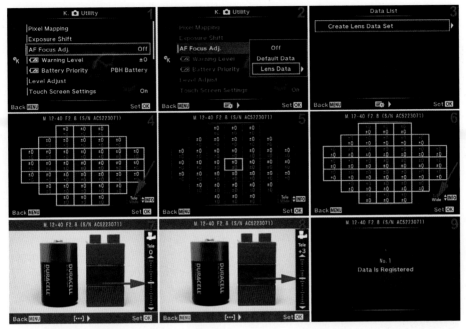

Figure 6.105B: Adjusting the focus for a single lens

Use these steps to adjust the focus for a single lens that is mounted on the camera:

1. Select AF Focus Adj. from the K. Utility menu and scroll to the right (figure 6.105B, image 1).
2. Highlight Lens Data on the menu and scroll to the right (figure 6.105B, image 2).
3. Notice in figure 6.105B, image 3, that there is a single selection, Create Lens Data Set. Later, after you have adjusted at least one lens, the lens name will appear in a list on this screen. In our example there are no adjusted lenses to show, so scroll to the right.
4. As soon as you scroll to the right, you will see the screen in figure 6.105B, image 4. This screen shows the 37 adjustable focus points in a highlighted grid. You can adjust all of the points at the same time for this lens, or you can adjust a single AF point. If you scroll to the left or right with the keys on the Arrow pad, you will see that only one focus point will be highlighted (figure 6.105B, image 5); the other 36 points have been deselected. In figure 6.105B, images 4 and 6 (red arrows), the words Tele and Wide are displayed. Press the Info button to move between Tele and Wide so you can adjust the lens for the corresponding ends of the zoom range. When you toggle between Tele and Wide you can see that the ±0 settings in each square of the grid change from the top to the bottom. This indicates that you can have separate adjustments for the Tele and Wide settings. To make the actual adjustment, you must choose one of the setting types, as shown in images 4–6. When the type of adjustment you want to make is displayed on the screen, press the OK button.

5. Now you will see the screen shown in figure 6.105B, image 7. This screen allows you to adjust the focus forward or backward for the AF points you selected in images 4–6. You can adjust the focus forward up to 20 increments (0 to +20) by scrolling up with the Arrow pad key. The yellow bar at the point of the red arrow in image 7 will move up or down as you scroll. Move the yellow bar down with the Arrow pad key to pull the focus backward by up to 20 increments (0 to −20). Image 8 shows that I have moved the bar (and focus) by +3 increments in a forward position, which means the lens now has a small amount of front focus dialed in. Also notice that the word Tele is displayed just above the indicator, signifying that I am adjusting focus only for the telephoto end of the zoom lens. Adjust the indicator up or down to move the focus forward or backward. When you have moved the bar to where you want it for both the Tele and Wide positions, you are ready to test the adjustment. Press the OK button to lock in the new adjustment, and take a few pictures to test your settings. Use the information in the upcoming subsection if you want to change an existing adjustment for greater accuracy.

6. When you have saved the adjustment by pressing the OK button, a screen will appear that says *Data Is Registered,* along with a lens number assignment (No. 1) (figure 6.105B, image 9). You can edit the lens number, as discussed in the next subsection.

Note: You will need to adjust each lens individually with this subfunction. If you want to fine-tune the focus on more than one lens, the camera will remember each lens separately. It will create a numbered list of up to 20 lenses that have been adjusted, and you can edit the adjustment for each lens.

You may have noticed that the AF point grid presented to you in this function does not contain the full 81 AF points you normally see when you use a Micro Four Thirds lens. Instead, the grid resembles the 37-point grid you see when you use an older Four Thirds lens. I've consulted with upper-level technical support at Olympus USA, and it appears that only 37 of the 81 AF points can be adjusted with this function. Any AF points outside the 37-point grid are not affected by this adjustment. However, the 37 adjustable AF points will work with either a Micro Four Thirds or Four Thirds lens.

Let's now consider how to edit the previous adjustment of a single lens.

Editing an Existing AF Focus Adjustment for a Single Lens

After you have created a lens adjustment for one or more lenses, the camera will allow you to edit the settings. You can change the amount of front or back focus adjustment then resave the Lens Data Set.

Let's examine how to edit one of your lens adjustments.

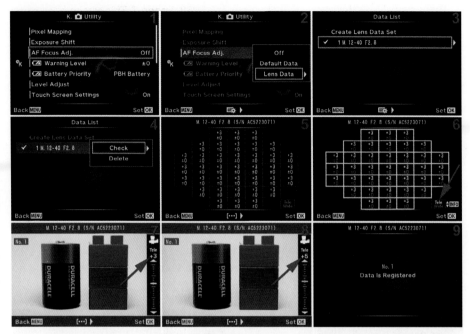

Figure 6.105C: Editing an existing focus adjustment

Use these steps to edit an existing focus adjustment:

1. Select AF Focus Adj. from the K. Utility menu and scroll to the right (figure 6.105C, image 1).
2. Highlight Lens Data on the menu and scroll to the right (figure 6.105C, image 2).
3. Notice on the screen shown in figure 6.105C, image 3, that there is an existing adjustment for a lens. It is displayed as 1 M. 12–40 F2.8 (1 indicates the lens number). Had I adjusted any other lenses, they would also appear in this list (up to 20 lens adjustments). Let's edit the current adjustment for my M.Zuiko ED 12–40mm f/2.8 PRO lens. The lens is already selected, so we will scroll to the right.
4. The next screen lets me either Check or Delete a current lens adjustment. Choose Check and scroll to the right (figure 6.105C, image 4).
5. As you can see in the boxes of figure 6.105C, image 5, the lens is adjusted to +3 on the Tele end of the zoom range. The Tele end of the lens is indicated by the top number of each square (which represents AF points), and the Wide lens position is indicated by the bottom number in each square. After you have examined the current settings, scroll to the right.
6. Figure 6.105C, image 6, is the screen that allows you to choose which part of the focus adjustment you want to change. At the point of the red arrow you can see that I was adjusting the Tele position, and the AF rectangles indicate that the current setting is +3 forward focus. If you scroll left or right, you can deselect all 37 of the AF points and

choose a single AF point to work with. If you press the Info button, you will toggle between Tele and Wide. When you have selected the AF points you want to change, press the OK button to move into the final adjustment screen.

7. At the point of the red arrow in figure 6.105C, image 7, you can see that the Tele position is set to +3 forward focus. Let's move that to +5 to add a little more forward focus. You can see the new adjustment in image 8. I am now ready to save this new focus adjustment and retest my lens.

8. Press the OK button to save the new focus adjustment. A screen that says *Data Is Registered,* along with the lens number, will appear briefly (figure 6.105C, image 9). The camera will switch back to the Data List menu and display your list of lenses in case you want to edit the adjustment for another lens.

Next let's consider how to get rid of a lens focus adjustment you no longer need.

Deleting an Existing AF Focus Adjustment for a Single Lens
If your lens has been repaired or if it miraculously starts focusing correctly, you will no longer need a focus adjustment. Let's see how to delete it.

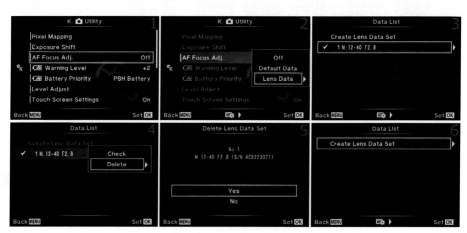

Figure 6.105D: Deleting an unneeded lens focus adjustment

Use these steps to delete an existing lens focus adjustment:

1. Select AF Focus Adj. from the K. Utility menu and scroll to the right (figure 6.105D, image 1).
2. Highlight Lens Data on the menu and scroll to the right (figure 6.105D, image 2).
3. Choose the Lens Data Set you want to Delete and scroll to the right (figure 6.105D, image 3).
4. Choose Delete from the menu and scroll to the right (figure 6.105D, image 4).
5. A Yes/No menu will appear, along with information on the Lens Data Set you are about to Delete. Select Yes and press the OK button to delete the lens adjustment

(figure 6.105D, image 5). When you are done, the camera will switch back to the Data List screen, with the lens removed from the list (figure 6.105D, image 6).

Settings Recommendation: This complex function allows you to control how all or a few of your lenses focus on your camera. Even if you don't want to use it now, why not experiment with AF Focus Adj. in case one of your lenses starts having focus problems in the future?

[Battery] Warning Level

When the battery gets low, the camera will display a battery icon with missing bars on all screens. The [Battery] Warning Level function changes the timing of when you see the low battery warning.

Let's see how to adjust the warning level so you can see a low-battery warning sooner instead of later, if you prefer.

Figure 6.106: Adjusting when you will see a low-battery warning

Use these steps to choose when you will see a low-battery warning:

1. Select [Battery] Warning Level from the K. Utility menu and scroll to the right (figure 6.106, image 1).
2. You will see an adjustment range from Lo to Hi (−2 to +2), which affects how soon the camera warns you that battery is low (figure 6.106, image 2). This is not an extremely precise system. If you select a value toward the Hi side, such as +1 or +2, the camera will warn you sooner when the battery gets low. If you select a value toward the Lo side, such as −1 or −2, the camera will wait longer to warn you when the battery gets low. Select the value you want to use by moving the yellow indicator bar next to the 0 position toward the Hi or Lo position. Move the indicator bar with the up and down keys on the Arrow pad.
3. Press the OK button to Set your choice.

Settings Recommendation: I keep the [Battery] Warning Level set to Hi (+2). I want as much warning as possible so I can be prepared to change the battery. If you set it all the way down to Lo (−2), the camera may warn you when you have only enough battery life for a few more shots. In a production environment, a late low-battery warning can mean missed critical shots. Why not set your low-battery warning to Hi and see if it needs to be adjusted later?

Battery Priority

When you are using an Olympus HLD-7 Power Battery Holder (PBH) on your E-M1, the camera has two batteries at its disposal: the PBH battery and the Body Battery. This Battery Priority function gives you a choice of which battery to use first. After the camera exhausts one battery, it will automatically switch to the other one.

Most people choose to have the camera use the battery inside the PBH first so the camera can continue to operate on the Body Battery if the PBH is removed. If the Body Battery is used before the battery in the PBH and you remove the PBH, the camera will not operate due to the lack of power.

Let's see how to select which battery the camera uses first.

Figure 6.107: Specify which battery is used first when an HLD-7 PBH is mounted

Use these steps to choose the order of battery use when an HLD-7 PBH is mounted:

1. Select Battery Priority from the K. Utility menu and scroll to the right (figure 6.107, image 1).
2. Use the up/down menu to select PBH Battery if you want the camera to use the battery in the PBH first (factory default), or select Body Battery to use the battery in the camera first (figure 6.107, image 2).
3. Press the OK button to Set your choice of battery order.

Settings Recommendation: I always use the battery in the PBH first. I am sure there are reasons to use the battery in the camera first, but I would rather have the camera switch to the internal Body Battery when the PBH is removed instead of shutting down due to a lack of power. A single battery for the E-M1 will generally not last through a day of intense shooting, so the PBH is a welcome addition to provide shooting longevity. The weaker batteries in the camera will eventually make this choice relevant for you, so go ahead and set it according to your preferences.

Level Adjust

Normally, the camera's leveling system tells you when your E-M1 is level for roll and pitch. However, if you need the camera to indicate that it is level at an unusual angle, you can adjust the level indicator.

Maybe you are shooting an unusual, off-level still life and you want the camera to line up with the still life's angles instead of really being level. You can set the camera's leveling system to match your special camera-angle requirements.

Let's see how to make the camera report that it is level when it really isn't—and yet it matches your special angle needs.

Figure 6.108: Adjusting the leveling system to give a false-level reading for special uses

Use these steps to adjust the angle the camera uses to indicate that it is level:

1. Select Level Adjust from the K. Utility menu and scroll to the right (figure 6.108, image 1).
2. Position the camera so it is at the exact angle you want it to consider level, then select Adjust from the up/down menu and press the OK button (figure 6.108, image 2). The camera will consider the new angle to be level. The level indicators will zero out and turn green when you place the camera at the new false-level angle.
3. When you are done shooting at the false-level setting, reset the camera so it will use the true level again. Select Reset from the up/down menu and press the OK button (figure 6.108, image 3).

Settings Recommendation: This is certainly an unusual setting. I have found no use for it yet since I shoot a lot of nature images. However, I can imagine that some photographers will use this feature for specialized angle shooting, especially in the studio and maybe for some types of architectural photography. If you have a need for this setting, I'm sure you will immediately recognize it.

Touch Screen Settings

The E-M1 has a nice touch screen built in to the Live View monitor on the back of the camera. You can activate various functions by simply touching an icon or button on the screen.

However, you may not like using the touch screen and would rather just use the menu system to control the camera features. Or maybe you accidentally keep touching the screen and things happen that you did not intend. In that case you can disable the touch screen. Let's see how.

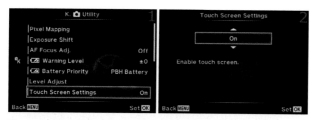

Figure 6.109: Enabling or disabling the touch screen capability

Use these steps to enable or disable the touch screen capability:

1. Select Touch Screen Settings from the K. Utility menu and scroll to the right (figure 6.109, image 1).
2. Use the up/down menu to select On to enable the Touch Screen, or select Off to disable it (figure 6.109, image 2).
3. Press the OK button to Set your choice.

Settings Recommendation: I leave the touch screen enabled on my camera. The E-M1 is the first camera I've ever used that has a touch screen. At first I was not all that interested in using it, then I started discovering various functions that are easier to manipulate by simply touching the screen instead of scrolling through menus. I suggest leaving the touch screen active on your camera unless you are having trouble with touching it at the wrong time.

Eye-Fi

Although the E-M1 has a built-in, full-featured Wi-Fi system that allows you to control the camera remotely and lets you transfer pictures, you can also use an Eye-Fi card (figure 6.110A) to transfer images directly to your computer over a local wireless network, to a remote computer through the Internet, or directly to a smart device (tablet or smartphone).

Figure 6.110A: Pro X2 and mobi Eye-Fi cards

Eye-Fi cards come in two basic versions: Pro X2 and mobi. Pro X2 cards can create a direct ad hoc connection to your Wi-Fi enabled computer for automatic, in-the-field image transfer from as far as 90 feet away. The mobi version is designed specifically for use with smart devices, such as tablets or smartphones.

You will find an Eye-Fi app at all the major app stores. For more information on Eye-Fi products, go to **http://www.eyefi.com/**.

I've been using Eye-Fi cards for many years, and although the E-M1 has built-in Wi-Fi, the Eye-Fi cards have some unique properties that make them worth looking into. Let's see how to enable or disable the Eye-Fi capability.

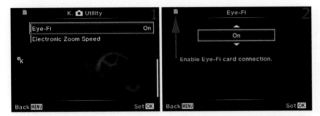

Figure 6.110B: Enabling or disabling an Eye-Fi card

Use these steps to enable or disable the camera's Eye-Fi capability:

1. Select Eye-Fi from the K. Utility menu and scroll to the right (figure 6.110B, image 1).
2. Use the up/down menu and select On to enable Eye-Fi capability, or select Off to disable it (figure 6.110B, image 2). You will see the green Eye-Fi symbol (red arrow) at the top-left corner of the menu when an Eye-Fi card is set to On. The symbol will also appear in the top-left corner of the Live View screen, just to the left of the Wi-Fi symbol. When the card is first enabled, the Eye-Fi card symbol will blink for a few seconds while the camera sets up initial communication with the card, and it will stop blinking when the card is ready to use.
3. Press the OK button to Set your choice.

Note: The Eye-Fi selection on the Custom Menu will be grayed out and not selectable unless an Eye-Fi card is inserted into the camera.

Settings Recommendation: The Eye-Fi card can do some things the camera's Wi-Fi system cannot do, such as send images across the Internet to a remote computer and use a local area network (Wi-Fi) to transfer images. Otherwise, the Eye-Fi functions are similar to the camera's built-in Wi-Fi system, with less functionality for remote camera control.

Electronic Zoom Speed

Olympus makes a few power zoom lenses that allow you to zoom in and out by turning a ring or pressing camera buttons. My favorite power zoom lens is the M.Zuiko ED 14–42mm f/3.5–5.6 EZ lens. When I am out with my family, having a good time like a tourist, I often use that sharp little pancake lens to cut down on weight and bulk.

The E-M1 allows you to select three speeds for how fast the camera zooms in and out. When I am shooting still pictures, I don't want to wait for the lens to zoom. I want it to zoom as quickly as possible so I won't miss my shot.

However, when I am shooting video, I want the lens to zoom in and out as slowly as possible because that is less jarring and looks better in a video. The slow zoom speed allows me to smoothly pull focus for those cool focus point changes that used to be available only on video cameras that cost thousands of dollars.

Let's see how to adjust the zoom speed of your power zoom lenses for shooting both still images and videos.

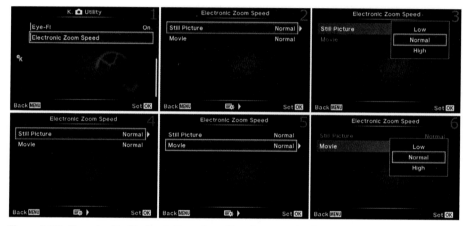

Figure 6.111: Changing the Electronic Zoom Speed for pictures and videos

Use these steps to change the power zoom speed for making pictures and videos:

1. Select Electronic Zoom Speed from the K. Utility menu and scroll to the right (figure 6.111, image 1).
2. Select Still Picture from the menu and scroll to the right (figure 6.111, image 2).
3. Select Low, Normal, or High from the menu and press the OK button to lock the Still Picture power-zooming speed (figure 6.111, image 3).
4. The camera will switch back to the menu shown in figure 6.111, image 4. Scroll down once and select Movie, as shown in figure 6.111, image 5, then scroll to the right.
5. Figure 6.111, image 6, is for adjusting the power zooming speed while you record a movie. Select Low, Normal, or High from the menu and press the OK button to lock in the Movie power-zooming speed.
6. Press the OK button to Set your choice.

Settings Recommendation: As I mentioned earlier, I like a fast power zoom when I am shooting pictures, so I set my Still Picture speed to High. I don't like making viewers dizzy when they watch high-speed zooming in a video, so I set the Movie speed to Low. Experiment with these settings and see if this method works for you. The default Normal

power-zooming speed works fine for general use, so that may be sufficient for many photographers.

Author's Conclusions

Have you ever seen so many functions in one camera? I have never seen a camera with so many configuration possibilities. The advantage is that all these functions let you make your camera do almost any type of photography you can think of. And all this power is packed into such a diminutive camera. Do you like your E-M1 as much as I like mine?

The next chapter, **Setup Menu,** will cover the final functions in the camera—the initial setup functions you will probably configure only a few times while you own the camera.

7 Setup Menu

Image © Darrell Young

The Setup Menu is the final menu in the E-M1. It gives you control over some functions that do not directly influence how an image is made. These are basic utility functions that you'll need primarily when you set up your camera.

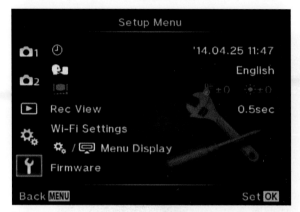

Figure 7.1: The Setup Menu for the E-M1

There are seven items on the Setup Menu:

- **[Date and Time]:** This option allows you to set the camera's date, time (in 24-hour format), and date format (month, day, and year).
- **[Language]:** Select your language from a list of 35 languages.
- **[Monitor Adjustments]:** You can adjust the hue (color temperature) and brightness level of the camera monitor.
- **Rec View:** Choose how long an image is displayed on the camera monitor and in the electronic viewfinder immediately after you take a picture.
- **Wi-Fi Settings:** Connect your E-M1 to your smartphone or tablet and remotely control the camera, transfer pictures, and geotag your images. Olympus provides free apps for the iOS (iPhone and iPad) and Android platforms. These settings control how the Wi-Fi system works when it is enabled in the Playback Menu.
- **Menu Display:** Choose whether the Custom Menu and the Accessory Port Menu appear in the list of available menus.
- **Firmware:** This function displays the camera and lens firmware versions.

Now, let's discover what each item in the Setup Menu does.

[Date and Time]

The [Date and Time] function allows you to set the date, time, and date format. These are, most likely, some of the first items you will adjust when you get your new camera. Let's see how to adjust each item.

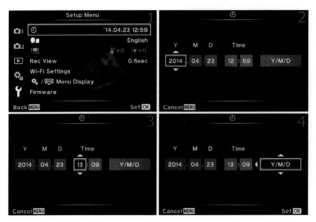

Figure 7.2: Setting the date, time, and date format

Use the following steps to adjust the date and time:

1. Select the clock symbol, which represents [Date and Time], from the Setup Menu and scroll to the right (figure 7.2, image 1).
2. The [Date and Time] screen has six up/down menus. We will use those menus to adjust the year (Y), month (M), and day (D). In figure 7.2, image 2, you can see that the year (Y) is selected. Press the up or down buttons on the Arrow pad to select from a range of years, starting at 2000 and ending at 2099. I chose 2014. Next, scroll to the right until month (M) is highlighted and press the buttons on the Arrow pad to select a month (1–12). Finally, scroll to the right until day (D) is highlighted and press the buttons on the Arrow pad until the day you want is selected (1–31). The camera knows how many days are in each month and will offer only that number of days for the month, including leap years. My camera is set to April 23, 2014.
3. Now let's set the time. Scroll to the right until the first up/down menu under Time is highlighted (figure 7.2, image 3). That is the hour field, with the minute field immediately to its right. Choose an hour, from 00–23. The camera uses a 24-hour clock, so 00 is midnight. Use the sidebar at the end of this section, titled **12- to 24-Hour Time Conversion Chart,** to choose the correct hour conversion if you use a 12-hour day. Press the buttons on the Arrow pad until the hour you want is selected, then scroll to the minute field. You can choose from 00–59 in the minute field. Select the minute you want. My camera is set to 13:09 (1:09 p.m.).

4. Now, let's set the date format. Scroll to the last up/down menu on the right, which is the date format selection (figure 7.2, image 4). You have three choices:
 - **Y/M/D:** Year/Month/Day (2014/12/31)
 - **M/D/Y:** Month/Day/Year (12/31/2014)
 - **D/M/Y:** Day/Month/Year (31/12/2014)

 Refer to the list of date formats and select the one you prefer to use. My camera is set to year, month, day (Y/M/D). Camera owners in the United States will probably use the second setting (M/D/Y).
5. Review each of the fields and make sure that all the values are correct. When you are happy with your settings, make sure the date format field is selected and press the OK button to save the settings. If any field other than date format is selected when you press the OK button, the camera will jump to the next field in the series.

Settings Recommendation: The factory default date format is Y/M/D, which I did not change on my camera before I photographed the camera screens. I changed my camera to M/D/Y because I live in the United States. Be sure to use the **12- to 24-Hour Time Conversion Chart** to make sure you set the time correctly.

12- to 24-Hour Time Conversion Chart	
Settings for a.m.	
12:00 a.m. = 00:00 (midnight)	06:00 a.m. = 06:00
01:00 a.m. = 01:00	07:00 a.m. = 07:00
02:00 a.m. = 02:00	08:00 a.m. = 08:00
03:00 a.m. = 03:00	09:00 a.m. = 09:00
04:00 a.m. = 04:00	10:00 a.m. = 10:00
05:00 a.m. = 05:00	11:00 a.m. = 11:00
Settings for p.m.	
12:00 p.m. = 12:00 (noon)	06:00 p.m. = 18:00
01:00 p.m. = 13:00	07:00 p.m. = 19:00
02:00 p.m. = 14:00	08:00 p.m. = 20:00
03:00 p.m. = 15:00	09:00 p.m. = 21:00
04:00 p.m. = 16:00	10:00 p.m. = 22:00
05:00 p.m. = 17:00	11:00 p.m. = 23:00

Note: There is no 24:00; 23:59 is followed by 00:00.

[Language]

The E-M1 is multilingual. It can use one of 34 languages for on-screen displays and error messages. Most likely your camera will come from the factory with the correct language already chosen for your area. However, if you prefer another language, simply scroll through the list and select your choice. Here's how.

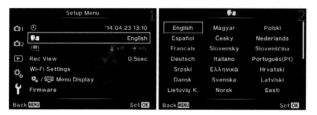

Figure 7.3: Choosing one of 34 languages for your camera

Use the following steps to select a language for your camera:

1. Choose the [Language] symbol from the Setup Menu. The symbol looks like a face with a speech bubble. Scroll to the right (figure 7.3, image 1).
2. As seen in figure 7.3, image 2, a screen will appear with a list of 34 languages (use the Arrow pad to scroll down and see all the languages). Highlight the language you want to use—if you are changing it from English—and press the OK button to Set the language.

Settings Recommendation: Most readers of this book will leave the camera set to the default of English, as I did in figure 7.3, image 2. If you are not a native English speaker, you may be more comfortable with a different language. You should be able to find your language by examining the list. The E-M1 has 10 or 15 more languages than most other cameras I've used.

[Monitor Adjustments]

The [Monitor Adjustments] setting lets you control two aspects of your camera monitor display: hue (color temperature) and brightness level. Each setting has an adjustment slider. You can also set the amount of monitor color saturation with two settings: Natural and Vivid. Let's see how.

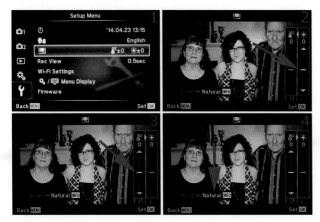

Figure 7.4: Changing the monitor hue, brightness, and color saturation

Use the following steps to change the monitor hue, brightness, and saturation. You can adjust one of the settings or all three:

1. Select the [Monitor Adjustments] symbol from the Setup Menu. It looks like a small screen with an adjustment slider beneath it (figure 7.4, image 1). Scroll to the right.
2. The next screen has two adjustable sliders. The brightness slider is on the right and has a sun symbol on top; it is automatically selected (figure 7.4, image 2). There are 14 steps of brightness change—seven steps (0 to +7) to increase brightness and seven steps (0 to −7) to decrease brightness. Choose a brightness level by scrolling up or down with the Arrow pad. The monitor will immediately reflect the brightness change. If you don't want to change the hue setting, press the OK button, which Sets the brightness level. If you do want to change the hue, don't press the OK button; instead, scroll to the left with the Arrow pad to select the hue slider.
3. The hue slider has a thermometer symbol at the top to indicate color temperature (figure 7.4, image 3). To adjust it, scroll up or down with the Arrow pad. There are 14 steps of hue change—seven steps (0 to +7) to cool down the image (add blue) and seven steps (0 to −7) to warm up the image (add red). The monitor will immediately reflect the change in hue. Press the OK button to Set all changes, or move on to the color saturation setting.
4. The camera has a special feature for those who want a more color-saturated monitor view. You can see the Vivid and Natural selections in figure 7.4, image 4, at the red arrow. If you select Vivid, the monitor will display a more saturated image than the actual scene. Natural reflects the scene as it actually appears. This setting affects only the camera monitor and does not change the saturation of the photograph, which is controlled by other settings such as the Picture Mode (e.g., Portrait, Muted, Natural, and Vivid). Choose a monitor saturation setting by pressing the Info button. You will see the selection change at the red arrow in figure 7.4, image 4. After you make your selection, press the OK button to Set your choices.

Note: The [Monitor Adjustments] settings affect only the monitor on the back of the camera. The electronic viewfinder (EVF) is not affected by the changes you make to the [Monitor Adjustments] setting.

 Settings Recommendation: The brightness setting is useful when you want to manually control the brightness level of the monitor. The hue and saturation settings are rather subtle. Unless you want to make the camera monitor more closely match the appearance of a profiled computer monitor, the hue and saturation settings may not be useful to most people.

Rec View

The unusually named Rec View sets the amount of time an image is displayed on the camera monitor, or in the viewfinder, after you press the Shutter button.

 Here's how to adjust the Rec View time.

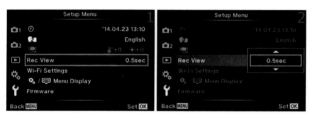

Figure 7.5: Setting a Rec View time for image display on the viewfinder or in the monitor

Use the following steps to choose how long your camera displays a picture after you take it:

1. Choose Rec View from the Setup Menu and scroll to the right (figure 7.5, image 1).
2. Use the up/down menu that appears to select a time from 0.3 to 20 seconds (0.3sec to 20sec), or choose Auto to let the camera decide. Press the OK button to Set the Rec View time. I chose one-half second (0.5sec) (figure 7.5, image 2).
3. After you take your pictures, the camera will display the image either in the viewfinder or on the monitor (mutually exclusive) for the Rec View display time you selected.

Settings Recommendation: If you have previously used a camera with an optical viewfinder (OVF), you may have to adjust your thinking when you use the E-M1 and its electronic viewfinder (EVF). With an OVF, it doesn't matter how long an image appears on the monitor because the OVF is not used to view images after you take them.

 With an EVF it can be surprising to see the picture you just took appear in the viewfinder because it briefly obscures your view of the subject, which seems to freeze in the viewfinder. Having used mostly Nikon cameras before getting my E-M1, I was totally unprepared for the viewfinder to display the image. On my Nikon cameras I had the image

display on the camera monitor set to at least one minute so I could show off my cool images after I took them (or at least admire them myself).

When I set Rec View to more than a half second so I could see my picture on the monitor longer, I was shocked when my subject seemed to freeze in the viewfinder while the EVF displayed the new photo during the Rec View time period. It seemed to disconnect me from the subject. I quickly set the Rec View time back to 0.5 second, which seems about right. You will briefly see your picture and then you can take more. But what if you are shooting action shots and don't want anything to obscure your viewfinder and cause you to lose tracking on your subject?

I eventually discovered that if you never fully release the Shutter button, and instead hold it halfway down while you shoot, the camera does not display the image in the viewfinder. When you release the Shutter button, the camera will display the last image you took until the Rec View time ends. Try it!

It's a good idea to set the Rec View period to a short value and press the Playback button to see your image on the monitor, or in the viewfinder if the light is too bright to see the monitor.

Wi-Fi Settings

The Wi-Fi Settings function has several parts that allow you to access the images on your memory card and transfer them to your smartphone or tablet; I'll call them smart devices. Olympus provides a free app called Olympus Image Share (OI.Share) for iOS (iPad, iPhone, iPod Touch) and Android devices.

The camera and app combo allows you transfer pictures to your smart device or to a friend's device. If you want to allow only certain people to access your memory card, you can mark images with the Share Order system. We'll talk more about Share Orders momentarily.

First, though, let's examine how to configure the settings for Wi-Fi and the ways you can connect to your camera with a smart device.

Use the following steps to configure the Wi-Fi system. After you start Wi-Fi, you can touch the Wi-Fi icon on the camera monitor, or select Connection to Smartphone from the Playback Menu, and the Wi-Fi system will function the way you want it to.

Figure 7.6A: Wi-Fi Settings configuration

1. Select Wi-Fi Settings from the Setup Menu and scroll to the right (figure 7.6A). There are four menu items on the Wi-Fi Settings menu. The following steps and figures describe each one.

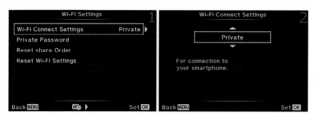

Figure 7.6B: Preparing the Wi-Fi connection type

2. Figure 7.6B continues where figure 7.6A leaves off. The first item on the Wi-Fi Settings menu is Wi-Fi Connect Settings. Choose it from the menu and scroll to the right (figure 7.6B, image 1).

3. You will now see an up/down menu with the following choices (figure 7.6B, image 2):
 - **Private:** You will connect to the camera with your smart device by using the same camera-supplied password each time, as shown on the camera's active Wi-Fi screen with the QR code. This password will not change unless you manually change it, as described in the next step.
 - **One-Time:** You will connect to the camera with your smart device with a new camera-supplied password each time, as shown on the camera's active Wi-Fi screen with the QR code.
 - **Select:** This very convenient feature offers you the choice of Private or One-Time connection in a menu that pops up when you start the camera's Wi-Fi.
 - **Off:** Wi-Fi is disabled when you select Off.

 Make your selection from the up/down menu, press the OK button, and your changes will be Set.

Figure 7.6C: Changing the Private Password for Wi-Fi sessions

4. You can change your camera's current Wi-Fi Private Password. Select Private Password from the Wi-Fi Settings menu and scroll to the right (figure 7.6C, image 1).

5. The Private Password change screen will display the current Password. Press the Movie button on top of the camera (with red dot in the middle), and the camera will generate a new Password and display it (figure 7.6C, image 2, red arrow). Each time you press the Movie button a new Password will appear.

6. When the Private Password has been changed, press the OK button to confirm the change.

Figure 7.6D: Resetting a Share Order

7. The camera allows you to create a Share Order that lets you mark individual images as shareable. When you allow someone to connect to your camera with their smart device (they need to install the OI.Share app), you can prevent them from seeing anything except the marked images. For example, you could take images at a party, mark the ones you want to share, and have a friend connect to your camera and download the marked images. (See the chapter called **Screen Displays for Camera Control**, on page 86, under the subheading **Share Order**, for instructions to create a Share Order.) If you have marked images in a Share Order and no longer want people to access them, you can reset the Share Order by selecting Reset share Order from the Wi-Fi Settings menu and scrolling to the right (figure 7.6D, image 1).

8. You will now see a menu with Yes and No choices (figure 7.6D, image 2). Select Yes to reset the Share Order or No to cancel and leave the Share Order intact. Press the OK button to execute your choice.

Figure 7.6E: Resetting the Wi-Fi system to factory defaults

9. To reset the Wi-Fi system to the factory defaults, select Reset Wi-Fi Settings and scroll to the right (figure 7.6E, image 1).

10. You will see a menu with Yes and No choices (figure 7.6E, image 2). You will also see a warning that says *Caution Resetting All Wi-Fi Settings*. Select Yes to reset the Wi-Fi system to the factory default, or select No to cancel and leave the current settings intact. Press the OK button to execute your choice.

Settings Recommendation: These Wi-Fi settings give you some flexibility in how your Wi-Fi system works. I leave my camera's Wi-Fi Connect Settings set to Select so my camera will offer me a Private Wi-Fi session or a One-Time Wi-Fi session if I want to give images to someone. All they need is a smart device and the free Olympus Image Share app, and I

can create a Share Order to wirelessly give them selected images from my camera. It's the neatest thing I've seen since zoom lenses were invented.

Can You Connect Your Computer to Your E-M1?

You can start Wi-Fi on your camera and connect to your computer with its Wi-Fi connection tool. The connection name and password are provided on the E-M1's active Wi-Fi screen (the one with the QR code). However, as of January 2015 Olympus has not provided software to support that connection for PC or Mac.

Being the curious type, I connected my iPad to my E-M1 and ran a network tool called Fing (free in the iOS and Android app stores) to find out that the IP address of my camera was 192.168.0.10. I connected my computer to the camera's Wi-Fi access point and provided the password from the camera. The computer connected to the camera with no problems.

Nothing happened since there was only an active Wi-Fi connection and no Olympus-supported software to use the connection. I looked under the network section of File Explorer and found that nothing was listed. I was able to ping the camera's IP address and received a reply, so a real connection existed.

I then tested three web browsers (Internet Explorer, Firefox, and Chrome) by typing 192.168.0.10 in the address bar, and I was able to connect to oishare/DCIM. Unfortunately, the browser did not display anything. I even tried connecting to http://192.168.0.10 using various URLs, such as http://192.168.0.10/oishare and http://192.168.0.10/oishare/DCIM, with no results. I marked some images for sharing via Wi-Fi with the camera's Share Order system, but no images were displayed. For curiosity's sake, I tried the same with https://and ftp://headers, but other than the initial browser connection to oishare/DCIM, nothing else was available.

Since browsers weren't doing the job, I tried mapping a drive to \\192.168.0.10\oishare\DCIM (and various other UNC path combinations), but still no joy!

Note: While I was talking about this subject on the Facebook page for this book, one member reported that when he did the same things he was able to access his photos in his web browser. He was using Windows 8.1, and I am using Windows 7. Maybe I should upgrade. You can also access your images with an iOS or Android smart device by direct connection, as previously described.

The potential for Wi-Fi local area network (LAN) connectivity is there, but Olympus has not fully implemented it yet. They really should provide connectivity software for wireless computers. The Wi-Fi system in the camera works so well from a smart device, so it would be a shame not to control the camera from a studio computer too. This is a professional camera, after all.

By the way, I also found that the camera allows only one Wi-Fi connection at a time, so you cannot connect multiple devices to the camera simultaneously.

Note: In October 2014, the Olympus firmware update version 2.0 provided extra functionality for those who need to use the camera in a studio environment. Though it is not a Wi-Fi solution, Olympus released their *Olympus Capture* software, which allows you to use a USB cable to tether your E-M1 to your computer.

Running the Olympus Capture software on the computer lets you control the camera remotely with a live view of your subject on your computer screen. You have full control of the camera through the Olympus Capture software on your computer. Visit the following website for more information on Olympus Capture software:

http://www.getolympus.com/us/en/olympuscapture

Menu Display

The camera has two menus that are normally hidden. One of them should *not* be, for people who want to use their camera as more than a point-and-shoot. The two hidden menus are the Custom Menu, which contains nearly 100 configurable camera settings, and the Accessory Port Menu, which is a special menu for people who have Olympus PEN cameras and have used its Accessory Port with an Olympus Bluetooth Peanut storage and transmitter device.

Along with its excellent free app, Olympus Image Share, the E-M1 has full Wi-Fi capability. I can import images to smart devices and maybe even to a computer when Olympus provides PC and Mac software, as they have for iOS and Android.

In talking with senior technical support at Olympus, I found out that the Peanut device has relatively obsolete technology. In fact, due to rapid changes in wireless technology after its development, the Peanut device works with only a few older smartphones and no iOS devices. There is a list of Peanut-compatible smartphones at this website:

http://www.olympusamerica.com/files/oima_cckb/
PENPAL_Smartphone_Compatibility_EN.pdf

Since the E-M1 has full Wi-Fi capability, including the *potential* for working with a wireless LAN, very few people will need to use the Accessory Port Menu. It supports only the Olympus Peanut's Bluetooth PenPal system to send pictures to a few devices.

Instead of using a Peanut device, simply fire up the camera's built-in Wi-Fi system and have people retrieve images over a Wi-Fi connection, which is faster, easier to use, and more stable than Bluetooth image transfers.

I decided not to include instructions for a device that is mostly obsolete. If you have a Peanut device and want to experiment with it on your E-M1, enable the Accessory Port Menu and refer to the user's manual for your Peanut device. If you want to use Wi-Fi for image transfers, you can safely ignore the Accessory Port Menu and enable only the Custom Menu.

Now, let's examine how to enable the extremely important Custom Menu and the Accessory Port Menu.

Use the following steps to enable the Custom Menu and Accessory Port Menu:

1. Choose the Menu Display setting from the Setup Menu and scroll to the right (figure 7.7A).

 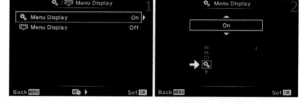

Figure 7.7A: Enabling the Custom Menu and the Accessory Port Menu

Figure 7.7B: Enabling the Custom Menu

2. Figure 7.7B takes up where figure 7.7A leaves off. The first option is the [Custom] Menu Display (figure 7.7B, image 1). Select the [Custom] option, which has small gears followed by Menu Display, and scroll to the right.

3. You will see an up/down menu that has two choices: On and Off. The gear icon for the Custom Menu (figure 7.7B, image 2, white arrow) will appear only if you select On. Press the OK button to enable the Custom Menu. If you select Off and press the OK button the Custom Menu will be disabled.

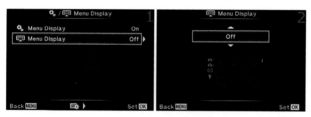

Figure 7.7C: Enabling the Accessory Port Menu

4. If you have an Olympus Peanut and want to use it with your E-M1, you can enable the Accessory Port Menu. Choose the second Menu Display option (figure 7.7C, image 1). The symbol for this option looks like a computer monitor. Scroll to the right.

5. Choose On or Off from the up/down menu (figure 7.7C, image 2)

6. After you make your selections, press the OK button to lock them in. Now you can see the menus you enabled when you press the Menu button.

Settings Recommendation: Most people can ignore the Accessory Port Menu selection and leave it Off (factory default). Most enthusiasts will use the Custom Menu often, so you should enable it and leave it active.

Firmware

The Firmware setting displays the current camera and lens firmware versions. You cannot do anything with this setting except see the version number and decide if you need to update the firmware in your camera or lens.

At the time of this writing, firmware version 1.3 had just been released and is installed on the camera. The lens on the camera I used for this book is an M.Zuiko PRO 12–40mm f/2.8 ED. Its current firmware version is 1.0.

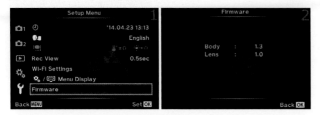

Figure 7.8: Viewing the firmware version

Use these steps to view the firmware version of your camera and mounted lens:

1. Select Firmware from the Setup Menu and scroll to the right (figure 7.8, image 1).
2. You will see two Firmware fields if you have a lens mounted on your camera. If no lens is mounted, you'll see only one field. Body is the current firmware version for the camera body (version 1.3 in my E-M1). Lens is the current firmware for the lens mounted on my camera (version 1.0) (figure 7.8, image 2).

Settings Recommendation: You can update the firmware in your camera and lenses by using the Olympus Digital Camera Updater software, which you can download from the following website:

http://www.olympusamerica.com/cpg_section/cpg_downloads_updater.asp

Download the software to your computer and use the included USB cable to keep your camera and lens firmware up to date.

Author's Conclusions

We've come a long way together, from taking a fresh camera out of the box with its myriad configuration abilities, to having a fully configured Olympus OM-D E-M1 ready to take on nearly any photographic task.

Thank you for sticking with me until the end of this technical book. I hope it has been useful to you and has helped you master your incredibly powerful and complex E-M1, one of the best mirrorless cameras on the market today.

Please write a short review of this book at the website of the retailer where you purchased it. Your good review can really help the book succeed.

I hope to stay in touch with you to answer questions and give you a place to report any major typos or logic errors you might find in this book. I created a special, non-public Facebook group called **Master Your Olympus** (MYO), at the following web address:

https://www.facebook.com/groups/MasterYourOlympus/

Please request membership at the Facebook site so we can discuss Olympus cameras, lenses, and photography as a community of enthusiasts who help one another.

Again, thank you for buying my book (and reviewing it, if you will). Until we meet again,

Keep on capturing time …

Appendix: Button Tasks Reference

Image © Darrell Young

The Button tasks are a group of 28 tasks that you can assign to various buttons on the camera. Let's examine each of the Button Functions. The tasks in this subsection are in alphabetical order for ease of reference.

This following **Button Tasks List** is a reference list of the 28 assignable Button tasks. Not all tasks can be assigned to all Button functions. In other words, each Button function may have a subset of the Button tasks assigned to it.

Following this list of assignable tasks you will find instructions for assigning these tasks to individual Button functions.

Here is a page number list for each task:

Appendix Page Numbers for the 28 Button Tasks

Button Tasks List

AEL/AFL

Press the button to assign AEL (autoexposure lock), AFL (autofocus lock), or Start AF (initiate autofocus) to a button. Which functionality is available is directly controlled by how you have the AEL/AFL settings (S-AF, C-AF, and MF) configured and selected in the AF/MF section of the Custom Menu *(Custom Menu > A.AF/MF > AEL/AFL)*.

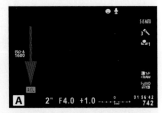

Figure 1: Using the AEL/AFL function

This task may be assigned to all assignable Button functions.

When you press the button that has been assigned to AEL/AFL, you should see a symbol appear in the location shown in figure 1 (red arrow). Pressing the button again turns off AEL/AFL and the symbol will disappear. Of course, if you have mode3 or mode4 selected under **Custom Menu > A.AF/MF > AEL/AFL > C-AF,** no symbol will display because that setting causes AF Start to activate, which requires no symbol.

[•••] AF Area Select

Press the button to assign the AF Target or which AF point to use in the grid of 81 AF points with m4/3 lenses or 37 AF points with 4/3 lenses.

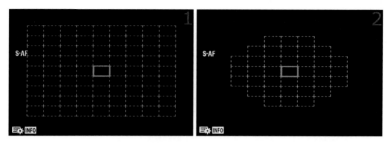

Figure 2: Using the AF Area Select function

Figure 2 shows one of the screens you will see when you press a button with factory-default [•••] AF Area Select assigned to it. If you are using an m4/3 lens you will see the screen shown in image 1, which has 81 AF points. If, instead, you are using a 4/3 lens with an Olympus MMF adapter, you will see the screen shown in image 2, which has 37 AF points. You can move the AF Area Pointer (green rectangle) around within the total number of AF points to select target areas on your subject for autofocus.

For the rest of this function description, we will use the 81-point m4/3 screen for sample screen images. Please keep in mind that if you normally use 4/3 lenses, the 37-point screen (figure 2, image 2) is what you will see with that lens type mounted.

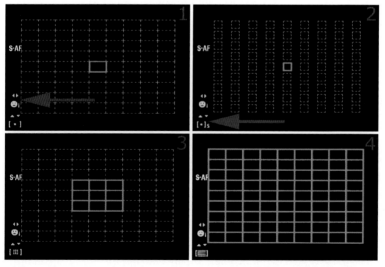

Figure 3: Selecting Face Priority and AF Target (press Info button to open controls)

Figure 3, image 1, shows a change to the [•••] AF Area Select screen when you press the Info button with the [•••] AF Area Select screen active. Notice in figure 3, image 1 that the red arrow is pointing to the small face symbol, with left (◄) and right (►) pointers just above it. By pressing left or right on the Arrow pad, you can adjust the Face Priority method, selecting one of the four modes we considered in the **Face Priority** subsection in chapter 6 (starting on page 291).

Just below the Face Priority setting is the AF Target setting (figure 3, image 2, red arrow). Notice that the AF Target setting has a representation of an AF Target along with up (▲) and down (▼) pointers. By pressing up or down on the Arrow pad, you will change the AF Target type from the default of Single Target, to Small Target, Group Target, or All Target.

Following is a description of each setting:

- **Single Target** (Figure 3, image 1): The Single Target function allows you to choose a single AF-point target that you can scroll around the screen with the Arrow pad, positioning the AF point where you would like on your subject. This is the default setting.
- **Small Target** (Figure 3, image 2): This setting is very similar to the Single target setting in that you can scroll the AF Area Pointer around the screen, positioning it where you would like it to be. The difference is in the size of the AF Area Pointer. Each AF point is significantly smaller than the normal green rectangle, which tends to make it more detail sensitive for smaller subjects. If you are doing macro photography and want to focus on a very small area of the subject, this is the best setting.
- **Group Target** (Figure 3, image 3): When this setting is selected, the camera uses an array of nine AF points in a small grid. The camera will decide which of the nine AF-point targets to use from within the grid, for best focus. You can move the entire nine-point group around the screen, just like with a single AF-point target. This grid arrangement allows you to use a much larger area to initially determine autofocus, by using nine AF points when Group Target mode is selected.
- **All Targets** (Figure 3, image 4): This setting allows the camera to decide which AF-point target to use for best autofocus. You have no choice as to which part of the subject(s) your camera will focus on.

Figure 4, image 1 (red arrow) shows the Face Priority adjustment, which appears when you press the Info button while the [•••] AF Area Select screen is active. By pressing left or right on the Arrow pad, as signified by the small ◄► pointers above the face symbol, you can select one of the Face Priority modes, or turn it off. See the subsection titled **Face Priority** on page 291.

Figure 4: Setting the Face Priority mode

The [•••] AF Area Select function may be assigned to any assignable button, except for Arrow pad right and Arrow pad down.

AF Stop

Press the L-Fn button on your camera's lens to manually lock focus where the lens is currently focused (figure 5). You must hold the button down to maintain focus lock. This function is available only on lenses with an L-Fn button.

AF Stop is not available for assignment to any of the buttons on the camera's body. It can be assigned to the L-Fn button only.

Figure 5: Using the L-Fn button

The red arrow in figure 5 shows the location of the L-Fn button on the M.Zuiko PRO 12–40mm f/2.8 ED Lens. It will probably be in a similar location on other lenses.

BKT

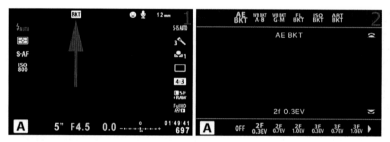

Figure 6: Bracketing (BKT) assignment and adjustment

Pressing the button toggles bracketing on and off, using the current BKT settings. You will see BKT appear in the top left of the viewfinder or monitor when bracketing is enabled (figure 6, image 1).

If you press and hold the assigned button for a moment, you will see the BKT menu appear. With the BKT menu you can modify the BKT settings (figure 6, image 2). Turning the Front Dial lets you modify the bracketing type listed at the top of the screen (e.g., AE BKT, WB BKT, ISO BKT). Turning the Rear Dial lets you control the settings along the bottom of the screen for each of the BKT methods.

Before you try to use bracketing, be sure that the BKT symbol is displayed at the top of the screen (figure 6, image 1). Once again, you press (not hold) the assigned button to toggle it on and off.

Let's consider how to use each of the camera's six bracketing systems.

AE BKT: Auto exposure bracketing allows you to shoot a number of bracketed images—from 2 to 7 in the bracket—while varying the exposure between each shot by 0.3, 0.7, or 1.0 EV steps. This allows you to capture a series of images with varying exposure values for either: selecting the best-exposed image from the series, or later combining the images into one high-dynamic-range (HDR) image.

As shown in figure 7, if you hold the assigned button and turn the Rear Dial, you can modify the number of frames in the bracket (i.e., 2F, 3F, 5F, 7F) and the amount of EV differential between each image in the bracket (i.e., 0.3 EV, 0.7 EV, 1.0 EV), as seen at the bottom of the screen (e.g., 2F 0.3EV, 2F 1.0EV).

On my camera 2F 1.0EV is selected, which means the camera will take 2 pictures (2F) with a one stop (1.0EV) difference between them.

Figure 7: AE BKT—Autoexposure bracketing

WB BKT A-B: This method of white balance (WB) bracketing lets you shoot one image and have the camera bracket the WB of the image on the Amber-Blue (A-B) axis.

As shown in figure 8, if you hold the assigned button and turn the Rear Dial, you can select two, four, or six steps of color change for the A-B axis. The camera will then create one WB-modified copy of the original image for each bracket step (3F = 3 images total).

In other words, if you selected 3F 2 Step, as seen at the bottom of the screen in figure 8, the camera will create a normal image (A+0), a minus amber image (A-2), and a plus amber image (A+2).

Figure 8: WB BKT A-B—White balance bracketing on the Amber-Blue axis

The more steps selected (2 Step, 4 Step, or 6 Step), the wider the range of color change. You can combine this bracketing method with the WB BKT G-M method discussed next—by setting them both at the same time—and have both axes (A-B and G-M) of color shift bracketed simultaneously.

WB BKT G-M: This method of white balance (WB) bracketing lets you shoot one image and have the camera bracket the WB of the image on the Green-Magenta (G-M) axis.

As shown in figure 9, if you hold the assigned button and turn the Rear Dial, you can select two, four, or six steps of color change for the G-M axis. The camera will then create one WB-modified copy of the original image for each single-axis bracket (3 images total).

In other words, if you selected 3F 2 Step, as seen at the bottom of the screen in figure 9, the camera will create a normal image (G+0), a minus green image (G-2), and a plus green image (G+2).

Figure 9: AE BKT—WB BKT G-M—White balance bracketing on the Green-Magenta axis

The more steps selected (2 Step, 4 Step, or 6 Step), the wider the range of color change. You can combine this bracketing method with the WB BKT A-B method discussed previously—by setting them both at the same time—and have both axes (A-B and G-M) of color shift bracketed simultaneously.

FL BKT: Flash bracketing causes the camera to vary the light output of the flash for three frames (3f) so that you can have the best exposure at the end of the bracket.

As shown in figure 10, if you hold the assigned button and turn the Rear Dial, you can select from 0.3EV, 0.7EV, or 1.0EV as the level of bracketing, which gives you as little as 1/3 stop between the images in the bracket and as much as 1.0 stop.

Figure 10: FL BKT—Flash bracketing

The bracketing order for the three frames is normal > underexposed > overexposed. The camera will take a normal exposure using the flash and then two more exposures with under- and overexposure governed by whether you select 0.3EV, 0.7EV, or 1.0EV.

My camera has 3F 0.3EV selected, which means it will take three (3F) pictures with 1/3 step (0.3EV) of exposure differential between each picture.

ISO BKT: ISO bracketing allows you to bracket three frames with a bracket level of 0.3EV, 0.7EV, or 1.0EV for two of the three pictures. The bracket order for the three frames is normal > underexposed > overexposed.

As shown in figure 11, if you hold the assigned button and turn the Rear Dial, you can select 3 frames with 0.3EV, 0.7EV, or 1.0EV exposure differential between them.

Figure 11: ISO BKT—ISO sensitivity bracketing

The camera will take a picture at the ISO sensitivity you have currently selected. You can then take two more pictures, one with an underexposed and another with an overexposed ISO sensitivity, per the EV value selected (0.3EV, 0.7EV, or 1.0EV).

My camera has 3F 0.3EV selected, which means it will take three (3F) pictures with 1/3 step (0.3EV) of exposure differential between each picture.

ART BKT: When using Art bracketing, the camera will make 12 copies of one picture with each of the Art filters applied (ART1–Art12).

If you hold the assigned button and turn the Rear Dial, you can set ART BKT to On (figure 12). You will then take only one normal picture and the camera will Art bracket that image by applying one of each of the 12 Art filters to a new copy of the image, leaving you with 13 pictures when it is done—one normal and 12 Art filtered copies.

Figure 12: ART BKT—ART filter bracketing

The BKT function may be assigned to any assignable button, except for Arrow pad right and Arrow pad down.

Note: Please see the chapter **Shooting Menu 2** under the heading **Bracketing** (page 202), for even deeper detail on each of these bracketing types. The E-M1 gives you multiple ways to approach image bracketing, both by assigning it to a button (this function), and also from Shooting Menu 2 *(Shooting Menu 2 > Bracketing)*.

Digital Tele-converter

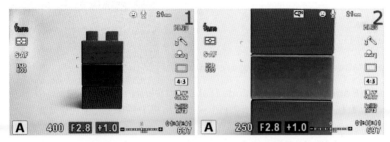

Figure 13: Using the Digital Tele-converter (2x fake zoom crop)

Pressing this button artificially enlarges the current subject in the camera's viewfinder or monitor by two times (2x). Figure 13, image 1, shows the normal subject on the camera's monitor, while image 2 shows it when the assigned button is pressed. You can toggle this effect on and off by repeatedly pressing the assigned button.

This is an in-camera digital enlargement, sort of like cropping the middle out of an image. It is not an optical zooming operation. When you take the picture, the camera acts like it has a much longer telephoto lens mounted.

However, this is an artificial enlargement of the subject and lowers image quality. This works the same as **Shooting Menu 1 > Digital Tele-converter,** except that it can be toggled on and off with the button. This function may be assigned to any assignable button, except for Arrow pad right and Arrow pad down.

Electronic Zoom

Press the button to enable the power zoom function for a lens having power zoom. After you press the button you can use the Arrow pad left and down keys to zoom in and out. This function is available only for the Arrow pad right and Arrow pad down buttons, and only when you have the main Arrow pad [◄ ▲ ▼ ►] function set to Direct Function mode **(Custom Menu > B. Button/Dial/Lever > Button Function > [◄ ▲ ▼ ►] Function)**.

There are no extra camera screens that will show when you press the Arrow pad buttons. Instead, you will see the lens zoom in or out.

Exposure +/−

Press the button to toggle the camera's exposure compensation system on or off. When using P, A, S, or M modes on the Mode Dial you will see exposure compensation controls appear above the shutter speed and aperture area of the cameras screens (figure 14, red arrows), when you enable Exposure +/−.

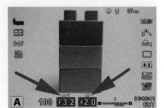

Figure 14: Using Exposure +/− (compensation)

You will make adjustments with the ▲▼◄► buttons on the Arrow pad, according to which exposure mode you are using. You can adjust exposure compensation in up to −5.0 to +5.0 EV steps.

Here is a description of your choices:

Exposure compensation in various exposure modes:

- **Program Mode (P and Ps):** When the Mode Dial is set to Program (P) or Program shift (Ps) mode, the ▲▼ buttons control entry and exit from Ps mode, while the ◄► buttons control exposure compensation (+/−5.0 EV).
- **Aperture-Priority (A) Mode:** When using Aperture-priority (A) mode, the ▲▼ buttons control the aperture directly, while the ◄► buttons control +/− exposure compensation by modifying the shutter speed (+/−5.0 EV).
- **Shutter-Priority (S) Mode:** When using Shutter-priority (S) mode, the ▲▼ buttons control the shutter speed directly, while the ◄► buttons control +/− exposure compensation by modifying the aperture (+/−5.0 EV).
- **Manual (M) Mode:** When using Manual (M) mode, the ▲▼ buttons control the shutter speed directly, while the ◄► buttons control the aperture directly (+/−5.0 EV). Exposure compensation will be handled by you, manually, while examining the small +/− exposure indicator to the right of the shutter speed aperture area.

Note: If you would prefer, you can use the front and rear dials to make the same adjustments otherwise made by the Arrow pad's ◄▼▲► buttons, when using this function.

This function can be assigned to all assignable buttons.

Flash Mode

Press the button to open a flash mode (e.g., Flash Auto, Redeye, Fill in) selection screen (figure 14, image 1). This function is available only for the Arrow pad right and Arrow pad down buttons, and only when you have the main Arrow pad [◄▲▼►] function set to Direct Function mode. When you press the Arrow pad key to which you have assigned this function (right or down buttons only), you can select a Flash mode.

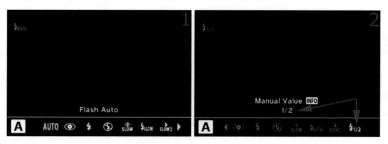

Figure 15: Using the flash modes

Figure 15, image 1, shows the screen you will see when you have assigned Flash Mode to one of the two available Arrow pad buttons and press the button. Along the bottom of the screen are eight available modes. You will use the left and right Arrow pad buttons to move the selection back and forth until you find the mode you want to use.

Figure 15, image 2, shows how to use Full (Manual Value). By selecting the last flash item on the right you will put the camera into manual flash mode. Once you have selected Full, you may press the Info button once and then turn the camera's Rear Dial to select from a range of manual flash output values, as described in our upcoming list. Image 2 shows that my camera has a Manual Value of 1/2 (half) power selected (red arrows).

Here is a description of your Flash Mode choices, in camera order from left to right:

- **Flash Auto:** This setting lets the camera decide when to fire the external flash attached to the camera's hot shoe.
- **Redeye:** This setting causes the flash to fire a short preflash and blink the bright red Focus assist light twice, just before the main flash burst fires. Hopefully, the two bright light sources shining in your subject's eyes just before the flash fires will cause your subjects pupils to contract, thereby reducing any red-eye reflections.
- **Fill in:** The flash fires regardless of the current ambient light conditions. Use this mode to have complete control over the flash at all times. This mode causes the flash to be the main source of light for your pictures.
- **Flash Off:** This setting disables the camera's flash signal so that a flash mounted in the camera's hot shoe will not fire under any circumstances. It will also disable your camera's ability to use flash RC Mode *(Shooting Menu 2 > RC Mode)* for remote control of external flash units.
- **Red-Eye Slow:** Selecting this function causes the camera to use both Redeye (red-eye reduction) and Slow (1st curtain) sync at the same time. Refer to Redeye and Slow elsewhere in this list for how these two functions work and then mentally add them together.
- **Slow** (1st curtain): This setting causes the camera to fire the flash as soon as the camera's first shutter curtain opens (beginning of the shutter speed cycle). In other words, if you have your camera set to a shutter speed of 1/125 sec, the flash will fire just as the camera starts timing the 1/125 second shutter open time. After the flash has fired, the camera uses ambient light for the rest of the 1/125 second shutter open time to balance out the exposure. This is perfect for shooting silhouetted subjects, or subjects where the background is important, because it will balance the flash with a bright background. However, be careful when you are shooting in this mode with low light levels. You may not be able to handhold the camera without subject ghosting due to slow shutter speeds. If low-light ghosting occurs—due to subject or camera movement—there will be both a sharp and blurred copy of your subject in the frame. The blurred (non-flashed) subject will appear as a trail in front of the sharp (flashed) subject.

- **Slow2** (2nd curtain): This setting causes the camera to fire the flash after the first shutter curtain has opened, the shutter speed time has passed, and the second shutter curtain is about to close. In other words, if you have your camera set to a shutter speed of 1/30 sec, the camera will use ambient light for the 1/30 second shutter open time, and then the flash will fire as soon as 1/30 second shutter speed has passed. For a moving subject you will see a sharp subject (flashed) followed by a blurred subject (non-flashed). This allows you to shoot pictures of moving subjects with a blur behind it. Again, as with Slow (1st curtain), be very careful when shooting in low-light levels. Otherwise, camera shake may ruin the picture.
- **Full:** This mode sets the camera to manual mode for the flash output (Manual Value). You can control the amount of flash from Full power (1:1) or from a range of 1/1.3 to 1/64 power. For someone who wants to control the flash output very precisely, such as a studio photographer, this mode may be very useful.

Settings Recommendation: I was shooting a graduation ceremony with the E-M1, and had the flash set to Flash Auto accidentally. The room was dark so the camera decided to use the flash for each graduate picture. However, afterward, I tried to take a picture of the large sheet cake for the graduates to snack on. I could not get the flash to fire. Finally, I cranked the aperture down to a small value and the flash decided to fire. Only then did I realize I had the flash set to Auto mode. Therefore, if you want to fully control the flash during an important event, why not use Fill in or another mode instead. Then you can control when and where you want the flash to fire.

Slow and Slow2 mode can be used to balance the flash with ambient light for nonmoving subjects. For moving subjects you will see a trail in front of the subject in Slow mode and a trail behind the subject in Slow2 mode. If you want to shoot a picture of a friend running by in front of you, the Slow2 mode will allow you to imply motion in an otherwise static picture. The blurred trail behind the subject makes it seem to be moving quickly.

I generally leave my camera set to flash Fill in mode, unless I am trying to achieve special effects with the other modes.

HDR

Press the button to enable the HDR mode for immediate use. Press the button again to disable HDR mode. The camera will use the settings you last used for HDR (e.g., HDR1, 3f 2.0EV, 5f 3.0EV). You can adjust the HDR settings in Shooting Menu 2 under the HDR function *(Shooting Menu 2 > HDR)*.

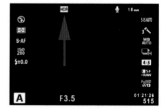
Figure 16: HDR on demand

When HDR mode is active, the HDR symbol will appear in the top left area of the screen (figure 16). This function may be assigned to any assignable button, except for Arrow pad right and Arrow pad down.

[•••] Home

This function works in conjunction with the Custom Menu function called [•••] Set Home, found under the AF/MF settings *(Custom Menu > A. AF/MF > AF/MF > [•••] Set Home)*.

You can store a single autofocus-point target (AF Target) position from the camera's 81 AF-points (or 37 for Four Thirds lenses) in the [•••] Set Home memory location. Then, when you assign the [•••] Home function to one of the camera's buttons, and press that button, the camera immediately moves the AF Area Pointer (green focus rectangle) to the AF Target position stored in [•••] Set Home (figure 17).

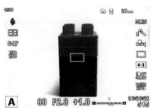

In figure 17 my camera's AF Target [•••] Home position was previously set to the center of the 81 AF points. I pressed the button and the AF Area Pointer (green focus rectangle) jumped from where it had been before to the home position in screen center. Once in home position, if the button is pressed again, the AF Area Pointer will return to its previous position—if it was moved away from its home position.

Figure 17: Jumping the AF Area Pointer to the Home position

This function may be assigned to any assignable button, except for Arrow pad right and Arrow pad down.

ISO

Press the button to adjust the camera's ISO sensitivity. You have a choice of ISO values that range from Low (ISO 50) to ISO 25600, and AUTO (ISO-A).

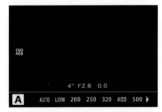

When you press the button, the screen shown in figure 18 will appear. Along the bottom of the screen is the range of ISO values you can select. Use the Arrow pad's left and right buttons to scroll back and forth until you find the ISO value you want to use. If you select AUTO, the camera will decide which ISO value to use, according to the level of ambient light it detects. My camera is set to ISO 400.

Figure 18: Choosing an ISO value

This function may be assigned to all assignable buttons.

Keystone Comp.

When you press the button, the camera enables the Keystone comp. screen. Your tiny E-M1 then acts like a big view camera, with its tilts, swings, and excellent perspective control.

You use the function while viewing the subject on the monitor, not later in post-processing. Keystone comp. allows you to correct the odd leaning-backwards perspective distortion you see when you point a wide-angle lens upwards to capture a tall subject

(vertical plane tilt). Additionally, you can use this function to correct perspective distortion on a horizontal plane (swing or shift). The results of this powerful function are easier to see than to describe, so let's examine how it works.

In figure 18A you can see my battery and blocks in a normal straight-on configuration. Notice that there are two adjustable indicators on the screen (red arrows). The top red arrow points to the tilt control, which allows you to tilt the top or bottom of the image toward or away from you. Tilt correction is applied with the Rear Dial. The bottom red arrow points to the swing control, which allows you to swing the left or right side of the image toward or away from you. Swing correction is applied with the Front Dial.

Figure 18A: Normal subject view with Keystone comp. function set to on

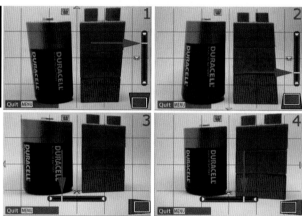

Figure 18B: Normal subject view with Keystone comp. function set to on

In figure 18B I used the tilt-swing features of the Keystone comp. function to make the subject swing left or right, or tilt from front to back, without moving the camera.

In image 1, the tilt indicator has been moved up toward the top of the scale, and the camera is tilting the top edge of the image toward you, while the bottom of the image stays the same.

In image 2, the tilt indicator has been moved down toward the bottom of the scale, and the camera is tilting the bottom edge of the image toward you, while the top of the image stays the same.

In image 3, the swing indicator has been moved to the left of the scale, and the camera is swinging the left side of the image toward you, while the right side of the image stays the same.

In image 4, the swing indicator has been moved to the right of the scale, and the camera is swinging the right side of the image toward you, while the left side of the image stays the same.

In figure 18C you can see a picture in which I used some vertical Keystone comp. correction to make the fire tower stand up straighter. I was standing below it with my wide-angle lens pointed upward.

Figure 18C: Keystone comp. correction in action

In the first frame the tower seems to be leaning away from you at the top. That's because the wide-angle lens is magnifying closer objects (the base of the tower) more than distant objects (the top of the tower).

In the second frame, notice how the camera has pulled the top of the image toward you, cutting off the edges of the frame to compensate, which tends to enlarge the subject a little. When you use this live function to make perspective corrections, you can see if the subject is cut off due to cropping, then you can make composition adjustments before you take the picture.

In the second frame, the fire tower is straighter, with a more normal perspective. I enjoyed using Keystone comp. much more than I expected. It corrects distortion without blurring the subject.

Note: When you have made your live Keystone comp. corrections, simply press the Menu button or touch the Shutter button to leave the Keystone comp. screen and take your pictures. Be sure to go back into the Keystone comp. task and set the correction indicators back to the center for horizontal and vertical correction, otherwise all future images will use Keystone correction until you turn the camera off and back on.

Also, when you are using Keystone comp. as a Button task, you cannot disable Keystone comp. with the function by that name in Shooting Menu 1.

Level Disp

Pressing the button turns on a small horizontal-only level display in the electronic viewfinder (EVF), replacing the −/+ exposure indicator scale.

The small leveling gauge is available only when you have the Built-in EVF style *(Custom Menu > J. Built-In EVF > Built-in EVF Style)* set to Style 1 or Style 2. It does not appear in Style 3 (see the subheading **Built-In EVF Style** on page 428, for more information on changing the EVF style of your camera).

You can use the Level Disp indicator to keep your camera level in a left-to-right direction, which is called roll (like with a car steering wheel). It does not work at all for forward or backward tilt (raising and lowering the front of the lens).

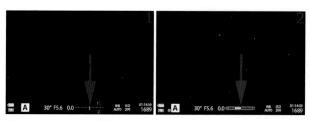

Figure 19: Using Level Disp

In figure 19, image 1, you can see the normal –/+ exposure indicator shown when the Built-in EVF Style is set to Style 1. When you press the assigned button, a small level indicator display replaces the –/+ exposure indicator display (figure 19, image 2).

From the reading on the Level Disp indicator in image 2, you can see that my camera was not level when the screen image was made. In fact, it was rotated a few degrees to the right.

Settings Recommendation: The new Level Disp indicator is useful for keeping the horizon level, if you don't mind using one of the retro Built-in EVF Styles.

A much more robust level indicator—showing both roll and tilt—is available when your subject appears on the monitor, by pressing the Info button multiple times until the dual indicator appears.

Live Guide

Pressing the button will open the Live Guide menu (figure 20) with six Live Guides (from top to bottom): Change Color Saturation, Change Color Image, Change Brightness, Blur Background, Express Motions, and Shooting Tips.

You can use these guides to change the appearance of your subject in various ways, before taking the picture; or, you may get Shooting Tips for various types of picture taking.

Figure 20: Using the Live Guides—opening screen

Let's consider each of the six Live Guides. I used a black background in the screen graphics to make the selections on the screen stand out. Normally, you would see your subject on the camera's monitor or in the viewfinder while you are making adjustments.

As seen in the next several graphics (e.g., figure 21, image 2), there is an adjustment slider available to make changes to the cameras settings. You will move the slider up or down. To move the slider use your finger on the camera's touch screen, the Arrow pad's up and down buttons, or turn the Rear Dial left and right:

Change Color Saturation: Change the color saturation on an image just before you make the picture.

Figure 21: Change Color Saturation

Select the top menu choice, as seen in figure 21, image 1, and press the OK button. Using the screen seen in figure 21, image 2, move the slider up toward Clear & Vivid (more saturation) or down toward Flat & Muted (less saturation). Press the OK button to set the value and then immediately take your pictures. The camera will stay set to the color saturation level you chose until you press the Menu button or turn the camera off.

Change Color Image: Change the color temperature of an image just before you make the picture. You can make the color warmer (more red) or cooler (more blue).

Figure 22: Change Color Image (color temperature)

Select the menu choice second from the top, as seen in figure 22, image 1, and press the OK button. Using the screen seen in figure 22, image 2, move the slider up toward Warm (reddish) or down toward Cool (bluish). Press the OK button to set the value and then immediately take your pictures. The camera will stay set to the color temperature you chose until you press the Menu button or turn the camera off. This is a fast way to modify the camera's white balance visually.

Change Brightness: Change the brightness of an image in real time, just before you make the picture.

Select the menu choice third from the top, as seen in figure 23, image 1, and press the OK button. Using the screen seen in figure 23, image 2, move the slider up toward Bright or down toward Dark. Press the OK button to set the value and then immediately take your pictures. The camera will stay set to the brightness level you chose until you press the Menu button or turn the camera off.

Figure 23: Change Brightness

Blur Background: Change the lens aperture by sliding the adjustment slider, while visually previewing depth of field (zone of sharp focus), just before you make the picture. A large aperture (Blur) will have less depth of field, blurring the background and foreground, while a small aperture (Sharp) will have more depth of field sharpening the background and foreground. The camera automatically adjusts shutter speed and ISO sensitivity to keep the exposure accurate while you are adjusting the aperture with the slider.

Figure 24: Change depth of field

Select the fourth menu choice from the top, as seen in figure 24, image 1, and press the OK button. Using the screen seen in figure 24, image 2, move the slider up toward Blur or down toward Sharp. Press the OK button to set the value and then immediately take your pictures. The camera will stay set to the visual depth of field value you chose until you press the Menu button or turn the camera off.

This function may be assigned to any assignable button, except for Arrow pad right and Arrow pad down.

Settings Recommendation: Blur Background is a useful method to change how much depth of field an image has, by adjusting it visually. This function may be used by macro shooters to adjust close up images with very shallow depth of field, or by a portrait shooter who wants to make sure there is enough depth of field to have a subject's face fully in focus. By moving the slider, you will be able to see the depth of field changing on the camera's monitor or in the viewfinder.

Consider this function to be a super-powered depth of field preview button. A new photographer can control the zone of sharpness in an image without fully understanding depth of field, because it is done visually. An experienced photographer can use this function for the luxury of fine-tuning depth of field in an accurate visual way.

To test the function, I took three pictures. One was a base test picture at the middle settings of 1/60 sec at f/8 and ISO 800. When I moved the slider all the way to the top (Blur), the camera selected 1/160 sec at f/2.8 and ISO 200, for very shallow depth of field (blurred background). When I moved the slider all the way to the bottom (Sharp), the camera selected 1/40 sec at f/16 and ISO 1600, for much deeper depth of field. It did not inform me of any of those settings, I got them from the resulting pictures (I'm a pedantically curious fellow). The camera adjusted shutter speed, aperture, and ISO so that depth of field could be fully controlled for blurred or sharp backgrounds (shallow or deep depth of field).

Express Motions: Control the camera's shutter speed by moving the adjustment slider (figure 25, image 2). The camera will give you no indication of what shutter speed you are using. However, by moving the adjustment slider toward the Blurred Motion choice, you are progressively slowing down the shutter speed. By moving the slider toward Stop Motion, you are progressively making the shutter speed faster.

The camera automatically adjusts the aperture and ISO sensitivity to keep the exposure accurate while you are adjusting the aperture with the slider.

Figure 25: Control motion

Select the fifth menu choice from the top, as seen in figure 25, image 1, and press the OK button. Using the screen seen in figure 25, image 2, move the slider up toward Blurred Motion or down toward Stop Motion. Press the OK button to set the value and then immediately take your pictures. The camera will stay set to the shutter speed you chose until you press the Menu button or turn the camera off.

Settings Recommendation: By varying the shutter speed you will be able to express subject motion, allowing blur with Blurred Motion or stopping action with Stop Motion. It is less apparent visually how fast the shutter speed is since it is used only during the exposure, so the function effect of this function will not be seen as easily on the monitor or in the viewfinder until after the picture is taken.

However, if you are shooting something like a waterfall and want to have wispy blurred water you can move the adjustment slider toward Blurred Motion and take your picture, experimenting visually with the results. If you are shooting action, you can set the camera toward Stop Motion and visually see how much the slider needs to be moved toward Stop Motion, from the resulting pictures.

I took a series of test pictures to see what the camera would do in this mode. My base test picture was at 1/100 sec at f/8.0 and ISO 800. When I moved the slider fully toward

Blurred Motion, the camera used 1/2 sec at f/22 and ISO LOW (ISO 50), thereby definitely allowing for blurred motion. In fact, the camera's shutter speed was so slow that it needed to be on a tripod to keep from ruining the image from camera shake. Few people can handhold a camera at 1/2 sec! Therefore, when you are shooting for blurred motion and it is not a bright day outside, you probably should have your camera on a tripod. When I moved the slider all the way toward Stop Motion, the camera used: 1/1600 sec at f/2.8 and ISO 1600, definitely in the range to stop most motion in its tracks.

Shooting Tips: Obtain special instruction from the camera on various photographic subjects including: Child, Pet, Flower, and Cuisine Photography. You will also find screens for suggestions on framing an image and using camera accessories.

Figure 26: Shooting Tips—opening screen

Select the last menu choice on the Live Guide menu—the Shooting Tips selection—as seen in figure 26, image 1, and press the OK button to open the secondary screen.

In figure 26, image 2, you can see four of the six available Shooting Tips icons. You can see only four because each icon is a large button with a small picture that represents the type of tip the choice will provide. The other two menu choices are accessed by scrolling down with the Arrow pad. Scroll up and down to select the type of instruction you want to receive. Pay attention to the text at the top of the screen, which describes the type of tips (i.e., Tips For Child Photo). Press the OK button to enter the chosen Shooting Tips screen. Each screen is very simple and requires little instruction to use. In each of the six upcoming graphics (figures 27 to 32) you will see the individual screens for Shooting Tips. We will use figure 26 as our sample; however, all six of the Shooting Tips screens work the same way. Press the OK button to open the actual Shooting Tips screen.

Figure 26, image 3, shows one of the actual Shooting Tips screens. Each of the Shooting Tips screens will have more than one screen full of tips for that subject.

There are from two to four instructional screens, as shown by a number at the top right of the actual tips screens (1/2, 1/3, or 1/4). You may access each successive tips screen by scrolling down. If there are only two Shooting Tips screens in the series for that type of Shooting Tips, and you scroll down a third time, the next Shooting Tips type will appear. In fact, you could simply select the screen shown in figure 26, image 3, and keep scrolling down until you have read all available Shooting Tips for all types of photography.

Following are six graphics, which show the selection screen and the first screen of tips for that Shooting Tips type.

Figure 27: Tips for Child Photo (two information screens)

Figure 28: Tips for Pet Photo (three information screens)

Figure 29: Tips for Flower Photo (four information screens)

Figure 30: Tips for Cuisine Photo (three information screens)

Figure 31: Tips for Framing (three information screens)

Figure 32: Tips for Camera Accessories (four information screens)

Settings Recommendation: These Shooting Tips are rather basic but do have good suggestions for the types of photography discussed. The number of actual tips are quite limited, thereby limiting the overall usefulness of this particular function.

Multiple Simultaneous Live Guide Settings: Beginning with firmware update 2.0, the camera allows you to select several of the Live Guide settings and use them at the same time on a single or multiple images.

Press the button assigned to the Live Guide task, and you will see the Live Guide selection screen. Use the method described in any of the Live Guide settings mentioned in this section to adjust the particular Live Guide value (e.g., Change Color Image, Blur Background). Afterward, you can use the screens shown in figure 32A to adjust and add another Live Guide value to the images you will take using Live Guide.

Figure 32A: Combining multiple simultaneous Live Guide settings

In figure 32A the camera has multiple Live Guide settings selected (figure 32A, image 2). In this case the Change Color Image (top arrow) and Blur Background (bottom arrow) settings are being combined in the image.

To select more than one Live Guide setting, you must configure the first setting, as previously described. Then you can touch the tab that sticks out on the right side of the screen, and the Live Guides will open again (figure 32A, image 1, red arrow).

The Live Guide setting you have already configured will have a yellow check mark to the right. Now configure any of the other Live Guide settings, and a yellow check mark will appear next to them as well. Touch the tab shown at the red arrow in screen 1 any time you want to see which Live Guide settings are currently in use. Take your pictures.

The camera will continue to use the Live Guide settings you have configured until you either press the Menu button to cancel the Live Guides or turn the camera off.

Note: Remember that you can cancel all current Live Guides by pressing the Menu button.

Magnify

Pressing the button opens a zoom frame, which is basically a less cluttered screen. Pressing it again immediately magnifies or zooms in on the image by ten times (10x). This lets you use autofocus or manual focus with great accuracy, while zoomed in.

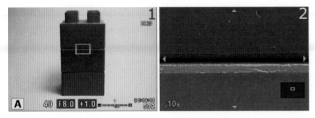

Figure 33: 10x zoom in at AF point on button press

While the zoom frame is active pressing the button toggles the zoom between 10x and normal subject view (figure 33). To get rid of the zoom frame, which tends to interfere with various other camera functions, simply press and hold the assigned button for a couple of seconds and the normal frame will appear. This function may be assigned to any assignable button, except for Arrow pad right and Arrow pad down.

Using MF Assist with Magnify: When the Magnify zoom frame is active and you have one or both of the subfunctions in *Custom Menu > A. AF/MF > MF Assist* (page 285) enabled, you can turn the focus ring on the lens manually and the camera will immediately use the features enabled under MF Assist. While using MF Assist you can use the Magnify and Peaking subfunctions to help you focus the camera.

The Magnify subfunction under MF assist works in a similar manner to the Magnify Button task that we are discussing in this section. The function is duplicated. However, where you would normally press the assigned button twice to magnify the image to 10x with the Magnify Button task, you can instead turn the lens focus ring when the image is not yet magnified and the zoom frame is active, which calls the extra MF assist functionality into play and allows you to use one or both of the MF Assist subfunctions (Magnify or Peaking).

In other words, the Magnify Button task allows you to zoom in to 10x for the best focusing, either by pressing the assigned button twice, or—if MF Assist is enabled—by turning the focus ring while the zoom frame is active and not already zoomed in. Enabling MF Assist adds focus peaking (Peaking), as well as an additional way to magnify the subject, to the Magnify Button task.

Settings Recommendation: I like the added functionality of having MF Assist enabled. I generally leave the *Custom Menu > A. AF/MF > MF Assist > Peaking* function constantly active because I like the accuracy that focus peaking gives me for manual focusing. Focus peaking easily replaces a split-prism focusing screen, which was used before the advent of autofocus.

MF

Press the button to toggle between the current autofocus setting and manual focus (MF). In other words, press the button once for MF and once again to return to the previous AF setting (e.g. S-AF, C-AF).

Figure 34: Toggling in and out of manual focus (MF) mode with a button press

At the point of the arrow in figure 34, image 1, you will see that the camera is set to S-AF mode. By pressing the button this function is assigned to, the camera immediately switched to MF mode, as seen in figure 34, image 2. This function may be assigned to any assignable button, except for Arrow pad right and Arrow pad down.

Settings Recommendation: If you frequently prefer to use manual focus and don't want to take the time to switch from AF to MF within a camera menu, this is a good function to assign to your favorite button. You can use AF until you need MF, and then quickly switch to MF with a single button press, toggling back to AF by pressing the assigned button again.

Multi Function

The camera provides four separate controls built into an assigned button. It is aptly named Multi Function due to its ability to provide multiple functionalities under one button. Here is a list of the functions:

Multi Function Control List

- **Highlight&Shadow Control:** Provides a standard curve scale to adjust highlights and shadows
- **Color Creator:** Creatively changes the colors in your image with an easy-to-use color wheel
- **Magnify:** Zooms in on your subject by 10 times (10x) for very accurate autofocus or manual focus
- **Image Aspect:** Selects from five image aspect ratios to change the horizontal and vertical size of your image

To access the Multi Function features, press and hold the assigned button while rotating the Rear Dial.

You will then see the screen shown in figure 35. While still holding the button down, continue rotating the Rear Dial to move through the control selections. When the control you want to use is highlighted in green, release the button.

Now that a selection has been made, you can access it with a single press of the assigned button (do not turn the dial), as seen in figure 36, image 2. The only time you will need to press the button and turn the dial again is

Figure 35: The four Multi Function controls (red arrow)

when you want to select a different one of the Multi Function controls. After a control is selected you simply have to press the button once to open that control.

Let's consider how each of the four functions within the Multi Function control works.

Highlights&Shadow Control: Hold the assigned button and rotate the Rear Dial until Highlight&Shadow Control is selected in green (figure 36, image 1). Now, release the button. From this point, any time you press the assigned button (no dial turn), with the camera's monitor or viewfinder active, the camera will present you with the Hi Light and Shadow adjustment screen, overlaying your subject on the screen.

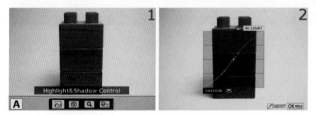

Figure 36: Adjusting the contrast ratio of the image (highlights to shadow)

Now, press the assigned button to open the Hi Light and Shadow adjustment screen (figure 36, image 2). Use this function to visually change the light to dark ratio (contrast) of the image using the Hi Light to Shadow curve scale (contrast ratio scale).

With your subject seen in the viewfinder or on the monitor, turn the camera's Front dial, which adjusts the Hi Light (brightness) of the image. You can adjust Hi Light up to +/−7 steps. You will see the top part of the curve move in response.

Turn the camera's Rear Dial to change the Shadow (darkness) of the image. You can adjust Shadow up to +/−7 steps. You will see the lower part of the curve respond.

A small icon will appear on the lower right side of the screen showing a small curve scale and the number of steps of adjustment (figure 37). This icon will stay on the screen until you reset the curve.

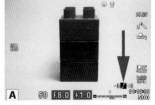

Figure 37: An active adjust to the contrast ratio is in effect

Since this is a visual process, you will be able to see how well the image looks on the monitor or in the viewfinder. After you make changes the camera remembers the high-lights to shadow curve you have created until you reset the function. The values you have entered on the curve scale stay in effect, even if you turn the camera off and back on. Therefore, if you use this control to change the contrast ratio of the camera, please remember to set the curve back to a straight line, which zeros out your changes, setting the camera back to its default contrast values. Or, you can open the Hi Light and Shadow adjustment screen and hold down the OK button until the contrast ratio curve resets back to a straight line.

Color Creator: Press the button to open the Color Creator control, which allows you to change the color balance of your image in very creative ways. You can adjust both the hue and saturation with the Color Creator.

Figure 38: Adjusting the color balance with the Color Creator control

In figure 38 you will see the Color Creator control set to three different states. In image 1 the control is set to neutral, with no adjustments made. Also, notice that the Color Creator is composed of two circles, an outer one and an inner one. The outer circle represent hue, and the inner circle represents saturation.

In image 2 the hue has been changed. Notice how the little dot with crosshairs and the dotted line running from the center of the circle has moved, like a clock hand, to about the 1 o'clock position. The position of the dotted line shows that the currently selected hue is in the yellow zone and is close to the reddish border between yellow and red. The position of the dot on the inner circle has not changed from neutral, signifying that the saturation is still at neutral. You will control the position of the dotted line's position on the outer circle with the camera's Front Dial. There are 30 positions (hue changes) avail-able around the outer circle as you turn the Front Dial, moving the dotted line a full 360 degrees around the circle.

In image 3, we see that the position of the dotted line has not changed; however, the bigger dot with cross hairs has moved toward the outer circle. This shows that the satura-tion has been increased. Moving the bigger dot toward the outer circle increases satura-tion, while moving it toward the center reduces saturation. There are 7 positions between the center of the circle and the outer circle, as represented with seven small dots on the dotted line. You will use the camera's Rear Dial to move the dot with crosshairs toward or away from the center of the circle. As you move the bigger dot with crosshairs along the

line of little dots, the saturation will change. When the dot with crosshairs is directly be-tween the center of the circle and the outer circle, the saturation is at neutral.

You can see that the saturation is at neutral in both images 1 and 2 of figure 38. Now, let's use the Color Wheel on an actual subject (figure 39).

Hold the assigned button and rotate the Rear Dial until Color Creator control is selected in green (figure 39, image 1). Now, release the button. From this point, any time you press the assigned button (no dial turn), with the camera's monitor or viewfinder active, the camera will present you with the Color Creator control adjustment screen, overlaying your subject on the screen (figure 39, image 2).

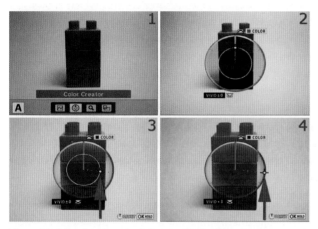

Figure 39: Adjusting the color balance with the Color Creator control

With the Color Creator at neutral, as seen in figure 39, image 2, turn the camera's Front Dial and you will notice that the dotted line moves around the outer circle.

In image 3 the dotted line is pointing well into the red hue, at a little past the 3 o'clock position. See how the background of image 3 (red hue position) is much redder than the background of image 2 (neutral position)?

Now, by turning the camera's Rear Dial so that the dot with crosshairs moves all the way out to the outer ring position (image 4), the red saturation of the image is greatly in-creased. If you were to turn the Rear Dial in the opposite direction, moving the dot with crosshairs toward the center, the saturation would decrease until you reached the center, at which point the image becomes monochrome.

Black-and-White Image: When you have the dot with crosshairs set to the center and the image set to monochrome, you can still affect the way the grayscale image renders the various colors into darker or lighter shades of gray, by turning the Front Dial (hue). This is better than using filters on the camera to adjust how a black-and-white image looks because it is all done visually.

Color Creator uses the Picture Mode: When I first started using the Color Creator, I was puzzled as to why the White Balance changed when I used the Color Creator. If you will notice, images 1 and 2 in figure 39 have distinctly different color temperatures.

When I selected the Color Creator in image 1, my camera was set to a direct white balance reading of the white background behind my Lego-block subject (under a small, warm fluorescent light). However, as soon as I selected the Color Creator and began to use it, I noticed that the white balance changed significantly. In figure 39, image 2 is much warmer than image 1. I didn't like the much warmer background color for this book so I went to select my saved previous white balance and couldn't. The camera was using WB Auto, and nothing I could come up with would make it change.

After several minutes of frustration, I found a sentence in small print in the E-M1 user's manual (page 58) which said, "The settings are stored under picture mode." Only then did I realize that, as soon as I selected the Color Creator, my camera stopped using the Natural Picture Mode I had selected previously and had switched, instead, to the Color Creator Picture Mode.

The point I want you to remember is this: if you are using Color Creator, the very act of selecting it sets the camera to WB Auto and switches away from whatever Picture Mode you were previously using to the Color Creator Picture Mode. Now, you should have no surprises when your white balance changes, even before you start using the Color Creator control to change it even more.

Indeed, the last settings you made with the Color Creator are saved inside the Color Creator Picture Mode so that you could select that mode again under Shooting Menu 1, and use those settings without switching to the Color Creator control.

Exiting Color Creator: When you are done with the Color Creator control and want to return to shooting with normal colors, you must have the Color Creator wheel displayed on the screen, then hold the OK button to reset the Color Creator back to normal color. Afterward, you can cancel Color Creator by pressing the Menu button.

Magnify: You can use this control to magnify your subject (zoom in) by ten times (10x) for very accurate autofocus or manual focus. This setting is exactly the same as the Magnify setting we considered previously in this list. The only difference is that you get to the Magnify control through the Multi Function setting instead of directly assigning Magnify to a button.

Hold the assigned button and rotate the Rear Dial until Magnify is selected in green (figure 40, image 1). Now, release the button. From this point, any time you press the assigned button (no dial turn) with the camera's monitor or viewfinder active, the camera will present you with the Magnify screen, overlaying your subject on the screen (figure 40, image 2).

Figure 40: Using Magnify from the Multi Function Group

Press the assigned button and you will see the screen shown in figure 40, image 2 appear. To magnify the subject by 10x for accurate focusing, place the camera's AF Area Pointer over the area you want to magnify and press the assigned button again. You will now see an extreme closeup of your subject, as shown in image 3. Pressing the button repeatedly will toggle the 10x magnification on and off.

Image Aspect: The camera has five different image aspect ratios, which change the relationship of the length of the image's sides to each other. A regular Micro Four Thirds images uses a 4:3 aspect ratio. The camera also offers: 16:9, 3:2, 1:1, and 3:4.

Hold the assigned button and rotate the Rear Dial until Image Aspect is selected in green (figure 41, image 1). Now, release the button. From this point, any time you press the assigned button (no dial turn) with the camera's monitor or viewfinder active, the camera will present you with the Image Aspect adjustment screen, with selections below your subject (figure 40, image 2).

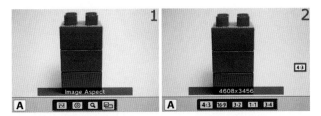

Figure 41: Changing the Image Aspect ratio of the image

Press the assigned button and you will see the screen shown in figure 41, image 2 appear. It offers you five separate Image Aspect ratios. Figure 41, image 2 (and Figure 42), shows all the Image Aspects you can choose from by turning the Rear Dial on the camera.

The 4:3 ratio is the normal shape for a Micro Four Thirds camera. The 16:9 ratio more closely fits displays on an HDTV, tablet, smart phone, or newer computer monitor. The 3:2 format matches the format most often seen from the 35mm world. The 1:1 ratio is square, like a Hasselblad medium format camera. The final format 3:4 is a vertical format in the same shape as a normal Micro Four Thirds image.

Figure 42: Various Image Aspect ratios for the E-M1

Settings Recommendation: I like to keep the unusually named Highlight&Shadow Control active on my camera because I enjoy fine-tuning the exposure. However, if you are more concerned with color balance, you may want to use Color Creator. You can also select the Magnify function for when you want to zoom in by 10x, or you may even want to change the image aspect ratio away from the standard Micro Four Thirds (4:3) to a different aspect ratio, such as 1:1 (square) or 3:2 (matching most 35mm cameras. There are four functions in this Multi Function group. You have access to all four of them with a button press and Rear Dial turn.

Myset1–Myset4

Press the button to load the previously saved camera configuration found in one of the four Myset memory locations (Myset1–Myset4). Each of the four Mysets must be individually assigned to a button. Therefore, you have Myset1 (My1) to Myset4 (My4) available for assignment.

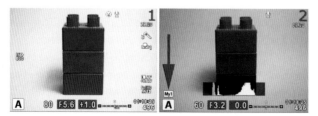

Figure 43: Loading a Myset configuration to the camera's active memory

Figure 43, image 1, is what was on my camera's screen before I pressed the assigned button to load in a Myset value, and image 2 is after I pressed the assigned button. At the

arrow in figure 43, image 2, you can see that I have loaded Myset1 (My1) into the camera's active memory because the My1 symbol has appeared. From the orange-looking background in image 2 it is clear that the white balance stored in Myset1 (My1) is different from the white balance I was previously using to shoot the Lego blocks in image 1. Also, in image 2 the Live Histogram is enabled, where it wasn't previously.

This function may be assigned to any assignable button, except for Arrow pad right and Arrow pad down.

[One-touch WB] (flower symbol)

This function is different from the WB setting considered previously in this list, which lets you choose from the camera's preset WB values (e.g., Sunny, Shadow, Cloudy). Instead, by pressing the assigned button, you can do an immediate white balance reading from a white card or other white object by pointing the lens at it and taking a picture. No picture is actually recorded to the camera's memory card, only a WB reading is taken. You can then save the newly determined white balance to one of four Capture WB memory locations (1–4) for recall later from the standard WB choices. You'll find this saved Capture WB in the menu that opens when you press the OK button with your subject appearing on the monitor or in the viewfinder.

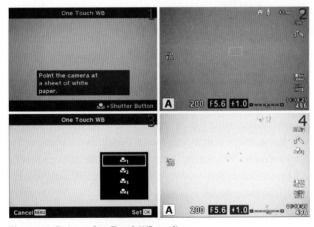

Figure 44: Doing a One Touch WB reading

In figure 44, image 1, the assigned button has been pressed and the camera is ready for making a white balance reading. From the orange color you can see that a white balance reading is truly needed. The white area is not white.

In image 2, the shutter button has been partially pressed and the camera is preparing to take the white balance reading.

Image 3 shows the screen that appears just after a WB reading has been taken. You must select one of the four locations to store the new WB value. You can also see from the white color, instead of orange, that the camera has set the white point correctly.

Image 4 shows the camera's monitor after the new WB reading has been saved. The new WB value will remain in use by the camera until you change it to a different white balance.

This function may be assigned to any assignable button, except for Arrow pad right and Arrow pad down.

Peaking

Pressing the button toggles Peaking on and off. If you are using a focus mode such as S-AF+MF or MF, you could use the button to turn Peaking on and then use it for either fine tuning the AF or during manual focus for MF. Peaking is a white border that appears on your subject's edges so that you can see when the image is in focus. When you turn the focus dial on your camera's lens, you can see the area of sharp focus moving forward and backward as the peaking outline moves. If the edges of your subject are white, it is in focus.

Figure 45: Using Focus Peaking for manual focus

Figure 45, image 1 shows the subject before the assigned button is pressed. Image 2 shows the subject after the assigned button is pressed. Do you see how the camera slightly darkens the background and puts a white border around the edges in the subject when it is in focus? The white in-focus edge enhancement will show on any edge the camera can find in the subject as it comes into focus. If the white border is not present the subject is not in best focus. Turn the focus dial on your camera's lens until you see the border appear on the area you want to be in focus.

Although this is much easier to see than describe, Peaking is a very accurate way to manually focus your camera.

This function may be assigned to any assignable button, except for Arrow pad right and Arrow pad down.

Preview

Press the button to cause the camera to close the aperture (stop down) to the currently selected aperture value so that you can preview the depth of field that aperture provides. You will be able to see the zone of sharp focus displayed in the viewfinder or on the monitor.

Figure 46: Previewing depth of field

Notice in figure 46, image 1, that the focus is set just in front of the subject, not on it, which means the subject is not in focus and is blurry. In image 2, the assigned button is pressed and held, previewing depth of field. The small aperture of f/16 has enough depth of field to cover the subject with sharpness, even though the camera is not focused directly on the subject. See how the subject is sharp in image 2, even though the focus position has not moved at all. In other words, the smaller aperture has sufficient depth of field to cause the subject to be sharp, even though it is slightly out of focus.

You may also notice that the screen does not darken when you press the depth of field preview button, even though the smaller aperture lets in less light. This is one of the features of an electronic viewfinder (EVF) compared to an optical viewfinder (OVF). The EVF adjusts its brightness automatically so that you can continue viewing your subject normally, where on a camera with an OVF, the screen would darken appreciably, making it more difficult to see the actual depth of field.

This function may be assigned to any assignable button, except for Arrow pad right and Arrow pad down.

RAW

Press the button to toggle between JPEG and JPEG+RAW Record Modes, according to which JPEG mode is set currently in *Shooting Menu 1 > [Record Mode] > Still Picture*.

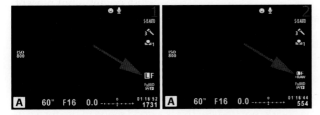

Figure 47: Quickly switching between RAW and JPEG+RAW modes

For instance, if Large Fine (LF) JPEG is set under Still Picture, the camera will toggle between LF and LF+RAW when you press the button (figure 47). This function may be assigned to any assignable button, except for Arrow pad right and Arrow pad down.

Rec

Press the button to record a video (Movie). This function is assignable to the Movie button only (figure 48).

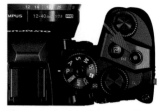

You can assign one of the other button functions to the Movie button, if you prefer; however, that will prevent you from shooting videos with the camera since there will be no button available to start the video recording.

Figure 48: Rec can be assigned to the Movie button only

Setting Recommendation: If you don't shoot video, then the Movie button is fair game to assign to other button functions. If you do shoot video, it may be best to leave Rec assigned to the Movie button since it cannot be assigned to any other button.

[Sequential shooting/Self timer]

When you press the Arrow pad key to which you have assigned this function (right or down Arrow pad buttons only), you can select a Sequential shooting or Self timer mode.

Press the assigned button on the Arrow pad (right or down) and then scroll left or right to select one of the modes from the menu at the bottom of the screen (figure 49).

This function uses the symbols for Sequential shooting and the Self timer. It can be assigned to the Arrow pad right or Arrow pad down button only, and only when you have the main Arrow pad's [◄▲▼►] Func-

Figure 49: Select a Sequential/Self timer mode

tion *(Custom Menu > B. Button/Dial/Lever > Button Function > [◄▲▼►] Function)* set to Direct Function mode.

Here is a list of the items available on the menu:

- **Single** (Single-frame shooting): The camera will take on picture for each press of the Shutter button.
- **Sequential H:** Pictures are taken at about 10 frames per second while the Shutter button is held down. The autofocus, exposure, and white balance are locked at the values determined in the first frame and do not update. This is a good mode to use for a subject moving left to right, or vise versa, relative to the photographer. It is not a good mode for a subject moving toward or away from you, into and out of dark and bright areas, or into and out of areas with different types of lighting.
- **Sequential L:** Pictures are taken at about 6.5 fps with firmware 2.0 or 9 fps with firmware 3.0 while the Shutter button is held down. The autofocus, exposure, and white balance all update normally, according to your camera's settings.

- **[Self-timer] 12 sec:** Press the Shutter button halfway down to initiate autofocus and then press it all the way down to start the timer. The shutter will release after 12 seconds have expired. The Self-timer lamp (AF illuminator) will shine solidly until 10 seconds have passed. For the last couple of seconds it will blink. Then the picture is automatically taken.
- **[Self-timer] 2 sec:** Press the Shutter button halfway down to initiate autofocus and then press it all the way down to start the timer. The shutter will release after 2 seconds have expired. The Self-timer lamp (AF illuminator) will blink during the 2-second count-down. Then the picture is automatically taken.
- **[Self-timer] C** (Number of Pictures): The C in the label stands for Custom. See the up-coming **Self-Timer Custom** subheadings for more information.

Self-Timer Custom: This function allows you to choose the number of pictures you want to shoot, with a one-second delay between each picture.

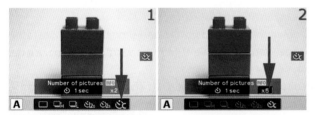

Figure 50: Choosing the number of frames to shoot with a 1 sec delay

Press the assigned button to open the Sequential shooting and Self-timer screen and then scroll left or right with the Arrow pad until [Self-timer] C is selected (figure 50, image 1).

Press the Info button and then turn either of the camera's dials to adjust the Number of pictures value (e.g., x2). My camera is set to x5 (figure 50, image 2), which means that once I press the Shutter button all the way down, the camera will fire 5 frames with a one-second delay before each frame. This allows time for vibrations to die down and is a good substitute for an external shutter release wire. With this function you can do hands-off shooting of from 1 to 10 frames (x1 to x10).

Self-timer Custom and Bracketing: An undocumented feature of this camera is that you can use the Self-timer Custom function in conjunction with the camera's bracketing (BKT) capability. If you will set the camera to Bracketing mode (see previous **BKT** sub-heading), and then set the custom Number of pictures to match the number of frames in the bracket, the camera will use both functions to fire the bracketed series. You can have a hands-off bracketing session with a one-second delay before each picture. This is a very powerful feature for those who bracket frequently!

Be sure to turn off Bracketing and the Self-timer when you are done shooting the self-timed bracket series.

Test Picture

Holding down the button while also pressing the Shutter button will take a test picture that will display on the camera's monitor for you to examine closely. However the picture will not be written to the camera's memory card.

Figure 51: Making a temporary Test picture

When you hold down the assigned button, the word TEST will appear in an orange rectangle at the bottom right of the screen (figure 51, image 1).

When you continue to hold down the assigned button and simultaneously press the Shutter button, a picture will appear on the monitor, with the word TEST in an orange rectangle (figure 51, image 2).

This image will not be written to the memory card and it is, therefore, a temporary image you can use to see how the camera settings affect the subject of your picture. This function is especially useful for studio shooters.

This function may be assigned to any assignable button, except for Arrow pad right and Arrow pad down.

[Touch Panel] Lock

Press and hold the button for about two seconds to enable or disable (toggle) the touch panel capability for the camera's rear monitor.

Figure 52: Locking the camera's Touch Panel capability

The Touch Panel capability is enabled when the Touch Panel symbol is seen on the monitor (figure 52, image 1). Image 2 shows the monitor with Touch Panel disabled.

This function is available for the Arrow pad right and Arrow pad down buttons only, and only when you have the main Arrow pad [◀▲▼▶] Function *(Custom Menu >*

B. Button/Dial/Lever > Button Function > [◄ ▲ ▼ ►] Function) set to Direct Function mode.

[Underwater Zoom] (Framed Fish Symbols)

Press and hold the button for a couple of seconds to enter Underwater Zoom mode. Afterward, you can press the button to toggle between wide-angle and telephoto zoom positions while an underwater camera housing is attached, if you are using a lens with power zoom capability—such as the M.Zuiko ED 12–50mm f/3.5–6.3 EZ.

It is impossible to zoom a lens in and out in most underwater housings. Therefore, this mode has been provided to give you a way to zoom from wide to telephoto and back.

Figure 53: Using the E-M1 in an underwater housing, zooming in and out, plus WB values

When the camera enters this mode, you will see a small square symbol with three fish in the lower left corner of the screen (figure 53, image 1). As you can tell from the subject, the power-zoom lens is zoomed to wide-angle mode.

If you press the button again, the power-zoom lens will zoom to telephoto and the symbol in the lower left corner of the screen will change from three fish to one fish (figure 53, image 2).

Also, please note that the camera is using underwater white balance in this mode, which from the appearance of the image background is quite warm. That makes perfect sense because light underwater is quite blue looking and needs warming up. The symbol for underwater white balance is the letters WB above a tiny bubble-blowing fish (figure 53, image 2, arrow on right).

Note: If this option is selected, the small, accessory FL-LM2 flash unit will fire even when it is not raised. When using a lens with power zoom, the lens will automatically zoom to wide-angle or telephoto when the button is pressed. This function may be assigned to any assignable button, except for Arrow pad right and Arrow pad down.

WB

Press the button to assign the current white balance (WB) by choosing from a list of preset WB values (e.g., Sunny, Shadow, Cloudy), Capture WB values (1–4), or directly input a Kelvin color temperature (CWB).

Normally, you will choose white balance by pressing the OK button while viewing your subject and selecting WB from the menu on the right of the screen. However, with this function you may assign WB to a button you find more convenient.

Press the assigned button and you will see the WB screen with a menu of selections at the bottom. Scroll left or right until you find the WB type you want to use. It is selected when you have highlighted it in green. The

Figure 54: Choosing WB in an alternate way

name of the WB type will appear just above the menu of selections, where WB Auto is showing in figure 54. Here is a list of WB types:

- **Auto:** The camera chooses the correct WB.
- **Sunny:** Use this WB setting for bright sunny days when your subject is in direct sunlight.
- **Shadow:** Use this WB setting when the sun is out but your subject is in the shade. This WB tends to warm the image up a little (adds red) to counteract the blue normally found in shadow.
- **Cloudy:** On an overcast day the image can appear very cool and bluish. This setting warms the image by adding red, removing the cool appearance.
- **Incandescent:** Incandescent lights make your subject appear quite reddish orange when photographed. This WB setting cools down the subject by removing red from the image.
- **Fluorescent:** This type of lighting often will cause a sickly, yellowish-green color to tint your images (blue deficit). The camera counteracts this look by adding blue.
- **Underwater:** When taking pictures underwater the images are often too cool looking because of the prevalence of blue light wavelengths. The camera counteracts the bluish look by warming up the image (adding red).
- **Flash:** The camera sets the white balance for use with electronic flash units.
- **Capture WB1** to **Capture WB4:** These four WB settings are user created. You will use a direct white balance reading by pointing your camera at a white card under the ambient light source and pressing the button assigned to One Touch WB. After a reading is made from the white card, the value can be stored in one of the four Capture WB memory locations for later recall. See the previous information in this list under the subheading **[One-touch WB] (flower symbol)**.
- **CWB:** Use this setting to manually choose a Kelvin WB value from 2000K to 14000K. See the upcoming subheading **CWB White Balance**.

CWB White Balance: The CWB setting is used to input a WB value from a range of Kelvin color temperatures. It allows you to choose a particular white balance very accurately. This is quite useful when you are working in a studio and you know the exact Kelvin temperature of the lighting you are using.

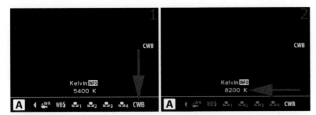

Figure 55: Directly choosing a WB value in Kelvin (2000K–14000K)

To use the manual Kelvin color temperature entry provided by the CWB setting, press the assigned button, and then scroll left or right with the Arrow pad until you highlight CWB in green (figure 55, image 1). As you can see under the words Kelvin (Info), the camera's default CWB Kelvin temperature is 5400K.

Next, you must press the Info button to let the camera know you want to change the CWB value. Once you have pressed the Info button simply turn either of the camera's dials until the Kelvin color temperature you want to use is dialed in. My camera has 8200K dialed in at the point of the arrow in figure 55, image 2. That is a very warm temperature and will make a red cast in the image.

Again, you can choose from 2000K (very cool and bluish) all the way up to 14000K (very warm and reddish). This function may be assigned to all assignable buttons.

Index

ROCKYNOOK.COM

Don't close
the book on us yet

Interested in learning more on
the art and craft of photography?

Looking for tips and tricks
to share with friends?

Visit

rockynook.com/information/newsletter

for updates on new titles, access to free
downloads, blog posts, our eBook store,
author gallery, and so much more.

 @rocky_nook